short guide / Kurzführer

Frances Colpitt

X

documenta X 21. Juni bis 28. September 1997
June 21 – September 28, 1997

cantz

Contents / Inhalt

This guide had to be finished several weeks before the opening of documenta, at which time certain projects had not yet taken their definitive form. This concerns particularly the artists: Cabelo, Bruna Esposito, Patrick Faigenbaum, Jozef Legrand, Feng Mengbo. Some of the following descriptions may also be incomplete or no longer entirely accurate. For the same reasons, the list of works provides technical information only for the pieces reproduced here. For these shortcomings we can only request the reader's understanding.

Die Redaktion dieses Kurzführers mußte mehrere Wochen vor Eröffnung der *documenta* abgeschlossen werden. Zu diesem Zeitpunkt waren einige Projekte noch nicht vollständig ausgearbeitet, Informationen fehlten zwangsläufig noch. Dies betrifft insbesondere die Künstler: Cabelo, Bruna Esposito, Patrick Faigenbaum, Jozef Legrand, Feng Mengbo. Aus diesem Grunde auch sind möglicherweise einige Angaben im Folgenden unvollständig oder nicht mehr in vollem Maße gültig. Aus demselben Grunde enthält die Werkliste nur technische Angaben für die im Kurzführer abgebildeten Werke. Wir bitten dafür den Leser um Verständnis.

Introduction / Vorwort

What can be the meaning and purpose of a documenta today, at the close of this century, when similar large-scale exhibitions have been called into question, and often for very good reasons? It may seem paradoxical – or deliberately outrageous – to envision a critical confrontation with the present in the framework of an institution that over the past twenty years has become a mecca for tourism and cultural consumption. Yet the pressing issues of today make it equally presumptuous to abandon all ethical and political demands.

In the age of globalization and of the sometimes violent social, economic, and cultural transformations it entails, contemporary artistic practices, condemned for their supposed meaninglessness or "nullity" by the likes of Jean Baudrillard, are in fact a vital source of imaginary and symbolic representations whose diversity is irreducible to the (near) total economic domination of the real. The stakes here are no less political than aesthetic – at least if one can avoid reinforcing the mounting spectacularization and instrumentalization of "contemporary art" by the culture industry, where art is used for social regulation or indeed control, through the aestheticization of information and forms of debate that paralyze any act of judgment in the immediacy of raw seduction or emotion (what might be called "the Benetton effect").

Overcoming the obstacle means seeking out the current manifestations and underlying conditions of a critical art which does not fall into a precut academic mold or let itself be summed up in a facile label. Such a project cannot ignore the upheavals that have occurred both in documenta's institutional and geopolitical situation since the inaugural exhibition in 1955 and in the recent developments of aesthetic forms and practices. Nor can it shirk the necessary ruptures and changes in the structure of the event itself.

Given...

In many respects, the history and the political and cultural project of documenta belong to the now-vanished era of postwar Europe, shaped by the Cold War and the world's division into two power blocs, and brought to a close by the fall of the Berlin wall and German reunification. The specific project of documenta also resulted from the progressive ideas of a local artist, Arnold Bode, and from the "exemplary" situation of Kassel, a city close to the eastern border, and almost entirely reconstructed after the 1943 bombing. 1955 was a time for reconciliation, indeed for expiation and redemption by means of modern art, which may explain the close association of the work and personality of Joseph Beuys with the history of the exhibition,

Welchen Sinn und Zweck kann heute, am Ende des 20. Jahrhunderts, eine documenta haben, zu einer Zeit, in der die großen Ausstellungen, und zwar aus oft sehr berechtigten Gründen, in Frage stehen? Will man im Rahmen einer Institution, die sich im Laufe der letzten zwanzig Jahre zu einer Hochburg des Kulturtourismus und des Kunstkonsums entwickelt hat, eine Veranstaltung durchführen, die sich als kritische Auseinandersetzung mit der Gegenwart versteht, kann das leicht nicht nur als paradox erscheinen, sondern auch wie eine gezielte Provokation wirken. Doch angesichts der drängenden Fragen der Zeit wäre es mehr als inkonsequent, auf jeden ethischen und politischen Anspruch zu verzichten.

In einer Zeit der Globalisierung und der sie begleitenden, manchmal gewaltsamen wirtschaftlichen, gesellschaftlichen und kulturellen Veränderungen repräsentieren die heute wegen ihrer angeblichen Bedeutungslosigkeit oder »nullité« (Jean Baudrillard) unterschiedslos verdammten zeitgenössischen Praktiken eine Vielfalt symbolischer und imaginärer Darstellungsweisen, die nicht auf eine (fast) gänzlich der Ökonomie und ihren Bedingungen gehorchende Wirklichkeit reduzierbar sind; sie besitzen damit eine ebenso ästhetische wie politische Potenz. Diese Potenz vermag allerdings nur dann fruchtbar zu werden, wenn sie nicht dazu mißbraucht wird, die im Rahmen der Kulturindustrie ständig zunehmende Instrumentalisierung und Vermarktung der »zeitgenössischen Kunst« und ihre darauf abgestimmte Zurichtung zum Spektakel noch zu verstärken und auch nicht einer »gesellschaftlichen« Regulierung oder gar Kontrolle dient (durch die Ästhetisierung von Information oder durch Pseudodebatten, die jegliche Urteilskraft in der Unmittelbarkeit von Verführung oder undifferenzierten Gefühlen ersticken – das, was man den »Benetton-Effekt« nennen könnte). Eine weitere Voraussetzung dafür ist die Erkenntnis der Formen und der aktuellen Bedingungen der Möglichkeit einer kritischen Kunst, die nicht auf akademische und mit einem Etikett versehene Formen reduzierbar ist.

Das Projekt einer unter diesen Voraussetzungen veranstalteten zehnten documenta kann weder die seit der ersten Ausstellung 1955 eingetretenen institutionellen und geopolitischen Umwälzungen ignorieren noch die jüngsten Entwicklungen, Veränderungen und unvermeidlichen Brüche in den ästhetischen Formen und Praktiken, in der Struktur der Veranstaltung selbst.

Etant donnés – Voraussetzungen

Das politische und kulturelle Projekt »documenta« ist in mancher Hinsicht insofern Geschichte, als es zur europäischen Nachkriegszeit gehört, zur Zeit des Kalten Krieges und der Teilung der Welt in zwei Blöcke, die mit

from the third edition in 1963 all the way to Beuys'
death at the time of documenta 8 in 1987. Documenta
also provided an occasion for the necessary reconstruc-
tion of the modern tradition and the history of the
vanguards, condemned by the Nazi regime with the
exhibition of Degenerate Art in Munich in 1937. But this
reconstruction remained incomplete, skipping over
dada and the radical forms that emerged in the Wei-
mar period to concentrate on the most recent develop-
ments of abstraction, which had reached their apogee
in America. Thus the early versions of documenta
appeared as a cultural showcase for the Marshall Plan
in the country that had become the privileged center-
piece of the newly forged alliance between northern
Europe and the United States. In the 1960s documenta
became the largest international show of contempo-
rary art. Harald Szeeman transformed the exhibition
into a hundred-day event attending to the aesthetic
"forms" and "attitudes" of the period; but his striking
synthesis of the major proposals of the 1970s did not
succeed in reversing the directions that documenta had
taken. The versions that followed struggled to concili-
ate an aesthetic demand with the imperatives of the
culture industry, and, soon enough, with the new eco-
nomic and geopolitical situation of Germany and of
Europe in the context of globalization.

In reality, the "new world disorder" commenced in
the 1970s with the oil shock and the transition to what
the geographer David Harvey describes as an economy
of "flexible accumulation." Nonetheless, it is 1989 that
symbolically marks the end of the Cold War and the
beginning of a new era of "hot wars," in Günter Grass's
phrase. The visible division of the world into two blocs
has been replaced by a complex network of exchanges
in which American hegemony is relativized by the Euro-
pean Union and the rising power of East Asia, while
the future remains uncertain for the former USSR,
China, and most of the Arab, Muslim, and African
countries. In Europe, the globalization of markets exac-
erbates the economic and social dysfunctions brought
on by the crisis of what Etienne Balibar calls "the
national social state" that developed after the war; the
result is an upsurge of nationalism and identity fixa-
tions. In this new context, the city of Kassel, now
located in the center of reunified Germany and seri-
ously affected by the current recession, can appear as
the "exemplary" site of an entire range of rifts and dis-
placements, and as the focus of a political and aes-
thetic inquiry that we have attempted to inscribe in
the very structures of documenta X.

dem Fall der Mauer und der deutschen Wiedervereini-
gung zu Ende ging. In der Nachkriegszeit kamen in Kas-
sel zwei Dinge zusammen, die die Verwirklichung des
Projekts begünstigten: einerseits die fortschrittlichen
Ideen und Ziele eines ortsansässigen Künstlers, Arnold
Bode, und andererseits die »exemplarische« Situation
der nun fast an der Grenze zwischen den beiden
Blöcken liegenden Stadt, die nach ihrer weitgehenden
Zerstörung durch die Bombenangriffe 1943–1945 fast
vollständig neu wiederaufgebaut wurde. Die erste
documenta 1955 stand unter dem Zeichen der Versöh-
nung durch die und mit der modernen Kunst und der
Wiedergutmachung an ihr (und von daher ist es nicht
überraschend, daß das Werk und die Person von Joseph
Beuys mit der Geschichte der documenta seit 1963,
documenta 3, bis zu seinem Tod 1986, vor der docu-
menta 8, so eng verbunden ist). Diese erste documenta
hatte die Aufgabe, die moderne Tradition und die
Geschichte der Avantgarde zu rekonstruieren, die vom
Naziregime (exemplarisch mit der 1937 in München
organisierten Ausstellung »entarteter Kunst«) abgeur-
teilt und systematisch verfolgt worden war. Es wurde
eine unvollständige Rekonstruktion, die den Dadaismus
und die in der Weimarer Zeit entwickelten radikalen
Formen überging, um sich direkt den neueren Entwick-
lungen auf dem Gebiet der Abstraktion zuzuwenden,
vor allem in ihren amerikanischen Spielarten. Die docu-
menta machte daher bei den ersten Veranstaltungen
eher den Eindruck, als fände sie in einem Deutschland
statt, das sich im Zuge seines Wiederaufbaus allmählich
zur bevorzugten Stütze der Amerikaner in Europa ent-
wickelte, als wäre sie ein »Kulturschaufenster« des
Marshallplanes. In den sechziger Jahren wurde sie zur
größten der zeitgenössischer Kunst gewidmeten inter-
nationalen Veranstaltungen. 1972 wurde Harald Szee-
mans Ausstellung ein hundert Tage dauerndes Ereignis,
das sich stärker mit den aktuellen ästhetischen »For-
men« und »Einstellungen« der Zeit auseinandersetzte.
Seine documenta machte mit ihrem Überblick über die
Hauptideen der siebziger Jahre Epoche, doch es gelang
ihm nicht, der Entwicklung, die die Veranstaltung ein-
mal genommen hatte, wirklich nachhaltig eine neue
Richtung zu geben. Die folgenden Ausstellungen ver-
suchten, einerseits einem ästhetischen Anspruch und
andererseits den Forderungen der Kulturindustrie
gerecht zu werden, und sie standen auch schon bald
vor dem Problem, der neuen wirtschaftlichen und geo-
politischen Situation Deutschlands und Europas im Kon-
text der Globalisierung Rechnung zu tragen.

Die »neue globale Unordnung« begann zwar bereits
mit der Ölkrise und dem Übergang zu einer »flexiblen
Akkumulation« des Kapitals (David Harvey) in den sieb-
ziger Jahren, doch symbolisch markiert das Jahr 1989
das Ende des Kalten Krieges und den Beginn einer

Retroperspectives

While making no concessions to the commemorative trend, the last documenta of this century can hardly evade the task of elaborating a historical and critical gaze on its own history, on the recent past of the post-war period, and on everything from this now-vanished age that remains in ferment within contemporary art and culture: memory, historical reflection, decolonization and what Wolf Lepenies calls the "de-Europeanization" of the world, but also the complex processes of postarchaic, post-traditional, postnational identification at work in the "fractal societies" (Serge Gruzinski) born from the collapse of communism and the brutal imposition of the laws of the market. Facing these problems also means reconsidering, from a timely and even programmatic perspective, certain major proposals that appeared in the 1960s in the work of artists who were born before, during, or immediately after the war, some of whom died prematurely (Marcel Broodthaers, Öyvind Fahlström, Gordon Matta-Clark, Hélio Oiticica), and almost all of whom began their work around the time of the first documenta (Gerhard Richter, Michelangelo Pistoletto, Richard Hamilton, Aldo van Eyck). For most of these figures, the critical dimension appears in a radical questioning of the categories of the "fine arts" and of the anthropological foundations of Western culture, through a subversion of the traditional hierarchies and divisions of knowledge: a critique of the primacy of the visual and a projection of language and its games into three-dimensional space with Broodthaers; an exposure of the economic perversion of spatial operations with Matta-Clark; an inversion of center and periphery through the emergence of "marginal" values with Oiticica; an extraordinarily playful dramatization of political and economic power relations with Fahlström; a poetic transformation of dogmatic, reductive modernism through the critical reactivation of the formal and spatial solutions of non-Western architecture with Aldo van Eyck. At a time when advertising, television, the new media, and the digital sophistication of virtual worlds are "swallowing the real in its spectacular representation" (Gruzinski), it seems particularly appropriate to foreground the processes of analysis and distancing at work in the practices of drawing and of documentary photography since the 1960s and sometimes even before (Maria Lassnig, Nancy Spero, Walker Evans, Garry Winogrand, Helen Levitt, Robert Adams, Ed van der Elsken). These practices find significant (if indirect) developments in the works of Martin Walde, William Kentridge, Jeff Wall, Craigie Horsfield, James Coleman, Johan Grimonprez, and Anne-Marie Schneider, who have been able to discover contemporary forms of non-spectacular dramatization.

neuen Ära der »heißen Kriege« (Günter Grass). Die deutlich erkennbare Aufteilung der Welt in zwei Blöcke ist durch ein komplexes Kräftefeld und ein globales Netz internationalen Austauschs ersetzt worden. Die Vormachtstellung der USA in diesem Kräftefeld wird durch die europäische Einigung und die neue Machtstellung Ostasiens relativiert, während sich andererseits eine ungewisse Zukunft der ehemaligen UdSSR, Chinas, eines großen Teils der arabischen und moslemischen Länder sowie Afrikas abzeichnet. In Europa verstärkt die Globalisierung der Märkte die wirtschaftlichen und sozialen Dysfunktionen, die mit der Krise des in der Nachkriegszeit entwickelten Modells vom »sozialen Nationalstaat« (Etienne Balibar) verbunden sind und die den Aufstieg des Nationalismus und die damit zusammenhängende krampfhafte Identitätssuche förderten. In diesem neuen Kontext vermag Kassel, das nun im Zentrum des wiedervereinten Deutschland liegt und ernsthaft von der Rezession betroffen ist, wiederum als »exemplarischer« Ort zu dienen – als Ort, der die vielfältigen Verschiebungen und die politischen und ästhetischen Auseinandersetzungen repräsentiert, die wir in die Strukturen der Veranstaltung hineinzutragen versucht haben, wenn wir sie schon nicht in sie übersetzen konnten.

Retroperspektiven

Die letzte documenta des Jahrhunderts mußte sich – ohne dem modischen Trend zur Jubiläumsfeier zu verfallen – die Aufgabe stellen, einen kritischen Blick auf die Geschichte, auf die jüngste Nachkriegsvergangenheit zu werfen und auf das, was davon die Kultur und die zeitgenössische Kunst umtreibt: die geschichtlichen Ereignisse, das Gedächtnis, die Dekolonisierungsbewegungen, die »Enteuropäisierung« der Welt (Wolf Lepenies), aber auch die komplexen – postarchaischen, posttraditionellen und postnationalen – Identifikationsbemühungen in den »fraktalen Gesellschaften« (Serge Gruzinski), die aus dem Zusammenbruch des Kommunismus und der Brutalisierung des Marktes entstanden sind. Das heißt, daß wir die Aufgabe hatten, unter einer kritischen, wenn nicht gar programmatischen, aktuellen Perspektive die wichtigen Positionen zu sichten und neu zu durchdenken, die in den sechziger Jahren aufkamen. Diese Positionen sind in den Werken unterschiedlich renommierter Künstler abzulesen, die während oder kurz nach dem Krieg geboren wurden (und zum Teil, wie Marcel Broodthaers, Öyvind Fahlström, Gordon Matta-Clark, Hélio Oiticica und Lygia Clark, viel zu früh verstarben) und die alle oder doch fast alle ihre Arbeit zur Zeit der ersten documenta begannen (Gerhard Richter, Michelangelo Pistoletto, Richard Hamilton, Aldo van Eyck). Bei den meisten von ihnen äußert sich ihre kritische Haltung in einer radikalen Infragestellung der

Parcours

Since 1955, documenta has always unfolded in a spatial relation to the city of Kassel, contributing greatly to the spread of the model of the exhibition-promenade developed in the late sixties as an acceptable compromise between traditional museum presentation and the extension to a mass public of the idea, the practice, and the consumption of the artistic vanguards. Today, while we witness the (final?) dissolution of the museum and of public space into the "society of the spectacle," the strategies that attempt to contrast institutional space with an "outside" appear naive or ridiculous, as do "in situ" interventions which turn their backs not only to the current transformation of the Habermasian model of public space, but also to the new modes of imaginary and symbolic investment of places by contemporary subjects. To combat the promenade or "rummage sale" effect, it seemed necessary to articulate the heterogeneous works and exhibition spaces – the old sites of the Fridericianum and the Orangerie and the new sites of the Kulturbahnhof, the Ottoneum, and the documenta Halle – with the "here and now" context of Kassel in 1997, by establishing a historical and urban parcours or itinerary, attentive to history as it is embedded in the city itself. From the Kulturbahnhof to the Orangerie and the banks of the Fulda, this itinerary lays the accent not only on the spectacularly restored tokens of the baroque era (the Friedrichsplatz and the Fridericianum, the Orangerie and the Auepark), but also on the recent past of postwar reconstruction: the old station, partially unused and currently being remodeled for commercial and cultural purposes, the underground passageways deserted by the public and destined for closure in the not-too-distant future, and the Treppenstraße or "stairway street," a model of the pedestrian street conceived in the fifties to conjugate promenade and consumption (the first of its kind to be built in Germany, and as such, an official "monument"). In the era of globalization, with all its local repercussions – including the highly visible recession in the city of Kassel – the marks of reconstruction and the failure of the political, economic, social, and urban project that they reveal can appear as "recent ruins." We have not sought to make these artifacts into museum pieces (not even for the time of an exhibition) but rather to identify and specify them through confrontations with recent and somewhat less recent works by artists such as Lois Weinberger, Jeff Wall, Peter Friedl, Dan Graham, and Suzanne Lafont. This parcours is also a real and symbolic itinerary through Kassel in relation to its possible "elsewheres," the cultural and urban realities of a "Whole-World" (Edouard Glissant) that documenta cannot claim to convoke or even to "represent" in Kassel.

Kategorie der »Schönen Künste« und der anthropologischen Grundlagen der westlichen Zivilisation wie auch in einer Infragestellung der Hierarchien und der traditionellen Abgrenzung von Wissenszweigen: Broodthaers' Kritik der Vorherrschaft des Visuellen und sein Übertragen von Sprache und Sprachspielen in den dreidimensionalen Raum, das Sichtbarmachen der Pervertierung räumlicher Operationen durch die Wirtschaft bei Matta-Clark, die Umkehrung von Zentrum und Peripherie durch »marginale Werte« bei Oiticica, Fahlströms spielerische Dramatisierung des Verhältnisses von ökonomischen und politischen Kräften sowie die Durchbrechung der Zwänge eines dogmatischen und reduzierenden Modernismus durch das kritische Aufgreifen von poetischen formalen und räumlichen Lösungen aus den Beständen der klassischen und der nicht westlichen Architektur bei Aldo van Eyck. In einer Zeit, in der die Werbung, das Fernsehen, die »Medien und die virtuellen digitalen Wunderwelten das »Versinken des Wirklichen in seiner Repräsentation als Spektakel« (Serge Gruzinski) noch beschleunigen, schien es angebracht zu sein, besonders auf die Verfahren der Analyse und der Verfremdung einzugehen, die in den Praktiken der Zeichnung und der Dokumentarphotographie seit den sechziger Jahren und manchmal auch noch früher entwickelt wurden (Maria Lassnig, Nancy Spero, Walker Evans, Garry Winogrand, Helen Levitt, Robert Adams, Ed van der Elsken). Diese Praktiken finden einen zwar sicherlich indirekten, aber dennoch sehr starken Widerhall in Werken von Martin Walde, William Kentridge, Jeff Wall, Craigie Horsfield, Suzanne Lafont, in denen eine zeitgenössische Form der nicht spektakulären Dramatisierung gefunden wurde.

Parcours

Veranstaltungsort der *documenta* war seit 1955 stets Kassel – und sie war von Anfang an ein Ereignis, das sich in der Stadt abspielte und sich zum richtungsweisenden Modell eines Ausstellungs-Spaziergangs entwickelte, was gegen Ende der sechziger Jahre einen akzeptablen Weg zu eröffnen schien, sich mit der massiven Verbreitung der Idee und der Praxis der Avantgarde und ihrer Vermarktung als Konsumartikel zu arrangieren. Heute, wo wir erleben, daß Museum und öffentlicher Raum (vielleicht endgültig?) unterschiedlos in einer »Gesellschaft des Spektakels« aufgehen, müssen alle Strategien als naiv oder lächerlich erscheinen, die sich gegen irgendeine Festlegung im Rahmen des institutionellen Raumes wenden, was als »draußen« oder »drinnen« zu gelten hat. Naiv und lächerlich sind auch die Arbeiten in situ, die die aktuellen Veränderungen des Habermasschen Modells des öffentlichen Raums ignorieren wie die Veränderung der komplexen symbolischen und ima-

That said, the city and urban space in general – its circumstances, its failures, its architectural, economic, political, and human projects, its conflicts, and the new cultural attitude and practices to which it gives rise and which it spreads throughout the world – now clearly appears as the privileged site of contemporary experience. In these respects, Kassel today, at its own scale, in its singularity as well as its archetypes, can be regarded as "exemplary."

Limits

The extreme heterogeneity of contemporary aesthetic practices and mediums – matched by the plurality of contemporary exhibition spaces (the wall, the page, the poster, the television screen, the Internet) and the very different, even irreconcilable experiences of space and time they imply – necessarily oversteps the limits of an exhibition held "entirely" in Kassel, just as art now oversteps the spatial and temporal but also ideological limits of the "white cube" which constituted the supposedly universal model of aesthetic experience, a model of which documenta, even in its "open" version, is a willing or unwilling offshoot. The universalist model is limited and limiting with respect to the (re)presentation of contemporary aesthetic forms and practices in all their diversity, and also with respect to the local fulfillments of a complex and now "globalized" modernity, which henceforth lacks the "exteriority" of the authentic, the traditional, and the pre- or antimodern – despite a lingering nostalgia for exoticism, at best, and colonialism, at worst. Indeed, the object for which the white cube was constructed is now in many cases no more than one of the aspects or moments of the work, or better yet, merely the support and the vector of highly diverse artistic activities. At the same time, the problem of universalism also arises with respect to non-Western cultural zones where the object of "contemporary art" is often a very recent phenomenon, even an epiphenomenon, linked, in the best cases, to an acceleration of the processes of acculturation and cultural syncretism in the new urban agglomerations, and in the worst cases, to the demand for rapid renewal of market products in the West. For reasons which have partially to do with interrupted or violently destroyed traditions, as well as the diversity of the cultural formations that have sprung from colonization and decolonization and the indirect and unequal access these formations have been given to Western modernity, it seems that the pertinence, excellence, and radicality of contemporary non-Western expressions often finds its privileged avenues in music, oral and written language (literature, theater), and cinema – forms which have traditionally contributed to strate-

ginären Konstruktionen, mit denen Menschen heute Orte besetzen. Um die Rezeptionshaltung des Spaziergangs und den »Kirmeseffekt« in Grenzen zu halten oder ihm entgegenzuwirken, schien es erforderlich zu sein, die Heterogenität der Ausstellungsorte, ihre Mischung aus »alten« (Fridericianum, Orangerie) und »neuen« (Kulturbahnhof, Ottoneum, documenta-Halle), und die Heterogenität der Werke im Kasseler »Hier und Jetzt«, im Kontext Kassel 1997, in einem historischen und urbanen Parcours zu artikulieren, um so die Aufmerksamkeit auf die Zeichen der Geschichte zu lenken, die sich in das Antlitz der Stadt eingeschrieben haben. Dieser Parcours, vom Kulturbahnhof bis zur Orangerie und zur Fulda, akzentuiert einerseits die jüngste Vergangenheit des Wiederaufbaus (der alte Bahnhof, der umgebaut wird, um kommerziellen und kulturellen Zwecken zu dienen, die als öffentlicher Raum aufgegebenen und zur Schließung verurteilten Fußgängerunterführungen wie auch die Treppenstraße, jenem in den fünfziger Jahren konzipierten Modellfall des Spaziergang und Konsum vereinenden Projekts »Fußgängerzone« der ersten in Deutschland und daher heute unter »Denkmalschutz« stehend) und andererseits die spektakulär restaurierten »Erinnerungen« an die Blütezeit des Barock (Friedrichsplatz und Fridericianum, Orangerie und Auepark). In einer Zeit, in der sich die Globalisierung lokal in einer deutlich sichtbaren Rezession manifestiert, müssen die Zeichen des Wiederaufbaus und die Zeichen des Scheiterns eines politischen, ökonomischen, sozialen und urbanen Projekts als »moderne Ruinen« erscheinen, bei denen es nicht darum gehen kann, noch nicht mal für die Dauer einer Ausstellung, sie zu musealisieren, sondern darum, sie durch die paradoxe Konfrontation mit neuen und älteren Arbeiten von Künstlern zuallererst als solche zu identifizieren (Lois Weinberger, Jeff Wall, Peter Friedl, Dan Graham, Suzanne Lafont). Dieser Parcours ist ein ebenso realer wie symbolischer Weg, er führt durch Kassel und zugleich durch das mögliche Anderswo, durch die urbanen und kulturellen Realitäten eines »Tout-Monde« (Edouard Glissant), das die documenta nicht behaupten kann, sie könne ihn in Kassel versammeln oder »repräsentieren«. Der städtische Raum erscheint so mit seinen Gegebenheiten, seinen Fehlschlägen, seinen (architektonischen, wirtschaftlichen, politischen und menschlichen) Errungenschaften und Risiken, mit den Konflikten und den neuen kulturellen Einstellungen und Lebensformen, die er weltweit hervorbringt und verbreitet, als privilegierter Ort zeitgenössischer ästhetischer Erfahrung. In dieser Hinsicht kann Kassel sowohl in seinen einzigartigen wie auch in seinen archetypischen Zügen als »exemplarisch« erscheinen.

gies of emancipation. This observation is pragmatic rather than programmatic; it makes no claim to antici- pate the course of developments in the future or the possible evolution that can already be glimpsed in the works and attitudes of younger generations, but it does lay the accent on certain strong alterities of con- temporary culture, particularly the Arab, Muslim, and African worlds, which are very much present during the "100 Days – 100 Guests" lecture program.

In full awareness of these inherent limits, we have sought to provide a multiplicity of spaces and a broad- ened platform of discussion and debate, in and outside Kassel, for highly diverse cultural expressions and pub- lics whose horizons and expectations are vastly differ- ent. To complement the exhibition in the city we have published a book which situates artistic productions from 1945 to today in their political, economic, and cul- tural context of appearance and in light of the multiple shifts and redefinitions that have now become mani- fest with the process of globalization. In the frame- work of the "100 Days – 100 Guests" program we have invited artists and cultural figures from the world over – architects, urbanists, economists, philosophers, scien- tists, writers, filmmakers, stage directors, musicians – to Kassel in order to debate, according to their fields of specialization and their orders of urgency, the great ethical and aesthetic questions of the century's close: the urban realm, territory, identity, new forms of citi- zenship, the national social state and its disappearance, racism and the state, the globalization of markets and national policy, universalism and culturalism, poetics and politics. These daily interventions will take place in the documenta Halle, specially reconfigured as a space of information and debate, and will be recorded and transmitted live on the Internet by Bundmedia. In addition, each of the evening events will be available on Internet as a Video On Demand, and the documenta will be present in three-minute clips broadcast daily by arte.

The "100 Days – 100 Guests" program also encom- passes cinema and theater. Seven films, produced jointly by the documenta, Sony, and a number of European television stations, will be premiered. And beginning on September 5, a three-night theatrical marathon will present the sketches proposed by ten directors who have been invited to explore the space and conditions of contemporary situations and develop them as works for the stage.

Other artistic productions will also be accessible far beyond the Kassel city limits: in addition to works on Internet, the medium offering the greatest possible range of circulation, three artists' projects will be dis- played on billboard spaces of the Deutsche Städte- Reklame in a number of German cities. In a program

Limites – Grenzen

Die extreme Heterogenität der ästhetischen Prakti- ken und ihrer heutigen Medien (Wand, Seite, Plakat, Bildschirm, Internet) sowie die unterschiedlichen oder gar nicht miteinander zu vereinbarenden Erfahrungen von Raum und Zeit, die damit verbunden sind, sprengen zwangsläufig die Grenzen einer Ausstellung, die »ganz« in Kassel stattfinden wollte. Sie sprengen auch die (räumlichen, zeitlichen und ideologischen) Grenzen des »white cube«, eines Modells mit universalistischem Anspruch, das die documenta selbst in ihrer »offenen« Form, nolens volens, auch reproduziert. Ein begrenztes und einengendes Modell angesichts der Vielfältigkeit der zeitgenössischen ästhetischen Formen und Prakti- ken wie auch der lokalen Ausprägungen einer komple- xen und »globalen« Modernität, die nichts außen vor läßt, die alles tangiert, selbst das Traditionelle, das Authentische, das Vor- oder Antimoderne – entgegen bestimmten nostalgischen Haltungen, die einem Exotis- mus huldigen, der im besten Fall romantisch, im schlech- testen aber neo-kolonialistisch ist. Oft ist heute ein »Objekt« nur einer von vielen Aspekten oder Momen- ten, in seinen besten Formen der Träger oder Vektor von sehr unterschiedlichen künstlerischen Aktivitäten. Ein gleichfalls zu beobachtendes, aber damit nicht in einem Kausalverhältnis stehendes paralleles Phänomen ist die Tatsache, daß es »zeitgenössische Kunst« in den nicht-westlichen Kulturen zumeist erst seit kurzer Zeit gibt und sie lediglich eine Begleiterscheinung ist – im günstigsten Fall eine Begleiterscheinung des beschleu- nigten Akkulturation und des kulturellen Synkretismus in den Großstädten und Riesenmetropolen, im schlimm- sten Fall eine des Zwangs zur Marktbelebung und zur Umsatzsteigerung im Westen. Zur Zeit bedient sich die nicht-westliche zeitgenössische Kunst, will sie relevant, aussagekräftig und radikal sein, vornehmlich der Musik, der gesprochenen und geschriebenen Sprache (Litera- tur und Theater), des Films – alles Formen, die Emanzi- pationsstrategien entsprechen. Die Gründe dafür sind vielschichtig, unterbrochene oder brutal ausgelöschte Traditionen spielen hier ebenso eine Rolle wie die aus der Geschichte der Kolonisierung und Dekolonisierung resultierende Vielfalt kultureller Formationen oder der indirekte und ungleiche Zugang, der den einzelnen Völ- kern während dieser Zeit zur westlichen Modernität gewährt wurde.

Diese pragmatische, aber nicht programmatische Bestandsaufnahme nimmt nichts von den zukünftigen möglichen Entwicklungen vorweg, die sich bereits in den Haltungen und den Arbeiten der neuen Generation abzeichnen, aber sie bevorzugt bestimmte »andere« Formen der zeitgenössischen Kultur – aus der arabi- schen und muslimischen Welt, und den afrikanischen

entitled "documenta meets radio/radio meets documenta," the Hessischer Rundfunk will broadcast the works of six artists.

In conclusion I would like to thank the many partners who accompanied us with great confidence and generosity during the often difficult work of preparation. And, of course, I would like to extend my warmest thanks to all the participants of documenta X, *who have contributed so much to making this project meaningful.*

Catherine David

Ländern, die in der Veranstaltung »100 Tage – 100 Gäste« sehr präsent sind. Da wir uns dieser räumlichen und objektiven Grenzen bewußt waren, wollten wir in Kassel und darüber hinaus der Vielfalt kultureller Ausdrucksformen sowie den unterschiedlichen Erwartungen eines heterogenen Publikums gerecht werden: durch das Angebot unterschiedlicher »Räume« und eines breiten Diskussionszusammenhangs. Neben der Ausstellung stellt ein Buch die künstlerische Produktion von 1945 bis heute in ihre politischen, ökonomischen und kulturellen Zusammenhänge, im Licht der neuen Verschiebungen und Neudefinitionen, die sich durch die Globalisierung manifestiert haben. An der Veranstaltung »100 Tage – 100 Gäste« schließlich nehmen Künstler und »acteurs culturels« (Architekten, Stadtplaner, Wirtschaftswissenschaftler, Philosophen, Schriftsteller, Filmemacher, Regisseure und Musiker) aus der ganzen Welt teil, die, entsprechend ihrer Tätigkeitsfelder, die brennenden ethischen und ästhetischen Fragen am Ende des Jahrhunderts debattieren werden, zu Themen wie: Urbanismus, Territorium, Identität, Bürgerrechte, »sozialer Nationalstaat«, Staat und Rassismus, Globalisierung der Märkte und nationale Politik, Universalismus und Kulturalismus, Kunst und Politik. Für dieses Forum wurde die documenta-Halle als ein Raum der Information und der Debatte eingerichtet. Die Beiträge werden täglich aufgezeichnet und von Bundmedia live ins Internet übertragen. Darüber hinaus werden alle Veranstaltungen als Video On Demand im Internet zur Verfügung stehen. Jeden Tag wird die *documenta* auch in einem dreiminütigen Clip in arte präsent sein. Film und Theater sind ebenfalls Teil der Veranstaltung »100 Tage – 100 Gäste«. Sieben von *documenta,* Sony und mehreren europäischen Fernsehkanälen produzierte Filme werden dabei präsentiert. Drei Abende lang, vom 5. bis zum 7. September stellen wir in einem Theatermarathon die Theaterskizzen von Regisseuren vor, die wir dazu eingeladen haben, die Räume und Bedingungen einer zeitgenössischen Situation zu erkunden und szenisch auszuarbeiten. Mit anderen Künstlerprojekten ist die *documenta* auch außerhalb Kassels präsent: es gibt einerseits Internetprojekte, die die größtmögliche Verbreitung bieten; andererseits werden drei Künstlerprojekte auf den Werbeflächen der Deutschen Städte-Reklame in vielen deutschen Städten zu sehen sein. In documenta meets radio/radio meets documenta im Hessischen Rundfunk werden sechs von Künstlern gestaltete Radiosendungen ausgestrahlt. Abschließend möchte ich allen Partnern danken, die mit viel Vertrauen und Großzügigkeit bisweilen schwierige Projekte zu begleiten wußten. Mein Dank gilt jedoch zuallererst allen Teilnehmern der *documenta* X, die zum guten Gelingen des Projektes in erster Linie beigetragen haben.

Catherine David

Vito Acconci Studio (Vito Acconci, Celia Imrey, Dario Nunez, Saija Singer, Luis Vera)

Vito Acconci, *1940 in New York. Lebt und arbeitet/lives and works in New York.

Vito Acconci, the legendary anti-hero of the 1970s, has developed his protean artistic activity over the last thirty years, gradually integrating an expanding range of parameters while continuing to twist established conventions. Acconci plays humorously with paradoxes and contradictions in work where a form of anxious idealism confronts structures of power and figures of authority.

*A large part of his artistic practice is founded on the occupation of space. First came the space of the blank page on which he wrote his poems. Next came urban space in which he physically engaged himself, for example, by choosing a person at random to follow in the street until he or she enters a private space (*Following Piece, *1969). Another space was that of his own body, which he treated as an object of experience, biting every part of himself in reach for* Trademarks *(1970). He then took up activities where "the 'I' interacts with other agents," as in the notorious performance where he lay masturbating under a specially constructed gallery floor while making comments about the people walking over him (*Seed Bed, *1972). In another piece,* Project for Pier 17 *(1971), he waited out on an abandoned jetty at night, revealing to any visitor an inadmissible personal secret which could potentially expose him to blackmail. In 1973 he gave up performance and began exploring the exhibition space, creating installations that combined slide projections and sound devices; his own body was replaced by that of the spectator, whom he invited to a reflection on existence in common, as in* Where are We Now (Who Are We Anyway) *in 1976. In the eighties he shifted his inquiry to private domestic spaces and public spaces of social interaction, summing up his concerns in a text entitled* Public Space in a Private Time. *He invented new models of habitation and city construction marked by a mythology of the mobile home, in works such as* House of Cars *(1983),* Portable City *(1982), and* Mobile Linear City *(1991). "What interests me in 'public art' is that it can exist in the same way as a train station: everyone who goes there passes through a public space," he declares. A multitude of projects (parks, playgrounds, anti-monuments, and so on) spring from a political conception of public art and testify to a will to transform public space into a place that can function as a forum. As he remarks: "Ideally, public art should be a place where you can reconsider the public order."*

For documenta *he has designed an installation for the Walther König bookstore in the interior space of the documenta Halle.*

P. S.

Vito Acconci, der legendäre Antiheld der siebziger Jahre, übt seit dreißig Jahren die vielgestaltigsten künstlerischen Tätigkeiten aus. Im Laufe der kontinuierlichen Entwicklung seiner Arbeit hat er es, trotz aller Versuche, ihn festzulegen, stets verstanden, die Ketten der Konventionen zu sprengen. Vito Acconci spielt in seiner Arbeit, in der sich ein uneingestandener Idealismus mit Machtstrukturen und Autoritätsfiguren anlegt, auf humorvolle Weise mit Paradoxen und Widersprüchen.

Bei einem großen Teil der Arbeit Vito Acconcis geht es um das Vordringen in Räume, die er sich erschließt. Da ist zunächst einmal der Raum der leeren Seite, auf die er seine Gedichte schreibt. Dann der städtische Raum, in den er sich selbst körperlich einschreibt, indem er seine eigenen Aktivitätsmuster erfindet, wie zum Beispiel, wenn er nach dem Zufallsprinzip eine Person auf der Straße auswählt und ihr folgt, bis sie einen privaten Bereich betritt (*Following Piece*, 1969). Dann der Raum seines eigenen Körpers, den er als Gegenstand der Erfahrung behandelt (indem er sich in alle Körperteile biß, die er erreichen konnte – *Trademarks*, 1970), um sich später jenen Aktivitäten zu widmen, bei denen »das *Ich* sich mit den anderen *Agenten* zu einer Aktion verbindet«, wie zum Beispiel in seiner berühmtesten Performance, bei der er unter einer in den Raum eingezogenen Zwischendecke lag und onanierte, während er zugleich Kommentare über die Personen abgab, die über ihm herumgingen (*Seed Bed*, 1972), oder auch, wenn er nachts an einer verlassenen Hafenmole jeder Person, die zu ihm kam, ein ihm stigmatisierendes persönliches Geheimnis anvertraute und sich so der Gefahr aussetzte, später erpreßt zu werden (*Untitled Project for Pier 17*, 1971). Nach 1973 macht er keine Performances mehr und beginnt nun, den Ausstellungsraum auszuloten, indem er Installationen kreiert, bei denen Diapositive und Tonaufnahmen kombiniert werden. Er ersetzt seinen eigenen Körper durch den Körper der Betrachter, die er zu einer gemeinschaftlichen Reflexion auffordert (*Where Are We Now (Who Are We Anyway)?*, 1976). Während der achtziger Jahre richtet er seine Erkundungsvorstöße auf den privaten Raum des häuslichen Bereichs sowie auf die städtischen Räume öffentlicher Geselligkeit – Reflexionen, die er *Public Space in a Private Time* nennt. Er erfindet – ausgehend von Autos (*House of Car*, 1983), Pyramiden (*Portable City*, 1982) oder von umwandelbaren Fahrzeugen (*Mobile Linear City*, 1991) – neue Modelle für Wohnungen und Städte, die der Mythologie des mobilen Heims gehorchen. »Was mich an der öffentlichen Kunst interessiert«, sagt Vito Acconci, »ist, daß sie auf die gleiche Art existieren kann wie ein Bahnhof: alle, die da hingehen, durchqueren einen öffentlichen Raum.« Seine viel-

Info-System/Bookstore for documenta X, 1997

fältigen Projekte (Parks, Spielplätze, Antidenkmäler etc.)
sind alle von einer politischen Kunstvorstellung geprägt
und bezeugen den Willen zur Umgestaltung des öffent-
lichen Raumes in einen Ort, der wie ein Forum zu funk-
tionieren vermag: »Idealerweise sollte öffentliche Kunst
ein Ort sein«, erklärt Acconci, »wo man die öffentliche
Ordnung überdenken kann.«

Für die *documenta* hat er den Innenraum der docu-
menta-Halle gestaltet, indem er dort für die Einrichtung
der Buchhandlung Walther König sorgte.

P.S.

Robert Adams

*1937 in Orange, New Jersey. Lebt und arbeitet/lives and works in Longmont, Colorado.

After finishing his studies of English literature in south-ern California, Robert Adams returned to live and work in Colorado, where he faced "an intellectual and emotional problem": reconciling himself with the land-scapes of his childhood, now marred by urban and suburban development. He began practicing photogra-phy in 1967, in an attempt to establish a new alliance with altered, fallen nature, through a process of formal reconstruction. His photographs are imbued with a will to return a sense of familiarity to a wounded landscape (damaged by roads, signs, buildings, and waste); the images do not merely underscore a disaster but assert the possibility to discover a new coherency. They attempt to restore what the artist calls an "intemporal reality," whose most powerful agent remains "beauty." Inspired by a redemptive conception of artistic form, Adams is an idealist in the tradition of the American romantic thinkers of the nineteenth century (Emerson, Thoreau). But the degradation of the contemporary environment forbids him from producing spectacular images of an Arcadian nature, wild and sublime. Making no concessions to facile denunciation or irony, he attempts to capture things through strict objective description, taking into account the facts of modern life and the transformation of the landscape by human activity. Los Angeles Spring (1986), a series of forty-nine landscapes, bears witness to this ambition. Each image presents a structural analogy with the work of nature.

Influenced by Walker Evans, Robert Adams stands explicitly apart from any symbolist idealization of beauty; yet he accepts the metaphorical dimension as a constitutive part of documentary description. Our Lives and Our Children (1983), a series of stop-action shots taken on the site of a shopping mall in the Rocky Mountains near a nuclear installation, is the only point where the human figure truly appears in his work. The images that compose the series are so many metaphors of the imminent outbreak of nuclear disaster: the population is bathed in irradiating white light and each individual is transfixed like an apparition in the splen-dor of the apocalypse.

This ambivalence of a light which at once reveals things and burns them away is at work throughout Adams' photography, as witnessed by the selection of pictures in the exhibition, taken like single cells from the connective tissue of his art. Without ever sinking into the aesthetics of banality or the rhetoric of entropy, these images show the fresh damage that suburban extension and its program of individual hou-sing has inflicted on nature.

P.S.

Nach Abschluß seines in Südkalifornien absolvierten Literaturstudiums kehrte Robert Adams nach Colorado in seine Heimatstadt zurück, um dort zu leben und zu arbeiten. Aber schon bald sah er sich, wie er sagte, mit einem »sowohl intellektuellen als auch emotionalen Problem« konfrontiert: dem Problem, sich mit der geliebten Landschaft seiner Kindheit wieder anzufreun-den, die inzwischen durch die fortschreitende Urbanisie-rung schweren Schaden genommen hatte. Robert Adams begann 1967 damit zu photographieren, in der Hoffnung, durch eine formale Rekonstruktion eine neue Bindung zu einer depravierten und entstellten Natur aufbauen zu können. Erfüllt von dem Wunsch, mit einer durch Verletzungen und Verwundungen (Straßen, Beschilderungen, Gebäude, Müll etc.) übel zugerichte-ten Landschaft erneut vertraut zu werden, geben sich seine Photographien nicht damit zufrieden, eine Kata-strophe zu bilanzieren, sondern suchen nach einer Mög-lichkeit, mit der Landschaft wieder in Einklang zu kom-men. Sie versuchen, wie der Künstler sagt, eine »zeitlose Wirklichkeit« zu rekonstruieren, deren bester Repräsen-tant immer noch das »Schöne« ist. Der von dem Glau-ben an eine erlösende Kraft der künstlerischen Form angetriebene Robert Adams ist ein Idealist, der bewußt in der Tradition der romantischen amerikanischen Den-ker des 19. Jahrhunderts steht (Thoreau, Emerson). Doch die heute überall zu beobachtende Umweltzer-störung verbietet ihm, eindrucksvolle Bilder einer arka-dischen Natur zu schaffen, die wild und erhaben zugleich ist. Er versucht daher, die Dinge mit einer des-kriptiven und objektiven Strenge zu erfassen, die den Tatsachen des modernen Lebens und den Veränderun-gen der Landschaft durch Eingriffe des Menschen Rech-nung trägt. Eine der hier gezeigten Serien, Los Angeles Spring (1986), ist Ausdruck dieser Ambition. Jedes seiner Bilder bezeugt eine strukturelle Analogie mit dem Werk der Natur.

Wenn Robert Adams, von Walker Evans beeinflußt, sich auch ausdrücklich von jeder symbolistischen Rheto-rik distanziert, so akzeptiert er doch, daß die Dimension des Metaphorischen ein wesentlicher Bestandteil jeder dokumentarischen Beschreibung ist. Die zweite Serie, Our Lives and our Children (1983), ist die einzige, in der der Künstler Menschen auftreten läßt. Es handelt sich um eine Reihe von Momentaufnahmen, die auf dem Gelände eines Geschäftszentrums gemacht wurden, das in der Nachbarschaft eines Atomkraftwerks in den Rocky Mountains liegt. Die Bilder dieser Serie sind zugleich auch Metaphern der drohenden Atomkata-strophe: Die Bevölkerung ist in weißes Licht gehüllt, dessen Strahlung sie ausgesetzt ist, und jedes Indivi-duum erscheint im gleißenden Glanz der Apokalypse.

Our Lives and Our Children, 1983
Detail

Diese Ambivalenz des Lichts, das die Dinge offenbart und zugleich verbrennt, ist im gesamten Werk von Robert Adams festzustellen. Das bezeugt die hier getroffene Auswahl aus seinem Werk. Ohne der Ästhetik des Banalen oder der Rhetorik der Entropie zu verfallen, zeigen diese Bilder die Zerstörungen, die die Natur heute durch die zunehmende Ausweitung der Vororte aufgrund des Trends zum Einfamilienhaus erfährt.

P.S.

Pawel Althamer

*1967 in Warschau/Warsaw. Lebt und arbeitet/lives and works in Warschau/Warsaw.

Pawel Althamer's project for documenta is an extension and rearticulation of previous works. The first of these consists of an action performed by two people dressed in something that looks like an astronaut's space suit, but is in fact a set of workman's overalls painted white, with motorcyclist's gloves, a hockey-player's shin guards, and a pilot's helmet. For several days just before the opening of documenta, the two astronauts will walk through the streets of Kassel. Video cameras attached to their suits will record everything they see. A third person, also equipped with a camera, will film them during this happening, and a video montage will document the whole performance.

Althamer has brought a trailer from Poland and set it up in the Aue. Two separate entrances allow viewers to enter this parked vehicle, which is divided in half by a sheet of plexiglass. The compartment that is open to the public contains various objects: a fan whose blades, slightly spread, turn a bit slowly, worn-out bus seats, a water dispenser, and a refrigerator. But most (or least) surprising, on the other side of the plexiglass there is an old man—the Polish watchman for Althamer's exhibition. His strange yet somehow normal presence forces the viewer to redefine this person and his function. To do so means paying a kind of attention to him he usually does not get. Althamer has frequently worked with people in this way, asking them simply to enact the roles of their social existence, whether that of a watchman or of a homeless person.

This subtle play on the real and its (non-)representation links Althamer's work to that of Tadeusz Kantor. Althamer, however, insists on the necessity of realism: "In my work, I'm a down-to-earth realist, or so I like to think. The interpretation can be surrealistic, of course. What I do is the result of contacts with a very material world, however… I think I don't want any of the works to focus on the object and end there. I don't want too much attention paid to how nicely everything has been done. I prefer it when things perform an auxiliary function." If the figure of the shaman comes up regularly in the artist's reflections – "shamanism is not peculiar to any culture or region, but is the product of the force behind every work" – it is because the main issue is the relationship to the world: "Not to lapse into clichés, an artist is someone trying to find a place for himself."

P.S.

Das Projekt, das Pawel Althamer bei der documenta vorstellt, knüpft an frühere Arbeiten an. Zum einen handelt es sich dabei um eine Aktion, realisiert von zwei Personen, die in eine Art Raumanzug gekleidet sind, bestehend aus einem Overall, Skischuhen, Stulpenhandschuhen, Beinschützern und einem Pilotenhelm, alles mit weißer Acrylfarbe überzogen. Vor Eröffnung der documenta spazieren die beiden Astronauten einige Tage lang durch die Straßen von Kassel. An ihrem Anzug ist eine Videokamera befestigt, die alles aufzeichnet, was sie sehen. Eine dritte Person, die ebenfalls eine Videokamera trägt, begleitet sie und filmt das Happening. Eine Videomontage wird die gesamte Performance dann dokumentieren.

Zum anderen hat Althamer aus Polen einen Wohnwagen mitgebracht und in der Aue aufgestellt. An seiner Rückseite befinden sich zwei separate Pforten, durch die man hinein und wieder heraus kann. Der Wohnwagen ist durch eine Plexiglasplatte in zwei Abteile geteilt. Das der Öffentlichkeit zugängliche Abteil enthält verschiedene Objekte: einen Ventilator, dessen weit ausladende Flügel nur langsame Drehungen erlauben; gebrauchte Autobussitze, die deutliche Spuren der Abnutzung zeigen; ein automatischer Trinkwasserspender und ein Kühlschrank. Am überraschendsten (oder am wenigsten überraschend) aber ist, daß sich auf der anderen Seite der Plexiglasscheibe ein alter polnischer Mann befindet. Er überwacht Althamers Ausstellung. Die seltsame und dennoch normale Anwesenheit dieser Person zwingt den Besucher, die Funktion dieses Individuums zu definieren und ihm somit eine Aufmerksamkeit zukommen zu lassen, die er normalerweise nicht genießt. Althamer hat in seinen Arbeiten immer wieder Personen eingesetzt, von denen er verlangte, daß sie einfach die Rolle spielten, die ihrer wahren sozialen Existenz entsprach, ob sie nun Aufseher waren oder Obdachlose.

Das subtile Spiel mit dem Wirklichen und seiner (Nicht-) Repräsentation rückt die Arbeiten Althamers in die Nähe der Werke Tadeusz Kantors. Doch Althamer erhebt einen realistischen Anspruch: »In meiner Arbeit bin ich ein ganz nüchterner Realist. Zumindest glaube ich das. Die Interpretation kann natürlich surrealistisch sein. Was ich mache, ist das Ergebnis von Kontakten mit einer ganz materiellen Welt, doch (…) ich möchte, glaube ich, nicht, daß sich irgendeines der Werke in seiner Objekthaftigkeit erschöpft. Ich möchte nicht, daß man zuviel Aufmerksamkeit darauf verschwendet, wie nett und ordentlich alles gemacht ist. Ich habe es lieber, wenn die Dinge eine Hilfsfunktion ausüben.« Althamer bezieht sich in seinen Äußerungen immer wieder auf die Figur des Schamanen, denn »der Schamanismus ist

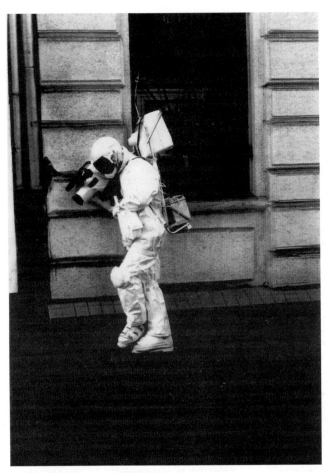

Astronaut, 1995

kein Spezifikum irgendeiner Kultur oder Region, son-
dern ein Produkt der Kraft, die hinter jeder Arbeit
steht«. Das Hauptproblem ist immer und überall das
Verhältnis zur Welt: »Ein Künstler ist jemand, der für sich
selbst einen Platz zu finden versucht.«

P.S.

Archigram (Ron Herron)

Ron Herron, *1930 in London. † 1994

Archigram, a contraction of architectural aerogram, was initially the name of a journal created by young English architects and students of architecture (Warren Chalk (1927), Peter Cook (1936), Denis Crompton (1935), David Greene (1937), Ron Herron (1930), Mike Webb (1937)) who unleashed a storm of revolt on architectural circles from 1961 to 1974. The fourth issue of the journal, entitled Amazing Archigram: Zoom (1964), announced the foundation of the group while radicalizing its provocative image through the use of comic-book form, with commentary appearing in "balloons." As Peter Cook says in the editorial: "One of the great weakenesses of the architecture of our cities is its inability to integrate quickly moving objects in its general aesthetic – precisely one of the areas where comic-book imagery has proved its superiority." The members of Archigram went on to invent a new architecture founded on a pop aesthetic derived from their predecessors in the Independent Group. They turned away from the modernist vision with its stress on integral urban planning, offering a new conception of functionality and a critical radicalization of the Americanization of urban space. Using contemporary materials in their collage works – from advertising to media information by way of science fiction and images of the space race – they proposed an ephemeral, leisure-oriented architecture, playful, fun, mobile, and changeable, whose conception responded to outside demands rather than internal rules.

This "architecture as consumer product" borrowed its imagery and concepts from a number of rapidly developing technical domains: inflatables, cockpits, mobile homes, shopping centers, off-shore platforms, container ports, cranes, hangars, refineries. Like pieces from an erector set, the various Archigram devices – displaceable footbridges, retractable staircases, snap-on floors – could also have come straight from a stock of theater decors. Indeed, the notion of "event" is one of the key points of their work: "When it rains on Oxford Street, the architecture is no more important than the rain." With an accent on mobility, they set cities into movement, transport living spaces, fold down walls, plug in additions, invent a contemporary nomadism, unpeel architecture from the soil, and finally project it into an environmental dimension, "beyond architecture" (the title of one of their exhibitions). Evoking a circus or a fair, their itinerant metropolis Instant City (1969) shuttles across the landscape like a home-delivery service, offering a range of playful activities from sport and education to "spectacular" events and entertainment (dance floors, rotating bars). The city can spring up in any empty spot of the urban fabric,

Archigram (eine Zusammenziehung aus »architectural aerogram«) war zunächst der Name einer von jungen englischen Studenten und Architekten (Warren Chalk (1927), Peter Cook (1936), Denis Crompton (1935), David Greene (1937), Ron Herron (1930), Mike Webb (1937)) ins Leben gerufenen Zeitschrift, die zwischen 1961 und 1974 in der Welt der Architektur für einen frischen, rebellischen Wind sorgte. Das vierte Heft der Zeitschrift, dessen Herausgabe den Anstoß zur Bildung der Gruppe gab (Amazing Archigram: Zoom, 1964), radikalisierte ihr provokantes Image, denn sie erschien in Form eines Comic strips, bei dem die Kommentare in Sprechblasen erschienen. Peter Cook schrieb damals in seinem Leitartikel: »Eine der größten Schwächen der Architektur unserer Städte ist ihr Unvermögen, sich rasch bewegende Objekte in ihre allgemeine Ästhetik zu integrieren – und genau das ist einer der Bereiche, wo sich die Bilderwelt der Comic strips als überlegen erwiesen hat.« Archigram schuf in der Tat eine neue Architektur, die auf einer (auf ihre Vorgänger, die Independent Group, zurückgehende) populären Ästhetik basierte, die sich vom modernen Stadtplanungsdenken löst und eine neue Vorstellung von Funktionalität sowie eine kritische Radikalisierung der Amerikanisierung der Stadtlandschaft bietet. In ihren Collagen verwendete die Gruppe die Versatzstücke ihrer Zeit, von der Werbung bis zur EDV, Science-fiction und den Traum von der Eroberung des Alls, um eine ephemere Architektur der Freizeit und der Muße vorzuschlagen – spielerisch, fröhlich, beweglich und veränderlich –, die eine Reaktion auf konkrete Erfordernisse darstellt und nicht nach festgeschriebenen inneren Regeln geschaffen wird.

Diese »Architektur als Produkt des Bedarfs« übernimmt ihre Bildwelt und ihre Konzepte von bestimmten, sich rasch entwickelnden technischen Bereichen (die aufblasbaren Hallen, Kommandokapseln, Mobilheime, Shopping-Center, schwimmenden Plattformen, großen Handelshäfen, Kräne, Hangars und Raffinerien). Die diversen Apparaturen von Archigram, die wie aus einem Stabilbaukasten zusammengebastelt erscheinen – mobile Fußgängerbrücken, zerlegbare Treppen, versetzbare Decken und Böden – scheinen direkt dem Bühnenapparat eines Theaters zu entstammen. Das »Ereignis« bestimmt die Gewichtung ihrer Arbeit (»wenn es in der Oxford Street regnet, dann ist die Architektur nicht mehr wichtiger als der Regen«). Sie privilegieren die Mobilität, sie setzen die Städte in Bewegung, transportieren die Wohnungen, verknüpfen die Elemente, erfinden ein modernes Nomadentum, lösen die Architektur vom Boden und zielen letztlich auf die das gesamte Umgebung einbeziehende Dimension »jenseits der Architektur«. Ihre Wandermetropole Instant City (1969)

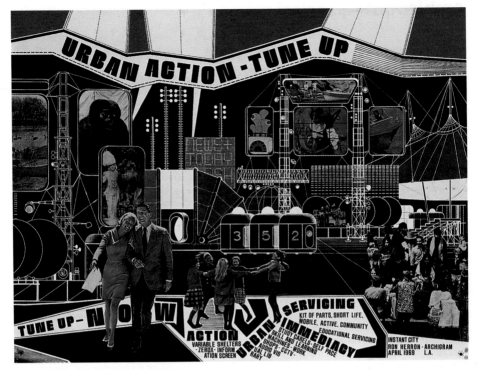

Instant City, Urban Action Tune-up, 1969

whether a public square or a no-man's land between freeway exchanges – only to fold back down and leave again the next day, packed into trailers carrying the sound and light equipment, the dirgibles, the pneumatic furniture, and the thirty-minute architecture.

P. S.

evoziert die Welt des Zirkus und des Jahrmarkts und begibt sich aufs Land, um dort, wie zu Hause, die Möglichkeit zu Spiel, Sport und Weiterbildung zu bieten sowie spektakuläre Ereignisse und Unterhaltung (Tanzflächen, rotierende Bars etc.). Diese Stadt schießt in allen vakanten Räumen des städtischen Gewebes aus der Erde (öffentlichen Plätzen, sich bei Autobahnkreuzen ergebenden Freiflächen etc.), um sich dann wieder in Karawanen aufzulösen, die ihre Licht- und Beschallungsanlagen, ihre Luftschiffe, ihre aufblasbaren Einrichtungsgegenstände und ihre dreißig Minuten auf- oder abbaubaren Strukturen weiter transportieren.

P.S.

Archizoom Associati (Andrea Branzi)

* in Florenz. Lebt und arbeitet/lives and works in Mailand/Milan.

Archizoom Associati (Branzi, Coretti, Deganello, Morozzi), founded in Florence in 1966, comes out of Radical Italian Architecture, itself strongly influenced by the English avant-gardes and, as Andrea Branzi reminds us, "less a specific cultural movement than a phenomenon of energy, a field of contradictory experiments which, from 1964 to 1974, went to the heart of the 'culture of the European project.'" Radical Italian Architecture sought to inaugurate a long-term progressive movement, and gave rise to the international phenomenon of New Design.

A designer, architect, and theoretician, Andrea Branzi was the leader of the Archizoom Associati group. He also founded the laboratory known as Global Tools in 1974, was the editor of the magazine Modo from 1983 to 1987, and started the celebrated Domus Academy. Branzi consistently approached design from the standpoint of its evolving relationship to the metropolis, taken both as a territory for the circulation of commodities and as a megaproject. For Branzi, the project is a "metaphor illustrating reality – and the metropolis – with great critical clarity." It is also "a proposal for modifying that reality." Thus, No-Stop City, the project presented here by Archizoom Associati, is a theoretical rather than real metropolis. It lays out in exemplary fashion the conceptions of Radical Italian Architecture. As Branzi notes, "The real revolution in radical architecture is the revolution of kitsch: mass cultural consumption, pop art, an industrial-commercial language. There is the idea of radicalizing the industrial component of modern architecture to the extreme." No-Stop City is an ironic project about the endless city, taking into account industrial diversification and the complex relationship between rationality and irrationality, along with the diversity of human behavior. Presented in a vitrine and conceived along the lines of a juke-box, this "partial utopia" also echoes the rhetoric of bricolage and the fairground attraction.

No-Stop City is an idealized model that corresponds to the aims of Radical Architecture. The radicalizing of the modernist tradition is a critique per absurdum of the underlying ideology of architectural modernism; at the same time it takes it to the furthest possible limit, overthrowing the idea of utopia to attain a new dimension and positivity, beyond the planning of the social state. As Branzi reminds us, "In Italy, the social and cultural revolution was conceived in opposition to the industrial revolution. The really new thing offered by technology was the possibility to free people's behavior. Radical architecture such as No-Stop City fits into this tendency. It leads to the idea that radical integration brings with it the possibility of a wider liberation."

Die 1966 in Florenz gegründete Gruppe Archizoom Associati (Branzi, Coretti, Deganello, Morozzi) ist aus der radikalen italienischen Architekturbewegung hervorgegangen. Diese war stark von der englischen Avantgarde beeinflußt (Archigram) und ist, wie Andrea Branzi sagte, »weniger eine festumrissene kulturelle Bewegung als ein energetisches Phänomen, ein Feld widersprüchlicher Erfahrungen, das sich von 1964 bis 1974 im Zentrum der ›Kultur des Europaprojekts‹ befand«. Die radikale italienische Architektur versuchte, eine weitreichende und progressive Bewegung in Gang zu bringen und mündete in das internationale Phänomen des Neuen Design.

Der Designer, Architekt und Theoretiker Andrea Branzi wurde zum führenden Kopf der Gruppe Archizoom Associati (er gründete 1974 auch das Labor Global Tools, leitete zwischen 1983 und 1987 die Zeitschrift Modo und gründete die berühmte Domus Academy). Branzi hat sich immer wieder mit der Entwicklung des Verhältnisses von Design und urbanem Raum beschäftigt, wobei er die Stadt als Territorium der Warenzirkulation und als Entwurfsraum betrachtete. Für Branzi ist ein Entwurf »eine Metapher, die die Wirklichkeit – und die Großstadt – mit großer kritischer Klarheit veranschaulicht«. Er ist zugleich auch »ein Vorschlag zur Veränderung dieser Wirklichkeit«. Dementsprechend ist No-Stop City, der hier gezeigte Entwurf von Archizoom Associati, eine theoretische Metropole und keine wirkliche. Er verdeutlicht exemplarisch die Vorstellungen der radikalen italienischen Architektur, für die, wie Branzi sagt, »die wahre Revolution der Kitsch ist, nämlich der massenhafte Kulturkonsum, die Pop Art, die Sprache der Industrie und des Kommerz. Die Idee ist, die industrielle Komponente der modernen Architektur bis ins Extrem zu radikalisieren.« No-Stop City ist daher ein ironischer Stadtentwurf, der die industrielle Diversifikation, die Komplexität der Beziehungen zwischen Rationalität und Irrationalität und die Vielfalt der Verhaltensweisen berücksichtigt. Er wird in einer dem Modell der Jukebox nachempfundenen Vitrine präsentiert und setzt auf die Rhetorik des Bastelns und der Schaubude.

No-Stop City ist ein idealisiertes Modell, das den Zielen der radikalen Architektur entspricht. Die Radikalisierung der modernen Auffassung ist zugleich auch eine Kritik an ihr, denn sie zeigt das Absurde der Ideologie, die der modernen Architektur zugrundeliegt. Zudem treibt sie die Utopie bis an den Punkt, wo sie umkippt, um hinter dem planverhaften Denken des Sozialstaats eine neue schöpferische Dimension des Entwerfens und eine neue Positivität zu erschließen. »In Italien«, erinnert Branzi, »glaubt man, die soziale und kulturelle Revolution stünde im Gegensatz zur industriellen Revolution.

P. S.

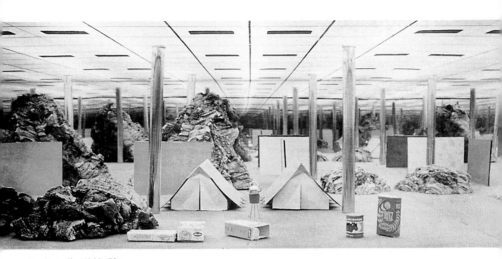

No-Stop City, 1969–72:
Paesaggi interni, 1970

Die wahre Neuerung, die die Technologie bietet, ist die
Möglichkeit, die Verhaltensweisen zu liberalisieren. Die
radikale Architektur, *No-Stop City*, greift diese Tendenz
auf und führt zur Idee, die radikale Integration berge in
sich die Chance zu einer weitergehenden Befreiung.«
P.S.

Art & Language

Michael Baldwin, *1945 in Chipping Norton, Oxfordshire. Lebt und arbeitet/lives and works in Middleton Cheney, Banbury, England.
Mel Ramsden, *1944 in Ilkeston, Derbyshire. Lebt und arbeitet/lives and works in Middleton Cheney, Banbury, England.

Art & Language was originally the name of a group of English artists devoted to anonymous collective practice, and of a journal, Art-Language, founded in 1968. By the very choice of their name the members of the group refuted any primacy of art over language, choosing a critical stance founded on the analysis of the relation between art, society, and politics. After their first decade the group underwent deep changes, and since 1976 only two artists, Mel Ramsden and Michael Baldwin, have continued the project of Art & Language. Faithful to the demands of so-called "conceptual" art, which they helped instigate, but weary of an iconoclastic practice that tended to lose its critical dimension through absorption into the field of official art, they decided to shift painting onto the terrain of their inquiry and to use it as a critical tool.

For documenta they have carried out a project that fills two rooms. It has been conceived on the basis of texts numbered 1 to 288, all entitled Sighs trapped by Liars. There are twelve vitrines in the first room. Each contains sixteen small "paintings" of various colors, in which images of an open book appear. The texts of the paintings, all by Art & Language, correspond to the sequence of double-page spreads in a book. They present varying degrees of legibility. The paintings, which look something like abstract monochromes, throw the spectator into a quandary: are we to grasp a theoretical concept or admire an expressive image? As Art & Language stress: "Reading is not 'looking'... unless it is..." Hanging from the walls above the vitrines are objects which resemble TV sets, fabricated from similar paintings. Like surveillance devices, they seem to observe or read the texts. In the second room one discovers "furniture" (a sofa, armchairs, and a coffee table) again constructed of the same paintings. Only two of the paintings are hung from the wall. "Strangely, the individual detail of the paintings which compose the 'furniture' is as readily recovered as the detail of the conventionally displayed small painting... The paintings which compose the sofa are 'not to be seen.' Are they in a form of domestic seclusion? This is a seclusion in distance which would imply that though constructed in the form of the sofa, they are in fact 'dismantled' in this form awaiting reformation en masse with the example on the wall. Is this seclusion in disguise which affords the possibility that they are not simply repeated signs?" An intruder figures among the texts by Art & Language in these rooms: a vicious attack on the group by an American critic.

Art & Language war ursprünglich der Name einer Gruppe englischer Künstler, die es vorzogen, kollektiv und anonym zu arbeiten, und einer 1968 gegründeten Zeitschrift. Die auf einer Analyse der Beziehungen zwischen Kunst, Gesellschaft und Politik beruhende kritische Position der Gruppe war bestimmend für die Wahl ihres Namens: Indem sie die Kunst mit der Sprache verknüpfte, bestritt sie die Vorstellung einer Priorität der Kunst. Nach zehn Jahren begann die Gruppe ihre Zusammensetzung zu verändern und langsam auseinanderzufallen. Seit 1976 betreiben nur noch zwei Künstler, Mel Ramsden und Michael Baldwin, das Projekt Art & Language. Noch immer den Maßstäben einer »konzeptuell« genannten Kunst verpflichtet, zu deren Anregern sie gehörten, aber der korrumpierten Bilderstürmerei überdrüssig, die ihre kritische Dimension gegen die Anerkennung auf dem Feld der offiziellen Kunst eingetauscht hatte, beschlossen sie, sich die Malerei vorzunehmen und sie nunmehr zum Werkzeug ihrer Kritik zu machen.

Für die documenta haben sie unter dem Obertitel Sighs trapped by Liars ein zweiteiliges Werk geschaffen. In einem ersten Raum sind zwölf Vitrinen, von denen jede 16 kleine, verschiedenfarbige »Gemälde« enthält, die in der Abfolge, wie sie beim Umblättern entstünde, die Doppelseiten eines aufgeschlagenen Buches zeigen. Alle von Art & Language stammenden Texte sind mehr oder weniger lesbar. Die wie abstrakte monochrome Bilder wirkenden Gemälde bringen ihren Betrachter in Verlegenheit. Soll er einen theoretischen Text erfassen oder sich von einem expressiven Bild ansprechen lassen? Art & Language meint dazu: »Lesen ist nicht betrachten – es sei denn, es ist es.« An den Wänden oberhalb der Vitrinen hängen Objekte, die an Fernsehmonitore erinnern und deren »Bildschirme« aus Gemälden gemacht sind, wie sie in den Vitrinen lagen. Wie Aufpasser scheinen sie die Texte zu überwachen oder zu lesen. Der zweite Teil ihrer Arbeit, in einem zweiten Raum, besteht aus »Möbeln« (einem Sofa, Sesseln und einem Couchtisch), die ebenfalls aus solchen Gemälden konstruiert sind. »Seltsamerweise«, so stellen Baldwin und Ramsden fest, »werden die individuellen ›Details‹ der Gemälde, aus denen die ›Möbel‹ bestehen, ebenso rasch entdeckt wie die Details der konventionell präsentierten kleinen Gemälde. Aber die ›Gemälde‹, die das Sofa bilden, sind ›nicht zu sehen‹. Diese Abgeschiedenheit beruht darauf, daß sie in den Hintergrund treten, was bedeuten würde, daß sie zwar in das Sofa

Sighs trapped by Liars 1–192, 1996–97
Detail

The group Jackson Pollock Bar will give performances on the basis of a text written by Art & Language: *"We aim to be amateurs."*

<div align="right">P.S.</div>

eingebaut sind und dessen Form ergeben, doch in Wirklichkeit in dieser Form ›demontiert‹ sind und darauf warten, zusammen mit dem Exemplar an der Wand umgeformt zu werden. Ist diese Abgeschiedenheit eine Verkleidung, die ihnen die Chance bietet, nicht bloß sich wiederholende Zeichen zu sein?« Unter den Texten in den beiden Ausstellungsräumen ist auch ein Fremdkörper: ein scharfer Verriß der Gruppe, geschrieben von einem amerikanischen Kritiker.

Jackson Pollock Bar macht bei der *documenta* Performances auf der Grundlage eines Textes von Art & Language: »Wir trachten danach, Amateure zu sein.«

<div align="right">P.S.</div>

AYA & GAL MIDDLE EAST

Jerusalem

AYA & GAL have been working together for five years. They added the indicator "MIDDLE EAST" to their names, thus constituting a (political) label for their artistic activities. Their work develops through a material and conceptual process, for which they have coined the verb "to neutralize." As Ariella Azoulay remarks, "this hybrid term evokes the processes of becoming-citizen (naturalization) and becoming-interlinked (network), both of which happen on the surface and which they allegorize by the motif of skin." They have created different latex skins which every future member of their project must wear to become a citizen, before being filmed in a short video segment where the participants engage in an everyday activity such as brushing their teeth, planting a tree, taking a picture, etc.

Their project for documenta *is entitled* The Naturalize/Local Observation Point *(1996). It is an interactive installation including a CD Rom and a mural video projection. The CD Rom was created on the basis of a cartographic work built up around the YMCA building in Jerusalem, where the piece was shown for the first time. There, as Ariella Azoulay recalls the event, "a citizen-network, isolated from the surrounding physical world by a latex skin, drove a car with a video camera attached to the steering wheel. He took different paths which led nowhere, but which gradually enveloped the YMCA tower, or "Local Observation Point," like the threads of a spider web. The "Local Observation Point" (which also designates the spectator's position) lost sight of the citizen-network. In replacement of the panoramic view offered by the tower, the spectator is invited to navigate among the network of crisscrossing lines projected on the wall." To participate in the work of AYA & GAL MIDDLE EAST, one merely sits down on a sofa to circulate through this virtual space. Beyond the film's perimeter are two specific sites, located on roads leading to Dead Sea and the Jerusalem woods. These sites are defined by videos showing two individuals in the process of "becoming-citizen": one takes an open-air shower, the other plants a tree. The area covered by the film is a very sensitive zone of Jerusalem which includes the houses of the President and Prime Minister. The video allows the spectator to study all the possibilities for automobile traffic in the area, and thus to plan a possible escape.*

The room where the piece is presented is tiled with a soft substance known as polyoriten. When the participant has finished with the computer and gets up off the sofa, she becomes conscious of the difference between the real place of installation where she is and the virtual space through which she has been navigating. A

AYA & GAL sind zwei Künstler, die seit fünf Jahren zusammenarbeiten. Ihren beiden Namen haben sie noch das Etikett »MIDDLE EAST« angehängt, das die politische Dimension ihrer Aktivitäten kennzeichnen soll. Ihre Arbeit verfolgt in materieller wie konzeptueller Weise ein Ziel, das sie als »To neutralize« bezeichnen. Diese Wortschöpfung aus Naturalisieren und Vernetzen evoziert, wie Ariella Azoulay sagt, »zwei Prozesse, die sich an der Oberfläche abspielen und die sie durch das Motiv der Haut allegorisieren«. Sie haben nämlich Häute aus Latex geschaffen, die jeder zukünftige Bürger ihres Projektes als Zeichen seiner Einbürgerung überziehen muß, bevor von ihm eine kurze Videoaufnahme gemacht wird, bei der er sich einer Alltagsbeschäftigung widmet, wie zum Beispiel Zähneputzen, einen Baum pflanzen, ein Photo machen etc.

Ihr Projekt für die *documenta* nennt sich *The Naturalize/Local Observation Point* (1996). Es handelt sich um eine interaktive Installation aus einer CD-ROM und der Projektion eines Videofilms auf die Wand. Die CD-ROM entstand nach einer von ihnen erstellten Karte eines Wegenetzes im Umkreis des YMCA-Gebäudes in Jerusalem, in dem das Werk zum ersten Mal gezeigt wurde. Ein vernetzter Bürger, von der materiellen Welt, die ihn umgibt, durch eine Latexhaut isoliert, fuhr einen Wagen, an dessen Lenkrad eine Videokamera befestigt war. Er nahm verschiedene Wege, die nirgendwohin führten, sich aber zu den Fäden eines Spinnennetzes entwickelten, in dessen Zentrum der Turm des YMCA, der »Local Observation Point« liegt. Der Ausstellungsbesucher kann nun dieses vor ihm auf die Wand projizierte Netz von ineinander verflochtenen Wegen nutzen, um darin zu navigieren. Er sitzt auf einem Sofa und steuert durch diesen virtuellen Raum. Videoaufnahmen, die die Einbürgerung zweier Personen zeigen – die eine nimmt im Freien eine Dusche, die andere pflanzt einen Baum – liefern zwei spezifische Hinweise auf Örtlichkeiten außerhalb des vom Netz abgedeckten Bereichs: Sie verweisen auf die beiden großen Ausfallstraßen aus Jerusalem, von denen die eine zum Toten Meer und die andere zum Jerusalemer Wald führt. Die Gegend, in der das Wegenetz liegt, ist ein politisch hochsensibler Bereich, in dem sich die Häuser des Präsidenten und des Premierministers befinden. Die virtuelle Navigation auf der Basis des Videofilms bietet so die Möglichkeit, alle Verkehrswege zu erkunden und damit auch alle eventuellen Fluchtwege zu studieren.

Der Bodenbelag des Installationsraumes besteht aus weichem, geschäumtem Material. Wenn der Teilnehmer den Computer verläßt und sich vom Sofa erhebt, wird ihm die Arbeit seines Gleichgewichtssinns bewußt und damit der Unterschied zwischen dem realen Ort der

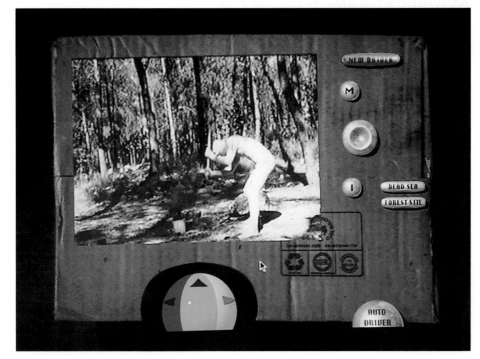

The Naturalize/Local Observation Point, 1996

series of postcards showing twelve processes of "becoming-citizen" can be taken away for free. AYA & GAL MIDDLE EAST thus hope to send their images migrating through the international postal networks.

<div align="right">P. S.</div>

Installation, in dem er sich befindet, und dem virtuellen Raum, in dem er navigiert hat. Eine Serie von Postkarten mit zwölf Bildern von Einbürgerungen kann man sich umsonst mitnehmen. AYA & GAL MIDDLE EAST hoffen, daß ihre Bilder dadurch auf den internationalen Postnetzen zirkulieren werden.

<div align="right">P. S.</div>

Oladélé Ajiboyé Bamgboyé

*1963 in Nigeria. Lebt und arbeitet/lives and works in London.

"My working practice aims to challenge the assumed knowledge that perpetuates the continual systematic denial of advancements in Africa both past and present in relation to those of the West. Within the field of the arts, there are often suspicious views by the Western establishment that confirm the claimed intellectual superiority of Western contemporary art über alles. This holds true despite the well-intended efforts of political and cultural correctness...

To watch almost anything on television about Africa in the West is to experience varying degrees of voyeurism. We are not presented with anything other than a tragic, phenomenological account of disasters and conflicts, man-made and natural. Africa continues to be naturalized, a poor relation to the developed world. What are needed are positive and real images of the materiality of Africa.

It is this very same materiality that has been plagiarized so often, Africa literally carved out by others who sought to consume its resources, while the only ones who didn't get a share of the spoils are the Africans themselves...

The Unmasking compares two workings of the same material, iron ore within Africa, as a metaphor for ideological stances, by the deconstruction of the very framework that is often used in anthropology, science, and art to define Africa. The first process is the development of the iron-smelting process in West Africa around the sixth century B.C. leading to the production of bronze artifacts some five hundred years later. The second is the mining process in Southern Africa more than one thousand years later, the process that has sustained the oppressive biological-political system called apartheid.

The refined nature of the technology that led to the production of the fine African bronze heads that populate many private and public collections in the West is now being hailed as a precursor in many ways of the Western industrial revolution. The project will be presented with digital technology precisely to locate it within that domain where it belongs...

My return to Nigeria has led to complex works such as Well Without End (1994), Homeward Bound (1995–1997), and the works in progress Rich Reddish Earth and Africa On Europe (documentary video, working title). These works problematize my own relationship with Africa and existence in Europe. It is my intention to destroy the antiquated views of Africa through my works, which offer images challenging those seen in the mass media, a strategy that I believe necessary for the normalizing of African representation."

O.A.B.

»Meine Arbeit wendet sich gegen jeden Versuch, auch weiterhin noch systematisch zu leugnen, daß es in Afrika jemals Errungenschaften gegeben hat oder heute gibt, die denen des Westens vergleichbar wären. Im Bereich der Kunst vertritt das westliche Establishment häufig Ansichten, die letztlich auf die Behauptung von der generellen intellektuellen Überlegenheit der zeitgenössischen Kunst des Westens hinauslaufen, und daran ändern auch alle gut gemeinten Bemühungen um politische und kulturelle Korrektheit nichts...

Schaut man sich im Westen irgendeine Fernsehsendung über Afrika an, so wird man mit verschiedenen Graden des Voyeurismus konfrontiert. Wir bekommen nur tragische Phänomene vorgesetzt, man präsentiert uns nur Katastrophen, naturbedingte und von Menschen verursachte, und bewaffnete Auseinandersetzungen. Afrika ist weiterhin naturalisiert, ein armer Verwandter der entwickelten Welt. Was wir brauchen, sind positive und echte Bilder von Afrikas Materialität.

Das ist genau jene Materialität, die oft plagiiert wurde. Afrika wurde von anderen, die sich seine Ressourcen anzueignen trachteten, regelrecht ausgeweidet, während die einzigen, die nichts von der Beute abbekamen, die Afrikaner selbst waren...

The Unmasking vergleicht zwei Methoden, wie in Afrika mit einem bestimmten Material, nämlich Eisenerz, umgegangen wurde. Der Vergleich dient durch die Dekonstruktion eben jenes Rahmens, der in Anthropologie, Wissenschaft und Kunst häufig benutzt wird, um Afrika zu definieren, als Metapher für ideologische Standpunkte. Die erste Methode ist die Entwicklung eines Verfahrens zur Eisenschmelze in Westafrika ungefähr im sechsten Jahrhundert vor unserer Zeit, die etwa fünfhundert Jahre später zur Produktion von Bronzegegenständen führte. Die zweite ist die Erzförderung und der Bergbau in Südafrika mehr als tausend Jahre später, ein Verfahren, das sich als wesentliche Stütze des biologisch-politischen Unterdrückungssystems namens Apartheid erweisen sollte.

Die entwickelte Technologie, die zur Produktion der eleganten afrikanischen Bronzeköpfe führte, die viele private und öffentliche Sammlungen im Westen schmücken, wird heute in mancher Hinsicht als Vorläufer der westlichen industriellen Revolution gepriesen. Das Projekt wird mit Hilfe digitaler Technologie präsentiert, um es genau in dem Bereich anzusiedeln, in den es gehört...

Meine Rückkehr nach Nigeria hat zu so komplexen Arbeiten geführt wie Well Without End (1994), Homeward Bound (1995–1997) sowie Rich Reddish Earth und Africa On Europe (Dokumentarvideo, Arbeitstitel), die allerdings noch nicht fertiggestellt sind. Diese Arbeiten

Homeward Bound, 1995
Installation view Ikon Gallery, Birmingham

problematisieren mein eigenes Verhältnis zu Afrika und mein Leben in Europa. Meine Arbeiten wollen die antiquierten Ansichten über Afrika zu Fall bringen, indem sie Bilder anbieten, die zu den in den Massenmedien zu sehenden Bildern in Konkurrenz treten und sie in Frage stellen – eine Strategie, die meiner Ansicht nach nötig ist, um die Darstellung Afrikas zu normalisieren.«

O.A.B.

Lothar Baumgarten

*1944 in Rheinsberg. Lebt und arbeitet/lives and works in Düsseldorf und/and New York.

Inspired by a Tuyi Indian myth, Lothar Baumgarten's film The Origin of the Night *plunges the spectator into the Amazonian jungle for almost two hours – only to reveal at the end that all the footage was shot "in the forests of the Rhine in 1973–77." The artist, whose father, an anthropologist, died when he was only six, decided from the outset to base his work on the desire to approach the "Other" of Western culture. While studying with Joseph Beuys at the Düsseldorf Akademie in 1971, he inscribed the names of South American Indians on photographs depicting a tropical forest. The compositions were actually created with broccoli. In 1973, collaborating with the anthropologist Michael Oppitz, he rendered critical homage to Marcel Broodthaers by filling a crate with eagle feathers on which were painted the names of North American Indian nations. In a photograph of the same period, he depicted himself from the back, decked out in feathers in a kind of parody of the shaman incarnated by Beuys. Since that time Baumgarten's installations, books, writings, photographs, films, and voyages have used an encyclopedic range of proper names to explore the possibilities for two cultures to meet without destroying their respective identities.*

His imaginary trip to South America became real in 1978, when he stayed for over a year in Venezuela with an Indian tribe, the Yanomami, of whom he took numerous photographs. For documenta he has conceived an arrangement of his archives on the walls, treated as pages in a book which give the photographs back their legitimate dimension: that of the album. These photographs belong to the tradition of anthropological photography, still insufficiently known by the art public. There is a difference, however: they were not conceived as an analytical study but as fragments of an intimate diary. They bear witness to Baumgarten's familiarity with the Indians and to his manner of sharing their everyday experience. Against the grain of traditional exoticism, these photographs constitute the traces of an experience of alterity, which is also the experience of an "other" community upon which the artist does not project the image of an organic totality. No doubt his affinity with Broodthaers' work and his knowledge of German anthropology and Kulturkritik have helped him elude that temptation. Baumgarten treats the nature/culture relation in a form that could be called "poetic anthropology." His radical shift to an "other space" is also an immersion in the space of the other, and his experience among the Yanomami constitutes a critique of the cultural categories of knowledge and an attempt at shedding the self.

P. S.

In seinem Film *Der Ursprung der Nacht*, der von einem Tuyi-Mythos angeregt wurde, entführt Lothar Baumgarten den Zuschauer fast zwei Stunden lang in den Amazonasdschungel, um ihm am Ende zu verraten, daß alle Aufnahmen zwischen 1973 und 1977 in Wäldern am Rhein gemacht wurden. Baumgarten, dessen Vater Anthropologe war und früh starb, zielte mit seiner Arbeit schon sehr früh darauf ab, sich dem »Anderen« in der abendländischen Kultur zu nähern. Bereits 1971, als er bei Beuys an der Düsseldorfer Kunstakademie studierte, schrieb er indianische Namen auf eine Serie von Photographien, die einen tropischen Wald zeigten. In Wirklichkeit handelte es sich um Kompositionen aus Brokkoli. In Zusammenarbeit mit dem Anthropologen und Ethnologen Michael Oppitz schuf er 1973 eine (kritische) Hommage an Marcel Broodthaers, bei der er eine Kiste mit Adlerfedern füllte, auf die die Namen von nordamerikanischen Indianerstämmen gemalt waren. Eine Photographie aus derselben Zeit zeigt ihn federgeschmückt als eine Art Parodie auf die von Beuys verkörperte Figur des Schamanen. Seitdem hat Baumgarten nie aufgehört, mit seinen Installationen, seinen Büchern, seinen Schriften, seinen Photographien, seinen Filmen und seinen Reisen zu erforschen, wie sich zwei Kulturen begegnen können, ohne sich gegenseitig ihre Integrität zu zerstören. Seine imaginäre Reise nach Südamerika wurde 1978 Wirklichkeit, als er für mehr als ein Jahr in Venezuela beim Stamm der Yanomami lebte, wo er zahlreiche Photographien machte. Er präsentiert hier seine Photographien wie die Seiten eines Buches und läßt sie so in ihrer legitimen Form als Album erscheinen. Diese Bilder reihen sich ein in die noch immer verkannte Tradition der anthropologischen Photographie, mit dem einzigen Unterschied, daß sie nicht zum Zwecke analytischer Studien gemacht wurden, sondern ein Tagebuch darstellen. Sie bezeugen die Vertrautheit Baumgartens mit den Indianern und erzählen davon, wie er mit ihnen ihr alltägliches Leben geteilt hat. Im Gegensatz zur traditionellen Darstellungsweise des Exotischen halten diese Photos die Spuren einer Erfahrung des Fremden fest, die auch die Erfahrung einer anderen Art von Gemeinschaft ist, auf die der Künstler nicht das Bild einer organischen Ganzheit projiziert. Man darf annehmen, daß er es seiner Vertrautheit mit dem Werk Broodthaers' sowie seiner Kenntnis der deutschen Anthropologie und Kulturkritik zu verdanken hat, daß er dieser Versuchung entgangen ist. Seine radikale Versetzung in eine ganz andere Weltgegend ist zugleich auch ein Eintauchen in die ganz andere Welt des Fremden, und seine Erfahrungen bei den Yanomami implizieren auch eine Lösung von seinem eigenen Selbst sowie eine Kritik an den kulturellen Kategorien des Wissens. P.S.

Kitama Kashorawë-t^heri, 1979

Catherine Beaugrand

*1953 in Mazingarbe. Lebt und arbeitet/lives and works in Paris.

In her first works, created in the early eighties, Catherine Beaugrand combined scale models, decals, and drawings to produce logical investigations of the structures of representation. Cultural crossings and formal combinations have continued to nourish her art. Thus, in the project Tantôt roi Tantôt reine (Now King Now Queen), developed from 1986 to 1988, she articulated theater, scenography, video tape, and a sound installation with a narrative crossing the stories of Feng (Chinese history), Oedipus (Greek history), and Judas (Christian history). In The Mask of the Red Death (1994) she drew on an Edgar Allan Poe story to explore the Europe/Japan relation, particularly through architecture.

LUNA PARK (1997) is a scenographic installation constituted of a film and a large table presenting mechanized amusement-park devices inspired by the tradition of automatons (ferris wheel, looping, swings, etc.). The movements of these devices echo the rhythm of the video film, projected on a large screen. The resulting scenography perturbs the traditional play of spatial oppositions (horizontal and vertical, two and three-dimensional). The film mingles documentary and fiction. The documentary aspect focuses on amusement parks of every sort, from the most antiquated to the most futuristic. It is composed of digital and analog images and sounds recorded both day and night in Luna parks, theme parks, fun fairs, or giant acquaria, in Europe and in Asia. In the fiction, a young woman discovers an espionage ring operating out of one of the huge amusement parks, which it uses as a cover. Recounted by a synthetic voice, this narrative advances through a succession of still images. The iconography borrows the style of comic books and mangas. The figures are veritable stereotypes (downloaded from a public-access Internet site). Written and spoken dialogues act to dramatize the interval between the two types of stories. Produced at the juncture between industry and the quest for entertainment, the great amusement parks, a symbol of nocturnal activity in the big cities, are places of illusion, pleasure, and dreams, where the marriage of modern man and the cosmos is consummated in an avid quiver of fright. Ironic and political, Catherine Beaugrand describes a kind of fairyland grown autonomous, increasingly sovereign and commercial. She also explores the Luna park as a model for the conception of the urban realm. "The idea is to question the world of consumption as a world of specialties and themes – from the World's Fairs all the way the amusement parks – which aim to enclose the entire world, and even the moon and the intervening space."

P.S.

In ihren ersten Werken, die zu Beginn der achtziger Jahre entstehen, kombiniert Catherine Beaugrand Modelle, Abziehbilder und Zeichnungen, um den Spielraum der Repräsentationsstruktur auf logische Weise auszuloten. Kulturelle Überschneidungen und formale Kombinationen kennzeichnen auch ihre späteren Arbeiten. In dem Projekt Tantôt roi Tantôt reine, das sie zwischen 1986 und 1988 entwickelt, verknüpft sie Theater, Bühnenbildnerei, Videoband und Lautsprecheranlage, um eine Geschichte zu erzählen, in der sich die Historien Chinas (Feng), Griechenlands (Ödipus) und des Christentums (Judas) überschneiden. In Le Masque de la mort rouge (1994) greift sie auf eine Erzählung Edgar Allan Poes zurück, um, ausgehend von der Architektur, vor allem die Beziehungen zwischen Europa und Japan zu untersuchen.

LUNA PARK (1997) ist eine szenische Installation, bestehend aus einem Film und einem großen Tisch, auf dem in der Tradition alter Spielautomaten mechanische Modelle von Kirmesattraktionen aufgebaut sind (Riesenrad, Looping, Schaukel). Deren Bewegungen sind auf einen Videofilm abgestimmt, der auf einem großformatigen Bildschirm zu sehen ist. Das auf diese Weise gestaltete Szenarium stört das traditionelle Spiel formaler Oppositionen (horizontal/vertikal, zweidimensional/dreidimensional). Der Film ist eine Mischung aus Dokumentar- und Spielfilm. Der dokumentarische Teil zeigt Vergnügungsparks jeder Art, von den altmodischsten bis zu den modernsten. Er besteht aus (digitalen und analogen) Bildern und Tönen, die tagsüber oder nachts im Lunapark und anderen Vergnügungsparks, in großen Aquarien und auf Jahrmärkten sowohl in Europa als auch in Asien aufgenommen wurden. In dem Spielfilmteil läßt eine junge Frau ein Spionagenetz auffliegen, das einen der großen Vergnügungsparks zur Tarnung benutzt. Die von einer synthetischen Stimme begleitete Spionagegeschichte entwickelt sich in starr typisierten Bildern. Die Ikonographie macht Anleihen beim Stil der Mangas und der Comics, und die Personen sind bloße Stereotypen (einem frei zugänglichen Eintrag im World Wide Web entnommen). Die geschriebenen und gesprochenen Dialoge dramatisieren den Abstand zwischen den beiden Erzählweisen des Dokumentarischen und des Fiktionalen.

Der Vergnügungspark, die Antwort des Industriezeitalters auf das Bedürfnis nach Unterhaltung und das Symbol des großstädtischen Nachtlebens, ist ein Ort der Illusionen, der Vergnügungen und der Träume, an dem eine moderne Spielart der Vereinigung mit dem Kosmos inszeniert wird. Dieses ironische und politische Werk Catherine Beaugrands beschreibt einen märchenhaften Ort, der in zunehmendem Maße ein autonomer, souve-

to be lo ca ted
to be looked at

LUNA PARK
Automaton version, 1997
Video still

räner Markt geworden ist. Für sie ist der Lunapark auch das Modell einer Vorstellung von Urbanität. »Es geht mir um eine Untersuchung der Welt des Konsums als Welt der Spezialgebiete und der thematischen Gebundenheit – von den Weltausstellungen bis zu den Vergnügungsparks –, die vorgibt, die ganze Welt zu enthalten, selbst den Mond und den Weltraum.«

P.S.

Joachim Blank/Karl Heinz Jeron

*1963 in Aachen. Lebt und arbeitet/lives and works in Berlin und/and Leipzig.
*1962 in Memmingen. Lebt und arbeitet/lives and works in Berlin.

*After creating Internet projects that involved active and conscious participation (*Handshake *in 1993–94 and* Even a Stopped Clock Tells the Right Time Twice a Day *in 1996), Blank and Jeron have now conceived a new project that further harnesses the power of the computer and the network to which it is attached. In* without addresses, *visitors to the website acquire no new knowledge of the site's overall structure. They leave traces that expand into paths and produce routes. They inscribe their presence on the map. The structure is generated by the visitors' passage. This self-writing website has no addresses, no index.*

Concretely, the website activates two applications alongside the document being opened. The first application opens a Simple Text input field in a separate window. The visitor is prompted by the words: "Tell me who you are." Here the visitor has an opportunity to begin the inscription procedure. The entered text is used as a search string for an on-line search of the Internet. An individual HTML page is generated on the basis of the findings of this search. The visitor has now left behind a trace in without addresses. *The results of this search are displayed in handwritten characters, images in gray tones.*

The second application generates a map on the basis of the HTML documents, showing them as dots on the map. The visitors' HTML pages are arranged on the map in chronological sequence. The visitor can select dots to view previously generated pages. This movement produces routes or connections between the dots. Only then does a structure emerge. The structure is expanded in real time and the chosen route is visualized. The visitor moves through the website by means of the map. Made up of nodes and interconnections, the two-dimensional map is the only agency of orientation within the virtual space of without addresses.

According to Roland Barthes in his text on orientation in Tokyo, visiting that city for the first time means beginning to write it. Addresses do not exist in Tokyo. Consequently, visual experience – as opposed to conventional representation – becomes a decisive element in orientation. To find one's way is to move. Movement gives rise to path configurations. The systems of routes which interest Blank and Jeron are unplanned two-dimensional structures that inscribe themselves on an immaterial surface. No superordinate routing system exists to point the visitors in the desired direction. Thus they use the computing and directive power of the machine to demonstrate to visitors the degree to which it is up to them to generate the environment within which they move. S.L.

Nachdem sie im Internet schon früher Projekte realisiert hatten, die eine aktive und bewußte Beteiligung des Rezipienten erforderten (*Handshake*, 1993/94; *Even a Stopped Clock Tells the Right Time Twice a Day*, 1996), haben Blank und Jeron für die *documenta* nun ein Projekt verwirklicht, das sich die Leistungsfähigkeit jener Maschine aus Computer und dem Netz, mit dem er verbunden ist, noch weitergehend zunutze macht. In *without addresses* erhalten die Besucher der Website keine Kenntnis über deren gesamten Aufbau. Sie hinterlassen Spuren, die sich zu Pfaden erweitern und Wege erzeugen. Sie schreiben sich ein. Die Gesamtheit der Besuche bildet die Struktur, das Wegesystem. Die sich selbst schreibende Website hat keine Adressen, keinen Index.

Die Startseite der Website aktiviert neben dem ersten Dokument zwei Applikationen. Die erste Applikation öffnet ein einfaches Texteingabefeld in einem eigenen Fenster. Hier erhält der Besucher die Möglichkeit, den Vorgang des Einschreibens zu starten. An ihn oder sie wird die Bitte gerichtet: »Sag mir, wer du bist.« Der eingegebene Text wird als Suchmuster für eine Online-Recherche im Internet benutzt. Aus dem Ergebnis der Recherche wird eine individuelle HTML-Seite erzeugt. Der Besucher hinterläßt eine Spur in *without addresses*. Das Abfrageergebnis wird durch verschiedene Layoutvorlagen gestalterisch manipuliert. Dabei wird Text handschriftlich repräsentiert und Bilder werden in Graustufen umgewandelt.

Die zweite Applikation erzeugt eine Karte aus den HTML-Seiten, die durch Punkte repräsentiert werden. Die HTML-Seiten der Besucher sind auf der Karte in einer zeitlichen Abfolge angeordnet. Der Besucher wählt Punkte an, um sich bereits generierte Seiten anzusehen. Diese Bewegung erzeugt Wege beziehungsweise Verbindungen zwischen den Punkten. Dadurch entsteht erst eine Struktur. Sie wird in Echtzeit erweitert und der persönlich gewählte Weg wird visualisiert. Über die Karte bewegt sich der Besucher durch die Website. Die zweidimensionale Karte, bestehend aus Knoten und Verbindungen, ist die einzige Instanz zur Orientierung im virtuellen Raum von *without addresses*.

Gemäß Roland Barthes' Text über die Orientierung in der Stadt Tokio bedeutet ein erster Besuch dieser Stadt den Beginn, sie zu schreiben: Tokio hat keine Adressen. Dadurch wird die visuelle Erfahrung und nicht, wie gewohnt, deren Repräsentation zu einem entscheidenden Element der Orientierung. Orientieren heißt sich bewegen. Bewegung läßt Wegesysteme entstehen. Die Wegesysteme, die Blank und Jeron bei diesem Projekt interessieren, sind ungeplante, zweidimensionale Strukturen, die sich auf einer immateriellen Oberfläche ein-

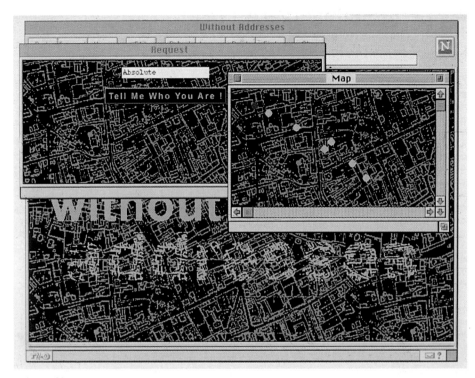

without addresses, 1997
Screenshot

schreiben. Es gibt keine übergeordnete Wegführung, die den Besuchern die Richtung vorgibt.

Auf diese Weise nutzen Blank und Jeron die Rechen- und Kontrollkapazität der Maschine, um den Besuchern die Tatsache deutlich zu machen, daß sie selbst die Umwelt schaffen, in der sie sich bewegen.

S.L.

Marcel Broodthaers

*1924 in Brüssel. †1976 in Köln.

"I, too, wondered if I couldn't sell something and suc- ceed in life. For some time I have been good for nothing. I am forty years old… The idea of inventing something insincere crossed my mind and I immediately set to work." With this declaration, Marcel Broodthaers put his literary career under wraps and made his appearance on the art scene in 1964. The text from which this quote is excerpted was drafted for the invi- tation card to his first exhibition, and juxtaposed over reproductions of advertising pages. Thus Broodthaers immediately established a relation between art and the commodity, announcing his affiliation with insincerity and lies. Conscious of the curse that lends the exchange value of capitalism to every art object, he considered artistic activity to be somewhat fraudulent by comparison to the "heroic and solitary position" of the poet.

Section Publicité (Advertising Section) opens the last installment of a fictive museum inaugurated by the artist in his home in 1968: Musée d´Art Moderne, Département des Aigles. Motivated by political events and particularly by the occupation of the Palace of Fine Arts in Brussels, Broodthaers undertook a critique of the museum institution. Initially constituted of empty crates and postcards of famous nineteenth-century paintings, this parodic museum gradually came to include numerous sections. The adventure was brought to a close with the presentation of Section Publicité at documenta 5 in 1972, and its transformation in the course of the exhibition. Strangely reminiscent of a collection of curiosities, the exhibition took the form of a taxonomic display of images of eagles, drawn from the archives of art and advertising. The eagle was a literary memory for the artist, it had appeared in one of his poems: "Oh Melancholy, Bitter Castle of the eag- les." At the same time it was also the metaphor of genius and of the sublime, the emblem of imperialism and the transhistorical symbol of power.

Section Publicité deploys a procedure of comparative montage, privileging discourse and didactic juxtaposi- tion over optical content and the dynamism of forms. Broodthaers confronts the work with the product, underscoring the logical transition that leads from the art object (now placed under the authority of the cul- ture industry) to the advertising sign. He reveals the way in which the mediation and media representation of aesthetic activity conditions the production and reception of art. Yet the reproductions of objects and images that Broodthaers employs are merely the agents or conceptual accessories of an artistic experi- ence (hence the inscription "this is not a work of art," in double reference to Magritte and Duchamp). The

»Auch ich habe mich gefragt, ob ich nicht irgend etwas verkaufen und im Leben erfolgreich sein könnte. Ich tauge jetzt schon eine ganze Zeit zu nichts. Ich bin vier- zig Jahre alt… Mir ist die Idee gekommen, irgend etwas Unaufrichtiges zu erfinden, und ich habe mich sogleich an die Arbeit gemacht.« Mit diesen Worten trat der Dichter Marcel Broodthaers 1964 auf die Kunstszene in Erscheinung und begrub seine literarischen Ambitionen. Der Text, dem dieses Zitat entnommen ist, stand auf der Einladung zu seiner ersten Ausstellung und auf deren Ankündigung war er ebenfalls zu lesen. Marcel Broodthaers verknüpfte von Anfang an Kunst und Kom- merz und verkündete seine Parteinahme für die Unehr- lichkeit und die Lüge. Er war sich des Fluchs bewußt, der unter der Herrschaft des Kapitalismus jedem Kunst- gegenstand einen Tauschwert zuweist, und er hielt die Tätigkeit des bildenden Künstlers im Vergleich zur »heroischen und einsamen« Tätigkeit des Dichters für betrügerisch.

Die Section Publicité ist der Beginn der letzten Abtei- lung eines fiktiven Museums, das der Künstler 1968 bei sich zu Hause eröffnete: des Musée d´Art Moderne, Département des Aigles. Motiviert durch die politischen Ereignisse und besonders durch die Besetzung des Palais des Beaux-Arts in Brüssel, verschrieb sich Broodthaers mit diesem Projekt einer Kritik an der Institution Mu- seum. Diese Museumsparodie, die zu Anfang aus leeren Kisten und Postkarten mit Abbildungen berühmter Gemälde des 19. Jahrhunderts bestand, erhielt im Laufe der Zeit zahlreiche weitere Abteilungen. Dieses Unter- nehmen lief bis 1972, dem Jahr, in dem auf der docu- menta 5 seine Section Publicité in einer veränderten Ausführung zu sehen war. Diese Abteilung, die auf selt- same Weise an ein Kuriositätenkabinett erinnert, be- steht aus einer systematischen Ausstellung von Adler- bildern, die den Archiven der Kunstgeschichte und der Werbung entnommen sind. Der Adler, eine literarische Reminiszenz des Künstlers (er hatte ihn in einer seiner Dichtungen verwendet: »O Melancholie. Herbes Adler- schloß«), ist zugleich Metapher für das Genie und das Erhabene, Emblem des Imperialismus und überge- schichtliches Symbol der Macht.

Die Section Publicité verfährt nach dem Prinzip einer vergleichenden Montage, die die Dimension des Diskur- siven und die didaktische Nebeneinanderstellung gegenüber der Dimension des Optischen und der Dyna- mik der Formen bevorzugt. Broodthaers konfrontiert das Produkt mit dem Werk und unterstreicht, wo das von der Kulturindustrie vereinnahmte Kunstwerk auf ganz logische Weise in die Reklame übergeht. Er deckt auf, wie sowohl die Produktion als auch die Rezeption von Kunst durch die Mediation und Mediatisierung

Marcel Broodthaers in Kassel, 1972
Section publicité, Musée d'Art Moderne, Département des Aigles
Installation view

aim of his activity is "to show ideology as it is and thereby to prevent art from rendering this ideology invisible, that is to say effective."

P.S.

bedingt werden, die jede ästhetische Tätigkeit erfährt. Die Reproduktionen von Gegenständen und Bildern, die Broodthaers verwendet, sind lediglich die Hilfsmittel und begrifflichen Requisiten einer künstlerischen Erfahrung (daher die auf Magritte und Duchamp anspielende Inschrift »dies ist kein Kunstwerk«), die die Absicht hat, »die Ideologie so vorzuführen, wie sie ist, und mit Recht verhindern möchte, daß die Kunst dazu dient, diese Ideologie unsichtbar und damit wirksam zu machen«.

P.S.

Heath Bunting

*1966 in London. Lebt und arbeitet/lives and works in London.

Heath Bunting's activism reveals itself not only in the pieces and projects he generates, but also in the communications networks he sets up. His engagement as an artist pervades all his activities, and it would be confining to demarcate them by type. The materials Bunting uses are the public telephone, the fax machine, e-mail, and the post office (or rather telecommunications companies as a whole). Concretely, his work has led him both to set up a number of independent Internet servers and to organize work and discussion groups. He has also created several interactive projects for the World Wide Web.

But when he uses networks or some other leading-edge technology, it is less to work on their behalf than to turn them to other ends by perverting them in some way. His projects are thus the result not of technical prowess, but of a very simple layout of images, texts, and zones of interactive dialogue which involve the viewer in a critical look at the medium itself or at society. Most of his considerable œuvre can be accessed at "irational.org".

What initially seems like a low-tech look comes out of his political commitment to easy and rapid access to the Net and to ideas. The size of the images has been kept to a minimum number of bytes for maximum impact and speed for the visitors to the site. Their low resolution also serves to promote the alternative discourse called for in his work.

In Visitors Guide to London (1994), initially a Hyper-Card project and then put on the Net, he offers a way of looking at London quite different from the usual tourist clichés. Bunting employs low-resolution black-and-white images with no gray-scales, along with a very simple navigational system. The visitor moves around the city by clicking on icons for north, northeast, east, etc., on a map of the Underground. From the map he or she can access any stations, but only to find banal photographs which Bunting has taken there at the surface. He thus accomplishes what he himself calls "the already out-of-date psycho-geographical tour of London, ideal for foreign visitors, with over 250 sites of anti-historical value, incomplete, without instructions, now available for all (the rich) on the World Wide Web."

S.L.

Der Aktivismus von Heath Bunting zeigt sich nicht nur in seinen Stücken und Projekten, sondern auch in der Aufstellung von Kommunikationsnetzen. Sein künstlerisches Engagement betrifft eigentlich all seine Aktivitäten, und es wäre eine Einschränkung, würde man sie nach Arten trennen. Die Materialien, die Bunting benutzt, sind das öffentliche Telephon, das Telefax, E-Mail, die Post (die gesamte Telekommunikation eigentlich). Seine Arbeit hat ihn auch dazu geführt, einige unabhängige Internet-Server zu schaffen, Arbeits- und Diskussionsgruppen zu gründen oder eben solche interaktiven Projekte für das World Wide Web zu realisieren.

Er benutzt diese Netze und Spitzentechnologien nicht direkt, um sie zu anderen als ihren eigentlichen Zwecken zu gebrauchen und sie auf verschiedene Weise zu verfälschen. Seine Projekte sind also nicht das Ergebnis irgendwelcher technologischer Hochleistungen, sondern eher die ganz einfache Aufstellung von Bildern, Texten oder interaktiven Dialogzonen, die den Betrachter in eine kritische Sicht auf das Medium oder die Gesellschaft involvieren. Das enorme Ausmaß seines zum größten Teil auf »irational.org« zusammengestellten Werks enthält einige Arbeiten, die in diese Richtung gehen.

Der in diesem Werk sofort vermittelte Eindruck von »low-tech« zeigt, daß sich Bunting politisch für einen einfachen Zugang zum Netz und ein schnelles Begreifen der Ideen engagiert. Der Großteil der Bilder wurde auf ein Minimum von Oktetten für ein Maximum an Impact reduziert, um so die Geschwindigkeit erhöhen zu können. Die niedrige Auflösung dient dem schnell wechselnden Dialog, den man in dieser Arbeit erreichen will.

In seinem Projekt Visitors Guide to London (1994), das auf Hypercard realisiert und dann ans Netz angeschlossen wurde, bietet er eine andere Sichtweise Londons als die der typischen Stadtpläne für Touristen. Bunting verwendet Schwarzweißbilder (ohne Graustufen) mit niedriger Auflösung und ein sehr einfaches Navigationssystem (der Besucher bewegt sich vom Metroplan der Stadt ausgehend, indem er Zeichen für Norden, Nordosten, Osten, Süden usw. anklickt). Mit Hilfe dieses Plans gelangt man zu allen Metrostationen, wo Bunting an der Oberfläche ganz banale Photos gemacht hat, und etwas realisiert, was er selbst nennt: »Die bereits veraltete psycho-geographische Tour durch London, ideal für fremde Nicht-Besucher, besteht aus über 250 Ansichten von anti-historischem Wert. Unvollständig ohne Anweisungen, jetzt zugänglich für alle (Reichen) über das World Wide Web«.

S.L.

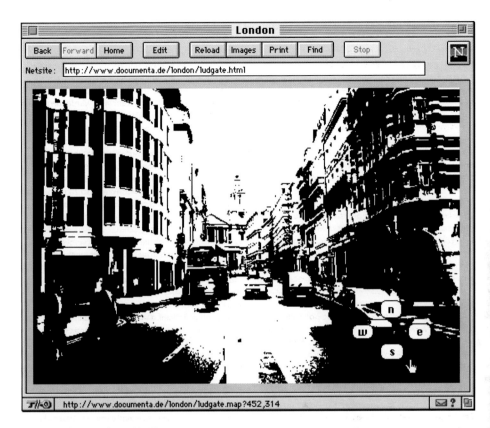

Visitors Guide to London, 1994–95
Screenshot

Charles Burnett

*1944 in Vicksburg, Mississippi. Lebt und arbeitet/lives and works in Los Angeles.

In his new film The Final Insult (Am Ende), *1977, Charles Burnett creates a vision of an evil future with humorous aspects. Burnett tells the story of "Box Brown", a "tongue-in-cheek" tale taking place in the impoverished city of Los Angeles. Box Brown, the man with the funny name. His mother christened him after the story of a slave who possessed the courage to have himself shipped from the southern states to the North in a box. Box Brown is an unsuspecting commercial clerk. One day he receives a tax assessment from the revenue office. The amount he is required to pay costs him all his worldly goods. He is forced to sell everything, managing to rescue only his car. From now on he lives outside, with only his car to protect him from rain and the attacks of people even poorer than himself. He feels comparatively good under the circumstances. Many of the others have nothing but a supermarket shopping cart in which to haul their plastic bags – their only property – around with them. Box's greatest fear is to end up that way: with only a cart, no car and no freedom.*

He quickly realizes that the whites and the blacks are drifting further and further apart, that Los Angeles has become a city of blatant racism. On the one hand the cityscape is characterized by expensive shops and thousands of swank mansions, while on the other hand, in the poorer neighborhoods and under the bridges, the number of cardboard shacks and temporary shelters built by the homeless is steadily and rapidly increasing. Box still has a few jobs, including – irony of fate – auditing accounts for the Bank of America. One day he gets beaten up and robbed of the remainder of his possessions. He can't go to see a doctor because he isn't insured. Box knows that the only solution is a revolution, that no miracle or lottery prize can help. People Power, that's what he believes in. Standing among a group of homeless, he is knocked down by a gang of kids. He falls on his head and loses consciousness. The kids tie him to his car and push it up the hill. Then they let go and Box is dragged downhill behind the car. When the kids get bored with the game a couple of adults pick up the bleeding man and put him into his car. He no longer moves, no longer breathes. All of the homeless people appear, pull the lifeless Box out of his car and carry him down the hill in a candle-light procession. They put him in a shopping cart with his name on it. His whole life long, Box tried to avoid winding up in a shopping cart. It's the final insult.

In this film Charles Burnett depicts his own bitterly humorous, tongue-in-cheek view of the megacity which becomes more radical from day to day. The economic and political bankruptcy can no longer be over-

In seinem neuen Film *The Final Insult (Am Ende)*, 1997, entwirft Charles Burnett eine böse Zukunftsvision mit witzigen Seiten. Burnett erzählt die Geschichte von »Box Brown«, eine »tongue in cheek«-Story aus dem verarmten Los Angeles. »Box Brown«, der Mann mit dem komischen Namen: Brauner Pappkarton. Seine Mutter nannte ihn so nach der Geschichte eines Sklaven, der den Mut besaß, sich in einem Karton aus den Südstaaten in den Norden schicken zu lassen. »Box Brown« ist kaufmännischer Angestellter und ahnt nichts Böses. Doch eines Tages bekommt er vom Finanzamt einen Steuerbescheid. Die Höhe der Nachzahlung kostet ihn Hab und Gut. Jetzt muß er alles verkaufen. Nur sein Auto kann er retten. Von nun an schläft er draußen, aber immerhin im Auto geschützt vor Regen und Übergriffen noch Ärmerer. Hier fühlt er sich vergleichsweise wohl. Viele um ihn herum haben nicht mehr als einen Einkaufswagen aus dem Supermarkt, in dem sie ihre Tüten, ihren einzigen Besitz, mit sich herumziehen. Das ist Box' größte Angst: Mit so einer Karre zu enden, ohne Auto, ohne Freiheit.

Er begreift schnell, daß Weiß und Schwarz immer weiter auseinanderdriften, daß Los Angeles eine Stadt voll offenem Rassismus geworden ist. Auf der einen Seite prägen teure Geschäftshäuser und tausende protziger Villen das Stadtbild, auf der anderen Seite, in den ärmeren Vierteln, unter den Überführungen, entstehen immer mehr Kartonbehausungen und provisorische »Shelters« von Obdachlosen. Noch hat Box verschiedene Jobs. Dazu gehört auch – Ironie des Schicksals –, für die Bank of America Konten zu prüfen. Eines Tages wird er zusammengeschlagen und ausgeraubt. Aber er kann nicht zum Arzt, denn er ist nicht versichert. Box weiß, daß hier nur eine Revolution Abhilfe schaffen kann, daß kein Wunder und kein Lotteriegewinn etwas bringen. »People Power«, daran glaubt er. Eine Kinderbande überwältigt Box, als er inmitten einer Gruppe Obdachloser steht. Die Kids binden ihn an sein Auto und schieben es den Berg hoch. Dann lassen sie los, und Box wird hinterher geschleift. Als die Kids ihr Interesse an diesem Spiel verlieren, retten ein paar Erwachsene den blutenden Box in sein eigenes Auto. Nichts bewegt sich mehr. Da erscheinen all die Obdachlosen und ziehen den leblosen Box aus seinem Auto und tragen ihn in einer Prozession mit Kerzenlicht den Hang hinab. Sie laden ihn in einen Einkaufswagen, auf dem sein Name steht. In einem Einkaufswagen zu enden, das wollte Box sein Leben lang vermeiden. Jetzt ist er am Ende.

Selbstironisch, mit bitterem Humor erzählt Charles Burnett in diesem kleinen Film seine eigene »tongue in cheek«-Sicht auf eine Megacity, die sich täglich radikalisiert. Der wirtschaftliche und politische Bankrott ist

Killer of Sheep, 1997
Film still

looked and Box is an outcast against his will. Burnett still manages to find the comic and tragic sides of the group of homeless who seek shelter... For us Los Angeles is the frightening city of the future, but for Charles Burnett it is home. And he is filled with panic when he thinks of the rapidly spreading conditions of poverty and the degradation which accompany them.

B.K.

nicht mehr zu übersehen, und Box ist »outcast« wider Willen. Noch kann Burnett dem Leben der Obdachlosen, die unter den Freeways hausen, komische und tragische Seiten abgewinnen. Nichts anderes als eine eigenwillige Tragikomödie kann aus dieser Umgebung resultieren. Allerdings: Für uns ist Los Angeles die erschreckende Stadt der Zukunft. Aber für Charles Burnett ist es »home«, seine Heimat. Und Panik ergreift ihn, wenn er an die Armut und die damit einhergehende Entwürdigung denkt, die jetzt in rasendem Tempo um sich greift.

B.K.

100 Tage – 100 Gäste/*100 Days – 100 Guest*

Jean-Marc Bustamante

*1952 in Toulouse. Lebt und arbeitet/lives and works in Paris.

It was in 1977 that Jean-Marc Bustamante began to conceive photographic images after the model of the painting form. These works, soberly entitled Tableaux (Paintings), depict urban landscapes somewhere between city and country, neutral spaces, "without qualities." Common places which initially distance the viewer, leaving one to oneself, with only the faculties of seeing and thinking. Bustamante's response to the profusion of spectacular images is a concern for economy. He counters the modern fetishizing of speed with an experience of slowness: "Photographing, as I did for a certain time, empty lots, spaces in transition, and the edges of cities constituted an assertion of a specificity of photography, not fixing some rapid movement but rather a slow one like that of the earth – a movement of decivilization."

From 1983 to 1986, Bustamante collaborated with the artist Bernard Bazile, creating hybrid works somewhere between object and image which functioned in relation to each other, taking into account the spaces which harbored them. They were signed with one name, BazileBustamante. In 1987 they parted and Bustamante began making abstract sculpture, mostly in steel, glass, metal, and rustproof paint, which extended his reflections on the relationship between sculpture, furniture, image, and environment. The treatment of surfaces brought out his interest in painting and a wish to propose transversal models that went beyond particular disciplines. He presents them in contradictory relations, composed of both agreement and opposition. "I like being situated in some kind of in-between," he contends.

His contribution to documenta is unusual, in the sense that it involves the publication of a book of images, Amandes Amères (Bitter Almonds). This particular project is in keeping with the object, a travel book made up of thirty-eight photographic color plates, which, although no longer subordinated to the pictorial form of the tableau, still play on the dialectic between documentary recording and pictorial composition. The photographs were taken in three different cities, all foreign to the artist (Buenos Aires, Miami, and Tel-Aviv), and are dispersed throughout the book without captions. Each one is bathed in the same late-afternoon light, which both brings things out and at the same dissolves them; they owe more to a searching psychology than to sociological research. These enigmatic photographs give off a feeling of melancholy and a somewhat tart sweetness. Bustamante has entitled his book Amandes Amères , which emphasizes the poetic dimension of this venture. This work is in fact a sequential montage which evokes the wanderings of

1977 begann Jean-Marc Bustamante photographische Bilder zu gestalten, die formal einem Gemälde nachempfunden waren. Diese Werke, die den nüchternen Titel Tableaux tragen, stellen urbane Landschaften dar, ein Zwischending zwischen Stadt und Land, neutrale Orte »ohne Eigenschaften«. Orte, die den Betrachter zunächst auf Distanz halten, ihn auf sich selbst und seine Fähigkeit zu sehen und zu denken verweisen. Der Überfülle spektakulärer Bilder antwortet Bustamante mit einem Bemühen um Ökonomie. Der modernen Fetischisierung der Geschwindigkeit stellt er eine Erfahrung der Langsamkeit entgegen: »Wenn man, wie ich, eine Zeitlang, unbebaute Grundstücke, örtliche Übergangsformen, Stadtrandgebiete und sich wandelnde Räume photographiert hat, so betont man damit eine besondere Eigenart der Photographie, bei der es nicht darum geht, eine schnelle Bewegung festzuhalten, sondern eine langsame, nämlich die der Erde, aber auch der ›Dezivilisation‹.«

Von 1983 bis 1986 schuf Bustamante zusammen mit einem anderen Künstler, Bernard Bazile, hybride Werke zwischen Objekt und Bild, die über ihre Beziehung zueinander und zu den Räumen, in denen sie sich befinden, funktionieren. Diese Werke sind mit einem gemeinsamen Namen gezeichnet: BazileBustamante. Jean-Marc Bustamante trennte sich 1987 von Bazile, um abstrakte Skulpturen zu entwerfen, hauptsächlich aus Stahl, Glas, Metall und Mennige, die seine Reflexionen über die Beziehungen zwischen Skulptur, Mobiliar, Bild und Environment weiterführen. Die Behandlung der Oberflächen läßt sein Interesse für die Malerei erkennen wie auch seine Absicht, Modelle zu unterbreiten, die sich nicht in die Grenzen der Disziplinen fügen, sondern sich quer stellen. Er stellt sie in eine widersprüchliche Beziehung, indem er Übereinstimmungen und Gegensätze aufzeigt. »Ich liebe es«, sagt Bustamante, »mich zwischen zwei Stühle zu setzen.«

Sein Beitrag zur documenta ist insofern einzigartig, als er aus einem Bildband besteht (Amandes Amères), der in den Buchhandlungen zu kaufen ist. Dieses Projekt steht in Einklang mit dem Objekt, um das es geht: Es handelt sich nämlich um ein Reisebuch, zusammengestellt aus 38 Farbbildtafeln, die nicht unbedingt mehr der traditionellen Bildform gehorchen, sondern ein dialektisches Spiel zwischen dokumentarischer Aufzeichnung und bildlicher Komposition inszenieren. Diese Photographien wurden in drei verschiedenen, dem Künstler vorher fremden Städten aufgenommen (Buenos Aires, Miami und Tel Aviv) und sind im Buch ohne erläuternden Text reproduziert. Die Bilder, die alle in das gleiche Licht des Spätnachmittags getaucht sind, das die Dinge gleichzeitig enthüllt und auflöst, sind mehr eine psycho-

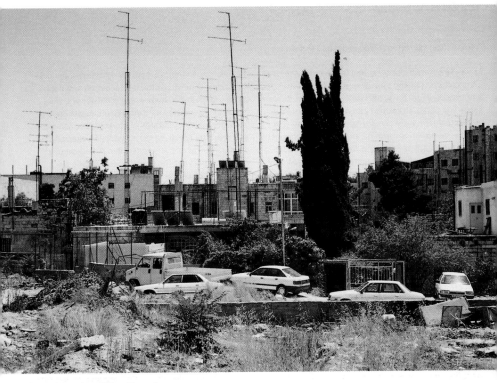

Amandes amères, Bitter Almonds,
Bittere Mandeln, 1997

the artist. Although each image is caught within the
movement of the book, it also presents itself as a
totality, a suspension or stasis.

P.S.

logische Suche als eine soziologische Studie. Diese rät-
selhaften Photographien wirken melancholisch und
erwecken den Eindruck einer herben Sanftheit. Der Titel
des Buches, *Amandes Amères, Bitter Almonds, Bittere
Mandeln,* unterstreicht die poetische Dimension seiner
Arbeit. Das Werk ist praktisch eine fortlaufende Mon-
tage, die den Spaziergang, das Umherschlendern des
Künstlers durch eine Stadt evoziert. So ist einerseits
jedes Bild Teil der vom Buch repräsentierten Bewegung,
doch andererseits repräsentiert es zugleich auch die
Unterbrechung der Bewegung, das Stillstehen, und ist
insofern ein abgeschlossenes Ganzes.

P.S.

Lygia Clark

*1920 in Belo Horizonte. †1988 in Rio de Janeiro.

Lygia Clark played a singular and influential role in Brazilian culture, weaving ever-closer links between artistic and therapeutic activity. Her work, which first emerged in the late fifties, developed at a moment of intense intellectual ferment when artists were attempting to situate their creations within a process of social transformation. In a Brazil suffering from the problems created by under-development, repression, and neocolonialism, Lygia Clark invented an experimental art.

She began on the terrain of geometric abstraction, but very rapidly understood that she was searching for something fundamentally organic, free from the constraints of pictorial form. After her prominent participation in the neoconcrete movement, in the company of her friend Hélio Oiticica, she went on to create ephemeral objects to be held in one's hands. Her relational objects from the early sixties were conceived as "living organisms" which take on form and meaning through their contact with the body of the spectator. Withdrawn from all possible financial speculation, they are fabricated from cheap, renewable materials. She then realized the Máscaras sensoriais (1967), which demand an increasingly intense sensorial and psychic investment from the spectator. In O eu e o Tu: série roupa-corpo-roupa (The I and You: Clothing/Body/Clothing Series (1967), a man and a woman blindfolded with bonnets explore the pouches and cavities in each other's clothes, experiencing tactile sensations which metaphorically evoke the genital organs. As Lygia Clark says, the idea is "discovering one's own sex in the other." At the 1968 Venice Biennial she exhibited The Home is the Body, a labyrinthine and penetrable space which analogically mimics all the different phases of birthing: penetration, ovulation, germination, expulsion. The same year there was a stiffening of military repression. She left in exile for Paris. There she explored collective working procedures, strongly influenced by the movement "antropofagia," where "the body is home" and people become "the living structure of a biological and cellular architecture." When she came back to Rio in 1977, she developed the therapeutic potential of her discoveries of what she called "the language of the body." She then invented procedures of silence and gestures ("rituals without myths") capable of liberating repressed instincts and conveying experiences buried at a subverbal level in the body.

The artworks of Lygia Clark bear on one of the fundamental aspects of Brazilian culture: the relation between the mind and the body, between rational analysis and the celebration of feelings of intuition. Like a journey of initiation, her project is founded in the apprehension of alterity and the transformation of experience into artwork (vivencias).　　　　　P.S.

Mit ihrer engen Verknüpfung von künstlerischer und therapeutischer Tätigkeit spielte Lygia Clark in der brasilianischen Kunst eine ebenso einzigartige wie einflußreiche Rolle. Ihre Laufbahn begann gegen Ende der fünfziger Jahre, so daß sich ihr Werk in einer Zeit intensiver geistiger Kreativität zu entwickeln begann, in der die Künstler gerade versuchten, ihre Arbeit zum Teil eines Prozesses der Gesellschaftsveränderung zu machen. Brasilien war das Opfer von Unterentwicklung, Unterdrückung und Neokolonialismus, und gegen diesen Hintergrund erarbeitete Lygia Clark ihre experimentelle Kunst.

Zunächst befaßt sie sich mit geometrischer Abstraktion, doch sie begreift sehr bald, daß sie in Wahrheit nach einer grundlegend organischen Ausdrucksform sucht, die von den Zwängen und Beschränkungen des Tafelbildes frei ist. Sie wird, wie ihr Freund Hélio Oiticica, ein wichtiges Mitglied der neo-konkreten Bewegung und beschäftigt sich zu Beginn der sechziger Jahre mit der Herstellung ephemerer und manipulierbarer Objekte. Ihre *Objeto Sensoriais* versteht sie als »lebende Organismen«, die Form und Sinn erhalten, wenn der Körper des Betrachters mit ihnen in Beziehung tritt. Sie sind jeder von finanziellen Gesichtspunkten bestimmten Logik entzogen, denn sie werden aus billigen und wiederverwendbaren Materialien hergestellt. Im Anschluß daran schafft Lygia Clark, die vom Betrachter eine immer größere Bereitschaft verlangt, sich mit seinen Sinnen und seinem Geist auf ihre Werke einzulassen, ihre *Máscaras sensoriais* (1967). In *O eu e o Tu: série roupa-corpo-roupa* (1967) erleben ein Mann und eine Frau, deren Augen mit einer Kapuze verhüllt sind, indem sie die Taschen und die Höhlungen in den Kleidern des anderen erforschen, taktile Sensationen, die eine bestimmte Art sexueller Erfahrung darstellen, bei der es, wie Lygia Clark sagt, darum geht, »das eigene Geschlecht im anderen zu entdecken«. In Venedig ist sie 1968 auf der Biennale mit *Das Haus ist der Körper* vertreten, einem labyrinthischen Raum, der auf analogische Weise alle Phasen der Geburt nachahmt (Penetration, Ovulation, Befruchtung, Keimung, Austreibung). Im gleichen Jahr noch übersiedelt sie wegen der ständig wachsenden Macht der brasilianischen Militärs nach Paris. Sie experimentiert nun mit kollektiven Arbeitsweisen, die stark von der Bewegung der »Antropofagia« beeinflußt sind. Den menschlichen Körper betrachtet sie als »Haus«, den Menschen begreift sie als »lebende Struktur einer biologischen und zellulären Architektur«. Als sie 1977 nach Rio zurückkehrt, entfaltet sie das therapeutische Potential ihrer Entdeckungen über die »Sprache des Körpers«. Sie entwickelt aus Schweigen und Gesten bestehende Verfahren (»Rituale ohne Mythen«),

O eu e o Tu: série roupa-corpo-roupa, 1967

die die eingedämmten Instinkte und die in der Erinnerung des Körpers auf einer subsprachlichen Ebene bewahrten Erfahrungen freizusetzen vermögen.

Lygia Clarks Arbeit konzentriert sich auf einen Punkt, der in der brasilianischen Kultur schon immer eine wesentliche Rolle gespielt hat: das Verhältnis zwischen Körper und Geist, zwischen der Welt der rationalen Analyse und der Welt der Empfindung und der Intuition. Ihr wegweisendes Projekt zielt ab auf die poetische Entfaltung der Subjektivität, das Erfassen der Andersheit und die Transformation der Existenz in ein Kunstwerk (»vivencias«).

<div align="right">P.S.</div>

James Coleman

*1941 in Ballaghaderreen, Co. Roscommon, Irland/Ireland. Lebt und arbeitet/lives and works in Dublin.

Since the outset of his career in 1970, James Coleman has appealed to the spectator's experience to complete an inquiry into the constitutive conditions of perception and the particular role of memory. He is primarily known for his slide projection works which simultaneously convoke the techniques of theater, cinema, painting, and the photonovel, presenting stories whose narrative twists operate on various levels of interpretation. His early pieces, created while he lived in Milan, were not yet involved with the conventions of theater and narration; nonetheless, they already explored the constitution of subjectivity by implicating the viewer in the process of resolving a dilemma or a perceptual problem, without offering any certainty that the solution exists. Thus he did installations such as Slide Piece (1972–73), where diverging interpretations arise from a single image. For Coleman it was less a matter of revealing a visual ambiguity than of showing that the ambiguity actually results from a perceptual process seeking to neutralize all potential conflicts.

The piece presented here, Connemara Landscape (1980), consists of the projection of a "cryptic" image, whose confusing linear configuration resists any identification. Though it does not offer a clear and precise representation, the image appears to be possibly decipherable and thus draws one into an infinite attempt at decoding. This irritating impossibility acts to unsettle the viewer, dislodging her from her habitual position as the subject of knowledge. "As a 'problem' picture Connemara Landscape functions as a visual riddle which might require a conceptual leap for its solution," remarks Michael Newman. "If the configuration is a signifier of some kind, which we are led to assume from the title and context, then perhaps it could be like hearing a foreign language which we do not understand, a 'language game' of a 'world' which is other to us." The installation itself is particularly important, since the viewer-participant can enter or exit by a door whose position very near to the projection wall affords an anamorphic perspective on the projected image. Still the image continually eludes the spectator's grasp. The title indicates that the landscape is situated in the region of Connemara, and thus takes account of a territorial dimension; but the installation refuses any identity-bolstering appropriation. Indeed, the problematic geopolitical reality of Ireland subtends all of Coleman's work, as evidenced by his later allegorical pieces which stand at the borders between different artistic practices, pointing back to the ideological and territorial divisions of his country.

P.S.

Schon seit dem Beginn seiner künstlerischen Laufbahn Anfang der siebziger Jahre widmet sich James Coleman in seiner Arbeit den Konstitutionsbedingungen der Wahrnehmung und der besonderen Rolle der Gedächtnisfunktion. Er ist vor allem bekannt für seine Diaprojektionen, die, indem sie Verfahren des Theaters, des Films, der Malerei und des Photoromans zitieren, verschlungene Erzählungen vorführen, die ständig auf verschiedenen Interpretationsebenen operieren. Als er in Mailand lebte und arbeitete, beschäftigten sich seine Arbeiten allerdings noch nicht mit den Konventionen des Theaters und des Erzählens. Seinen neueren Arbeiten geht es dafür im wesentlichen um die Konstitution von Subjektivität. Sie verwickeln den Betrachter in einen Prozeß zur Lösung eines Wahrnehmungsdilemmas, ohne daß er sich sicher sein kann, daß es überhaupt eine Lösung gibt. Ein Beispiel dafür ist seine Installation Slide Piece (1972–73), die verschiedene Deutungen ein und desselben Bildes bietet. Für Coleman handelt es sich dabei weniger darum, eine Mehrdeutigkeit aufzuzeigen, als darum, zu zeigen, daß diese Mehrdeutigkeit allein das Resultat einer Wahrnehmungsweise ist, die darauf abzielt, Konflikte zu beseitigen.

Das bei der documenta gezeigte Werk Colemans, Connemara Landscape (1980), besteht aus der Projektion eines »kryptischen« Bildes, dessen Linienkonfiguration sich jeder Identifikation verweigert. Obwohl dieses Bild nichts klar erkennen läßt, wirkt es doch so, als sei es möglich, es zu entschlüsseln, und verleitet den Betrachter dazu, dies unaufhörlich zu versuchen. Daß dieses Unterfangen nicht gelingt, ist irritierend und läßt den Betrachter in seinen gewohnten Mustern der Gegenstandserkenntnis schwankend werden. Michael Newman sagte über diese Arbeit: »Als ›Problembild‹ funktioniert Connemara Landscape als visuelles Rätsel, das zu seiner Lösung vielleicht eines begrifflichen Sprunges bedarf. Wenn die Konfiguration sich auf irgend etwas bezieht, wie wir wegen des Titels und des Kontextes des Werkes anzunehmen versucht sind, dann könnte es sich bei ihr vielleicht um so etwas wie eine fremde Sprache handeln, die wir nicht verstehen, um ein ›Sprachspiel‹ einer ›Welt‹, die uns fremd ist.« An der Installation selbst ist noch auffällig, daß der Betrachter/Teilnehmer sie durch eine Tür in der Nähe der Projektionswand betreten oder verlassen kann, die eine anamorphotische Perspektive auf das projizierte Bild bietet, das sich allerdings immer noch jeder Zuordnung und jeder Aneignung entzieht. Sein Titel, der anzeigt, daß es eine bestimmte irische Landschaft darstellen soll, verweist auf die geopolitische Realität Irlands. Diese Problematik ist im Werk Colemans stets unterschwellig präsent, wie seine späteren allegorischen Arbeiten zeigen, die sich

Note:

Connemara Landscape, 1980, is to be experienced as a projected image. The artist kindly requests that the image is not photographed or visually recorded.

© James Coleman

Connemara Landscape, 1980

im Grenzbereich verschiedener künstlerischer Praktiken bewegen und damit auf die ideologische und territoriale Teilung seines Landes verweisen.

P.S.

Collective (La Ciutat de la Gent)

La ciutat de la gent *(The City of the People) is a project by: València Bergallí, Josep Bonilla, Manuel J. Borja-Villel, Eduard Bru, Jean-François Chevrier, Miren Etxezarreta, Juan de la Haba, Craigie Horsfield, Juan José Lahuerta, Carles Martí, Lucas Martínez, Antonio Pizza, Maurici Pla, Albert Recio, Rosa Saíz, Isabel Sametier, Antonio Vargas i Lourdes Viladomiu.*

La ciutat de la gent *borrows its title from a well-known slogan used by the city of Barcelona, a city where in recent years consensus has been engineered to an extent unparalleled almost anywhere else, making it appear that no action can be taken. Although Barcelona is no different from many other cities in the industrially developed world, in the past fifteen years it has evolved so rapidly into a model of an outwardly focused city that it has somehow become a paradigm.*

We all know that modernity has not brought demystification, a total enlightenment of the world. Modern society has instead taken new conditions and shaped a new mythology, casting a new spell over our relationships. On the pretext of rationalizing city planning, modern architects and city planners have produced a mythical architecture par excellence: the new labyrinth that is the city of today. In this context, art can be a source of regeneration whose objective is not so much to depict a collective dream as to liberate us from it.

The image depicted here is not the product of an individual: it is collective, an image that does not dissolve history in myth but instead places the myth in its historical perspective. Logically enough, this project is the outcome of close cooperation between representatives of the museum and a number of groups whose knowledge of, and research and actions in, the city include a variety of viewpoints: economic, social, anthropological and, of course, political. It is these groups which have helped us enter a particular human community, acting as our interpreters. Their subjective viewpoints, their own individual actions are, of course, also a part of our project.

La ciutat de la gent *was an exhibition and a book published as part of the Fundació Antoni Tàpies, Barcelona project of a collective. It was developed as a platform for dialogue and for the building of models that could be effective in this changed world, to speak about how we think and live within the public sphere and the private space, of what community may be and how we may conceive self: the individual and the social world. The project was developed over three years and is being continued in Rotterdam, Berlin, Kraków and Ghent.*

Moll de Sant Bertran, Zona Franca, Barcelona, març 1996, 1996

Stephen Craig

*1960 in Larne, County Antrin, Nordirland/Northern Ireland. Lebt und arbeitet/lives and works in Hamburg.

The terms of architecture instead of sculpture, frame instead of painting would seem more appropriate in describing Stephen Craig's Treppen Str. Pavilion (1996–97). Installed in Kassel's old railway station, it refers both in form and content to Treppenstrasse, the street that directly links Kurfürstenstrasse, Friedrichsplatz, and the Fridericianum with the station. The continuous video loop running in the interior of the pavilion consists of short scenes and interviews recorded in and around Treppenstrasse. These show the past and present of an urban space whose social and practical function has been greatly influenced by an architecture that emerged in Albert Speer's office during the Second World War.

The unusually large scale of the model (1:2) makes it easier for the observer to appreciate the artist's intention. Even if Craig's pavilion were a full-size reproduction, when seen from one side it would still convey the impression of being a model, while opening up on the other side into a normal-sized, accessible room. Craig's architectural form is, among other things, a cypher for the exhibition hall as an institution, though he does not wish either to parody or glorify that institution. "In one sense, I take the form as a metaphor for the exhibition," he writes. "Today, pictures are made, in general, in studios. Modern objects are also made in studios. In general the modern artist thinks in his studio, and works in his studio. He hopes, he envisages perhaps, that the endeavors of his mind and body can be shown to 'the public' in a gallery, perhaps, on a white wall. There is a fundamental rule and that is, that when 'Art' 'produced' in the studio is to be seen by any one other than the artist, then the 'Art' must be exhibited. Usually, as I said, it is put in galleries and museums. In my rooms art is also to be exhibited."

At the same time, Craig's rooms are sculptural objects that comply with their own aesthetic rules. A new entity emerges out of the symbiotic relationship between them and the items exhibited inside them: "There is an essential link between the place where the exhibition is mounted and the form of the exhibition. The exhibition location is an essential criterion when selecting the exhibits." Thus Craig's pavilions are works of art and functional boxes in one. As a result, the visitor to the exhibition can "walk around art," participating directly and physically in the work and possibly even recognizing him or herself in the projections. For Craig, the categorically fixed roles of subject and object no longer apply.

S.P.

Architektur statt Skulptur, Rahmen statt Bild scheinen die passenden Termini zur Beschreibung von Stephen Craigs Treppen Str. Pavilion (1996–97) zu sein. Ausgestellt im Kulturbahnhof, bezieht er sich formal und inhaltlich vor allem auf die Treppenstraße, die vom Friedrichsplatz und dem Fridericianum über die Kurfürstenstraße direkt auf diesen zuführt. Die Videoendlosschleife, die im Innern des Pavillons läuft, besteht aus kurzen Szenen und Interviews, die in und an der Treppenstraße aufgenommen wurden. In ihnen vermitteln sich Vergangenheit und Gegenwart eines städtischen Raums, dessen soziale und praktische Funktion entscheidend durch die von der Kommission Albert Speers vorgesehene Stadtplanung geprägt ist.

Der ungewöhnlich große Maßstab (1:2) des Modells erlaubt es dem Betrachter, die Intention des Künstlers direkt nachzuvollziehen, denn auch ein in voller Größe ausgeführter Pavillon sollte von einer Seite weiterhin die Dimensionen eines großen Modells vermitteln, während er sich, von der anderen Seite betrachtet, zu einem normal großen, betretbaren Raum öffnet. Nicht zuletzt versteht sich die architektonische Form bei Craig auch als Chiffre für den institutionellen Ausstellungsbetrieb, ohne ihn karikieren oder zelebrieren zu wollen. »In gewisser Weise ist die gewählte Form für mich eine Metapher für die Ausstellung«, schreibt er. »Heutzutage werden Bilder gewöhnlich in Ateliers gemacht. Ebenso moderne Objekte. Der moderne Künstler pflegt in seinem Atelier zu denken; er arbeitet in seinem Atelier; er hofft; er malt sich vielleicht gerade aus, daß die Schöpfungen seines Geistes, seines Körpers öffentlich gezeigt werden… in einer Galerie vielleicht… an einer weißen Wand. Es gibt ein fundamentales Gesetz, welches lautet: daß, wenn im Atelier produzierte Kunst von irgend jemand anderem als dem Künstler selbst gesehen werden soll, die Kunst ausgestellt werden muß. Normalerweise steckt man sie, wie schon gesagt, in Galerien oder Museen. In meinen Räumen gilt es ebenfalls, Kunst auszustellen.«

Gleichzeitig sind Craigs Räume skulpturale Objekte mit einer ganz eigenen ästhetischen Gesetzmäßigkeit. In Symbiose mit den darin befindlichen Ausstellungsgegenständen entsteht eine neue Entität. »Der Ort, wo die Ausstellung stattfindet, steht in wesentlichem Zusammenhang mit der Struktur der Ausstellung. Der Ort der Ausstellung wird als wesentliches Kriterium in die Auswahl der Ausstellungsgegenstände mit einbezogen.« Craigs Pavillons sind also Kunstobjekt und funktionale Box in einem. Dadurch wird der Ausstellungsbesucher zum »Kunstbegeher«, der unmittelbar körperlich am Werk teilhaben und sich unter Umständen auch in den Projektionen wiederfinden kann. Kategorische Rollen-

Treppen Str. Pavilion, 1996–97

festlegungen von Subjekt und Objekt lösen sich auch für ihn auf.

S.P.

Jordan Crandall

*1958 in Detroit, Michigan. Lebt und arbeitet/lives and works in New York.

It is often said that we are currently undergoing the second major technological revolution. The first brought us the acceleration of traffic, the railway system, the automobile and, finally, aviation. The current revolution is riding on electromagnetic waves and has led to such an acceleration of communications that information is now available in real time – that means immediately, no matter where it comes from. With the aid of equipment such as computers, mobile phones, scanners etc., people can call up this information any time and be present everywhere – as long as they are in a position to use the media and analyze the information. This means that the patterns of reception have been more or less reworked, in order to adapt them to the patterns prescribed by technology. As electronic proximity does not require physical contact, a new sphere has emerged that no longer distinguishes between the private and the public. Jordan Crandall's multimedia installation suspension *observes this space created by the mediation of a variety of technical networks as "a dynamic combination of reality and virtuality," inquiring into "alternate modes of access, navigation, and inhabitation" of electronic space. "Suspension explores the ways in which viewing agencies, bodies and inhabited spaces are mobilized and cross-formatted through various 'protocols' and 'vehicles.'"*

The interactive system of video cameras, video players, projectors, computers, digital image processors, scan converters, animations, and various adjustment facilities automatically catapults the exhibition visitor into one of those new hybrid spaces of simultaneously real and virtual (distributed) presence. Voluntarily or not, the visitor begins to exert an influence. "The installation is crisscrossed with networks of projections and multiple agencies both local (within the Kassel exhibition space) and remote (via the Internet). Inhabitants simultaneously originate and interrupt the projective flow. The location of viewing is multiplied and mobilized, dispersed and re-routed. The interference patterns generate fields of competing orientations, which prompt calibrations no longer measured in terms such as distance and magnitude." Rhythm and speed of events determine the changes within the system of suspension *in which matter and energy (in the sense of electro-optical or electromagnetic power) influence each other reciprocally and force the user/viewer into constant reorientation between changing protocols and viewpoints.*

Jordan Crandall's artistic activities are complex and interdisciplinary. For example, he has been performing under the name The X-Art Foundation for some time now. In this role, he explores other forms of authorship

Man sagt, wir befänden uns im Augenblick mitten in der zweiten großen technologischen Revolution. Die erste brachte uns die Beschleunigung der Verkehrsmittel, des Eisenbahnsystems, der Autos und letztendlich den Flugverkehr. Die jetzige reitet auf elektromagnetischen Wellen und führte zu einer derartigen Beschleunigung der Kommunikation, daß Informationen heute in Echtzeit – das heißt sofort, egal woher sie kommen – zur Verfügung stehen. Mit Hilfe von Medienprothesen (Computer, Handy, Scanner etc.) kann der Mensch diese Informationen jederzeit abrufen und überall präsent sein – sofern er in der Lage ist, die Medien anzuwenden und ihre Nachrichten auszuwerten. Das bedeutet, daß er seine Rezeptionsmuster weitestgehend überarbeitet hat, um sie den durch die Technik vorgegebenen Mustern anzupassen. Da die elektronische Nähe nicht des physischen Kontakts bedarf, entsteht ein neuer Raum, der nicht mehr zwischen Drinnen und Draußen zwischen privat und öffentlich unterscheidet. Jordan Crandalls Multimedia-Installation *suspension* betrachtet diesen durch die Vermittlung verschiedenster technischer Netzwerke entstandenen Raum »…als eine dynamische Kombination von Realem und Virtuellem und erforscht seine alternativen Arten des Zugangs, der Navigation und der Inhabitation. (…) *suspension* erkundet die Wege, durch die Sehinstanzen, Körper und bewohnte Räume mobilisiert und durch verschiedene Protokolle und Vehikel durchformatiert werden.«

Das interaktive System von Videokameras, Videoeditoren und Projektoren, Computern, Scannern, digitalen Bildprozessoren und Bildkonvertern, ebensolchen Animationen, sowie diverser Justierungseinrichtungen versetzt den Ausstellungsbesucher bei Betreten von *suspension* automatisch in einen jener neuen Hybridräume von gleichzeitig realer und virtueller (distributed) Präsenz. Ob er will oder nicht, beginnt er diesen zu beeinflussen. »Die Installation wird durch ein Netzwerk von Projektionen, von mehrfachen sowohl lokalen (in Kassel, im Raum der Ausstellung) wie auch fernen Instanzen (via Internet) durchkreuzt. Die Einwohner setzen den Projektionsfluß in Gang und unterbrechen ihn gleichzeitig. Der Ort des Sehens wird multipliziert und mobilisiert, zerstreut und wieder zusammengeführt. Die Interferenzmuster generieren Felder von konkurierenden Orientierungen, die Kaliber einsetzen, die nicht mehr in Begriffen wie Distanz oder Ausmaß zu definieren sind.« Rhythmus und Geschwindigkeit der Ereignisse bestimmen die Veränderungen im System *suspension*, wo Materie und Energien (im Sinne elektro-optischer oder elektromagnetischer Kräfte) sich gegenseitig beeinflussen und den Benutzer/Betrachter zur steten Neuorien-

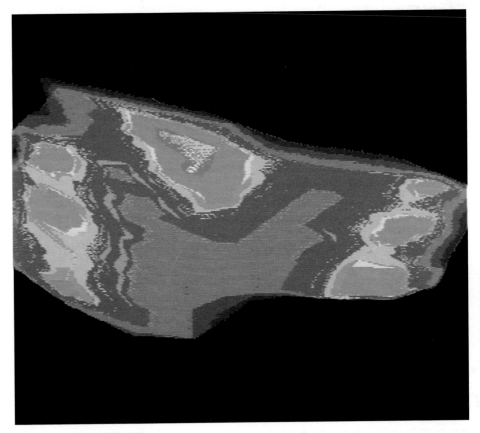

suspension vehicle RF-7600, 1997
Detail

connected with new technologies. In 1990, under the name Blast, he launched a project addressing the transformation of conventional patterns of perception and reception in reading and seeing. On this basis, changing forms of production in the field of publication and various techniques of systematization and regulation are being studied.

S. P.

tierung zwischen sich verändernden Protokollen und wechselnden Gesichtspunkten zwingen.

Jordan Crandalls künstlerische Aktivitäten sind vielschichtig und grenzüberschreitend. Beispielsweise tritt er seit einiger Zeit auch unter dem Namen »The X-Art Foundation« auf. In dieser Rolle erkundet er andere Formen der Autorenschaft, die im Zusammenhang mit neuen Technologien entstehen. Unter dem Namen »Blast« begann er 1990 ein Projekt, das sich mit dem Wandel herkömmlicher Wahrnehmungs- und Rezeptionsmuster beim Lesen und Sehen beschäftigte. Darauf basierend, entstanden Analysen veränderter Produktionsformen im Publikationsbereich und Studien verschiedener Systematisierungs- und Reglementierungstechniken.

S.P.

Stan Douglas

*1960 in Vancouver, Kanada/Canada. Lebt und arbeitet/lives and works in Vancouver.

Stan Douglas's work articulates historical and political reflection with research into audiovisual systems, whether those of yesterday (the phantasmagoria, the panorama, silent film, player pianos) or of today (cinema and television).

Der Sandmann (1995) is a cinematic installation based on the story of the same name by E.T.A. Hoffmann. This tale of uncanny doubling unfolds through an exchange of letters. Nathanael, having returned to Potsdam after a long absence, is troubled by the sight of a strange man working busily in a garden, known as a Schrebergarten. He writes to his friend Lothar for information. Lothar, astonished at his friend's lapse of memory, recalls how during their childhood they took this old man for the evil Sandman who steals the eyes of children who lie awake at night. One night as they searched the garden for the stolen organs, they were discovered and cursed by the old man, whose machines and piles of sand proved to be the components of an impracticable invention. Finally, a letter from his sister Klara reminds Nathanael that their father was murdered that very night. This coincidence, also repressed, was probably the reason why young Nathanael had kept repeating through his tears: "It was the Sandman."

Douglas shot the film twice in a UFA studio in Potsdam where he and his crew reconstructed two Schrebergartens from before and after reunification. The later one is partially defigured by parasitical constructions. Since 1989, the law governing these gardens forbids people from using them for financial or material gain (black market exchanges, free lodging). About half the Schrebergartens have succumbed to real-estate investment schemes.

For each of the two films, a centrally positioned camera pans over the set and the rest of the empty studio. "For exhibition," Douglas notes, "the two takes have been spliced together and duplicated so they may be presented from a pair of projectors focused on the same screen. They are out of phase with each other by one complete rotation of the studio, and only one half of each projector's image is seen on left and right of the screen. The effect created is that of temporal wipe. Left and right halves meet at the center of the screen in a vertical seam that pans with little effect over Nathanael and the studio. However, as the camera passes the set, the old garden is wiped away by the new one and later, the new is wiped away by the old; without resolution, endlessly." The vertical line of meeting between the two projections dramatizes the separation and suture. Douglas articulates psychic and historical repressions. The two gardens correspond to Nathanael's past and present and the looped structure matches

Die Arbeit von Stan Douglas verknüpft eine historische und politische Reflexion mit einer Recherche auf dem Gebiet der audiovisuellen Spektakel, denen von gestern (Phantasmagorie, Panorama, Stummfilm, mechanische Musik) und denen von heute (Kino, Fernsehen).

Der Sandmann (1995) ist eine kinematographische Installation, die auf der gleichnamigen Erzählung E.T.A. Hoffmanns basiert. Die beunruhigende und seltsame Geschichte über »Duplizität« erhält bei Stan Douglas folgende Gestalt: Nathanael ist nach langer Abwesenheit nach Potsdam zurückgekehrt. Verstört durch den Anblick eines fremden Mannes, der sich in einem Schrebergarten zu schaffen macht, schreibt er an seinen Freund Lothar, um nähere Informationen über diesen Mann zu erhalten. Lothar ist erstaunt über das schlechte Gedächtnis Nathaels und erinnert ihn daran, daß sie diesen Mann in ihrer Kindheit für den bösen Sandmann hielten, der den Kindern, die nicht einschlafen wollten, die Augen raubt. Eines Abends, als sie in seinem Garten nach den geraubten Organen suchten, wurden sie von dem alten Mann entdeckt und verflucht, dessen Sandhaufen und dessen Maschinen sich als Werkzeuge einer nutzlosen Erfindung erwiesen. Ein Brief seiner Schwester Klara ruft Nathanael endlich wieder ins Gedächtnis, daß damals in der gleichen Nacht ihr Vater ermordet wurde. Dieses Zusammentreffen, das Nathanael ebenfalls verdrängt hatte, war wahrscheinlich der Grund, warum er an jenem Abend ständig unter Tränen rief: »Es war der Sandmann!«

Stan Douglas hat seinen Film in zwei Teilen in einem Studio der UFA in Potsdam gedreht, wo man zwei Schrebergärten nachbaute, einen aus DDR-Zeiten und einen aus der Zeit nach der Wende. Der von heute ist zur Hälfte durch Bauarbeiten verunstaltet. Seit 1989 ist nämlich in Potsdam den Eignern der Schrebergärten gesetzlich untersagt, sie für Erwerbs- oder Wohnzwecke zu nutzen. Die Hälfte der Schrebergärten ist heute Objekt von Bauspekulationen.

Bei beiden Filmen dreht sich eine rechts positionierte Kamera und nimmt den Set und das leere Studio auf. Stan Douglas sagt zu seinem Werk: »Für die Ausstellung wurden die beiden Takes zusammengeklebt und kopiert, so daß sie von zwei Projektoren vorgeführt werden können, die auf die gleiche Leinwand gerichtet sind. Sie sind um eine vollständige Umdrehung des Studios phasenverschoben, und nur eine Hälfte von dem Bild jedes Projektors ist auf der linken und rechten Seite der Leinwand zu sehen. Dadurch entsteht der Effekt einer zeitlichen Überblendung. Die linken und die rechten Hälften treffen sich im Zentrum der Leinwand, in einer vertikalen Naht, die ziemlich folgenlos über Nathanael und das Studio schwenkt, doch wenn die Kamera über den Set

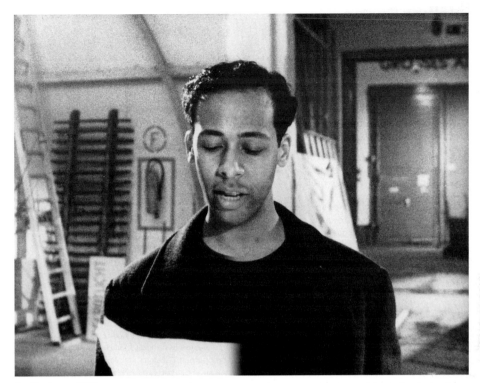

Der Sandmann, 1995
Video still

the temporal circle of the return of repressed memory. In the gardens, the doubled Sandman works busily on his machine, like a phantom from the past.

P.S.

fährt, wird der alte Garten durch den neuen weggeblendet und später der neue durch den alten, ohne Lösung, endlos.« Die vertikale Nahtstelle, wo die beiden Projektionen zusammentreffen, dramatisiert die Trennung und die Vereinigung. Douglas verknüpft eine fiktive und eine historische Unterdrückung. Die beiden Gärten entsprechen der Vergangenheit und der Gegenwart Nathanaels, und der zeitliche Ablauf in einer Schleife entspricht dem Kreislauf der Rückkehr einer verdrängten Erinnerung. In den Gärten macht sich der verdoppelte Sandmann zu schaffen, ein sich in die Gegenwart fortschreibendes Phantom der Vergangenheit.

P.S.

Walker Evans

*1903 in Saint Louis, Missouri. †1975 in New Haven, Connecticut.

From 1938 to 1940, Walker Evans photographed the passengers of the New York subway, his camera hidden beneath his overcoat, without any precise control over the framing. Men and women unwittingly filed before the lens of his camera, appearing and disappearing by chance. The subway ride offered no distraction, no landscape to contemplate; the figures drift into a voyage of dreams, or lose themselves in their reading. Their absent faces float pallidly against the dark windows and the signs.

For Evans, this experience constituted an "unfulfilled aim" in a conceptual project attempting to systematize the "record method" of photography. He took Daumier's work as a model, and set about a "photographic editing of society" (his own definition of the portraits of August Sander). The book presenting this collection of snapshots was only published in 1966, under the strangely biblical title Many Are Called. In his preface to the book, Evans explained his inquiry into the dark side of modernism by admitting his feeling of guilt before a popular tribunal: "The portraits on these pages were caught by a hidden camera, in the hands of a penitent spy and an apologetic voyeur… These pictures were made twenty years ago, and deliberately preserved from publication. As it happens, you don't see among them the face of a judge or a senator or a bank president. What you do see is at once sobering, startling, and obvious: these are the ladies and gentlemen of the jury."

Evans was fascinated by nineteenth-century French literature, Baudelaire and Flaubert in particular. The allegorical dimension of Many Are Called is an extension of Baudelairean poetics. It re-emerges in a little-known series of photographs of decaying tombstones, bearing the evocative title The Athenian Reach (1962–64). These heavily ornamented, gothic-style tombs are grotesque vestiges, ruined "relics." They convey the melancholy humor that filters throughout the artist's work. Evans always stood apart from the humanist ideology that characterized documentary photography in the thirties. Indeed, he preferred to speak of a "documentary style," thus designating an impersonal and distanced procedure that links photography with information. The greater part of his work is an exploration of the diversity of American vernacular culture, which is particularly apparent in the sequential montage of his book American Photographs. As Jean-François Chevrier remarks: "If Walker Evans was able to invent the image of America inherited by pop art, it was because he had given himself the ability to transform his melancholy passion into a lyricism attached – at a distance – to the lot of the common."

P.S.

Zwischen 1938 und 1940 photographiert Walker Evans, den Photoapparat unter dem Mantel versteckt und ohne jede visuelle Kontrolle der Bildeinstellung, Passagiere der New Yorker U-Bahn. Ohne daß sie es wissen, werden Männer und Frauen, wie der Zufall es will, von seinem Objektiv erfaßt. In den Waggons hebt sich die Blässe der geistesabwesenden Gesichter scharf von den dunklen Fenstern und den Werbeplakaten ab. Der unterirdische Beförderungsweg bietet weder Abwechslung noch eine Landschaft zum Betrachten, und die Menschen hängen ihren Träumen nach oder sind in ihre Lektüre vertieft.

Diese Erfahrung war Teil von Evans' Projekt zur systematischen Ausschöpfung der Möglichkeiten photographischer Dokumentierung. Er orientierte sich an der Arbeit Daumiers und widmete sich einer »photographischen Bestandsaufnahme der Gesellschaft«, um die Definition aufzugreifen, die er selbst dem Werk August Sanders gab. Das Buch, das diese Serie von Schnappschüssen präsentiert, erschien unter dem der Bibel entnommenen Titel Many Are Called erst 1966. Evans war klar, daß diese Bestandsaufnahme einer düsteren Seite der modernen Zeiten mit der Anerkennung einer Schuld und des Urteilsspruchs des Volkes verbunden ist: »Die Portraits in diesem Buch sind mit einer versteckten Kamera aufgenommen worden, die ein reumütiger Spion und Voyeur in den Händen hielt… Diese Bilder wurden vor zwanzig Jahren gemacht und damals absichtlich nicht veröffentlicht. Offensichtlich sehen Sie unter diesen Menschen weder das Gesicht eines Richters noch das eines Senators oder eines Bankpräsidenten. Was Sie hier sehen, ist verblüffend, erschreckend und eindeutig: Es sind die Damen und Herren der Jury.«

Walker Evans begeisterte sich für die französische Literatur des 19. Jahrhunderts, vor allem für Flaubert und Baudelaire. Die allegorische Dimension von Many Are Called ist an der Poetik Baudelaires orientiert, deren Prinzipien auch für eine wenig bekannte Serie von Photographien bestimmend sind, die Grabsteine zeigt und den vielsagenden Titel The Athenian Reach (1962–64) trägt. Diese mit Ornamenten im gotischen Stil verzierten Grabsteine sind groteske Relikte, ruinierte »Reliquien«. Aus diesen Bildern spricht der melancholische Humor, der das gesamte Werk Walker Evans' kennzeichnet. Evans war nie der humanistischen Ideologie erlegen, die die Dokumentarphotographie der dreißiger Jahre prägte. Wenn er seine Arbeiten als »dokumentarisch im Stil« bezeichnet hat, dann wollte er damit anzeigen, daß er eine unpersönliche und distanzierte Einstellung anstrebte, die die künstlerische Tätigkeit an die Gewinnung und Vermittlung von Informationen bindet. Sein Werk steht im wesentlichen im Dienst einer

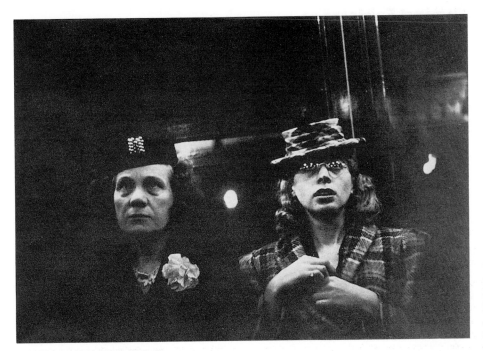

Subway Portrait, New York, 1938–40

Erforschung der Vielfalt regionaler amerikanischer Kulturformen, wovon die fortlaufende Montage von Bildern in seinem Buch *American Photographs* Zeugnis ablegt. Jean-François Chevrier schrieb über ihn: »Wenn Walker Evans das Bild Amerikas hat schaffen können, dessen Erbe die Pop Art antrat, dann deshalb, weil er die Fähigkeit besaß, seine melancholische Passion in einen Lyrismus umzuformen, der sich – von ferne – mit dem Schicksal des einfachen Volkes verbunden weiß.«
P.S.

Öyvind Fahlström

*1928 in São Paulo. †1976 in Stockholm.

Öyvind Fahlström was born in Brazil, died in Sweden, and lived many years in the United States. He was a poet, artist, journalist, activist, filmmaker, documentarian, performer, and playwright. He spoke many languages, considered himself the first Swedish surrealist artist, drafted the first manifesto of concrete poetry, and was fascinated with precolumbian art as well as Pop – with which he was erroneously associated. He took a passionate interest in game playing, not as a separate world, but as a floating distribution of relations liable to trouble the world economy.

The Little General (Pinball Machine), *1967–1968, is a pure poetic game which sets the planetary tableau into motion. It is the projection of a political and economic map onto the mobile element par excellence: water. Cutout figures, made of photographs from tabloids, ads, porno magazines, or political posters, create a fluid miniature replica of postindustrial consumer society and international commercial and economic interests. The image-objects float like so many bottles cast into the shrunken sea of a shallow basin. Here, everything is limpid, blurring into an endless play of combinations that likens the work to an aquatic pinball machine, with its horizontal and vertical transparencies (the water and the plexiglass). The spectator, transformed for the occasion into the little general of a squadron of moving targets, blows on the images at will to produce a new signifying constellation, a new geopolitical fable.*

This ripple of folly also runs through the work 1969 Meatball Curtain (for R. Crumb)*, a complex composition of free-standing objects inspired by an episode from the underground comics of Robert Crumb: meatballs fall from the sky and each person hit on the head is filled with a revelation of intense happiness.*

The colors, which also appear in the working notes drawn by the artist, are coded in a simple schema that divides the forces or structures of world power: blue for the sphere of American influence, green and brown for the Third World, purple, yellow, and orange for the socialist countries.

Fahlström sought to produce works which could figure and dramatize social and political information, integrating effects of blurring and distortion. He even idesigned games that he wanted to commercialize at modest prices. The work of art as play: a metaphor of everyone's chance to invent his or her own rules of existence and to set up a dynamic social system.

P.S.

Der in Brasilien geborene, später lange Zeit in den USA lebende und schließlich in Schweden gestorbene Öyvind Fahlström war Dichter, Künstler, Journalist, Aktivist, Filmemacher und Dokumentarist, Performer und Bühnenautor. Er hielt sich für den ersten schwedischen Surrealisten, verfaßte das erste Manifest der konkreten Poesie und begeisterte sich für präkolumbianische Kunst und die Pop Art, der er fälschlicherweise zugerechnet wurde. Er liebte das Spiel, nicht als festgeschriebenes Universum, sondern als fließende Veränderung von Relationen, die in der Lage ist, die Ökonomie der Welt zu stören.

The Little General (Pinball-Machine), 1967–1968, ist ein rein poetisches Spiel, das das planetarische Bild in Bewegung setzt. Es handelt sich um die Projektion einer Kartographie der politischen und sozialen Gegebenheiten auf das Milieu des Sich-Bewegenden, Sich-Verändernden par excellence: das Wasser. Aus Photographien ausgeschnittene Figuren, deren Vorlagen aus der Skandalpresse, aus der Werbung, aus Pornomagazinen oder politischen Plakaten stammen, ergeben ein flüssiges Abbild en miniature der postindustriellen Konsumgesellschaft und der internationalen ökonomischen und kommerziellen Interessen und ihrer Verflechtungen. Diese Bilder-Objekte schwimmen wie eine Flaschenpost in einem Bassin – einem miniaturisierten Meer. Hier ist alles klar, doch alles verwirrt sich zugleich in einem Spiel endloser Kombinationen, die das Werk mit seinen durchsichtigen horizontalen und vertikalen Flächen (dem Wasser und den Plexiglaswänden) zu einer Art Wasserflipper, einer aquarischen Pinball-Machine werden lassen. Je nach den zufälligen Interventionen des Betrachters, der sich bei dieser Gelegenheit in den kleinen General eines Geschwaders aus beweglichen Zielscheiben verwandelt, produziert jeder Luftzug eine neue signifikante Konstellation, eine neue geopolitische Fabel.

Diese Brise des Wahnsinns findet man auch in dem 1969 entstandenen Werk Meatball Curtain (for R. Crumb), wieder, einer komplexen Komposition freistehender Objekte, die von einem Comic strip Robert Crumbs inspiriert sind. In diesem Comic strip fallen Fleischbälle vom Himmel, und jede Person, der ein solcher Ball auf den Kopf fällt, wird durch die Offenbarung eines intensiven Glückes wiederbelebt. Die Farben, die in den Bildern des Comic strip verwendet werden, bestimmen auch die Arbeit Fahlströms, die sie nach einem einfachen Schema codiert, das an den Weltmächten und den globalen Machtstrukturen orientiert ist: Blau für die amerikanische Einflußsphäre; Grün und Braun für die Dritte Welt; Violett, Gelb und Orange für die sozialistischen Länder. Fahlström wollte Arbeiten

Meatball Curtain (for R. Crumb), 1969

schaffen, die eine soziale und politische Information
darstellen und dramatisieren und zugleich eine Störung
integrieren. Er hat sogar Gesellschaftsspiele erfunden,
die er zu geringen Preisen kommerziell verwerten
wollte. Das Kunstwerk als Spiel – Metapher der Mög-
lichkeit eines jeden Menschen, sich seine eigenen
Lebensregeln zu schaffen und ein dynamisches Gesell-
schaftssystem zu installieren.

P.S.

Harun Farocki

*1944 in der Tschechoslowakei/Czechoslovakia. Lebt und arbeitet/lives and works in Berlin.

Harun Farocki, who was one of the chief editors of the German journal Filmkritik, *has directed a great number of films since his beginnings in 1966. At first overtly militant, and always both poetic and reflective, his films have never ceased exploring the interaction between the political, the economic, and the aesthetic. With* Stilleben/Creating a Still-Life, *the author of* Videogram of a Revolution *(1992) and* Images of the World *(1989) continues exploring the universe of representation.*

Creating a Still-Life is a documentary about the long and expensive creation of an advertising image for consumer goods, a procedure which requires many stages in order to arrive at an original image for the product and to make it into a modern fetish. As the director puts it, "The greater the economic pressure on a product, the longer the debate about an advertising campaign's 'concept' will last, and the greater the number of people that produce and apply the idea will be." Although the photographer's studio is the locus around which marketing constraints are organized, there is a whole structure brought to bear on the elaboration of a definitive image. Among the protagonists in this film are the art directors and clients, but above all the photographers and technicians. The latter endlessly huddle around the object, which, partially stripped of its use-value and ordinary qualities, becomes the stuff of a reified dream, transfigured by the effects of image and light. Today the still life, a once-important genre in the history of painting, is almost exclusively the domain of the advertising industry, which strives to differentiate products and their images in a system of production of stereotypes. Not only does commercial photography not escape the division into sectors (people, fashion, still life), but each sector requires further specialization (food, cars, or shoes). Photographers' assistants push the specificity of their skills even further, since, as Farocki notes, "'food designers,' thanks to optical techniques, can make a carrot look more tender and a sauce more elegant." A story with many twists and turns, from enlargement to the creation of trompe-l'œil effects necessary for technical reasons (the ice-cream bar melting under artificial light in the studio), Creating a Still-Life *tells the history of the triumph of appearance over function. "What is suggestive about this work results, among other things, from the fact that so much effort is put into producing such a small facet of the world," states the artist. This closer look at cosmetic merchandise is also the occasion for questioning the inanimate. Farocki emphasizes that the film undertakes to be "both a recounting of this procedure and a revelation of the secret life of objects."*

P.S./B.K.

Seit 1966 hat der Filmemacher Harun Farocki, der einer der wichtigsten Redakteure der Zeitschrift *Filmkritik* war, eine große Zahl von Filmen gedreht. Seinem zuerst militanten Kino ging es stets darum, die Wechselwirkungen zwischen Politik, Ökonomie und Ästhetik auf ebenso poetische wie reflektierte Weise zu untersuchen. Auch mit *Stilleben/Creating a Still-Life* (1997) setzt der Schöpfer von *Videogramme einer Revolution* (1992) und *Images of the World* (1989) seine Erforschung des Universums der Repräsentation fort.

Stilleben ist ein Dokumentarfilm über den langen und kostspieligen Prozeß der Produktion von Werbephotos, die Konsumobjekte zeigen. Diese Prozedur setzt sich aus vielen Einzelschritten zusammen, die nötig sind, um zu einer originellen Darstellung des Produkts zu kommen und aus ihm einen modernen Fetisch zu machen. Farocki sagt dazu: »Je größer der wirtschaftliche Druck ist, der auf einem Produkt lastet, desto länger dauert die Diskussion über das ›Konzept‹ der Werbekampagne und desto größer ist die Zahl der Leute, die die Ideen liefern und umsetzen.« Das Photostudio ist der zentrale Ort, um den sich die Zwänge des Marketing organisieren, und es ist in seiner Struktur voll und ganz darauf abgestimmt, ein definitives Bild zu erarbeiten. Die Protagonisten des Films sind die Art-directors der Werbeagenturen und die Kunden, vor allem aber die Photographen und die Techniker. Denn diese bemühen sich um das Objekt, das zum Teil seines Gebrauchswerts und seiner gewöhnlichen Eigenschaften beraubt wird, um durch die Arbeit des Bildes und des Lichts zum überzeugenden Träger eines verdinglichten Traumes zu werden.

Das Stilleben, früher ein wichtiges Genre der Malerei, ist heute fast ausschließlich Sache der Werbeindustrie, der es darum geht, in einem System der Produktion von Stereotypen eine Differenzierung der Produkte und ihrer Bilder zu erreichen. Nicht bloß die kommerzielle Photographie wird Opfer der Einteilung in Kategorien (Menschen, Mode, Stilleben), sondern jede Kategorie erfährt obendrein noch eine Spezialisierung in Unterabteilungen (Nahrungsmittel, Autos, Schuhe etc.). Die Assistenten der Photographen betreiben eine weitgehende Spezialisierung ihrer Kompetenzbereiche, und so gelingt es manchen der »food designers«, wie Farocki bemerkt, »durch optische Techniken eine Möhre zarter und eine Soße eleganter wirken zu lassen«.

Indem *Stilleben* zahlreiche einzelne Schritte der Prozedur erzählt, von der Vergrößerung bis zur aus technischen Gründen nötigen Herstellung von Trompe-l'œils (ein Eis am Stiel schmilzt unter der Hitze der Studiolampen), erzählt es die Geschichte vom Triumph des Scheins über die Funktion. »Diese Arbeit ist unter anderem

Stilleben/Creating a Still-Life, 1997

darum so faszinierend«, sagt Farocki, »weil man so
große Anstrengungen unternimmt, um eine so kleine
Facette der Welt zu produzieren.« Der Blick, den er auf
die kosmetische Behandlung der Waren wirft, bietet
ihm gleichzeitig Gelegenheit, die leblosen Gegenstände
näher in Augenschein zu nehmen. Sein Film beabsich-
tige, erklärt Farocki, »diese Prozedur nachzuerzählen
und zugleich das geheime Leben der Objekte zu enthül-
len«.

P.S./B.K.

100 Days – 100 Guests/100 Tage – 100 Gäste

Fischli & Weiss

Peter Fischli, *1952 in Zürich. Lebt und arbeitet/lives and works in Zürich.
David Weiss, *1946 in Zürich. Lebt und arbeitet/lives and works in Zürich.

Peter Fischli and David Weiss began working together in 1979. Their first piece, a series of color photographs entitled Wurstserie (1979), is a parody of scenes from everyday life, using sausages and quotidian objects as materials of representation. Since then the two artists have not ceased exploring the crossing mechanisms of common experience and scientific knowledge, through films, sculptures, photographs, objects, books, and installations. In their first film, Der geringste Widerstand, (1980), a bear and a rat set off to conquer the world and to plumb the depths of science: but each discovery opens up new horizons and finally they are overwhelmed by innumerable questions. Another film, Der Lauf der Dinge (1987), is a faux-naive investigation of chain reactions. Plötzlich diese Übersicht (1981), an installation of 250 clay sculptures, is described by the artists in these terms: "Scenes and situations from the past and present of terrestrial and human history, essential or forgettable, decisive or accessory, are depicted in associative succession and encyclopedic profusion."

Fischli & Weiss most often work with stereotypical images and everyday tools (kitchen utensils and do-it-yourself supplies). For them the notions of order and disorder, of chance and necessity, of difference and similarity, all rest on theoretical distinctions which are constantly contradicted in practice. Thus when they set up processes of randomly developing sequences, these processes are rendered necessary by the nature of the improvised devices. Similarly, their images show the dispersal, confusion, or entropy of the urban landscape, even while revealing the regulated, normative character of the same phenomenon. They conceive "clichés" and commonplaces as a self-repetition of the diverse.

For documenta they have created a video film with materials from their archives. The images, classified by theme, are linked together in a succession of fade overs. Taken during trips and excursions since 1987, these are "tourist" images, average-looking snaps. Some of them, tinged with exoticism and close to the aesthetic of travel-agency catalogues, have the character of "collective pictures of longing." They have no particular qualities. Weiss: "Taking pictures, one shouldn't talk about the grain or the photographic style. Formal aspects should not be the content. Things should be in the middle of the frame, and the weather should be nice." The video film, eight hours long, will be broadcast at night in one-hour segments over arte. People looking at the work without any previous knowledge of the project might not even dream that it results from an artistic attitude. P.S.

Peter Fischli und David Weiss begannen ihre Zusammenarbeit 1979. In ihrem ersten Werk, *Wurstserie* (1979), einer Serie von Farbphotographien, stellten sie mit Würsten und Alltagsgegenständen Szenen des Alltagslebens parodistisch nach. Seitdem haben die beiden Künstler immer wieder mit Filmen, Skulpturen, Photographien, Objekten, Büchern und Installationen die Mechanismen des Alltäglichen und der Erkenntnis erforscht. Der erste Film, den sie machten, *Der geringste Widerstand* (1980), handelt von einem Bären und einer Ratte, die sich daranmachen, die Welt zu erobern und Wissen zu erwerben. Jede Entdeckung eröffnet neue Horizonte, und schließlich stehen sie vor unzähligen offenen Fragen. Ein anderer Film, *Der Lauf der Dinge* (1987), präsentiert sich als scheinbar naive Untersuchung über Kettenreaktionen. *Plötzlich diese Übersicht* (1981), eine Installation aus 250 Tonskulpturen, wird von den Künstlern folgendermaßen beschrieben: »Hier werden in einer assoziativen Abfolge und in einer enzyklopädischen Fülle Szenen dargestellt, die für die Geschichte und die Gegenwart der Erde und des Menschen wesentlich, unwichtig, entscheidend oder nebensächlich waren.«

Fischli & Weiss arbeiten vornehmlich mit längst abgewirtschafteten und kompromittierten Bildern und ganz alltäglichen Gegenständen (Küchengeräten und Bastelmaterial). Für sie beruhen die Vorstellungen von Ordnung und Unordnung, Zufall und Notwendigkeit, Unterschiedlichkeit und Ähnlichkeit auf einer theoretischen Differenzierung, die von der Praxis ständig unterlaufen wird. Wenn sie daher Prozesse zufälliger Verkettungen in Gang bringen, dann ist der Ablauf dieser Prozesse aufgrund der zusammengebastelten Vorrichtung notwendig. Ihre Bilder zeigen die Zersplitterung, die Konfusion oder die Entropie der urbanen Landschaft, indem sie den geregelten, ja sogar normierten Charakter dieses Phänomens enthüllen. Dementsprechend begreifen sie die »Klischees« und die Gemeinplätze als eine Wiederholung des Mannigfaltigen.

Für die *documenta* haben sie einen Videofilm gedreht, der auf ihrem photographischen Archivmaterial basiert. Die nach Themen gruppierten Bilder sind durch Überblendungen aneinandergereiht. Die seit 1987 bei Reisen und Ausflügen geknipsten Photos sind banale »Touristenbilder«. Manche von ihnen haben mit ihrer »Exotik« und ihrer Nähe zur Ästhetik der Kataloge von Reiseveranstaltern den Charakter von »kollektiven Sehnsuchtsbildern«. Sie besitzen keine besonderen Eigenschaften. Weiss sagt dazu: »Wenn man Bilder macht, dann sollte ihr Thema nicht die Körnigkeit oder der Stil des Photographierens sein. Formale Aspekte

Untitled, 1997
arte: daily 01 a.m./täglich 01 Uhr nachts

sollten nicht Inhalt sein. Dinge sollten in der Bildmitte sein, und das Wetter sollte schön sein.« Der insgesamt acht Stunden dauernde Videofilm wird nachts in jeweils einstündigen Folgen von arte ausgestrahlt. Wer sich den Film anschaut und das Projekt nicht kennt, wird nicht vermuten, daß er es mit dem Resultat einer künstlerischen Einstellung zu tun hat.

P.S.

Peter Friedl

*1960 in Oberneukirchen, Österreich/Austria. Lebt und arbeitet/lives and works in Berlin und Wien/and Vienna.

A man in an underground passage puts money into a cigarette machine but does not succeed in obtaining his packet. Frustrated, he kicks the machine. As he walks away, a junkie comes up asking for money. The man brushes him off without a word. The junkie, vexed, punches him. This little sketch is projected in a loop, day and night, on a monitor set up in the final vitrine of the underground passage, on the way out of the train station, right where the action takes place. The absence of the cigarette machine, installed for the occasion, then taken away, may indicate that something is missing here.

On the roof of the documenta Halle stands the word KINO (cinema). These letters in the sky could almost go unnoticed, so perfectly do they conform to a typical urban function – unless one remarks the incongruity of a sign that does not correspond to the place it overarches and, normally, indicates.

These two geographically distant works constitute the two poles of Peter Friedl's intervention. His artistic activity, related to what he calls a "spiritual infiltration," consists most often of conceptual aesthetic acts, which by "creating exact misunderstandings.. slightly indicate from where to where the desired transfer of meaning, content, and assignment should take place." Friedl's works infiltrate a gap in representation, between the description of the world and the evocation of an ideal. They pose a melancholy question about the progressive dissolution of the utopian and spiritual dimension into the profane: "The substance of art has disappeared more into the fragile interhuman sphere." These works always contain a missing element and this lack intimates that the viewer must engage in a mental process of completion.

The letters of the word KINO, in Helvetica script – "a little too fat and a little too big" – constitute a sarcastic allusion to the neighboring sign of the Staatstheater, asserting a contradictory and polysemic presence. The video film, shot with "professional amateurism," constitutes a serious reflection and a skeptical commentary on the notion of "site-specific," as well as a laconic reflection on the role of the artist in the social politics of the city (Friedl himself plays the man struggling with the cigarette machine). The video is also an inquiry into the contemporary conception of the flâneur and the passage, in a place which, for the artist, represents "an urbanistic failure."

At night, while a TV monitor endlessly replays Peter Friedl's double quarrel in an underground passage, the red neon letters of KINO blaze in solitude above a deserted documenta Halle.

P.S.

In einer unterirdischen Fußgängerpassage wirft ein Mann Geld in einen Zigarettenautomaten, aber der Automat spuckt kein Zigarettenpäckchen aus. Frustriert hämmert er auf den Automaten ein. Als er weitergehen will, kommt ein Junkie und bettelt ihn um Geld an. Der Mann schiebt ihn wortlos zur Seite. Der Junkie wird pampig und versetzt dem Mann einen Schlag. Der kleine Sketch wird Tag und Nacht pausenlos auf einem Monitor gezeigt, der in der letzten Auslage eben jener unterirdischen Passage am Bahnhof steht, wo sich der Videofilm abspielt. Das Fehlen des Zigarettenautomaten, der eigens für die Aufnahmen installiert und dann wieder entfernt wurde, zeigt vielleicht an, daß hier noch etwas anderes fehlt.

Auf dem Dach der documenta-Halle ragen Buchstaben in den Himmel, die das Wort KINO bilden. Sie könnten als gängige Funktionsträger des urbanen Raums leicht der Aufmerksamkeit des documenta-Besuchers entgehen, würde man nicht wissen, daß hier ein Ort als etwas ausgewiesen wird, das er eigentlich nicht ist.

Diese beiden räumlich weit auseinanderliegenden Werke repräsentieren die beiden Pole der Interventionen Peter Friedls. Seine künstlerische Aktivität besteht, ähnlich dem, was er eine »spirituelle Unterwanderung« nennt, oft in einem ästhetischen Akt, der »exakte Mißverständnisse erzeugt« und auf diese Weise »zart andeutet, von wo nach wo die erwünschte Übertragung von Bedeutung, Inhalt und Zuschreibung stattfinden sollte«. Die Werke Friedls unterwandern die Repräsentation, indem sie die Lücke nutzen, die zwischen dem Beschreiben der Welt und dem Evozieren eines Ideals klafft. Sie erkunden auf melancholische Weise den fortschreitenden Auflösungs- und Profanierungsprozeß der utopischen und spirituellen Dimension: »Die Substanz der Kunst hat sich noch weiter in den fragilen zwischenmenschlichen Bereich verflüchtigt…«. Seine Werke enthalten immer ein fehlendes Element, und diese Unvollständigkeit fordert den Betrachter auf, eine geistige Arbeit des Vollendens zu erbringen.

Die in Helvetica geschriebenen, »ein wenig zu fetten und zu großen« Buchstaben des Wortes KINO, eine sarkastische Anspielung auf die für das Staatstheater Reklame machenden Lettern, sind von einer widersprüchlichen und vieldeutigen Präsenz. Der mit professioneller Amateurhaftigkeit gedrehte Videofilm, ein ernsthafter und zugleich skeptischer Beitrag zur »ortsspezifischen« Kunst, ist eine lakonische Reflexion über die Rolle des Künstlers in der städtischen Sozialpolitik (Friedl spielt den Mann am Zigarettenautomaten, während der Junkie aus den Obdachlosen rekrutiert wurde, die sich am Friedrichsplatz aufhalten), wie auch eine Hinterfragung der zeitgenössischen Vorstellung vom

Dummy, 1997
Video still

Flaneur und der Passage an einem Ort, der in Friedls
Augen ein »urbanistisches Versagen« dokumentiert.
 Nachts, während in einer leeren unterirdischen Pas-
sage ein Fernsehmonitor zum x-tenmal den doppelten
Ärger Peter Friedls vorführt, leuchten die Buchstaben in
rotem Neonlicht einsam auf dem Dach einer verlasse-
nen documenta-Halle.

P.S.

Holger Friese

*1968 in Saarbrücken. Lebt und arbeitet/lives and works in Köln.

With a background in graphics and programming, Holger Friese brings another view to bear on what is being spread over the networks. On one hand he attempts to push the machine and its computing power to the limits, and on the other to bring out its inherent formal contingencies.

His project unendlich, fast... (endlessly, almost), 1995, does full justice to both perspectives. Indeed, Friese manages the great feat of concentrating, quite poetically and on just one page, a certain number of contingencies inherent in the way things appear on a computer screen connected to the Internet. That great blue surface, too great to be taken in all at once, with a few typographical signs in a little corner which might remind someone of stars, must come from somewhere: but is it from the computer, the viewer, the server, or the infinity of the networks? In any case this image, so simple in appearance, must necessarily be (inter)activated by the viewer, who, if he or she wishes to view the whole, must scroll the image from side to side using cursors. It is with this gesture that awareness begins.

First of all, the computer screen is really a rectangular surface, almost flat and delimited by its physical edges. Friese's image is devised to extend beyond the usual limits, so it necessarily spills beyond this frame. Next, this same screen displays the results of the operations executed by the machine, to which the user generally has little access. If the computer is connected to the World Wide Web, it can just as easily display things in internal mode as in external. It is difficult to determine where an image or a piece of data comes from. In this particular case, Friese's page is the result of local interpretation (by the viewer's computer) of data originating elsewhere (the server). That intense blue is almost as infinite in size as it is in situation. The surroundings in which it appears may give the impression that it originates not in some cinematographic off-screen, but in some great information-system beyond. But to evoke the beyond is not mystical. Rather, there is a dimension of depth to provenance: beyond the screen, wires, chips, and networks, and other machines, other cables, other wires.

S.L.

Als Graphiker und Programmierer wirft Holger Friese einen anderen Blick auf das, was über die Netze verbreitet wird: Er versucht einerseits, die Grenzen der Maschine und die ihres Rechenvermögens nach außen zu verschieben, und andererseits, ihre inneren, formellen Abläufe hervorzuheben.

Die Arbeit unendlich, fast... (1995) ist die perfekte Antwort auf diese Sichtweise. Auf einer einzigen Seite vollbringt Friese die hervorragende Leistung, eine gewisse Anzahl von Abläufen, die für das Erscheinen der Dinge nötig sind, auf dem Schirm eines an das Internet angeschlossenen Computers auf sehr poetische Weise zu sammeln. Diese große blaue Oberfläche, die zu groß ist, um auf einmal erfaßt werden zu können, und die in einem Winkel kleine typographische Zeichen, die uns an Sterne erinnern, aufweist, muß von irgendwoher kommen: vom Computer des Betrachters, vom Server, aus der Unendlichkeit der Netze? Auf jeden Fall muß dieses Bild, das so einfach aussieht, durch den Betrachter, der (wenn er alles sehen will) das Bild mit seinen seitlichen Cursern absuchen muß, interaktiviert werden. So beginnt man, sich des Bildes bewußt zu werden.

Der Schirm eines Computers ist in Wirklichkeit zuerst einmal eine rechteckige, fast flache Oberfläche, die durch ihre physischen Ränder abgegrenzt wird. Mit dem Werk von Friese wurde geplant, diese gewöhnlichen Grenzen zu überschreiten, es geht über diesen Rand hinaus. Dann zeigt dieselbe Schirm das Resultat der von der Maschine durchgeführten Operationen an, zu dem der Benutzer normalerweise nur wenig Zugriff hat. Ist der Computer ans World Wide Web angeschlossen, kann er genausogut Dinge im internen wie im externen Modus anzeigen. Es ist schwierig festzustellen, woher ein Bild oder eine Information kommt. In diesem Fall ist die Seite von Holger Friese das Ergebnis der lokalen Interpretation (der Computer des Betrachters) der Daten, die anderswoher stammen (dem Server).

Demnach ist dieses intensive Blau sowohl in seinem Ausmaß als auch in seiner Lokalisierung beinahe unendlich, und die Umgebung, in der es auftritt, kann einem das Gefühl vermitteln, daß es nicht von einem (kinematographischen) Äußeren, sondern von einer Grenzüberschreitung (der Informatik) her erscheint. Die Evokation dieses Übersinnlichen hat jedoch nichts Mystisches, sie betrifft viel eher eine Dimension der Tiefe des Ursprungs: über dem Schirm, den Drähten und den Netzen gibt es wieder Maschinen, Kabel, Drähte.

S.L.

unendlich, fast…, 1995
Screenshot

Liam Gillick

*1964 in Aylesbury. Lebt und arbeitet/lives and works in London und/and New York.

After developing parallel activities in the fields of architecture, design, decoration, journalism, and information structures – "in order to occupy spaces alongside other setups" – Liam Gillick wrote the scenario of the film McNamara in 1992. Only the first scene would achieve visual realization, in the form of an animated cartoon. Initially conceived as yet another activity, the scenario in fact gave rise to an extended reflection on parallel stories.

"Central here is the idea of the middle. The spaces in between effects and social setups. The use of the ideas that have sprung from the application of 'role playing' and 'the scenario' (and their overuse in other areas) has ensured that the most dynamic potential terrain for artists and other manipulators of visual and sociopolitical space is that center area which also embraces strategy, compromise, negotiation, mediation, game playing, and so on."

In the same way that McNamara focuses on shadowy figures from the Kennedy administration, the text Erasmus is Late proposes a reflection on the development of socialism and capitalism through the intermediary of a series of secondary figures captured over a long span of time ("the book flashes between 1810 and 1997"). While writing the book, Gillick created plastic prototype structures and Ibuka ("a musical outline"), in order to present and "reframe" certain ideas and questions that had come up during the process of writing. His project Discussion Island: The What If? Scenario (1996) is a political reflection on the elaboration of a "near future."

"Discussion Island articulates the blurred relationship between people and effects in order to consolidate a concept of the future within a post-utopian context, an analysis of possibilities through the creation of a series of environmental tools."

Gillick slips through the gap that separates art and society, thanks to "different levels and speeds of communication." His first installations were related to decors, often including a table at whose center, like a theater prop, stood the book from which the decor was drawn. These books themselves contain a central element (a figure, event, or idea) whose contours are traced by peripheral figures and a kind of temporal flickering. Today, with his hanging Platforms, Gillick lights up another empty stage in the exhibition space, an ambient field that invites the viewer to a symbolic occupation. On the basis of a series of objects "that are designed for development rather than mute consideration," he produces the image of a form whose incompletion sketches out an empty figure of sociability, a metaphor of that "central region" where the process

Nachdem er, um ein möglichst breit gefächertes Spektrum abzudecken, sich parallel auf den Gebieten Architektur, Design, Dekoration, Journalismus und Informationsstrukturen betätigt hatte, schrieb Liam Gillick 1992 das Drehbuch des Filmes McNamara, von dem lediglich die erste Szene eine visuelle Konkretisierung in Form einer Zeichentrickepisode erfuhr. Dieses Drehbuch, das ursprünglich nur als weiteres paralleles Betätigungsfeld gedacht war, gab dann aber den Anstoß zu einem Projekt der Reflexion über parallele (auch historische) Situationsverläufe.

»Zentral ist hier die Idee der Mitte. Die Zwischenräume zwischen Auswirkungen und sozialen Situationen. Die Verwendung von Ideen, die aus der Applikation von ›Rollenspiel‹ und ›Drehbuch‹ (und ihrer Überstrapazierung in anderen Gebieten) hervorgingen, hat dafür gesorgt, daß das dynamischste potentielle Terrain für Künstler und andere Manipulatoren des visuellen und soziopolitischen Raumes jenes zentrale Gebiet ist, in dem auch Strategie, Kompromiß, Verhandlung, Vermittlung, Modellspiel zu Hause sind.«

Auf dieselbe Weise, wie sich McNamara für Personen im Hintergrund der Kennedy-Administration interessiert, unterbreitet der Text Erasmus is Late eine Reflexion über die Entwicklung des Sozialismus und des Kapitalismus anhand einer Reihe zweitrangiger Personen verschiedener Epochen (»das Buch springt zwischen 1810 und 1997 hin und her«). Während er dieses Buch schrieb, schuf Gillick zugleich prototypische plastische Strukturen sowie Ibuka (einen Musicalentwurf), um bestimmte Ideen und Fragen aufzugreifen und schärfer zu fassen, die sich ihm bei der Niederschrift des Buches aufgedrängt hatten. Sein Projekt Discussion Island: The What If? Scenario (1996) ist eine politische Reflexion über die Ausarbeitung einer unmittelbar bevorstehenden Zukunft.

»Discussion Island verdeutlicht die verschwommene Beziehung zwischen Menschen und Wirkungen zur Konsolidierung eines Zukunftskonzeptes innerhalb eines post-utopischen Kontextes – eine Analyse von Möglichkeiten anhand der Schaffung einer Reihe von Mitteln zur Manipulation der Umwelt.«

Gillick nutzt die Lücke, die sich aufgrund »verschiedener Kommunikationsniveaus und -geschwindigkeiten« zwischen Kunst und Gesellschaft auftut. Die ersten Installationen Gillicks zeigen Ähnlichkeit mit Bühnenbildern, oft steht ein Tisch in der Mitte, auf dem, wie ein Theaterrequisit, das Buch liegt, dem das Bühnenbild entstammt. Diese Bücher enthalten selbst wieder ein zentrales Element (Person, Ereignis oder Reflexion), das sich aber nur in Andeutungen abzeichnet. Mit seinen hängenden Platforms beleuchtet Gillick eine andere

The What If? Scenario, Cantilevered Delay, Platform, 1996

of "discussion, delay, negotiation, conciliation" takes place.

P.S.

leere Bühne im Raum der Ausstellung, ein Umfeld, das den Betrachter zu einer symbolischen Okkupation einlädt. Durch eine Serie von Objekten, die »nicht für eine stumme Betrachtung, sondern zum Entwickeln und Ausarbeiten entworfen sind«, bringt er das Bild einer Form hervor, in deren Unvollständigkeit sich ein Ort der Geselligkeit abzeichnet, Metapher jener zentralen Region, in der der Prozeß der »Diskussion, Verzögerung, Verhandlung und Versöhnung« stattfindet.

P.S.

Heiner Goebbels

*1952 in Neustadt/Weinstraße. Lebt und arbeitet/lives and works in Frankfurt am Main.

"When I'm directing it's more like composing, and when I'm composing it's more like directing."

In his use of music as a ready-made which he integrates into a collage of various musical trends from classic to pop to rock – in a manner only inconceivable after the postmodern era, more like loosely threaded pearls than narrated stories – the music theater of composer, director, and much-acclaimed radio-playwright Heiner Goebbels maintains a distance from opera, hovering above the territory of a new theatrical form which has yet to be fully explored. In their reference to the experimental concepts of the avant-garde, Goebbels' works blaze new trails for music theater, acoustic experience, and visual repose.

Ideas are not copied, but are placed instead into new contexts, rendered accessible to sense perception: sound as music, silence as space, the laborious eradication of musical hierarchies. Scenes become graphic outgrowths of a musical tapestry, visual associations with the acoustic material. Goebbels allows the individual elements free rein, enabling them to intermingle in a tranquil flow, as if part of a new semantics. Styles are not intended to combine but to clash, though without having to forfeit their musical identity, culminating in something new that possesses the force of the individual, independent parts. In Goebbels' music theater, the autonomy of music, language, and space are maintained in a harmonious balance, instead of individual elements serving as theatrical illustration. Musical structures become spatial perspectives.

Personal authorship is not essential in Goebbels' view. He offers many different voices. Of importance to him in avoiding arbitrariness is the economy of the heterogeneous materials. What he is aiming at is the opposite of a Gesamtkunstwerk. He would like to make a product out of the possibility of experience and highlight the transparent contradictions between the different media and styles. His work is concerned with the way various levels of perception run parallel and intertwine, giving rise to a composite multimedia whole without ever blending into an illusionistic total work.

Heiner Goebbels' music theater is inconceivable without text. His love of language is as characteristic as his concept of music. Writing interests him more as script than as written word, the voice as tone, as tonal mood and tonal memory, the text as musical composition. He often begins with texts by Heiner Müller. His own last work, Schwarz auf Weiss, was composed and staged as a requiem for the poet and playwright.

Goebbels has frequently worked at the Theater am Turm in Frankfurt where he created Ou bien le débarquement désastreux (1993), Die Wiederholung

»Als Regisseur komponiere ich eher und als Komponist inszeniere ich eher.«

Die Musik als Readymade benutzen, zu einer Collage neu zusammenfügen, Kombinationen unterschiedlicher Musikrichtungen von klassischer Musik über Pop und Rock, wie sie nur nach der Postmoderne denkbar sind, eher Perlen loser Ketten als erzählte Geschichten – so schwebt das Musiktheater von dem Komponisten, Regisseur und vielfach prämierten Hörspielautor Heiner Goebbels fern von der Oper über dem zu erforschenden Raum des neuen Musiktheaters. In bezug auf die experimentellen Konzepte der Avantgarde weist Goebbels mit seinen Stücken dem Musiktheater, dem Hör-Erlebnis und der Seh-Ruhe neue Perspektiven.

Es wird nicht kopiert, sondern Ideen werden in neue Kontexte gebracht und sinnlich gefüllt: der Laut als Musik, die Stille als Raum, die Arbeit an der Auflösung musikalischer Hierarchien. Szenen werden zu bildhaften Auswüchsen eines Klangteppichs, zu optischen Assoziationen des akustischen Materials, und Goebbels gibt den einzelnen Elementen freien Lauf, die, wie in einer neuen Semantik, im ruhigen Fluß ineinandergreifen. Die Stile sollen nicht amalgamieren, sondern aufeinandergestoßen werden, ohne daß die musikalische Identität eingebüßt wird, damit etwas Neues entsteht, das die Kraft der unabhängigen Einzelteile hat. Die Autonomie von Musik, Sprache und Raum seines Musiktheaters werden in harmonischem Gleichgewicht gewahrt, anstatt einzelne Elemente das Theater illustrieren zu lassen. Aus musikalischen Strukturen werden Raumperspektiven.

Für Goebbels ist seine Autorenschaft nicht wesentlich. Er offeriert Vielstimmigkeit. Die Strenge der fremden Stoffe ist ihm wichtig, um Beliebigkeit zu vermeiden. Sein Ziel ist das Gegenteil eines Gesamtkunstwerks. Er möchte die Möglichkeit der Erfahrung als Produkt schaffen und die Transparenz der Widersprüche zwischen den verschiedenen Medien und Stilen deutlich machen. Seine Arbeit geht um das Neben- und Ineinandergreifen verschiedener Wahrnehmungsebenen, die zusammen ein heterogenes, multimediales Ganzes ergeben, ohne je zum illusionistischen Gesamtkunstwerk zu verschmelzen.

Ohne Text ist das Musiktheater von Heiner Goebbels nicht möglich. Seine Liebe zur Sprache ist so eigen wie seine Vorstellung von Musik. Ihn interessiert das Schreiben auch als Schrift und nicht nur das Wort, die Stimme als Klang, als Klangstimmungen und Klangerinnerungen, der Text als musikalische Komposition.

Goebbels, der oft mit Texten Heiner Müllers gearbeitet hat, hat mit seiner letzten Arbeit, Schwarz auf Weiß, ein Requiem auf den Dichter komponiert und inszeniert.

Ou bien le débarquement désastreux – Oder die glücklose Landung, 1993

(1995), and his most recent work Schwarz auf Weiss (1996) together with the Ensemble Modern.

J.H./B.F.

Heiner Goebbels inszenierte unter anderem am Theater am Turm/Frankfurt, wo er neben *Ou bien le débarquement désastreux* (1993) und *Die Wiederholung* (1995), auch sein letztes Stück *Schwarz auf Weiß* (1996), zusammen mit dem *Ensemble Modern* erarbeitet hat.

J.H./B.F.

Dorothee Golz

*1960 in Mülheim/Ruhr. Lebt und arbeitet/lives and works in Mülheim/Ruhr.

The disquiet and relative insecurity that washes over a viewer at the sight of Dorothee Golz's drawings and sculpture comes from the kind of dim recognition provoked by the presence of some uncanny phenomenon. Her work resembles a visit, tinged with humor, to the imaginary and unconscious of everyday life.

Hohlwelt (1996) evokes the domestic universe enclosed in a bubble. This environment, which could almost be qualified as an autistic space, is perturbed by a kind of amorphous and indeterminate growth in the presence of two more familiar-looking elements (a chair and a lamp). The eruption of such a figure gives the work an ambiguous quality somewhere between protectiveness and angst. As the artist puts it, "The fish-eye perspective of the bubble internalizes the scene and separates it from our outer experience. The interior reveals itself as something that follows its own laws. The space at the center of the bubble can be viewed from all sides; nothing is hidden from our gaze, but it doesn't follow the rules that govern the reality to which we actually physically belong. In spite of all this openness, a clear line is drawn between here and there. It represents something else."

Golz often draws on sources from the utopian imagery of the 1960s. For example, some of the figures in her drawings come from magazines of the period that earnestly explain the miracles of the mechanical world, marvelous scientific discoveries, or the kind of "do-it-yourself" techniques that show husbands how to make something for their wives. These stereotypical characters coexist with complex, fascinating figures – clusters, vortices, swirls – from some other dimension. Through this retrospective exploration of the sixties aesthetic, Golz puts a finger on our disappointed expectations and futuristic anticipations of radiant tomorrows. She takes hold of the fantasmagorical aspects inherent in the design and imagery of the time, and in her fascination with "the psychological dynamics hidden behind what seems to be unambiguous and familiar," Golz sees the object as the manifestation of a hidden desire that largely conforms to its functionality. So much so that the disquieting familiarity emanating from the artist's sculpture and drawings is due less to psychological projection on the part of the artist than to a process whereby she brings out the unconscious and impersonal charge with which things are already invested, along with the latent derangement they contain, and which she merely has to disclose. As she notes, the viewer "should be conscious of a world of thought, an imagined world, that exists alongside the real and tangible world."

P.S.

Die Irritation und relative Unsicherheit, die den Betrachter angesichts der Zeichnungen und Skulpturen von Dorothee Golz befällt, rührt daher, daß er hier mit Phänomenen konfrontiert wird, die sich dem Zugriff der Erkenntnis entziehen. Ihr Werk erinnert an einen etwas humoristischen Besuch auf der imaginären und unbewußten Seite der Alltagswelt. Ihre Arbeit Hohlwelt (1996) besteht aus einer Kunststoffblase, in der sich zwei Elemente vertrauter Form befinden, die den häuslichen Bereich evozieren (ein Stuhl und eine Lampe), sowie ein drittes Element, dessen Form undefinierbar und amorph ist. Das amorphe Element, das sich in diesen fast autistisch zu nennenden Raum »eingeschlichen« hat, verleiht dem Werk ein ambivalentes Oszillieren zwischen Schützendem und Beängstigendem. »Die Fischaugenperspektive der Kugel unterstreicht das«, sagt die Künstlerin, »weil sie die Szene innen von unserer Erfahrung außen abgrenzt. Das Innere stellt sich als etwas dar, das eigenen Gesetzmäßigkeiten folgt. Der Raum im Zentrum der Blase ist von allen Seiten einsehbar, es wird nichts vor unseren Augen verborgen, aber er folgt nicht den Regeln jener Realität, an der wir körperlich teilhaben. Trotz aller Transparenz wird eine exakte Grenzlinie zwischen Hier und Dort gezogen. Es repräsentiert etwas anderes.«

Dorothee Golz greift in ihrer Arbeit häufig die utopische Bilderwelt der sechziger Jahre auf. Zum Beispiel entstammen bestimmte Figuren ihrer Zeichnungen aus Zeitschriften von damals, die auf naive Weise die Wunder der Technik erklärten, von großartigen wissenschaftlichen Entdeckungen schwärmen oder Anleitungen für Heimwerker nach dem Motto »Wie bastele ich etwas für meine Frau« gaben. Diese stereotypen Figuren setzt Golz neben komplexe, faszinierende Figuren – Wirbel, Strudel, Ballungen –, die eine andere Dimension zu erschließen scheinen. Mit der retrospektiven Erkundung der Ästhetik der sechziger Jahre konstatiert Golz, wie sehr die damaligen Hoffnungen und Träume von einer strahlenden Zukunft enttäuscht wurden. Sie bemächtigt sich der sehnsüchtig-phantastischen Dimension des Designs und der Bildsprache der damaligen Zeit. Dorothee Golz ist »fasziniert von der psychologischen Dynamik, die sich hinter dem scheinbar Eindeutigen und Vertrauten verbirgt«, und es geht ihr darum, die geheimen Sehnsüchte sichtbar zu machen, die unter der offenkundigen Funktionalität der Dinge deren Gestalt im Verborgenen prägen. Daher entspringt die beunruhigende Vertrautheit ihrer Skulpturen und Zeichnungen letztlich weniger einer psychologischen Projektion der Künstlerin, sondern ist das Resultat eines Prozesses der Offenlegung der versteckten, unbewußten und unpersönlichen Bürde, die die Dinge tragen, des

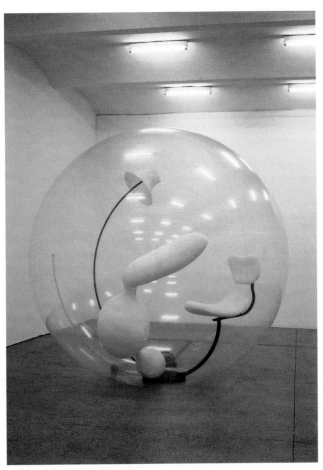

Hohlwelt, 1996

latenten Wahnsinns, den sie enthalten und den man nur ans Licht bringen muß. Dem Betrachter, sagt Dorothee Golz, »soll bewußt werden, daß es eine Welt des Denkens gibt, eine gedachte Welt, die neben der realen, der greifbaren existiert.«

P. S.

Dan Graham

*1942 in Urbana, Illinois. Lebt und arbeitet/lives and works in New York.

Successively a gallerist, critic, photographer, performer, video artist, architect, and artist-historian, Dan Graham is one of the leading figures in the conceptual current that emerged in the wake of pop art in the late 1960s. Difficult to sum up in a single formula, his complex and highly diverse production bears witness to a continuing social and political contextualization.

After his early conceptual works, he began teaching at the Nova Scotia College where he carried out performances focusing on perceptual, kinaesthetic, and psychological processes. Using mirrors and cameras, he probed the notions of identity, subjectivity, and objectivity. This lead him quite logically to the construction of complex video installations such as Video for Two Showcase Windows (1976). This installation, like so many others he has created, is based on an analysis of the capitalist social system. Graham exacerbates the alienation of an everyday activity: "window shopping." As he remarks: "The glass used for the showcase, displaying products, isolates the consumer from the product at the same time as it superimposes the mirror-reflection of his own image onto the goods displayed. This alienation, paradoxically, helps arouse the desire to possess the commodity." By identifying the viewer with the product through the play of reflection and separation, the glass showcase, a border between inside and outside, public and private, acts to generate desire. Momentarily captivated by his or her own reflection, the passer-by experiences a feeling of incompleteness that can only be dispelled with the purchase of the product. Graham's installation accentuates the effect of this ordinary alienation, in order to render it explicit and oppose it.

In 1978 the video installations were followed by the conception of Pavilions, semimonumental combinations of sculpture and architecture which crystallize the utopian fictions of transparency in modern functionalist architecture, while at the same time remaining open for use as a temporary shelter. Three Linked Cubes, from 1986, is a pavilion to be illuminated by the sunlight when placed outside, and becomes New Design for Showing Videos (1995) when installed indoors. Three different programs can be projected for an audience divided into six groups. At once an exhibition design and a work of optical art, the work displays "both the video images and the spectators' reaction to the video-viewing process in the social space of the video exhibition situation."

On the basis of his analyses of urbanism and spectacle technology, Dan Graham has created works which demonstrate how a structure of alienation is produced by the hybridization of the contradictory technologies

Dieser Künstler, der nacheinander Galerist, Kritiker, Photograph, Performer, Videokünstler, Künstler-Architekt und Künstler-Historiker war, ist eine der Hauptfiguren der konzeptuellen Kunstströmung, die in den späten 60er Jahren mit dem Beginn der Pop Art aufkam. Sein komplexes und vielfältiges Werk läßt sich nur schwer in einer Formel zusammenfassen und zeugt von einer ständigen sozialen und politischen Kontextualisierung.

Nach ersten konzeptuellen Arbeiten realisiert Dan Graham im Rahmen seines Unterrichts am Nova Scotia College Performances, die auf kinästhetische und physiologische Wahrnehmungsprozesse ausgerichtet sind. Mit Hilfe von Spiegeln und Kameras stellt er die Begriffe von Identität, Subjektivität und Objektivität in Frage. Das führt ihn dann folgerichtig dazu, komplexe Videoinstallationen zu konstruieren, wie zum Beispiel das Video for Two Showcase Windows (1976). Diese Installation beruht wie viele andere seiner Installationen auf einer Analyse der Struktur des kapitalistischen Gesellschaftssystems. Dan Graham verstärkt hier die Entfremdung, die die alltägliche Tätigkeit des Schaufensterbummels kennzeichnet. Der Künstler erklärt dazu: »Das Glas, aus dem ein Schaufenster besteht, in dem Waren ausgestellt sind, isoliert den Konsumenten vom Produkt, während es gleichzeitig dessen Spiegelbild über die ausgestellten Waren blendet. Diese Entfremdung steigert paradoxerweise das Verlangen, den Artikel zu besitzen.« Das Schaufenster, diese Grenze zwischen Drinnen und Draußen, zwischen Privatem und Öffentlichem, die durch das Spiel von Spiegelung und Trennung den Betrachter mit dem Produkt identifiziert, erzeugt das Begehren. Es vermittelt dem von seinem eigenen Spiegelbild gefangenen Passanten ein Gefühl der Unvollständigkeit, das nur durch den Kauf des Produkts wieder verschwindet. Die Videoinstallation Dan Grahams akzentuiert diesen Effekt einer alltäglichen Entfremdung, um sie explizit zu machen und durchkreuzen zu können.

Auf die Videoinstallationen folgte seit 1978 die Konzeption der Pavilions, eine Art halbmonumentaler Mixtur aus Skulptur und Architektur, die die utopischen Transparenzvorstellungen der modernen funktionalistischen Architektur in komprimierter Form zum Ausdruck brachten und sich als provisorische Zufluchtsorte präsentierten. Three Linked Cubes von 1986 ist so ein Pavillon, der, wenn er draußen steht, von der Sonne erhellt wird, und wenn er drinnen installiert ist, zu einem New Design for Showing Videos (1995) wird. Man kann hier für ein Publikum zu sechs Gruppen drei verschiedene Programme ausstrahlen. Dieses Werk, das Ausstellungsort und Kunstwerk zugleich ist, »zeigt Videobilder und die Reaktionen der Betrachter auf den Vorgang des

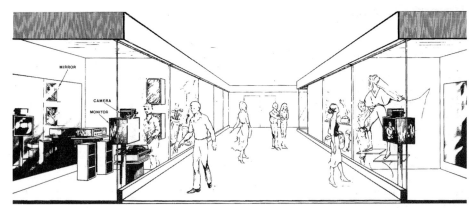

Video for Two Showcase Windows, 1976–1997

that underlie the utopia of social planning and its
concomitant systems of control.

<div style="text-align: right">*P.S.*</div>

Videofilmbetrachtens im sozialen Umfeld einer Video-
ausstellung«.

Auf der Basis seiner Analysen des Urbanismus und
der Technologien des Spektakels hat Dan Graham
Werke geschaffen, die zeigen, wie durch die Vermen-
gung widersprüchlicher utopischer Ideologien und die
Kontrolle des sozialen Wandels eine Struktur der Ent-
fremdung erzeugt werden kann.

<div style="text-align: right">P.S.</div>

Hervé Graumann

*1963 in Genf, Schweiz/Switzerland. Lebt und arbeitet/lives and works in Genf.

When Hervé Graumann created a painter-machine, gave it a name and something to work with (ink, paper, and electricity), he did not realize that he had just created a personage which was to plunge him into obsession and challenge the very individuality of his artistic production. If at first "Raoul Pictor" was indeed something produced by Graumann (after all, hadn't he written all the lines of code in the program?), it now seems it has gotten paint all over its author. Is it possible that the author, an individual who creates and expresses himself, has now been reduced to the mute speech of his machines?

Without hiding behind such questions of identity, Graumann nonetheless situates his work on that abstract, blurry boundary between author and machine. In his project for documenta's website, it is hard to know who is expressing himself and who is the depressive, abandoned figure calling for help. Yet the latter is doing just that from a specific place on the World Wide Web. Furthermore, he can only be reached there. (Or is he in fact only on the viewer's screen)?

In fact, it all begins with a blank screen. By moving the cursor with a mouse over the screen, one moves a white disc that looks something like the beam of a flashlight. Little by little, this shape reveals a text that is legible only by sweeping it with the beam of light: "ugh! this isn't my day," then "no" and "for how long?" Or "total darkness, locked up," then "alone" and "locked up, alone, lost! alone, forgotten." One can never predict where the words, brought to life but broken to bits and spread over the screen, written in small letters or big, will appear next; nor can we say whence they come, nor who is uttering them. Yet suddenly a window appears, allowing one to write directly to lost@sgg.ch, like a despairing appeal for contact. It remains to be seen who the person to be contacted will be, or what will become of the messages.

As much as man may be seduced by the machine, he nonetheless fears it. Similarly, Graumann's work plays on both these feelings. Neither a positivist nor a catastrophist, he can make machines execute a number of operations sufficient to feign their independence, enough for them to have an opportunity to seduce us, thereby revealing yet another form of human genius.

S.L.

Hervé Graumann zweifelt bei seiner Maler-Maschine, der er einen Namen und etwas zu arbeiten gibt (Tinte, Papier und elektrischen Strom), nicht daran, daß er soeben eine Persönlichkeit geschaffen hat, die ihn überwältigen, ihn verfolgen, ja sogar mit ihrer Individualität provozieren wird. Ist »Raoul Pictor« anfangs auch das Produkt von Hervé Graumann (hat er nicht jede einzelne Zeile seines Programms geschrieben?), so scheint es doch, daß dieser mittlerweile auf seinen Schöpfer abgefärbt hat. Ist der Schöpfer, das Individuum, das etwas schafft und sich dabei ausdrückt, nun zu einer stummen Aussage seiner Maschinen reduziert worden?

Ohne sich hinter Identitätsfragen verstecken zu wollen, positioniert Hervé Graumann seine Arbeit doch auf dieser abstrakten und fließenden Grenze zwischen dem Autor und der Maschine. Bei seinem Projekt für die Website der *documenta* weiß man nicht genau, wer sich ausdrückt, wer diese traurige, verlassene Person ist, die um Hilfe bittet. Dennoch macht sie es von einem bestimmten Ort irgendwo im World Wide Web. Außerdem ist sie nur dort zu erreichen. Außer sie ist nur auf dem Schirm des Betrachters.

Tatsächlich beginnt alles mit einem schwarzen Bildschirm. Bewegt man den Curser mit der Maus auf diesem, bewegt man auch eine weiße Scheibe, die an einen von einer Taschenlampe erzeugten Lichtstrahl erinnert. Diese Form gibt Schritt für Schritt einen Text preis, den man nur lesen kann, wenn man diesem Lichtstrahl über den Schirm zieht: »aargh! nicht mein Tag heute«, dann »wirklich nicht« und »wie lange schon?« oder »tief schwarze Nacht« und weiter unten »allein«, »eingesperrt, allein, verloren! allein, vergessen«. Die Wörter bewegen sich, sind zerstückelt, über den ganzen Schirm verteilt, groß oder klein geschrieben, und es ist nicht möglich vorherzusehen, wo die Wörter auftauchen, von wo oder wem sie kommen. Doch erscheint plötzlich ein Fenster, wo man direkt lost@sgg.ch anschreiben kann, wie ein verzweifelter Aufruf zur Kontaktaufnahme. Jetzt müßte man noch wissen, wer die Kontaktperson ist und was mit den Nachrichten passiert.

Einerseits fühlt sich der Mensch von der Maschine angezogen, andererseits fürchtet er sie. Die Arbeit von Hervé Graumann spielt sowohl mit dem einen als auch mit dem anderen Gefühl. Er läßt die Maschinen eine gewisse Anzahl von Operationen durchführen, damit sie so ihre Unabhängigkeit vorgeben können und eine Chance haben zu verführen, und gerade dadurch eine andere Form von menschlichem Genie aufzuzeigen.

S.L.

l.o.s.t., 1997
Screenshot

Toni Grand

*1935 in Gallargues, Frankreich/France. Lebt und arbeitet/lives and works in Mouriès.

Toni Grand has been working in sculpture for over thirty years. In the early seventies he was close to the Supports/Surfaces group, and shared their desire to fabricate work that is literal, founded in a will to deconstruction, and as attentive to material as it to gesture. Ironic, silent, and distant, the artist nonetheless split from the group through an approach that favored experience over theory as a means of knowing. "I prefer a discourse of possibilities – with all the detours, discontinuity, chance, surprise, and attachments that implies – to explanation. The wish to define, to find preconditions and foundations for securing a work, is tantamount to making something it doesn't need: a base."

As simple and unquestionable as they may appear, Grand's sculptures demonstrate their desire to play with our awareness of sculpture, its history, the means available to it, and its limits. Close to minimalism, his sculpture from the sixties in lead, resin, or steel reflects, in its very simplicity, his critical spirit with respect to prior concepts of what sculpture is. In the early seventies, Grand began working almost exclusively in wood, cutting directly into it with elemental gestures induced by the material itself and which offer no possible pentimento. In 1977 he began combining resin with the wood, creating pieces with long lines where the void formed by the curves becomes an integral part of the work. In the mid-eighties he also integrated huge boulders and animal bones into his sculpture.

In 1987 Grand used a fish embedded in plastic, layered with resin and fiberglass, to consolidate a damaged wooden piece dating from 1977. The resulting sculpture, Réparation, inaugurated a series where the fish (a conger or eel) becomes the principal material of the work. It is sculpture from this series that is being shown at documenta. Combined with wood, aluminum, or bronze, hung on the wall or set on the floor, horizontal or vertical, serving at times as an instrument of measure for sculpture, the fish enter the realm of representation. Although the creatures are, as the artist states, "no longer with us," the sculpture preserves them. The opaque or transparent resin that encompasses them espouses their oblong forms. The element thus obtained opens the possibility of manifold formal declensions. At once a line, a delineation, a design for the whole, and an element of its construction, the stratified fish organize the composition. Both static and dynamic, some of the works fix the fish in their movement and reconstitute an undulation that runs counter to the rigidity of the metal rectangles.

P.S.

Toni Grand arbeitet seit mehr als dreißig Jahren als Bildhauer. Zu Beginn der siebziger Jahre steht er den Künstlern der Gruppe Supports-Surfaces nahe, denn er ist wie sie entschlossen, ein Werk im eigentlichen Sinne zu schaffen, das auf dem Willen zur Dekonstruktion gründet und das den Gesten die gleiche Aufmerksamkeit schenkt wie dem Material. Doch der ironische, schweigsame und reservierte Künstler unterscheidet sich von der Gruppe insofern, als für ihn eher die Erfahrung als die Theorie der geeignete Weg zur Gewinnung von Erkenntnissen ist: »Ich ziehe der Erklärung einen Diskurs vor, der die Möglichkeiten ausschöpft, mit all dem, was dabei an Umwegen, Unzusammenhängendem, Zufälligkeiten, Überraschungen und Neigungen ins Spiel kommt. Das ganze Definieren und Festsetzen von Vorbedingungen und Grundlagen ist so, als wollte man für eine bestimmte Arbeit etwas machen, dessen sie gar nicht bedarf: einen Sockel.«

Obwohl sie schlicht und unproblematisch erscheinen, verraten die Skulpturen Toni Grands dennoch das Verlangen nach einem spielerischen Umgang mit dem Bewußtsein vom Wesen der Skulptur, ihrer Geschichte, ihrer Mittel und ihrer Grenzen. Seinen in den sechziger Jahren entstandenen, dem Minimalismus nahestehenden Strukturen aus Blei, Polyester und Stahl ist selbst noch in ihrer Einfachheit die kritische Auseinandersetzung mit verschiedenen Konzeptionen aus der Geschichte der Bildhauerei anzusehen. Von den siebziger Jahren an beginnt Toni Grand vornehmlich mit Holz zu arbeiten. Seine Werke entstehen nun als unmittelbarer bildhauerischer Akt, mit elementaren Gesten, die von der Natur des Materials induziert sind, ohne Möglichkeit, nachträglich noch etwas zu ändern. Seit 1977 kombiniert er Holz mit Polyesterbeschichtung und schafft langgliedrige Objekte, bei denen die von den Formen umschlossenen Hohlräume integraler Bestandteil des Werkes sind. Mitte der achtziger Jahre integriert er in seine Skulpturen massive unbehauene Steine und Tierknochen.

Mit Hilfe eines in Polyester eingeschlossenen Fisches sowie Harz und Glasfaser repariert und verstärkt Toni Grand 1987 eine 1977 entstandene Arbeit aus Holz, die inzwischen beschädigt worden war. Das so entstandene Werk *Réparation* ist der Auftakt zu einer Serie, in der der Fisch (ein Meeraal oder Aal) zum wichtigsten Material des Werkes wird. Skulpturen aus dieser Serie sind auf der *documenta* zu sehen. Die Fische sind verbunden mit Holz, Aluminium oder Bronze, sie hängen an der Wand oder stehen auf dem Boden, ihre Lage ist mal horizontal, mal vertikal, und mitunter sind sie auch Maßstab der Skulptur. Wenn die Tiere, wie der Künstler sagt, »nicht mehr sind«, so konserviert sie die Skulptur.

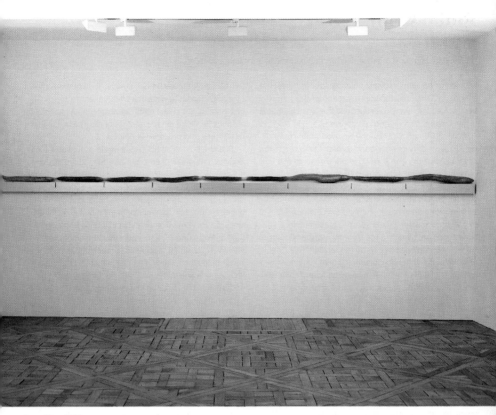

Sans titre, 1990

Der sie umgebende Polyester, der manchmal durchsichtig und manchmal undurchsichtig ist, schmiegt sich ihren länglichen Formen an. Das so gewonnene Element läßt viele formale Abweichungen zu. Die mit Polyester überzogenen Fische sind das Organisationsprinzip der Kompositionen: Sie sind gleichzeitig sowohl Linie, Strich, Zeichnung des Ganzen als auch Elemente der Konstruktion. Und sie sind nicht nur ein statisches, sondern auch ein dynamisches Prinzip: Bestimmte Werke lassen die Fische in ihrer Bewegung erstarren und evozieren dadurch eine Wellenbewegung, die der Starrheit der metallenen Rechtecke widerspricht.

P.S.

Johan Grimonprez

*in Trinidad. Lebt und arbeitet/lives and works in New York und/and Gent.

Known for his ethnographic videos with their effective critique of Western ethnocentrism, Johan Grimonprez here carries out two projects about the way the media shape culture, history, and reality today.

Dial H-I-S-T-O-R-Y (1995–97) is a video film structured in two fifty-minute parts, presented in the form of an installation. The guiding visual thread of the piece is the almost exhaustive chronology of airplane highjackings in the world. The soundtrack is constituted of a fictive narrative inspired by two Don DeLillo novels – White Noise and Mao II – which, for Grimonprez, "highlight the value of the spectacular in our catastrophe culture." Judging the dogmatic opposition of fiction and documentary to be inoperable today, he responds with "pseudo-documentary as a work of rewriting." Dial H-I-S-T-O-R-Y blends photographic, electronic, and digital images, interspersing reportage shots, clips from science fiction films, found footage, and reconstructed scenes filmed by the artist. The work denounces the media spectacle and seeks to "detect the impact of images on our feelings, our knowledge, our memory."

*Prends garde! A jouer au fantôme, on le devient (Beware! in playing the phantom you become one), 1995–97, is a videotheque on the history of television, constituted with the collaboration of the critic **Herman Asselberghs**. It is conceived as at once an installation and a viewing station. The piece lends an important role to the spectator, who can choose between more than forty films. The corpus here is heterogeneous: fictions, documentaries, cartoons, video clips, experimental cinema… The spectator-turned-curator can even bring his or her own video tapes. "Just as in life, the spectator-visitor of this site creates a personal hypertext," writes Asselberghs. The videotheque is based on the conviction that reality and history are inevitably manipulated by various underlying mediations and ideologies. In a world "ready to collapse under its own representation," this project takes an "iconoclastic pleasure" in using video, a medium obsolete in the age of multimedia. A brochure modeled on popular magazines – La réalité, mode d'emploi – Reality, A User's Guide – includes critical texts, descriptive notes, and fanciful propositions. An enlarged equivalent of this brochure is also proposed for consultation by Internet. The video has been simultaneously installed at the Georges Pompidou Center in Paris. Its peripatetic nature and intercultural dimensions are an integral part of the project: it has already been presented in different spots, with specific selections for each host country.*

P. S.

Der für sein ethnographisches, als Kritik am westlichen Ethnozentrismus angelegtes Werk bekannte Johan Grimonprez ist mit zwei Projekten vertreten, die kritisieren, auf welche Weise die Medien heute die Kultur, die Geschichte und die Realität prägen.

Dial H-I-S-T-O-R-Y (1995–97) ist ein aus zwei je fünfzig Minuten langen Teilen bestehender Videofilm, der in Form einer Installation präsentiert wird. Sein visueller Ariadnefaden ist eine fast erschöpfende Chronologie der Flugzeugentführungen, die es bisher auf der Welt gegeben hat. Sein Ton repräsentiert eine fiktive Erzählung, die von zwei Romanen Don DeLillos inspiriert ist (*White Noise* und *Mao II*), in denen, so Grimonprez, »der Wert des Spektakulären in unserer Katastrophenkultur beleuchtet wird«. Der dogmatischen Entgegensetzung von Spielfilm und Dokumentarfilm, die er für undurchführbar hält, stellt Grimonprez »den Pseudodokumentarfilm als Arbeit des Neuschreibens« entgegen. *Dial H-I-S-T-O-R-Y* vermischt photographische, elektronische und digitale Bilder und verzahnt Reportagen mit Stücken aus Science-fiction-Filmen, existierendem Filmmaterial und vom Künstler selbst gedrehten rekonstruierten Szenen. Die Fiktion macht es möglich, daß in diese Montage heterogene Elemente einfließen, so daß sich kritische Perspektiven mit privaten Geschichten vermischen. Dieses Werk, das das Medienspektakel anprangert, »versucht den Einfluß der Bilder auf unsere Gefühle, unser Wissen und unser Gedächtnis aufzudecken«.

Prends garde! A jouer au fantôme, on le devient (Beware! In playing the phantom you become one), 1995–97, eine zusammen mit dem Kritiker **Herman Asselberghs** entworfene Videothek zur Geschichte des Fernsehens, ist Installation und Vorführraum zugleich. Dem Betrachter, der sich aus einem Angebot von mehr als vierzig Filmen einen Videofilm seiner Wahl ansehen kann, fällt hier eine wichtige Rolle zu. Die Auswahl ist heterogen: Spielfilme, Dokumentarfilme, Zeichentrickfilme, Videoclips, Experimentalfilme etc. Der zum Ausstellungsorganisator avancierte Betrachter kann sich sogar seine eigenen Kassetten mitbringen. »Der Besucher/Betrachter dieser Videothek kreiert, wie im wirklichen Leben, seinen eigenen Hypertext«, schreibt Asselberghs. Diese Videothek basiert auf der Überzeugung, daß die Realität und die Geschichte zwangsläufig durch die verschiedenen Mediatisierungen und die diesen zugrundeliegenden Ideologien manipuliert sind. In einer Welt, »die bereit ist, unter ihrer Darstellung zusammenzubrechen«, greift dieses mit einer »bilderstürmerischen Lust« geschaffene Projekt auf das im multimedialen Zeitalter obsolete Medium der Videotechnik zurück. Eine im Stil populärer Zeitschriften aufgemachte Bro-

Dial H-I-S-T-O-R-Y, 1995–1997
Video still
Projections: 10 a.m., 12 p.m., 2 p.m., 4 p.m., 6 p.m.
Projektionen: 10 Uhr, 12 Uhr, 14 Uhr, 16 Uhr, 18 Uhr

schüre (*La réalité, mode d'emploi – Die Realität.
Gebrauchsanweisung*) enthält Kritiken, Beschreibungen
und frei erfundene Verweise. Eine erweiterte Fassung
dieser Broschüre ist über das Internet frei zugänglich.
Die Videothek ist zur gleichen Zeit auch im Pariser Cen-
tre Pompidou installiert. Ihr Charakter als Wanderaus-
stellung und ihre interkulturelle Dimension – sie wurde
mit eigens für das jeweilige Gastland geschaffenen
Abteilungen bereits an verschiedenen Orten gezeigt –
sind integraler Bestandteil des Projekts.

P.S.

Ulrike Grossarth

*1952 in Oberhausen. Lebt und arbeitet/lives and works in Berlin.

Ulrike Grossarth inquires into the relations between the body and space. She began with the practice of dance, attempting from 1969 through 1975 to attain a method where the body becomes "an agency of thought and action" through performances, actions, and dance. As she says herself: "you create space through motion more distinctly from self-awareness and thus perceive your own materiality more strongly," or again, "in the course of 15 years I developed a method in seminars, which pose the key question of motion as the principle of permanently changing form. My aim is to return to an assumed neutral point in thinking and acting." Her last action in Berlin, Material für's Diktat III (1988) marks a culminating point in the search for a formulation of the self through movement, "without following a theme, an idea, or my knowledge of movement, without reflection or planning distance, in order to fully be there for the moment."

After the long isolation brought about by a quest directed toward her own body, and also out of a desire to visualize the results of her research, Grossarth undertook works of plastic art. She began with the phenomenological difference between horizontal and vertical. At the same time, she studied the history of National Socialism and its propagandistic use of representation. She then understood that she must inquire into "the body in its totality – in the program and practice of extermination." Even in her early installations she concentrated on the relation between the materials and the spectator: "I was led by the attempt to remove the aura of the specific objects, their history of meaning and the implied readings in their arrangements, i.e. to lead the object to a certain 'presence.'"

In the work she is presenting for documenta, BAU I (Construction 1), she uses common materials such as tables, slide projectors, sheets of glass, commodities, photos, and plaster models to construct an environment on the basis of the relation between manipulable objects laid out on the tables and projections of dematerialized images. "I created sculptural and pictorial action models as well as perception and projection models out of simple materials," she says. The spectator who passes through one of Ulrike Grossarth's spaces experiences a renewed questioning of the traditional space/object distinction. As the artist emphasizes: "I try to place the objects so that distance and non-distance become indifferent, so that it becomes quite impossible to create contexts of meaning that work in everyday usage as well as in relation to a system of art. First of all I want to create an area, in which the way you imagine does not correspond to anything material... For

Ulrike Grossarth untersucht die Beziehungen zwischen Körper und Raum. Sie praktizierte zwischen 1969 und 1975 den Tanz und erarbeitete sich anschließend eine Methode, um ihren Körper in Performances, Aktionen und Tänzen zu einem »Organ des Denkens und Handelns« werden zu lassen. »Das bedeutet«, sagt sie, »sich deutlicher vom Selbstbewußtsein her in den Raum hineinzuplastizieren und somit die Wahrnehmung der eigenen Materialität zu verstärken ... Im Laufe von 15 Jahren habe ich in Seminaren eine Methode entwickelt, in der die Frage der Bewegung als Prinzip der sich ständig wandelnden Form zentral ist. Es geht mir um die Rückführung auf einen angenommenen neutralen Punkt im Denken und Handeln.« Ihre letzte Aktion in Berlin, Material für's Diktat III (1988) markiert einen Endpunkt ihrer Versuche, sich bewegend selbst zu formulieren: »ohne einem Thema zu folgen, einer Vorstellung oder meinem Bewegungswissen, ohne Reflexion und planende Distanz, um ganz im Augenblick zu sein.«

Um aus der Einsamkeit der auf ihren eigenen Körper gerichteten Suche herauszukommen und aus dem Verlangen, das Resultat ihrer Studien zu visualisieren, begann sie dann eine bildnerische Arbeit, bei der es ihr vor allem auch um die »phänomenologische Verschiedenheit der beiden Hauptachsen Vertikale und Horizontale und ihre Nutzbarkeit im kommunikativen Raum« ging. Sie befaßte sich mit der Geschichte des Nationalsozialismus und seiner propagandistischen Nutzung von Repräsentationsformen. Sie begriff, wie sie sagt, daß in den nationalsozialistischen Vernichtungsprogrammen und deren Durchführung »die Frage des Körpers in seiner Totalität gestellt« worden war. Ein weiteres Feld ihrer Arbeit ist der Untersuchung des Verhältnisses zwischen den materiellen Dingen und den sie gebrauchenden Menschen gewidmet, wobei es ihr vor allem darum geht, »die Aura der einzelnen Objekte, ihre Bedeutungsgeschichte und die sich ergebenden Lesarten aus ihren Arrangements abzubauen, das heißt, den Gegenstand zu einer Art ›Präsenz‹ zu führen.«

In dem Werk, das sie auf der documenta präsentiert, BAU I, verwendet sie einfache Materialien wie Tische, Projektoren, Glasscheiben, Warenartikel, Photos und Gipsformen, um eine Anordnung zu schaffen, die aus der Beziehung zwischen dem auf den Tischen arrangierten manipulierbaren Objekt und der Projektion eines entmaterialisierten Bildes ein vielschichtig sinnkonstitutives Wahrnehmungsmodell entwirft. Dem Betrachter, der den Raum Ulrike Grossarths durchquert, gerät die traditionelle Unterscheidung von Raum und Gegenstand in Auflösung: »Ich versuche die Gegenstände so zu plazieren, daß genau die Indifferenz zwischen Abstand und Abstandslosigkeit passiert, also, daß es

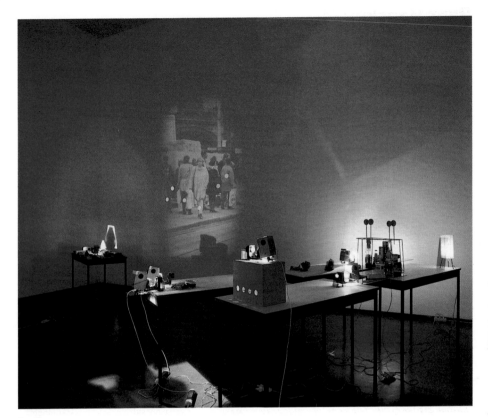

Bau 8
Installation view Portikus, Frankfurt, 1996
Detail

me this is a sort of relief, so I can physically open up a space that does not yet exist as such."

P.S.

nicht recht möglich ist, Bedeutungszusammenhänge herzustellen, die auch funktionieren, sowohl im Alltagsgebrauch als auch in der Zuordnung in ein Kunstsystem. Ich will erst mal einen Bereich schaffen, in dem die Vorstellungsweise keine materielle Entsprechung hat ... Das ist für mich eine Art Entlastung, um *physisch* einen Raum aufschließen zu können, den es so noch nicht gibt«.

P.S.

Hans Haacke

*1936 in Köln. Lebt und arbeitet/lives and works in New York.

During the first half of the sixties, Hans Haacke was making work at the intersection of minimal, conceptual, and process art which depended on the surroundings and was subject to variations in space, light, and climate control. In 1965, he moved to New York. Beginning in 1969, the focus of his work shifted to bringing to light the covert relationships between art, business, and power. As in much conceptual art, Haacke based his artistic practice on the production of information, defined as institutional critique and denouncing various economic and political practices. He exposed censorship and violations of democratic principles, and his installations, signs, collages, texts, photographs, architectural models, and urban design projects demonstrated a will to constant formal renewal. Although his work has become less austere over time, it requires active reception, and though it is fully aware of the limits of art, it leans toward the overthrow of existing political mechanisms. "Information presented at the right time and in the right place," Haacke says, "can be potentially very powerful. It can affect the general social fabric. Such things go beyond established high culture as it has been perpetrated by a taste-directed industry."

Shapolsky et al. Manhattan Real Estate Holdings, A Real-Time Social System, as of May 1, 1971, was realized in 1971. The work consists of 146 photographic views of New York apartment buildings, six pictures of transactions, an explanatory wall panel, and maps of Harlem and the Lower East Side. Each photograph is accompanied by a typed text that describes the location and the financial transactions involving the building in the picture. Haacke discloses the transactions of a real-estate firm between 1951 and 1971. Harry Shapolsky, the key figure, who is well protected by influential friends, is guilty of an assortment of fraudulent practices of which the judicial system has been exceedingly forgiving. Haacke's one-artist show at the Guggenheim, of which this work was to be a part, was canceled by the director of the museum six weeks before the opening, and artists occupied the premises in protest against this censorship.

For documenta, Haacke has prepared a DSR poster project entitled Standortkultur (Corporate Culture). The poster is made up of quotations from business leaders who use corporate sponsorship as a communications medium. Each quotation is accompanied by an indication of the source from which it has been taken. The following are only a few examples: "It is a tool for public opinion." "We are not patrons. We want something for the money we spend. And we are getting it." "Whoever pays, controls."

P.S.

In der ersten Hälfte der sechziger Jahre schafft Hans Haacke im Schnittpunkt von Minimal Art, Concept Art und Process Art Werke, die von ihrer Umgebung und variierenden Lichtverhältnissen abhängig sind sowie unterschiedlichen räumlichen und klimatischen Bedingungen ausgesetzt werden. 1965 läßt er sich endgültig in New York nieder. Seit 1969 verfolgen seine Arbeiten das Ziel, die unsichtbaren Beziehungen zwischen Kunst, Kapital und Macht ans Licht zu bringen. Haackes künstlerische Tätigkeit im Umkreis der Concept Art ist darauf ausgerichtet, kritische Informationen zu liefern und bestimmte wirtschaftliche und politische Praktiken anzuprangern. Er entlarvt die Zensur und deckt das Fehlen demokratischer Prinzipien auf. Die Installationen, Plakate, Collagen, Texte, Photos, Architekturmodelle und urbanen Realisationen des Künstlers zeigen seinen Willen, in formaler Hinsicht ständig neue Wege zu gehen. Seine Werke, die im Laufe der Zeit an Strenge und Nüchternheit verlieren und eine aktive Rezeption erfordern, zielen darauf ab, politische Mechanismen zu unterminieren, wobei sie sich jedoch der Grenzen der Kunst voll bewußt sind. »Liefert man sie im richtigen Moment und an der richtigen Stelle«, sagt Haacke, »dann kann eine Information sehr wirksam sein. Sie kann die Gesellschaft im allgemeinen beeinflussen. Ein solches Vorgehen verletzt die Konventionen der Hochkultur, die uns von einer sich am Geschmackskriterium orientierenden Industrie aufoktroyiert werden.«

Shapolsky et al. Manhattan Real Estate Holdings, a Real-Time Social System, as of May 1, 1971, entstand 1971. Das Werk setzt sich zusammen aus 146 photographischen Ansichten von New Yorker Gebäuden, sechs tabellarischen Übersichten von geschäftlichen Transaktionen, einer Erklärungstafel sowie Plänen von Harlem und der Lower East Side. Jeder Photographie ist ein maschinegeschriebener Text beigegeben, der die Lage des dargestellten Gebäudes und die es betreffenden finanziellen Transaktionen beschreibt. Hans Haacke macht die dunklen Geschäfte transparent, die hier zwischen 1951 und 1971 von einer Gruppe von Immobilienhaien abgewickelt wurden. Harry Shapolsky, die durch einflußreiche Beziehungen geschützte Schlüsselfigur dieser Machenschaften, setzte bei seinen Immobiliengeschäften eine Vielzahl betrügerischer Praktiken ein, denen gegenüber sich die Justiz erstaunlich nachsichtig zeigte. Die Einzelausstellung Haackes im New Yorker Guggenheim-Museum, bei der auch dieses Werk gezeigt werden sollte, wurde vom Direktor des Museums sechs Wochen vor Eröffnung abgesagt. Die Ausstellungsräume des Museums wurden daraufhin von solidarischen Künstlern in einer Protestaktion gegen diese Zensur eine Zeitlang besetzt.

Shapolsky et al. Manhattan Immobilienbesitz, ein gesellschaftliches Realzeitsystem, Stand 1. Mai 1971, 1971
Shapolsky et al. Manhattan Real Estate Holdings, a Real-Time Social System, as of May 1, 1971, 1971
Detail

Hans Haacke hat für die *documenta* ein Projekt mit
dem Titel *Standortkultur* (Corporate Culture) realisiert.
Das Plakat besteht aus Zitaten (samt Quellenangabe)
von verschiedenen Unternehmern, die sich als Kultur-
sponsoren betätigen, um Geschäftsverbindungen zu
knüpfen. Einige Kostproben: »Das hilft uns, die öffent-
liche Meinung zu verführen.« »Wir sind keine uneigen-
nützigen Förderer. Wir wollen etwas für unser Geld.
Und wir kriegen es.« – »Wer bezahlt, hat das letzte
Wort.«

P.S.

DSR-Project/Projekt

Raymond Hains

*1926 in Saint-Brieuc. Lebt und arbeitet/lives and works in Paris und Nizza.

The manifold oeuvre of Raymond Hains cannot be reduced to the label of "Nouveau Réalisme," a movement whose institutionalization was ironically decried by the artist. His work is organized around a single obsession: the exploration of the world through the underlying weft of language, with all the freedom of action and being that language permits. True to this obsession, his project for documenta, like most of his exhibitions, will only take final form at the last moment, through the interruption of an incessant process of creation.

Hains used a fluted-glass lens to carry out his first "hypnagogic photographs" in 1947. This was the technique that allowed him and his friend Jacques de la Villeglé to render a phonetic poem by Camille Bryen illegible. Hépérile, shattered into Hépérile éclaté, was the "first poem to be unread: de-lyrics." The play on the word "délire" reveals the fundamental role that delirium played for Hains, who associated it with a practice of urban drifting [dérive]. In the late forties, shortly after the war, he let his wanderings lead him to the dé-collage of posters ripped and torn by passers-by. La France déchirée (France Torn Apart), his collection of political posters, bears formal and symbolic witness to the rifts of French society in the years 1949–61, a particularly tense period marked by the war in Algeria and a situation of quasi-civil war. Influenced by surrealism and the notion of objective chance, Hains saw the collective unconscious written on the walls, with all its censorship, condensations, and displacements.

"To invent, for me, is to go before the works. My works existed without me, but they were not seen, because they were staring everyone in the face," he declared. The techniques of appropriation constantly used by Hains are complex cultural operations, whose keys are found in the play of language and the laws of the unconscious formulated by psychoanalysis. In the tradition of Raymond Roussel and Marcel Duchamp, Hains lets himself be guided by puns and witticisms that tap the wellspring of free association. Beginning with a play on commonplaces and found proper names, he improvises a fragmentary narrative, a bricolage of the most heterogeneous contents and the most improbable dimensions of space and time. In the precision of semantic delirium, myth and reality intertwine.

With a blend of autobiographical reference and self-effacement, Hains engages in the humorous exercise of a shattered subjectivity that lends an excessive value to the act of enunciation. For Hains, historical space is indissociable from the discursive elements that inhabit it; indeed, every space is a labyrinth of language, particularly the city, where peripatetic wandering bears every

Das reiche Werk von Raymond Hains läßt sich nicht auf das Etikett »Nouveau Réaliste« reduzieren, dessen Institutionalisierung der Künstler ironisch geißelt. Es geht in ihm stets um ein und dieselbe Obsession: um die Erforschung der Welt auf der Grundlage der Sprache und des durch sie eröffneten Lebens- und Handlungsspielraums. Dementsprechend erhält sein Projekt für die documenta, nicht anders als bei den meisten seiner Ausstellungen, erst im letzten Augenblick seine definitive Gestalt, die nur einen Moment der Unterbrechung eines unablässigen Schaffensprozesses markiert.

Hains hat 1947 mit Hilfe von geriffelten Linsen seine ersten »hypnagogischen Photographien« geschaffen, die ihm 1953 erlaubten, zusammen mit seinem Freund Jacques de la Villeglé ein phonetisches Gedicht von Camille Bryen unlesbar zu machen. Hépérile wird zu Hépérile éclaté, dem ersten »poème à dé-lire«. Dieses Spiel mit den Wörtern »délire« (»Wahnsinn«) und »delire«, einer Wortschöpfung aus dem Präfix »de-« und dem Verb »lire« (»lesen«), läßt erkennen, welche fundamentale Rolle der Wahnsinn für Raymond Hains spielt, den er mit dem Niedergang der Städte in Verbindung bringt. Gegen Ende der vierziger Jahre, in der Zeit nach dem Krieg, beschäftigt er sich bei seinen Spaziergängen mit dem Ablösen von Plakaten, die Passanten zerrissen hatten. La France déchirée (»das zerrissene Frankreich«), seine zwischen 1949 und 1961 in Paris zusammengetragene Sammlung politischer Plakate, ist ein formales und symbolisches Zeugnis der »Zerrissenheit« der französischen Gesellschaft in einer vor allem vom Algerienkrieg und einer bürgerkriegsähnlichen Situation geprägten Periode, in der die innenpolitische Lage Frankreichs besonders gespannt war. Hains, der vom Surrealismus beeinflußt war und sich für die Vorstellung einer objektiven Zufälligkeit begeisterte, sah in den zerfetzten Plakaten das kollektive Unbewußte mit seiner Zensur, seinen Verdichtungen und Verschiebungen.

»Erfinden bedeutet für mich, vor meine Werke zu treten. Meine Werke existierten ohne mich, aber man sah sie nicht, denn sie lagen einem direkt vor Augen«, erklärt er. Die Aneignungsverfahren, die Hains ständig benutzt, sind komplexe kulturelle Operationen, deren Beherrschung über das Sprachspiel und die von der Psychoanalyse formulierten Gesetze des Unbewußten verläuft. In der Tradition Raymond Roussels und Marcel Duchamps spielt Raymond Hains mit der unerschöpflichen Befruchtung des Prozesses der Ideenassoziation durch Wortspiele und andere Verfahren. Ausgehend von einem Spiel mit Gemeinplätzen und Eigennamen bastelt er eine fragmentarische Erzählung, die es gestattet, die heterogensten Elemente und die am wenigsten miteinander zu vereinbarenden raumzeit-

Déménagement de la rue Marbeau, Paris, Juillet 1988

relation to verbal digression. The rhetoric of strolling, with its linguistic and pathfinding figures, permits the projection of a poetic geography onto the real geography of the world.

<div align="right">P.S.</div>

lichen Dimensionen zusammenzubringen. Die Präzision des semantischen Deliriums verknüpft Mythos und Realität.

Mit seiner Mischung aus autobiographischen Bezügen und Tilgung alles Persönlichen verschreibt sich Raymond Hains auf humorvolle Weise einer zersplitterten Subjektivität, die den Akt der Äußerung übersteigt. Für Hains ist der historische Raum nicht in die ihn konstituierenden diskursiven Elemente zerlegbar, jeder Raum ist ein Sprachlabyrinth, erst recht also die Stadt, in der die Wege der Spaziergänger einer sprachlichen Abschweifung ähneln. Die Rhetorik des Spaziergangs mit ihren Figuren der Sprache und der Wege gestattet es, auf die reale Geographie der Welt eine poetische Geographie zu projizieren.

<div align="right">P.S.</div>

Richard Hamilton

*1922 in London. Lebt und arbeitet/lives and works in Northend, Oxon.

Since the mid-1950s, Richard Hamilton has explored the reshaping of the image by modern technology. From his activity in the Independent Group, when he prefigured the iconography of pop art in his early collages, all the way to his work with computers today, Hamilton has pursued his fascination with the distortions of the pictorial tradition. With his own paintings, with the organization of major exhibitions such as Growth and Man (1951), Man, Machine and Motion (1955), and the famous This is Tomorrow (1956), with his reconstruction of Duchamp's Large Glass (1965–66), his reading of James Joyce and his experiments in typographic analysis, Hamilton's work constitutes a contemporary approach to the differing figures of complexity. The Seven Rooms (1994–1996) were conceived for an exhibition at Anthony d'Offay Gallery in London. Hamilton photographed the blank walls of the space and scanned seven of his black-and-white negatives for transfer to a Quantel paintbox, whose characteristics allow the artist "to combine the manipulative ability of the painter with the instant creativity of photography." The inevitable distortions induced by the use of a wide-angle lens were brought back into perspective and the photos were recomposed by cropping. Thus the "spaces" were prepared to receive the exhibition. Rather than choosing among his earlier works or from already existing images, Hamilton decided to carry out computer-assisted paintings, incrusted with multiple photos from seven rooms of his own house: Dining Room, Passage, Kitchen, Dining Room/Kitchen, Bedroom, Bathroom, Attic. As he explains: "The 'interior' theme was fundamental to the site-referential idea, so it was sensible to use my immediate environment as a unifying framework. The group of seven rooms developed into a portrait of a house." The resulting compositions were then hung on the gallery walls. For their installation at documenta, the space of the Anthony d'Offay Gallery has been identically reconstructed. The Seven Rooms contain numerous references to earlier works, including the series of Site Referential Paintings whose founding idea is to carry out a painting describing the site for which it is destined (Interior I & II, Langan's, Northend I & II), as well as images which have been particularly important in his work (for example, the vacuum cleaner or the Large Glass). This project also pursues a continually unfolding inquiry into the relations of virtual and actual space, whose first articulation Hamilton identifies in the technique of photography. Finally, Seven Rooms offers a public exhibition of the artist's domestic and intimate world, operating as a synthesis of his work, an infinitely self-reflective retrospective of

Seit Mitte der fünfziger Jahre beschäftigt sich Richard Hamilton mit den Möglichkeiten der Neugestaltung des Bildes durch die moderne Technologie (»reshaping«). Ob in seiner Aktivität als Mitglied der Independent Group, wo er mit seinen ersten Collagen die Ikonographie der Pop Art einleitete, oder in seiner Verwendung der Computertechnik, stets begeisterte sich Hamilton für »Verzerrungen« der Bildtradition. Mit seinen Gemälden, seiner Organisation zahlreicher bedeutender Ausstellungen (Growth and Form, 1951; Man, Machine and Motion, 1955; und, vor allem, This is Tomorrow, 1956), seiner Rekonstruktion von Duchamps Großem Glas (1965/66), seiner Rezeption der Werke von James Joyce oder auch seinen typographischen Analysen stellt das Werk Hamiltons einen zeitgenössisch-komplexen Zugang zu verschiedenen Erscheinungsformen zeitgenössischer Komplexität dar.

Die Seven Rooms (1994–1996) wurden anläßlich einer Ausstellung in der Londoner Galerie Anthony d'Offay konzipiert. Hamilton photographierte die nackten Wände des Ausstellungsraums und scannte sieben seiner Schwarzweißnegative in eine »Quantel paintbox«, die es ihm erlaubte, »das manipulative Potential des Painters mit der momenthaften Kreativität der Photographie zu kombinieren«. Diese Photographien wurden zur Aufnahme der »Exponate« präpariert, indem man die unvermeidlichen Verzerrungen der mit einem Weitwinkelobjektiv gemachten Aufnahmen durch Cropping perspektivisch korrigierte. Anstatt alte Arbeiten oder bereits existierende Bilder als »Exponate« einzuarbeiten, entschied sich Hamilton, neue Gemälde mit Hilfe eines Computers zu realisieren, die vielfältige Ansichten von sieben Räumen seines eigenen Hauses darstellen. Er selbst sagt dazu: »Das Thema des Interieurs war für die Idee der Ortsbezüglichkeit grundlegend, daher war es vernünftig, meine unmittelbare Umgebung als einheitsstiftenden Rahmen zu benutzen. Die Gruppe von sieben Räumen entwickelte sich zum Portrait eines Hauses.« Diese Kompositionen wurden anschließend an den Wänden der Galerie aufgehängt. Für ihre Installation bei der documenta wurde der Ausstellungsraum der Galerie Anthony d'Offay identisch rekonstruiert.

In den Seven Rooms findet man Verweise auf zahlreiche seiner früheren Werke wieder, so etwa auf seine Serie von Site Referential Paintings – Gemälde, die den Ort beschreiben, für den es bestimmt ist (Interior I & II, Langan's, Nothend I & II), wie auch auf wichtige Bilder, die seine Arbeit beeinflußten (wie zum Beispiel der Staubsauger oder das Große Glas). Das Projekt beschäftigt sich zugleich auch mit der Beziehung zwischen virtuellem und aktuellem Raum, einer Beziehung, die für Hamilton schon im photographischen Verfahren

Seven Rooms – Bathroom, 1994–1995

his œuvre. These interiors are a kind of self-portrait.

<div align="right">*P. S.*</div>

gegeben ist. Und schließlich ist es eine öffentliche Ausstellung des häuslichen und privaten Bereichs, die wie eine Synthese seiner Arbeit wirkt, wie eine auf einen imaginären Fluchtpunkt zustürzende Retrospektive eines Werkes. Diese Interieurs stellen gewissermaßen ein Selbstportrait des Künstlers dar.

<div align="right">P. S.</div>

Richard Hamilton & Ecke Bonk

*1922 in London. Lebt und arbeitet/lives and works in Northend, Oxon.
*1953 in Verona. Lebt und arbeitet/lives and works in Primersdorf, Österreich/Austria.

Ecke Bonk founded the typosophic society in the late 1980s. The very name "typosophic society" denotes an intention to escape from any strict identification or individual privatization of a research activity. A hybrid between typography and philosophy, the name plays on all the meanings of the term "typo." As Ecke Bonk explains, typosophy "seeks to monitor the interaction of media and focuses on the aesthetics of information—typosophy aspires to a new poetic reconciliation between art and science."

In the history of science, the notion of "program" is situated at the intersection of molecular biology and information theory; the typosophic society stresses that the majority of our instruments for creating types or standards are roughly modeled on biomolecular processes, and that mathematical programs produce only vague copies of vital phenomena operating at a quite different level: "A computer language is a notation for the unambiguous description of computer programs. Such languages are synthetic in that their vocabulary, punctuation, grammar, syntax, and semantics are precisely defined in the context of a particular operating system. They suffer from an inability to cope with autonomous expression—an essential attribute of an organic language… Perfect copy and pure identity exist only on the level of atoms." Through binary mathematics, symbolic logic, statistical mechanics, measurement systems, artistic practices, biological reality, electronic circuits, and quantum physics, the typosophic society weaves the interlacing flux of stories that constitutes "typosophic texture."

After the publication of his book Marcel Duchamp, The Portable Museum, Inventory of an Edition, Ecke Bonk initiated an exchange of letters with Richard Hamilton, who himself had created a typographic version of Duchamp's Green Box in the late fifties. This epistolary relation became a sustained collaboration in 1993, culminating today in the presentation of The Typosophic Pavilion: "a free rendering of tenets and operandi assumed by the typosophic society." The Typosophic Pavilion is composed of subjectively chosen elements: two computers constructed by Hamilton, plasma screens, a page of Finnegan's Wake by James Joyce, a Wilson Cloud Chamber whose condensation system visually simulates the invisible atomic process of cloud formation, paintings including Dürer's Melancholia and Sebastien Le Clerc's Allegory of Art and Science, and an illuminated manuscript. In this presentation, text and texture are the major vectors of the typosophic society, whose recurring leitmotif is the French language palindrome, "AIDE MOI : O MEDIA." P.S.

Gegen Ende der achtziger Jahre gründete Ecke Bonk die »typosophic society«. Der Name dieser Gesellschaft ist Programm für eine Forschungstätigkeit, die sich jeder strengen Festlegung zu entziehen trachtet. Die Typosophie erforscht alle Bedeutungsnuancen des Wortes »typo« und versucht, so Bonk, »die Interaktion der Medien zu überwachen, wobei sie sich auf die Ästhetik der Information konzentriert – die Typosophie strebt nach einer neuen poetischen Versöhnung zwischen Kunst und Wissenschaft«. Im Begriff des »Programms« treffen Molekularbiologie und Informationstheorie aufeinander. Die »typosophic society« betont, daß sich unsere Methoden zur Schaffung von Typen oder Standards an molekularbiologischen Prozessen orientieren und daß kein mathematisches Programm an lebendige Phänomene heranreicht, die auf einem anderen Niveau operieren: »Eine Computersprache ist ein Notationssystem zur eindeutigen Beschreibung von Computerprogrammen. Solche Sprachen sind insofern synthetisch, als sie hinsichtlich Vokabular, Interpunktion, Grammatik, Syntax und Semantik im Kontext eines bestimmten Betriebssystems exakt definiert sind. Sie sind nicht fähig, eine autonome Ausdrucksweise zu ermöglichen – eben das aber ist ein entscheidendes Merkmal der organischen Sprachen. (…) Eine vollkommene Kopie und reine Identität gibt es nur auf der Ebene der Atome.« Die »typosophic society« greift bei ihrem Versuch, eine »typosophische Textur« zu weben, auf binäre Mathematik, symbolische Logik, statistische Mechanik, Maßsysteme, künstlerische Praktiken, biologische Realität, elektronische Schaltkreise und Quantenphysik zurück. Nach der Veröffentlichung seines Buches Marcel Duchamp, The Portable Museum, Inventory of an Edition trat Bonk mit Richard Hamilton in Verbindung, der zwischen 1957 und 1960 eine typographische Version von Duchamps Boîte Verte geschaffen hatte. Aus ihrem zunächst nur brieflichen Austausch wurde 1993 eine intensive Zusammenarbeit, die in der Präsentation des Typosophic Pavillon gipfelt: »eine freie Wiedergabe von Thesen und Verfahrensweisen der typosophic society«. Der Typosophic Pavillon setzt sich aus subjektiv ausgewählten Elementen zusammen: zwei Computern, konstruiert von Hamilton, Plasmabildschirmen, eine Seite aus Finnegan's Wake, eine Wilsonsche Nebelkammer (die die Verläufe unsichtbarer atomarer Prozesse durch die Kondensationswirkung ionisierender Teilchen sichtbar zu machen gestattet), Bilder (Dürers Melancholia, Sebastien Le Clercs Allegory of Art & Science etc.) sowie ein illuminiertes Manuskript. Er repräsentiert das Leitmotiv der typosophic society, das französische Palindrom »AIDE MOI : O MEDIA«. P.S.

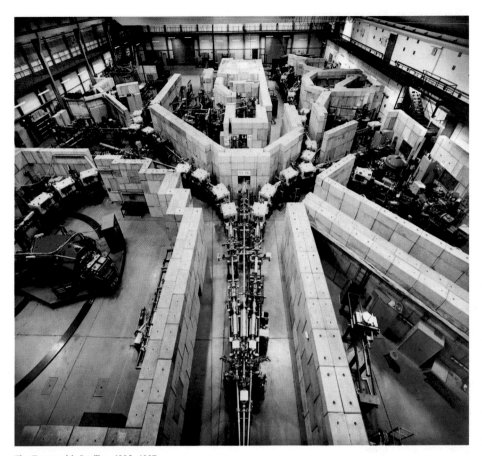

The Typosophic Pavilion, 1996–1997

Siobhán Hapaska

*1965 in Belfast. Lebt und arbeitet/lives and works in London.

"I have always wanted, as far as possible, to pull my person, my character, everything, out of these objects so that they appear to have no 'umbilical cord,' no trace of their maker, so that they look as if they have always existed on their own, as perfect, contained unquestionable objects in their own right… I like it to be a free entity in itself, because once you have made something it is no longer yours, it is a free autonomous object." This is how Siobhán Hapaska explained her relationship to the objects she creates in an interview with Ingrid Swenson in January 1996. Her sculptures do not actually betray the arduous craft that went into them. A characteristic signature, style, or preference for a certain material, to say nothing of traces of the work process, are not easily ascertainable. Her work cannot simply be reduced to a single aesthetic denominator. It evades hasty interpretation. *"I am not trying to produce a clear, distinct narrative or anything like that. I am just trying to touch an overall feeling."*

Yet at second glance it would seem that the sculptures share, nevertheless, a common underlying theme which can be readily deduced from their titles. Stray (1997) and Here (1995) are terms associated with location, and though not clearly defined, they are unequivocal in their reference to movement in space and its opposite, abiding. Insatiable wanderlust, the urge to travel, is evoked by Heart, a wall sculpture from which the roar of the sea and the distant strains of a fog horn resound. The uprooted undergrowth in Stray would seem to be a metaphor for aimless drifting. Here deals with travels of another kind: *"One of the reasons for the title Here is that it contains so many elements that evoke physical or mental transportation… I wanted to call it Here because it is within each person that the potential lies, not within a piece of art."* The artist does not use these words cynically. On the contrary, she is intent on ensuring that her sculptures resist the metaphysical expectations of their observers, though without making fun of them. Art cannot fulfill all the utopian hopes that people pin on it, but it can avail itself of them as subject matter.

S.P.

»Ich wollte immer schon meine Person, meinen Charakter, überhaupt alles soweit wie möglich aus diesen Objekten herauslassen, so daß sie aussehen, als hätten sie keine ›Nabelschnur‹, keine Spuren ihres Schöpfers, so daß sie aussehen, als hätten sie immer schon aus sich heraus existiert, als perfekte selbständige Objekte. … Ich möchte, daß es ein freies Wesen ist, weil, wenn man etwas schafft, es einem nicht mehr gehört, es ist ein autonomes Objekt.« Mit diesen Worten erklärte Siobhán Hapaska in einem Interview mit Ingrid Swenson im Januar 1996 ihr Verhältnis zu den Dingen, die sie schuf. Tatsächlich sieht man ihren Skulpturen die langwierige Handarbeit nicht an, die in ihnen steckt. Weder Handschrift noch Stil, auch nicht die Vorliebe für ein bestimmtes Material, geschweige denn Spuren des Fertigungsprozesses sind auszumachen. Kaum auf einen ästhetischen Nenner festzumachen, entzieht sich ihre Arbeit der raschen Interpretation. »Ich versuche nicht, eine klare deutliche Geschichte oder etwas ähnliches zu erzählen. Ich versuche nur ein allgemeines Gefühl zu erreichen.«

Daß den Skulpturen dennoch ein gemeinsames Thema zugrunde zu liegen scheint, erschließt sich erst auf den zweiten Blick und ist am ehesten von den Titeln der Arbeiten abzulesen. Stray (1997) und Here (1995) sind Vokabeln der Ortsbestimmung und verweisen – nicht genauer definiert – aber dennoch unmißverständlich auf Bewegung und ihr Gegenteil, das Verharren im Raum. Unstillbares Fernweh und der Drang zu Reisen wird durch Heart, eine Wandskulptur, aus der Meeresrauschen und das ferne Tuten eines Nebelhorns dringt, hervorgerufen, während das wurzellose Gestrüpp in Stray Metapher ziellosen Umherdriftens zu sein scheint. Here handelt von Reisen ganz anderer Art: »Einer der Gründe für den Titel Here ist der, daß er so viele Elemente enthält, die körperlichen oder geistigen Transport hervorrufen … Ich möchte es Here nennen, weil das Potential in der einzelnen Person liegt, nicht innerhalb eines Kunstwerks.« Die Künstlerin meint das keineswegs zynisch. Vielmehr scheint ihr daran gelegen, daß ihre Skulpturen sich den metaphysischen Erwartungen eines Publikums widersetzen, ohne sich über es lustig zu machen. Kunst kann die utopischen Vorstellungen unterschiedlichster Art nicht erfüllen, die an sie herangetragen wird, sie kann sie aber thematisieren.

S.P.

Here, 1995

Michal Heiman

*1954 in Tel Aviv. Lebt und arbeitet/lives and works in Tel Aviv.

Michal Heiman thinks of her work as questioning the very problematic relationship we have to photographs, the unconscious charge with which we invest them, and the many instances where images cross paths with systems of control and the exercise of power. Her inquiries are also an enacted reflection on the function of the photographer (whether artist, eyewitness, voyeur, or accomplice). One of the paradigms for her art is the voyage and the role the photograph plays in it, from the picture on the passport which serves as proof of identity to the ones we take while abroad in guise of a souvenir or memento. In Israel, while she is away, she is exhibiting a life-size cutout photograph of herself, suitcase in hand. This suitcase probably contains her personal belongings, as well as her photographic archives, the tools of her trade.

A few years ago, she came across the TAT (Thematic Apperception Test). This test, which originated in the United States, is widely used, in particular by the Israeli Army and judicial system, as well as by employers. It consists of a series of ambiguous images which are to be interpreted on model of the Rorschach test. The person administering the test presents the images and encourages the testee to freely express his or her personal concerns, unknowingly betraying the deepest parts of the personality. According to the instructions in the TAT manual, "the tendency is for people to interpret an ambiguous human situation in conformity with their past experiences and present wants." Thus the TAT checks on the psychology of those undergoing the test.

Heiman has realized a critical project based on the test which she calls the Michal Heiman Test (M.H.T.). *This test builds on the operational mechanisms of the TAT: the viewer takes a seat in the artist's installation and is presented with a series of images. But Heiman's archives consist of images which generate ambivalence owing to the conditions in which they were produced. They were collected according to the context that determined them and not for their inherent psychological interest. These are anonymous pictures which come from the photo albums of Israeli families dating from the beginning of the Zionist movement. They have been classified into various sections, one of which is entitled "The Frontier." The latter consists of photographs taken in front of monuments along the Israeli borders. They often attest to a kind of collective fantasy, that of territorial conquest. As Ariella Azoulay points out, "The 'unknown photographer,' the main figure behind these archives and the producer of these images, almost always provides the same colonial gesture in various places. The photographic practice*

Michal Heiman begreift ihre künstlerische Tätigkeit als Auseinandersetzung mit einer problematischen Beziehung zu Photographien und einer unbewußten Aufladung dieser Art von Bildern sowie als Erforschung der vielfältigen Gelegenheiten, bei denen Photographien mit Kontrollsystemen und der Ausübung von Macht zu tun haben. Ihre Arbeit ist auch eine praktische Reflexion über die Rolle des Photographen (Künstler, Zeuge, Voyeur, Komplize). Ein Thema ihrer Kunst ist beispielsweise die Reise und die Rolle, die Photographien dabei spielen (von dem Photo, das auf dem Paß zur Identifikation dient, bis zu jenem, das man in der Fremde macht und das als Souvenir dient). Wenn sie nicht dort ist, stellt sie in Israel eine Photographie aus, die sie in Lebensgröße mit einem Koffer in der Hand zeigt, der wahrscheinlich außer Kleidung und dem, was man für eine Reise braucht, auch ihr Photoarchiv enthält, das ihre Arbeitsgrundlage darstellt.

Vor einigen Jahren fing sie an, sich näher mit dem thematischen Apperzeptionstest (TAT) zu beschäftigen. Dieser von dem amerikanischen Psychologen Murray entwickelte Projektionstest wird häufig verwendet, zum Beispiel von der israelischen Armee und Justiz und auch als Eignungstest bei Stellenbewerbungen. Er besteht aus einer Reihe von mehrdeutigen Bildern, die auf ihren Bedeutungsgehalt hin zu interpretieren sind. Jemand zeigt der Testperson die Bilder und bittet sie, etwas über die dargestellten Situationen zu sagen, wobei die Testperson, ohne es zu wollen, zugleich auch etwas über ihre Persönlichkeitsstruktur und ihr psychologisches Profil verrät. Im Leitfaden zum Test heißt es: »Die Menschen neigen dazu, eine mehrdeutige Situation in Übereinstimmung mit ihren früheren Erfahrungen und ihren derzeitigen Wünschen zu interpretieren.«

Michal Heiman hat, ausgehend von diesem Test, ein kritisches Projekt entwickelt, das sie *Michal Heiman Test (M.H.T.)* nennt. Dieser Test geht nach dem gleichen Muster vor wie der TAT, doch bei den Bildern aus den Archiven Heimans, die hier dem Betrachter vorgelegt werden, entspringt die Ambivalenz ihren Entstehungsbedingungen. Sie sind im Hinblick auf ihre kontextuelle Determiniertheit gesammelt worden und nicht im Hinblick darauf, ob sie psychologisch interessant sind. Es handelt sich um anonyme Photographien, die aus den Photoalben israelischer Familien stammen und bis zum Beginn der zionistischen Bewegung zurückreichen. Sie sind in verschiedene Abteilungen eingeteilt, von denen eine unter dem Oberbegriff »Grenze« firmiert. Dabei handelt es sich um Photographien, die in der Nähe von Grenzen aufgenommen wurden, die sich in der Nähe von Grenzen befinden. Sie zeugen oft von einer kollektiven Fiktion: dem falschen Glauben, jenes Territorium sei

Michal Heiman Test (M.H.T.), 1997
Detail

takes part in the transformation of the real conquest into a touristic conquest."

<div align="right">P.S.</div>

erobert worden. Wie Ariella Azoulay sagt: »Der ›unbekannte Photograph‹, die entscheidende Figur hinter diesem Bildarchiv und der Produzent dieser Bilder, produziert fast immer die gleiche besitzergreifende kolonialistische Geste, wo er auch ist. Diese Praktik des Photographierens ist Bestandteil der Transformation der realen Eroberung in eine touristische Eroberung.«

<div align="right">P.S.</div>

Jörg Herold

*1965 in Leipzig. Lebt und arbeitet/lives and works in Leipzig und Berlin.

Jörg Herold once described the experience of the demise of the GDR and the collapse of its social and artistic values as a "discharge from an ideology and an induction into the random." In attempting to reorient himself, Herold chanced upon the figure of Kaspar Hauser and began working on the artistic double life of Hauser-Herold.

To this extent his super-8 film Körper im Körper (Body in the Body), Leipzig 1989, is a self-portrait which, in retrospect, proved to be an important preliminary stage in the Hauser-project. It was filmed mainly on location in Leipzig, where the artist lived until he was 18 years old. Jörg Herold reminisces: "Born in 1965, I grew up as an only child in a caring household run by two women. I cannot recall that I felt anything was missing in my life at that time. My mother worked as a draftswoman for a technical combine while my grandmother devoted her time to my upbringing. It seemed as if everything was in good order and would remain so for ever and ever. It was an ideal world and its definition of good and bad was crystal clear."

With a detective's instinct, Herold investigates the mystical period of childhood when everything is self-evident and relationships to surrounding places and things are practically unquestioned. The self is formed in the social and local context. As Herold puts it: "At my point of arrival, ordering realms confronted one another silently in an indolent transition to the light. In this terrain I became a body in a body. Redolent of the mechanical principle of photography, our body is exposed at birth, becoming visible and developing an immediate relationship to time and to its surroundings." Vice versa, things are only constituted by being named. No signifier, no signified. In other words, a phenomenon only becomes concrete by being communicated in some way. In films, this happens by means of a condensed symbolic language. The same applies to space. Only when one perceives its limits does it become real. Space is formed, takes on shape, with reference to other bodies – first and foremost one's own. This is made physically perceptible in the projection cube specially designed for Körper im Körper.

In his constant attempts over the past years to bring social and historical realities within the observer's realm of experience, Jörg Herold has developed his own language, a type of pictographic alphabet with which we are confronted in most of his works. As products of subjective impressions, and hand in hand with other data possibly manifest in the chosen material or place, these works communicate comprehensible information. In this way, the artist succeeds in arriving at the general via the personal. S.P.

Als »Entlassung aus einer Ideologie und Ankunft in der Beliebigkeit« beschrieb Jörg Herold die Erfahrung des Zusammenbruchs sozialer und künstlerischer Wertesysteme mit dem Ende der DDR. Beim Versuch der Neuverortung stieß er auf die Figur des Kaspar Hauser und begann, die künstlerische Doppelexistenz Hauser-Herold zu erarbeiten.

Der Super-8-Film Körper im Körper (Leipzig 1989), der sich rückblickend als wichtige Vorstufe des Hauser-Projekts erweist, ist insofern ein Selbstportrait. Er wurde vorwiegend an Orten in Leipzig gedreht, an denen der Künstler bis zu seinem 18. Lebensjahr lebte. »Geboren 1965 und aufgewachsen als Einzelkind, umsorgt von einem Zweifrauenhaushalt, kann ich mich noch heute nicht erinnern, daß es mir in dieser Zeit an irgendetwas gefehlt hätte. Meine Mutter arbeitete als Zeichnerin in einem technischen Kombinat und meine Großmutter verwendete ihre ganze Zeit auf meine Erziehung. Es schien so, als sei alles für die Ewigkeit geregelt. So war die Welt heil und ihre Einteilung in Gut und Böse kristallklar«, erinnert Jörg Herold sich.

Wie ein Spurensucher erkundet er die mystische Zeit der Kindheit, gekennzeichnet durch Selbstverständlichkeit und unmittelbare, wenig entfremdete Beziehungen zur Umgebung und den Dingen. Die Konstituierung des Ichs erfolgt im sozialen und lokalen Kontext. »Am Ort meiner Ankunft standen sich ordnende Flächen im leblosen Übergang zum Licht schweigend gegenüber. In diesem Feld wurde ich zum Körper im Körper. Ähnlich dem photomechanischen Prinzip wird unser Körper bei der Geburt belichtet. Er wird sichtbar und entwickelt sofort eine Beziehung zur Zeit und zu seiner Umgebung«, schreibt der Künstler. Umgekehrt konstituieren sich auch die Dinge nur dadurch, daß man sie benennt. Ohne Signifikant kein Signifikat. Anders ausgedrückt, ein Sachverhalt konkretisiert sich erst dadurch, daß man ihn in irgendeiner Form, im Film geschieht dies durch eine zeichenhaft verkürzte Sprache, kommuniziert. Ähnliches gilt für den Raum. Erst wenn man seine Grenzen wahrnimmt, gewinnt er Realität. In Referenz zu anderen Körpern, in erster Linie dem eigenen, formiert er sich und gewinnt Gestalt. Diese Erfahrung ist in dem speziell für Körper im Körper konzipierten Vorführkubus nachvollziehbar.

Auf der ständigen Suche nach Erfahrbarmachung von gesellschaftlichen und historischen Realitäten hat Jörg Herold im Laufe der Zeit eine ganz eigene Sprache, eine Art piktographisches Alphabet entwickelt, das dem Betrachter in den meisten seiner Arbeiten wiederbegegnet. Produkte subjektiver Eindrücke, vermitteln sie im Zusammenhang mit weiteren Informationen, die im gewählten Material oder Ort liegen können, nach-

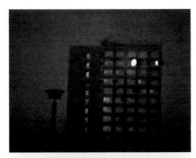

Körper im Körper, Leipzig 1989
(Body in the body)
Film still

vollziehbare Informationen. Auf dieser Basis gelingt es
dem Künstler, über das Persönliche zum Allgemeinen zu
gelangen.

S.P.

Christine Hill

*1968 in Binghamton, New York. Lebt und arbeitet/lives and works in Berlin.

During her studies at the Maryland Institute College of Art, Christine Hill was dubbed "Artslut," a nickname she finally adopted as her own on the grounds of her basic artistic philosophy: "deal with what you've got." It led her to reconsider the term artist in a somewhat less idealized way. Thus, since her arrival in Berlin, she has successively been a masseuse, a concessions girl, a rock singer, a shoeshiner, a striptease dancer – all of which are service activities requiring no laborious apprenticeship. These works were occasions for Hill to slip into a variety of roles and to exchange an identity of being, with its fantasy of originality and authenticity, for an identity of making, always provisional and constantly reinvented. The project of the Volksboutique springs from this series of works which extend over a period of four years and which, in the artist's words, "deal with service, interaction, the portrayal and assumption of roles, the generation of conversation between individuals and the information therein."

Volksboutique is an artistic project which takes the form of a store. Initially set up in Berlin Mitte, it consists of two rooms, one for working and the other for display. It functions as an installation space which continually exhibits and sells the production of the work that takes place in it. The spectator is transformed into a visitor and the role of the store is to generate an interactive system. As the artist says, "the entrapment of store space, merchandise, and opening hours is intended to produce a natural medium through which conversation, action, and individuality can be accessed." Volksboutique attempts to create a space of discussion and a situation of exchanges on the basis of the physical presence of individuals (neither mail-order shopping nor Internet). Symptomatic of a conception of artistic activity as a catalyst of sociality, one of the central ideas of the Volksboutique project is, as Christine Hill recalls, "creating a grounded space, a situation where the stuff of my work can occur: the provision for conversation on various topics and the sharing of information; discourse and assessment of the role that personal appearance and stature in society play (this includes how people present themselves in a public/social context, how much attention is placed on appearance and rank in social appearance, and how people present themselves 'orally')."

P.S.

Seit sie am College of Art des Maryland Instituts studierte, trägt Christine Hill den Spitznamen »Artslut« (etwa: »Kunstschlampe«), ein Spitzname, mit dem sie fertig wurde, indem sie sich ihn, gemäß ihres künstlerischen Credos »deal with what you've got« (»verkauf das, was du hast«), zu eigen machte und nun eine entidealisierte Vorstellung vom Künstlertum vertritt. So wurde sie nach ihrer Ankunft in Berlin 1991 nacheinander Masseurin, Bauchladenverkäuferin, Schuhputzerin, Rocksängerin, Stripperin... Alles Aktivitäten, die mit Dienstleistung zu tun haben und keine lange Ausbildung erfordern. All diese Arbeiten gaben Christine Hill Gelegenheit, in viele Rollen hineinzuschlüpfen und eine Identität des Seins mit ihrer eingebildeten Ursprünglichkeit und Authentizität durch eine Identität des Tuns zu ersetzen, die stets provisorisch ist und unaufhörlich neu erfunden werden muß. Das Projekt der Volksboutique entstammt dieser Serie von Arbeiten, die sich über einen Zeitraum von vier Jahren erstrecken und die, so die Künstlerin, »mit Dienstleistung, Interaktion, dem Portrait und der Übernahme von Rollen ebenso zu tun haben wie mit der Entfaltung von Gesprächen zwischen Individuen und den darin enthaltenen Informationen«.

Die Volksboutique ist ein künstlerisches Projekt in Gestalt eines Ladens, der zuerst in Berlin-Mitte eingerichtet wurde. Der Laden besteht aus zwei Abteilungen: einer, in der gearbeitet wird, und einer, in der die Ergebnisse ausgestellt werden. Er funktioniert als Installationsort, wo einerseits ausgestellt und verkauft, andererseits zur gleichen Zeit auch gearbeitet und produziert wird. Der Betrachter wird zum Besucher, und der Laden hat die Funktion, ein System von Interaktionen zu installieren. Die Künstlerin sagt dazu: »Die Verführung des Ladenlokals, der Waren und der Öffnungszeiten dient dazu, ein natürliches Medium zu schaffen, das zur Entstehung und Entfaltung von Konversation, Interaktion und Individualität beiträgt.« Die Volksboutique versucht, ausgehend von der physischen Präsenz der Individuen (man kann bei ihr keine schriftlichen Bestellungen aufgeben und sie auch nicht über Internet erreichen), einen Diskussionsraum und eine Situation des Austauschs zu schaffen. Symptomatisch für das Konzept, künstlerische Aktivität als eine Art sozialen Induktionsapparat zu begreifen, ist eine der zentralen Ideen des Projekts Volksboutique, die Christine Hill folgendermaßen beschreibt: »Es geht darum, einen etablierten Raum zu schaffen, eine Situation zu etablieren, in der meine Arbeit geschehen kann: Das ist die Voraussetzung für Gespräche über verschiedene Themen und den Austausch von Informationen; für die Besprechung und Einschätzung der Rolle, die das persönliche Erscheinungsbild und das Format eines Menschen in der Gesell-

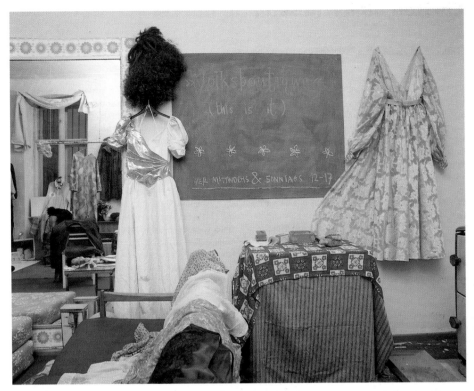

Volksboutique, (1996…)
Volksboutique in Kassel will be open during documenta X on Fridays and Saturdays from 10 a.m.–8 p.m. / geöffnet freitags und samstags 10–20 Uhr
Volksboutique in Berlin will be open on Sundays from 5 p.m.–9 p.m. and Mondays from 12 p.m.–8 p.m. / geöffnet sonntags 17–21 Uhr, montags 12–20 Uhr

schaft spielen (dazu gehören auch die Fragen, wie sich Menschen in einem öffentlichen oder sozialen Kontext präsentieren, wieviel Aufmerksamkeit sie ihrem Erscheinungsbild und ihrem Platz in der gesellschaftlichen Hierarchie schenken und wie sie sich selbst in Gesprächen darstellen).«

P.S.

Carsten Höller/Rosemarie Trockel

*1961 in Brüssel. Lebt und arbeitet/lives and works in Köln.
*1952 in Schwerte. Lebt und arbeitet/lives and works in Köln.

A lot of Carsten Höller's work as an artist is based on his knowledge as a biologist and explores theories of evolution that regard human sentiments such as love and happiness primarily as strategies for the successfull reproduction of genetic material. In the early nineties, he invented a number of ingeniously wicked objects aimed at the products of unfettered reproductive instincts – that is to say, at children. These included, for example, a bicycle which explodes at the first push of the pedal, and a sandpit full of jellyfish. In 1996, at the Cologne Kunstverein, he devoted an entire exhibition to the theme. On the basis of scientific considerations, he created an experimental obstacle course which allowed visitors to see themselves as the subjects of experiments and as the conductors of experiments at one and the same time.

Rosemarie Trockel's œuvre includes drawing, painting, installation and sculpture as well as photography and video, and, of course, the famous knitted pictures she showed for the first time at Bonn in 1985. The unifying strand that runs through all her work is her feminist world view. She kicks against the pricks with an occasionally refreshing display of aggression, undermining the conventional gender roles that hold sway in the male-dominated art system. For some time now, largely unnoticed, animal portrayals have been creeping into her work. At first it took the form of the moth, gnawing at the artist's signature knits. This was later followed by her bibliophile artist's book Jedes Tier ist eine Künstlerin (Every animal is a female artist) which revealed Beuys' dictum "Every man is an artist" as an expression of male hubris. In 1994, as part of the Anima exhibition, the Museum für angewandte Kunst in Vienna showed a series of animal films by Rosemarie Trockel. Aesthetically oriented towards educational nature study films, they clearly signaled a move in a new thematic direction.

Ein Haus für Schweine und Menschen (A House for Pigs and People) would appear to be an ideal symbiosis of the different approaches taken by Carsten Höller and Rosemarie Trockel. On an area measuring 8 x 12 meters, a concrete building has been erected, half of which is open to documenta visitors, while the other half is cordoned off for a little herd of pigs consisting of a boar and three sows with a few piglets. The pigsty side has feeding and drinking troughs, boxes for the piglets, shower, fodder store, and a yard behind the house. For the visitors, there are mats that can be placed on a ramp in the "human" half of the building, from which they can comfortably enjoy a view of the pigs. As in a scientific study, a one-way window allows

Ein großer Teil der Arbeit des Künstlers Carsten Höller beschäftigt sich – beruhend auf den Kenntnissen des Biologen Carsten Höller – mit Evolutionstheorien, die in menschlichen Gefühlen wie Liebe und Glück in erster Linie Strategien zur erfolgreichen Reproduktion des eigenen Erbguts sehen. Anfang der neunziger Jahre erfand er eine Anzahl ingeniös bösartiger Objekte, die den Folgen ungezügelten Fortpflanzungsdrangs – den Kindern – zu Leibe rücken. Darunter befanden sich Dinge wie ein Fahrrad, das beim ersten Pedaltritt explodiert oder ein Sandkasten voller Quallen. Dem Thema Glück widmete er Ende 1996 im Kunstverein Köln eine komplette Ausstellung. Auf der Basis wissenschaftlicher Überlegungen entstand ein Versuchsparcours, auf dem der Besucher sich als Experimentator und Versuchsperson in einem fühlte.

Rosemarie Trockels bildnerische Arbeit umfaßt Zeichnung, Malerei, Installation und Skulptur genauso wie Photographie und Video und natürlich die berühmten Strickbilder, die sie 1985 in Bonn erstmals ausstellte. Allen gemein ist eine feministische Weltsicht, die häufig erfreulich aggressiv, mit dem differenzierten Bewußtsein geschlechtsspezifischer Rollenzuweisungen im männerdominierten »System Kunst« erfolgreich wider den Stachel löckt. Weitestgehend unbemerkt hat sich in dieses Werk seit einiger Zeit das Tier eingeschlichen. Zunächst in Gestalt der Motte, die am gestrickten Markenzeichen der Künstlerin nagt, dann auch in dem bibliophilen Künstlerbuch Jedes Tier ist eine Künstlerin, das das Beuyssche Diktum »Jeder Mensch ist ein Künstler« als Ausdruck männlicher Hybris enttarnt. 1994 zeigte das Museum für angewandte Kunst in Wien im Rahmen der Ausstellung Anima eine Reihe von Tierfilmen von Rosemarie Trockel, die, ästhetisch an Lehrfilmen orientiert, offensichtlich eine Hinwendung zu neuen Themen signalisierten.

Das Haus für Schweine und Menschen scheint eine ideale Symbiose der unterschiedlichen künstlerischen Methoden Carsten Höllers und Rosemarie Trockels zu sein. Auf einer Grundfläche von 8 x 12 Metern wurde ein Betonbau errichtet, dessen eine Hälfte für die Besucher der documenta geöffnet ist, während die andere Hälfte einer kleinen Schweineherde, bestehend aus einem Eber und drei Sauen mit einigen Ferkeln, vorbehalten bleibt. Die Stallseite bietet Futter-, Tränk- und Ferkelbuchten, einen Ferkelkasten, Dusche, ein Futterlager und einen genügend großen Auslauf im Freien hinter dem Haus. Für die Besucher sind Matten vorgesehen, die sie auf einer Rampe in ihrer Hälfte des Baus deponieren können, um von dort aus entspannter Haltung den Ausblick auf die Schweine zu genießen. Wie in einer wissenschaft-

Ein Haus für Schweine und Menschen, 1997

the people to observe the pigs without disturbing them.

It is more than likely that the exhausted documenta visitors will be only too glad to accept Höller and Trockel's invitation and will enjoy a moment of relaxation in full view of the pigsty. Yet they will also be aware of the fact that the domesticated pig, which has lived side by side with humans for thousands of years, has also developed similar capacities of sensitivity – provoking some reflection on the extent to which the mores of intensive rearing is more than just a symptom of the brutal exploitation of the individual for the benefit of maximum profit, but a basic premise of our society.

This project has been realized in collaboration with EXPO 2000 in Hanover. *S.P.*

lichen Langzeitstudie üblich, garantiert ein einseitig durchsichtiges Spionglas, daß zwar die Menschen die Tiere beobachten können, diese jedoch ungestört bleiben, da ihre Seite der Trennwand verspiegelt ist.

In diesem Schweine/Menschen-Idyll stellt sich die Frage, warum das dem Menschen an Empfindungsfähigkeit ähnliche Hausschwein auf Kotelett- und Schinkenproduktion reduziert wurde und inwieweit Massentierhaltung nicht nur Symptom einer auf brutaler Ausbeutung des einzelnen zum Wohle der Gewinnmaximierung beruhenden Gesellschaftsform ist.

Das Projekt wurde in Zusammenarbeit mit der Weltausstellung EXPO 2000 Hannover realisiert. *S.P.*

Rosemarie Trockel

Christine & Irene Hohenbüchler

* 1964 in Wien/Vienna. Leben und arbeiten/live and work in Berlin and Vienna/und Wien.

Christine and Irene Hohenbüchler are twin sisters who have been working together for eight years. They have expanded their joint project, which is based on a very precise division of the tasks involved, to collective work with artists living in clinical and penal institutions (the Kunstwerkstatt Lienz, the De Berg Prison in Arnhem, as well as the KB-Nervenklinik in Berlin). Although they set up a creative process based on intersubjective communication, the sisters do not act as therapists. Their sessions lead to many kinds of work – drawings, computer graphics, and small objects – as well as hybrid furniture, somewhere between art brut and functionalism, where one can sit and view the works. Seeking the highest degree of freedom and exchange possible, the group installations they realize cannot be reduced to a mere collection of objects. These works are but a provisional achievement within a much larger process. For documenta they, and the artists they work with, have taken over the exhibition space in order to produce an event which, as they put it, "should radiate something joyful and lively to be submerged into the narrative of the images."

They declare their intentions in a brief text entitled multiple autorenschaft *(multiple authorship): "To provide the framework for a volume in the space of which colorful 'stances' can be played with and played out. The focus will be on the collaboration between the Kunstwerkstatt Lienz and the Hohenbüchler sisters. An amalgam of many postures and perceptions of 'reality' will thus be constituted… Each artist will be represented in his or her own characteristic mode of expression, and will be shown in (inter)action with the other works. In this way the communication between individual personal fantasy and its narrative qualities will be imaginatively exemplified and described… An attempt at a polyphonic visual language where associations begin to interconnect. Conclusions are drawn. A web of simultaneities and multifariousness arises… finding a rhythm, fostering growth… and achieving a common openness."*

P. S.

Christine und Irene Hohenbüchler sind Zwillingsschwestern, die seit acht Jahren zusammenarbeiten. Ihre auf einer präzisen Aufgabenteilung beruhende Zusammenarbeit haben sie zu einer kollektiven Arbeit erweitert, indem sie Künstler einbeziehen, die in Nervenheilanstalten oder in Gefängnissen untergebracht sind (z. B. Kunstwerkstatt Lienz, De Berg Gefängnis Arnhem oder KB-Nervenklinik Berlin), um auf diese Weise im kommunikativen Austausch mit behinderten oder eingeschränkten Personen einen kreativen Prozeß in Gang zu setzen. Dennoch verstehen sich die beiden Schwestern nicht als Therapeutinnen. Die Arbeitssitzungen führen zu den verschiedensten Werken: Zeichnungen, computergestützte Graphiken, kleine Objekte, aber auch hybride Möbel zwischen Art Brut und Funktionalismus, auf denen man Platz nehmen und die Werke begutachten kann. Da die Hohenbüchlers in der Gruppenarbeit einen optimalen gegenseitigen Austausch anstreben und allen Beteiligten die größtmögliche Ausdrucksfreiheit gelassen wird, sind die Installationen, die aus dieser Gruppenarbeit hervorgehen, nicht auf eine Ansammlung von Objekten reduzierbar. Die Werke sind nur ein provisorisches Übergangsstadium in einem längeren Prozeß. Für die *documenta* hatten sie und die Künstler, mit denen sie zusammenarbeiten, sich vorgenommen, ein Ereignis zu produzieren, das, wie sie sagen, »etwas Fröhliches ausstrahlen und dazu animieren sollte, in die Erzählung der Bilder einzutauchen«.

In einem kurzen Text mit dem Titel *multiple autorenschaft* erklären sie, daß es ihnen darum geht, einen Rahmen zu schaffen, in dem sich »farbige ›Handlungen‹ abspie(u)len«. Aus der Zusammenarbeit der Geschwister Hohenbüchler mit der Kunstwerkstatt Lienz sei ein Werk entstanden, das ein »Konglomerat aus vielen Haltungen und Wahrnehmungsweisen von ›Realität‹« bilde. Jeder Künstler sei dabei mit seiner »charakteristischen Ausdrucksweise« vertreten und würde »in (Inter)Aktion mit den anderen Arbeiten« präsentiert. Das habe den Effekt, daß »die Kommunikation zwischen den einzelnen persönlichen Phantasien und deren erzählerische Qualität verbildlicht« würde. Das ganze sei der »Versuch eines mehrstimmigen visuellen Gesprächs«, in dessen Verlauf »Assoziationen beginnen, sich aneinanderzuketten«. Es würden »(Rück)Schlüsse« gezogen und es entstehe ein »Geflecht von Gleichzeitigkeiten, Vielseitigkeiten«, das dazu diene, einen »Rhythmus zu finden«, »Wachstum zu fördern« und eine »gemeinsame Öffentlichkeit zu erreichen«.

P. S.

multiple autorenschaft. Ein Kommunikationsraum, 1996–1997
Detail

Edgar Honetschläger

*1963 in Linz, Österreich/Austria. Lebt und arbeitet/lives and works in Tokio und Wien/ Tokyo and Vienna.

"Japan is a strange country. A country which – in what it represents at the present time – is actually younger than America. It is a country with a very confused identity or no identity whatsoever. The Japanese have succeeded in colonizing themselves – and in this have done a better job than all those Asian countries which were physically colonized by European nations," writes Edgar Honetschläger. This cosmopolitan artist, living between Vienna, New York, and Tokyo, undertook a long period of work in Japan resulting in three pieces: Schuhwerk, which consists in plaster casts of footprints (a metaphor of repression in Asian culture), 97 – (13 +1), which he is presenting at documenta, and the film Milk, which he is currently finishing.

In Japanese, the terms for "sitting down" and "possessing" are precisely connected. The chair, a powerful symbol in Western culture where it is traditionally associated with authority, has recently been added to Japanese culture, supplementing the traditional tatami. In 1993 a collective of Austrian architects, Poor Boys Enterprise, brought ninety-seven chairs picked up off the streets of New York to Vienna. "This is where my story with these ready-mades begins," recounts Honetschläger, who selected fourteen of them and brought them to Tokyo, to put them through a cycle of activity before sending them back "to their fate" in the streets of New York. However, one of the fourteen arrived in too shattered a state to still serve as a chair. Three times he asked people in the street to sit down in the chairs: fourteen homeless people, fourteen employees, and twenty-eight students (fourteen boys, then fourteen girls). Each time he recorded this brief encounter where a Japanese, living in a "rigid and body unconscious" system, is exposed in his or her vulnerability. Finally he asked fourteen persons of highly diverse social status to come to his studio and sit naked on the chair of their choice while he took pictures and filmed them with a video camera. As Honetschläger says, "I'm mainly interested in confronting individualism with conformism . . . the obvious uniformity vs. the individual. Once more, I try to question prejudices which exist in the West toward the Eastern world." Dealing with an anthropological reality, his photos and video question the state of cultural difference in the era of globalization. The same holds for Milk, the film he is now completing. "Today Japan is – as I call it – a communist country with a capitalistic face… Milk stands for the Westernization of Japan – it was the Westerners who introduced dairy products to the Japanese archipelago." For the artist, Milk constitutes "the third leg of a tripod on which I will be able to take a final photograph." P. S.

»Japan ist ein merkwürdiges Land. Ein Land, das, wie es sich heute darstellt, tatsächlich jünger ist als Amerika. Es ist ein Land mit einer sehr verworrenen Identität oder vielleicht sogar gar keiner. Den Japanern ist es gelungen, sich selbst zu kolonisieren – und sie sind dabei gründlicher kolonisiert worden als die anderen asiatischen Länder, die direkt das Opfer europäischer Kolonialmächte wurden«, schreibt Edgar Honetschläger. Dieser kosmopolitische Künstler, der in Wien genauso zu Hause ist wie in New York und Tokio, hat sich lange mit Japan beschäftigt, und die Auseinandersetzung mit diesem Land hat ihren Niederschlag in drei Werken gefunden: Schuhwerk, das aus Gipsabgüssen von Fußabdrücken besteht (eine Metapher der Unterdrückung, die für die asiatische Kultur kennzeichnend ist); das Stuhl-Projekt 97 – (13 + 1), das er auf der documenta zeigt, und Milk, ein Film, dessen Dreharbeiten noch nicht abgeschlossen sind.

Der Stuhl, ein starkes Symbol der abendländischen Kultur, das traditionell mit Autorität verknüpft ist, wird heute Teil der japanischen Kultur, wo er neben dem traditionellen Tatami immer mehr in Gebrauch kommt. Eine Gruppe österreichischer Architekten, Poor Boys Enterprise, holte 1993 siebenundneunzig Stühle nach Wien, die man in den Straßen New Yorks aufgelesen hatte. »Das war der Anfang meiner Geschichte mit diesem Ready-made«, erzählt Honetschläger, der vierzehn davon auswählte und mit nach Tokio nahm, um sie einen Kreislauf vollziehen zu lassen, der sie dann wieder in die Straßen New Yorks zurückführt, wo sich »ihr Schicksal« erfüllt. Einer von ihnen wurde auf der Reise allerdings zu sehr beschädigt, um noch als Stuhl benutzt werden zu können. Dreimal hat er auf der Straße Leute aufgefordert, sich auf diese Stühle zu setzen: 14 Obdachlose, 14 Angestellte und 28 Studenten (erst 14 junge Männer, dann 14 junge Frauen). Schließlich bat er 14 Personen von sehr unterschiedlichem sozialem Status, in sein Atelier zu kommen und sich nackt auf einen Stuhl ihrer Wahl zu setzen. Er filmte alles mit einer Videokamera und machte Photographien. Jedesmal registrierte er diesen kurzen Kampf, in dem sein in einem »rigiden und körperunbewußten« System lebendes japanisches Opfer seine Verletzlichkeit zeigt. Wie Honetschläger sagt: »Ich bin hauptsächlich daran interessiert, den Konformismus mit dem Individualismus, die offensichtliche Uniformität mit der Individualität zu konfrontieren. Wieder einmal versuche ich, Vorurteile zu überprüfen, die im Westen hinsichtlich der Welt des Ostens bestehen.« Er nähert sich einer anthropologischen Realität und untersucht mit seinen Photographien und den Videoaufnahmen, wie es in einer Zeit der allgemeinen Globalisierung um einen bestimmten

97 – (13 + 1), 1994–95
A project by / Ein Projekt von Edgar Honetschläger in collaboration with / in Zusammenarbeit mit Poor Boys Enterprise. View of the thirteen chairs + one in Fugino, 1995

kulturellen Unterschied bestellt ist. Dasselbe Ziel verfolgt der Film *Milk*, den er zur Zeit gerade dreht. »Heute ist Japan in meinen Augen ein kommunistisches Land mit einem kapitalistischen Antlitz... Milch steht für die Verwestlichung Japans – Milchprodukte haben erst durch die Europäer und Amerikaner Einzug auf den japanischen Archipel gehalten.« Der Film *Milk* wird nach den Worten Honetschlägers »das dritte Bein des Stativs sein, auf das gestützt ich eine letzte, abschließende Aufnahme werde machen können«.

P.S.

Felix S. Huber/Philip J. Pocock/Udo Noll/Florian Wenz

*1957 in Zürich. Lebt und arbeitet/lives and works in Köln.
*1954 in Ottawa. Lebt und arbeitet/lives and works in Karlsruhe.
*1966 in Hadamar. Lebt und arbeitet/lives and works in Köln.
*1958 in München. Lebt und arbeitet/lives and works in Zürich.

A Description of the Equator and Some OtherLands (1997) is an experimental, word-based, film-related Internet project which is scripted and edited by the visitors to the virtual exhibition site as a daily updated series of digital "hypermovies," commanded not by a single scripting and editorial authority as is normally the case in filmmaking, but instead by traces left by those navigating the site, whose words are filtered through a neural net installed on the server, vaulting the users (the "audience") into the screenplay and into their new roles as a global, collaborative group of authors.

Everyone as an author can upload scenes from their lives, private or fictional, and respond to the storylines of others, creating an on-line world of "legible bodies." Their words punctuate scenes like intertitles or subtitles that float somewhere between a newsgroup and a movie.

A Description of the Equator and Some OtherLands (1997) is a sequel to Huber and Pocock's previous two network art projects, Arctic Circle and Tropic of Cancer, both involving real travel, through the Canadian Northlands in the former, and as tourists in Mexico in the latter.

A Description of the Equator and Some OtherLands is also a travel-as-art loop, although this time the travel is less destination-oriented and more interpersonal. Like its two predecessors, A Description of the Equator and Some OtherLands is a double voyage – on the one hand, in virtual reality, as symbolic exchanges between authors and users over the network, and on the other hand, in real reality to Entebbe, on the Equator in East Africa, and other geographic destinations (Quito, Ecuador; the Galapagos Islands; Singapore; Borneo). Of particular interest are moments when the authors actually travel with one another and visit one another to produce scenes which are then uploaded to the documenta server for view and response.

And so a game ensues. What begins as a classic experimental film, a movie made up primarily of words, fuses with a game-like dramaturgy caused by the instance of users becoming authors, users and story becoming indistinguishable from one another.

The Equator described here is "identity in contemporary global society," identity as the corroborative correspondence between two identities, never however being absolutely "identical." As such, memory is identity, the correspondence between mentally stored events and the real experiences they contain. Film is

Das Werk A Description of the Equator and Some OtherLands (1977) ist ein experimentelles Internet-Projekt, auf Wörtern basierend und mit dem Film verwandt, das als täglich aktualisierte Serie digitaler »Hypermovies« erscheint, deren Drehbücher und Schnitt von den Besuchern der virtuellen Ausstellungs-Site besorgt werden. Dies geschieht nicht nach Maßgabe einer einzigen für Drehbuch und Schnitt verantwortlichen Autorität, wie es beim Filmemachen normalerweise der Fall ist, sondern nach Maßgabe der Spuren, die diejenigen hinterlassen, die in der Site navigieren. Die Wörter werden durch ein neuronales Netz gefiltert, das auf dem Server installiert ist und die Benutzer, das Publikum, in das Drehbuch und ihre neue Rolle als globale, kollaborierende Gruppe von Autoren hineinversetzt.

Jeder kann als Autor selbst erlebte oder erfundene Szenen hochladen, auf die Erzählstränge der anderen reagieren und online eine Welt aus »lesbaren Körpern« schaffen. Ihre Wörter unterstreichen oder unterbrechen Szenen wie Untertitel oder Zwischentitel, die irgendwo zwischen einer Newsgroup und einem Film angesiedelt sind.

A Description of the Equator and Some OtherLands ist eine Fortsetzung der beiden vorhergehenden Netzwerk-Kunstprojekte Hubers und Pococks – Arctic Circle und Tropic of Cancer –, die beide ein wirkliches Reisen beinhalten, im einen Fall durch den Norden Kanadas, im anderen als Tourist in Mexiko.

A Description of the Equator and Some OtherLands ist an sich ebenfalls eine Reisen-als-Kunst Programmschleife, obwohl das Reisen diesmal weniger auf das Reiseziel als auf den interpersonalen Austausch orientiert ist. Wie seine beiden Vorgänger ist auch A Description of the Equator and Some Otherlands eine doppelte Reise – einerseits in der virtuellen Realität, als symbolischer Austausch zwischen Autoren und Benutzern via Netzwerk und andererseits in der wirklichen Realität, als Reise nach dem am Äquator liegenden ostafrikanischen Entebbe und anderen geographischen Reisezielen (Quito, Ecuador, die Galapagosinseln, Singapur, Borneo). Besonders interessant sind Bewegungen, wenn Autoren miteinander reisen und einander besuchen, um Szenen zu produzieren, die sie zum documenta-Server hochladen, damit andere sie rezipieren und auf sie reagieren.

Und so nimmt das Spiel seinen Lauf. Was als klassischer Experimentalfilm beginnt, der in erster Linie aus Wörtern besteht, verschmilzt mit einer spielähnlichen Dramaturgie, die von Benutzern hervorgebracht wird, die zu Autoren werden; und Autoren, Benutzer und

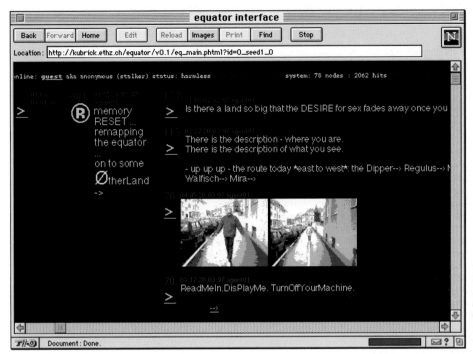

A Description of the Equator and Some OtherLands, 1997
Screenshot

another valid identity, corresponding directly to, forming as well as informing, events in our real and virtual lives.

S.L.

Geschichte werden ununterscheidbar.

Äquator steht hier für eine »Identität in der heutigen globalen Gesellschaft«. Identität bedeutet hier eine sich bestätigende und erhärtende Entsprechung zweier Entitäten, die jedoch niemals absolut »identisch« sind. Die Erinnerung ist eine solche Identität, nämlich eine Entsprechung zwischen im Geiste aufbewahrten Ereignissen und den wirklichen Ereignissen, die sie enthalten. Auch der Film ist eine echte Identität, denn er entspricht direkt Ereignissen unseres wirklichen und unseres virtuellen Lebens.

P.S.

Jackson Pollock Bar

Freiburg

The Jackson Pollock Bar is concerned with the "installation" of theory.

The theories of theoreticians, and indeed the theoreticians themselves, no longer form a neutral abstract background (flip side) to the aesthetic. They have developed so as to constitute its material. The "aesthetic" has become discursive and "discourse" has become aesthetic. That is the implosion of art and language. Theories and art works are thoroughly distinctive only insofar as first-order levels of observation (in the sense of cognitively active seeings, hearings, etc.) are identified in logical and qualitative terms.

Developments in the semantics of systems of communication—particularly in connection with self description in autopoetic systems—have led to an operational closure. As a consequence, the paradigm of the work of art as the privileged constituent of "the exhibition" is no longer tenable: the world has become an exhibition, an exhibition which consists of observations.

The conventional show, or exhibition, is no longer linked by necessity to the process of exhibiting. To exhibit something is simply to render it observable with a communicative purpose. The exhibition or show has, therefore, become a special case—a methodological site of the reflexively self-observing (second-order) exposition of observations. Theories which develop a consciousness of their position in the course of a communicative process must necessarily pay attention to the way they are observed: they must be exhibited. It is important that the installation rupture the sense of theory as something authentically direct. Through this rupture an awareness of concreteness and artificiality together with contextuality is created; this facilitates the production of observations of a second order type. (Brecht's "V-effect" was aimed at something similar.) The theoretical "presence" is diversified between author, work, interpretation and performance—which is itself diversified between sound and picture or image. In this connection, the playback method has been developed. This is not playback with a mimetic purpose, but a vocal performance of coarse texture which is experienced as a relatively autonomous redoubling of the putative "original."

The appropriate locations for theory installations are where art's objects and spaces tend to overlap and to merge with talk and the other processes of human communication. They might be the margins of art sites, or bars and foyers, or be connected with such events as openings and symposiums.

J.P.B.

Der Geschäftszweck der Jackson Pollock Bar ist die Installation von Theorien.

Theorien, und vor allem ästhetische Theorien, bilden nicht länger einen neutralen, abstrakten Hintergrund der Kunst. Sie sind vielmehr sein materieller Bestandteil geworden. Das Ästhetische ist diskursiv geworden und der Diskurs ästhetisch. Dies ist die Implosion der Kunst in den Diskurs.

Theorien unterscheiden sich von Werken nur auf der Beobachtungsebene erster Ordnung – durch unterschiedliche Qualitäten, Logiken und Erfahrungsmodi.

Wenn die Welt zur Ausstellung wird, nämlich zur Selbstausstellung von Beobachtungen, dann kann das Ausstellen kein Privileg der Kunst mehr sein.

Ausstellen ist nicht mehr an die Ausstellung gebunden; Ausstellen heißt einfach: für den Kommunikationsprozeß beobachtbar machen. Die Ausstellung ist seither ein Spezialfall: nämlich der methodische Reflexionsort des Sich-der-Beobachtung-Aussetzens-von-Beobachtungen. Theorien, die ein Bewußtsein für ihre Stellung im Kommunikationsprozeß entwickeln, müssen auf die Art ihres Beobachtetwerdens achten, d.h. sie müssen ausgestellt werden. Dadurch entfalten sie eine Art ästhetisches Bewußtsein. Wichtig ist die Brechung der authentischen Unmittelbarkeit von Theorie.

Dadurch wird die Wahrnehmung von Künstlichkeit, Konkretheit und Kontextualität, also die Beobachtung zweiter Ordnung ermöglicht.

(Auf etwas ähnliches zielte ja bekanntlich Brechts V-Effekt.)

Die Präsenz von Theorie muß ausdifferenziert werden in Autor, Werk, Interpretation und Darstellung – und die Darstellung ihrerseits in Bild und Ton. Dazu wurde das Playback-Verfahren entwickelt. Das Playback-Verfahren muß für dieses Anliegen aus der üblichen Simulationsabsicht herausgelöst und zu einer sinnlichen Verdoppelung vergröbert werden.

Bevorzugter Spielort sind die Ränder des Kunstsystems, die Schnittstellen zwischen Theorie und Kunst: Bars, Foyers, Vernissagen und Symposien, Orte, in denen sich objekthaft-mediale ästhetische Kommunikation (Werke, Räume) und zwischenmenschliche Kommunikation (»Reden«) überlagern und durchmischen.

J.P.B.

*Art & Language »We Aim to be Amateurs« installed in the style of the
Jackson Pollock Bar,* 1997
Performance: June 19, 20, 21 1997 at 5 p.m. and every Friday at 5 p.m./
19., 20., 21. Juni 1997, 17 Uhr und freitags 17 Uhr.

jodi

Joan Heemskerk, *1968 in Kaatsheuve, Niederlande/Netherlands. Lebt und arbeitet/lives and works in Barcelona.
Dirk Paesmans, *1965 in Brüssel/Brussels. Lebt und arbeitet/lives and works in Barcelona.

The question of how to take over the machine, along with an interest in viruses and the disturbances and dysfunctions they cause in computer systems, have been constant elements in Jodi's work. This artistic duo works tirelessly on the growth of their website, which so far has a total of 350 pages. Constantly updated, with pages piled one on top of another and recent additions stuck right over older ones, their site gets bigger and bigger, like a machine completely out of control.

When the users access jodi.org *(1994–97), they inevitably end up wondering whether their own computer has been infected by some virus. The windows on the screen start to shift, text begins blinking all over the place, and characters start writhing on the screen, which is filled with ever-changing colors. Everything suddenly seems unstable and infected. But there is nothing of the sort. Heemskerk and Paesmans' work is elaborate programming, a formal game played on the computer world.*

On their website, they manage the feat of visually assembling a great number of electronic elements: texts in ASCII, windows, cursors, and images produced by the host computer. All of this creates an environment unto itself, one which integrates the ever-more familiar aesthetic of the computer screen.

In general, the screen displays the results of the operations executed by the machine, to which the user generally has little access. It can just as easily display things in internal mode as in external (the Web). It is often difficult to determine where an image or a piece of data comes from or how it was generated. Heemskerk and Paesmans' page is the result of a local interpretation on the user's computer of data originating on a server situated elsewhere. This confusion between local and remote often recurs on the Internet. Nowhere else does one so often have the feeling of being simultaneously both here and elsewhere, and from one place having access to such an infinite number of other places.

S.L.

Einer Maschine eine andere Bedeutung geben, sich für Viren, Störungen und Fehler des Computers interessieren, das ist die Aufgabe von jodi. Unermüdlich arbeitet dieses Duo zweier junger Künstler am Wachstum seiner Website, die jetzt schon aus über 350 Seiten besteht. Ihre Site, die ständig erneuert und mit neuen Errungenschaften, die direkt vor die schon vorhandenen angebracht werden, angereichert wird, wächst wie eine Maschine, über die man jede Kontrolle verloren hat.

Wenn der Betrachter in ihre Site *jodi.org* (1994–97) einsteigt, fragt er sich unwillkürlich, ob dadurch nicht auch auf seinen eigenen Computer ein Virus übertragen wird: die Fenster des Bildschirms verschieben sich, Texte erscheinen plötzlich überall, ungleichmäßige Buchstaben zeigen sich, der Bildschirm wechselt ständig seine Farbe. Alles scheint plötzlich durcheinander und verseucht zu sein. Dennoch ist nichts passiert. Die Arbeit von Heemskerk und Paesmans ist ein Programm, das wie ein formelles Spiel in der Welt der Informatik ausgearbeitet wurde.

Es gelingt ihnen, in ihrer Site eine gewisse Anzahl von Abläufen, die nötig sind, um auf dem Bildschirm eines Computers gewisse Ergebnisse erscheinen zu lassen, sichtbar zu machen. Indem sie E-Mail, Texte in ASCII, Fenster, Curser und Bilder des Computers miteinander vermischen, kreieren sie eine neue Umgebung, die die immer familiärer werdende Ästhetik von Informatikschirmen integriert.

Normalerweise zeigt der Bildschirm das Ergebnis aller von der Maschine ausgeführten Operationen an, zu dem der User keinen Zugriff hat. Er kann genausogut Dinge im internen wie im externen Modus (Web) anzeigen, und es ist oft schwierig festzustellen, von wo ein Bild kommt oder wie es entstanden ist. Die Site von Heemskerk und Paesmans erscheint wie das Ergebnis einer lokalen Interpretation von Daten auf dem Computer des Betrachters, die von einem Server kommen, der ganz woanders ist. Diese Verwirrung zwischen dem Lokalen und dem Entfernten gibt es im Internet nicht mehr; nirgendwo sonst hat man so sehr das Gefühl, gleichzeitig hier und anderswo zu sein, von einem Ort Zugang zu unendlich vielen anderen zu haben wie im Internet.

S.L.

jodi.org, 1994–97
Screenshot

 Medienpartner der documenta X

Mike Kelley/Tony Oursler

*1954 in Detroit, Michigan. Lebt und arbeitet/lives and works in Los Angeles.
*1957 in New York. Lebt und arbeitet/lives and works in New York.

Mike Kelley is a multidisciplinary artist who comes from a background in performance. Tony Oursler is principally known for his video installations. What they have in common is working with objects and images drawn from the diversity of American popular culture. These elements, at the very core of their work, emerge as echoes of the mutations and crises of postindustrial capitalist society. In 1977, while they were students at Cal Arts, they started The Poetics, *a punk-rock band which stayed together until 1983. They have decided to realize their project for* documenta *around this common past.*

Kelley and Oursler propose to make an installation composed of painted panels utilizing imagery drawn from their original collaborative notebook. These paintings will be formed into an architecture of open display booths within which historic period materials will be exhibited, and upon which video images will be projected. Their music will function as an overall soundtrack. They will also exhibit sculptures conceived in the late seventies but executed only recently; in keeping with a conceptual logic, the latter are dated according to the time of conception. The Poetics *do not exist in the archives of the history of rock music. They have never made a record. In one sense, what the installation presents is a fiction. The contemporary forms that attest to* The Poetics' *activity were realized subsequently to their history: three CDs and videos that recreate their performances and rehearsals and contain images of California that go beyond the usual clichés, comments from people who saw* The Poetics *perform or took part in their activities, interviews with rock critics who attempt to historically recontextualize* The Poetics *and define the subcultural aesthetics of the late seventies. This will lead to a discussion of related topics in current aesthetic practices.*

The project takes the punk-rock movement as an occasion to reflect on the historical and institutional validation of a certain type of artistic activity, one which sets out to question official criteria. As Kelley emphasizes, "I considered the work to be an exercise in the construction of a history, and specifically a minor history. Minor histories are ones that have yet found no need to be written. They must find their way into history via forms that already exist, forms that are considered worthy of consideration. Thus minor histories are at first construed to be parasitic... In the end, this work is not so much a portrait of The Poetics *as it is an examination of how history is constructed. And in this examination, hopefully the present historicization of the punk period will be perceived as a war for the*

Mike Kelley begann als Performancekünstler, doch inzwischen ist er auf vielen Gebieten tätig. Vor allem kennt man ihn wegen seiner multimedialen Installationen. Tony Oursler hat bisher im wesentlichen Videoinstallationen gemacht. Für beide ist typisch, daß sie mit Objekten und Bildern arbeiten, die sie der ganzen Vielfalt populärer amerikanischer Kultur entnehmen. Diese Elemente fungieren in ihren Installationen als Echo der Mutationen und Krisen der postindustriellen kapitalistischen Gesellschaft. Als Kunststudenten gründeten sie 1977 in Kalifornien eine Art-Band, die sich dem Punkrock verschrieben hatte und bis 1983 aktiv war: The Poetics. Diese gemeinsame Vergangenheit gab den Anstoß zu ihrem Projekt für die documenta.

Kelley und Oursler planen eine Installation, die aus Bildern besteht, die nach Entwürfen aus ihrem damaligen gemeinsamen Zeichenbuch entstanden. Diese Arbeiten liefern eine räumlich offene Ausstellungsarchitektur, in der das historische Material aus ihrer gemeinsamen Zeit ausgestellt ist und auf welche Videobilder projiziert werden. Ihre Musik fungiert wie eine überall vernehmbare Hintergrundsmusik. Gezeigt werden ebenfalls Skulpturen, zu denen die Ideen in den späten siebziger Jahren entstanden, die aber erst jetzt realisiert wurden. Der Logik der Konzeptkunst gemäß sind sie nach dem Zeitpunkt datiert, zu dem ihr Konzept entwickelt wurde. In den Archiven der Rockmusik wird man die Poetics vergeblich suchen, denn es sind keine Aufnahmen von ihnen auf den Markt gekommen. Die Installation präsentiert daher in gewissem Sinne eine Fiktion. Was hier die Aktivitäten der Band bezeugt, ist entstanden, als es sie schon längst nicht mehr gab: Drei CDs, die auf der Grundlage von alten Tonbandmitschnitten produziert wurden, und Videofilme mit Aufnahmen von nachgestellten Performances und Proben, klischeehaften Bildern von Kalifornien, Erzählungen von Leuten, die die Poetics damals gesehen oder sich an ihren Aktivitäten beteiligt hatten, Gesprächen mit Rockkritikern, die die Poetics in die Geschichte der Rockmusik einzuordnen und die subkulturelle Ästhetik der späten siebziger Jahre zu bestimmen versuchen.

Dieses Projekt hinterfragt am Beispiel der Punkbewegung die historische und institutionelle Gültigkeit einer sich als Infragestellung der offiziellen Kriterien entwickelnden künstlerischen Aktivität. »Für mich«, sagt Mike Kelley, »war diese Arbeit der Versuch einer Geschichtsschreibung, und zwar einer, die ein relativ unbedeutendes Stück Geschichte zum Thema hat. Unbedeutende Geschichte ist Geschichte, die man bisher zu schreiben nicht für nötig hielt. Sie kann ihren Weg in die akzeptierte Geschichte nur finden, indem sie

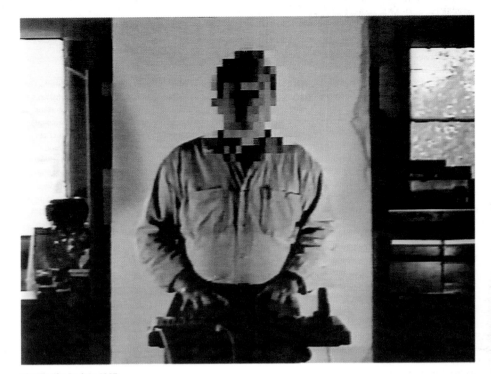

The Poetics Project, 1997
Ecstatic Synthesizer Playing (1996–97)
Detail

control of meaning – a war that one can still fully
participate in. The history is not yet etched in stone."

P. S.

sich an Formen hält, die bereits existieren und die man
für beachtenswert hält. Daher muß unbedeutende
Geschichte zunächst auf parasitäre Weise geschrieben
werden. Letztendlich ist diese Arbeit weniger ein Por-
trait der Poetics als eine Untersuchung, wie Geschichte
konstruiert und geschrieben wird. Und dabei wird hof-
fentlich klar werden, daß die gegenwärtige Historisie-
rung der Punkzeit ein Krieg um die Kontrolle ihrer
Bedeutung ist – ein Krieg, an dem man noch immer teil-
nehmen kann. Seine Geschichte ist noch nicht in Stein
gemeißelt.«

P. S.

documenta meets radio/radio meets documenta with/mit Diedrich Diederichsen
Mike Kelley 100 Days – 100 Guests/100 Tage – 100 Gäste

115

William Kentridge

*1955 in Johannesburg. Lebt und arbeitet/lives and works in Johannesburg.

William Kentridge's films chronicle the saga of Felix Teitlebaum (a man whose anxiety, says the artist, "flooded half the house") and Soho Eckstein (a high-rolling real-estate promoter). The films are cartoons which result from long and patient application; a week's drawing gives rise to approximately forty seconds of animation. In these melancholic and tormented tales, the outlines of the obsessive events of apartheid and the trauma of the Holocaust gradually become visible. Maintaining an affinity with the work of Max Beckmann, the films take multiple narrative paths, prohibiting any univocal interpretation.

Kentridge's cartoons often have several departure points which he exploits or not as he chooses. Thus Felix in Exile (1994) springs simultaneously from various plays on words (Felix/Exile/Elixir, Historical/Hysterical, Exit/Exist), from a visual idea (Soho shaves and loses his face in the mirror), and from a mental image (that of bodies lying outstretched in a landscape, inspired by a series of forensic photographs showing murder victims). Created in September 1993 and February 1994, just before the first general elections in the new South Africa, Felix in Exile testifies to a deep anxiety: will the victims of apartheid be remembered? Influenced by Claude Lanzmann's Shoah, Kentridge uses the landscape as a metaphor of memory: "In the same way that there is a human act of disremembering the past, both immediate and further back, that has to be fought through writing, education, museums, songs, and all the other processes that we use to try to force us to retain the importance of events, there is a natural process in the terrain through erosion, growth, dilapidation that also seeks to blot out events." The landscape of Felix in Exile is the artificial landscape of East Rand, the country's largest industrial center, which today looks like nothing so much as a gigantic vacant lot.

Created eighteen months later during the hearings of the "Truth and Reconciliation" commission, History of the Main Complaint (1996) is a reflection on collective and individual responsibility and on latent pangs of conscience at past injustice. Plunged into a coma, Soho Eckstein is haunted by the images of a car crash which cost someone's life. In this agonizing delirium it is he at the wheel of the vehicle, while Felix's eyes appear in the rear-view mirror. For this film Kentridge did research into the techniques of inner-body observation (X-rays, CAT and MRI scans, sonar, etc.) as a metaphor for the probing of the unconscious: "What is hidden under the skin, and is our blindness to this similar to our blindness to the effects of our actions?"

P. S.

Die Filme von William Kentridge erzählen die Geschichte zweier fiktiver Personen: Felix Teitlebaum (ein Mann, dessen Angst, wie der Künstler sagt, »das halbe Haus überflutete«) und Soho Eckstein (ein großer Baulöwe). Es handelt sich um Zeichentrickfilme, die die Früchte einer geduldigen Handwerksarbeit darstellen (eine Woche Zeichnen ergibt etwa vierzig Sekunden Film). In diesen kurzen melancholischen und bizarren Erzählungen schimmern die obsessiven Erinnerungen an die Ereignisse der Apartheid und die Traumata des Holocaust durch. Diese Filme, die eine Verwandtschaft zum Werk Max Beckmanns verraten, verfolgen mehrere Erzählstränge, so daß sie keine eindeutige Interpretation zulassen.

Die Zeichentrickfilme William Kentridges haben oft mehrere Ausgangspunkte, auf die man sich einlassen kann oder auch nicht. So hat *Felix in Exile (1994)* seinen Ursprung in verschiedenen Wortspielen (Felix/Exil/Elixir, historisch/hysterisch, exit/exist), in einer visuellen Idee (Soho rasiert sich und verliert sein Gesicht im Spiegel) wie auch in einem mentalen Bild (eines in einer Landschaft ausgestreckten Körpers, inspiriert durch die von einem Freund stammende Beschreibung einer Serie von gerichtsmedizinischen Photographien, die Mordopfer zeigen). Der zwischen September 1993 und Februar 1994 entstandene Film *Felix in Exile* (er wurde also kurz vor der ersten allgemeinen Wahlen in Südafrika fertig) kündet von einer großen Sorge: Wird man sich an die Opfer der Apartheid erinnern? Unter dem Einfluß von Claude Lanzmanns Film *Shoah* verwendet Kentridge die Landschaft als Metapher für die Arbeit des Erinnerns: »Wie es einen menschlichen Akt des Vergessens der Vergangenheit gibt, sowohl der unmittelbaren als auch der weiter zurückliegenden, gegen den durch Schreiben, Erziehung, Museen, Lieder und all die anderen Verfahren angekämpft werden muß, die wir einsetzen, um zu erreichen, daß wir uns der Bedeutung der Ereignisse weiterhin bewußt sind, so gibt es auch innerhalb der Landschaft einen natürlichen Prozeß der Erosion, der Entwicklung und des Zerfalls, der Ereignisse zu tilgen und auszulöschen trachtet.« Die Landschaft von *Felix in Exile* ist künstlich, sie entspricht der Gegend von East Rand, dem ersten Industriezentrum Südafrikas, das heute den Anblick eines gigantischen Ödlandes bietet.

Der achtzehn Monate später, während der Tätigkeit der Kommission »Wahrheit und Versöhnung« entstandene Film *History of the Main Complaint* (1996) ist eine Reflexion über kollektive und individuelle Verantwortung, über das latente schlechte Gewissen in Anbetracht der früheren Ungerechtigkeiten. Der im Koma liegende Soho Eckstein wird von den Bildern eines Autounfalls verfolgt, bei dem jemand umgekommen ist. In diesem

History of the Main Complaint, 1996
Patience
Conference

quälenden Delirium sieht er sich am Steuer des Wagens sitzen, doch die Augen, die im Rückspiegel zu sehen sind, sind die Augen von Felix. Kentridge interessiert sich in diesem Film für die Techniken zur Beobachtung der Vorgänge im Körperinneren (Röntgenstrahlen, Ultraschall, Computertomographie, Kernspintomographie etc.), die er als Metaphern für das Ausspionieren des Bewußtseins verwendet: »Was ist unter der Haut verborgen, und ist unsere diesbezügliche Blindheit mit unserer Blindheit in bezug auf die Auswirkungen unseres Handelns zu vergleichen?«

P.S.

Martin Kippenberger

*1953 in Dortmund. †1997 in Wien/Vienna.

Martin Kippenberger, a provocative figure from the Cologne scene, was an extraordinarily prolific artist who worked in every possible medium: painting, drawing, collage, objects, editions, stickers, posters, signboards. He engaged in an all-out exploration of the models and underlying stakes of modern art history, interrogating the field of art from the perspective of politics. His grating humor, manifestly inspired by dada, betrays an unresolved hesitation between radicalism and derision. With his hyperactivity, the disquieting inflation of his production, and his ironizing style, he seemed to engage in a parody of the market, seeking to cut its powers of absorption short with a bid at inundation. Through provocatively titled works – The Capitalist Futurist Painter in his Car, Selling America & Buying El Salvador, Jeans Against Fascism, Arbeiten bis alles geklärt ist, Psychobuildings, Knechte des Tourismus, Kennzeichen eines Unschuldigen, Eurobummel, I Had a Vision – and a number of spectacular installations, he often succeeded in putting a finger on the profoundest contradictions of the systems through which he moved.

The work presented at the documenta is the last he completed. It partakes of a larger project which parodies the networks of globalization. This project bears the generic title Metro-Net and consists of a series of metro entries installed in the strangest and most unexpected places. The project began with the opening of one such entry on the island of Syros in Greece, in September 1993. Conceived for installation in various spots around the world so as to form a useless, imaginary network, these metro entries have only materialized in two locations outside documenta: one on Syros and the other in Dawson City West in Canada. The Greek station entry is built in cement, the Canadian one of wood, each meant to match the climate and design styles of the place it occupies. The documenta entry gapes on the banks of the Fulda. Like the others, it contains a ventilation system that simulates the currents of hot air common to all subways. The stairways descend to a condemned space, indicating an impossible access to the world. The Kippenbergermetro also exists on an Internet site, thus participating in a virtual network. Kippenberger liked to stay on the island of Syros, where he had installed a museum in a complex of five cement buildings in ruins, originally a meat-packing facility. He regularly invited artists to create projects on the island, organizing their distribution and publicity through post cards. The title of Kippenberger's museum parodied the acronym of the Museum of Modern Art in New York, to which he added the S of Syros to form MOMAS. P. S.

Martin Kippenberger, eine provokante und einflußreiche Figur der Kölner Kunstszene, war ein extrem wandlungsfähiger Künstler, der sich jedes nur denkbaren Ausdrucksmittels bediente: Gemälde, Zeichnungen, Collagen, Objekte, Editionen, Aufkleber, Poster, Schilder... Er widmete sich einer umfassenden Durchsicht der Themen und Modelle der modernen Kunst und befragte die Geschichte der Kunst nach ihrem Zusammenhang mit politischen Problemen. Sein galliger, stark vom Dadaismus inspirierter Humor bezeugte gleichermaßen seinen Radikalismus wie seine Spottlust. Mit seiner Hyperaktivität, der beunruhigenden Unmäßigkeit seiner Produktion und seinem ironischen Stil schien er sich einer Parodie des Marktes verschrieben zu haben, den er mit seinem Überschwang zu überrumpeln suchte. Mit Arbeiten, denen er vielsagende Titel gab (The Capitalistic Futuristic Painter in his Car, Selling America & Buying El Salvador, Jeans Against Fascism, Arbeiten bis alles geklärt ist, Psychobuildings, Knechte des Tourismus, Kennzeichen eines Unschuldigen, Eurobummel, I Had a Vision) und einigen spektakulären Installationen wies er oft treffsicher auf die Widersprüche der Systeme hin, in denen er sich bewegte.

Das Werk, das auf der documenta präsentiert wird, ist das letzte, das er vor seinem Tod noch fertiggestellt hat. Es ist Teil eines größeren Projekts, das die weltumspannenden Netze parodiert und den Obertitel Metro-Net trägt. Dabei handelt es sich um eine Serie von U-Bahn-Eingängen, die an den ungewöhnlichsten und unerwartetsten Orten installiert werden. Das Projekt begann mit der Installation eines solchen Eingangs auf der griechischen Insel Syros im September 1993.

Diese U-Bahn-Eingänge, die an vielen Orten der Welt installiert werden und ein imaginäres und unbrauchbares weltumspannendes Verkehrsnetz bilden sollten, finden sich heute, abgesehen von dem anläßlich der documenta installierten Eingang, nur an zwei Orten, in Syros und in Dawson im Nordwesten Kanadas. Der Eingang in Griechenland ist aus Beton, während der in Kanada aus Holz gebaut ist, so daß jeder dem Klima und dem Aussehen des Ortes angepaßt ist, an dem er sich befindet. Der U-Bahn-Eingang der documenta befindet sich am Ufer der Fulda. Er enthält, wie schon die beiden anderen, ein Ventilationssystem, das die Welle heißer Luft simuliert, die man aus U-Bahn-Schächten kennt. Die hinabführenden Treppen enden im Nichts – ein Zugang zur Welt ist auf diese Weise unmöglich. Dieses Projekt ist zugleich über das Internet zugänglich, wo es Teil eines virtuellen Netzes wird.

Kippenberger hielt sich gerne auf Syros auf, wo er in einem Komplex aus fünf verfallenen Betonbauten, die ursprünglich als Schlachthaus dienten, ein Museum ein-

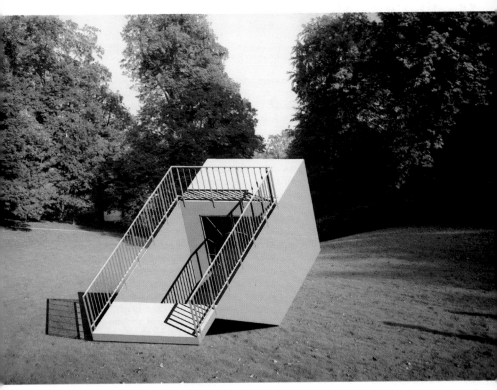

Metro-Net, Skulptur »Transportabler U-Bahn Eingang«, 1997
Metro-Net Sculpture "Transportable Subway-Entrance", 1997

richtete. Er lud regelmäßig andere Künstler ein, bei ihm auf Syros Projekte zu verwirklichen, für die mit Postkarten geworben wurde und die auf diesem Wege Verbreitung fanden. Der Name, den Kippenberger seinem Museum gab, parodiert das bekannte Kürzel für das New Yorker Museum of Modern Art, MoMA, dem er noch ein S für Syros anhängte: MOMAS.

P. S.

Internet

Joachim Koester

*1964 in Kopenhagen/Copenhagen. Lebt und arbeitet/lives and works in New York.

In the room is an empty stage, a kind of platform. A set of stairs invites the viewer to mount this platform. On the wall a video projection shows a chamber group playing a work by Shostakovich (his eighth String Quartet in C minor, op. 110); the spectators on the stage watch and listen to the concert taking place in the pit. Looking at the video more closely, one notices that the concert did not take place in the room where it is being presented, but in some gallery. The video is a documentation of the concert, but, because of the montage, it constantly slips into fiction.

The title of Koester's installation is Pit Music (1996), referring to the orchestra pit found in many theaters. The film plays on the difference between the musical composition and its documentary recording, and as the music continues throughout the video, it may be perceived at various moments as an element in a fictional structure or not. The passive behavior of the viewers, broken only by slight disturbances like sipping water, an aside to one's neighbor, or scratching an itch, stands in sharp contrast to this effect of musical dramatization. This visual flow is interrupted by the use of freeze-frame, stop-motion, and slow-motion. The video is structured around this interaction between the musicians and the viewers, its nodal point. Koester stresses the fictional dimension through the use of two simple filmic devices, sound and image, whose respective narrative modalities enrich each other as they contrast and blend. The experience of the viewer is thus transported into a zone of indeterminacy where the usual polar distinctions collapse. The impossibility of reconstructing the totality of an event leads to a permanent slippage between its status as documentary or fiction, between spectator and actor, event and representation, and a work and its absence.

After finishing several other projects inspired by cinema, ranging from horror films to the French Nouvelle Vague, Koester is now working on a project called Day for Night, Christiana 1996. Christiana is the name of a community created by Danish hippies squatting on a former military base in 1971. The commune exists to this day as an independent society in the middle of Copenhagen. The first phase of the work is a series of photographs shot in day for night, a cinematic technique for shooting night shots during the day. This artifice blurs any clear distinction between the description of reality and the construction of a different space.

P. S.

Beim Betreten des Ausstellungsraums steigt man über eine Treppe auf eine Art Podium. Oben angekommen, blickt man in den tiefer gelegenen Rest des Raumes wie in einen Orchestergraben und sieht an der Wand die Projektion einer Videoaufnahme: Ein Streichquartett spielt eine Komposition von Schostakowitsch (op. 110 Nr. 8. in c-Moll), und die Musik ist über Lautsprecher zu hören. Betrachtet man das Video aufmerksam, so bemerkt man, daß das Konzert nicht im Ausstellungsraum der documenta, in dem man sich befindet, sondern in einer Galerie stattfand. Der Videofilm ist ein Dokument des Konzerts, doch er kippt durch seine Montagetechnik ständig in eine Fiktion um.

Der Titel dieser Installation Joachim Koesters lautet Pit Music (1996) und verweist auf den Orchestergraben im Theater. Der Film spielt mit der Differenz zwischen der musikalischen Komposition und ihrer dokumentarischen Aufzeichnung, da die Musik, die während des gesamten Videos hindurch ohne Manipulation abläuft, mit dem Film nicht immer synchron ist, dessen kontinuierlicher Ablauf durch Standbilder und Zeitlupen unterbrochen wird, um dann wieder zum synchronen Ablauf zu springen. Die Kamera zeigt auch das Publikum, das sich allerdings nicht wie ein Konzertpublikum verhält, sondern eher wie das einer Vernissage. Der dramatische Effekt der Musik wird durch das eher desinteressierte Verhalten des Publikums konterkariert, das trinkt und miteinander plaudert. Koester betont die fiktive Dimension durch die Entgegensetzung zweier in der Regel gleichgeschalteter filmischer Elemente: Die narrativen Modalitäten von Ton und Bild laufen hier parallel, kontrastieren dann und verschmelzen wieder miteinander und so weiter. Das führt zu einem ständigen Oszillieren zwischen Dokumentation und Fiktion, Ereignis und Darstellung, Werk und Abwesenheit des Werkes.

Nachdem er mehrere vom Kino (vom Horrorfilm bis zur Nouvelle Vague) inspirierte Projekte realisiert hat, arbeitet Joachim Koester zur Zeit an einem Projekt mit dem Titel Day for Night, Christiana 1996. »Christiana« ist der Name einer 1971 auf einem ehemaligen Militärstützpunkt gegründeten Hippiekommune, die auch heute noch als unabhängige kleine Gesellschaft im Herzen Kopenhagens weiter Bestand hat. Der erste Teil dieser Arbeit besteht aus einer Serie von Photographien, die mit der Technik der »amerikanischen Nacht« aufgenommen werden, einem filmtechnischen Verfahren, bei dem die Nachtszenen durch Verwendung von Filtern oder Unterbelichtung am hellichten Tag gedreht werden. Dieser Kunstgriff trübt die klare Grenzziehung zwischen einer Beschreibung der Realität und der Konstruktion eines fiktiven Bereichs.

P. S.

Pit Music, 1996
Installation view Galeri Nicolai Wallner, 1996

Peter Kogler

*1959 in Innsbruck. Lebt und arbeitet/lives and works in Wien/Vienna.

The basic idea behind an ornament that is not entirely abstract is to reproduce existing things in an orderly process of repetition that obeys the laws of geometry. With the onset of the modern era and the concomitant notion of the autonomous artist, the ostensible occasion and the specific space for the creation of a work of art became unimportant, so that ornament – which is always bound to a specific surface – became a thing of the past. Subsequently, there was no figurative ornamentation that availed itself of contemporary motifs. Only recently has a new interest in ornamentation been developing, ornamentation that utilizes, above and beyond traditional floral and figurative motifs, technical and natural objects, usually in abstract symbolic form. For the documenta-Halle Peter Kogler has chosen the motif of the tube. In labyrinthine curves, the motif covers practically the whole wall surface. One essential aspect of an unlimited surface ornament is that it can be extended continuously in all directions. At the same time, it takes the respective space into account, adapting itself to it, throwing itself like a net over the existing structures, dominating them to an extent, by forcing itself on our human perception. The means it has at its disposal for appropriating space are extremely simple, it being a variation on one and the same basic module transferred to rolls of wallpaper. The complex pictorial patterns are digitally generated, so that the emerging spaces are the result of an uncompromising computer logic. The artist radically transforms painting into a source of almost physical experience for the observer. Its overwhelming presence forces the observer to adopt some kind of stance. In 1992 Kogler wallpapered the entire entrance area of the Fridericianum. Then it was ants that crept around the walls of the exhibition hall along complicated though precise routes. If these could be regarded as cyphers for social community, then the tubes would seem to hint at channels of information in a technologically oriented society. Faltering between labyrinthine confusion and comforting repetition, the ornament – symbolizing information networks – insinuates itself into the interface, that point of intersection between image generator and social manipulator. Peter Kogler's approach involves several very different artistic considerations. On the one hand, his wall designs are as archaic as the ritual wall and body paintings of African tribes, his repetitive ornamentation as classical as the patterns on ancient vessels or baroque fabrics. On the other hand, the computer-assisted digital process behind the genesis of his all-over pictorial worlds point to the unbridled production and distribution of the image in the age of its random reproducibility.

Grundidee eines nicht rein abstrakten Ornaments ist die Wiedergabe realexistierender Dinge in geordneter, den Gesetzen der Geometrie gehorchender Wiederholung. Da mit dem Aufstieg der Moderne und der damit einhergehenden Vorstellung vom autonomen Künstler der äußere Anlaß und ein spezifischer Raum für die Entstehung des Kunstwerks unwichtig wurden, fiel das Ornament – immer gebunden an eine spezifische Oberfläche – der Vergessenheit anheim. Die Folge war, daß es keinerlei figurative Ornamentik gab, die sich zeitgenössischer Motive bediente. Erst in jüngster Zeit entwickelt sich ein neues Interesse am Ornament, das jenseits traditioneller floraler und figürlicher Motivik technische und natürliche Objekte, meist in zeichenhafter Abstraktion, einsetzt.

Peter Kogler hat für die documenta-Halle die Röhre als Motiv gewählt. Sie dehnt sich dort labyrinthisch gewunden über fast die gesamte Wandfläche aus. Zum Wesen des unbegrenzten Flächenornaments gehört es, daß es nach allen Seiten hin endlos ausgedehnt werden kann. Dennoch nimmt es auf den gegebenen Raum Rücksicht, paßt sich an, wirft sich wie ein Netz über vorgefundene Strukturen und beginnt sie in gewisser Weise zu beherrschen, indem es sich in den Vordergrund menschlicher Wahrnehmungsfähigkeit drängt. Die Mittel zur Aneignung des Raumes sind dabei denkbar einfach. Handelt es sich doch um die Variation ein und desselben Grundmoduls, das auf Tapetenbahnen übertragen wird. Die Generierung der komplexen Bildmuster erfolgt auf digitalem Weg. Die entstehenden Räume sind so Resultate unbestechlicher Computerlogik. Radikal überführt der Künstler die Malerei in eine für den Betrachter beinahe physische Erfahrung. Durch ihre überwältigende Präsenz zwingt er ihn, auf irgend eine Art Stellung zu beziehen.

Bereits 1992 tapezierte Kogler den Eingangsbereich des Fridericianums flächendeckend. Damals krochen Ameisen auf komplizierten aber dennoch präzisen Bahnen über die Wände des Ausstellungsraums. Konnten jene als Chiffren sozialer Gemeinschaft gedeutet werden, scheinen die Röhren auf die Informationskanäle technologischer Gesellschaften zu verweisen. Schwankend zwischen labyrinthischer Verwirrung und beruhigender Wiederholung schiebt sich das Ornament als Symbol vernetzter Informationsstrukturen an die Schnittstelle von Bildgenerator und sozialem Manipulator.

Peter Koglers Arbeitsansatz umfaßt mehrere, ganz unterschiedliche künstlerische Überlegungen. Einerseits sind seine Wandgestaltungen so archaisch wie die rituellen Wand- und Körpermalereien afrikanischer Stämme, die repetitive Ornamentik so klassisch wie antike Gefäß-

documenta X, 1997
Model

oder barocke Stoffmuster, andererseits verweist der
computerabhängige, digitale Entstehungsprozeß seiner
All-Over-Bildwelten auf unkontrollierbare Produktion
und Distribution des Bildes im Zeitalter seiner beliebi-
gen Reproduzierbarkeit.

S. P.

Aglaia Konrad

*1960 in Salzburg. Lebt und arbeitet/lives and works in Brüssel/Brussels.

Aglaia Konrad's photographs are often views from above taken at dawn or dusk, when the low raking light brings out the layout of a city. In her photographs, the various urban configurations all strangely resemble each other. The photographs bear the name of the city where they were taken and the date (for example, Rotterdam, 1993; Cairo, 1992; and New York, 1993). Even when they are not views from above, they are always photographs of a metropolis or megalopolis and the surroundings, one in which she has always lived for a certain period. They all become part of her archive and provide the basic materials of her site-specific interventions. She prints proofs onto a transparent film which is then stuck onto glass walls in the building where she is showing. The glass surfaces she chooses are systematically those that connect the interiors with the outside. The viewer is thus confronted with a double environment: that of the image and that represented in the image. This mode of display, not unlike the diorama, superimposes the immateriality of image onto the materiality of place. Atmospheric light traverses that of the photograph. Konrad plays on opacity and transparency, as well as on the alternation and the simultaneity of perception between the image of a city and the reality observable through the glass surfaces that remain uncovered.

Although one can easily see the problematizing of inside and outside in the work of this Austrian artist, she is mostly interested in our relationship to the urban and to the outsize universe of the megalopolis, made so palpable in the panoramic and descriptive quality of her photographs. Far from exalting urban gigantism, however, her images take into consideration the aestheticization of the megalopolis and create correspondences to the actual experience of the place where they are being exhibited. Viewers thus find themselves in a kind of world-in-between, with their perceptions split between the here of their presence and the "sublimated" elsewhere of the modern megalopolis.

P. S.

Die Photographien Aglaia Konrads sind oft Ansichten aus erhöhter Perspektive, im Morgengrauen oder bei Sonnenuntergang aufgenommen, wenn das flach einfallende Licht der tiefstehenden Sonne das Panorama der Städte enthüllt. In ihren Photographien ähneln sich die verschiedenen städtischen Konfigurationen auf seltsame Weise. Die Photos tragen als Titel den Namen der betreffenden Stadt und das Datum der Aufnahme (z. B. Rotterdam, 1993; Kairo, 1992; New York 1993). Auch wenn es sich nicht um Aufnahmen aus der Vogelperspektive handelt, so sind es doch stets Ansichten aus der Umgebung der Großstädte, in denen sie eine Zeitlang gelebt hat. All ihre Photographien sind archiviert und dienen als Ausgangsmaterial für ihre ortsspezifischen Interventionen. Von diesen photographischen Dokumenten macht sie Abzüge auf einem transparenten Film, die sie auf die Glasflächen der Gebäude klebt, in denen sie ausstellt. Sie sucht sich dafür systematisch stets solche Glasflächen aus, die das Drinnen zum Draußen in Beziehung setzen. Der Betrachter sieht sich so mit einer doppelten Umgebung konfrontiert: der vom Bild dargestellten und der sich durch das Bild hindurch oder auch im Bild darstellenden. Dabei überlagern sich Immaterialität des Bildes und die materielle Realität des Ortes. Das Licht der Atmosphäre durchdringt das Licht der Photographie. Aglaia Konrad spielt mit Undurchsichtigkeit und Transparenz wie auch mit dem Nacheinander und der Gleichzeitigkeit der Wahrnehmung des Bildes einer Stadt und der durch die nicht abgedeckten Glasflächen sichtbaren Realität.

Wenn man in der Arbeit dieser österreichischen Künstlerin eine Problematisierung des Verhältnisses von Drinnen und Draußen erkennen kann, so gilt ihr Hauptaugenmerk doch dem Problemfeld des Urbanen und hier besonders dem ins Maßlose wuchernden Universum der Riesenstädte, das sie durch die panoramische und deskriptive Qualität ihrer Photographien sinnfällig macht. Dennoch verherrlicht sie den urbanen Gigantismus nicht, sondern bringt die Ästhetisierung der Großstadt in Verrechnung mit der aktuellen Erfahrung des Ortes, an dem die Bilder ausgestellt sind. Dadurch findet sich der Betrachter in einer Zwischenwelt gefangen: Seine Wahrnehmung ist gespalten zwischen dem durch seine Präsenz definierten Hier und dem ästhetisierten Anderswo der modernen Riesenstadt.

P. S.

Without Title
Installation view Museum Dhondt-Dhaenens, Deurle, 1997

Rem Koolhaas

*1944 in Rotterdam. Lebt und arbeitet/lives and works in Rotterdam und/and London.

Founded in London in 1975, the Office for Metropolitan Architecture (OMA) brings together a team of architects, urban planners, and landscape designers, whose numbers are frequently augmented by consultants and critics. The agency is directed by Rem Koolhaas. Among the most striking of OMA's projects are the Rotterdam Kunsthal, the Dall'Ava villa, the Karlsruhe Center for Art and Media and Technology, the housing project in Fukuoka, the gigantic urban and architectural transformation of Euralille, or the mysterious Dutch House.

Koolhaas completed his architecture studies in London, after working as a journalist, then as a scriptwriter in Los Angeles; the dynamics of his entire œuvre betray a cinematographic dimension. In 1978 he published the now-mythic Delirious New York: A Retroactive Manifesto for Manhattan, where he hailed New York for "having been a sort of exploratory terrain for the way the artificial was going to replace reality." The book "documents the symbiotic relationship between mutant metropolitan culture and unique architecture."

His second book, S,M,L,XL (1995), done in collaboration with the graphic artist Bruce Mau, is a montage of diverse images and texts. This "novel of architecture" to fit the age of globalization is conceived as "a free-fall in the space of the typographic imagination." Its title, referring to clothing sizes, evokes an image of the architect as tailor of the urban planet. S,M,L,XL echelons texts and projects according to their scale. It closes on a definition of the "generic city," a polemical model of hybrid urbanity without specific qualities, which, the author observes, can be found at all four corners of the planet today. Exalting the "bigness" of the major cities, where disproportionate size exudes its own beauty independently of any particular building, Koolhaas develops a demographic understanding of architecture, exacerbating and idealizing its tensions and contradictions through an ambiguous approach. With black humor he traces an exhilarating portrait of a spectacular urban phenomenon that "elevates mediocrity to a higher level." The generic city is without history, superficial, anomic, incoherent, vertical, congested, and productive of isolation. It is founded on the residual and renders any notion of planning ridiculous.

For documenta Koolhaas is presenting New Urbanism: Pearl River Delta (1996) an accumulation of facts and information – urban, economic, human, financial, etc. – on the present and future of the Asian city. This research project carried out with his students at Harvard testifies to the importance of the theoretical moment and its founding role at OMA. The study

Das 1975 in London gegründete Office for Metropolitan Architecture (OMA) ist das Büro einer Vereinigung von Architekten, Stadtplanern und Landschaftsdesignern, zu denen sich häufig noch Kritiker und Berater hinzugesellen. Dieses Büro wird von Rem Koolhaas geleitet. Zu den wichtigsten Projekten des OMA gehört die Rotterdamer Kunsthalle, die Villa Dall'Ava, das Zentrum für Kunst und Medientechnologie in Karlsruhe, ein Wohnkomplex in Fukuoka, die gigantischen urbanen und architektonischen Arbeiten in Euralille oder auch das rätselhafte Dutch House.

Koolhaas war Journalist, dann Drehbuchautor in Los Angeles, bevor er in London Architektur studierte. In seinem Werk ist auch eine filmische Dimension vorhanden. Er veröffentlichte 1978 sein inzwischen zum Mythos gewordenes Buch Delirious New York: A Retroactive Manifesto for Manhattan, in dem er New York als eine Art Laboratorium preist, wo man schon einmal durchspielen konnte, auf welche Weise in Zukunft das Wirkliche durch das Künstliche ersetzt werden wird. Dieses Buch dokumentiert »die symbiotische Beziehung zwischen einer sich wandelnden großstädtischen Kultur und einer beispiellosen Architektur«.

Sein zweites Buch S,M,L,XL (1995), das in Zusammenarbeit mit dem Graphiker Bruce Mau entstand, ist eine Montage aus Bildern und verschiedenen Texten. Dieser »Architekturroman« ist als »freier Fall im Raum des typographischen Imaginären« konzipiert. Sein Titel bezieht sich auf Kleidungsgrößen und evoziert ein Bild vom Architekten als Modeschöpfer des urbanen Kleides unseres Planeten. S,M,L,XL ordnet die Projekte und Texte nach ihrer Größe. Es definiert die »allgemeine Stadt«, ein polemisches Modell der hybriden Stadt ohne spezifische Eigenschaften, wie sie sich heute überall auf der Welt findet. Er rühmt die »bigness« der großen Städte, wo schon allein die unverhältnismäßige Größenordnung, unabhängig von den Gebäuden selbst, ihre eigene Schönheit ausschwitze. Indem er auf kritische und vieldeutige Weise die Spannungen und Widersprüche verstärkt, führt er ein architektonisches Denken vor, das von der Demographie bestimmt ist. Er zeichnet mit Humor das übersteigerte Portrait einer spektakulären Urbanität, die »der Mittelmäßigkeit eine neue Dimension verleiht«. Die allgemeine Stadt ist geschichtslos, oberflächlich, anonym, unzusammenhängend, vertikal, angeschwollen und isolationsfördernd. Sie gründet sich auf Restbestände städtischer Strukturen und macht jede Planung zu einem lächerlichen Unterfangen.

Bei der documenta präsentiert Koolhaas New Urbanism: Pearl River Delta (1996), eine Sammlung von Informationen und Daten aller Art über die asiatische Stadt. Dieses Forschungsprojekt, das er zusammen mit

ote in Confucianism finances an ancestor's stay in the hereafter, foreigner's funds are the AUSTIAN MONEY that pays for speculation (and overdevelopment) in the PRD. Faust's is a tory of lost innocence. **BUSINESS VACATION** Tourism for China's new private sector, now merging in a... st-style... triction of luxury and dealmaking. A BUSINESS ACATION m... the lifestyle of a pre-... emperor (freshly solvent farmers host g... hotels-...e bordellos-- for factory owners and their bodyguards; wives Number Two, umber Three, even Number Four are ensconced in luxury condominiums play... Mah Jongg, waiting the tired businessman arrived late in his Mercedes from Hong Kong). The BUSINESS ACATION proves that getting rich *is* glorious in the PRD. **VIRGIN** Untouched (pre-occupied) rban substance (i.e. VIRGIN CITY). **EMPTY/FULL RECLAMATION** Newly-developed, but noccupied VIRGIN cities represent a spatial new frontier for re-inhabitation. While the RD's coastal landscape is reclaimed into fresh ground for development, its buildings under-o a similar takeover. RECLAMATION turns *western* space Chinese in an indigenous STEALTH) occupation that takes advantage of the Chinese liberation of use, utility, and pro-ram (see FACTORY AND HOTEL AND OFFICE). **SOVEREIGNTY AMBIGUITY** Ancient

New Urbanism: Pearl River Delta, 1996
Detail

manifests one of the constant preoccupations of the office, which always derives the specificity of its projects from a precise reading of the context. It also allows Koolhaas to work at the very limits of his profession, as an observer rather than an architect, seeking to shed the cultural reflexes of his trade.

P. S.

seinen Studenten in Harvard entwickelt hat, beweist die Bedeutung, die er der Theorie zubilligt wie auch deren konstitutive Rolle im OMA. Es zeugt von einem konsequenten Hauptgesichtspunkt in der Arbeit des OMA: Ein Projekt gewinnt seine Besonderheit durch eine genaue Lektüre des Kontextes. Das Projekt *New Urbanism* gestattete Koolhaas zudem, die Perspektive seines Berufes zu verlassen. Er versuchte hier, sich von seinen Sehgewohnheiten und seinem Metier zu lösen und arbeitete eher wie ein Beobachter als wie ein Architekt.

P. S.

100 Days – 100 Guests/100 Tage – 100 Gäste

Hans-Werner Kroesinger

*1962 in Bonn. Lebt und arbeitet/lives and works in Berlin.

Hans-Werner Kroesinger's works stage theater as distance, interposing walls, video cameras, and loudspeakers between the audience and the "actors." Formerly an assistant to Robert Wilson and Heiner Müller, Kroesinger has never shied away from political discourse. He broached the theme of solitary confinement in his Camera Silens – Stille Abteilung, and confronted the aftermath of Nazi crimes in his Adolf Eichmann – Questions & Answers, each time with a perfect dramaturgy, fully integrating the media into the theater. So doing, he precludes any contact between the stage and the outside world, letting video images, i.e., transmissions of events, speak instead. In this way he has eliminated a fundamental aspect of theater (the audience's experience of people present on the stage, of a plot unfolding right before their eyes) and replaced it with a mediated experience. This fourth wall transforms the theater-as-peep-show into a theater-as-prison, a prison that allows no direct involvement and thus bears a resemblance to high-security detention centers where the surveillance methods practiced allow no direct contact – leaving such places to exist only in our minds, as video and television images that continue to nurture the illusion that we viewers are being kept generally informed.

In Kroesinger's most recent work the two guards who witnessed the interrogation of Eichmann have been replaced by two video cameras – silent observers of the scene. The media records, the tape recording, and the text read out at the table provide no new information on Eichmann. What remains is the presentiment that we have been confronted with technical resources that are capable of producing truth and falsehood in like manner. Kroesinger's is surely a media theater worthy of the designation.

Hans-Werner Kroesinger last directed Stille Abteilung in 1995 at the Center for Art and Media Technology in Karlsruhe, and Questions & Answers in 1996 at Akademie Schloß Solitude, Stuttgart and Podewil in Berlin.

J.H./B.F.

Die Arbeiten von Hans-Werner Kroesinger inszenieren das Theater als Distanz und schalten zwischen den Zuschauer und die »Schauspieler« Wände, Videokameras und Lautsprecher. Er wagt wieder den politischen Diskurs und bringt die Themen Isolationshaft mit der Camera Silens – Stille Abteilung und den Umgang mit Naziverbrechen mit Adolf Eichmann – Questions & Answers mit perfekter Dramaturgie der Integration von Medien in das Theater. Der ehemalige Assistent von Robert Wilson und Heiner Müller verhindert jeglichen Kontakt der Bühne mit der Außenwelt und läßt statt dessen Videobilder als Übertragung des Geschehens sprechen. Das Erlebnis der Präsenz des Menschen auf der Bühne, der Handlung, die direkt vor den Augen des Zuschauers abläuft, als fundamentale Charaktereigenschaft des Theaters, hat er so ausgeschaltet und statt dessen das mediatisierte Erlebnis zwischengeschaltet.

Diese vierte Wand macht den Guckkasten des Theaters zu einem Gefängnis ohne unmittelbare Anteilnahme, entsprechend der realen Überwachung in Hochsicherheitstrakten, die keine Unmittelbarkeit zulassen, deshalb nur als Bilder von »Video-controlling« und Fernsehübertragungen in unseren Köpfen existieren und die Illusion einer allgemeinen Informiertheit produzieren. Die beiden Wächter, die damals bei dem Eichmann-Verhör Zeugen waren, wurden von Kroesinger bei seiner letzten Arbeit durch zwei Videokameras ersetzt. Stille Beobachter auf der Bühne des Geschehens. Die medialen Protokolle, das Tonband und der am Tisch gelesene Text verraten nichts, was man nicht schon über Eichmann wüßte. Was bleibt, ist die Ahnung, die Mittel vorgeführt bekommen zu haben, die jede Wahrheit und jede Lüge gleichermaßen produzieren können. Es ist somit sicher ein Medientheater, das diesen Begriff verdient.

Hans-Werner Kroesinger inszenierte zuletzt Stille Abteilung (1995), im Zentrum für Kunst und Medientechnologie (ZKM), Karlsruhe, sowie Questions & Answers (1996), an der Akademie Schloß Solitude in Stuttgart und am Podewil in Berlin.

J.H./B.F.

Stille Abteilung, 1995

Suzanne Lafont

*1949 in Nîmes. Lebt und arbeitet/lives and works in Paris.

Suzanne Lafont's work develops as a progressively deepening inquiry into multiple contextualizations of the human figure. In her art practice she has always conceived the photographic image as the constitutive element of a speculation.

For documenta she has created Trauerspiel, a project destined for public space. The work, consisting of posters glued onto two corridor walls in an underground passageway in Kassel, retraces the migration route between southeastern Europe (Turkey) and northwestern Europe (Germany). Five cities mark the stages of the journey: Istanbul, Belgrade, Budapest, Vienna, and Frankfurt. This photographic sequence, built up from nine alternating tableaux each organized into a grid structure, proceeds by discrete leaps from the city of origin to the city of arrival. Each composite tableau includes three registers of images: image-places (a documentary photograph of architecture for each city), image-characters (four staged photographs), and image-words (the inscription of the names of the cities, in their original languages). Each element is distinct and equivalent in its placement within the grid structure.

As Lafont remarks: "The presentation of each tableau in the form of a grid indicates a rupture in the linear time of history, in the ideas of progress and evolution. The horizontal axis of movement and travel carries the historical tale along, and with it, the sentiments of sadness and mourning (Trauer), brought on by the separation from the land of birth. This axis is constantly interrupted by the static lines occupied by the play (Spiel) of the figures." The play consists in a "displacement from the scene of phenomena to the abstract scene of meanings," in order to assert the state of separation through a pantomime. Stripped of individual qualities or psychological interiority, the characters desert the cities in a humorous, yet frankly political escape from the painful drama of social history. The move in a disordered space, neither public nor private, domestic nor urban: a kind of junk room, a place in the hall where one stocks cumbrous items with a merely utilitarian value. The characters inhabit the underground, joining the local vendors in the passageway. But their social indetermination separates them from the vendors, as their domestic bustle separates them from the passers-by. The disposition of the tableaux in the underground corridors compels the viewer to walk past the work and to seek out the political meaning of the event. As the artist notes: "Each step taken by the passer-by in the real space of the passageway, on the scale of the city and the neighborhood, is also a step on the continental scale, in the mental space of history. At the hurried pace of bodily motion, the pedestrian in

Das Werk Suzanne Lafonts ist eine sich schrittweise entwickelnde Erforschung der vielfältigen Kontextualisierungen der Figur. In ihrer Arbeit hat sie das photographische Bild stets als konstitutives Element einer Spekulation begriffen.

Für die documenta hat sie mit Trauerspiel ein Werk geschaffen, das für den öffentlichen Raum bestimmt ist und aus Plakaten besteht, die in Kassel an den Wänden unterirdischer Fußgängerpassagen angebracht sind. Dieses Werk zeichnet die Route der Wanderungsbewegung zwischen Südosteuropa (Türkei) und Mitteleuropa (Deutschland) nach. Fünf Städte markieren die Etappen dieser Reise: Istanbul, Belgrad, Budapest, Wien und Frankfurt. Diese photographische Sequenz entfaltet sich auf neun Tafeln, von denen jede drei Arten von Bildern enthält: Bilder von Orten (ein dokumentarisches Architekturphoto von jeder Stadt), Bilder von Personen (vier inszenierte Photographien) und Bilder von Wörtern (die Namen der Städte in der jeweiligen Landessprache). Die Bilder sind so in Gitterform arrangiert, daß alle Elemente gleichwertig sind und sich jedes deutlich von den anderen abgrenzt.

Suzanne Lafont sagt über ihre Arbeit: »Die gitterförmige Anordnung ist Indiz für einen Bruch mit der linearen Zeit der Geschichte, mit den Ideen von Fortschritt und Evolution. Die horizontale Achse der Fahrt und der Reise trägt die Geschichte und mit ihr die Gefühle der Niedergeschlagenheit und der Trauer, die mit der Trennung von der heimatlichen Erde verbunden sind. Diese Achse wird ständig durchbrochen von den statischen Linien, die vom Spiel der Personen ausgefüllt werden.« Dieses Spiel besteht darin, »sich von der Ebene der Phänomene auf die abstrakte Ebene der Bedeutung zu begeben«, um durch eine Pantomime den Zustand der Getrenntheit sichtbar zu machen. Indem sie die Städte verlassen, entziehen sich die keine individuellen Eigenschaften oder seelisches Innenleben besitzenden Personen dem leidvollen Drama der Sozialgeschichte. Sie begeben sich in einen ungeordneten Raum, der weder privat noch öffentlich, weder häuslich noch städtisch ist: eine Art Abstellraum, jener Ort im Haus, in den man die sperrigen Dinge tut, die nur als Gebrauchsgegenstände von Wert sind. Diese Personen bewohnen das Kellergeschoß und gesellen sich zu den Händlern, die in der Passage ihren Stammplatz haben. Aber ihre soziale Unbestimmtheit trennt sie von den Händlern ebenso, wie ihre häusliche Geschäftigkeit sie von den Passanten trennt. Die Anbringung der Tafeln in den unterirdischen Fußgängerpassagen zwingt den Betrachter, das Werk zu durchlaufen und den politischen Sinn des Ereignisses zur Geltung kommen zu lassen. »Jeder Schritt, den ein Passant auf der Ebene der Stadt oder eines Stadtviertels in

Trauerspiel, 1997
Detail

the electronic light of the underground tunnel fulfills
the act of renaming the displaced human beings."
P.S.

dem realen Raum der Passage macht«, sagt Lafont, »ist
auf der Ebene des Kontinents zugleich auch ein Schritt
im geistigen Raum der Geschichte. Im Rhythmus seiner
motorischen Aktivität vollzieht der Fußgänger in dem
vom elektrischen Licht hell erleuchteten unterirdischen
Bereich einen Akt der Rehabilitierung entwurzelter
Wesen.«

P.S.

Sigalit Landau

*1969 in Jerusalem. Lebt und arbeitet/lives and works in Jerusalem.

Sigalit Landau has set up a container near the train station. The spectator is invited to enter this sheet-metal rectangle, echoing with the sound of Arab music picked up over the radio. Once through the door, the spectator-visitor is confronted by a mound of metal created by the upthrust of the floor. The sheet-metal surface is distended, forced upward to the point where it looks like a fine membrane, dented by a series of brutal yet attentive blows. It analogically evokes a mountain. The visitor who clambers over this false "wrinkle in the terrain" finds two hammers stood up on end. Landau used these tools and a cutting torch to batter out the floor. Across the mount, the visitor also sees where the music is coming from: a kind of box hanging from the upper right corner of the container. Light enters from an orifice through which you can poke your head. So doing, you realize you have passed through the hole of a "Turkish toilet": your body is caught between two imbricated spaces, feet resting on ground that defines a third space, negative and inaccessible. As Landau says: "the container is a common and international alien – my container will be an alien with thin skin – so thin that the space within it will be a negative space of occurrences underneath it."

Habitually a container is a utilitarian industrial object used to pack commodities and transport them under protection from the weather. During a stay in Berlin, Sigalit Landau met some Irish workers who lived in such a container. It served as a shelter and a "domestic" space. In her earlier work, Landau has often transgressed institutional space to areas of difficult access, zones of survival and residence for unintegrated communities. For her, these were places of withdrawal, intimate shelters and performance terrains offered up to the spectator's experience. Thus she considers her container a transportable refuge: "The container serves as litmus paper / a seismograph / a polygraph – and I plan to place and design this air-pocket in a variety of other contexts as a catalyst for 'reversed geology' and 'reversed archeology.'" In host spaces such as Kassel it projects the image of a separate, conflict-ridden territory. Instead of merchandise, it contains the marks and traces of the artist's activity. Through the intermediary of this isolated structure, Landau seeks to "transfer people to a place where my act is meaningful." The title of this work is Resident Alien *(1996).*

P. S.

Sigalit Landau hat in der Umgebung des Bahnhofs einen Container aufgestellt. Der Betrachter ist eingeladen, zu erkunden, was es mit diesem großen Blechkasten auf sich hat, aus dem eine arabisch klingende Musik ertönt, die anscheinend aus einem Radio kommt. Nachdem er die Tür passiert hat, ist aus dem Betrachter ein Besucher geworden, der sich einer metallenen Anhöhe gegenübersieht, die durch die Anhebung des Bodens zustandekommt. Das Blech ist so ausgewalzt, daß es wie eine feine Membrane erscheint, und durch eine Reihe von Schlägen verbeult, die von einer brutalen und doch sorgfältigen Behandlung zeugen. Es läßt an einen Berghang denken. Der Besucher, der diese falsche »Geländeunebenheit« hinaufsteigt, entdeckt zwei Hämmer, die auf ihren Köpfen stehen. Mit diesen Werkzeugen sowie mit einem Schweißbrenner hat Sigalit Landau den Boden des Containers bearbeitet. Auf der anderen Seite der Erhebung kann der Besucher dann erkennen, woher die Musik kommt, nämlich aus einem Kasten, der in der oberen rechten Ecke des Containers hängt. Licht dringt aus einer Öffnung, durch die man seinen Kopf stecken kann. Tut man das, so findet man sich in einer arabischen Toilette wieder, der Körper allerdings steckt nun zwischen zwei ineinander verzahnten Räumen fest und die Füße stehen auf einem Boden, der quasi als Negativ einen dritten, unzugänglichen Raum definiert. Landau sagt dazu: »Der Container ist ein überall vorkommender und internationaler Ausländer – mein Container ist ein dünnhäutiger Ausländer, dessen Haut so dünn ist, daß der Raum in ihm der negative Raum von Ereignissen ist, die sich unter ihm abspielen.«

Für gewöhnlich ist ein Container ein großer Behälter zur Aufbewahrung und zum Transport von Gütern, die in ihm vor Witterungseinflüssen geschützt sind. Bei einem Aufenthalt in Berlin begegnete Sigalit Landau irischen Arbeitern, die in einem ganz ähnlichen Container lebten. Er war ihr Refugium und ihr »häuslicher« Bereich. Schon in ihren früheren Arbeiten hat Landau oft den institutionellen Raum verletzt, um schwer zugängliche Gegenden aufzuspüren, die Zonen des Überlebens und Wohnsitz nicht integrierter Gemeinschaften sind. Eine solche Gegend ist für sie ein Ort der Zurückgezogenheit und Abkapslung, ein intimer Schlupfwinkel wie auch ein Terrain, das Betrachtern neue Erfahrungen zu vermitteln vermag. Daher ist ihr Container für sie ein transportables Refugium: »Der Container dient als Lackmuspapier, Seismograph oder Polygraph – und ich habe vor, diesen Lufteinschluß noch in viele andere Kontexte zu bringen, wo er als Katalysator für eine ›umgekehrte Geologie‹ und eine ›gegenläufige Archäologie‹ fungieren soll.« Er projiziert in die Städte, in denen er aufgestellt wird, wie hier in

Resident Alien, 1996

Kassel, das Bild eines konfliktgeladenen und ausgegrenzten Territoriums. Anstelle der Güter enthält er die Spuren und die Zeichen der Aktivität der Künstlerin. Mit Hilfe dieser isolierten Struktur versetzt sie Menschen an einen Ort, wo ihr Handeln und das der mit ihrem Werk interagierenden Menschen plötzlich eine neue Bedeutungsdimension gewinnt. Der Titel dieses Werks ist *Resident Alien* (1996).

<div align="right">P.S.</div>

Maria Lassnig

*1919 in Kappel. Lebt und arbeitet/lives and works in Wien/Vienna.

"For more than forty-five years now nothing has altered the fact that in painting and drawing I proceed from the same reality: the physical event of bodily experience. To find where concentrations of experience are located – independently of empirical memory by means of the eyes – has not always been so easy. Each part of our body can, by becoming aware of it, be awakened: the knee can start tingling, the back becomes a vibrating surface, the nose a hot hole, the legs screws. At the same time it reassures me that neurophysiology has not yet unlocked all the secrets of the nervous system... Everyone can have physical perceptions, but since for me they are reality I paint them. The most extreme subjectivity is transformed through the process of form into objectivity." These were the terms in which Maria Lassnig described her life's work a few years ago. The artist began her study of drawing at the age of six and entered the Akademie der Bildenden Kunst in Vienna in 1941. The first professor she met refused to admit her to his class on the pretext that her art was "degenerate." In effect, the expressionistic violence of her early drawings recalls the portraits of Kokoschka. These early works already bear the seeds of her art to come. In the late forties, influenced by analytical cubism, she painted her own self-symbiosis with foreign bodies. Later, her interest in surrealism led her to explore automatic processes. She continued to blend her own features with images of natural elements, animals, and diverse creatures. She was a friend of Paul Celan, lived in Paris for a time and then for ten years in New York in the seventies, before moving back to Vienna where she accepted a professorship in painting.

Lassnig has always concentrated on research into herself, into the reality of what she calls "body awareness" (the name of a series undertaken in 1956, itself a continuation of the "introspective experiences" of preceding years). Convinced that the only truth resides in the emotions produced within the "physical shell," she concentrates on her own physiological nature and on her internal sensations. Through drawing, she engages in an introspection conceived as a psychic and physical investment of the labyrinth of the unconscious, fulfilled in labyrinthine gestures. Though the works are generally quite small in format, they serve to inscribe a virtual matrix of expansion all the way to the scale of architecture.

Among the drawings presented here – some of which have been reworked in watercolors – a small number date from 1960s, including the celebrated drawing L'Intimité (Intimacy), 1967, which she took as the basis for an animated film. The others have been created over the course of the last few years. P. S.

»Seit nun mehr als fünfundvierzig Jahren gehe ich beim Malen und Zeichnen unverändert von der gleichen Realität aus: dem physischen Ereignis körperlicher Erfahrung. Es war nicht immer leicht, unabhängig von der empirischen Erinnerung mittels des Auges herauszufinden, wo sich die Erfahrungen konzentrieren. Jeder Teil unseres Körpers kann, wenn wir uns seiner bewußt werden, erweckt werden: Das Knie kann zu kribbeln anfangen, der Rücken wird zu einer vibrierenden Oberfläche, die Nase zu einem heißen Loch, und die Beine werden zu Schrauben. Gleichzeitig beruhigt mich, daß die Neurophysiologie bis jetzt noch nicht alle Geheimnisse des Nervensystems entschlüsselt hat. ... Jeder kann körperliche Wahrnehmungen haben, doch da sie für mich Realität sind, male ich sie«, schrieb Maria Lassnig vor einigen Jahren. Die Künstlerin, die von ihrem sechsten Lebensjahr an Zeichenunterricht erhält, beginnt 1941 in Wien an der Akademie der Bildenden Kunst mit dem Studium. Der erste Professor, bei dem sie vorstellig wird, weigert sich, sie in seine Klasse aufzunehmen, da ihre Arbeiten »entartet« seien. Zu Beginn ihrer Laufbahn macht sie vornehmlich expressionistische Zeichnungen, die in ihrer Wut an die Portraits Kokoschkas erinnern und in denen im Keim bereits ihr späteres Schaffen angelegt ist. Am Ende der vierziger Jahre stellt sie, beeinflußt vom analytischen Kubismus, ihre eigene Symbiose mit fremden Objekten dar. Später führt sie das Interesse für den Surrealismus zur Erforschung automatischer Prozesse. Sie kombiniert aber stets weiter ihr eigenes Bild mit Dingen der Natur, mit Tieren und diversen Kreaturen. Sie ist mit Paul Celan befreundet, lebt in Paris und dann zehn Jahre in New York, bevor es sie mit dem Ende der siebziger Jahre wieder nach Wien zieht, wo man ihr den Professorentitel verleiht.

Maria Lassnigs Arbeit war stets der Selbsterforschung gewidmet und konzentrierte sich auf jene Realität, die sie »Körperbewußtsein« nannte (das war auch der Name einer Serie von Arbeiten, die sie ab 1956 in Angriff nahm und die ihre »introspektiven Erfahrungen« der früheren Jahre fortsetzten). Überzeugt davon, daß die einzige Wahrheit in den Gefühlen liegt, die in ihrer »Körperhülle« entstehen, konzentriert sie sich auf ihre eigene physiologische Natur und ihre inneren Empfindungen. Die Introspektion, der sie sich verschreibt, begreift sie als psychisches und physisches inneres Erleben, bei dem sich das Labyrinth des Unbewußten mit seinen assoziativen Figuren in eine labyrinthische Geste umsetzt.

Die berühmteste der hier gezeigten, manchmal auch in Aquarelltechnik ausgeführten Arbeiten ist das Bild L'Intimité, 1967, das auch die Grundlage eines Animationsfilms war. Es entstand, wie auch einige andere der

Koordinatenvernetzung, 1994

hier gezeigten Arbeiten, gegen Ende der sechziger
Jahre, die übrigen Werke sind neueren Datums.

P. S.

Jan Lauwers

*1957 in Antwerpen. Lebt und arbeitet in Brüssel/lives and works in Brussels.

"No beauty for me there where human life is rare."
A correspondance between Jan Lauwers and Rudi
Laermans:
Dear Rudi,
With Rilke in mind, one might define a work of art as a
"silent, patient thing" that gradually sows the seeds of
unrest by making the unnecessary necessary.

The concept of time is an important element in this
idea. The only essential difference between the theater
and the visual arts is precisely this one – the time fac-
tor. Anyone looking at a painting decides for them-
selves how much time they will spend looking at the
object. In a work of theater the viewing time is
imposed.

In my work for theater I try to deal with time in such
a way that, by means of a sort of inertia, the given
information (image, word, action) brings about an
enhanced form of concentration that freezes time, so
that memory can start work.

This brings me to the following thought: a work of
art is never topical because it must transcend topicality.
I call this transcendence memory.

If this transcendence does not occur, we cannot call
it art.

With my best wishes,
Jan Lauwers

Dear Jan,
An unreasonable but compelling experience forces me
to say that it is only as an image that reality acquires a
certain necessity. Again and again I am overcome by
images: the wandering gaze that is suddenly caught, as
if snagged on something, and then loses itself in obses-
sive staring. Seeing is at that moment non-seeing, and
the image viewed is a pure surface without depth or
meaning. Crucial is the experience of being inter-
pellated by the image: for literally an instant the world
changes into an image that looks at me.

Contemporary visual culture is iconoclastic: one
moment it wants to tame the magic of the image, the
next it wants to shatter it. Day after day it offers us
near-images which never get the chance to become a
face and to see, before they are seen in their turn. That
is why one can look at them, even enjoy them, but
never experience them: the gaze never loses itself in
them as it does in another gaze.

All significant modern art has a visual nature and
attempts in an aesthetic way to save the intensity of
the wordless.

In "good" or "interesting" images, the world is
brought to a standstill for a second. Images of this sort
are ruled by neither time nor logic: they break into

»Für mich gibt es keine Schönheit, dort wo kein
menschliches Leben ist.«
Ein Briefwechsel zwischen Jan Lauwers und Rudi
Laermans:
Lieber Rudi!
Mit Rilke im Hinterkopf könnte man die künstlerische
Arbeit als »stille, geduldige Sache« umschreiben, die
dadurch, daß sie das Unnötige nötig macht, stufenweise
Samen der Rastlosigkeit sät.

Das Konzept von Zeit ist bei dieser Idee ein wesentli-
ches Element. Der einzig wichtige Unterschied zwischen
dem Theater und der bildenden Kunst ist ganz genau
nur dieser: der Zeitfaktor. Jeder, der vor einem Bild
steht, entscheidet selbst, wieviel Zeit er damit verbrin-
gen möchte, das Objekt anzuschauen. Beim Theater ist
die Zeit des Zuschauens vorgegeben.

In meiner Arbeit im Theater versuche ich so mit Zeit
umzugehen, daß, in einer gewissen Form von Trägheit,
die gegebene Information (Bild, Wort, Handlung) eine
erhöhte Form von Konzentration ergibt, die Zeit gefrie-
ren läßt, so daß Erinnerung beginnen kann zu arbeiten.

Das bringt mich zu dem folgenden Gedanken: ein
Kunstwerk ist niemals aktuell, denn es muß Aktualität
transzendieren. Diese Transzendenz nenne ich
Erinnerung.

Wenn diese Transzendenz nicht entsteht, ist es keine
Kunst.

Mit besten Wünschen
Jan Lauwers

Lieber Jan!
Eine unvernünftige, aber unwiderstehliche Erfahrung
zwingt mich zu sagen, daß Wirklichkeit nur als Bild eine
bestimmte Notwendigkeit verdient. Wieder und wieder
bin ich von Bildern überwältigt: das wandernde Schauen,
das plötzlich gefangen ist und sich dann im obsessiven
Starren verliert. Sehen ist in dem Moment dann Nichtse-
hen, und das Bild erscheint als bloße Oberfläche ohne
Tiefe oder Bedeutung. Brutal ist die Erfahrung, von
einem Bild »interpelliert« zu sein: für einen Augenblick
wechselt die Welt wortwörtlich in ein Bild, das mich
ansieht.

Die zeitgenössische Kultur ist ikonoklastisch: einmal
möchte sie die Magie des Bildes zähmen, ein anderes
Mal möchte sie es zerschmettern. Tag um Tag bietet sie
uns Beinah-Bilder an, die niemals die Chance erhalten,
ein Gesicht zu werden und selbst zu sehen, bevor sie an
der Reihe sind, selber gesehen zu werden. Deshalb kann
man sie anschauen, sie sogar genießen, aber niemals
erleben: das lange Schauen wird sich niemals in ihnen
verlieren so wie in einem anderen langen Blick.

Jede bedeutende moderne Kunst hat eine visuelle

The Snakesong, Part 2: Le Pouvoir, 1996

time and create a zone of eternity. As such they save the world from its own indifference: in a "good" image, reality changes into a portrait that looks at us. So all interesting art is portraiture.

Kind regards,
Rudi Laermans

Jan Lauwers founded the Epigonen-Ensemble *in 1979, out of which the* Needcompany *was created in 1986. In 1987, Needcompany staged their first show, Need to Know, at the legendary Mickery Theater in Amsterdam. Jan Lauwers' recent work includes the* Snakesong Trilogy *in 1994-96 and* Needcompany's Macbeth, *which premiered at the Kaaitheater in Brussels in 1996.*

Natur und versucht, auf einem ästhetischen Weg die Intensität der Wortlosigkeit zu bewahren.

In »guten« oder »interessanten« Bildern ist die Welt für eine Sekunde zum Stillstand gebracht worden. Bilder dieser Art sind weder von Zeit noch von Logik bestimmt: sie brechen in die Zeit hinein und kreieren eine Zone von Unendlichkeit. Als solche bewahren sie die Welt vor ihrer eigenen Indifferenz: in einem »guten« Bild verwandelt sich die Realität in ein Portrait, das uns ansieht. Folglich ist jede interessante Kunst ein Portrait.

Freundliche Grüße
Rudi Laermans

Jan Lauwers gründete 1979 das *Epigonen-Ensemble*, aus dem 1986 die *Needcompany* hervorging. Die erste Inszenierung der *Needcompany, Need To Know,* fand 1987 im legendären Mickery Theater, Amsterdam, statt. Zuletzt arbeitete Jan Lauwers an der *Snakesong Trilogie,* 1994–1996, sowie an *Needcompany's Macbeth,* das am Kaaitheater in Brüssel 1996 uraufgeführt wurde.

Theater Outlines/Theaterskizzen 5.–7. 9. 1997

Antonia Lerch

*in Mainz. Lebt und arbeitet/lives and works in Berlin.

In Letzte Runde *we experience nine different stories taking place in Berlin – but not only there. The stories bring us into every part of the city and to a wide range of milieus. They are stories of love, old age, childhood, death, good and bad business deals, rage and sorrow, nasty tricks and crimes, and – naturally – desire and hope. The constantly recurring motif is the last round before closing time.*

Even in the clubs and bars of Berlin the last round must be served, sometime between midnight and dawn. Who will order another one, a last, lingering drink? Loners, losers, weirdoes, left-behinds, melancholics, addicts, singles, the despairing and the talkative, drunk at last.

An African woman speaks of her grandmother from Kenya, who has been dead for many years and whom she admires profoundly. She is full of rage and passion. She is standing at the bar or playing the pinball machine, she doesn't know where her life will go from here. Passionate but nonchalant… until she starts to move.

A couple, little more than twenty years old, is arguing about the future. Will their love last? It could be over tomorrow. Who can think of tomorrow? It's today that counts. Until now they have been happy together, but the eternal question remains: is she the one? Is he Mister Right? It gnaws at their emotions. Jealousy and fear become a test of strength.

At the bar of a famous Berlin cabaret, a Tunisian woman orders a mineral water, just as she does every night after work. She works as a toilet attendant and stays until the show is over. She has been in Germany now for thirty years, but soon she will return to her home country. With her savings she will build a house in Tunisia.

Berlin, asleep at night and in early morning.

Everyone who speaks in this film has something to say. Perhaps they have only gone out for a drink in order to be alone, to forget their worries, just to be left in peace without thinking of what has to be done.

The way Antonia Lerch approaches people, they want to tell their stories. They tell of themselves, of their daily lives and their routine, of injustice and of the struggle called living.

Lerch often meets her characters on a decisive night. Something was different about their day. Something that gave them a reason to go out for a drink. Something went wrong, an argument, a misunderstanding, a stupid remark that betrayed them.

An encounter, a surprise – or an over-salted meal. Thirst.

For what? Thirst for life and company.

In *Letzte Runde* erleben wir neun Geschichten, die sich in Berlin abspielen, aber eben nicht nur hier. Die Erzählungen führen uns in viele Stadtviertel, in ganz verschiedene Milieus. Und es geht immer um die letzte Bestellung. Dann ist Feierabend.

Es sind Geschichten von der Liebe, vom Alter, von der Kindheit, vom Tod, von guten und von schlechten Geschäften, von Wut und Trauer, von Gemeinheiten und Verbrechen, und – natürlich – von Sehnsucht und Hoffnung.

Zwischen Mitternacht und Morgengrauen wird selbst in den Bars und Kneipen in Berlin irgendwann die letzte Runde ausgeschenkt. Wer bestellt jetzt noch eine Runde, einen letzten einsamen Drink?

Loner, Loser, merkwürdige Leute, Übriggebliebene, Melancholicos, Süchtige, Singles, Verzweifelte, Redselige, endlich Besoffene…

Eine afrikanische Frau spricht mit ihrer Großmutter aus Kenia, die seit vielen Jahren tot ist. Diese Frau bewundert sie zutiefst, aber die eigene Mutter verachtet sie. Sie ist voller Wut und voller Leidenschaft. Und sie steht am Tresen oder flippert und weiß auch nicht, wie es weitergeht in ihrem Leben. Leidenschaftlich, aber lässig… Bis sie sich in Bewegung setzt.

Ein Pärchen, gerade 20, streitet über die Zukunft. Wird ihre Liebe halten? Es könnte ja morgen schon aus sein. Wer kann an morgen denken? Das Heute zählt. Beide waren bis eben noch glücklich miteinander, aber die ewige Frage: Ist sie die Richtige? Ist er der Mann fürs Leben? zermürbt ihre Gefühle. Eifersucht und Angst werden zur Belastungsprobe.

An der Bar eines berühmten Berliner Varietés bestellt sich eine Tunesierin ein Mineralwasser. Das macht sie jeden Abend so, wenn sie mit der Arbeit fertig ist. Sie arbeitet als Klofrau und bleibt bis nach der Vorstellung. Seit dreißig Jahren lebt sie nun in Deutschland, aber bald ist es soweit: Sie wird zurückgehen in ihre Heimat. Mit ihrem Ersparten baut sie sich in Tunesien eine Villa.

Berlin, nachtschlafend und frühmorgens.

Alle, die hier erzählen, haben etwas zu sagen. Vielleicht sind sie nur einen trinken gegangen, um einmal allein zu sein, die Sorgen zu vergessen, einfach in Ruhe gelassen zu werden und die Pflicht zu verdrängen.

Aber so wie Antonia Lerch Menschen aufspürt, wollen sie ihre Geschichten erzählen. Sie berichten von sich, vom Tag, vom Alltag, von den ganzen Träumen, den Ungerechtigkeiten, diesem täglichen »Raus und Durch«, was man Leben nennt.

Aber oft trifft Antonia Lerch ihre Figuren in einer entscheidenden Nacht. Irgend etwas lief an dem Tag davor anders. Ein Grund, noch einen trinken zu gehen. Eine Panne, ein Streit, ein Mißverständnis, ein ganz blö-

Letzte Runde, 1997

Sometimes anything is reason enough to go out to a bar. Alone or with someone else…

And when Antonia Lerch sets out with her camera, strange things invariably happen, because strange things always happen in front of an inquisitive camera.

Lerch's love of the night and of the stories that occur in between times, in between places, in between cultures, becomes tangible in Letzte Runde.

A film from Berlin in which hardly any of the characters originally come from that city. They speak their own language. Berlin. Like any city anywhere else in the world.

B.K.

der Versprecher, der einen verrät.

Eine Begegnung, eine Überraschung, …oder ein zu salziges Essen.

Durst.

Durst? Hunger nach Leben, nach Gesellschaft.

Manchmal ist alles Grund genug, in eine Bar zu gehen. Allein, zu zweit…

Und wenn Antonia Lerch mit ihrer Kamera loszieht, geschehen immer eigenartige Geschichten, weil sich vor einer neugierigen Kamera immer und grundsätzlich Geschichten ereignen.

Lerchs Liebe zur Nacht und zu den Geschichten zwischen den Zeiten, den Orten, den Kulturen wird in *Letzte Runde* zu spüren sein.

Ein Film aus Berlin, und fast keine der Personen stammt aus dieser Stadt. Alle sprechen ihr ganz eigenes Deutsch. Berlin, wie überall auf der Welt.

B.K.

Helen Levitt

*1913 in Bensonhurst, New York. Lebt und arbeitet/lives and works in New York.

Helen Levitt's fiercely independent character makes it hard to connect her with any particular artistic movement. To be sure, she was attracted to surrealism at the outset of her career, but partially through the concourse of circumstances and also because of certain elective affinities. She moved in New York's bohemian circles, where she met and frequented Luis Buñuel, Henri Cartier-Bresson, and Walker Evans; but her closest ties were with the poet and writer James Agee. In 1944 she created the film In the Street, East Harlem (1945–46) with Agee and Janice Loeb. The film anticipated a tendency that would later be developed in American experimental cinema; it constitutes, in a way, the cinematographic translation of her photographic work.

Levitt's most celebrated photographs date from the late thirties and forties. They were taken in New York, and for the most part, in East Harlem. Levitt was born in New York and left the city only once, for a trip to Mexico in 1941. Yet it was not the city that interested her (East Harlem was as yet almost untouched by the modernist urban transformation); rather it was the street, or more precisely the sidewalk as a space of play and of life, and also the walls covered with graffiti, where pictographic messages in chalk sketched out communal ties.

Levitt's images never bear on the commonly exploited themes, the poverty and danger of Harlem in the forties. On the contrary, they convey the fluid and permanent presence of the inhabitants of the sidewalk, and in particular, the free invention of the children who snatch the pleasures of play from the stern grid of urban order. The mobility of the bodies and the language of the wall describe an American vernacular culture, as Agee observed. In the preface to Levitt's first published book, A Way of Seeing, in 1965, he described the people of the Harlem streets: "The cardinal occupations of the members of this culture are few, primordial and royal, being those of hunting, war, art, theater, and dancing. Dancing, indeed, is implicit in nearly all that they do."

In effect, what Helen Levitt's images retain and transmit from this sonorous space are the choreographic figures and their vital energy, imbued with a certain lyricism. Strangers never chance to stroll through this narrow realm, tightly bordered by the facades and defined by the width of the sidewalk. A marginal community has sprung up here, outside any possibility of productive labor. The houses are open to the street, the neighbors freely mingle, making it hard to distinguish between public and private space. The messages on the walls convey rumors and gossip. In this urban theater, the bodies dance and the plasticity

Mit ihrem sich durch große Unabhängigkeit auszeichnenden Wesen läßt sich Helen Levitt nur schwer dem Einflußbereich einer besonderen Kunstströmung zuordnen. Am Anfang ihrer Karriere fühlt sie sich sicherlich stark vom Surrealismus angezogen, doch liegt das zum Teil an den Umständen und an einer gewissen Wahlverwandtschaft. Sie gehört zur New Yorker Boheme, verkehrt mit Luis Buñuel, Henri Cartier-Bresson und auch mit Walker Evans – meistens ist sie allerdings in Gesellschaft des Schriftstellers und Dichters James Agee, mit dem sie befreundet ist. Mit ihm und Janice Loeb macht sie 1944 den Film In the Street, East Harlem (1945–46). Dieser Film ist bahnbrechend für eine neue Tendenz des amerikanischen Experimentalfilms und stellt auf gewisse Weise eine kinematographische Umsetzung ihrer photographischen Arbeit dar.

Die berühmtesten Photographien Helen Levitts stammen aus den vierziger Jahren und noch aus den Jahren davor. Sie wurden in New York aufgenommen – die meisten im Ostteil Harlems –, der Stadt, in der sie geboren wurde und die sie nur einmal für eine Reise nach Mexiko im Jahr 1941 verlassen hat. Dennoch gilt das Interesse Levitts nicht der Stadt – in Ost-Harlem ist von den modernen Veränderungen ihrer Zeit noch wenig zu sehen –, sondern der Straße, oder genauer, dem Bürgersteig als Ort, wo sich das Leben abspielt, und den mit Graffiti übersäten Mauern und Wänden, wo die mit Kreide gezeichneten piktographischen Botschaften zu lesen sind, die das Gewebe einer Gemeinschaft darstellen.

Die Bilder Helen Levitts gehen niemals, wie es so oft geschieht, mit dem Elend und der sozialen Gefährdung im Harlem der vierziger Jahre hausieren. Im Gegenteil, sie zeigen, welche Ausstrahlung die Bewohner des Bürgersteigs besitzen, besonders aber zeigen sie die ungebundene Phantasie der Kinder, die den Gesetzen der städtischen Lebenswelt einen Freiraum abzuringen vermögen, in dem sie ihre Freude am Spiel ausleben. Indem sie die Mobilität der Körper und die Sprache der Mauern einfängt, beschreibt Helen Levitt, wie James Agee betont hat, eine bestimmte regionale amerikanische Kulturform. Im Vorwort zu A Way of Seeing, 1965, dem ersten Buch Helen Levitts, schreibt er: »Die Mitglieder dieser Kultur widmen sich in der Hauptsache nur wenigen Tätigkeiten, und die sind ursprünglich und königlich: Jagd, Krieg, Kunst, Theater und Tanz. Tatsächlich ist das Tanzen fast allem, was sie tun, immanent.«

Was die Bilder Helen Levitts mit einer gewissen lyrischen Begeisterung festhalten und vermitteln, ist in der Tat die vitale Energie tänzerischer Figuren. In diesem engen Raum, begrenzt von Hausfassaden und durch die Breite des Bürgersteigs bestimmt, wagt es kein Fremder

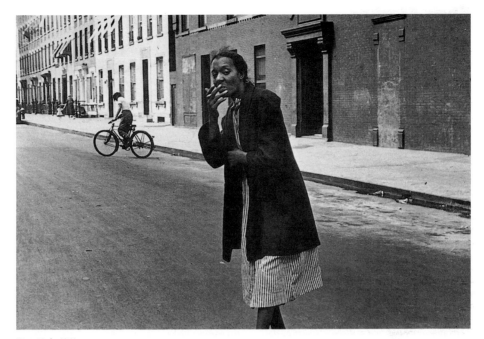

New York, 1941

of their movements seems to echo the linearity of the graffiti and the graphic concision of the drawings sketched in chalk.

<div align="right">P. S.</div>

spazierenzugehen. Eine beschäftigungslose Bevölkerungsgruppe am Rande der Gesellschaft konstituiert sich hier als Gemeinschaft. Die Wohnungen sind zur Straße hin offen, das enge nachbarschaftliche Zusammenleben läßt kaum noch einen Unterschied zwischen öffentlichem und privatem Raum erkennen, die Botschaften auf den Hausmauern sind mitunter auch nur Gerüchte und Klatsch über Nachbarn und Mitbewohner. Die in diesem städtischen Theater tanzenden Körper spiegeln in ihren anpassungsfähigen Bewegungen die Geradlinigkeit der Schriftzüge und die graphische Prägnanz der Kreidezeichnungen wider.

<div align="right">P. S.</div>

Chris Marker

*1921 in Neuilly sur Seine. Lebt und arbeitet/lives and works in Paris.

Chris Marker is a singular filmmaker, and a great one. His work, rich with a diversity of experimentation, is marked by continuing political engagement. His most famous film remains La Jetée (1963). Just to recall a few moments of his career: in 1953 he and Alain Resnais created the anticolonialist film Statues Die Too; in 1961, Cuba Sí! in 1977, Red in the Distance; then Sans Soleil in 1982, and more recently, Confessions of a "Blue Helmet," with testimony from a conscript who had participated in the UN mission in Bosnia. His last movie, Level 5, was carried out with an exceptional economy of means. In a very small room, a woman addresses her dead lover and tries to complete the film left to her by Chris Marker. The film is a computer-based video game devoted to the battle of Okinawa (1945), a massacre in the course of which 150,000 civilians perished – most of them compelled to suicide by the Japanese army. This decisive episode for the close of the Second World War led Washington to its decision to use atomic weapons; yet it has been obliterated by the collective memory. The falsification of history was partially conveyed by doctored images – propaganda manipulation or censorship – whose meaning and absence are explored by Marker.

Marker has always been fascinated by science fiction and conspiracy theory. His demystification of history and the present is accompanied by an investigation of new image technologies. At documenta he is presenting the CD Rom he has just completed, 1996–97, named Immemory, in which, as he says, "the imaginary will have just as much room as memory in the strict sense." Divided into "zones," the interactive structure of the CD Rom is above all topographic. With it you navigate through a contiguous labyrinthic system where the regions of Memory are transformed into regions more geographic than historical. The CD Rom, a kind of Remembrance of Things Past, begins with the departure of Madeleine, the heroine of Hitchcock's film Vertigo. Yet as Chris Marker remarks: "This work in no way constitutes an autobiography, and I'll permit myself every excursus – nonetheless, if you're going to work on memory, you might as well use the one you've always got on you." He carries us from the world of postcards to the worlds of childhood, from cemeteries to the battle of Okinawa, from Marcel Proust to warfare.

For Marker, history and images of history go together and often the latter are what condition individual or collective memory. Against the grain of media news and at antipodes from classical narrative, Chris Marker draws on ancient theoretical models of the "meanders of the mind." Computer navigation, according to Marker, branches into a conception of memory

Chris Marker ist ein bedeutender und einzigartiger Filmemacher. Sein an vielen Experimenten reiches Werk ist geprägt von einem niemals nachlassenden politischen Engagement. Sein berühmtester Film ist immer noch La Jetée (1963). Es sei nur auf einige Höhepunkte seiner Laufbahn hingewiesen: 1953 drehte er zusammen mit Alain Resnais den antikolonialistischen Film Les Statues meurent aussi, 1961 Cuba si!, 1977 Le fond de l'air est rouge, 1982 Sans Soleil und vor kurzem erst entstanden die Confessions d'un »casque bleu«, die Bekenntnisse eines Soldaten, der als »Blauhelm« in Bosnien zum Einsatz kam. Sein letzter Film, Level 5, wurde mit sparsamsten Mitteln gedreht. In einem winzigen Zimmer spricht eine Frau mit einem verstorbenen Liebhaber und spielt auf einem Computer ein Videospiel, bei dem es um die Schlacht von Okinawa (1945) geht, die 150 000 Zivilpersonen das Leben kostete, von denen die meisten durch die japanische Armee zum Selbstmord gezwungen wurden. Diese Episode war für den Ausgang des Zweiten Weltkriegs im Pazifik von entscheidender Bedeutung – sie führte zur Entscheidung Washingtons für den Einsatz der Atombombe –, doch im kollektiven Gedächtnis wurde ihre Bedeutung später heruntergespielt. Diese historische Fehldeutung wurde zum Teil durch die Bilder bewirkt (ihre propagandistische Manipulation oder ihr Fehlen), über deren Bedeutung Marker Klarheit zu gewinnen sucht.

Schon immer besaß Marker ein leidenschaftliches Interesse an Science-fiction einerseits und Verschwörungstheorien andererseits. Seine Entmystifizierung der Geschichte und des Zeitgeschehens ging immer einher mit einer Erprobung neuer Technologien. Dementsprechend präsentiert er auf der documenta eine von ihm gestaltete interaktive CD-ROM mit dem Titel Immemory (1996–97), bei der »das Imaginäre genauso viel Platz einnimmt wie die eigentliche Erinnerung«. Die interaktive Struktur dieser CD-ROM ist in »Zonen« zerlegt und daher in erster Linie topographischer Art. Sie erlaubt die Navigation in einem labyrinthischen Kontiguitätssystem, in dem die Regionen des Gedächtnisses in geographische statt historische Einheiten übertragen sind. Der Ausgangspunkt der eine Art Suche nach der verlorenen Zeit darstellenden CD-ROM ist Madeleine, die Heldin von Hitchcocks Film Vertigo. Doch Marker warnt davor, diese Suche als Konstitution von Autobiographie zu begreifen: »Ich gestatte mir Abschweifungen, aber ich studiere nicht die Funktionsweise des Gedächtnisses und ich bediene mich auch nicht der, die man immer zur Verfügung hat.« Er führt uns so vom Universum der Postkarten zu dem der Kindheit, von den Friedhöfen zur Schlacht um Okinawa, von Marcel Proust zum Krieg. Für Marker ist Geschichte gleichbe-

Immemory, 1996–97
Screenshot

as arborescence, a idea familiar to certain seventeenth-century thinkers such as Robert Hooke.

P. S.

deutend mit den Bildern der Geschichte, und oft sind es diese Bilder, die das (individuelle oder kollektive) Gedächtnis konditionieren. Konträr zur Information durch die Medien wie auch zur klassischen Erzählung folgt Chris Marker alten theoretischen Modellen der »verschlungenen Pfade des Geistes«. Die digitale Navigation knüpft laut Marker wieder an eine manchen Denkern des 17. Jahrhunderts (wie zum Beispiel Robert Hooke) vertraute Vorstellung an, die das Gedächtnis als etwas Baumartiges begriff.

P. S.

Kerry James Marshall

*1955 in Birmingham, Alabama. Lebt und arbeitet/lives and works in Chicago.

In a letter written in the summer of 1994, Kerry James Marshall explained to Arthur Jafa the reasons and motives behind his work: "I've always wanted to be a history painter on a grand scale like Giotto and Géricault ... but the moment when that kind of painting was really possible seems so distant, especially after Pollock and Polke. Nevertheless, I persist, trying to construct meaningful pictures that solicit identification with, and reflection on Black existential realities... Robert Johnson's blues are a musical equivalent. Their undeniable spiritual power is at once irreverently profane, formally complex, viscerally accessible, and hauntingly beautiful."

To account for a multifaceted reality that is prey to violent political, cultural, and psychic contradictions, this Afro-American artist prefers allegorical figuration to naturalistic description. Veritable patchworks, his critically ironic paintings recycle the iconography of a social dream and an ideological manipulation. An idyllic landscape stretches out before our eyes, an idealized suburb where city and nature harmoniously intertwine: billboards welcome the visitor to these gardens where vegetation flowers luxuriously, where birds flit happily to and fro and the sun shines like a saint's halo. This pacified land is peopled by faceless Afro-Americans. In the background, blocking the horizon, rise nondescript housing projects, all the same. We are in a suburb of Chicago inhabited by middle-class blacks, where Marshall and his family moved at the time of the famous "urban renewal" programs of the sixties, satirized as "Negro removal" back then, and still indissociable in memory from the Watts riots. As Marshall declares: "These figures I paint are a literal reality of our rhetorical identity: 'Black' people – highly stylized, unequivocal, and completely self-conscious." The flat black color of his figures recalls the metaphor of Ralph Ellison in his book The Invisible Man.

These large-format paintings, evoking posters or murals, proceed from a coherent accumulation of heterogeneous elements which spring from a very precise historical and social situation. Imbued with artistic references drawn as much from the classical tradition of Western painting (drapery, phylacteries, halos) as from modern art, but also from Afro-American culture (the art of voodoo flags, sign painting, or accumulative African sculpture), these works embody a veritable syncretism which shakes up hierarchies and subverts established codes.

P. S.

In einem Brief an Arthur Jafa vom Sommer 1994 erklärt Kerry James Marshall die Intentionen und Motivationen, die seine Arbeit leiten:»Ich habe immer ein Historienmaler in großem Stil sein wollen, wie Giotto und Géricault..., doch die Zeit, wo diese Art von Malerei noch wirklich möglich war, scheint, vor allem nach Pollock und Polke, so weit weg zu sein. Trotzdem versuche ich beharrlich, bedeutungsvolle Bilder zu schaffen, die sich um eine Identifikation mit den Existenzbedingungen der Schwarzen bemühen und darüber reflektieren... Robert Johnsons Blues ist ein musikalisches Äquivalent dazu. Die unbestreitbare geistige Kraft seiner Musik ist gleichzeitig auf respektlose Weise weltlich, formal komplex, unmittelbar eingängig und betörend schön.«

Um dem Problem der Schilderung einer komplexen Realität gerecht zu werden, die gewaltigen politischen, kulturellen und psychischen Widersprüchen ausgesetzt ist, greift dieser afroamerikanische Künstler lieber eine allegorische Darstellungsweise zurück als auf eine naturalistische Beschreibung. Seine Bilder sind wahre Patchworks und verwerten mit kritischer Ironie die Ikonographie eines sozialen Traumes und einer ideologischen Manipulation. In einer idealisierten Gegend am Stadtrand, wo sich Stadt und Natur in Harmonie verbinden, erstreckt sich eine idyllische Landschaft: Freundliche Schilder entbieten einen Willkommensgruß, die Gärten sind voller Blütenpracht, die Vögel jubilieren und die Sonne scheint wie die Aureole eines Heiligen. Die friedliche Gegend ist von gesichtslosen Afroamerikanern bewohnt. Im Hintergrund dieser Bilder, den Blick auf die Horizontlinie versperrend, erstrecken sich gleichförmige Mietshäuser des sozialen Wohnungsbaus. Wir sind in einem Vorort von Chicago, wo die schwarze Mittelschicht wohnt und wohin Kerry James Marshall mit seiner Familie zog, als in den sechziger Jahren das berühmt-berüchtigte »Urban Renewal«-Programm zur Stadtsanierung anlief, das dann »Negro Removal« getauft wurde und das bis heute untrennbar mit den damaligen Rassenunruhen verbunden ist. Marshall sagt dazu:»Die Figuren, die ich male, entsprechen buchstäblich der Wirklichkeit unserer rhetorischen Identität: ›Schwarze‹ – stark typisiert, unverwechselbar und völlig gehemmt und unsicher«. Die schwarze, nuancenlose Farbe seiner Personen gemahnt an die Metapher Ralph Ellisons in seinem Roman The Invisible Man.

Diese großformatigen Bilder, die an Plakate oder Wandmalereien erinnern, entstehen aus einer kohärenten Anhäufung heterogener Elemente, die mit einer ganz bestimmten historischen und sozialen Situation in Zusammenhang stehen. Geprägt von kunsthistorischen Bezügen, die ebenso aus der mittelalterlichen Tradition (die Draperien, die Spruchbänder und die Aureolen) wie

Better Homes Better Gardens, 1994

aus der modernen Malerei oder der afroamerikanischen Kultur schöpfen (die Kunst der Voodoofahnen, die Schildermalerei und die akkumulativen afrikanischen Skulpturen), sind diese Werke Ausdruck eines echten Synkretismus, der die Hierarchien durcheinanderbringt und die Codes zersetzt.

P. S.

Christoph Marthaler/Anna Viebrock

*1951 in Erlenbach am Zürichsee. Lebt und arbeitet/lives and works in Basel, Hamburg, Berlin und/and Frankfurt.
*1951 in Köln. Lebt und arbeitet/lives and works in Hamburg, Berlin, Frankfurt und/and Stuttgart.

Christoph Marthaler's staging of the fates and fortunes of a broken petty bourgeoisie places a finger on the pulse of a world for whom the bell has already tolled. Casting an affectionate eye on the banality of the everyday and of life in general, the director and theater musician updates the process of catharsis as no other in the world of theater.

We are relieved to note the gentle rhythm in which the limitations and boredom of our lives has been composed. Through the repetition of minor tragic episodes, Marthaler lends rhythm to the plot, lets ugliness fall by the wayside, gives anonymity the stature of a tragic poet, and makes history out of gray reality.

Text collages in the surrealist tradition, impertinence in the provocative dadaist mold, vulgar street slang, and theater texts are the sources he draws upon. In his hands, obstinate solitude and unreconciled autism are transformed into charmingly apocalyptic worlds. He uses music to transform men in string vests and baggy shorts into veritable choirs of angels reminiscent of some lost civilization.

Set designers Anna Viebrock and Christoph Marthaler have been working together for eight years. Without their dreamlike realities in the form of latently surreal spaces, the narratives of alienated attempts at life that lead to nothing, set to the tune of a merry song about the absurdity of our existence, would be inconceivable. Everything in Viebrock's installations that seems familiar yet troubling is both highly functional and misleading. Starting with the banality of an interior, a boiler or a ventilation shaft, she develops closed stage sets with stairs that lead into nothingness, lifts that move squeaking and grinding, but transporting nothing so that all the figures on the stage, however persistently optimistic they may be, are bound to failure in the space in which they are located.

Christoph Marthaler and Anna Viebrock have worked on Goethes Faust $\sqrt{1}$ + 2 *as well as* Stunde Null *and* Hochzeit *at the Deutsches Schauspielhaus in Hamburg and the Volksbühne in Berlin (*Murx den Europäer! Murx ihn! Murx ihn! Murx ihn ab!; Sturm *and* Eindringling*). Their latest joint project was* Fidelio *at the Frankfurt Opera House.*

J. H./B. F.

Christoph Marthalers inszenierte Schicksalsgemeinschaften eines gebrochenen Kleinbürgertums treffen die Stunde ins Herz, die geschlagen hat. Mit liebevollem Blick auf die Banalitäten des Alltags und des Lebens an sich aktualisiert der Regisseur und Theatermusiker den Vorgang der Katharsis wie kein anderer in der Theaterlandschaft.

Wir sind erleichtert durch den sanften Rhythmus, in dem die Begrenztheit und Langeweile unseres Lebens komponiert worden ist. Durch Wiederholungen kleiner tragischer Anekdoten rhythmisiert Marthaler die Handlungsabläufe, läßt Häßlichkeit verlorengehen, läßt Anonymitäten zu tragischen Poeten und graue Wirklichkeiten zu Geschichten werden.

Text-Collagen surrealistischer Tradition, Frechheiten à la dadaistischer Provokation, Vulgäres und Gesprächsfetzen von der Straße sind neben Theatertexten Marthalers literarische Quellen, aus denen er schöpft. Er zaubert aus verbohrten Einsamkeiten und nicht versöhnten Autisten liebevolle Endzeitwelten. Über Musikalität verwandelt er die Männer in Netzhemden und schlabbrigen Turnhosen in Chöre, rührend schön wie Engel, die an eine zerstörte Kultur erinnern möchten.

Seit acht Jahren arbeiten die Bühnenbildnerin Anna Viebrock und Christoph Marthaler zusammen. Ohne ihre erträumten Wirklichkeiten in Form von latent surrealen Räumen sind die Erzählungen von entfremdeten Lebensversuchen, die zu nichts führen und zu einem fröhlichen Lied über die Absurdität unseres Daseins rhythmisiert werden, nicht denkbar. Alles an den Räumen Viebrocks, die einem bekannt vorkommen und doch irritieren, ist hochfunktional und dennoch trügerisch. Ausgehend von der Alltäglichkeit von Innenräumen, von einem Boiler oder Entlüftungsschacht, entwickelt sie geschlossene Bühnenräume mit Treppen, die ins Nichts führen, Fahrstühle, die zwar quietschend und krachend fahren, aber nichts transportieren, so daß letztendlich alle Insassen des Bühnenbilds trotz zähem Optimismus an dem Raum, in dem sie sich befinden, scheitern werden.

Christoph Marthaler und Anna Viebrock arbeiteten bereits bei *Goethes Faust* $\sqrt{1}$+2 sowie bei *Stunde Null* und *Hochzeit*, am Deutschen Schauspielhaus, Hamburg und an der Volksbühne, Berlin (*Murx den Europäer! Murx ihn! Murx ihn! Murx ihn ab!; Sturm* und *Eindringling*) zusammen. Ihr letztes gemeinsames Projekt war *Fidelio* an der Oper Frankfurt.

J. H./B. F.

Hochzeit, 1995

Gordon Matta-Clark

* 1943 in New York. †1978 in New York.

New York, 1973, a public auction: Gordon Matta-Clark buys fifteen irregularly shaped microparcels in Queens. These strange chunks of terrain – bits of residual urban space – are at once "fake estates" and "reality properties": a three-inch strip along a driveway, a square of blacktop, a stretch of gutte...

"What I basically wanted to do was to designate spaces that wouldn't be seen and certainly not occupied," said Gordon Matta-Clark of these "existing property demarcation lines" which prove that "property is everywhere." Isolating these "metaphoric voids" where functionality runs aground was also a way of subtracting places from the containerization of exploitable space, and considering architecture as environment.

New York, 1976, at the Institute of Architecture and Urbanism: At three o'clock in the afternoon, Gordon Matta-Clark enters the building with a pellet gun. He has been invited to participate in Idea as Model, ready for exhibition the following day. Once in the exhibition space, he opens fire on the windows. In the holes he hangs photographs taken in the South Bronx, showing buildings whose windows were broken by the inhabitants. The images are turned outward, toward the street.

Window Blow-Out (1976) was censored by the architects, who took away the photographs and replaced the broken panes. It was as though by shattering the glass, Matta-Clark had destroyed a symbol and profaned a sanctuary. By pulverizing the window panes to bring in the outside that they held at a comfortable distance, he suddenly connected city central to the poverty-stricken neighborhoods on the urban fringe. His violence against the institution conveyed a critique of the discipline of architecture, which foregrounds its purity in order to background its socio-economic determinants and its underlying ideology.

These two actions express the biting humor, assertive force, and profound sense of political urgency that moved Gordon Matta-Clark. In the years before his death at the age of thirty-five he sought to escape the restraining borders of the gallery and to experiment with alternatives to architecture. Best known for his cutout work on all kinds of buildings, he liked to use the term "Marxist hermeneutics" to describe his artistic activity, which often took "the form of a theatrical gesture that cuts through structural space." Among the many films he realized, City Slivers (1976) is the only one that brings the cutting edge to the film itself. Initially conceived for projection on the façade of a building, the film is a montage of images of New York in knife blades.

P. S.

New York, 1973: Bei einer öffentlichen Versteigerung erwirbt Gordon Matta-Clark fünfzehn in Queens gelegene Kleinstparzellen unregelmäßiger Form. Es handelt sich um merkwürdige kleine Überbleibsel städtischen Lebensraums, die Scheingrundstücke (»Fake estates«) und wirkliches Eigentum (»Reality Properties«) zugleich sind: ein Streifen Asphalt von dreißig Zentimetern Breite entlang einer Garagenzufahrt, ein Stück Gehweg, Teile vom Rinnstein...

»Ich wollte auf Räume aufmerksam machen, die man nicht sehen konnte und die nicht Gefahr liefen, okkupiert zu werden«, sagte Gordon Matta-Clark später über diese »vorhandenen Demarkationslinien«, die beweisen, daß »das Eigentum überall ist«. Die Isolierung dieser »metaphorischen Freiräume«, an denen die Funktionalität Schiffbruch erleidet, läuft darauf hinaus, Orte vor der Containerisierung des nutzbaren Raums zu bewahren und die Architektur als Umwelt zu betrachten.

New York, 1976: Es ist drei Uhr nachmittags, als Gordon Matta-Clark, bewaffnet mit einem Luftgewehr, in das Institut für Architektur und Städtebau eindringt. Er ist eingeladen, sich an der Ausstellung Idea as Model zu beteiligen, die am nächsten Tag eröffnet werden soll. Nachdem er die Ausstellungshalle erreicht hat, zerschießt er alle Fenster. In die Löcher hängt er, mit der Bildseite zur Straße, Photographien von Häusern in der South Bronx, deren Fensterscheiben von den Bewohnern zerschlagen wurden.

Window Blow-Out (1976) wurde von den Architekten zensiert – die Photos wurden entfernt und die Fensterscheiben ersetzt –, als hätte Gordon Matta-Clark, indem er das Glas zerschmetterte, ein Symbol zerstört und ein Heiligtum geschändet. Mit der Zerstörung der Glasscheiben, durch die der zuvor ausgesperrte und auf Distanz gehaltene Außenraum plötzlich Zugang erhielt, hatte Matta-Clark mit einem Schlag die privilegierte Stadtzentrum mit seiner Peripherie benachteiligter Viertel verbunden. Sein gegen die Institution gerichteter Akt der Zerstörung war eine Kritik an der Architektur als Disziplin, die sich hinter der Maske ihrer angeblichen Reinheit versteckt, um ihre Abhängigkeit von den bestehenden sozioökonomischen Verhältnissen und die ihr zugrundeliegende Ideologie zu verschleiern.

Diese beiden Interventionen bezeugen den grimmigen Humor, die lebensbejahende Kraft und die politische Motivation, die Gordon Matta-Clark auszeichneten. Der Künstler, der im Alter von 35 Jahren starb, versuchte sich den enge Grenzen setzenden Zwängen des Galeriebetriebs zu entziehen und experimentierte mit Alternativen zur Architektur. Er war bekannt wegen seiner »Tranchierarbeiten«, die er in den verschieden-

City Slivers, 1976
Film still

sten Gebäuden ausgeführt hatte, und bezeichnete
seine künstlerische Tätigkeit, die oft »die Form einer
den strukturellen Raum tranchierenden theatralischen
Geste« annahm, gerne als »marxistische Hermeneutik«.
Von den vielen Filmen, die er gedreht hat, ist *City Slivers*
(1976) der einzige, der seine Tranchierarbeit mit filmi-
schen Mitteln fortsetzt. Der Film, der eine Montage aus
schmalen, lamellenförmigen Bildern mit New Yorker
Motiven darstellte, sollte ursprünglich auf die Fassade
eines Gebäudes projiziert werden.

P.S.

Steve McQueen

*1969 In London. Lebt und arbeitet/lives and works in London.

Using simple actions and unexpected framings, Steve McQueen creates films in which plot is supplanted by the dramatization of body postures. Outside any conventional narrative, his works question cinematographic language and its laws. Two types of movement, bodily and filmic, enmesh to generate an inner logic whereby political and social issues ranging from the economy of desire to the constitution of identity are experimentally explored.

McQueen exacerbates the tension produced by the conjunction of two theoretically contradictory conceptions of framing. In one, which is geometrically dynamic, the camera seems to compose the image by determining the frame in advance; in the other, marked by a dynamics of action, the camera tends to embrace the movement of the figures and the frame appears to exuded by the bodies themselves. The works play on the contradiction between the modernist aesthetic with its constructed points of view and a naturalist aesthetic attentive to physicality and weight. Thus McQueen can experiment with the filmic process on the basis of the figures, their bodily exertion, the sensuality that emanates from them, and the choreographic grace of their movements in space. For example, Bear (1993) shows two naked men wrestling, clasping each other, striking and embracing, at grips with the substance of life, between combat, desire, and play. In Just Above My Head (1996), a high-angle sequence shot records the appearance and disappearance of the head and occasionally the shoulders of a walking figure, framed at the very bottom of the image against a background of open sky. The projection covers the entire wall from top to bottom, offering the image of a face continually bobbing above and plunging beneath the level of the floor, at times evoking a hallucinatory vision of drowning.

The physical exertion of the protagonist is echoed by the erratic activity of the viewer. Conceived specifically for exhibition galleries, McQueen's films invite one to move about and occupy the space. The experience of these silent films is shaped by the conditions of their presentation. The unaccustomed camera angles reinforce the viewer's keen awareness of his or her own presence. As Steve McQueen relates: "I like to make films in which people can almost pick up gravel in their hands and rub it, but at the same time, I like the film to be like a wet piece of soap – it slips out of your grasp; you have to readjust your position in relation to it, so that it dictates to you rather than you to it." At the intersection of two spaces and two movements – between the gallery and the film – the viewer is also invited to an exercise of mental mobility, a transforma-

Mit Hilfe von einfachen Handlungen und überraschenden Bildeinstellungen realisiert Steve McQueen Filme, in denen die lebendige Darstellung von Körpersprache das Grundlegende ist. Jenseits aller konventionellen Regeln hinterfragt er in seinen Werken die filmische Sprache und ihre Gesetze. Die ihnen zugrundeliegende Logik ergibt sich aus dem Ineinander-Übergehen von zwei Bewegungen: die der Körper und die des Films. In diesen Werken wird so ein ganzes Bündel von politischen und sozialen Problemen, von der Begierde und ihrer Ökonomie bis zur Identitätsbildung experimentell behandelt.

Die Spannung, die in der Verbindung von zwei theoretisch widersprüchlichen Auffassungen von Bildeinstellung liegt, wird von Steve McQueen noch gesteigert. Eine dieser Auffassungen ist eine geometrisch dynamische, das heißt, die Kamera macht das Bild und legt den Rahmen fest, die andere ist dynamisch in der Handlung, die Kamera verschmilzt mit der Bewegung der Personen und der Rahmen scheint von den Körpern selbst abgesondert zu werden. Steve McQueen spielt mit dem Widerspruch zwischen der modernen Ästhetik, mit ihren konstruierten Gesichtspunkten, und einer naturalistischen Ästhetik, die das Physische und die Schwere der Körper berücksichtigt. Mit der Verausgabung der Körper, der daraus entstehenden Sinnlichkeit und der choreographischen Grazie, mit der sie die Bewegungen ausführen, macht Steve McQueen ein filmisches Experiment. In Bear (1993) zum Beispiel kämpfen zwei nackte Männer miteinander, sie schlagen sich und ihre Körper umklammern, umschlingen sich in einem phänomenalen Kampf. In diesen Kampf mischen sich Begierde und Spiel. In Just above My Head (1996) sieht man in einer lang andauernden Szene eine Bildaufnahme, die vor dem Hintergrund des Himmels im unteren Teil des Bildes das Auftauchen und Verschwinden eines Kopfes und eines Teils des Oberkörpers einer gehenden Person zeigt. Durch die vom Fußboden bis zur Decke reichende Projektion auf eine Wand wird das Bild eines Gesichtes geboten, das ständig aus dem Fußboden auftaucht und wieder in ihm versinkt. So wird die Vorstellung geweckt, diese Person würde ertrinken.

Der physischen Verausgabung der Protagonisten entspricht die erratische Aktivität des Zuschauers. Die Filme von Steve McQueen, die für Ausstellungsräume konzipiert werden, regen den Zuschauer dazu an, sich zu bewegen und den Raum einzunehmen. Diese Stummfilme lassen sich nur über bestimmte Präsentationsbedingungen vermitteln. Die ungewohnten Blickwinkel verstärken beim Zuschauer noch das Bewußtsein für seine eigene Körperlichkeit. Zwischen ihm und dem Film entwickelt sich eine intensive Beziehung. Steve McQueen

Catch, 1997
Video still

tion of the self through experience.

 For documenta, *McQueen is preparing a new piece
entitled* Catch.

<div align="right">P. S.</div>

beschreibt das so: »Ich mache gerne Filme, bei denen
die Leute das Gefühl haben, Kieselsteine in der Hand zu
reiben, aber gleichzeitig mag ich es, wenn der Film wie
ein nasses Stück Seife ist – er entgleitet ihnen. Sie müs-
sen ihre Position an den Film anpassen, das heißt also,
der Film sagt ihnen, was sie zu tun haben und nicht
umgekehrt.« Bei der Überschneidung der zwei Räume
und der zwei Bewegungen, denen des Raumes und
denen des Films, wird der Zuschauer zusätzlich zu einer
geistigen Beweglichkeitsübung angeregt: die Transfor-
mation seiner selbst durch das Experiment.

 Für die *documenta* präsentiert Steve McQueen den
Film *Catch*.

<div align="right">P. S.</div>

Yana Milev

*1964 in Leipzig. Lebt und arbeitet/lives and works in Berlin.

The motif of Yana Milev's project for documenta derives from her exploration of the theme of urbanization. Here she differentiates between the sociohistorical and individual/biographical levels, between thesis and antithesis. For her urbanization means "a broadening of horizons." As a "method of tapping and developing ethnic resources and potentials in the individual sphere of experience and communications," urbanization means for her an "expedition into the corporeal realm." Milev sees corporeality as the mystery of existence (hence the Black Box metaphor in her work) and as the necessary point of departure for any cognitive research or cultural production. She brings this concept to bear on the (private and public) urban strategies, manifestoes, and demarcations of Western civilization. Her program system A.O.B.B.M.E. Research <-Urban-> Intervention is embedded within this context.

From the standpoint of a rotating projector, Yana Milev has realized her projection forum in the Ottoneum as an "urban intervention."

The projection cuts across the room at head height as a horizontal field of light, touching the wall as a radial film frieze. Fade-overs turn visual information into film, a commentary on Yana Milev's assertion that "the border is a sculpture of transition." The "sculpture of transition" is an aesthetic principle of deconstruction and is legible as a successive visual text over slides of Berlin's gaping building sites. Archaeology in border areas and interim spaces means archaeology in the border areas of thought which, for her, are the primary manifestation of urbanity.

With "one-way handy screens," the visitor can acquire the projected visual text and thereby dispossess the public viewpoint. By leaving the focal point, the visitor reopens the discourse. After this, the viewer can add data and information to the handy screen and can deposit it at the "A.O.B.B.M.E. checkpoint" on leaving the forum. Thus the roles of "sender" and "receiver" are reciprocal in this discourse.

A.O.B.B.M.E. – Association of Black Box Multiple Environment, is a "Society for Practical Cultural Science" initiated by Yana Milev in 1994.

A.O.B.B.M.E. is used by the artist as an initial and as a stigma (marking oneself by branding one's own skin), as a signet and as a logo, as a designation for her program system and as a designation for her free enterprise, as an identicode and as a label.

Y.M.

Das Motiv von Yana Milevs Projekt für die documenta ist in ihrer Auseinandersetzung mit dem Thema »Urbanisierung« begründet. Sie differenziert dabei zwischen einer gesellschaftlich-historischen Urbanisierung und einer individuell-biographischen Urbanisierung, zwischen These und Antithese. Urbanisierung heißt bei ihr »Erkenntnisgewinnung«. Als »Methode der Erschließung und Entfaltung von ethnischen Ressourcen und Potentialen im individuellen Erfahrungs- und Kommunikationshaushalt« bedeutet Urbanisierung bei ihr »Expedition in den Leib«. Für Milev ist der Leib ein Mysterium der Existenz (daher die Black-Box-Metapher) und Ausgangspunkt jeder Erkenntnisforschung und Kulturproduktion. Dieses Konzept konfrontiert sie mit den urbanen (öffentlichen und privaten) Strategien, Manifesten und Demarkationen der westlichen Zivilisation. In diesem Kontext begründet sie ihr Programmsystem A.O.B.B.M.E. Research <-Urban-> Intervention.

Ausgehend vom Standpunkt einer rotierenden Projektionsmaschine, realisiert Yana Milev im Ottoneum das Projektionsforum als »Urban Intervention«. Die Projektion durchdringt in Kopfhöhe, als horizontal gleitendes Lichtfeld den Raum und tastet als radiales Filmfries die Wände ab. Durch Überblendung wird Bildinformation zum Film und zum Fließtext der Behauptung von Yana Milev: »Die Grenze ist eine Skulptur des Übergangs«. Die »Skulptur des Übergangs« ist ein ästhetisches Prinzip der Dekonstruktion und wird als sukzessiver Bildtext über Dias von aufgerissenen Landschaften Berliner Baustellen lesbar. Archäologie in Grenzen und Zwischenräumen bedeutet für sie Archäologie in den Grenzgebieten des Denkens, das für sie die primäre Manifestation von Urbanität ist.

Mit »Einweg-handy screens« kann sich der Besucher den projizierten Bildtext privat aneignen und das Forum um den öffentlichen Gesichtspunkt (view point) enteignen. Verläßt er seinen Brennpunkt (focal point), gibt er den Diskurs wieder frei. Nach dieser Aktion kann er seine handy screen mit Daten und Informationen versehen und beim Verlassen des Forums am »A.O.B.B.M.E.-checkpoint« hinterlassen. Damit sind die Rollen von »Empfänger« und »Sender« in diesem Diskurs wechselseitig.

A.O.B.B.M.E. – Association Of Black Box Multiple Environments ist ein von Yana Milev 1994 initiiertes »Institut für Angewandte Existenzforschung«.

A.O.B.B.M.E. wird von der Künstlerin benutzt als Initial und als Stigma (Selbstmarkierung durch Einbrennen in die eigene Haut), als Signet und als Logo, als Bezeichnung für ihr Programmsystem und als Bezeichnung für ihr freies Unternehmen, als Identcode und als Label.

Y.M.

A.O.B.B.M.E.
Research <-Urban-> Intervention
Expeditionen – Exkursionen, Berlin 1996
(Projektionsforum mit Material aus »Kinetisches Archiv«, 1996–97)
A.O.B.B.M.E.
Research <-Urban-> Intervention
Expeditions – Excursions, Berlin 1996
(Projection Forum with material from the "Kinetic Archive", 1996–97)
Installation view Galerie EIGEN+ART, Berlin, 1996

Mariella Mosler

*1962 in Oldenburg. Lebt und arbeitet/lives and works in Hamburg.

The point of departure for Mariella Mosler's complex ground reliefs is an analysis of the given space. On the basis of her findings she creates exact geometric designs on paper which are later transferred to the ground and then executed in sand. Important prerequisites for this transposition – alongside the regular size of the grains and the absolute dryness of the industrially sorted sand – are strict adherence to the design and technical precision, unencumbered by any striving for artistic autonomy.

Whereas many of her earlier ornamental ground works were reminiscent of the opulent patterns on oriental brocades, for the Zwehrenturm, a largely neutral, closed space, the artist has created an almost classical meandering surface ornament made up of bordered circular segments. Capable, theoretically, of being continued infinitely, the ornament replicates and shifts the optical center of the room. The original secure sense of space vanishes, giving rise in its place to a feeling of expansion, opening out beyond the existing architectural boundaries.

For Mosler the very process out of which her works emerge is as important as the spatially and geometrically determined construction of her wall and ground images. As the artist herself points out, the enormous effort obviously required to complete one of her sand reliefs provokes repeated comments about the apparent "waste of time." This is a consistent reaction within the logic of a system that speaks shamelessly of "cultural capital." The fact that her aesthetically satisfying works resist being consumed directly seems to be perceived by many as an irritating contradiction. All the more so, as Mosler's ornamental carpets superficially confirm the romantic notion of the artist as genius, imposing order on chaos and thus transforming it into beauty. The very material she has chosen immediately questions this aspiration, as the particular order it forms can only be maintained in a protected space, that is to say, it requires an institutional framework to safeguard its material existence. Metaphors for the paradoxical role of art in capitalist societies, Mosler's designs defy any attempt to introduce them directly into the commercial circuit that exploits "art" as a commodity. In cash terms, the value of the commodity work remains unredeemable.

S.P.

Ausgangspunkt der komplizierten Bodenreliefs Mariella Moslers ist die Analyse des gegebenen Raums. Auf der Basis des Vorgefundenen entstehen auf dem Papier exakte geometrische Entwürfe, die auf den Boden übertragen und anschließend in Sand ausgeführt werden. Wichtige Voraussetzung für die Umsetzung – neben der gleichmäßigen Körnung und vollkommenen Trockenheit des industriell vorsortierten Sandes – ist die von jedem künstlerischen Autonomiestreben freie Unterordnung unter den Entwurf und die handwerkliche Präzision.

Glichen viele ihrer früheren ornamentalen Bodenarbeiten den opulenten Textilmustern orientalischer Brokate, entwickelte die Künstlerin für den Zwehrenturm, einen weitestgehend neutralen, abgeschlossenen Raum, ein klassisch anmutendes mäanderndes Flächenornament aus angeschnittenen Kreissegmenten. Theoretisch unendlich fortsetzbar, vervielfältigt und verschiebt es das optische Zentrum des Raums. Das ursprünglich sichere Raumempfinden löst sich zugunsten einer Öffnung über die existierenden architektonischen Grenzen hinaus auf.

So wichtig wie die situativ bestimmte geometrische Konstruktion ihrer Wand- und Bodenbilder ist Mariella Mosler der Entstehungsprozeß ihrer Arbeiten. Der offensichtliche Arbeitsaufwand, der bis zur Fertigstellung eines ihrer Sandreliefs notwendig ist, provoziert immer wieder Kommentare zur scheinbaren »Verschwendung von Zeit«, erzählt die Künstlerin. Eine nach der Logik eines Systems, das ganz ungezwungen von »kulturellem Kapital« spricht, folgerichtige Reaktion. Daß sich die ästhetisch so befriedigenden Arbeiten einer direkten Konsumption widersetzen, scheint als störender Widerspruch empfunden zu werden.

Um so mehr, als die romantische Vorstellung vom Künstler als Genie, das ordnend Chaos in Schönheit verwandelt, vordergründig durch die Ornamentteppiche Mariella Moslers bestätigt wird. Allein, das gewählte Material stellt diesen Anspruch sofort in Frage, denn die Ordnung kann nur in einem geschützten Raum bestehen bleiben, bedarf also des institutionellen Rahmens zur Sicherung seiner materiellen Existenz. Metapher für die paradoxe Rolle der Kunst in kapitalistisch geprägten Gesellschaften, entziehen sich Moslers Entwürfe einer direkten Einspeisung in den Verwertungskreislauf der Ware »Kunst«. Der in Geld ausgedrückte Wert der Ware Arbeitskraft bleibt nicht eintauschbar.

S. P.

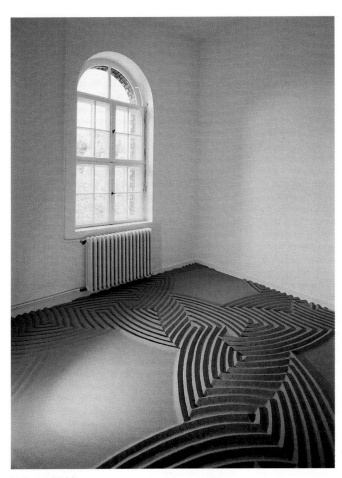

Linien und Zeichen
Installation view Künstlerhaus Bethanien, Berlin, 1996
Detail

Jean-Luc Moulène

* 1955 in Reims. Lebt und arbeitet/lives and works in Paris.

Jean-Luc Moulène uses photography as a tool for studying natural and cultural phenomena as they have been redefined by the development of industry, the media, and commerce.

For documenta, Moulène has devised an experimental procedure both antecedent to and on the periphery of the exhibition. He has conceived a series of color photographs to serve as advertising images for this artistic event. They have been adapted to various advertising media, with no mention of the artist's name. By taking advantage of the sanction offered by documenta's *symbolic legitimacy, Moulène sets up an anonymous procedure for disseminating his images. With this intrusion into distribution networks, where information is entwined with power, he attempts to maintain the experience of alterity precisely where it is endangered. Although, as he notes, "every 'photographic object' is a product," still every photographic image, if it is a public image, may constitute a response to the visual conventions of advertising and counteract the ideology of communication. "The communication model," Moulène asserts, "supports a now quite powerful functionalist utopia, which dreams of an infallible tool for appropriating the social imaginary, and consequently determining social behavior. To get away from this model, it may be enough to stress the gap between the tool and the imaginary so as to produce real poetic alternatives."*

Though simple and familiar in appearance, Moulène's photographs harbor a subtle formal complexity. Since each is intended for public space, the layout of the image presents a figure organized into an axonometric volume (cubes and the interferences formed by the weblike vascularity of leaves, or bodies, reflections, stones, etc.). Each figure is connected to real space via the monochrome background, itself contaminated by the figure and the play of light. The internal configuration of each image outlines a web of analogical associations and anthropological inflections. Still lifes recall stylistic norms from the last three decades: the rock aesthetic in sausages, rap in eggplants, and techno in apples and oranges. Through the composition of the natural elements (matter, body, food), and the play of imaginary resonances, each image becomes a concrete exploration of the physical universe that verges on metaphysical investigation. The bone, akin to a meditation on death, inverts the normal poetic play of its evocations, since the veins of the leaves are what trace the metaphorical outlines of a skeleton. Seated nude is in the typical position of a patient being examined by the doctor, but it also embodies the more exploratory position of shamans

Jean-Luc Moulène verwendet die Photographie als Mittel zum Studium natürlicher und kultureller Phänomene und ihrer Veränderungen infolge des wachsenden Einflusses von Industrie, Kommerz und Medien.

Für die *documenta* hat Moulène mit einem Verfahren experimentiert, das auf einer Metaebene der Ausstellung arbeitet. Er schuf eine Serie von Farbphotographien, die die Rolle von Werbeplakaten für dieses künstlerische Ereignis spielen. Sie wurden in verschiedenen Kommunikationsmedien eingesetzt, ohne daß dabei der Name des Künstlers erwähnt wurde. Indem er unter dem Deckmantel der symbolischen Legitimität operiert, die ihm die *documenta* bietet, installiert Moulène ein anonymes Verfahren zur Zirkulation seiner Bilder. Durch diese Infiltrierung der Kommunikationsnetze, die gleichermaßen Information und Macht repräsentieren, versucht er eine andersgeartete Option gerade dort offenzuhalten, wo sie am gefährdetsten ist. Wenn jedes Objekt der Photographie, wie er sagt, ein Produkt ist, dann kann sich auch jede zum öffentlichen Bild werdende Photographie als Alternative zu den visuellen Konventionen der Werbung anbieten und sich als Gegenmaßnahme zur herrschenden Kommunikationsideologie präsentieren. »Das Kommunikationsmodell«, sagt Moulène, »unterstützt eine heute sehr mächtige funktionalistische Utopie, die von einem unfehlbaren Werkzeug zur Aneignung des gesellschaftlichen Imaginären und damit zur Determinierung des Verhaltens träumt. Diesem Modell kommt man vielleicht schon bei, indem man den Abstand zwischen dem Werkzeug und dem Imaginären betont und so wirksame poetische Realitäten freisetzt.«

Die einfach und vertraut wirkenden Bilder Moulènes sind in Wahrheit von einer subtilen formalen Komplexität. Jede seiner Photographien wurde für den öffentlichen Bereich konzipiert, die Bildebene zeigt ein axonometrisch dargestelltes räumliches Gebilde (Würfel und aus Nervatur gebildete Interferenzen, Körper, Leuchtdichten, Steine etc.). Jede Figur ist mit dem realen Raum durch einen monochromen Grund verbunden, der seinerseits von der Figur und dem Spiel des Lichts infiziert ist. Die innere Konfiguration jedes Bildes entwirft ein Netzwerk aus analogischen Assoziationen und anthropologischen Schwingungen. Stilleben evozieren die stilistischen Normen der drei letzten Jahrzehnte: Rock bei den Würsten, Rap bei den Auberginen und Techno bei den Äpfeln und Orangen. Durch die Verwendung natürlicher Elemente (Materie, Körper, Nahrungsmittel) und das Spiel der imaginären Resonanzen wird jedes Bild zu einer konkreten Erforschung des physikalischen Universums, die an eine metaphysische Fragestellung grenzt. Der Knochen ähnelt einer Meditation über den Tod und

Project documenta X, 1997

healing the ill, linking the "here below" to the "great beyond." Exhibiting nothing while showing oneself entirely.

<div align="right">P. S.</div>

kehrt das poetische Spiel von Evokationen um, denn hier ist es die Nervatur, die das Skelett metaphorisch zur Erscheinung bringt. Der sitzende Nackte nimmt die Haltung eines Kranken ein, der vom Arzt abgehorcht wird, aber diese Haltung ist zugleich auch die forschende Haltung eines heilkundigen Schamanen, der das Diesseits mit dem Jenseits in Einklang bringt. Indem man sich ganz zeigt, zeigt man nichts.

<div align="right">P. S.</div>

<div align="right">**DSR-Project/Projekt**</div>

Reinhard Mucha

*1950 in Düsseldorf. Lebt und arbeitet/lives and works in Düsseldorf.

"The specific pleasure of traveling is not being able to stop off along the way when one is tired, it is to render the difference between departure and arrival not insensible, but as profound as possible, feeling it in its totality, intact, just as we felt it within us when our imagination carried us from the place we lived to the heart of a desired place, in a leap which we found miraculous less because it spanned a distance than because it united two distinct individualities of the earth, leading us from a name to another name, and schematizing (much better than a stroll, where, since one disembarks at will, there is hardly any arrival) the mysterious operation fulfilled in those special places, railway stations, which are almost not part of the city but which contain the essence of its personality just as they bear its name on a lettered sign...

Alas, these marvelous places, railway stations, whence one leaves for a faraway destination, are also tragic places; for if it is there that the miracle whereby the countries which as yet had no existence in our thought become those amidst which we live, for that very reason, upon leaving a waiting room, we must renounce the idea of soon regaining the familiar chamber where we were just a moment before. We must leave all hope of returning to bed in our own home, once we have decided to enter the fetid cavern that gives access to the mystery, in one of those great glass-roofed workshops like that of Saint-Lazare where I went to board the train to Balbec, and which raised above the disemboweled city one of those immense raw skies heavy with the accumulated threat of drama, like unto to certain skies by Mantegna or Veronese, of an almost Parisian modernity, beneath which could only unfold some terrible and solemn act like a departure in a railroad train or the erection of a cross."

Marcel Proust, A la recherche du temps perdu, vol. II, Paris 1954. Transl. B. H.

Auto Reverse (1994–95) (1997) is nothing but another image of the old dream (which has become a childhood dream of the art of this century): overcoming the autonomy of the artwork. That this dream remains unfulfilled is indicated in Auto Reverse. History always draws art back again. The quest to bind art and life together has largely been a failure. What remains are so many images of futility and frustration, as here: a motion, an emotion, frozen in an image, stillness on wheels, in endless repetition. The snake bites its own tail. Please pay the conductor.

<div align="right">R. M.</div>

»Aber im Grunde besteht das spezifische Vergnügen einer Reise nicht darin, die Landstraße entlangzufahren und anzuhalten, wenn man müde ist, sondern den Gegensatz von Abreise und Ankunft statt möglichst unmerklich so einschneidend wie irgend tunlich zu machen, ihn in seiner Ganzheit zu erfassen, wie wir ihn, noch ganz intakt, in unsern Gedanken trugen, als unsere Einbildungskraft uns von jenem Orte, an dem wir lebten, bis ins Herz jener ersehnten Stätte in einem gewaltigen Schwunge trug, der uns wunderbar nicht deshalb schien, weil er eine Entfernung durchmaß, sondern gerade weil er zwei deutlich unterschiedene Orts-individualitäten der Erde miteinander in Verbindung brachte, uns von einem Namen zu einem anderen führte, einen Gegensatz, den uns gerade (besser als eine Spazierfahrt, bei der es, da man inzwischen beliebig aussteigen kann, keine eigentliche Ankunft mehr gibt) das geheimnisvolle Weben an jenen besonderen Orten, den Bahnhöfen, die nicht eigentlich einen Teil der Stadt bilden, sondern ihre Wesen nur noch insofern enthalten, als sie auf einer Signaltafel ihren Namen tragen, in reiner, schematischer Form zum Bewußtsein bringt. ...

Leider sind diese wunderbaren Stätten, die Bahn-höfe, von denen man fernen Bestimmungsorten entge-geneilt, zugleich auch von Tragik durchweht, denn wenn sich in ihnen zwar das Wunder vollzieht, durch das Länder, die bislang nur in unseren Gedanken für uns existierten, zu solchen werden, in denen wir leben und wohnen, müssen wir doch auch aus dem gleichen Grund beim Betreten des Wartesaals darauf Verzicht leisten, gleich wieder in das vertraute Zimmer zurückzu-kehren, in dem wir eben noch waren. Man muß jede Hoffnung fahren lassen, am Abend zu Hause zu schla-fen, sobald man sich entschlossen hat die verpestete Höhle zu betreten, durch die man zum Schauplatz der Mysterien eingehen soll, eine jener großen, glasverklei-deten Werkstätten, wie der Bahnhof Saint-Lazare ist, in dem ich den Zug nach Balbec nahm und der über der offen in ihrer Blöße vor ihr liegenden Stadt einen jener ungeheuren rohen und von dramatischen Drohun-gen trächtigen Himmel aufrollt, ähnlich gewissen Him-meln von fast pariserisch anmutender Aktualität bei Mantegna und Veronese, einen Himmel, unter dem sich einzig ein Akt von furchtbarer Feierlichkeit vollziehen kann wie eine Abreise mit der Eisenbahn oder die Kreuz-erhöhung.«

Marcel Proust: Auf der Suche nach der verlorenen Zeit, Band 2. Frankfurt am Main 1979.

Auto Reverse (1994–95) (1997) ist nichts anderes als ein weiteres Bild aus dem alten Traum (der ein Kindheits-traum der Kunst dieses Jahrhunderts gewesen ist), den

Auto Reverse
Installation view Anthony d'Offay Gallery, London, 1995

Status der Autonomie des Kunstwerkes zu überwinden. Daß dieser Traum unerfüllt geblieben ist, wird in *Auto Reverse* angedeutet. Die Geschichte holt Kunst immer wieder ein. Der Versuch, Kunst und Leben miteinander zu verbinden, ist weitgehend mißlungen. Was bleibt, sind die zahlreichen Bilder der Vergeblichkeit und des Scheiterns, so wie hier: Ein Bild festgestellter Bewegung, Stillstand auf Rädern, in endloser Wiederholung. Die Schlange beißt sich in den Schwanz. Kasse beim Fahrer.
R.M.

Christian Philipp Müller

*1957 in Biel, Schweiz/Switzerland. Lebt und arbeitet/lives and works in New York.

Whether in the form of performances or installations, Christian Philipp Müller's work uses its historical reference to question the conditions of artistic production and reception. Müller decided on his project for documenta during a trip he made to Kassel to begin thinking about his intervention. He was intrigued by the transformation of the Friedrichsplatz following the construction of an underground parking garage. He noticed that the modifications worked against the idea behind the conception as well as our perceptions of two historic artworks installed on the square. As Müller notes, the first and last of Beuys' 7,000 Oaks from documenta 7 "obviously stand in an illogical proportion to the system of the pathways." The red clay plaque that marks the presence of Walter de Maria's Vertical Earth Kilometer *from documenta 6 is now off-center. As it happens, the drilling that was done in the middle of the square met with vehement protests on the part of the residents of Kassel, which were widely reported in the media. Almost a year later, Müller recalls, "the Dia Art Foundation, represented by Heiner Friedrich, had tried, in the deed of gift offered to city of Kassel, to link the ownership of the work of art to certain obligations. The city never accepted the conditions."*

Müller has conceived a project which is an exhibition within an exhibition, proposing a reflection on public art. On the upper story of the Fridericianum, he has built a room around the only window that looks out onto the Friedrichsplatz. Thus, "the change in recognition of Beuys' and De Maria's works via the pseudohistorical form of the square will be evident." The room contains a tightrope-walker's pole, half oak and half brass. The ends of the pole point to the side walls of the room, on each of which is posted information about the production and financing of each artist's works. On each side of the window there is further information about the history of the Friedrichsplatz and of past documenta. A video shows a performance by Müller, pole in hand, walking a tightrope stretched along the ground on the Friedrichsplatz. Müller's work is entitled Ein Balanceakt/A Balancing Act.

In this homage to two artists he greatly admires, Müller has identified with Philippe Petit, famous for walking a tightrope stretched between the two towers of the World Trade Center, carrying a similar pole twenty feet long. "The artists of today have only a small degree of balance between art and its social aspects," Müller states. He adds, "Having neither financial support from a foundation nor the market value of a Joseph Beuys or a Walter de Maria, I am balancing between the great demands and expectations of visitors to documenta." P. S.

Ob als Performances oder als Installationen, in den voller historischer Bezüge steckenden Arbeiten Christian Philipp Müllers geht es stets um die Bedingungen der Produktion und Rezeption von Kunst. Müller entwickelte das Konzept seines Projekts für die *documenta* anläßlich eines Besuchs in Kassel, den er im Hinblick auf seine Beteiligung an der Ausstellung unternommen hatte. Er bemerkte, daß die Umgestaltung des Friedrichsplatzes im Anschluß an den Bau einer Tiefgarage der Konzeption und Rezeption der beiden dort befindlichen Kunstwerke zuwiderlief. Die Standorte des ersten und des letzten Baums von Joseph Beuys' Aktion *7000 Eichen* anläßlich der *documenta 7* »stehen offensichtlich in einem unlogischen Verhältnis zu dem System der Wege«, und die Platte aus rotem Sandstein, die das Vorhandensein des Werks *Der vertikale Erdkilometer* von Walter de Maria signalisiert (*documenta 6*), befindet sich nicht mehr im Zentrum. Gegen die Bohrung in der Mitte des Platzes gab es damals übrigens vehemente Proteste seitens der Kasseler Bevölkerung, von denen die Medien groß berichteten. Beinahe ein Jahr später, erinnert sich Müller, »versuchte die DIA Art Foundation, vertreten durch Heiner Friedrich, in einer Schenkungsurkunde an die Stadt Kassel den Besitz des Kunstwerks an bestimmte Verpflichtungen zu knüpfen. Die Stadt hat die Bedingungen nie akzeptiert.«

Müller hat aufgrund seiner Beobachtungen also ein Projekt realisiert, das eine Ausstellung in der Ausstellung und eine Reflexion über öffentliche Kunst darstellt. Im zweiten Stock des Fridericianums ließ er einen Ausstellungsraum um das einzige Fenster herum bauen, das auf den Platz hinausgeht. »Die Veränderung in der Anerkennung, die die Werke von Beuys und de Maria durch die pseudohistorische Gestaltung des Platzes erfahren haben, wird somit evident.« In dem Saal befindet sich die Balancierstange eines Seiltänzers, deren eine Hälfte aus Eichenholz und deren andere Hälfte aus Messing ist. Ihre beiden Enden zeigen auf die beiden Seitenwände des Saals, auf denen Informationen über die Produktion und die Finanzierung der Werke von Beuys und de Maria zu lesen sind. Zu beiden Seiten des Fensters finden sich Informationen über die Geschichte des Friedrichsplatzes und über die verschiedenen *documenta*-Ausstellungen. Ein Videofilm zeigt eine Performance, bei der Müller mit der Stange in der Hand über ein Seil geht, das auf dem Friedrichsplatz liegt. Das Werk Müllers trägt den Titel *Ein Balanceakt/A Balancing Act*.

Als es darum ging, die beiden von ihm bewunderten Künstler zu ehren, erinnerte sich Müller an den Seiltänzer Philippe Petit, der vor allem dadurch bekannt wurde, daß er über ein zwischen den beiden Türmen des World Trade Center gespanntes Kabel balancierte,

Ein Balanceakt/A Balancing Act, 1997

wobei er eine sechs Meter lange Stange in den Händen hielt. »Heute«, sagt Müller, »müssen die Künstler einen Balanceakt zwischen Kunst und gesellschaftlichen Aspekten vollführen. Ich werde weder von einer Stiftung finanziell unterstützt noch besitze ich den Marktwert eines Joseph Beuys oder eines Walter de Maria, und daher balanciere ich mit einem kleinen Budget zwischen den großen Ansprüchen und den Erwartungen der *documenta*-Besucher.«

P. S.

Matt Mullican

*1951 in Santa Monica. Lebt und arbeitet/lives and works in New York.

Since the early eighties, Matt Mullican has been work-
ing on a great, stratified metaphysical construction.
Though close to an urban structure (since it is described
by the fictive model of a city), this mental construction
was never conceived for physical realization except in
computer-generated images or in the form of scale
models, drawings, or hypertext itineraries, as in his pro-
ject for the website of documenta X.

Conceived more as a cosmology than a utopia,
Mullican's model city is based on an encyclopedic
vocabulary of images and signs whose forms recall the
pictographs one finds in public spaces, on roads or in
airports. This vocabulary constitutes an elusive system
of poetic indicators, highly specific to the artist (a
group of concentric circles does not signify a simple tar-
get or all targets, but a very particular aim: heaven).
Moreover, his sign system is grouped (or subdivided)
into five essential colors each referring to precise sets:
red encompasses the Subjective (pure meaning), black
is for Language (signs and symbols), yellow is what he
calls the World Framed (a microcosm of the whole),
blue is the World Unframed (close to the world in
which we exist), and green denotes the Elements (nat-
ural and raw).

His project for documenta X, Up to 625, functions on
a structure accessed through the five key colors. A first
image in five colors ramifies into five images, which in
turn lead to twenty-five, and so on up to a corpus of
625 images. As the visitor moves through the website
she is led to penetrate deeper and deeper into the
structure, reaching increasingly precise elements. The
overall, abstract vision of the initial images gradually
gives way to concrete and particular objects, whose
location simultaneously becomes less evident. Indeed,
the arborescent pathway lends the deeper-level images
a more intimate quality. Seeing them all would require
a systematic process of remounting and redescending
so as to explore each of the available paths.

In this respect, Matt Mullican has made good use of
the hypertext potential of the net. The visitor is
encouraged to wander fluidly and rapidly through the
structure and the images of the website, as though in
an urban grid with all it contains.

S.L.

Seit dem Beginn der achtziger Jahre arbeitet Matt
Mullican an einer großen, geschichteten metaphysi-
schen Konstruktion. Obwohl diese mentale Konstruk-
tion einer urbanen Struktur ähnlich ist, da sie über den
Umweg des fiktiven Modells einer Stadt beschrieben ist,
war sie dennoch nie dazu gedacht, realisiert zu werden.
Es sei denn in einem zusammenfassenden Bild, und
zwar in Form von Plänen, Zeichnungen oder einem
hypertextuellen Verlauf wie in seinem Projekt für die
Website der documenta X.

Das Modell der Stadt von Mullican, das mehr als Kos-
mologie denn als Utopie geplant wurde, basiert auf
einem enzyklopädischen Vokabular von Bildern und Zei-
chen, die an die Piktogramme für öffentliche Plätze wie
Flughäfen oder auf Straßen erinnern. Dieses Vokabular
besteht aus poetischen, symbolischen Merkmalen, die
sich der Künstler ausdenkt (ein Spiel mit konzentrischen
Kreisen hat nicht die Bedeutung einer Zielscheibe oder
aller Zielscheiben, sondern eines ganz bestimmten Ziels:
des Paradieses, »heaven«). Außerdem ist sein Zeichen-
system in fünf Farben unterteilt, von denen jede ein-
zelne etwas ganz Genaues bedeutet: Rot entspricht
dem »subjective« (»pure meaning«), Schwarz der »lan-
guage« (»signs and symbols«), Gelb dem, was er »world
framed« nennt, (»a microcosm of the whole«), Blau der
»world unframed« (»close to the world in which we
exist«) und Grün den »elements« (»nature and raw«).

Up to 625, sein Projekt für die documenta X, funktio-
niert nach einer Struktur, deren fünf Farben der Schlüs-
sel für den Zutritt sind. Über eine baumartige Verzwei-
gung gibt ein erstes Bild mit fünf Farben Zutritt zu
weiteren fünf Bildern, die wiederum den Zutritt zu 25
Bildern ermöglichen, und so weiter, bis man bei einer
Gesamtheit von 625 Bildern angelangt ist. Je nach Vor-
gehensweise des Besuchers wird er immer tiefer in die
Struktur selbst vordringen und so Zugriff auf immer
konkretere Dinge haben. Die globale und abstrakte
Sichtweise am Anfang tritt Schritt für Schritt ihren Platz
an konkretere, ganz bestimmte Objekte ab, während
gleichzeitig ihre Lokalisierung immer unklarer wird. Da
man auf die Bilder nur über einen verästelten Weg
Zugriff hat, haben die 625 Bilder der untersten Schicht
alle einen intimeren Wert. Um sie alle zu sehen, müßte
man systematisch von einem Niveau zum anderen auf-
und absteigen und alle Wege erforschen.

In dieser Beziehung benutzt Matt Mullican alle hyper-
textuellen Möglichkeiten des Netzes. Der Besucher wird
dazu gebracht, sich rasch und behende in der Struktur
und den Bildern der Website zu bewegen. Er soll sich in
der Website genauso verhalten wie in einer urbanen
Struktur und mit den Bildern genauso umgehen wie mit
den Dingen innerhalb einer solchen Struktur. S.L.

Up to 625, 1997
Screenshot

Antoni Muntadas

*1942 in Barcelona. Lebt und arbeitet/lives and works in New York.

For more than twenty years, Muntadas has been making installations which use deconstructive strategies to reveal the symbolic and political meanings behind agencies and structures like the media, the art gallery, the home, the stadium, the automobile, and television. In all these works, Muntadas has analyzed power relations and exposed their underlying value systems.

On Translation, Muntadas' Internet project, is one part of a series of four projects he realized between 1995 and 1997. The first was On Translation: The Pavilion, which highlighted the importance of translation during international conferences like the European Conference on Security and Cooperation in Helsinki in 1975. The second project, On Translation: The Games, created for the Olympic Games in Atlanta, revealed the cultural disparities in national representations of those Games (an analysis later picked up by the media, which broadened the impact of this work). On Translation: The Transmission consisted of a televised lecture with simultaneous translation.

On Translation: The Internet Project conceived especially for documenta X's website, links three simple concepts: a) the way news spreads by word of mouth; b) the process of translation; and c) the Internet as system and network. Implementing this project requires the use of both public and private networks, in order to link the twenty-odd translators, posted in as many countries, whose job it is to endlessly repeat the translation of a sentence into twenty languages. Transmitted directly from one translator to another by e-mail or fax, "the" sentence varies endlessly, being retranslated anew each time. The difficulty of transmitting information thus recurs on several levels: the co-ordinated network of translators, the interpretation of the text, the illegibility of certain characters as they are transmitted by e-mail, and the constantly evolving nature of the whole.

It is possible to follow this evolution of the phrase from day to day on the World Wide Web. In this new project, Muntadas continues to explore what is at stake in transcription, interpretation, and translation, from language to code, from science to technology, from subjectivity to objectivity. Thus he contributes to making visible the role of translation and translators.

S.L.

Seit mehr als zwanzig Jahren realisiert Muntadas Installationen, die zerlegende Strategien benutzen, um den symbolischen und politischen Sinn aufzudecken, der hinter Instanzen oder Strukturen wie den Medien, Kunstgalerien, dem Heim, dem Stadion, dem Auto, dem Fernsehen steckt. In diesen Arbeiten analysiert Muntadas die Möglichkeiten der Macht, indem er die ihr zugrundeliegenden Wertsysteme aufdeckt und zur Schau stellt.

Das Internet-Projekt On Translation ist Teil einer vierteiligen Arbeit, die Muntadas zwischen 1995 und 1997 realisierte. Das erste Projekt On Translation: The Pavilion zeigt die Bedeutung von Übersetzungen anläßlich einer Konferenz wie der KSZE auf, die 1975 in Helsinki abgehalten wurde. Das zweite Projekt On Translation: The Games wurde während der Olympischen Spiele von Atlanta realisiert und wies auf die kulturellen Unterschiede in den nationalen Darstellungen der Spiele hin (dieses Thema wurde übrigens später auch von den Medien aufgegriffen, was natürlich noch mehr Aufmerksamkeit auf diese Arbeit lenkte). On Translation: The Transmission bestand aus einer Telekonferenz mit simultanen Übersetzungen.

Die nur für die Website der documenta X angefertigte On Translation: The Internet Project setzt drei einfache Konzepte miteinander in Beziehung: a) Flüsterpost; b) den Prozeß der Übersetzung, c) das Internet: das System und das Netz. Für die Realisierung dieses Projekts braucht man private und öffentliche Informationsketten, da ein ganzes Netz von Übersetzern in zwanzig Ländern damit beschäftigt ist, ständig einen Satz in zwanzig verschiedene Sprachen zu übersetzen. Die Übersetzung wird durch E-Mail oder per Fax direkt von einem Übersetzer zum anderen übertragen, und es stellt sich heraus, daß sich »der« Satz permanent ändert, da er jedesmal neu interpretiert wird. Die Schwierigkeit der Übertragung dieser Information liegt also auf mehreren Ebenen: das koordinierte Netz an Übersetzern, die Interpretation des Textes, die Unleserlichkeit mancher Buchstaben durch die E-Mail, die konstante Entwicklung.

Auf dem World Wide Web kann man die Entwicklung dieses Satzes Tag für Tag verfolgen. So beschäftigt sich Muntadas nun auch in seinem neuen Projekt weiterhin mit dem Spiel der Übertragung, der Interpretation und der Übersetzung der Sprache in einen Code, der Wissenschaft in eine Technologie, der Subjektivität in die Objektivität und trägt so dazu bei, die Rolle der Übersetzung und der Übersetzer deutlich zu machen.

S.L.

On Translation: The Internet Project, 1997
Screenshot

Matthew Ngui

*1962 in Singapur/Singapore. Lebt und arbeitet/lives and works in Perth, Australien und Singapur/Australia and Singapore.

One of Matthew Ngui's primary concerns is the relation between cultural traditions and contemporary reality. He travels frequently between Singapore and Australia and much of his work develops between the two places, in conceptions that are marginal, crossed or mixed. In this process, he contends, "individual and cultural identity is challenged and then affirmed."

"You can order and eat delicious poh-piah", amongst other things is a performance installation whose title invites verification. As Ngui says: "the only way to test the 'truth' is to attempt to order it through the tube ... the installation in a nutshell deals with the need to test representations so as to ascertain the 'true meaning' of it." "You can order and eat delicious poh-piah", amongst other things articulates several different spaces. The "red thread" is a tube through which one can talk with the cook. He answers by typing on a computer keyboard connected to a screen placed at the visitor's feet. Successive rooms contain documents on the artist's personal identity, along with various other works such as the anamorphic chairs. These three-dimensional illusions lead the artist to observe that "a singular point of view can be false and incorrect." Indeed, as he explains further, "the idea of the shifting point of view as a tool of investigation is central to much of the work."

Cooking is an activity that is at once fundamentally human and culturally coded to an extreme. In the installation it contributes to an interactive scenario where each participant brings different meanings into play: "ideas around taste, aesthetic pleasure, pleasurable kitsch, representation (and expression) and how the diverse nature of 'cultural' identity is related to these." Thus the work concentrates on highly specific points with an extremely general value: "it is because of this intrinsic participation in a wider game that much of the artwork is focused onto the very particular smaller but interesting bits of culture (what can sit outside of culture?) which are often overlooked because of their ubiquity. Through analysis and visual investigation, these emerge as major players within aspects of culture, be it as aesthetic expression, practical solution, or representative of philosophical trends held by people. Talking, arguing, cooking, eating, seeing, investigating, resting, and being become the food for making the work."

P. S.

Eines der zentralen Themen Matthew Nguis ist die Beziehung zwischen kulturellen Traditionen und heutiger Wirklichkeit. Da er viel zwischen Singapur und Australien hin und her pendelt, ist ein großer Teil seiner Arbeit von diesem Leben zwischen zwei Kulturen geprägt und reflektiert ihren Gegensatz, ihre Mischung und vielleicht auch ihre Randlage. Dadurch stellt sie die individuelle und kulturelle Identität zunächst in Frage, um sie dann von einem neu gewonnenen Standpunkt wieder zu bejahen. Das Werk Matthew Nguis (Installationen, Filme, Performances) hinterfragt die Konstitution von Bedeutung in Repräsentation, Illusion und Kommunikation.

»You can order and eat delicious poh-piah«, amongst other things ist eine Performance/Installation, deren Titel zu einer Verifizierung verlockt. Ngui sagt dazu: »Die einzige Möglichkeit, herauszubekommen, ob das stimmt, besteht darin, über das Rohr die Bestellung aufzugeben. Bei der Installation geht es um die Notwendigkeit, Repräsentationen zu überprüfen, um ihre wahre Bedeutung zu ermitteln.« »You can order and eat delicious poh-piah«, amongst other things ist eine Installation, die sich über mehrere Räume erstreckt. Ihr »Interaktivposten« ist ein Rohr, durch das man mit dem Koch sprechen kann. Dessen mit Hilfe einer Tastatur gegebene Antwort entnimmt man einem Computerbildschirm. In den anderen Räumen sind Objekte und Dokumente zu sehen, die die persönliche Identität des Künstlers betreffen, sowie einige andere seiner Arbeiten wie zum Beispiel die »verzerrten Stühle«. Diese dreidimensionalen Illusionen belegen für den Künstler, daß »es falsch und unrichtig sein kann, die Dinge nur aus einem einzigen Gesichtspunkt zu betrachten«, und sie zeigen dem Betrachter an, daß im Zentrum eines großen Teils von Nguis Arbeit die Idee steht, den tiefsten Einblick in die Dinge erhalte man aus einem »sich verschiebenden Blickwinkel«.

Kochen ist eine fundamentale menschliche Tätigkeit und zugleich auch eine der kulturell am meisten codierten. In Nguis Installation trägt sie zu einem interaktiven Szenarium bei, innerhalb dessen von den Beteiligten jeweils unterschiedliche Sinnsysteme ins Spiel gebracht werden: »unterschiedliche Vorstellungen über Geschmack, ästhetisches Wohlgefallen, gefälligen Kitsch, Repräsentation (und Expression) sowie darüber, wie die ›kulturelle‹ Identität in ihren vielfältigen Formen damit in Zusammenhang steht.« Diese Arbeit zeugt auch von einer Konzentration des Künstlers auf etwas Spezifisches von zugleich übergeordneter Bedeutung: »Weil die Kunst stets in ein umfassenderes Spiel verstrickt ist, vermag sie sich auf jene ganz besonderen kleineren, aber dennoch interessanten Bestandteile der Kultur zu

You Can Order and Eat Char Kwey Teow (Cooking fried Rice)
Installation view Biennale São Paulo, 1996

konzentrieren (was könnte sich außerhalb der Kultur befinden?), die oft wegen ihrer Allgegenwärtigkeit übersehen werden. Werden sie zum Gegenstand einer Analyse und visuellen Untersuchung, so sieht man plötzlich, daß sie im Gefüge einer Kultur eine Hauptrolle als ästhetische Ausdrucksform, praktische Lösung oder Repräsentant philosophischer Neigungen spielen. Sprechen, Streiten, Kochen, Essen, Sehen, Erforschen, Ausruhen und Existieren sind der Stoff, aus dem meine Arbeiten sind.«

P.S.

Carsten Nicolai

*1965 in Chemnitz (Karl-Marx-Stadt). Lebt und arbeitet/lives and works in Chemnitz und/and Berlin.

Vast areas of the city of Kassel were totally destroyed during the war, and today the city center is primarily service-oriented. Thus, like most larger cities in Germany, Kassel's architectural and social design is functional.

With his work ∞ Carsten Nicolai was determined to enter into that urban space. For this purpose he has utilized sounds, so-called SPINs, generated out of technical signals, radio transmission noises, or human speech. By superimposing several continuous loops – made up of these everyday noises and played at either an extremely slowly or extremely fast speed – new, none too easily identifiable sounds emerge. At various points throughout the city of Kassel where one would normally expect background sounds or music of some kind, these SPINs are being filtered in, places such as the airport, department stores, the railway station, and the radio.

The work's visual emblem is a logo consisting solely of one sign, and is to be found in various forms around the city (stamps, stickers, stencils). This logo, borrowed from the world of mathematics, stole its way into Nicolai's painting and graphic work some time ago where it became part of a private iconography. As used in Kassel, however, the sign has again been reduced to its essence. The artist refers to it as a homunculus, a hybrid being which he utilizes like a logo. "Like the sounds, this graphic motif is to be integrated into the urban space in an attempt to smuggle an individual 'language' into everyday life. My work is intended as a disruption of everyday life, aimed at encouraging observers to concern themselves with their surroundings and to use their own sensitivity."

The public presentation of the SPINs is of central importance in defining the work. The ramp in the Kaufhof parking lot, more precisely, the eye of the double spiral leading up to the parking levels, has been chosen as the ideal place for this performance. On June 21 and 22, 1997, all the SPINs distributed throughout the city will be linked for a single performance that will take place here on a platform shaded by a sail bearing a large ∞ sign. After the performance, the platform and sail will remain in place as an installation.

From the very beginning, Carsten Nicolai's work has betrayed a tendency to regard art as a social practice, functioning on the basis of a half open set of signs. This was clearly recognizable in his Cellar exhibition in 1988. Since the early 1990s and the founding of NOTON, Archiv für Ton und Nicht-Ton (Archive for Sound and Non-Sound), he has been concentrating on the production of auditory works. His performative interventions into the world of the everyday aim not

Kassel ist eine weitestgehend kriegszerstörte Stadt, deren Zentrum in erster Linie Dienste leistet. Sie ist daher, wie die meisten größeren Städte in der Bundesrepublik, sowohl architektonisch als auch sozial funktional ausgerichtet.

Carsten Nicolai beschloß, mit seiner Arbeit ∞ in diesen Stadtraum hineinzugehen. Er benutzt dazu Töne, sogenannte SPINs, die aus technischen Signalen, Radiogeräuschen oder menschlicher Sprache generiert wurden. Durch die Überlagerung mehrerer Endlosschleifen, die auf der Basis dieser Alltagsgeräusche entstanden und entweder extrem verlangsamt oder stark beschleunigt abgespielt werden, entstehen neue, schwer identifizierbare Sounds. Die SPINs werden an verschiedenen Plätzen im Stadtraum, wo gewöhnlicherweise mit Beschallung in irgendeiner Form zu rechnen ist, infiltriert. Der Flughafen, die Kaufhäuser, der Bahnhof und das Radio sind solche Orte.

Als visuelles Signet der Arbeit dient ein auf ein Zeichen reduziertes Logo. In verschiedenen Ausführungen (Stempel, Sticker, Pochoir) findet es sich überall in der Stadt. Dieses Logo, aus der Welt der Mathematik entliehen, hatte sich schon vor geraumer Zeit in das malerische und zeichnerische Schaffen Carsten Nicolais eingeschlichen. Dort eher Teil einer privaten Ikonographie, reduziert sich das Zeichen in Kassel wieder auf sich selbst. »Ein Homunculus, ein Hybridwesen«, nennt es der Künstler, das wie ein Logo eingesetzt wird. »Das Zeichnungsmotiv wird sich – ähnlich den Sounds – im Stadtraum einordnen und den Versuch unternehmen, eine individuelle ›Sprache‹ in das Alltagsleben einzuschleusen. Meine Arbeit soll eine Störung des Alltäglichen sein«, erklärt Carsten Nicolai, »daß der Betrachter beginnt, sich mit dem, was ihn umgibt, zu beschäftigen, und seine eigene Sensibilität nutzt.«

Eine zentrale Rolle für die Definierbarkeit der Arbeit hat die Aufführung der SPINs. Als idealer Ort für diese Performance wurde die Auffahrt des Parkhauses der Kaufhof AG, genauer das Auge der doppelläufigen Spirale, die zu den Parkdecks führt, ausgewählt. Auf einer Plattform, die ein Segel überschattet, das ein großes ∞ Sign trägt, kommen vom 21. zum 22. Juni 1997 die im Stadtraum verteilten SPINS ein einziges Mal miteinander verknüpft zur Aufführung. Plattform und Segel bleiben danach als Installation zurück.

Die Tendenz, Kunst als gesellschaftliche Praxis zu verstehen, die auf der Basis halboffener Zeichensysteme funktioniert, ist bei Carsten Nicolai bereits am Anfang seiner Karriere, in der Keller-Ausstellung 1988, zu erkennen. Seit Beginn der neunziger Jahre, mit der Gründung von NOTON Archiv für Ton und Nicht-ton, entstehen vermehrt Soundarbeiten. Mit seinen performativen Ein-

NOTO, 1996

only at re-introducing art back into life, but at transforming life, at least in places, into art by questioning our everyday perceptions.

S.P.

griffen in die Welt des Alltäglichen soll nicht nur die Kunst ins Leben zurückgeführt, sondern durch die Selbstbefragung unserer Alltagswahrnehmung das Leben wenigstens streckenweise in Kunst überführt werden.

S.P.

Olaf Nicolai

*1962 in Halle/Saale. Lebt und arbeitet/lives and works in Leipzig und/and Berlin.

Olaf Nicolai studied literature, philology, and semiotics. A seminal idea in his artistic works is the concept of "collection." Collection not only as principle in museums for art or natural science but, more generally, in the sense of arrangements that form our contemporary world as mediated presentations. Therefore, collection is understood as a program that structures and interprets. But the principles of collecting in institutions such as libraries, museums, and archives are not exclusively administrative. They are processes of production that begin to structure our daily life and environment. Nicolai takes up these techniques in his work and makes reference to their underlying axioms. "All things in this cosmos function as signs, and are part of a matrix which works as a kind of grammar organizing the assignment of particles. In this way structures are created that, like texts, are revelation and program at the same time – the world as text." It is sufficient to know the code, its elements and its rules, to be able to produce new configurations. His work is a process of "synthetic analysis" that discusses by representing.

For documenta he has realized a work which questions the disappearance of a distinction fundamental to Western culture, the distinction between the natural and the cultural. "The interplay of nature and construction is the theme of my work for documenta, Interior/ Landscape. A Cabinet," states Nicolai. With the help of a botanist from the University of Leipzig, he used plants to construct miniature landscapes on five volcanic rocks, expressing the "beauty" of nature through the artificiality of process. "The criteria of design are transmitted to the biological material," Nicolai points out. The plants will continue to grow throughout the course of the exhibition. In the same room, he has complemented these "biological sculptures" using two traditional elements of interior design. The walls are papered with the motif of a plant in silhouette, one that has no existence in reality, but is a kind of idealized representation of a plant, a pictogram. On the wall he has hung what seems to be the photograph of a landscape with great quantities of foliage, as in Italian vedute. That image is in fact a microphotograph of volcanic lava.

Endlessly pushing the relationship between perception and the identity of the thing perceived, this installation was realized for an exhibition commemorating the bicentennial of German romanticism, which emerged around the Jena circle. As the artist puts it, "Here the path leads from romanticism (as in Edgar Allan Poe's idea that natural beauty is never as great as beauty that can be added) to the contemporary utopia of biotechnology (as in Kevin Kelly's vision of the artifi-

Olaf Nicolai studierte Literatur, Philologie und Semiotik. Eine zentrale Idee seiner künstlerischen Arbeit ist das Konzept der »Sammlung«. Es bezieht sich jedoch nicht nur auf Kunstsammlungen oder naturwissenschaftliche Museen, sondern meint vor allem die Arrangements unserer heutigen Lebenswelten als mediale Präsentationen. In diesem Sinn ist die »Sammlung« als ein Programm zu verstehen, das interpretiert und strukturiert. Sammlungstechniken, die an Orten wie Bibliotheken, Museen oder Archiven benutzt werden, sind weniger Verwaltungstechniken, als vielmehr Produktionstechniken, die die Umgebungen und den Alltag zu bestimmen beginnen. »Urbane Räume, Landschaften, Privatheit, der eigene Körper sind Konstruktionen aus verschiedensten Elementen und werden selbst zu Elementen von Konstruktionen.« In seinen Arbeiten greift Olaf Nicolai Techniken dieser Konstruktionen auf und verweist zugleich auf das ihnen innewohnende Axiom: »Alle Dinge in diesem Kosmos ähneln Zeichen, sind Teil einer Matrix, die als eine Art Grammatik funktioniert und die die Verteilung der Partikel organisiert. Auf diese Weise bilden sich Strukturen, die Texten gleichen und Offenbarung wie Programm zugleich sind – die Welt als Text.« Dies bedeutet auch: Kennt man den Code, seine Elemente und seine Regeln, wird auch die Gestaltung neuer Konfigurationen möglich. Nicolai begreift seine Arbeitsweise als »synthetische Analyse«, die dies zur Diskussion stellt, indem sie es vorführt.

Bei der *documenta* ist er mit einem Werk vertreten, das dem Verschwinden eines für die abendländische Kultur grundlegenden Unterschieds nachspürt, nämlich des Unterschieds zwischen dem Natürlichen und dem Künstlichen. »Das Thema meiner Arbeit *Interieur/Landschaft. Ein Kabinett* (1996–97), ist das Wechselspiel zwischen Natur und Konstruktion«, erklärt Nicolai. Aus fünf Lavasteinen und aus Pflanzen hat er mit Hilfe einer Botanikerin der Universität Leipzig Miniaturlandschaften konstruiert. »Das Kriterium des Designs«, sagt Nicolai, »wird auf das biologische Material übertragen.« Durch das Wachstum der Pflanzen verändern sich diese Konstruktionen in der Zeit der Präsentation. Seine »biologischen Skulpturen« sind von zwei traditionellen innenarchitektonischen Elementen gerahmt. Auf Teilen der Wände des Ausstellungsraumes befindet sich eine Mustertapete, die das Motiv einer in ihren Umrissen dargestellten Pflanze wiederholt. Diese Pflanze ist eine imaginäre und ähnelt einem exemplarischen Modell: eine fiktive idealtypische Pflanze, ein Piktogramm. Auf der Tapetenwand findet sich auch das zweite Element. Es sind Photographien, die Ausschnitte aus Landschaften zeigen und an italienische Veduten erinnern. Diese Bilder zeigen jedoch tatsächlich Detailvergrößerungen

Interieur/Landschaft, 1996–97
Installation view Carl Zeiss Jenoptik AG, Jena, 1996
Detail

*cial habitat, rather than nature, as the ideal construct)
– the world as text to be laid out. And the program-
mers start to dream."*

P.S.

von den Miniaturlandschaften der Lavasteine.

Diese Installation, die das Verhältnis der Wahrneh-
mung zur Identität der Dinge unablässig verwirrt, wurde
für eine Ausstellung geschaffen, die aus Anlaß des zwei-
hundertjährigen Jubiläums an die Bildung des Jenaer
Frühromantikerkreises erinnern sollte. Nicolai sagt dazu:
»Hier führen die Wege von der Romantik (E.A. Poe:
›Die ursprüngliche Schönheit ist niemals so groß, wie
jene, welche noch hinzugefügt werden kann.‹) zu den
heutigen biotechnologischen Utopien (Kevin Kellys
Vision eines idealen künstlichen Lebensraums, bei dem
die Konstruktion an die Stelle der Natur tritt). Die Welt
als Text, den man nicht nur auslegen, sondern auch
layouten muß. Und die Programmierer beginnen zu
träumen.«

P.S.

Stanislas Nordey

*1966 in Neuilly sur Seine. Lebt und arbeitet/lives and works in Paris.

Stanislas Nordey's plays go back to a tradition of using theatrical means for speaking out publicly. To do so, the director has made the question of language the very heart of his "laboratory" – specifically when this question is brought to the point of literal incarnation, when the body of the actor becomes the "spokesman" bearing the text in the strict sense of the word. No doubt this came about as a reaction to the many years of domination by the image, a time when theatrical practice moved away from directly and politically addressing the public. The theater of images found itself suddenly turned (in the sense that one "turns" a secret agent) under the pressure of the present-day worldwide bath of the visual, and the parallel assault of commodity and spectacle. It thereby lost the critical sense that, since the time of the great Greek tragedies, has constituted the deepest meaning of the theatrical act.

For Nordey, this act of returning to the text extends to a veritable politique des auteurs. Foremost in this regard is the director's journey through the opus of Pier Paolo Pasolini. In taking this aesthetic position, Nordey cited the fact that the author of Accatone and Teorema had argued in his manifesto for a "theater of language." Even more significantly, it is the circulation and recycling of all those physical, social, political and sexual energies that interests Nordey, just as Pasolini, in his films and novels, had worked to expose societal mechanisms of alienation. This twofold task culminated in Nordey's trilogy of Bête de style, Calderon and Pylade.

The most emblematic achievement of his approach was the staging, in 1994, of Hervé Guibert's play Vole mon dragon, originally written for the deaf-mutes of the International Visual Theater. Confronted with a language of signs, with words made visible through the gestural, the director went straight to the heart of the matter: the delineation of various states of the body (nudity, the theater of cruelty) as it undergoes experiences of extreme limits. This production, which lasted seven hours, proved that a "time for speaking," when it connects with the lived time of the spectator, can reach hallucinatory heights. The following year Nordey brought his troupe to the Théâtre des Amandiers in Nanterre, outside Paris, for a coproduction with Jean-Pierre Vincent.

Thus began a period of collaboration with one of the most powerful theatrical machines in France. Nordey put on Jean Genet's Splendid's, Heiner Müller's Cement, Shakespeare's A Midsummer Night's Dream, as well as Wyspianski's The Wedding. Without giving up his research into the political status of representation, he began exploring a continent closer to collective his-

Die Inszenierungen Stanislas Nordeys ergreifen mit den Mitteln des Theaters öffentlich das Wort. Zu diesem Zweck widmet der Regisseur sich in seinem »Laboratorium« wieder vor allem der Frage, wann der Punkt erreicht ist, an dem Sprache wirklich verkörpert wird, das heißt, wann der Körper des Schauspielers im eigentlichen Sinne zum »Sprachrohr« des Textes wird. Das stellt sicherlich eine Reaktion auf die langen Jahre der Dominanz des Bildes dar. Die Praxis des Theaters ging weg von einer direkten und politischen Ansprache des Publikums. Das Theater des Bildes mußte plötzlich feststellen, daß es unter dem Druck der allgegenwärtigen, weltumspannenden hautnahen Präsenz moderner Visualisierungen »umgedreht« worden (wie ein Geheimagent, den man umdreht) und zur Ware und zum Spektakel verkommen war. Es hatte sein kritisches Potential eingebüßt, das seit den großen griechischen Tragödien der tiefere Sinn des Theaters ist.

Diese Geste der Rückkehr zum Text ist für Stanislas Nordey mit einer Autorenpolitik verbunden. In diesem Zusammenhang ist vor allem seine Auseinandersetzung mit dem Werk Pier Paolo Pasolinis zu erwähnen. Die Ästhetik Stanislas Nordeys greift teilweise die Ästhetik wieder auf, die der Autor von Accatone und Teorema in seinem Manifest für ein »Theater des Worts« theoretisch formuliert hatte. Aber signifikanter noch ist Nordeys immer wieder von neuem erfolgende Auseinandersetzung mit den Phänomenen der Aneignung physischer, sozialer, politischer und sexueller Energien, ähnlich der Vorgehensweise Pasolinis, der in seinen Filmen wie in seinen Romanen immer darauf abzielte, die Entfremdungsmechanismen in unserer Gesellschaft zu entlarven. Diese Gemeinsamkeit gipfelte in Nordeys pasolinischer Trilogie Bête de style, Calderon und Pylade.

Der Weg Nordeys fand seinen sinnbildlichsten Ausdruck 1994 mit der Inszenierung von Vole mon dragon, eines Stücks, das Hervé Guibert für die Taubstummen des International Visual Theatre geschrieben hatte. Konfrontiert mit einer Sprache der Zeichen, mit einem durch die Geste sichtbar gemachten Wort, geht der Regisseur sein wahres Thema an: die Sichtung der Körperzustände (Nacktheit, Theater der Grausamkeit), wenn sie einer Grenzerfahrung unterworfen sind. Dieses siebenstündige Schauspiel war der Beweis dafür, daß eine »Redezeit«, wenn sie mit der vom Betrachter erlebten Zeit zusammenfällt, eine halluzinatorische Wahrheit erlangt. Im Jahr darauf übernahm Stanislas Nordey zusammen mit Jean-Pierre Vincent die Leitung des Théâtre des Amandiers in Nanterre, wohin er seine um neue Kräfte erweiterte Truppe mitnahm.

Damit begann eine Periode, in der er mit Hilfe einer der leistungsfähigsten Theatermaschinerien Frankreichs

Le Songe d'une nuit d'Eté, 1995

tory. The productions are sparer, seeking a return to the origins of individual speech. On another level, one cannot disregard the director's engagement in the great social movements that France is currently experiencing, continuing his work as a civil artist in other forms, committed to "the weapons of poetry," in Pasolini's words, for redefining public space, and calling for radical resistance against the forces of exclusion.

Y. C.

Splendid´s von Jean Genet, *Zement* von Heiner Müller, *Ein Sommernachtstraum* von William Shakespeare und *Die Hochzeit* von Stanislaw Wyspianski inszenierte. Ohne seine Erforschung des politischen Status der Darstellung zu vernachlässigen, erkundet er nun auch einen stärker mit der kollektiven Geschichte verbundenen Bereich. Die Inszenierungen reinigen und verfeinern sich, um wieder zu einem Ursprung des individuellen Sprechens vorzustoßen. Andererseits darf man allerdings das Engagement des Regisseurs für die großen sozialen Bewegungen nicht vergessen, die Frankreich beunruhigen. Damit setzt er in anderer Form seine Arbeit als politischer Künstler fort, der mit den »Waffen der Poesie« (Pasolini) um die Neubestimmung des öffentlichen Raums kämpft und gegenüber den Mächten der Exklusion zu einem radikalen Widerstand aufruft.

Y.C.

100 Days – 100 Guests / 100 Tage – 100 Gäste
Theater Outlines/Theaterskizzen 5.–7. 9. 1997

Hélio Oiticica

*1937 in Rio de Janeiro. †1980 in Rio de Janeiro.

Hélio Oiticica, a major figure of the Brazilian avant-garde in the sixties and seventies, began his work amid the cultural effervescence of the late fifties, marked by a strong desire for political reform. His generation shared the basic assumption that cultural change was necessary for social transformation. He participated in the neoconcrete movement, which rejected the easel painting and attempted to move the experience of color into space and time, as in the work of Mondrian. Oiticica rapidly sought to broaden his conceptions to embrace a "general constructive will." Melding an original interpretation of artistic modernity with contributions from Brazil's highly pluralistic society, he developed his art as a kind of ordered delirium, an organized trance.

The Bólides (1963–66) bear witness to his research into sensorial perception and color. They are manipulable works which, as the artist says "are consumed with light, through color." Oiticica defines them as "trans-objects," thereby underscoring their lack of autonomy and their relational, participatory role. In his view, an open work, calling for the total participation of the viewer, can be modeled on the interactions of popular gatherings, so as to achieve a collective dimension of an ethical, social, and political order. Thus in 1964 he carried out his first Parangolés, derived from his experience as a dancer in Mangueira and conceived to be worn during samba parades. These colored clothing pieces transform the wearer into a living sculpture. Even more than in his preceding works, Oiticica began recycling elements of the daily life in the street and the favellas. Projeto cais te caça (Hunting Dogs Projects), 1960, is a model for an environmental project: a garden composed of five of his Pénétrables, along with Ferreira Gullar's Buried Poem and Reynaldo Jardim's Integral Theater. The labyrinthine structure of the work was meant to be revealed only to those who walk through it.

An artist, theorist, and poet, seeking for a vocabulary at once plastic and verbal, Oiticica took his inspiration from Oswald de Andrade's definition of "anthropophagia," that is, the process whereby the colonized devour and digest elements of the dominant culture, to juxtapose them with other elements found on their own cultural terrain. Without any recourse to a mythological universalism, Oiticica's work proposes an expressly Brazilian artistic image, in response to Americanized modernist norms. His work inspired the tropicalist movement, whose initial, broadly anti-imperialist intention (before its unfortunately rapid watering-down) was to reveal the vital and specific potentiality of an indigenous culture in formation, freed from the exotic gaze. Through his work on sensory perception,

Hélio Oiticica, einer der wichtigsten Vertreter der brasilianischen Avantgarde der sechziger und siebziger Jahre, begann seine künstlerische Laufbahn in jener kulturellen Aufbruchsstimmung, die das Land gegen Ende der fünfziger Jahre erfaßte und die mit einem Verlangen nach politischen Reformen einherging. Wie seine ganze Generation, so war auch Oiticica von der Idee beseelt, daß man, um die Gesellschaft zu verändern, die Kultur verändern müsse. Er beteiligte sich an der neokonkreten Bewegung, die das Staffeleigemälde ablehnte und die Erfahrung der Farbe (jener Farbe, um die es Mondrian ging) räumlich und zeitlich zu verschieben trachtete. Oiticica versuchte schon sehr bald, seine Vorstellungen auf einen »konstruktiven Allgemeinwillen« hin zu erweitern. Er verband eine eigenständige Deutung künstlerischer Modernität mit spezifisch brasilianischen gesellschaftlichen Komponenten, und so gelang es ihm, sein Werk als eine Art von geregeltem Delirium, von organisierter Trance zu entwickeln.

Die Bólides (1963–66) sind Ausdruck seiner Arbeit über Probleme der Sinneswahrnehmung und der Farbe. Es sind manipulierbare Arbeiten, die, wie der Künstler sagte, »sich durch die Farbe vor Licht verzehren«. Oiticica definierte sie als »Trans-Objekte« und betonte damit ihre fehlende Autonomie und ihre Ausrichtung auf Beziehung und Beteiligung. Für ihn kann ein Kunstwerk, das eine totale Beteiligung des Betrachters verlangt und in ethischer, politischer und sozialer Hinsicht eine kollektive Wirkung erzielen will, sich getrost an populären Manifestationen ein Beispiel nehmen. Aus diesem Grund entstehen 1964 seine ersten Parangolés, die dazu gedacht waren, während der Sambafestivals auf den Straßen getragen zu werden, und die sich aus seinen Erfahrungen als Tänzer in Mangueira herleiten. Diese farbenfrohen Gewänder verwandeln ihren Träger in eine lebende Skulptur. Mehr noch als bei seinen vorherigen Werken setzt Oiticica hier auf die Verwendung von Elementen des Alltagslebens in den »favellas« und auf den Straßen Rios. Projeto cais te caça (1960) ist das Modell eines Environments. Es handelt sich um einen Garten aus fünf seiner Pénétrables, dem Buried Poem von Ferreira Gullar und dem Integral Theater von Reynaldo Jardim. Die labyrinthische Struktur des Werkes enthüllt sich nur jenen, die es durchlaufen.

Der Künstler, Theoretiker und Dichter Oiticica orientiert sich bei seiner Erkundung eines zugleich plastischen und sprachlichen Vokabulars daran, wie Oswald de Andrade 1928 »Anthropophagie« definierte, also an einem Prozeß, bei dem der kolonisierte Mensch ausgewählte Elemente der Kultur seines Kolonialherrschers in sich aufnimmt, um sie sich anzueignen und sie disparaten heimischen oder entlehnten kulturellen Elementen

Oiticica in seinem Atelier/his studio, Ataulfo de Paiva, Rio de Janeiro, 1972

Oiticica aimed at an overall deconditioning which would invite, in Mario Pedrosa's words, "an experimental exercise of freedom."

<div style="text-align: right">P.S.</div>

gegenüberzustellen. Ohne sich auf einen mythologischen Universalismus zurückführen zu lassen, bietet das Werk Oiticicas in Reaktion auf die modernistischen Kunstnormen amerikanischer Provenienz ein ausdrücklich brasilianisches Bild. Es inspirierte die rasch wieder korrumpierte tropicalistische Bewegung, deren ursprüngliche Intention es war, auf der Grundlage eines Antiimperialismus die vitalen Besonderheiten und Möglichkeiten einer im Entstehen begriffenen Kultur aufzuzeigen, die sich vom Stigma des Exotischen befreit hat. Oiticica zielte mit seiner Arbeit über die Sinneswahrnehmung auf eine Befreiung von Zwängen und äußeren Einflüssen, was, wie Mario Pedrosa gesagt hat, »einer experimentellen Übung in Sachen Freiheit« gleichkam.

<div style="text-align: right">P.S.</div>

Gabriel Orozco

*1962 in Veracruz, Mexico. Lebt und arbeitet/lives and works in New York.

A human skull formed the departure point for this con-
tribution by Gabriel Orozco. In deliberate, highly con-
centrated work, the artist has covered the skull with a
network of narrow lines. Orozco calls this unusual skull-
topography a "drawing in the third dimension" whose
process of emergence has been carefully documented
in photographs. In coming to terms with the sculptural
structures of the skull, Orozco succeeds in imbuing its
original iconography with a fresh, poetically abstract
quality, giving rise to a new object that can obviously
comply with several possible definitions of sculpture.
On the one hand, it satisfies the abstract aesthetic aspi-
rations of a modern Western concept. On the other, it
transports ritual and cult features that link it with tra-
ditions cherished even in Europe, especially in Catholic
countries: bleaching the skeletons of the dead, deco-
rating them, and then putting them on display in spe-
cially erected charnel houses.

One fundamental principle behind Orozco's work is
that competing concepts and treatments of objects can
be experienced simultaneously. The highly varied pro-
duction methods adopted by the artist find their corre-
spondence in the wealth of possible patterns of per-
ception. Traces of manual shaping play a decisive role in
many of his objects. Plasticine, sand, or clay frequently
bear the imprints of his own or other people's hands,
as in Sandball & Chair I + II (1995) or My Hands are my
Heart (1991). Another of Orozco's sculptural strategies
avails itself of the tradition of the ready-made. On the
basis of one and the same material totally new works
emerge in different contexts. In 1991 Orozco arranged
oranges on the empty wooden stalls of a deserted
market as colorful and formal fixed points. As is his cus-
tom, he documented this intervention, called Crazy
Tourist, in photographs. Two years later, oranges
turned up again in Home Run, a work Orozco created
for the Museum of Modern Art in New York. This time
the artist placed the oranges, grouped and in lines, in
apartment and office windows that are visible from
the Museum's garden and which themselves offer
views of that garden. This installation of banal every-
day objects, which in their removed, elevated position
behind window panes resisted both culinary and aes-
thetic consumption, linked otherwise separate social
and institutional locations, if only for a short period of
time. The work Orange without Space also dates from
1993. Here the orange is an organic constituent of a
huge, manually formed plasticine ball. Taken together,
the harmless banality of these initially rather amusing
looking sculptures and interventions promptly reveals
itself to be a precise reflection on traditional ways of
seeing things and on sculptural conventions.

Ausgangspunkt des Beitrags von Gabriel Orozco ist ein
menschlicher Schädel, den der Künstler in langsamer,
konzentrierter Arbeit mit einem Netzwerk schmaler
Linien überzog. Eine »Zeichnung in der dritten Dimen-
sion« nennt Orozco diese eigenartige Schädeltopogra-
phie, deren Entstehungsprozeß sorgfältig dokumentiert
wurde. In Auseinandersetzung mit den skulpturalen
Strukturen des Totenschädels gelingt es ihm, eine neue
poetische Qualität der Abstraktion über die ursprüng-
liche, ikonographische des Schädels zu legen. So ent-
steht ein neues Objekt, das offensichtlich mehrere mög-
liche Definitionen von Skulptur ausfüllen kann. Genügt
es einerseits abstrakt-ästhetischen Ansprüchen einer
westlichen Moderne, transportiert es gleichzeitig ritu-
elle und kultische Eigenschaften, die an auch in Europa
– dort vor allem in katholischen Ländern – gepflegte
Traditionen anknüpfen, Gebeine Verstorbener zu blei-
chen, auszuschmücken und dann in extra dafür vorge-
sehenen Beinhäusern zur Schau zu stellen.

Daß konkurrierende Vorstellungen und Formen des
Umgangs mit Objekten simultan erfahrbar werden, ist
grundlegendes Prinzip in Orozcos Werk. Die Vielfalt
möglicher Wahrnehmungsmuster findet ihre Entspre-
chung in den unterschiedlichsten Produktionsmethoden
des Künstlers. In vielen seiner Objekte spielen die Spu-
ren manueller Gestaltung eine entscheidende Rolle. Pla-
stilinmasse, Sand oder Ton tragen in Arbeiten wie Sand-
ball & Chair I + II (1995) oder My Hands are my Heart
(1991) die Abdrücke seiner eigenen oder die fremder
Hände.

Auf der Tradition der Ready-mades basiert eine wei-
tere skulpturale Strategie Orozcos. In jeweils unter-
schiedlichen Kontexten entstehen mit ein und demsel-
ben Material vollkommen neue Arbeiten. 1991 verteilt
Orozco Orangen auf den leeren Holzständen eines ver-
lassenen Markts als farbige und formale Fixpunkte und
dokumentiert diese Crazy Tourist betitelte Intervention
wie immer photographisch. Zwei Jahre danach tauchen
die Orangen in Home Run, einer Arbeit für das Museum
of Modern Art in New York wieder auf. In Reihen und
Gruppen zusammengefaßt, positioniert der Künstler sie
in Fenstern von Apartments und Büros, die vom Garten
des Museums aus sichtbar sind und selbst wiederum
Einblick in den Museumsgarten gewähren. Mit der
Installation dieser banalen Alltagsobjekte, die sich –
hoch oben entrückt hinter Fensterscheiben – kulinari-
schem und ästhetischem Konsum gleichermaßen entzie-
hen, verbinden sich für kurze Zeit sonst getrennte
soziale und institutionelle Räume. Ebenfalls 1993 ent-
steht die Arbeit Orange without Space. Diesmal ist die
Orange organischer Teil eines massiven handgeformten
Plastilinballs. Die harmlose Banalität dieser zunächst

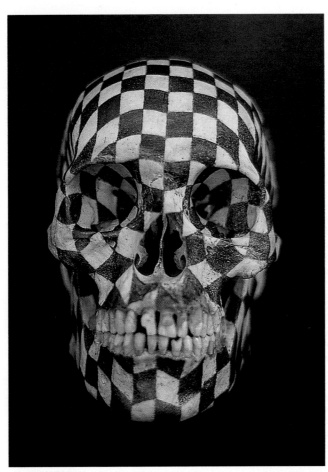

Black Kites, 1997

eher witzig anmutenden Skulpturen und Interventionen erweist sich im Zusammenhang schnell als genaue Reflexion traditioneller Sehweisen und skulpturaler Konventionen.

P.S.

Adam Page

*1966 in Bedford/England. Lebt und arbeitet/lives and works Dresden.

It has been some time since the concept of art in public places became separate from that of sculpture as a monument, becoming replaced by aspects of the architectonic. Usually, these aspects bear some relationship to specific paradigms determined by the given place. It is almost impossible that they should exist outside that place, particularly in a neutral institutional framework.

In Dresden, where he lives, Adam Page has been observing the sell-out of public property, a process that has transformed "the concept a public place once promoted by state policy into the concept of a public thoroughfare dictated by private strategies." In his text "Space Politics" Page reflects on the extent to which architectural structure can regulate social behavior patterns and further the private appropriation of space: "The precision and physicality of the built frame makes the volume of a space absolute, so that it becomes the yardstick for all others. It introduces a division between inside and outside, private and public." It is to this inner link between architecture and social behavior that the artist devotes his particular interest. What he is concerned to do is to make a precise analysis of the functions that define public architecture, and to elucidate the question of how public it actually is and who is in control of it. Adaptable structures, such as the Executive box at Friedrichsplatz, are not absolute sculptures but communicative artistic acts. Ideally, they can react to specific situations and promote communicative exchange between places, institutions, and society. Artistic interventions of this kind "may not even need to be specific to a site, because present notions of site, like space, are being further delocalized, dematerialized. They do however need to be specific to a situation – the present, the temporary, the physical, the spatial." Such are the conditions for this short circuit to succeed.

S.P.

Von Kunst im öffentlichen Raum wird im allgemeinen erwartet, daß sie sich zu spezifischen, durch den gegebenen Ort bestimmten Paradigmen in irgendeiner Weise in Beziehung setzt. Ihre Existenz außerhalb dieses Ortes, besonders im neutralen institutionellen Rahmen, ist quasi unmöglich.

Adam Page untersucht, wie öffentlich dieser Ort eigentlich noch ist, wer ihn kontrolliert, wie er sich konstituiert und auf welche Art und Weise er von welcher Gruppe genutzt wird. In seinem Wohnort Dresden beobachtet er den Ausverkauf kommunalen Eigentums, der »die Vorstellung vom öffentlichen Ort, vorangetrieben durch staatliche Politik, in die eines öffentlichen Durchgangs, diktiert durch private Strategien«, verändert hat. Wie wichtig bei der Inbesitznahme dieser Räume die physischen Begrenzungen sind, beschreibt Page in einer Reflexion zur vorherrschenden Konsum-Architektur (Raum konsumierend, selbst leicht konsumierbar, dem Konsum gewidmet): »Die physische Existenz und Präzision eines gebauten Rahmens macht den beanspruchten Raum absolut und ist der Maßstab alles anderen. Sie grenzt Innen und Außen, privat und öffentlich voneinander ab.« Veränderbaren Strukturen wie die Executive box am Friedrichsplatz, einem zusammenfaltbaren Container mit Münztelephon, Klapptisch, zwei Stühlen und einer Kaffeemaschine, fehlt genau dieses Absolute. Statt dessen haben sie die Fähigkeit, situationsspezifisch zu reagieren. Adam Page versteht darunter auch die kontextuelle Situation eines Werks jenseits der besonderen räumlichen Gegebenheiten. Kunst »muß möglicherweise nicht ortsspezifisch sein, weil derzeit Vorstellungen von Ort – im Sinne von Raum – weiter delokalisiert, entmaterialisiert werden. Sie muß allerdings spezifisch für eine Situation sein – für das Derzeitige, Vorübergehende, für eine physische und räumliche Gegenwart.«

S.P.

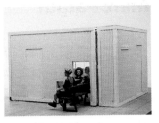

Executive box/V.I.P. Raum, 1997
Model

Executive box *is available for public use without charge from 10 a.m. to 8 p.m. daily during documenta X for appointments, transactions, entertaining or private concentration. Bookings for use of space can be made on tel (0561) 707270 and at the* documenta X *information container on Friedrichsplatz.*

V.I.P. Raum ist während der *documenta X* von 10.00 bis 20.00 Uhr für die Öffentlichkeit gebührenfrei verfügbar für geschäftliche Meetings, private Treffen oder andere Versammlungen. Buchungen können unter (0561) 707270 und am *documenta*-Informationscontainer auf dem Friedrichsplatz vorgenommen werden.

Marc Pataut

*1952 in Paris. Lebt und arbeitet/lives and works Paris.

The area known as "Le Cornillon" is located in a former industrial zone of the Paris region, squeezed between the Saint-Denis canal and the A1 freeway. Since June 1995 it has been the construction site of the future Stadium of France, destined to host the World's Cup soccer match in 1998. But before becoming the field of a spectacular sporting event, this twenty-five hectare space formed the territory of a small community of people, now dispersed.

After the official announcement of the construction plans on November 3, 1993, Marc Pataut decided to go see this place and its inhabitants, and to undertake a slowly developing photographic project, a "study" unfolding over a long span of time (from January 1994 to May 1995). Far from the media news flash and outside any institutional commission, he produced a series of hybrid images which partake both of the testimonial and of the lyrical constitution of a territory and a fragile community: a community of site and encounter, founded on the shared occupation of a common territory, and contained within the time of that experience.

As these photographs show, a site or an environment only becomes a territory through the contingent modes of existence that constitute a place, marking out its boundaries, giving it a function and making it the object of sensuous experience. This is why the work is not only concentrated on the "victims of expropriation," but also on the territory in its entirety, as a domain, with its makeshift shelters, its limits, its border zone, and its outside, its qualities as a terrain (earth, trees, flowers), its indexes or marks (garbage dumps).

"With this work," says Marc Pataut, "I wanted to show the distance between a mediated language (a discourse, a project) with the power and the tools to express itself – the language of elected officials, of architects, of journalists, and so forth – and a language without a fixed dwelling place, an everyday speech (acts, facts) issuing from exactly the same location, the same site, the same city." Thus, the people who fill his images are less the objects of a reportage than the subjects of an intimate diary and a collective narrative. This intimacy, which is also the intimacy of the territory, is replayed in the experience of the viewer, obliged to enter a relation of proximity by the small format of the photos and their arrangement in a frieze.

Marc Pataut is a founding member of the association NE PAS PLIER (Do Not Bend), which brings together artists and sociologists. The association creates and distributes materials on political and social themes, producing images on no one's orders.

P.S.

In einem alten Industrieareal in der Pariser Vorstadt, eingeklemmt zwischen dem Canal de Saint-Denis und der Autobahn A1, befindet sich ein Gebiet, das »Le Cornillon« genannt wird. Seit Juni 1995 baut man hier für die Fußballweltmeisterschaft 1998 das »Stade de France«. Bevor diese Gegend jedoch zum Austragungsort eines spektakulären Sportereignisses bestimmt wurde, war dieses Areal von 25 Hektar das Territorium einer kleinen Anzahl von Menschen, die heute in alle Winde verstreut sind.

Nach der offiziellen Ankündigung des Stadionbaus am 3. November 1993 beschloß Marc Pataut, sich diese Gegend und ihre Bewohner einmal näher anzusehen und eine andauernde photographische Bestandsaufnahme von beiden zu machen, eine Studie, die sich über lange Zeit hinziehen sollte (vom Januar 1994 bis Mai 1995). Im Verlauf dieser Arbeit hat er, fern von der Aktualität der Medienlandschaft und ohne jeden Auftragszwang, eine Reihe von Bildern geschaffen, die in einer Mischung aus Augenzeugenbericht und lyrischer Darstellung ein Territorium und eine zerbrechliche Gemeinschaft zeigen, die sich dadurch konstituiert, daß sie sich ein Territorium teilt.

Wie die Photographien zeigen, wird ein Gebiet nur dadurch zum Territorium, daß zufällige Existenzformen aus ihm einen bewohnten Ort machen, Spuren hinterlassen, ihm eine Funktion geben und es zum Objekt einer sinnlichen Erfahrung machen. Aus diesem Grunde konzentriert sich die Arbeit Patauts nicht allein auf die »Entwurzelten«, sondern beschäftigt sich auch mit dem Territorium als Ganzem, mit seinen Behelfsunterkünften (den Hütten), seinen Grenzen, seinen Randzonen und seiner Außenwelt, seinen Qualitäten als Grund und Boden (Erde, Blumen, Bäume) und seinen Erkennungsmerkmalen (Müllhaufen und Schuttabladeplätzen).

»Mit dieser Arbeit«, erklärt Marc Pataut, »will ich zeigen, welche Distanz möglich ist zwischen einer über die Medien verbreiteten Sprache (einem Diskurs, einem Projekt), die über die nötige Macht und die geeigneten Mittel verfügt, sich Ausdruck zu verschaffen (die Sprache der Politiker, der Architekten, der Journalisten…), und einer Sprache ohne festen Wohnsitz, einer Alltagssprache (der Handlungen, der Ereignisse, der Tatsachen), eine andere Sprache, die dem gleichen Ort, der gleichen Gegend, der gleichen Stadt entstammt.« Daher sind die Menschen in seinen Bildern weniger Personen einer Reportage als eines Tagebuchs und einer kollektiv erzählten Geschichte. Diese Vertrautheit, die zugleich auch die Intimität des Territoriums ist, wird in der Bilderfahrung des Betrachters durch das kleine Format der Photographien und deren Aneinanderreihung nachvollzogen, wodurch die Rezipienten zur Nähe genötigt werden.

Projet du Grand Stade Plaine Saint Denis, 1994–95
Detail

Marc Pataut ist Gründungsmitglied der Vereinigung
NE PAS PLIER (Nicht knicken), in der sich Künstler und
Wissenschaftler zusammengeschlossen haben, um Materialien über politische und soziale Themen zu erstellen
und zu verbreiten und Bilder hervorzubringen, die niemand kontrolliert und beherrscht.

P.S.

Raoul Peck

*1953 in Port-au-Prince, Haiti. Lebt und arbeitet/lives in Port-au-Prince.

Ten years ago Raoul Peck left Berlin. He had studied film at the DFFB.

Haitian Corner is a politically engaged film showing victims of persecution who cannot cure their wounds, not even far away from home. Lumumba – La Mort du prophète (1992) is a documentary in which Raoul Peck reflects upon his childhood in Belgian Congo and interweaves the political degradation of colonialism, to which Patrice Lumumba and his country were subjected, with his own biography and the history of the continent. An artistic, beautifully narrated biographical-political film.

With his feature L'Homme sur les quais of 1994, Peck gives a look at the political developments of the past years in Peck's homeland Haiti through the eyes of a child. From Berlin to Africa, Paris, New York, Haiti. The stopovers of a traveler, a fugitive, a man without a homeland? Whether documentary or feature, all of Peck's cinematic works are thoughts about homelessness, uprootedness, disorientation, decolonization, the political situation. Arriving on his native island of Haiti, the author reflects on Europe as seen from a distance. Racism is breaking out openly in France and Germany, in today's Europe.

Wounds cannot be forgotten. They cause scars. Is it time to take stock? he asks himself. Ten years after his departure from Berlin: "The same old Berlin like an opulent, glutted mistress with no remorse, who left me before I could make HER that insult myself."

In search of some kind of home Raoul Peck looks back over his last ten years between the cinema and politics, between a gorged Europe and a hungry Haiti. He writes a cinematic diary, achieving in the process not only the biographical but also the political stock-taking of a man who has lived in all worlds and wishes only the best for his homeland. Strange Europe, familiar Haiti? His film Le Temps des Lassitudes (Times of Lassitude) reflects upon homeland, dictatorship, the past. But also time and the media, seeing and forgetting, memory and pain, in the personal sphere as well as in art and politics. The radical document of an unexpected personal and political development has been created in this film.

B.K.

Vor zehn Jahren ging Raoul Peck weg aus Berlin. Hier hatte er an der DFFB Film studiert.

Haitian Corner (New York ist nicht Haiti) ist ein engagierter Spielfilm, der Verfolgte zeigt, die ihre Wunden aus einem diktatorischen Land auch fern der Heimat nicht kurieren können. In Lumumba – La Mort du prophète (1992), dem berühmten Dokumentarfilm, reflektiert Raoul Peck seine Kindheit in Belgisch-Kongo und verwebt die politischen Gemeinheiten des Kolonialismus gegenüber Patrice Lumumba und seinem Land mit der eigenen Biographie und der Geschichte eines Kontinents. Ein kunstvoller, schön erzählter biographisch-politischer Film.

L'homme sur les quais (Der Mann auf dem Quai, 1994) zeigt aus Kinderaugen die politischen Entwicklungen der letzten Jahre in der Heimat Haiti. Von Berlin aus: Afrika, Paris, New York, Haiti. Stationen eines Reisenden, eines Flüchtigen, eines Mannes ohne Heimat? Ob Dokumentarfilme oder Spielfilme, alle filmischen Arbeiten Pecks sind offene Gedanken zur Heimatlosigkeit, zur Entwurzelung, zur Desorientiertheit, zur Dekolonialisierung, zur politischen Lage. Auf seiner Heimatinsel Haiti angekommen, reflektiert der Autor ein Europa aus der Ferne gesehen. Da bricht offener Rassismus in Frankreich und Deutschland aus, in einem heutigen Europa.

Wunden kann man nicht vergessen. Sie hinterlassen Narben. Ist es Zeit für eine Bilanz, fragt er sich. Jetzt, zehn Jahre nach dem Abschied von Berlin: »Berlin wieder, das mich wie eine üppige, satte Geliebte ohne Gewissensbisse verlassen hat, bevor ich IHR selbst diese Kränkung antun konnte…«

Auf der Suche nach einer Art Heimat reflektiert Raoul Peck seine letzten zehn Jahre zwischen Kino und Politik, zwischen einem übersättigten Europa und einem hungrigen Haiti. Er schreibt ein filmisches Tagebuch, und es ist nicht nur die biographische, sondern auch die politische Bilanz eines Mannes entstanden, der in allen Welten gelebt hat und sich für seine Heimat nur das Beste wünscht. Fremdes Europa, nahes Haiti? Sein Film Le Temps des Lassitudes (Zeit der Müdigkeit) reflektiert Heimat, Diktatur, Vergangenheit. Aber auch Zeit und Medien, Sehen und Vergessen, Erinnerung und Schmerz, im Persönlichen auch Kunst und Politik. Es ist ein radikales Dokument unerwarteter persönlicher und politischer Entwicklung entstanden.

B.K.

Le Temps des Lassitudes, 1997
Times of Lassitude
Zeit der Müdigkeit

Marko Peljhan

*1969 in Nova Gorica. Lebt und arbeitet/lives and works in Ljubljana, Slowenien/Slovenia.

PROJEKT ATOL was founded by Marko Peljhan in 1992 as an independent non-profit organization in Slovenia, working in the cultural sphere. At first it was only a framework for artistic and social activities like theater, performances, and lectures. At documenta, it will present MAKROLAB, a project which closes that phase and opens another of an ongoing cycle entitled LADOMIR-FAKTURA. Ladomir is a name of a utopian poem written in 1920 by the Russian Futurist Velimir Khlebnikov which describes the universal landscape of the future through the destruction of the old world and the synthesis of the new. The word is a combination of lad, meaning both "harmony" and "living creature," and mir, both "peace" and "world, universe." The term faktura, a central notion of the Russian avant-gardes, refers to a technique or method which results in the conferring of a tactile and sensorial quality onto abstract artistic or scientific elements. LADOMIR-FAKTURA proposes to undertake a program of research into "dreams, psychoacoustics, acoustics, weather and low-energy-consumption systems."

MAKROLAB is a research station set up on Lutterberg hill on the edge of Kassel, a first step before being set up in other parts of the world. Conceived as both a life and work environment, it is wind- and solar-powered and capable of providing three people with independent life-support for forty days. Although physically isolated, it is linked through various communications hookups to the documenta-Halle (via video, Internet site, and cell phone). Visitors will, however, have the possibility of going directly to the Lutterberg site. After forty days in the station, Projekt Atol will present the results of their research and then commence a period of reflection. The data will be accessible on the Internet, transmitted over the radio, compiled in a publication, and presented publicly in a performance in the "100 Days - 100 Guests" series.

From the moment of its founding, PROJEKT ATOL has been fond of defining the preconditions for social utopias. Alluding to avant-garde projects in the tens and twenties, as well as the experiences and thinking of Guy Debord and the Situationist International, it "tries to enable the creative communication of individual forces to converge into a scientific/psychic entity that would, in the final stage, result in the creation of an insulated/isolated environment and space-time. Insulation/isolation is understood as a vehicle to achieve independence from, and a reflection of, actual entropic social conditions." Combining the isolation proper to research and poetry with the need to convey information, PROJEKT ATOL makes a utopian wager on the experience of tension between elitist thinking with

PROJEKT ATOL wurde 1992 von Marko Peljhan gegründet. Diese Organisation, die keine kommerziellen Interessen verfolgt und in der slowenischen Kulturszene ihre Unabhängigkeit behauptet, diente zunächst als Rahmen für künstlerische und soziale Aktivitäten (Theater, Film, Performances, Lesungen, Situationen). Bei der documenta repräsentiert das Projekt MAKROLAB eine neue Etappe eines LADOMIR-FAKTURA genannten Werkzyklus. Ladomir ist der Titel eines 1920 entstandenen utopischen Gedichts des russischen Futuristen Velemir Chlebnikow, in dem die universelle Landschaft der Zukunft beschrieben wird, die durch die Zerstörung der alten Welt und die Synthese einer neuen entsteht – der Titel ist eine Zusammenziehung aus »Lad« (Harmonie, Eintracht) und »Mir« (Frieden). Der Begriff »Faktura« ist ein Schlüsselbegriff der russischen Avantgarde und bezeichnet eine Technik oder Arbeitsmethode, die darauf abzielt, künstlerischen und wissenschaftlichen Abstrakta eine taktile und sinnfällige Qualität zu verleihen. LADOMIR-FAKTURA bietet einen Rahmen, in dem »Träume, Tonpsychologie, Akustik, das Wetter, Systeme mit geringem Energieverbrauch und die Sprache« erforscht werden können.

MAKROLAB ist eine auf dem Lutterberg außerhalb Kassels installierte Forschungsstation, die später dann auch in anderen Weltgegenden aufgestellt werden wird. Sie ist als Lebens- und Arbeitsraum konzipiert, wird durch Wind- oder Sonnenenergie versorgt und kann drei Personen auf annehmbare Weise vierzig Tage lang mit allem Lebensnotwendigen versorgen. Diese materiell isolierte Station ist mit der documenta-Halle über verschiedene Kommunikationsmittel verbunden (Video, Internet, Funktelephon), doch man kann sie auch direkt auf dem Lutterberg besuchen. Wenn die vierzig Tage um sind, wird PROJEKT ATOL über die Ergebnisse seiner Forschungen Bericht erstatten, dann wird eine Phase der Auswertung und der Reflexion folgen. Das produzierte Material wird über Internet zugänglich sein, über Radiowellen verbreitet, zu einem Buch zusammengestellt und bei einer Konferenz im Rahmen der »100 Tage – 100 Gäste« öffentlich erläutert werden.

PROJEKT ATOL ist seit seiner Gründung bestrebt, die Voraussetzungen sozialer Utopien zu definieren. Unter Bezug auf die Geschichte und avantgardistische Projekte aus den ersten Jahrzehnten unseres Jahrhunderts wie auch unter Rückgriff auf die Erfahrungen und Reflexionen Guy Debords und der Situationistischen Internationale versucht PROJEKT ATOL »die schöpferische Kommunikation individueller Kräfte zu befähigen, in einer wissenschaftlichen/psychischen Realität zu konvergieren, die in ihrem letzten Stadium zur Schaffung einer isolierten/insularen raumzeitlichen Umgebung

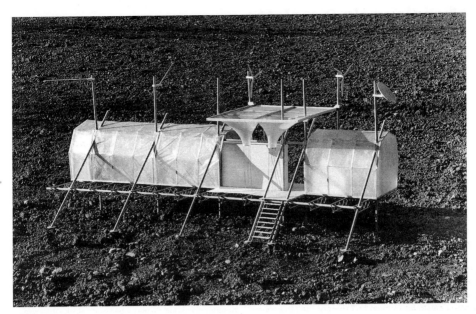

MAKROLAB
autonomous modular solar and wind powered communication and survival environment
(a LADOMIR project – insulation/isolation strategy)
PROJEKT ATOL – PACT, 1997

pedagogical aims and the project of emancipating civil society.

P. S.

führt. Isolierung ist hier begriffen als Vehikel zur Erlangung einer insularen Unabhängigkeit von den aktuellen entropischen sozialen Verhältnissen.« Indem *PROJEKT ATOL* einerseits die zur Forschung und zur Dichtung nötige Isolierung und andererseits zugleich auch die notwendige und unerläßliche Informationsvermittlung gewährleistet, setzt es seine Hoffnungen auf die Fruchtbarkeit einer Spannung zwischen einem elitären, auf wissenschaftlichen und künstlerischen Erkenntnisgewinn ausgehenden Denken und einem emanzipatorischen Entwurf der bürgerlichen Gesellschaft.

P. S.

Michelangelo Pistoletto

*1933 in Biella, Italien/Italy. Lebt und arbeitet/lives and works in Turin.

Michelangelo Pistoletto's Oggetti in meno (Minus Objects) are one of the key works of the 1960s; they open the inventory of artistic proposals gathered together by the critic Germano Celant in 1967 under the name of Arte Povera. Pistoletto's heterogeneous ensemble integrates singular objects, resulting from diverse circumstances. The pieces are inherently literal, as their titles indicate. Thus the idea for Struttura per parlare in piedi (Structure for Talking on Your Feet) came to Pistoletto at an opening, when he noticed how the gallery's white walls were smeared with two black streaks, marking the places where people rested hands and feet against the wall. Rosa bruciata (Burnt Rose) was created after it appeared to the artist in a dream.

These Minus Objects are tangible, physical projections of images in space. "My works," Pistoletto explained, "are not constructions or fabrications of new ideas, any more than they are objects which represent me, to be imposed on others or used to impose myself on others. Rather, they are objects through which I free myself from something – not constructions but liberations. I do not consider them more but less, not pluses but minuses, in that they bring with them a perceptual experience that has been definitively externalized."

The spectator discovers these perceptual experiences while passing among the objects. The distance between them gives metaphorical expression to the temporal intervals that separated their realization. By subtracting the objects from the tyranny of the author, Pistoletto stood apart from the models of seriality and accumulation employed by pop and minimal art. Post-artisanal yet not industrial, governed by the principle of contingency, the Minus Objects demonstrate a refusal to model artistic activity on commercial capitalistic production.

This series naturally found its place, in the form of a photographic reproduction, in Ufficio dell'Uomo Nero (The Office of the Black Man) (1969), where Pistoletto began to work on the administration of his own past. The man in black is the negative double of the artist. He belongs to the shadows of modernity, living on the dark side of reality that the ideology of progress has attempted to hide since the Enlightenment. He appeared after an experiment with a social alternative: the experience of collective creation with the theater group Zoo, founded by Pistoletto in 1968 and active until 1970. The man in black incarnates the "unbearable side" of existence; but he is also the specular double necessary for any knowledge of oneself and of the world, according to the dialectical logic of irreconcilable opposites (white/black, full/empty, past/future, life/death).

Die ein Stück Kunstgeschichte der sechziger Jahre repräsentierenden Oggetti in meno von Michelangelo Pistoletto sind der Beginn der künstlerischen Konzeptionen, die 1967 von dem Kritiker Germano Celant unter dem Namen »Arte Povera« zusammengefaßt wurden. Dieses heterogene Ensemble umfaßt singuläre Objekte, deren Entstehung sich jeweils spezifischen Umständen verdankt. Ihre Titel sind von einer konstitutiven Wörtlichkeit. So kam Pistoletto die Idee zu Struttura per parlare in piedi während einer Vernissage, wo ihm die weißen Wände der Galerie auffielen, auf der zwei schwarze Streifen zu sehen waren – Spuren, die aussahen, als hätte sich hier jemand mit Händen und Füßen abgestützt. Rosa bruciata hingegen schuf der Künstler nach einem Traum, in dem sie ihm erschienen waren.

Als körperliche und greifbare Projektionen von Bildern in den Raum versuchen diese Arbeiten, wie Pistoletto erklärt, »keine neuen Ideen zu konstruieren oder zu fabrizieren, und sie versuchen auch nicht, Objekte zu sein, die mich repräsentieren, die ich anderen aufdrängen oder durch die ich mich anderen aufdrängen will. Durch sie befreie ich mich von etwas – es handelt sich nicht um Konstruktionen, sondern um Befreiungen. Sie sind für mich nicht zuviel Objekt, sondern zuwenig Objekt, womit ich sagen will, daß sie eine definitiv in die Außenwelt zurückprojizierte Wahrnehmungserfahrung in sich bergen«.

Der Betrachter erlebt diese verschiedenen Wahrnehmungserfahrungen, wenn er sich zwischen den Objekten bewegt. Die Distanz, die sie voneinander trennt, ist eine Metapher der Zeitabstände, die zwischen ihrer jeweiligen Realisierung liegen. Indem Pistoletto die Objekte vor der Tyrannei des Schöpfers bewahrt, setzt er sich auch von dem die Pop Art und die Minimal Art dominierenden Modell der Serialität und der Akkumulation ab. Die Oggetti in meno mit ihrer keineswegs industriellen, sondern handwerklichen Machart werden vom Prinzip des Zufalls beherrscht, in ihnen manifestiert sich die Verweigerung der künstlerischen Tätigkeit gegenüber den Regeln der kapitalistischen Produktionsweise.

Dieses Werk fand natürlich als Reproduktion Eingang in das Ufficio dell'Uomo Nero (eine aktualisierte Version wird hier gezeigt, die uns auch etwas über die derzeitige Arbeit des Künstlers, Progetto arte, sagt), mit dem Michelangelo Pistoletto 1969 begann, seine eigene Vergangenheit zu verwalten und dadurch aufzuarbeiten. Der schwarze Mann ist das doppelte Negativ des italienischen Künstlers. Er gehört zur dunklen Moderne und wohnt auf der obskuren Seite der Realität, welche die Ideologie des Fortschritts seit der Aufklärung auszublenden versucht. Er resultierte aus der Erfahrung einer gesellschaftlichen Alternative: dem Abenteuer der kol-

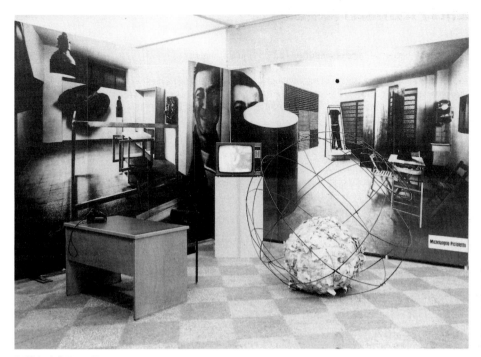

L'Ufficio dell' Uomo Nero
Installation view, Museo Civico, Bologna, 1970

An updated version of The Office of the Black Man, *is presented at documenta. It includes information on the artist's current work in progress:* Progetto Arte.

P. S.

lektiven Kreativität der Theatergruppe Zoo, die Pistoletto 1968 gründete und die bis 1970 aktiv war. Der schwarze Mann verkörpert die «unerträgliche Seite» von etwas, die zugleich doch immer das Spiegelbild eben jenes Etwas ist und jedem Wissen von sich und der Welt gemäß einer dialektischen Logik der Gegensätze innewohnt (Schwärze/Weiße, Fülle/Leere, Vergangenheit/ Zukunft, Leben/Tod).

P.S.

Lari Pittman

*1952 in Los Angeles. Lebt und arbeitet/lives and works in Los Angeles.

"My desire to fetishize the surface of my paintings is similar to my desire to fetishize my home," Lari Pittman declares. The œuvre of this artist does, in fact, constitute a public extension of his private domain. The baroque surfaces, with their inextricable complexity, of the paintings by this graduate of Cal Arts are saturated with imagery that is overtly sexualized, politicized, and culturally marked. It is also linked to a deeply personal meaning. Lari Pittman lays full claim to his hybrid identity – "Half of my family is Anglo-Saxon Presbyterian, and half is Spanish-Italian South American Catholic" – and to his homosexuality. But for him this is neither a marginalizing position nor a pulling back in terms of identity: "I don't see my work as a critique or as a statement of my marginalization – it's about the centrality of my experience."

Although his painting is brimming with determinations of identity, it is not reducible to them, nor does it constitute some illustrational manifestation. Rather, it mobilizes the rhetoric of illustration into a process of reinventing the pictorial model, or tableau, from a decorative dimension. This reinvention is on the order of an idealization. The energy and grace of Pittman's work does come about through the exalting character of the decoration and the exuberant dimension of its ornamentation. Nonetheless, in this psychedelic vortex of images, motifs, figures, and colors, the clear lines of the draftsmanship sharply distinguish between things and create situations of unusual shared presence where, for example, scatology and architecture mix. So much so that the web of formal and conceptual relationships covering his canvases appears more a labyrinth where each element is identifiable: "When you look at the paintings, it's not the confusion you're looking at, but a simultaneity of events in time. That's the layering in the paintings. It's not about confusion. It's about being able to circumnavigate through the painting, where there is something horrific and really silly, disturbing and very buoyant."

These narrative and symbolist works, where the organic becomes schematic and eroticism is desublimated, often seem borne on some epic gust of wind. This can be witnessed in his painting for documenta, Once a Noun, Now a Verb. *Furthermore, the titles of previous works attest to a constant preoccupation with American values:* An American Place; The New Republic; This Landscape, Beloved and Despised; *and* A Decorated Chronology of Insistence and Resignation. *If in this way he celebrates the promises of American democracy, he does so primarily to recover, through the edges and the margins, the aspirations of an ideal free of ideological exclusion. In his work, the stridency coupled with*

»Mein Verlangen, die Oberfläche meiner Gemälde zu fetischisieren, entspricht meinem Verlangen, meine Wohnung zu fetischisieren«, erklärt Lari Pittman. Das Werk dieses Künstlers stellt sich praktisch als »Veröffentlichung« seines privaten Bereichs dar. Die Bildsprache der barocken, unentwirrbar komplexen Oberflächen der Bilder dieses ehemaligen Cal Arts-Studenten ist einerseits offen sexualisiert, politisiert und kulturell bedingt, andererseits zugleich aber auch von grundlegend persönlicher Bedeutung. Lari Pittman bekennt sich in ihnen zu seiner multikulturellen Herkunft – »die Hälfte meiner Familie besteht aus angelsächsischen Presbyterianern und die andere Hälfte aus spanisch-italienisch-südamerikanischen Katholiken« – und seiner Homosexualität. Doch daraus resultiert für ihn weder ein Gefühl marginaler Existenz noch ein Identitätsproblem: »Ich begreife meine Arbeit nicht als Ausdruck einer Randposition oder als Kritik daran, sondern als Ausdruck der Zentralität meiner Erfahrung.«

Wenn seine Malerei also seinen speziellen Identitätsbedingungen entspringt, so reduziert sie sich doch nicht darauf und ist auch nicht deren Illustration. Die Rhetorik der Illustration dient ihr als Instrument einer idealisierenden schöpferischen Aneignung des Modells traditioneller dekorativer Tafelmalerei. Die Energie und Anmut seiner Werke kommt gerade in der Üppigkeit der Dekoration und der Fülle der Ornamente zum Ausdruck. Dennoch scheiden in diesem Wirbel psychedelischer Bilder, Motive, Figuren und Farben die einzelnen Dinge durch die klare Linie der Zeichnung präzise voneinander geschieden, wodurch ganz neue Situationen gemeinsamer Präsenz entstehen, in denen sich zum Beispiel Skatologie und Architektur mischen. Das geschieht so vollkommen, daß sich das Netz formaler und konzeptueller Wechselbeziehungen, das diese Leinwände überzieht, als Labyrinth präsentiert, in dem jedes Element identifizierbar ist: »Wenn man auf diese Gemälde schaut, dann schaut man nicht auf ein heilloses Durcheinander, sondern auf gleichzeitige Ereignisse, die sich in den Gemälden überlagern. Es geht nicht darum, verwirrt zu sein, sondern darum, sich durch das Schreckliche, Alberne, Verstörende und Lebhafte eines Gemäldes hindurchzufinden.«

Seine narrativen und symbolischen Werke, in denen das Organische schematisiert und das Erotische entsublimiert sind, sind häufig von einem epischen Atem getragen, wie sein Bild beweist, das er für die *documenta* geschaffen hat: Once a Noun, Now a Verb. Die Titel seiner früheren Werke bezeugen seine ständige Auseinandersetzung mit amerikanischen Werten: *An American Place; The New Republic; This Landscape, Beloved and Despised; A Decorated Chronology of Insi-*

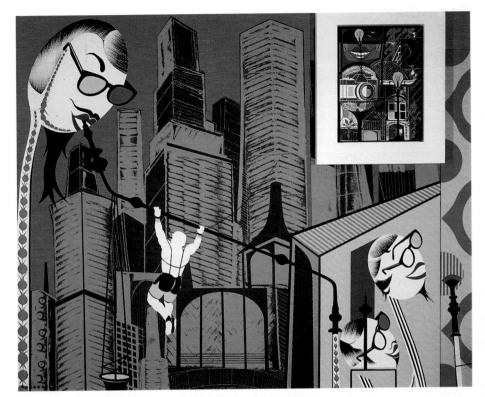

Once a Noun, Now a Verb, 1997
Detail

vivaciousness recalls the "bittersweet" feeling that Pitt-
man ascribes to existence.

<div align="right">P. S.</div>

stence and Resignation. Sein Loblied auf die Verheißun-
gen der amerikanischen Demokratie dient vor allem
dazu, über alle Tabus und Schranken hinweg die Hoff-
nungen eines nicht zur Ideologie verkommenen Ideals
wiederzufinden. In Pittmans Werken verbindet sich eine
grelle Schärfe mit ausgelassener Freude zur Empfindung
des »Bittersüßen«, die nach seiner Auffassung die
menschliche Existenz kennzeichnet.

<div align="right">P. S.</div>

Emilio Prini

*1943 in Stresa. Lebt und arbeitet/lives and works in Rom/Rome.

Associated with Arte Povera from the very first exhibition at the La Bertesca gallery in Genoa in 1967, Emilio Prini probably went the furthest of all the artists of that movement in his desire to fuse art with life. Thus, for example, in May 1968, the work he exhibited in Teatro delle Mostre at the Tartaruga Gallery in Rome, consisted of the names of the people he had met in the train coming from Genoa to Rome for the opening of the exhibition.

For thirty years thereafter, Prini has conducted his artistic practice in accordance with the complex play of a subjectivity grappling with ordinary instances of the everyday. The elements of the material he shows are never more than the "leftovers" of a transient relation fixed for a brief moment in an object. This operation of condensing a moment perceived to be aesthetic in one way recalls the Joycean idea of epiphany. Each of his shows consists of a "repeat" (often including a reconstruction) of a previous work. Exhibited and re-exhibited over the years, Prini's works are always replayed according to the new situation with which he is confronted. Repetition, for him, is something on the order of resurgence, sharing in the infinite dispersion of a poetic space otherwise resistant to the constraints of historicizing.

One of the first pieces Prini presented at La Bertesca was a spool wound with neon tubes. This became the matrix for Perimetro d'Aria, a work made up of five neon "vermicelli," one in each corner and one in the center of the room, gradually turning on and ringing, thus creating a sound piece going beyond the fixedness of the object. In the text accompanying this first presentation of Arte Povera, Germano Celant said of Prini: "In his work, space can and should arise everywhere and abruptly. It becomes both the stage and the surrounding theater. Attention focuses on the optical-acoustic rhythm. The image and the sound element work in parallel to the spatial elaboration."

Prini shares this affirmation of space with other Arte Povera artists who conceive of space as ambiente: "an area of individual or collective mobility that one appropriates subjectively," to recall Jean-François Chevrier's definition. For Prini, this appropriation takes the liberating form of an experience whereby one detaches oneself from an object that is the result of contingent circumstance. Thus, L'ho gettato dalla finestra, Pozze di colore is a work repeated on three occasions, in 1968, 1973, and 1995. It is a chance synthesis of two different moments of an action (a sheet of gray painted lead is thrown out a window and lands on the green felt cushion of a vitrine), subsequently constituted as a work.

P.S.

Dieser zur Arte Povera gehörende Künstler hatte seine erste Ausstellung 1967 in der Galerie La Bertesca in Genua. Emilio Prini hat wahrscheinlich von allen Künstlern dieser Gruppe am radikalsten versucht, Kunst und Leben zu verschmelzen. So bestand zum Beispiel sein Werk, das er im Mai 1968 bei der in der Galerie Tartaruga in Rom organisierten Ausstellung Teatro delle Mostre präsentierte, aus der Sammlung der Namen jener Leute, denen er in dem Zug begegnet war, der ihn zur Ausstellungseröffnung von Genua nach Rom gebracht hatte.

Emilio Prinis künstlerische Tätigkeit ist so seit gut dreißig Jahren auf jene komplexen Spielzüge der Subjektivität kapriziert, die sich in gewöhnlichen Momenten des Alltagslebens inszenieren. Die Materialien und Elemente, die er ausstellt, sind nichts als die »Reste« einer vorübergehenden Beziehung, die sich momenthaft in einem Objekt fixiert. Diese Operation der Verdichtung eines als ästhetisch wahrgenommenen Augenblicks erinnert auf gewisse Weise an die Joycesche Epiphanie. Jede seiner Ausstellungen besteht aus einer »Wiederaufnahme« früherer Arbeiten (die oft auch deren Rekonstruktion beinhaltet). Sie haben Teil an der unendlichen Zersplitterung eines poetischen Raums, der so den einengenden Zwängen einer Historisierung zu widerstehen trachtet. Die im Laufe der Jahre ausgestellten und wiederausgestellten Werke Prinis werden stets mit der neuen Situation in Einklang gebracht, mit der sie konfrontiert werden. Wiederholung ist für Prini eine Form des Ursprungs.

Eine der ersten Arbeiten Prinis, die damals auch in der Galerie La Bertesca gezeigt wurde, war eine aufgewickelte Rolle leuchtender Neonröhren. Daraus ging der Perimetro d'Aria hervor, der aus fünf »Nudeln« aus Neonröhren bestand, zu einem Viereck angeordnet mit einer »Nudel« in der Mitte, die nach und nach immer mehr zu leuchten und zu tönen begannen und so eine Dynamik entwickelten, die die statische Fixierung des Objekts übertrumpfte. Im Begleittext zu dieser ersten Manifestation der Arte Povera sagt Germano Celant über Prini: »Bei ihm kann und muß der Raum überall und plötzlich entstehen; er wird zur Bühne und gleichzeitig zum Zuschauerraum. Die Aufmerksamkeit ist auf den optisch-akustischen Rhythmus konzentriert. Das Bild und das tönende Element bewirken gemeinsam Entstehung und Aufbau des Raums.«

Prini teilt diese Neigung zur schöpferischen Raumkonstitution mit den anderen Künstlern der Arte Povera, die den Raum als »Ambiente« betrachten, das heißt, wie Jean-François Chevrier sagt, »als Bereich individueller oder kollektiver Mobilität, den man sich subjektiv aneignet«. Diese Aneignung nimmt bei Prini oft

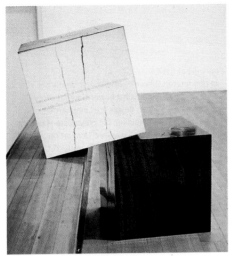

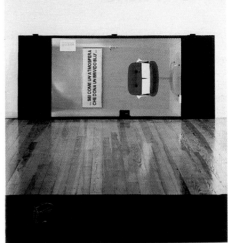

Cubo 1974

1984 Vitrina

die befreiende Form der Erfahrung einer Lösung von einem sich kontingenten Umständen verdankenden Objekt an. So zum Beispiel bei *L'ho gettato dalla finestra, Pozze di colore*, einem Werk, das er dreimal wiederaufgenommen hat (1968, 1973, 1995): Es handelt sich um das zufällige Zusammentreffen zweier Momente einer Aktion – ein mit grau angemaltes Blatt aus Blei, das aus dem Fenster geworfen wird, landet auf dem grünen Tuch einer Vitrine –, das anschließend zu einem Werk wird.

P.S.

Stefan Pucher

*1965 in Gießen. Lebt und arbeitet/lives and works in Berlin.

"Pop will eat itself."

In recent years, it has become increasingly clear that pop culture is an essential component in the work of the post-1960s generation of artists. They are empiricists who describe precisely what surrounds us and what has accompanied their generation as they grew up in the seventies and eighties. An artificially extended puberty leads to minor psychodramas of superficiality and monotony. This is the new bohème whose lives are shaped by superfluity, boredom, consumerism, and boundless possibilities and whose attitude is frequently misconstrued as cynical indifference.

Pucher takes the "mass culture" with which we are constantly bombarded at various levels in the media world and stages it as a horror trip in which bodies are reduced to projection screens. He has designed a techno fairytale and a splatter performance and is still in search of new theatrical narratives, rolling back the conventional boundaries between "high" and "low" art and sampling cultural forms without hierarchy.

Pucher's characters are strange creatures that blend soul and soulless, and are touched by the life of the undead. They are the zombies of cultural history. Remixing a pop classic is, for Pucher, the same as staging a classical tragedy. Kurt Cobain and Oedipus are both figures damned to immortality.

One may debate whether the world he describes runs its course in ecstasies of superficiality or whether it is merely exaggerated descriptions that create this impression. It would be wrong to interpret Pucher's work as cultural pessimism. On the contrary, his plays express a latent optimism derived from the sheer pleasure he takes in juggling with the codes and metaphors of pop culture.

For documenta, Stefan Pucher will work with the British performance group Gob Squad. His collaboration with the members of Gob Squad began in 1996 when he directed Ganz nah dran at the Theater am Turm in Frankfurt, and continues this year under the name Copy Club with their contribution to the Theater outlines and Dreamcity – die Stadt in Worten, to be staged in Hamburg (Kampnagel) and Berlin (Podewil).

J.H./B.F.

»Pop will eat itself.«

In den letzten Jahren wurde immer deutlicher, daß die Popkultur für viele Künstler der Generation nach 1960 zum wesentlichen Bestandteil ihrer Arbeit geworden ist. Sie sind die Empiriker, die genauestens beschreiben, was uns umgibt und was ihre Generation während ihres Aufwachsens in den Siebzigern und Achtzigern begleitet hat. Am Ende einer künstlich verlängerten Pubertät werden kleine Psychodramen voller Oberflächlichkeit und Monotonie entfaltet. Eine neue Boheme, deren Lebensgefühl – häufig als zynische Gleichgültigkeit mißinterpretiert – von Überfluß, Langeweile, Konsum und schwebendem Möglichkeits-Taumel geprägt ist.

Die »Kulturmasse«, die einen alltäglich auf unterschiedlichen Ebenen der Medienwelt umgibt, inszeniert Pucher als Horrortrip, bei dem die Körper zu Projektionsflächen reduziert werden. Er hat ein Technomärchen und eine Splatter-Performance entworfen und sucht weiter nach neuen Erzählarten des Theaters, indem er keine Grenzen zwischen der sogenannten Hoch- und der Populär-Kultur zieht, alle kulturellen Formen hierarchielos sampelt.

Puchers Charaktere sind Zwitter aus Beseeltem und Unbeseeltem, denen immer wieder das Leben von Untoten eingehaucht wird. Zombies der Kulturgeschichte. Das Remixen eines Pop-Klassikers entspricht bei Pucher der Neuinszenierung einer antiken Tragödie, Kurt Cobain und Oedipus, zwei Figuren, die zur Unsterblichkeit verdammt sind.

Man kann sich darüber streiten, ob sich die Welt, die er beschreibt, in einer rauschhaften Oberflächlichkeit erschöpft oder ob erst die zugespitzte Beschreibung diesen Eindruck erzeugt. Es wäre ein Mißverständnis, Puchers Stücke als Kulturpessimismus zu interpretieren. Sie sind im Gegenteil Ausdruck eines latenten Optimismus, der seine Begründung in der Lust am Spiel mit den Codes und Metaphern der Popkultur findet.

Für die documenta wird Stefan Pucher mit der britischen Performancegruppe Gob Squad zusammenarbeiten. Die Kooperation mit Mitgliedern von Gob Squad begann 1996 mit dem Stück Ganz nah dran (Theater am Turm, Frankfurt), bei dem Stefan Pucher Regie führte, und wird in diesem Jahr, neben der Produktion für die Theaterskizzen, mit dem Stück Dreamcity – Die Stadt in Worten unter dem Namen Copy Club in Hamburg (Kampnagel) und Berlin (Podewil) fortgesetzt.

J.H./B.F.

Ganz nah dran, 1996

David Reeb

*1952 in Rehovot, Israel. Lebt und arbeitet/lives and works in Tel Aviv.

David Reeb makes paintings based on press photographs. He recounts the history of his country practically day-to-day: the Occupation, the Intifada, and even, in Let's have another war, the work shown here, the possibility of another conflict. His paintings do not, however, deal with grand gestures or major events. Nor do they stress the dramatic dimension or the most obscene episodes of the war's violence. They portray the routine of arrests and gun battles, the banality of oppression, and existence in the midst of danger and everyday anger. The protagonists of these paintings are neither heroic figures, leaders, nor martyrs. They are anonymous soldiers, ordinary citizens and people. Similarly, none of the images he employs is hierarchically privileged or presented as an icon; each of them is drawn from and returned to the painful continuum of real life. The geopolitical complexity of Israel cannot be reduced to a symbolic image, nor can it be fixed in any form, not even that of the border that marks the territorial Occupation. When Reeb does use the famous "Green Line," it is to remind us of what is at stake in the future shape of Israel, and to draw the viewer's attention to the very real process of framing to which things are subject. Reeb selects photographs which have been featured in the Israeli press, and which therefore condition the emotional understanding of events. For the past few years, he has been mostly using images by Miki Kratzman, whose photographic work he greatly respects. As he paints these press photos, Reeb is translating them more than copying them. He passes over the minutiae and their descriptive nuances in favor of nervous brushstrokes that convey the urgency of interpretation, thus shattering the fantasies of transparency inherent in photographic vision. But as subjective as Reeb's interventions may be, by virtue of these images, he nonetheless chronicles a collective history. Although Reeb's work shows strong political commitment – several years ago, during his exhibition at a museum in Tel-Aviv, he painted the banner of the P.L.O. on the wall, but was forced by the museum to erase it and punished by the non-publication of his catalogue – the Israeli Occupation is not the only theme in his work. Other, less politically charged subjects have been the focus of his sustained attention. This somewhat unbalanced dualism reflects the daily reality of Israel. Through the diversity of his subject-matter and the variation in his treatment of a given image, Reeb asserts his belief in the possibilities of painting, but the very fact that he permits himself to be provoked by current events prevents him from falling into a fetishistic fixation on the medium as an autonomous and self-sufficient reality. P. S.

David Reeb malt Bilder auf der Grundlage von Pressephotographien, die von der Geschichte seines Landes erzählen: von der Besetzung palästinensischer Gebiete, von der Intifada oder auch, und das betrifft einige der hier präsentierten Werke, von der Möglichkeit eines neuen Krieges (Let's have another war). Doch geht es in seinen Gemälden nicht um glorreiche Taten oder entscheidende Ereignisse. Sie betonen weder die dramatische Dimension noch die obszönsten Seiten der Gewalttätigkeiten, sondern zeigen die Routine der Verhaftungen und kleinen Scharmützel, die Banalität der alltäglichen Unterdrückung, der Gefahr und der Wut. Entsprechend sind die Protagonisten dieser Bilder denn auch keine heroischen Gestalten, Führer oder Märtyrer. Es sind anonyme Soldaten, Durchschnittsbürger, Leute aus dem Volk. Auf den Bildern, die er verwertet, gibt es keine Hierarchie, niemand genießt einen Vorzug oder wird als Ikone stilisiert, jeder ist in gleicher Weise Teil des leidvollen zeitgeschichtlichen Kontinuums. Die geopolitische Problematik Israels läßt sich in ihrer Komplexität nicht auf ein symbolisches Bild reduzieren und besitzt auch keine für alle Zeiten gültige Form, auch nicht in Gestalt einer Grenze, die die Besetzung von Gebieten markiert. Wenn Reeb oft die berühmte »Grüne Linie« zum Vorwurf nimmt, dann tut er das, um daran zu erinnern, daß hier die zukünftige Form Israels auf dem Spiel steht, und um die Aufmerksamkeit des Betrachters auf die Rolle der Bildeinstellung selbst zu lenken, aus der die Dinge wahrgenommen werden. Nach diesen Kriterien wählt Reeb seine Bildvorwürfe aus den vielen Photographien aus, die die Aktualität der israelischen Presse bestimmen und die emotionale Bewertung der Ereignisse bedingen. Seit einigen Jahren arbeitet er hauptsächlich mit Bildern von Miki Kratzman, dessen photographische Arbeit er sehr schätzt. Reebs Gemälde kopieren die Pressebilder nicht, sie übersetzen sie vielmehr in eine andere Sprache. Die minuziösen Einzelheiten und deskriptiven Nuancen gehen in den schnellen und nervösen Pinselstrichen verloren, die dafür aber um so energischer nach einer Deutung des Ganzen verlangen und die dem Pressephoto eigene Fiktion zerstören, es sei doch alles klar. Doch wie subjektiv seine Intervention auch sein mag, die Geschichte, die Reeb mit seinen Bildern erzählt, ist eine kollektive.

Wenn die Arbeit David Reebs auch durch ein starkes politisches Engagement bestimmter Couleur geprägt ist – vor einigen Jahren malte er bei seiner Ausstellung im Museum von Tel Aviv die Fahne der PLO auf die Wände und wurde von der Museumsleitung gezwungen, dies zu entfernen, und damit bestraft, daß sein Katalog nicht erschien –, so ist die israelische Besetzung palästinensischer Gebiete doch nicht das einzige Motiv seiner

Let's have another war, 1997

Arbeit. Seine Aufmerksamkeit galt stets auch anderen, historisch weniger bedeutsamen Themen. Diese Zwiespältigkeit spiegelt die Alltagswirklichkeit seines Landes wider. In der Vielfalt seiner Themen und seinen Variationen ein und desselben Bildes zeigt sich Reebs Glaube an die Möglichkeiten der Malerei, doch seine Provozierbarkeit durch Aktualität verhindert, daß er das Medium der Malerei zu einer autonomen und selbstgenügsamen Realität fetischisiert.

P.S.

Gerhard Richter

*1932 in Dresden. Lebt und arbeitet/lives and works in Köln.

Gerhard Richter left East Germany to live in Düsseldorf in 1961, not long before the construction of the Wall. He had learned his trade as a painter according to the norms of socialist realism. His discovery of pop art led him to profoundly transform his work. He asserted the potential of the photographic image to attain pictorial form, through fulfillment by painterly reproduction: "I was surprised by photography, which we all use so massively every day. Suddenly, I saw it in a new way, as a picture that offered me a new view, free of all the conventional criteria I had always associated with art. It had no style, no composition, no judgment. It freed me from personal experience. For the first time, there was nothing to it: it was pure picture. That's why I wanted to have it, to show it – not use it as a means to painting but use painting as a means to photography."

Richter has always protected himself from any dogmatic belief, never ceasing to contest the identification of any ideological or programmatic dimension in his work. Early on, he decided to make archives of the images he collected as documentary sources for his work: press clippings, amateur snaps, photos by the artist, utopian and "megalomaniacal" sketches of projected installations. He first exhibited his Atlas in 1972. In an interview that same year he claimed "an authentic reference to romanticism," setting himself apart from the hyperrealist trend with which he had been hastily confused. By actualizing romanticism through the use of photography, he found the possibility to reinvent informel painting, in his abstract paintings.

Begun in 1962, the Atlas is a work in progress, today numbering almost 5,000 images presented on 600 panels, covering the period from 1945 to the present. Over the course of various public exhibitions, these montage panels have evolved from their early, contingent and empirical order into a coherent, even taxonomic structure, on the basis of a heterogeneous accumulation of document-images. In the transition it effects from the particular to the general, from the private to the public, the Atlas is as much an intimate diary as an encyclopedic project: concentration camps, landscapes, fragments of paintings, trifling incidents, family photos, news pictures, pornography, portraits, cityscapes, blurred images of the Red Army Fraction, flowers, etc., etc. Thus the Atlas becomes a particular kind of "black box," a possible figure of the stratifications of memory where individual episodes and historical events coincide – the personal and collective unconscious that informs the artist's pictorial work.

P. S.

Gerhard Richter verläßt 1961 kurz vor dem Bau der Mauer die DDR, wo er als Maler gemäß den Normen des Sozialistischen Realismus ausgebildet worden war, und läßt sich in Düsseldorf nieder. Die Begegnung mit der Pop Art führt zu einer grundlegenden Änderung seiner Arbeitsweise. Er greift nun auf Photographien als Arbeitsgrundlage zurück, die er als potentielle Gemälde begreift, die nur darauf warten, durch die Malerei zur Vollendung gebracht zu werden. Auf die Frage, warum die Photographie in seinem Werk eine so wichtige Rolle spiele, antwortete Richter: »Weil ich überrascht war vom Photo, das wir alle täglich so massenhaft benutzen. Ich konnte es plötzlich anders sehen, als Bild, das ohne all die konventionellen Kriterien, die ich vordem mit Kunst verband, mir eine andere Sicht vermittelte. Es hatte keinen Stil, keine Komposition, kein Urteil, es befreite mich vom persönlichen Erleben, es hatte erstmals gar nichts, war reines Bild. Deshalb wollte ich es haben, zeigen – nicht als Mittel für eine Malerei benutzen, sondern die Malerei als Mittel für das Photo verwenden.«

Richter hat sich immer vor jedem Dogmatismus gehütet und stets bestritten, daß sein Werk eine ideologische und programmatische Dimension besitze. Sehr früh schon beschloß er, die von ihm gesammelten und die Quellen seiner Arbeit dokumentierenden Bilder zu archivieren: aus Zeitungen ausgeschnittene Bilder, Schnappschüsse von Amateuren, von ihm selbst aufgenommene Photographien, utopische und »größenwahnsinnige« Installationsprojekte. Dieses Archiv, seinen Atlas, stellt er 1972 zum ersten Mal aus. Im gleichen Jahr erhebt er den Anspruch auf einen authentischen historischen Bezug zur Romantik und distanziert sich explizit vom Hyperrealismus, dem man ihn vorschnell zugerechnet hatte. Indem er mittels der Photographie romantische Ansätze aufgreift, schafft er sich die Möglichkeit, in seinen abstrakten Bildern zu einer neuen informellen Malerei vorzustoßen.

Der Atlas ist ein Work-in-progress, das, 1962 begonnen, zur Zeit aus ungefähr 5000 Bildern besteht, die auf 600 Tafeln verteilt sind. Er umspannt den Zeitraum von 1945 bis heute. Für die öffentliche Präsentation des Werks wird aus dieser bunt zusammengewürfelten Anhäufung von Bildern jeweils eine fast schon taxonomisch strukturierte Dokumentenmontage. Der Atlas, der den Übergang vom Besonderen zum Allgemeinen, vom Privaten zum Öffentlichen sicherstellt, ist gleichermaßen intimes Photoalbum und enzyklopädisches Projekt: Konzentrationslager, Landschaften, Fragmente von Gemälden, Bilder von lokalen Ereignissen, Familienphotos, zeitgeschichtliche Bilder, Pornographie, Portraits, Stadtansichten, unscharfe Bilder von Angehörigen der RAF, Blumen etc. Der Atlas ist auf gewisse Weise eine

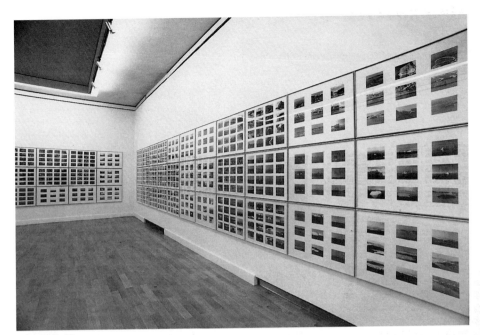

Atlas, 1962–96
Installlation view Städtische Galerie im Lenbachhaus, München, 1989
Detail

Black-box, in der alle Schichten der Erinnerung präsent
und die individuellen Episoden wie auch die geschichtli-
chen Ereignisse verwahrt sind, die im Zusammenspiel
von persönlichem und kollektivem Unbewußtem das
Werk des Künstlers prägen.

P.S.

Liisa Roberts

*1969 in Paris. Lebt und arbeitet/lives and works in New York.

A film is made up of photographs. Its temporal dimension is based on an illusion that requires little manipulation. All the human eye requires is 24 frames a second in order to perceive continuous sequences as a realistic reproduction of motion in time and space. In other words, a mechanical deficit, the slowness of the human eye, is one prerequisite for the successful simulation of reality in film. Another is the inexplicable willingness of human beings to accept two-dimensional images as adequate representations of three-dimensional space.

These mechanical and psychological characteristics of film are the basis for Liisa Roberts' work. As in her earlier works betraying a portrait and a film (both 1995), Trap Door (1996) reflects the relationship between viewer and work in time and space. She uses 16 mm film shot at 1,000 frames per second and projected at the usual speed of 24 frames per second. The effect is one of extreme slow motion. Each individual image gains in significance while the overall sequence is softened. The labor-intensive techniques of filming and processing involved in Liisa Roberts' work contribute to the discourse on film's origins in photography. For example, in Roberts' method of filming the hands of women in conversation from three different angles at the same time, we find a reflection of Eadweard Muybridge's prefilmic attempts to capture movement in images. The scene she has created in this way is then projected onto three almost square screens which form a closed triangle. A fourth, rectangular screen is free-standing opposite one side of the triangle. The three smaller projection screens are made of semitransparent material so that the images projected onto the screens from behind shimmer through, whereas the film on the large screen is projected frontally, as in the cinema. The result is a space that is both closed and open at the same time. The viewer can walk around it, enter it, or observe it, for it adheres to sculptural principles as well as visual principles. It is both exhibition space and object.

Liisa Roberts employs and explores the specific possibilities of film and, at the same time, creates a new and multi-layered space that permits a disturbing oscillation of scenic and spatial experience between reality and illusion, constantly challenging the viewer to seek new positions.

S. P.

Ein Film setzt sich aus Photographien zusammen. Seine zeitliche Dimension beruht auf einer Täuschung, die nicht einmal besonders trickreich erzeugt werden muß. Dem menschlichen Auge reichen 24 Aufnahmen pro Sekunde, und es liest zufrieden kontinuierliche Abläufe ab, die als realistische Wiedergabe von Bewegung in Zeit und Raum empfunden werden. Ein mechanisches Defizit, die Langsamkeit des Auges, ist also eine Voraussetzung für die erfolgreiche Simulation von Wirklichkeit im Film. Die andere ist die nicht erklärbare Bereitschaft des Menschen, offensichtlich zweidimensionale Bilder als adäquate Repräsentation des dreidimensionalen Raums zu akzeptieren.

Diese mechanischen und psychologischen Eigenschaften des Films sind Ausgangspunkte für Liisa Roberts' Arbeit. Wie auch ihre früheren Arbeiten betraying a portrait oder a film (beide 1995) reflektiert Trap Door (1996) das Verhältnis von Betrachter und Werk in Zeit und Raum. Für die Projektion verwendet sie einen 16 mm-Film, der mit 1000 Bildern pro Sekunde aufgenommen wird. Die Wiedergabe erfolgt in der üblichen Geschwindigkeit von 24 Aufnahmen pro Sekunde. Der Effekt ist der einer extremen Zeitlupe. Jedes einzelne Bild gewinnt dadurch an Gewicht, während gleichzeitig der Bewegungsablauf weicher wird. Der Diskurs über die Herkunft des Films aus der Photographie wird durch die arbeitsintensive Aufnahmetechnik und Bearbeitung des fertigen Films weitergeführt. So spiegeln sich Eadweard Muybridges vorfilmische Versuche, Bewegung in Bildern festzuhalten, in Roberts' Methode, die Hände von sich offensichtlich unterhaltenden Frauen aus drei Richtungen gleichzeitig aufzunehmen. Die so entstandene Szene wird wiederum auf drei, annähernd quadratische Leinwände projiziert, die ein geschlossenes Dreieck bilden. Eine vierte, querrechteckige, steht frei einer Seite des Dreiecks gegenüber. Die drei kleineren Projektionsflächen sind aus halbtransparentem Material, so daß die Bilder, die von hinten auf die Leinwände fallen, durchscheinen, während der Film auf die große Leinwand wie im Kino frontal projiziert wird. Es entsteht ein Raum, der gleichzeitig geschlossen und offen ist. Man kann ihn umgehen, ihn betreten oder ihn betrachten, denn er gehorcht skulpturalen Prinzipien genauso wie bildnerischen. Er ist Ausstellungsort und Objekt in einem.

Liisa Roberts nutzt und thematisiert die spezifischen Möglichkeiten des Films und schafft gleichzeitig einen neuen, mehrschichtigen Raum, der szenische und räumliche Erfahrungen ermöglicht, die unruhig in Real- und Illusionsraum oszillieren und die permanente Neupositionierung des Betrachters herausfordern.

S. P.

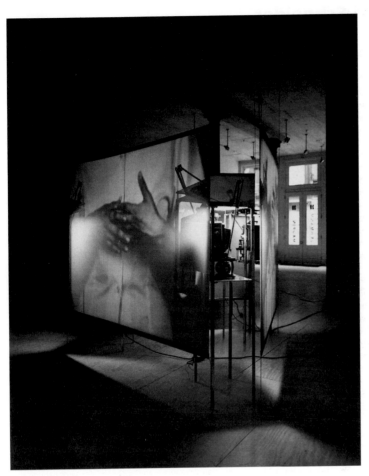

Trap Door, 1996
Installation view Lehmann Maupin, New York, 1997
Detail

Anne-Marie Schneider

*1962 in Chauny. Lebt und arbeitet/lives and works in Paris.

For the past several years, drawing has been the lead-
ing element in the work of Anne-Marie Schneider, who
brings other techniques and procedures into play
around it (photography, cinema, performance, sculp-
ture). Originally a musician, she is now creating short
animated films which unfold the narrative dimension
and the contained mobility of the drawings.

For documenta she is presenting recent drawings
moved by the need to confront current events, to
poetically rework media information and lend fugitive
meaning to words that tend toward abstraction. Thus
the drawing of a burnt match stick serves as the initial
letter of the term "information"; buckets filling up with
different levels of milk contain the scattered fragments
of the word "flexibility" (Maastricht, 1996); the distort-
ed reflection of the word "monde" ("world") is in-
scribed on a shiny can. Other drawings depict more
precise events: a person equipped with a bicycle lock
attempts to stop an abortion (I.V.G., 1997); Algerian
women stand against a background of satellite dishes
and TV sets on Boulevard de la Chapelle in Paris; hel-
meted police drag illegal immigrants from the symbolic
squat of Saint Bernard church; a man in overalls sleeps
standing up against a vertical bed; a dark mass
adorned with a crocodile trademark emerges from a
sewing machine in a sweatshop.

Each of these drawings appears as a psychic narra-
tive in concentrated form. They are motivated by a
wide range of stimulations: the provocation of media
information, the memory of things seen, the confusion
of rumors, biographical circumstances, intimate events,
the upsurge of the unconscious. They respond with
tactical maneuvers: shedding learned skills, rusing with
illustration, lending renewed trust to musical balance.
Schneider's drawings are often risky undertakings,
treading tensed or broken lines. The graphic quality of
the execution, sometimes combined with a principle of
automatic drawing, sketches out situations jolted by
the shock of current events, private or public. Where
media information may be simply consumed – like a
match – the drawing seizes on the possibility of experi-
ence that persists in all information: that almost imper-
ceptible sign, vacillating like a flame, the event in itself.
The event takes place neither inside or outside the art-
ist, but works as a vector between these two poles. The
figuration of meaning partakes of a writing of self.
Anne-Marie Schneider's drawings describe this battle.

P. S.

Seit einigen Jahren steht das Zeichnen im Zentrum der
Arbeit der früheren Musikerin Anne-Marie Schneider,
die aber auch noch andere Verfahren und Techniken
einsetzt (Photographie, Film, Aktion, Skulptur). Heute
macht sie kurze Animationsfilme, die die narrative
Dimension und die Dynamik der Zeichnungen entfalten.

Bei der documenta präsentiert sie neuere Zeichnun-
gen, in denen sie Informationen über das Zeitgeschehen
poetisch bearbeitet und abstrakte Begriffe in eine bildli-
che Darstellung umsetzt, die ihnen einen vorläufigen
konkreten Erfahrungssinn erschließt. Beispiele dafür
sind etwa die Zeichnung eines abgebrannten Streichhol-
zes, das als Initiale des Begriffs »Information« dient,
jene manchmal Milch enthaltenden Eimer, auf denen
die Buchstaben des Wortes »flexibilité« verteilt sind
(Maastricht, 1996), oder auch das auf einer Konserven-
dose stehende Wort »monde«, das in vielfache Spiege-
lungen zersplittert. Bei den anderen Zeichnungen sind
die Ereignisse noch präziser: In einem Operationssaal
versucht eine Person, die mit einer Diebstahlsicherung
ausgerüstet ist, eine Abtreibung zu verhindern (I.V.G.,
1997); in Barbès heben sich algerische Frauen vor
einem Hintergrund aus Fernsehantennen und Fernseh-
geräten ab (Boulevard de la Chapelle, Paris); ein Mann
im Arbeitsanzug schläft im Stehen, gegen ein aufrecht-
stehendes Bett gelehnt; in einer Fälscherwerkstatt quillt
aus einer Nähmaschine eine schwarze Masse, die mit
einem Krokodil geschmückt ist.

Jede dieser Zeichnungen präsentiert sich als Verdich-
tung eines psychischen Geschehens. Sie sind vielfältigen
Anregungen unterworfen (provozierenden Informatio-
nen, der Erinnerung an Gesehenes, der Vermischung
von Geräuschen, den biographischen Umständen, per-
sönlichen Erlebnissen, dem Einfluß des Unbewußten)
und reagieren mit taktischen Operationen (der Preis-
gabe technischer Möglichkeiten). So präsentieren sich
die Strichzeichnungen Anne-Marie Schneiders häufig als
gewagte Unternehmungen, die sich in gebrochenen
und gespannten Linien vollziehen. Die Qualität des
manchmal mit einem Automatismus verbundenen
Strichs zeichnet und ist gezeichnet von Situationen, in
denen sich die Erschütterungen des Zeitgeschehens
nachhaltig auswirken. Und wenn die Information sich
erschöpft, wie ein Streichholz sich erschöpft, ergreift
die Zeichnung das, was in der Information noch immer
die Möglichkeit einer Erfahrung beinhaltet, jenes win-
zige, wie eine Flamme flackernde Zeichen. Dieses Zei-
chen repräsentiert weder das Innere des Künstlers noch
seine Außenwelt, es ist vielmehr ein Vektor zwischen
diesen beiden Polen. Die bildliche Darstellung von
Bedeutungen der Dinge ist Teil einer Selbstauslegung.
Die Zeichnungen Anne-Marie Schneiders sind die

Saint Bernard, Paris, 23 août 1996

»Beschreibung eines Kampfes«, jenes Kampfes nämlich, der auch das Thema von Kafkas gleichnamiger Erzählung ist – der Erfahrung eines ungesicherten Weltbezugs, eines Kampfes mit den »Dingen« der Außenwelt, die sich für jede Zurichtung durch das Ich zu rächen drohen.

P.S.

Jean-Louis Schoellkopf

*1946 in Colmar. Lebt und arbeitet/lives and works in Saint-Etienne.

When Jean-Louis Schoellkopf began to take photographs in the early 1970s in Montreal, his aim was to show the working conditions of people whose means and modes of living he shared. He sought to make up for the deficit in the representation of everyday life by media images. Photography for him was primarily a tool of inquiry and description. Taking his distance from reportage, he discovered the documentary tradition of photography as a way to carry out a political activity of testimony while affirming a poetic attitude and an ethical stance.

In 1974 he moved to Saint-Etienne, which still had a traditional working-class culture, and began a process of observation and analysis of the city in its time-depth and complexity, and above all in its transformation, conditioned by historical, economic, and social processes. While remaining attentive to the local specificity of Saint-Etienne, today he considers it primarily as a model through which he can observe the evolution of European cities and the ideological crisis they are currently undergoing. "Because Saint-Etienne has never had coherent city planning, its aspect is chaotic, juxtaposing the traces of different periods and of the different ideologies to which its elected officials have subscribed, without any apparent logic in the results. The successive ideologies have produced urban forms that can be identified today, whether Christian capitalism with forms issuing from hygienist conceptions, or Taylorist capitalism with the large-scale housing complexes. In our day, has ultraliberalism produced a coherent form?"

The project he has created for documenta *is a selection of images from his work, presented in the form of two sequences playing on a system of oppositions and dualities: square/rectangle, color/black-and-white, inside/outside, empty public space/inhabited private space. This typological montage also reveals the relation between spaces of circulation and domestic spaces. The two sequences are answered by a highly sensual image: the photograph of a rabbit ready to be cooked. This image, which can't help but recall the flayed body of anatomical studies, comes from a series where the artist "began with the intuition that there exists an intimate link between architecture and food," a relation between the evolution of architectural materials and culinary ingredients. Here he metaphorically contrasts the rawness of the flesh to the precooked components of defrostable postmodern architecture, with its ready-to-use prefab materials and ornamental fixtures, "like a shiny, colored glaze."*

P. S.

Als Jean-Louis Schoellkopf zu Beginn der siebziger Jahre in Montreal anfängt, Photographien zu machen, will er die Arbeitsbedingungen der Arbeiter zeigen, deren Leben er teilt. Er beabsichtigt damit, das in den Bildmedien festzustellende Defizit hinsichtlich der Darstellung der Alltagswirklichkeit so gut es geht zu beheben. Die Photographie ist für ihn zunächst und vor allem ein Werkzeug der Dokumentierung und Beschreibung. Er distanziert sich von der Reportage und sieht in der Tradition der Dokumentarphotographie die Chance, eine politische Aussage zu machen und zugleich eine poetische Einstellung zu bewahren wie auch eine ethische Position zu vertreten.

Schoellkopf zieht 1974 nach Saint-Etienne, einer Stadt, die noch eine traditionelle industrielle Kultur besitzt, und beginnt zu beobachten und zu analysieren, wie sich die Stadt, bedingt durch die historischen, wirtschaftlichen und sozialen Ereignisse, in ihrer Komplexität verändert. Er registriert aufmerksam die lokalen Besonderheiten der Stadt, doch er betrachtet sie vor allem als Modell, an dem er die Entwicklung der europäischen Städte und die ideologische Krise beobachten kann, die sie durchmachen. »Da es nie eine sich durchhaltende urbane Politik gab, bietet Saint-Etienne einen chaotischen Anblick, denn die Stadt zeigt gleichzeitig, ohne daß eine Logik darin zu erblicken wäre, die Spuren verschiedener Perioden und verschiedener Ideologien, denen sich ihre gewählten Vertreter verschrieben hatten. Die Ideologien, die sich gegenseitig ablösten, haben urbane Formen geschaffen, die man heute in ihrer Eigenart erkennen kann: der christliche Kapitalismus mit seinen dem Hygienismus entstammenden Formen oder der tayloristische Kapitalismus mit seinen Wohnsiedlungen. »Ist der Ultraliberalismus unserer Tage«, fragt Schoellkopf, »in der Lage, eine kohärente Form hervorzubringen?«

Auf der documenta ist er mit einer in zwei Sequenzen präsentierten Auswahl von Bildern aus seinem Gesamtwerk vertreten, die ein System von Oppositionen und Dualitäten durchspielen: quadratisch – rechteckig; farbig – schwarzweiß; innen – außen; leerer öffentlicher Raum – privater bewohnter Raum. Diese typologische Montage enthüllt die Beziehungen zwischen der Organisation der öffentlichen Verkehrsräume draußen und der Organisation der privaten Räume des Hauswesens drinnen. Den beiden Sequenzen entspricht ein Bild von großer Sinnlichkeit: die Photographie eines fertig zubereiteten Hasen. Dieses Bild, das durchaus an die traditionellen »Küchenstücke« erinnert, stammt aus einer Serie, bei der der Künstler »von dem Gefühl ausging, es gebe eine innere Verbindung zwischen Bauweise und Ernährungsweise«, eine Beziehung zwischen

(Saint-Etienne), 1986–96

der Entwicklung der architektonischen Materialien und der Nahrungsmittel. Er kontrastiert hier auf metaphorische Weise die Roheit des Fleischs mit der Vorgekochtheit der postmodernen Tiefkühlarchitektur (mit ihren vorgefertigten und gebrauchsfertigen Materialien, ihrem ornamentalen, einem »farbigen Zuckerguß« gleichenden Schnickschnack).

P. S.

Thomas Schütte

*1954 in Oldenburg. Lebt und arbeitet/lives and works in Düsseldorf.

Architecture is a recurrent theme in Thomas Schütte's work, although he himself prefers not to see his preoccupation with buildings and models as architectonic exercises. On the contrary, as he explained in 1985 in an interview with Ulrich Loock: "For me (architecture) simply crops up as one motif among others, as a nature substitute so to speak, because I find it difficult to work with nature." In the meantime, nature has made its entrance into Schütte's art, and, along with it, human beings. They are to be found initially in the works of the draftsman and painter Schütte, who does not hesitate to take up supposedly trivial themes, committing whole series of portraits to paper and producing water colors of flowers, landscapes, and fruit-laden still lifes. If Thomas Schütte's works on paper reveal the narrator in him, it is possible to detect the theatrical designer in his sculptures. Irrespective of whether they are models or actually walk-in architecture in public places, they all possess an intrinsic vacuum that dominates the surroundings and does not necessarily invite one to fill it.

For his first participation in documenta, in 1987, Schütte constructed a pavilion in the Karlsaue which during the whole course of the exhibition served visitors as a kiosk. Given the summer context of the exhibition, the title of the work, Eis (ice-cream), was highly suggestive and filled with tangible meaning, its "measure of utility," often referred to by the artist in connection with his art, being fully satisfied by the sale of ice cream in the pavilion. Historically related to English and French park and garden architecture, the pavilion's outward form was reminiscent of an upturned paint bucket. Yet whereas in former times the masters of narrative architecture arranged a simultaneous and eloquent rendezvous in the Orangerie, Schütte's ice cream kiosk effected a monosyllabic and ironic counterpoint.

Thomas Schütte was represented at documenta again in 1992 by one work. This time he positioned a group of almost life-size, glazed ceramic figures in the portico of the former Rote Palais, which today makes up the facade of Leffers' department store on Friedrichsplatz. These resolutely abstract figures have odd, unfamiliar facial features and, with their large sweeps of color, are reminiscent both of figures from Oskar Schlemmer's Triadisches Ballett and of Christmas wood carvings. Their bags, sacks, and earthenware vessels, seem like various exotic means of transporting goods.

Since then, Die Fremden (The Strangers), an expression of strong sympathy for all the strangers among us, have become dispersed all over the world. One small family – a man, a woman, and a child – remained in Kassel, complete with baggage, another made it to

Ein wiederkehrendes Moment in der Kunst Thomas Schüttes ist die Architektur. Doch möchte er seine Beschäftigung mit Bauten und Modellen nicht als architektonische Übungen verstanden wissen. Vielmehr »taucht (die Architektur) da einfach als Motiv auf, praktisch als Natursatz, weil es mir schwerfällt, mit Natur zu arbeiten«, erklärt Schütte 1985 anläßlich eines Interviews mit Ulrich Loock. Inzwischen hat die Natur Einzug gehalten in das Werk Thomas Schüttes und mit ihr die Menschen. Sie finden sich zunächst bei dem Zeichner und Maler Thomas Schütte, der sich nicht scheut, vermeintlich triviale Themen aufzugreifen und ganze Porträtserien aufs Papier zu bringen oder Blumen, Landschaften und Früchtestilleben in Aquarell auszuführen. Offenbart sich in den Papierarbeiten der Erzähler Thomas Schütte, so könnte man in seinen Skulpturen etwas Bühnenbildhaftes erkennen. Egal ob als Modell oder als real betretbare Architektur – im öffentlichen Raum ist ihnen eine Leere zu eigen, die das Umfeld dominiert und nicht unbedingt zum Auffüllen einlädt.

1987, bei seiner ersten documenta-Beteiligung, baute Thomas Schütte in der Karlsaue einen Pavillon, der den Besuchern während der Dauer der Ausstellung als Kiosk zur Verfügung stand. Der im Rahmen der sommerlichen Veranstaltung höchst suggestive Titel Eis war damals unmittelbar mit Inhalt gefüllt und der »Maßstab der Brauchbarkeit«, von dem der Künstler häufig im Zusammenhang mit seiner Kunst spricht, durch den Verkauf von Eis in seinem Pavillon voll erfüllt. Bauhistorisch mit den Gartenarchitekturen englischer und französischer Parkanlagen verwandt, beruhte die äußere Form auf einem umgestülpten Farbeimer. Während damals gleichzeitig die Meister narrativer Architektur in der Orangerie ein beredtes Stelldichein gaben, setzte Schüttes Eiskiosk einen einsilbigen Kontrapunkt voller Ironie.

1992 war Thomas Schütte wieder mit einer Arbeit auf der documenta vertreten. Diesmal installierte er eine Gruppe fast lebensgroßer glasierter Keramikfiguren auf dem Portikus des ehemaligen Roten Palais, der heute die Fassade des Kaufhauses Leffers am Friedrichsplatz bildet. In ihrer großflächigen Farbigkeit zwischen Figuren aus Oskar Schlemmers Triadischem Ballett und weihnachtlichen Holzschnitzereien angesiedelt, haben die stark abstrahierten Figuren eigentümlich fremdländische Gesichtszüge. Auch die zahlreichen Taschen, Säcke und Tongefäße scheinen am ehesten exotische Warentransportbehältnisse zu sein.

Die Fremden, Ausdruck starker Empathie für die anderen unter uns, sind inzwischen in alle Welt verteilt. Eine kleine Familie – ein Mann, eine Frau, ein Kind – blieb mit ihren Gepäckstücken in Kassel erhalten. Eine

Liebesnest, 1997

Lübeck, and a third was granted asylum in New York.
The Eis pavilion has also disappeared, surviving
merely as an image in the archives of the art experts.

S. P.

andere ist inzwischen in Lübeck und eine dritte genießt
derzeit Asyl in New York.

Auch der Pavillon *Eis* ist inzwischen verschwunden
und existiert nur noch als Bild in den Berichten der
Kunstsachverständigen.

S. P.

Michael Simon

*1958 in Neumünster. Lebt und arbeitet/lives and works in Berlin.

Michael Simon couldn't care less about texts. He prefers to take his inspiration from video installations, pop music, and films. His criticism – that most theater authors write as though they were contributing to the Sunday papers – is balanced by an aesthetic that seeks to respond to current cultural practices. He regards the new media such as Internet and virtual reality as sources of aesthetic inspiration and future prospects for his notion of theater.

Accordingly, he abducts us into acoustic spaces and imaginary visual worlds, experimenting with the works of William Burroughs, Carl Orff, Richard Wagner, Arnold Schönberg, and Luigi Nono. Simon puts his quiet acoustic precision to truly astonishing effect. In Narrative Landscape he presents the stage in semidarkness as though he wished to lend form to an unreal twilight zone between nightmare and dream.

Changing levels of light are atmospherically condensed with virtuoso precision to narrative landscapes. There are no scenes in the conventional sense, nor any plot or narrative material – at most there are changing experiments in the worlds of light and sound. The classical theater situation with language, sounds, music, movement, images, and light is tested to the utmost. Electrified sound fragments rip through the solemnity of the music. For all the acoustic fragmentation, Simon succeeds time and time again in finding an archaic calm. It is the calm of the gray zone, of the nocturnal landscape that is like an emotional wasteland. Time and time again, the stage setting freezes to a stop and the actors slow down to the absolute minimalism of mere presence, allowing the gentle architecture of light and shade to develop its hypnotic effect. Seemingly familiar images merge in the fluid forms of their appearance. Shuddering building-site noises and temperamental expressiveness might break the stillness at any moment.

Simon takes the courageous step of staging a fragile multimedia musical theater that is fragmented enough to leave room for association and imagination, juxtaposing free jazz, accordion, and speech performance to forge a highly charged relationship between the archaic and the high tech. He chooses the path of open structures rather than that of the unequivocally illusory or even the illustration of a text.

In the last two years, Michael Simon has staged Black Rider at the Schauspielhaus Dortmund, Dr Jekyll and Mr Hyde at the Volksbühne Berlin and Tosca at the Burgtheater in Vienna. The Goya project Schlaflos was the first in his current residence at the Schaubühne am Lehniner Platz in Berlin.

J.H./B.F.

Texte sind Michael Simon ziemlich egal. Er läßt sich dagegen von Videoinstallationen, Popmusik und Filmen inspirieren. Seiner Kritik, die meisten Theaterautoren schrieben wie für das Feuilleton, setzt er eine Ästhetik entgegen, die auf die veränderte Wahrnehmung der gegenwärtigen kulturellen Praktiken reagieren will. Die Neuen Medien, wie das Internet und Virtual Reality sind für ihn ästhetische Anregungen und Perspektiven für sein Theater.

So entführt er uns in akustische Räume und imaginäre Bildwelten, experimentiert mit Partituren und Stücken von William Burroughs, Carl Orff, Richard Wagner, Arnold Schönberg und Luigi Nono. Seiner leisen Genauigkeit von Klangräumen vertraut Michael Simon, die uns das Staunen lehren. In Narrative Landscape präsentiert er die Bühne in einem Halbdunkel, als wolle er einer unwirklichen Grauzone aus Alptraum und Wachzeit Gestalt geben.

Wechselnde Lichtebenen werden in virtuoser gestalterischer Präzision zu erzählenden Landschaften atmosphärisch verdichtet. Szenen im klassischen Sinn gibt es nicht, keinen Handlungsstrang und keinen erzählbaren Stoff, allenfalls wechselnde Versuchsanordnungen aus Lichtwelten und Klangzeichen. Die klassische Theatersituation mit Sprache, Geräuschen, Musik, Bewegungen, Bildern und Licht wird auf die Probe gestellt. Elektrisierte Geräuschsplitter durchlöchern immer wieder die feierliche Traurigkeit der Musik. Trotz aller akustischer Brüche gelang es Michael Simon immer wieder, zu einer archaischen Ruhe zu finden. Es ist die Ruhe der Grauzone, der nächtlichen Landschaft, die einer Wüstenei der Gefühle gleicht. Immer wieder gefriert das Bühnengeschehen zu einem Standbild, erstarren die Schauspieler in minimalistischer Langsamkeit zu ihrer reinen Präsenz, so daß die sanfte Architektur aus Hell und Dunkel eine hypnotische Wirkung entfalten kann. Bilder, an die man sich zu erinnern glaubt, zerfließen in weichen Formen ihrer Erscheinung. Erbebender Baulärm und auffahrende Expressivität können jeden Moment das stille Bild abwechseln.

Michael Simon geht den mutigen Weg, ein labiles multimediales Musiktheater zu inszenieren, mit Brüchen und Raum für Assoziationen und Phantasie, wo Free Jazz, Akkordeon und Sprach-Performance nebeneinander bestehen, ein Spannungsfeld zwischen Archaik und High-Tech aufgebaut wird. Er geht den Weg der offenen Strukturen anstatt der eindeutig vorgespielten Illusion oder gar der Illustration eines Textes.

In den letzten zwei Jahren realisierte Michael Simon Projekte am Schauspielhaus Dortmund (Black Rider), an der Volksbühne Berlin (Dr. Jekyll and Mr. Hyde) sowie Tosca am Burgtheater in Wien. Das Goya-Projekt

Newton's Casino, Raumentwurf, 1990

Schlaflos (1996) war die erste Inszenierung seines derzeitigen Engagements an der Schaubühne am Lehniner Platz in Berlin.

J.H./B.F.

Abderrahmane Sissako

*1961 in Mauretanien. Lebt und arbeitet/lives and works in Paris.

Abderrahmane Sissako was born in Mauritania and raised in Mali. From 1983 to 1989 he had the opportunity to study cinema in Moscow. Prior to his studies he had to learn Russian for a year in the city of Rostov. There he became friends with another foreigner, Baribanga, a young Angolan student and revolutionary who was also learning Russian. In Rostov-Luanda – his first documentary, after three fictional shorts – Sissako leaves in search of his old friend. The story of the journey combines his discovery of Angola (a country where "recent African history is expressed with unusual violence and confusion"), an experience of "personal retrospection," portraits of the people he meets, and an inquiry into the events that have shaped the history of contemporary Africa.

Rostov (former USSR) and Luanda (Angola): the two cities are stations in the filmmaker's biography. The presence of the narrator, marked only by an off-screen voice, primarily emerges as a position of retreat and listening. The structure of the film is determined by the journey; it is based on waiting. At once a strategy and a structural device, the posture of waiting allows the author to share in "an enduring affinity with persons and places." In Angola, a country which has not been at peace over the last thirty years, Sissako is accompanied night and day by a bodyguard, Pinto, a former soldier with whom he discusses the horrors of war.

"To a large degree, making a film is always for me an attempt to translate an experience of exile, of foreignness, of otherness. The desire to make films, and the way I have made them, has to do with the experience of traveling, as seen through the eyes of the nomad whom I try to remain," declares Sissako. The film begins with an "act of return" to his native land of Mauritania. Kiffa and Oualata – the birthplaces of his mother and father – are the places of departure for Angola. Thus Sissako immediately seeks to inscribe an idea of belonging, as much historical as geographic. This prologue or "opening song," constructed around the presence of a griot with ties to the filmmaker's family, allows the viewer to discover the symbolic and material stakes underlying the film.

The Biker, situated in the center of Luanda, is also at the heart of the film. A building from the early century houses the oldest bar in the city – an open place, a place of passage, a theater of everyday life peopled with rumors and vestiges. The Biker is the "home port" for the film crew. Sissako lingers over the stories of two older men: Beto Gorgel, a well-known journalist, and Roberto Passas, the owner of the bar. Their voices evoke Angola's past and future, the war, the question of métissage, the traces of the Portuguese colonial pres-

Abderrahmane Sissako wurde in Mauretanien geboren und wuchs in Mali auf. Zwischen 1983 und 1989 studierte er in Moskau Filmwissenschaft, allerdings mußte er zuvor ein Jahr lang in Rostow Russisch lernen. In Rostow schloß er Freundschaft mit Baribanga, einem jungen Studenten und angolesischen Revolutionär, der sich dort mit dem gleichen Ziel aufhielt. In Rostov – Luanda, seinem ersten Dokumentarfilm nach drei kurzen Spielfilmen, berichtet Sissako von seiner Suche nach diesem alten Freund und zugleich auch von seinen eigenen Reiseerfahrungen und seiner Entdeckung Angolas (»die jüngere Geschichte dieses Landes ist besonders gewalttätig und verworren«), begleitet von einem »persönlichen Rückblick« und angereichert mit Portraits von Personen, denen er begegnete, sowie einem Blick auf die Ereignisse, die die jüngere afrikanische Geschichte prägten.

Rostow (in der ehemaligen UdSSR) und Luanda (Angola): zwei Stationen in der Biographie des Filmemachers. Der nur als Stimme aus dem Off präsente Erzähler nimmt sich zurück und beschränkt seine Anwesenheit in erster Linie aufs Hören. Der durch den Verlauf der Reise strukturierte Film zeichnet sich durch sein geduldiges Abwarten aus. Diese Geduld ist Strategie und Technik zugleich, sie erlaubt Sissako »eine anhaltende Affinität zu den Personen und den Schauplätzen«. In Angola, das seit dreißig Jahren keinen Frieden gekannt hat, wird Sissako Tag und Nacht von einer Leibwache begleitet, einem ehemaligen Soldaten namens Pinto, mit dem gemeinsam er die Schrecken des Krieges erlebt.

»Der Film ist für mich zum großen Teil eine Erfahrung des Exils, der Fremdheit, der Andersheit. Das Bedürfnis, ihn zu machen, und die Art, wie ich ihn gemacht habe, haben etwas mit dem Blickwinkel des Nomaden und dem Prinzip der Reise zu tun«, erklärt Sissako. Der Film beginnt mit »einem Akt der Wiederanknüpfung«, einer Fühlungnahme mit Mauretanien, dem Land seiner Geburt. Kiffa und Oualata, die Stadt seiner Mutter und die Stadt seines Vaters, sind die Orte, an denen die Reise nach Angola beginnt. Damit will Sissako gleich zu Beginn eine sowohl historische wie geographische Zugehörigkeit zum Ausdruck bringen. Der Prolog, das »Auftaktlied«, in dem der Autor einen mit seiner Familie verwandten Sänger und Magier auftreten läßt, eröffnet dem Zuschauer die Möglichkeit, die symbolischen und materiellen Bezüge des Films zu entdecken.

Das im Zentrum Luandas gelegene Biker ist ein weiteres Herzstück des Films. Das vom Anfang des Jahrhunderts stammende Gebäude ist die älteste Kneipe der Stadt. Als offener Durchgangsort, der ein lärmendes und spurenreiches Theater des Alltagslebens bietet, ist

Abderrahmane Sissako bei den Dreharbeiten zu/shooting *Rostov – Luanda*, Angola, 1997

ence. In musical counterpoint, the blind, wandering musician Maré (known by many as Ray Charles) sings of love and of the experiences that forge a collective memory.

P.S./B.K.

das Biker der »Heimathafen« der Filmcrew. Sissako konzentriert sich auf zwei alte Männer: den berühmten Journalisten Beto Gorgel und den Besitzer der Bar, Roberto Passas. Was sie sagen, hilft, Angola zu begreifen, es erklärt seine Vergangenheit, seine Zukunft, den Krieg, die Rassenvermischung, die Spuren der portugiesischen Kolonialherrschaft. Den kontrapunktischen Hintergrund dazu bildet die Musik des blinden Wandermusikers Maré (der manchmal Ray Charles genannt wird), seine Lieder von Liebe und Leid, die eine gemeinschaftliches Gedächtnis beschwören.

P.S./B.K.

100 Days – 100 Guests / 100 Tage – 100 Gäste

Alison & Peter Smithson

(with Nigel Henderson)

In 1950, shortly before leaving London for Newcastle, Alison and Peter Smithson began the construction of a school in Hunstanton. Completed in 1954, it was rapidly recognized as one of the great creations of modern architecture, even while constituting a critique of the modern movement's formalism. Yet the Smithsons, who had won the public competition for this project, received no other commissions throughout the 1950s. They began to use all sorts of media to express their architectural ideas. One of their principal concerns was a redefinition of the architect's task in a society preoccupied above all with mobility. Working in the Independent Group along with Richard Hamilton, Eduardo Paolozzi, Nigel Henderson, Lawrence Alloway, and Reyner Banham – at the inception of what would later be called Pop Art – they rapidly came to concentrate on the problematic of the city and the urban realm. In 1953 they presented CIAM Grille at the ninth edition of the famous International Congresses of Modern Architecture, held in Aix-en-Provence. The work stood as a manifesto, proclaiming that the real urban question to be "human association" and not the mechanical division of the city into the separate zones of lodging, transportation, industry, and leisure, as decreed by the Charter of Athens adopted at the 1933 CIAM.

CIAM Grille proposes a veritable "urban re-identification" replacing the four distinct zones with interconnections between four scales of urban habitation: the house, the street, the district, the city. Influenced by Nigel Henderson, the Independent Group photographer who created the images of the grid, the Smithsons referred to vernacular culture and to what David Robbins has called "the 'as found' social and physical realities of London's working class streets." In their subsequent conception of architecture they integrated media and advertising images as well as functional objects, in a will to come to grips with the new lifestyle of the citizen-consumer. An international group of young architects soon joined the Smithsons in their contestation of the modern movement and in their challenge to a functionalist program whose rigidity had become untenable. Meeting in 1954 in Holland under the name of Team X, they prepared their program for CIAM 10, held in 1956. The Smithsons continued to participate in the projects of the Independent Group, playing a central role in the exhibition This is Tomorrow (1956), which founded pop art and launched an aesthetic whose influence is still being felt today.

P. S.

Alison und Peter Smithson begannen 1950, kurz nachdem sie von London nach Newcastle gezogen waren, mit dem Bau der Schule von Hunstanton, bei dessen Ausschreibung ihr Entwurf erfolgreich gewesen war. Der 1954 fertiggestellte Bau galt schon bald als eine der bedeutenden Schöpfungen moderner Architektur wie auch als Kritik am Formalismus der Moderne. Dennoch erhielten die beiden Architekten erst am Ende der fünfziger Jahre weitere Aufträge. Um ihre architektonischen Ideen zum Ausdruck zu bringen, griffen die Smithsons auf alle zur Verfügung stehenden Mittel zurück. Eine Hauptgrundlage ihrer Vorstellungen ist ihre Neudefinition der Aufgabe des Architekten in Übereinstimmung mit den neuen Bedürfnissen einer Gesellschaft, deren Hauptsorge der Mobilität gilt. Sie waren, zusammen mit Richard Hamilton, Eduardo Paolozzi, Nigel Henderson, Lawrence Alloway und Reyner Banham, Mitglieder der englischen Independent Group (die den Ausgangspunkt jener Bewegung bildete, die man später Pop Art nennen sollte), und sie konzentrierten sich in zunehmender Weise auf die Probleme der Stadt und des Urbanen überhaupt. Beim neunten Congrès International pour l'Architecture Moderne (CIAM) in Aix-en-Provence präsentierten sie CIAM Grille. Dieses Werk, das den Charakter eines Manifestes hatte, macht klar, daß das eigentliche Problem der urbanen Wirklichkeit die »Vereinigung der Menschen« darstellt und nicht die mechanische Aufteilung der Stadt in vier verschiedene, getrennte Bereiche von Stadt, Industrie, Verkehr und Landschaft (Wohngebiete, Industriegebiete, Verkehrszonen und Freizeitbereiche), wie sie von der berühmten Charta von Athen beim CIAM von 1933 gefordert wurde. CIAM Grille tritt daher für eine grundsätzliche urbanistische Neubestimmung ein, die die vier obengenannten Zonen durch Verbindungen zwischen vier Größenordnungen urbaner Lebensbereiche ersetzt: Haus, Straße, Bezirk, Stadt. Zum Teil beeinflußt durch Nigel Henderson, dem Photographen der Independent Group, der auch die Bilder für CIAM Grille gemacht hatte, beziehen sie sich auf die regionale Kultur und die » ›vorgefundene‹ soziale und materielle Wirklichkeit von Londons Arbeitervierteln«, wie David Robbins sagte.

In der Folgezeit integrierten sie in ihre Vorstellung von Architektur die Bilder der Medien und der Werbung sowie funktionale Objekte, um dem Lebensstil der neuen Konsumgesellschaft Rechnung zu tragen. Die Smithsons gewannen mit ihren Alternativen zur Tradition moderner Architektur und ihrer Kampfansage gegen ein funktionalistisches Programm, dessen Rigidität kaum noch aufrechtzuerhalten war, rasch eine internationale Gefolgschaft junger Architekten. Sie alle fanden sich 1954 in den Niederlanden unter dem

HOUSE	STREET	RELATIONSHIP	CIAM 9	HOUSE	STREET	DISTRICT	CITY

Grille de Alison & Peter Smithson, CIAM Aix-en-Provence, 1952/53

Namen *Team X* zusammen und bereiteten das Programm des CIAM 10 vor, der 1956 stattfinden sollte. Die Smithsons beteiligten sich auch weiterhin an den Projekten der Independent Group und spielten eine zentrale Rolle bei der Ausstellung *This is Tomorrow* (1956), die die Pop Art hoffähig machte und eine Ästhetik propagierte, die auch heute noch Gültigkeit beansprucht.

P.S.

Alexander Sokurow

*1951 in Irkutsk, Rußland/Russia. Lebt und arbeitet/lives and works in St. Petersburg.

Mutter und Sohn/Mat'i sin *(Mother and Son)* tells a love story. It is about the deep affection between parent and child. The mother is seriously ill, her body emaciated, her strength gone. Her son cares for her lovingly. He feeds her, prepares her a bed on a bench in front of the house, reads old postcards to her. They reminisce about the time when he was a child and she could not let him out of her sight for fear of losing him. The mother wants to conceal her approaching death from her son. She asks him to take her for a walk, wants to have people around her, but can no longer stand on her own two feet. Her son carries her through lonely streets. The two are the last inhabitants of a deserted area.

The landscape in which the mother and son live is one of sad beauty. Alexander Sokurow depicts it as a German romantic would; his scenes are more like the paintings of Caspar David Friedrich than like shiny film images. There are long takes of wheat fields swaying in the wind, above them clouds creeping over hills; the places are dusky, full of shadows crossed by sudden rays of light. Mother and son remain alone in these pictures until the end. The outside world appears only twice, in the form of the smoke trail of a locomotive, the only trace of other people, seen only by the son who follows it longingly with his gaze. When his mother dies he is even more alone, left in a world that offers no comfort.

Sokurow studied with Alexander Sguridi in the class for popular science films at the VGIK film academy in Moscow. In 1978, instead of a twenty-minute film he submitted the full-length feature Odinokij golos tschelowjeka as his thesis. The film was rejected and denied a projection permit. This was the fate of all the films he made at the documentary film studio of Leningrad from 1980 on. Andrei Tarkovsky, living in exile, spoke up for the young director, who was practically barred from practicing his profession, and started a relief fund. Sokurow's films were not granted projection permits until 1986. To date Sokurow has directed nearly thirty documentaries and features. He is considered one of the most important contemporary Russian directors and has won several international film prizes.

V.H.

Mutter und Sohn *(Mat' i sin)* erzählt eine Liebesgeschichte. Sie handelt von der tiefen Zuneigung, die eine Mutter und ihren Sohn verbindet. Die Mutter ist schwer krank, ihr Körper abgemagert, die Kraft gewichen. Der Sohn pflegt sie liebevoll. Er füttert sie, bettet sie auf eine Bank vor dem Haus, liest ihr alte Postkarten vor. Sie erinnern sich an die Zeit, als er ein Kind war und sie ihn nicht aus den Augen lassen konnte vor Angst, ihn zu verlieren. Die Mutter will vor ihrem Sohn den näher kommenden Tod verbergen. Sie bittet um einen Spaziergang, möchte unter Menschen, dabei kann sie nicht einmal mehr gehen. Der Sohn trägt sie durch verlassene Straßen. Die beiden sind die letzten Bewohner einer menschenleeren Gegend.

Die Landschaft, in der Mutter und Sohn leben, ist von trauriger Schönheit; Sokurow inszeniert sie wie ein deutscher Romantiker, seine Bilder sind den Gemälden eines Caspar David Friedrich näher als glänzenden Filmbildern. Lange Einstellungen von Weizenfeldern, die vom Wind bewegt werden, darüber Wolken, die über Hügel kriechen; die Räume sind dämmrig, voller Halbschatten, durch die plötzlich Licht fällt. Bis zum Schluß bleiben Mutter und Sohn allein in diesen Bildern. Nur zweimal taucht in der Ferne mit der Rauchfahne einer Lokomotive die Außenwelt auf, gibt es eine Spur von anderen Menschen, die nur der Sohn sehen kann und der er sehnsüchtig nachblickt. Als seine Mutter stirbt, er vollends allein und bleibt in einer Welt zurück, die keinen Trost spenden kann.

Sokurow studierte an der Moskauer Filmhochschule VGIK in der Klasse für populärwissenschaftliche Filme bei Alexander Sguridi. Anstelle eines zwanzigminütigen Films reichte er 1978 den abendfüllenden Spielfilm *Odinokij golos tschelowjeka* als Diplomarbeit ein. Dem Film wurde die Abnahme und das Vorführrecht verweigert. Dieses Schicksal teilten alle Filme, die er ab 1980 bei den Leningrader Dokumentarfilm Studios drehte. Andrej Tarkowskij setzte sich von seinem Exil aus für den praktisch mit Berufsverbot belegten Alexander Sokurow ein und gründete einen Hilfsfonds. Sokurows Filme konnten erst ab 1986 gezeigt werden. Bisher hat Sokurow bei annähernd dreißig Dokumentar- und Spielfilmen Regie geführt. Er gilt als einer der wichtigsten zeitgenössischen Regisseure Rußlands und hat mit seinen Filmen international eine Reihe von Preisen gewonnen.

V.H.

Mutter und Sohn/Mat' i sin, 1997

Nancy Spero

*1926 in Cleveland, Ohio. Lebt und arbeitet/lives and works in New York.

After studying art in Chicago, Nancy Spero and her husband, the painter Leon Golub, lived between Europe and the United States. They settled down permanently in New York in 1964. In 1966, horrified by the atrocities of the Vietnam War and scandalized by the media coverage of the events, Spero undertook the War Series, which she continued through 1970. The force of these drawings derives from their combination of graphic finesse and violent imagery. At times using collage, she gave up oil on canvas for ink and gouache on paper: the white of the paper becomes the site of inscription for a psychic reality, a mental nightmare. Carried ahead by a feeling of rage, these works deal with the obscenity of war, transcribing a scatological and pornographic vision of military violence. In a twisted, unstable space, military equipment becomes anthropomorphic; faces vomiting unknown bodily fluids emerge from the smoke of napalm attacks. Evoking the traumatic iconography of the Second World War (the Nazi swastika and the nuclear mushroom of Hiroshima), Spero associates destructive fury with an affirmation of virility. Helicopters are represented as gigantic monsters eating and defecating people. The bodies are disjointed, torn, dismembered; they are primarily the bodies of victims. Spero attempts an exorcism through this figuration of barbarism: "my sons, too young then, could have been called up for that war. Those works were exorcism to keep the war away."

Spero's raw expressions contrasted sharply with the cool pop and minimal aesthetics that dominated New York at that time. The artist long remained on the edges of the art scene. The figure of the outcast and the victim haunt her work. As she said of the cycle she undertook from 1969 to 1973 around the figure of Antonin Artaud: "In choosing Artaud, I chose a pariah, a madman. He was the Other, a brilliant artist, but a victim running in circle." Deeply involved in the feminist movement, she decided in 1974 never again to use images of men: "The female image is universal. And when I show difference, I want to show differences in women, women's rite of passage, rather than men's rite of passage. Woman as protagonist: the woman on stage." On the basis of her own works and archival images, she has constituted a lexicon of three hundred cutout figures, forming the visual vocabulary with which she constructs her narrative systems directly on the walls. Approaching suffering in its collective and intimate forms, the work of Nancy Spero continues to develop even today with an unusual freedom of invention, mixing painting, drawing, collage, mechanical images, and text. It is a constant reply to authority under all its forms. P. S.

Nach ihrem Kunststudium in Chicago lebten Nancy Spero und ihr Mann, der Maler Leon Golub, abwechselnd in Europa und den USA, bis sie sich 1964 endgültig in New York niederließen. Entsetzt über die Greuel des Vietnamkriegs und empört über deren Verschleierung in den Medien begann Nancy Spero 1966 mit ihrer War Series, die sie bis 1970 fortsetzte. Die Kraft dieser Zeichnungen entspringt der Verbindung von graphischer Feinfühligkeit und gewaltsamer Bildsprache. Manchmal verwendet sie eine Collagetechnik, doch stets zieht sie Tusche oder Gouachefarbe auf Papier der Verwendung von Ölfarbe auf Leinwand vor: Dem Weiß des Papiers wird die psychische Realität eines Alptraums eingezeichnet. Diese von einem Gefühl der Wut getragenen Werke haben die Obszönität des Kriegs zum Thema und zeigen das pornographische und skatologische Antlitz der militärischen Gewalt. Die militärischen Geräte und Ausrüstungsgegenstände nehmen in einem unsteten Raum anthropomorphe Gestalt an, und aus dem Qualm der Napalmbomben tauchen Gesichter auf, die eine nicht zu identifizierende Körperflüssigkeit erbrechen. Hakenkreuz und Atompilz evozieren die traumatische Ikonographie des Zweiten Weltkriegs, und die destruktive Raserei wird mit einer sich selbst bestätigenden Virilität assoziiert. Die Helikopter werden als riesenhafte Monster dargestellt, die Individuen verschlingen und ausspucken. Die Körper sind verrenkt, verstümmelt und zerstückelt, es sind in der Regel Körper von Opfern. Mit Hilfe dieser Darstellung der Barbarei vollzieht Spero einen Exorzismus: »Meine Söhne waren damals zu jung, andernfalls hätten auch sie in diesen Krieg geschickt werden können. Diese Arbeiten sind ein Exorzismus, um den Krieg fernzuhalten.«

Diese schonungslosen Werke stehen in scharfem Kontrast zu den damals tonangebenden New Yorker Kunstformen Pop Art und Minimal Art. Ohnehin wurde Nancy Spero lange Zeit von der New Yorker Kunstszene ignoriert. Das ist vielleicht mit ein Grund dafür, daß ihr Werk stets vom Motiv des Außenseitertums und des Opfers geprägt ist. Über ihre von 1969–73 dauernde künstlerische Auseinandersetzung mit Artaud sagt sie: »Indem ich mich für Artaud entschied, entschied ich mich für einen Paria, einen Verrückten. Er war der andere, ein brillanter Künstler, aber ein im Kreis laufendes Opfer.« Infolge ihrer starken Involvierung in die aufkommende feministische Bewegung beschließt sie 1974, in Zukunft nur noch Bilder von Frauen zu machen: »Das weibliche Bild ist universell. Und wenn ich Unterschiede zeige, dann möchte ich weibliche Unterschiede zeigen, weibliche Übergangsriten statt männlicher. Die Frau als Protagonistin: die Frau auf der Bühne.« Aus eigenen Arbeiten und Archivbildern hat sie ein Lexikon zusam-

The Great Mother Victim, 1968

mengestellt, das ein visuelles Vokabular aus 300 ausge-
schnittenen Figuren enthält, aus dem sie direkt auf den
Wänden ihre narrativen Konstellationen zusammensetzt.
Das sich mit dem Leid in seiner kollektiven wie seiner
intimen Form auseinandersetzende Werk Nancy Speros
hat sich bis heute in einer Mischung aus Malerei, Zeich-
nung, Collage, mechanischen Bildern und Texten mit
einer seltenen Ausdrucksfreiheit entfaltet. Es wider-
spricht beharrlich jeder Form von Autorität.

P. S.

Gob Squad (Sean Patton/Alex Large/Liane Sommers/Sarah Thom/Johanna Freiburg/Berit Stumpf)

1994 gegründet/founded in Nottingham. Arbeiten in/work in Nottingham und Berlin.

What does it mean to be young and living in a city at the edge of Europe as the millennium draws to a close?

Gob Squad, a British-German performance group working in the here and now, seeks truth in the banality of everyday rituals and finds beauty and spirituality in all that is familiar, worldly, and mundane. They use this to develop scenes that tell not only of their own dreams, fears, and longings, but also of the realities of their generation.

Gob Squad love the glittering, garish face of pop culture. They place their works within the context of everyday routine, and tell of the difficulty involved in lending some kind of meaning to their urban life. This explains why the projects by Gob Squad are staged in places between the public and the private sphere – in houses, offices, theaters, shopping centers, galleries, railway stations, and parks.

This is theater that no longer has a textual base. It addresses the everyday, confronting anxiety and loneliness with idealistic notions of how to live life. In short, it is a cautious search for identity.

Gob Squad takes a closer look at the phenomenon that is normally dismissed out of hand as fun-loving consumerism. Following Ganz nah dran at the Theater am Turm in Frankfurt and Dreamcity – Die Stadt in Worten, scheduled to premier at Kampnagel in Hamburg this year, the project for Theater outlines marks the third joint project by Gob Squad and the German director Stefan Pucher.

J. H./B. F.

Was bedeutet es, jung zu sein und in einer Großstadt am Ende Europas kurz vor der Jahrtausendwende zu leben?

Gob Squad, eine britisch-deutsche Performance-Gruppe, arbeiten an dem Hier und Jetzt, suchen nach der Wahrheit in den banalen Alltagsritualen, nach der Schönheit und Spiritualität des Vertrauten und des Weltlichen (Mondänen). Sie entwickeln daraus Inszenierungen, die nicht nur von ihren eigenen Träumen, Ängsten und Sehnsüchten, sondern von den Realitäten ihrer Generation erzählen.

Gob Squad sind vernarrt in die glitzernden und schrillen Seiten der Popkultur. Sie plazieren ihre Arbeiten innerhalb des routinierten Alltags, erzählen von den Schwierigkeiten, ihrem städtischen Leben Sinn zu geben. Die Projekte von Gob Squad werden deshalb an Orten zwischen Öffentlichkeit und Privatheit inszeniert: in Häusern, Büros, Theatern, Einkaufszentren, Galerien, Bahnhöfen und Parkanlagen.

Texte sind in diesem Theater keine Basis mehr. Verarbeitet werden Alltagsreflexionen, konfrontiert werden ihre Ängste und Einsamkeiten mit ihren idealistischen Vorstellungen, wie sie ihr Leben leben möchten, eine vorsichtige Suche nach Identität.

Was sonst kurz und einfach als Spaß- und Konsumkultur bezeichnet wird, wird von Gob Squad genau unter die Lupe genommen.

Nach Ganz nah dran von 1996 am Theater am Turm, Frankfurt und Dreamcity – Die Stadt in Worten, in diesem Jahr in Hamburg (Kampnagel) uraufgeführt, ist das Projekt für die documenta die dritte Zusammenarbeit von Gob Squad mit dem deutschen Regisseur Stefan Pucher.

J. H./B. F.

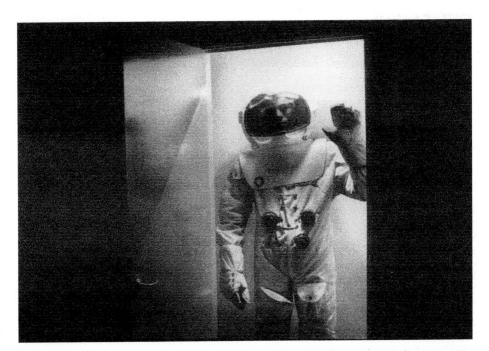

Work, 1996

Erik Steinbrecher

*1963 in Basel. Lebt und arbeitet/lives and works in Berlin.

The urban space of the metropolis, with its manifold and unforeseeable techno-economic extensions, is increasingly losing its coherence and legibility. The grids through which urban scenography is traditionally read have been invalidated by the explosion and decomposition of the cities, pushed by interest-group demands. The metropolitan symbolic order has given way to semantic heterogeneity. To experience this new reality more fully, Erik Steinbrecher moved to Berlin after finishing his training as an architect in Zurich. For documenta he has created a work in three parts: posters hung at a bus stop outside the train station, an edition of post cards, and a DSR poster. The overall title of the project is FARMPARK, a polysemic term which, through the verbal montage of two heterogeneous elements, conveys the juxtaposition of two dissonant urban realities. We encounter the same process at work in his images.

This series of posters in a bus shelter outside the train station constitutes a sequence which traces the path of a visitor in the course of a visit around the exhibition. Choosing this reiteration is in fact but an excuse, a pretext for constructing an imaginary scenario, somewhere between documentary and fiction, moving through the diversity of the postindustrial urban fabric. From representative, mostly found, images, Steinbrecher investigates the mutual modification and contamination of the antinomian and polar conceptual couples that make up "the city" – private vs. public space, nature vs. artifice, and so on. The artist sees metropolitan space as a gigantic collage of inharmonious details. But rather than espousing the aesthetic notion of a search for purity inherent in modernism, he prefers to accept what he calls the "urban grotesque" as a positive reality. He thus seeks to integrate elements that are usually excluded or left behind in our understanding of contemporary architecture. Using computers in the montage allows him to replay the formation of urban aggregates and the fragmentation of perceptual experience within the space of the image. As he does so, he tries to disturb viewers and draw them into a zone of undecidability where the identificational process gives way to the strangeness of things. In this work Steinbrecher adopts the model of the advertising poster – the public image with an urban dimension. As for the series of postcards, they echo certain elements from the itinerary through the exhibition, but play more on the rhetoric of representations of tourism, its bad taste and its kitsch imagery.
P. S.

Der urbane Raum der Metropolen mit seinen vielfältigen und unvorhersehbaren techno-ökonomischen Ausweitungen verliert mehr und mehr seinen Zusammenhang und seine Lesbarkeit. Die traditionellen Lektüreschemata der urbanen Bühne haben aufgrund der Zersplitterung und Zergliederung der Städte ihre Gültigkeit verloren: Alles gehorcht nun der Logik der Impulse einzelner Wirtschaftssektoren. Die großstädtische Symbolik ist hinter die Heterogenität der Zeichen zurückgetreten. Um diese neue Realität zu erfahren, zog Erik Steinbrecher, nachdem er in Zürich eine Ausbildung als Architekt erhalten hatte, 1987 nach Berlin. Für die documenta hat er eine dreiteilige Arbeit entworfen: Plakate, die an einer Bushaltestelle am Bahnhof angebracht sind, eine Postkartenedition und ein Plakat für die Deutsche Städte-Reklame. Das Projekt trägt den Obertitel FARMPARK, dessen Wortmontage zwei uneinheitliche Lebensräume verknüpft. Das gleiche Verfahren findet sich auch bei den Bildern, die er präsentiert.

Die Serie von Plakaten, die auf den Wänden eines Unterstandes an der Bushaltestelle am Bahnhofsausgang angebracht sind, zeichnet den Weg des Besuchers entlang des Ausstellungsparcours nach. Aber diese Wiederholung des Parcours ist in Wahrheit nur ein Vorwand, ein Alibi, um ein imaginäres Szenarium zu konstruieren, das zwischen Dokumentation und Fiktion angesiedelt ist und die Vielfalt der postindustriellen urbanen Strukturen ausschöpft. Ausgehend von typologischen Bildern – meistens sind sie als »images trouvées« übernommen – untersucht Steinbrecher, wie sich die antinomischen Pole jener für die »Stadt« konstitutiven Begriffspaare wie »privater Raum – öffentlicher Raum«, »natürlich gewachsen – künstlich geschaffen« etc. gegenseitig modifizieren und kontaminieren. Der Künstler begreift den großstädtischen Raum als eine gigantische Collage aus unharmonischen Teilen. Doch anstatt sich für eine modernistische Ästhetik der Reinheit stark zu machen, zieht er es vor, das »Groteske« des Städtischen als positive Realität zu akzeptieren. Daher versucht er, in seine Bilder Elemente zu integrieren, die für gewöhnlich ignoriert und vernachlässigt werden, wenn es darum geht, sich ein Bild von der zeitgenössischen Architektur zu machen. Die Montage per EDV erlaubt ihm, im Raum des Bildes die Bildung urbaner Aggregate und die Fragmentierung der Wahrnehmungserfahrung nachzuspielen. Das soll den Betrachter so sehr verunsichern, daß er in eine Zone der Unentscheidbarkeit gerät, wo die Identifikationsprozesse vor der Fremdheit der Dinge kapitulieren. In dieser Arbeit greift Steinbrecher auf das Modell des Werbeplakats zurück, also auf das den städtischen Lebensraum dominierende öffentliche Bild. Die Postkartenserie greift zwar bestimmte Elemente des

FARMPARK/Station, 1997
Detail

Ausstellungsparcours auf, doch in der Hauptsache geht
es ihr um das Spiel mit der Rhetorik der vom Tourismus
geprägten Darstellungsweise wie auch um die Anpran-
gerung des Kitschigen ihrer Bildsprache.

P. S.

DSR-Project/Projekt ⚑

Schleef

Kleist

Goethe

PLATO

τί οὖν; ἀναμιμνησκόμενον αὐτὸν τῆς πρώτης οἰκήσεως καὶ τῆς ἐκεῖ σοφίας καὶ τῶ
ἐλεεῖν; – καὶ μάλα. –

τιμαὶ δὲ καὶ ἔπαινοι εἴ τινες αὐτοῖς ἦσαν τότε παρ' ἀλλήλων καὶ γέρα τῷ ὀξύτατα κ
ὕστερα εἰώθει καὶ ἅμα πορεύεσθαι, καὶ ἐκ τούτων δὴ δυνατώτατα ἀπομαντευ
τοὺς παρ' ἐκείνοις τιμωμένους τε καὶ ἐνδυναστεύοντας, ἢ τὸ τοῦ 'Ομήρου ἂν πεπ
ἀκλήρῳ" καὶ ὁτιοῦν ἂν πεπονθέναι μᾶλλον ἢ 'κεῖνά τε δοξάζειν καὶ ἐκείνως ζῆν;

– οὕτως, ἔφη ἔγωγε οἶμαι, πᾶν μᾶλλον πεπονθέωαι ἂν δέξασθαι ἢ ζῆν ἐκείνως. –

καὶ τόδε δὴ ἐννόησον, ἦν δ'ἐγώ. εἰ πάλιν ὁ τοιοῦτος καταβὰς εἰς τὸν αὐτὸν θακον
τοῦ ἡλίου; – καὶ μάλα γ', ἔφη. –
τὰς δὲ δὴ σκιὰς ἐκείνας πάλιν εἰ δέοι αὐτὸν γνωματεύοντα διαμιλλᾶσθαι τοῖς ἀε
χρόνος μὴ πάνυ ὀλίγος εἴη τῆς συνηθείας, ἆρ' οὐ γέλωτ' ἂν παράσχοι καὶ λέγο
ἄξιον οὐδὲ πειρᾶσθαι ἄνω ἰέναι; καὶ τὸν ἐπιχειροῦντα λύειν τε καὶ ἀνάγειν

σφόδρα γ', ἔφη. –

Raimund

Mozart

Beckett

εσμωτῶν οὐκ ἂν οἴει αὐτὸν μὲν εὐδαιμονίζειν τῆς μεταβολῆς, τοὺς δὲ

ι τὰ παριόντα, καὶ μνημονεύοντι μάλιστα ὅσα τε πρότερα αὐτῶν καὶ
λλον ἥξειν, δοκεῖς ἂν αὐτὸν ἐπιθυμητικῶς αὐτῶν ἔχειν καὶ ζηλοῦν
ἢ σφόδρα βούλεσθαι, „ἐπάρουρον ἐόντα θητευέμεν ἄλλῳ ἀνδρὶ παρ'

ἆρ' οὐ σκότους ἀνάπλεως σχοίη τοὺς ὀφθαλμούς, ἐξαίφνης ἥκων ἐκ

ς ἐκείνοις, ἐν ᾧ ἀμβλυώττει, πρὶν καταστῆναι τὰ ὄμματα, οὗτος δ' ὁ
αὐτοῦ ὡς αναβὰς ἄνω διεφθαρμένος ἥκει τὰ ὄμματα καὶ ὅτι οὐκ
ν ταῖς χερσὶ δύναιντο λαβεῖν καὶ ἀποκτείνειν, ἀποκτεινύναι ἄν;

Syberberg 1997

Meg Stuart

*1965 in New Orleans. Lebt und arbeitet/lives and works in Brüssel/Brussels.

What happens to choreographic composition when one considers the body not as dance's basic unit, but as an already prefigured landscape of displacements? Since her first evening-length piece Disfigure Study (1991), Meg Stuart's choreographic project has been engaged in a constant rearticulation of this promise. A rearticulation that never ceases to become more complex, and is never solely physical.

This careful dismemberment of the dancing body, this dismemberment of the body of dance, is carried out, formally, by Stuart's strenuous use of duration, repetition, pose, and stillness. Through the persistence of the body's image, through the invocation of its restful presence, through the detailed dissection of a certain physiology of performance, she entails in her audience a need to reconfigure, to figurally and mnemonically re-member and re-organize a new, unexpectedly coherent body. In this archaeological endeavor, what becomes clear for the audience is the density of uncanny revelation in Stuart's choreographies: in the landscape these bodies compose we find familiar traces of ourselves, almost dancing with the tremors, in less than comfortable poses.

Stuart's dance, spreading its duration somewhere between the performing and the visual arts, invades us with the precarious lucidity of a body too aware of its immersion in time, a body embracing its all too human degeneration. Degeneration is addressed here consciously, for Stuart's participation in documenta X takes place thirty years after another degeneration that had been identified and denounced by Michael Fried when he started that "art degenerates as it approaches the condition of theater" (Art And Objecthood, 1968). As much as Fried's statement has been discussed, critiqued and surpassed, it is important to note that he was (not at all willingly) nevertheless right. For, ontologically, where there is "theater" there is also degeneration, fragmentation, and disappearance. If there is to be power in theater and if there is to be ontology in these arts, such power must be based precisely in a quality that is designated by the word degeneration, akin to an always-already being-in-dying, to the precarious condition of living.

As long as we move and are moved (in the two senses of the word move, as motion and emotion), there will always be this disquieting accumulation, generation and degeneration of bodies inside the limits of our skin and inside the patterns of our daily choreographies: bodies of knowledge, bodies of feelings, bodies of lovers, bodies of sorrows.

A.L.

Was geschieht mit einer choreographischen Komposition, wenn man den Körper nicht als grundlegende Einheit des Tanzes versteht, sondern als eine schon vorgeformte Landschaft von Verschiebungen? Seit ihrem ersten abendfüllenden Stück Disfigure Study (1991) haben sich Meg Stuarts choreographische Projekte als kontinuierliche Neuordnung dieses Gedankens weiterentwickelt. Eine Neuordnung, die niemals aufhört, sich weiterzuentwickeln; eine Neuordnung, die niemals ausschließlich körperlich ist.

Diese vorsichtige Zerstückelung des tanzenden Körpers, des Tanzes als Körper, wird formal durch Stuarts Einsatz von Wiederholung, Pose und Stille präsentiert. Durch das Beharren auf dem Bild des Körpers und durch die detaillierte Zergliederung einer bestimmten Körperlichkeit von Performance überträgt Meg Stuart auf das Publikum die Notwendigkeit, sich selbst neu zu ordnen, sich körperlich und gedanklich zu erinnern. Während dieser archäologischen Bemühung werden den Zuschauern die Enthüllungen von Meg Stuarts Choreographien klar: Wir finden vertraute Spuren unserer selbst, tanzend in uns unbekannten Haltungen.

Meg Stuarts Tanz entfaltet sich irgendwo zwischen der darstellenden und der bildenden Kunst. Er überfällt uns mit einer unsicheren Klarheit eines Körpers, der sich fast schon zu bewußt ist über sein Eintauchen in Zeit, eines Körpers, der von allen seinen »Entartungen« umgeben ist. »Entartung« ist hier bewußt gewählt, weil Meg Stuarts Teilnahme an der documenta X dreißig Jahre nach einer anderen »Entartung« stattfindet. Eine »Entartung«, die von Michael Fried erkannt und verurteilt wurde, als er feststellte, daß »Kunst entartet, wenn sie den Voraussetzungen des Theaters näher kommt« (Michael Fried, Art And Objecthood, 1968). So sehr auch diese Aussage von Michael Fried diskutiert und kritisiert wurde, bleibt es wesentlich zu sagen, daß sie nichtsdestotrotz (nicht unbedingt gewollt) richtig war. Denn ontologisch gesehen gibt es dort, wo Theater stattfindet, auch »Entartung«, Zerstreuung und Verschwinden. Sollte es Kraft im Theater geben und sollte es Ontologie in den Künsten geben, dann gründet diese Kraft genau in einer Qualität, die mit dem Wort »Entartung« bezeichnet wird, verwandt mit dem immer schon Dabei-Sein zu sterben, der prekären Voraussetzung zum Leben.

Solange wir uns bewegen und wir bewegt sind (im doppelten Sinn des Wortes bewegt: als Bewegung und als Gefühl), wird es immer Akkumulation, Generation und Degeneration (»Entartung«) von Körpern innerhalb der Grenzen und Strukturen unserer täglichen Choreographien geben: Körper von Wissen, Körper von Gefühlen, Körper von Liebenden und Körper von Trauernden.

A.L.

No One Is Watching, 1995

Slaven Tolj

*1964 in Dubrovnik. Lebt und arbeitet/lives and works in Dubrovnik.

Slaven Tolj, who has directed the Lazareti Art Work-Shop in Dubrovnik since 1988, creates essentially from the "material" offered by this city and its history. Tolj was a soldier in the Croatian army from 1991 to 1992. On numerous occasions he has transported signs and trifling tokens of his native city to foreign countries, neighboring cities, institutions, or "other spaces." Carrying out displacements of very specific found objects accompanied by subtle shifts and distortions of meaning, he invents minimal forms of intervention such as the installation of his gallery's blinds, tattered by mortar fire, on the windows of the Zagreb museum, or the exhibition of a glass recipient containing sea water from Dubrovnik. He has also done many performances with his wife Marija Grazio-Tolj. In Food for Survival (1993) each one covered the other's naked body with a mixture coming from tins furnished by humanitarian organizations, bearing the label "Food for Survival" written in various languages. They then set about licking each other, consuming this humanitarian product on the very body of the other.

For documenta, Slaven Tolj has chosen an extremely discreet form of intervention. It consists of two lamps borrowed from a church in Dubrovnik and installed by Tolj in the Kulturbahnhof of Kassel just before the opening of the exhibition. Isolated and static, these two luminous globes are suspended high above the incessant flux of travelers and the bustling activity of the station. Hanging at a distance from each other, the two lamps represent at once division and balance. They are distinct, yet connected by two productions of energy: the electric system and the photons they emit. Far from the people, high above, these lamps so inappropriate to the space they occupy, still exhaling their origins in a sacred place, are able to maintain an insular dimension even while surprising the gaze of passers-by, in an appearance that recalls the forgotten notion of the epiphany.

P. S.

Slaven Tolj leitet seit 1988 den Lazareti Art Work-Shop in Dubrovnik und arbeitet im wesentlichen mit dem »Material«, das diese Stadt und ihre Geschichte ausmacht. Zwischen 1991 und 1992 war Tolj Soldat in der kroatischen Armee. Er transportierte bei mehreren Gelegenheiten Zeichen oder Merkmale seiner Geburtsstadt in fremde Länder, Nachbarstädte, Institutionen oder andere Räume. Mit dieser Verlagerung bestimmter »objets trouvés« und den damit verbundenen subtilen Bedeutungsverschiebungen schafft er minimale Formen von Interventionen, wozu auch jene Installation der von Geschossen durchlöcherten Jalousien seiner Galerie vor den Fenstern des Museums von Zagreb und die Ausstellung eines gläsernen, Meerwasser aus dem Hafen von Dubrovnik enthaltenden Wasserbehälters gehören. Zusammen mit seiner Frau Marija Grazio-Tolj realisiert er zudem auch zahlreiche Performances. In Food for Survival (1993) beschmierte jeder den nackten Körper des anderen mit dem Inhalt einer Konservendose, die aus den Lieferungen der humanitären Hilfsorganisationen stammte und auf der in verschiedenen Sprachen die Aufschrift »Food for Survival« zu lesen war. Dann leckten sie sich gegenseitig ab und verzehrten so unmittelbar vom Körper des anderen dieses humanitäre Produkt.

Die Intervention Slaven Toljs bei der documenta gestaltet sich äußerst diskret. Sie besteht aus zwei Lampen, die aus einer Kirche von Dubrovnik stammen und die er kurz vor Ausstellungseröffnung in dem Kulturbahnhof Kassels installierte. Diese beiden leuchtenden Kugeln hängen isoliert und statisch hoch über dem stetigen Strom von Reisenden und der hektischen Betriebsamkeit des Bahnhofs. Die beiden entfernt voneinander hängenden Lampen repräsentieren Teilung und Gleichgewicht. Obwohl sie getrennt voneinander sind, sind sie doch durch zwei Systeme der Energieaussendung miteinander verbunden: durch die Stromversorgung und durch die Photonen, die sie ausstrahlen. Hoch oben, fern der Menschen, bewahren diese Lampen, die von einem geheiligten Ort kommen und nicht in den Raum gehören, in den sie versetzt wurden, ihre insulare Dimension, und wenn der Blick eines Passanten auf sie fällt, vermögen sie so überraschend zu wirken, daß es fast einer Epiphanie gleichkommt.

P. S.

Untitled, Jesuit-St. Ignacije, Dubrovnik

Tunga

*1952 in Palmares, Pernamboue, Brasilien/Brazil. Lebt und arbeitet/lives and works in Rio de Janeiro.

Tunga belongs to the generation of Brazilian artists following Hélio Oiticica and Lygia Clark. An architect by training, steeped in literature (from Nerval to Borges) and philosophical and scientific references (archaeology, paleontology, zoology, medicine), his work bears the stamp of the great fictions of the Latin American continent. Often proceeding by excess – many of his works having been carried out by accumulation of heavy materials (iron, copper, magnets) – he stages familiar objects which have undergone a strange transformation: thimbles, giant needles, or combs. He invents a fantastic bestiary of lizards and mutant-looking serpents which seems to have sprung straight from a surrealist anthology. Playing with differences of scale, Tunga takes sculpture as a set of enigmatic forms and figures, whose fabulous proportions and "uncanniness" puzzle the spectator and trouble one's habitual perception of near and far, inside and outside, full and empty. His interest in the unconscious and particularly in the associative processes of the dreamwork as well as the figure of the metaphor have led him to construct works with multiple ramifications and effects of meaning. These intertwine with eruptions of the fantastic, inviting the viewer to enter a baroque universe where the real is indiscernible from the imaginary.

For documenta he has given a new complexity to a piece presented at the last Venice Biennial. The work consists of three sets of interdependent elements, with fourteen actors in between. A giant straw boater's hat is periodically worn by seven young girls dressed in white. On this classically made hat are set ten normal-size hats, upside down, each containing a skull. Another version of the hat, this time in felt, hangs on strings like a marionette suspended on a double cross. Its brims grow into another concentric hat, and so on, forming seeming rings of hats. Seven actors, each coifed with a standard felt hat of classic size, stroll among the suspended hat and the giant hat worn by the girls. The felt-hatted actors, Nordic-looking and all dressed in an identical, neutral manner, each carry a black leather suitcase which, after a collision or in a wholly spontaneous way, opens and spills out all its contents onto the floor. The actors quickly put these contents – fragments of the human anatomy in latex – back into the suitcase. When they aren't being used for the performance, these pieces are exhibited in the old train station of Kassel.

P. S.

Tunga gehört zu jenen brasilianischen Künstlern, die die Nachfolge der Generation antraten, zu der Hélio Oiticica und Lygia Clark gehörten. Er ist seiner Ausbildung nach Architekt, doch seine Interessen sind breit gefächert und reichen von Literatur und Philosophie bis zur Archäologie, Paläontologie, Zoologie und Medizin. Sein Werk ist geprägt von den großen Fiktionen Südamerikas. In oft exzessiver Weise – zahlreiche seiner Werke bestehen aus einer Anhäufung schwerer Materialien wie Eisen, Kupfer oder Magnete – unterzieht er vertraute Objekte einer seltsamen Verformung (riesenhafte Fingerhüte, Nadeln oder Kämme) und erfindet ein phantastisches Bestiarium (mutierte Eidechsen oder Schlangen), die einem surrealistischen Fundus entsprungen zu sein scheinen. Oft spielt er mit unterschiedlichen Größenordnungen, und seine Skulpturen sind Ensembles rätselhafter Formen und Figuren, die durch ihre phantastische Maßlosigkeit und ihre beunruhigende Fremdheit den Betrachter verwirren und die gewohnten Wahrnehmungsmechanismen von nah und fern, innen und außen, leer und voll ins Stolpern bringen. Tungas Interesse für die Phänomene des Unbewußten, darunter vor allem die sich während der Traumarbeit abspielenden Assoziationsprozesse, wie auch für die Figur der Metapher führt dazu, daß seine Werke vielfältig verzweigte Sinnzusammenhänge repräsentieren und so den Betrachter in ein phantastisches Universum entführen, das eine Zone der Unentscheidbarkeit zwischen dem Realen und dem Imaginären darstellt.

Für die documenta hat er eine Performance/Installation bearbeitet und erweitert, die er bereits auf der letzten Biennale in Venedig präsentiert hatte. Dieses Werk besteht aus drei Ensembles miteinander in Beziehung stehender Elemente, in deren Mitte vierzehn Akteure interferieren. Ein riesiger Strohhut wird von sieben jungen Mädchen getragen, die ganz in Weiß gekleidet sind. Auf dem Strohhut, einer klassischen »Kreissäge«, liegen mit der Öffnung nach oben zehn Strohhüte normaler Größe, von denen jeder einen Schädel enthält. An einem Doppelkreuz hängt ein anderer riesiger Hut aus Filz wie eine Marionette an Fäden. Er hat nicht nur eine Krempe, sondern viele, so daß es aussieht, als ob hier viele Hüte ineinandergeschachtelt wären. Sieben Akteure, jeder mit einem klassischen Filzhut normaler Größe, spazieren zwischen dem am Kreuz hängenden Hut und dem riesigen Strohhut, den die Mädchen tragen, hin und her. Jeder der Akteure im Filzhut, die nordischen Typs sind und alle dieselbe neutrale Kleidung anhaben, trägt einen Koffer aus schwarzem Leder, der ist, weil sie irgendwo anstoßen oder auch scheinbar unvermittelt, plötzlich öffnet, so daß sein Inhalt, der aus Nachbildungen menschlicher Körperteile

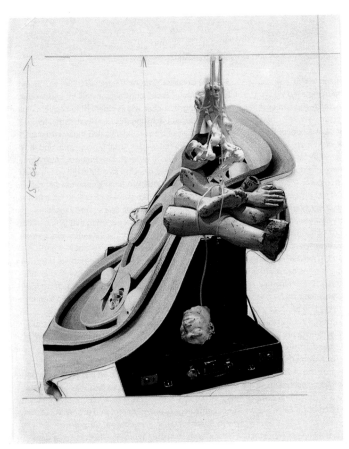

Inside out, upside down (Ponta Cabeça), 1994–1997
Installation/Performance:
June 19, 4 p.m./19. 6., 16 Uhr
June 20, 21, 22, 11 a.m./20., 21., 22. 6., 11 Uhr
Sept. 5, 6, 7, 27, 28, 11 a.m./5., 6., 7., 27., 28. 9., 11 Uhr

besteht, auf den Boden fällt, wo ihn die Akteure hastig wieder einsammeln. Wenn die Requisiten der Performance nicht für eine Vorführung gebraucht werden, kann man sie im Kulturbahnhof besichtigen.

P.S.

Zaremba/Tunga & Cabelo documenta meets radio/radio meets documenta

Uri Tzaig

*1965 in Kiryat Gar, Israel. Lebt und arbeitet/lives and works in Kiryat Gar.

For The Universal Square/The Movie (1996), a small, intimate projection space has been installed where the viewer can sit comfortably and watch the film as if in a cinema. It does not matter when you arrive or how long you stay, as the film has neither a beginning nor an end and is projected in an endless loop. It shows shots of a football game organized by Uri Tzaig in Lydda in 1996. Supervised by twice the number of referees, two teams play with two balls. The players and viewers are confronted with the problem of having no common focal point. The linearity of the game is interrupted and leads to an entirely new and surprising choreography. In the language of film, one might say that there are two parallel narratives which occasionally merge and nevertheless result in no real meaning. In Tzaig's video, the absurd game is transformed into abstract movement which contradicts the narrative character of this medium. The underlying text – the artist has deliberately avoided using English, today's lingua franca – only seems to contribute towards an approximation between The Universal Square and narrative cinema. "And then the need arose in me to create a real situation that would undermine our tendency to focus our gaze towards the center, and our conception of motion as unfolding according to an ordered narrative," explains Tzaig in describing the concept of the game which he pursues by filmic means in the video projection.

Unlike The Universal Square, Desert has been given German subtitles. This time, the text is in English and can be understood at least in part by most viewers, but the images are difficult to identify because the artist has digitally reworked his footage of a basketball game with two balls. An uncontrollable virus has been installed, causing distortions and interruptions which make it impossible for the viewer to achieve continuous reception.

In 1993, Tzaig was invited to Berlin by the Künstlerhaus Bethanien. As in Israel, he began collecting random items. Objects found at flea markets, graffiti on walls, and anecdotes linked with certain places are collated in the Book of Objects (part of Tzaig's 1994 book The Story Teller) to create a new story. "I'm interested in art that teaches me to move in a different way every time," is how Tzaig explains his act of acquisition. By listening to the true or imagined stories of the objects and by trying to find their viewpoint, the artist has succeeded in seeing the familiar in a different light. Tzaig's videos involve a similar shift of focus. Familiar modes of perception are broken and an open interpretation is introduced in their place.

S.P.

Für The Universal Square/The Movie (1996) wurde ein kleiner intimer Projektionsraum installiert, in dem der Ausstellungsbesucher wie in einem Kino bequem einige Zeit mit der Betrachtung des Films verbringen kann. Ankunftszeit und Verweildauer sind individuell variabel, denn der Film hat weder Anfang noch Ende und wird in einer Endlosschleife gezeigt. Zu sehen sind Aufnahmen eines Fußballspiels, das Uri Tzaig 1996 in Lydda veranstaltet hat. Unter Aufsicht einer doppelten Anzahl von Schiedsrichtern spielten damals zwei Mannschaften mit zwei Bällen gegeneinander. Spieler und Zuschauer sahen sich dem Problem gegenüber, daß kein gemeinsamer Fokus mehr bestand. Die Linearität des Spielverlaufs war unterbrochen und führte zu einer ganz neuen, überraschenden Spielchoreographie. Übertragen in die Sprache des Films könnte man von zwei Erzählsträngen sprechen, die parallel ablaufen, sich gelegentlich mischen und dennoch keinen wirklichen Sinn ergeben. Das absurde Spiel verwandelt sich in Tzaigs Video in abstrakte Bewegung, die dem narrativen Charakter dieses Mediums widerspricht. Der unterlegte Text – absichtlich nicht in englischer Sprache, der Lingua franca unserer Zeit – trägt nur scheinbar zur Wiederannäherung von The Universal Square an das Erzählkino bei. »Und dann erwachte in mir das Bedürfnis, eine reale Situation zu schaffen, die unsere Neigung, den Blick auf ein Zentrum zu konzentrieren, und unsere Vorstellung von Bewegung als sich geordnet abspulender Erzählstrang unterminieren würde«, erläutert Tzaig das Konzept des Spiels, das er in der Videoprojektion mit den Mitteln des Films weiterverfolgt.

Im Gegensatz zu Universal Square wurde Desert mit deutschen Untertiteln versehen. Während der Film diesmal auf englisch ist und daher von der Mehrheit der Ausstellungsbesucher zumindest annähernd verstanden wird, hat der Betrachter Schwierigkeiten, die Bilder genau zu identifizieren, weil der Künstler seinen Mitschnitt eines Basketballspiels mit zwei Bällen digital nachbehandelt hat. Durch einen nach Initiierung unkontrollierbaren Virus entstanden Bildverzerrungen und Bildstörungen, die eine kontinuierliche Rezeption der Aufnahmen durch den Betrachter unmöglich machen.

1993 war Uri Tzaig auf Einladung des Künstlerhauses Bethanien für einige Zeit in Berlin. Wie zuvor schon in Israel begann er zufällige Fundstücke zusammenzutragen. Auf Flohmärkten gesammelte Objekte, auf Wänden angebrachte Graffitis und kleine Geschichten, die sich mit bestimmten Orten verbinden, fügen sich im Book of Objects (Teil des Buchs The Story Teller, 1994, von Uri Tzaig) zu einer neuen Erzählung. »Ich interessiere mich für Kunst, die mich lehrt, mich jedesmal anders zu bewegen«, erläutert Tzaig seinen Akt der

The Universal Square/The Movie, 1996

Aneignung. Indem er den wahren oder eingebildeten Geschichten der Objekte zuhört und versucht, ihre Sichtweise anzunehmen, gelingt es dem Künstler, längst Bekanntes in anderem Licht zu sehen. Tzaigs Videos handeln von einer ganz ähnlichen Perspektivverschiebung. Gewohnte Wahrnehmungsweisen werden aufgebrochen und an ihrer Stelle eine offene Lesart eingeführt.

S. P.

Danielle Vallet Kleiner

*1958 in Paris. Lebt und arbeitet/lives and works in Paris.

Since 1987 Danielle Vallet Kleiner's art practice has involved the placing of silver leaf in diverse sites, imperiled or sometimes abandoned, where the painful weight of an urban situation takes on a symbolic valence (churches, cinemas, public pools, railroad tracks). Of these ephemeral, endangered works, she retains photographic and filmic traces: "the transposition onto another silvered surface of a work already inhabited by the gaze and its human bearers." This matter-memory of a disappearance and an impossible representation permits her to "articulate the time and space of an exhibition site with the time and space of the work itself." The work then becomes a "time accelerator," like the church on boulevard Serrurier in Paris, walled up for ten years, which reopened six days after the application of three silver doors. As Joël Savary stresses, the artist's approach "constitutes unrepresentable energy as the work." In Lithuania in 1991, in the context of the project Paris–Berlin–Vilnius, Mémoires du Futur (Memories of the Future), Vallet Kleiner's work took on historic dimensions. On Zveryno Tiltas bridge, situated in central Vilnius, looking back on the parliament building under a state of siege, Danielle Vallet Kleiner traced two silver lines, metaphors of a possible alliance between two Europes. A week later Lithuania became independent.

Her project Inspection Istanbul – Helsinki (La traversée du vide) (Crossing the Void) began in April 1994: a crossing of the countries of Central Europe at a turning point in their history, a voyage through the zone of unstable identity, or what Yeltsin's new terminology calls the "nearby foreign countries." Along the way she carried out a variety of actions and on her return she constructed three different works: two films and a book.

Inspection Istanbul-Helsinki (La Traversée du vide) is presented in the Kulturbahnhof, at the traveler's point of arrival and at the outset of the documenta parcours. The film does not follow any real chronology but constitutes itself in a succession of swings back and forth through the space-time of the trip. Built around the architectural space of the installation, the physical space of the itinerary, and the mental space of memory, this artwork on time, limits, frontiers, and disappearance has taken form out of rescued matter: the silver leaf and the film that remained after a third of the images were stolen in the course of the journey. The book of the same name obeys "a similar cinematographic development, where the blank space of the page permits a rhythm of the void, through the appearance of brief freeze-frames." Finally, a short film will be projected on the giant screens installed in the

Seit 1987 interveniert Danielle Vallet Kleiner in politisch-urbane Situationen, indem sie Silberfolien an verschiedenen Orten anbringt, in deren Gefährdetsein und auch öder Tristesse sich die Problematik heutiger Urbanität konzentriert und die eine symbolische Rolle in der Stadt spielen (Kirche, Kino, Schwimmbad, Gleisanlagen). Diese ephemeren, gefährdeten Werke bewahrt sie in Form von Photographien und Filmen auf und überträgt sie so auf eine andere silberne Folie, deren Materie ein Erinnerungsbild festhält, das gestattet, »die Zeit und den Raum eines Ausstellungsortes mit der eigentlichen Zeit und dem eigentlichen Raum des Werkes zu verbinden«. Ihr Werk erweist sich oft als »Beschleuniger der Zeit«, wie etwa bei jener Kirche am Boulevard Serrurier in Paris, die seit zehn Jahren zugemauert war und sechs Tage nach der Anbringung von drei silbernen Pforten wieder geöffnet wurde. Wie Joel Savary sagt, setzen die Vorstöße Vallet Kleiners eine »als Werk nicht darstellbare Energie« frei. Im Rahmen des Projekts Paris–Berlin–Vilnius, Mémoires du Futur nahm ihre Arbeit im August 1991 in Litauen eine historische Dimension an. Auf der im Zentrum Vilnius gelegenen Brücke Zveryno Tiltas, gegenüber dem belagerten Parlament, zog Danielle Vallet Kleiner zwei silberne Linien, Metaphern einer möglichen Allianz zwischen West- und Osteuropa. Eine Woche später wurde Litauen unabhängig.

Im April 1994 läuft ihr Projekt Inspection Istanbul – Helsinki (La traversée du vide) an, eine Durchquerung Zentraleuropas an einem Wendepunkt seiner Geschichte, eine Reise in eine Übergangszone fließender Identität, so wie das »nahe Ausland« in der neuen Terminologie der Jelzin-Ära genannt wird. Sie realisiert nach und nach zahlreiche Interventionen. Nach ihrer Rückkehr entstehen daraus zwei Filme und ein Buch.

Der dort, wo der Besucher ankommt und der Parcours der documenta beginnt, nämlich im Kulturbahnhof, zu sehende Film Inspection Istanbul – Helsinki (La traversée du vide) entspricht nicht der realen Chronologie. Er konstituiert sich aus einer Abfolge von Sprüngen vorwärts und rückwärts im zeitlichen und räumlichen Ablauf der Reise. Der reale Raum der Reiseroute und der geistige Raum der Erinnerung, den diese Installation erschließt, konstituiert sich auch aus buchstäblich vor dem Verschwinden geretteten Material, denn ein Drittel der Bilder wurde Vallet Kleiner im Verlauf der Reise gestohlen. Das gleichnamige Buch gehorcht ebenfalls einem filmischen Ablauf, da es »der weiße Raum der Seite erlaubt, das Bild des Leeren durch kurz eingefrorene Filmbilder zu rhythmisieren«. Ihr Kurzfilm schließlich ist zwischen Informationsanzeigen und Werbung auf den großen Bildschirmen zu sehen, die im Kasseler Kulturbahnhof installiert sind. Er spielt mit der Rhetorik

Inspection Istanbul – Helsinki (La traversée du vide), Feb. 1997
Video prints

Kulturbahnhof, in between sequences of news and advertising. Playing off the rhetoric of the video clip, this work proceeds in a blur of speed, in contrast to the meandering of the full-length film.

P. S.

der Videoclips und konterkariert mit seinem verwirrenden Tempo die ebenso irritierende Langsamkeit des langen Films.

P.S.

Ed van der Elsken

*1925 in Amsterdam. †1990 in Edam.

Ed van der Elsken was a tireless traveler. A photojournalist and documentary filmmaker, he crisscrossed the planet for forty years, visiting the great cosmopolitan cities and bringing back fiercely realistic photographs and films that betray his uncommonly powerful drives. If no other photographer took such a direct attitude before the world as van der Elsken, it is because the world imposed itself on him with all the violence of its economic, cultural, and political conditions. His investigation of reality was also guided by irrepressible desire to affirm his presence as a photographer. In his first book, Love on the Left Bank – a kind of documentary photonovel created during the period when he lived in Paris, from 1950 to 1955 – he staged himself as the observer of his own entourage, contravening the principle of distance that reigned in the documentary photography of the time. Individualist and nonconformist, van der Elsken liked to work in the street. He asked people's permission to photograph them, and after having been assured of their collaboration he subjected them to a kind of embarrassing round whereby he constantly sought to provoke a reaction.

Van der Elsken enjoyed making books. He published some twenty volumes, working with professionals on the page layout and the design. They are often large-format works, saturated with images and pushed ahead by a epic rhythm, with incisive texts that never shy away from taking a stance. The images presented here are drawn from Sweet Life (1966), perhaps van der Elsken's most characteristic achievement. It is a collection of photographs shot during a trip around the world from 1959 to 1960, through countries as diverse as South Africa, India, the Philippines, Japan, the United States, Mexico, etc. Sweet Life testifies with vigor to the exacting demand that van der Elsken considered to the function of the photojournalist. Without ever sinking into the visual rhetoric of the shocking image, these photographs deftly convey his vision, applying no cosmetic touches to reality. They illustrate his strong sense of framing and his work on the very physiology of the image, which is dense and granular with deep charcoal blacks. Here as in his films, which are close to cinéma-vérité, the massive presence of people and things echoes the integrity of his vision. He often took the defense of sincerity, which for him was a fundamental virtue of existence. His last film ends on these words: "Show who you are."

P. S.

Der Photojournalist und Dokumentarfilmer Ed van der Elsken war unermüdlich auf Reisen. Er durchstreifte vierzig Jahre lang die Welt, besuchte die großen Metropolen und brachte von dort Photographien und Filme mit, deren brutaler Realismus eine außergewöhnliche Motiviertheit verrät. Wenn vielleicht kein anderer Photograph zur Welt einen so unmittelbaren Zugang hatte wie Ed van der Elsken, so liegt das daran, daß sich ihm die Welt in ihrer ökonomischen, kulturellen und politischen Determiniertheit mit aller Macht aufdrängte. Seine Erforschung der Wirklichkeit war zudem von dem sonst eher unüblichen Wunsch beseelt, auch seine Anwesenheit als Photograph festzuhalten. Schon in seinem ersten Buch Love on the Left Bank (eine Art dokumentarischer Photoroman, den er zwischen 1950 und 1955 machte, als er in Paris lebte) setzt er sich selbst als Beobachter seiner Umgebung in Szene und bricht mit dem Prinzip der Distanz, das damals die Dokumentarphotographie beherrschte. Der Individualist und Antikonformist van der Elsken arbeitete mit Vorliebe im Freien, auf den Straßen. Er bat Leute um Erlaubnis, sie photographieren zu dürfen, und nachdem er sich ihrer Mitarbeit versichert hatte, umkreiste er sie auf lästige Weise, mit dem Ziel, eine Reaktion zu provozieren.

Ed van der Elsken hat etwa zwanzig Bücher veröffentlicht, bei denen er für die Montage und den Umbruch die Hilfe professioneller Designer in Anspruch nahm. Die häufig großformatigen Bücher sind voller epischer Bilder, die von einem engagierten und bissigen Text begleitet werden. Der 1966 erschienene Band Sweet Life, aus dem die hier gezeigten Bilder stammen, ist wahrscheinlich das charakteristischste Buch van der Elskens. Hierbei handelt es sich um eine Sammlung von Photographien, die van der Elsken während einer zwischen 1959 und 1960 unternommenen Weltreise in so unterschiedlichen Ländern wie etwa Südafrika, Indien, den Philippinen, Japan, den USA und Mexiko gemacht hatte. Sweet Life bezeugt eindrücklich den Anspruch, den van der Elsken an die Arbeit eines Photojournalisten stellt. Ohne jemals in der visuellen Rhetorik des schockierenden Bildes aufzugehen, vermitteln diese Photographien sehr genau, wie schonungslos er die Wirklichkeit erfaßt. Seine Arbeitsweise zeigt sich sogar an der Physiologie der Bilder selbst: verdichtet, körnig, mit tiefem, kohligem Schwarz. Wie in seinen dem »Cinéma vérité« nahestehenden Filmen ist auch hier die geballte Präsenz von Menschen und Dingen ein Echo der Geschlossenheit seiner Sehweise. Häufig macht er sich zum Anwalt einer Aufrichtigkeit, die für ihn eine grundlegende existentielle Tugend darstellt. Sein letzter Film schließt mit den Worten: »Zeig, wer du bist.«

P. S.

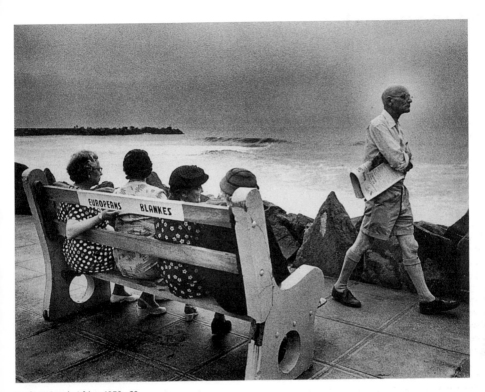

Durban, South Africa, 1959–60
(published in *Sweet Life*, 1966, pp. 8–9)

Aldo van Eyck

*1918 in Driebergen, Holland. Lebt und arbeitet/lives and works in Amsterdam.

Throughout his life, Aldo van Eyck has developed a conception of the city based on a relation of triple inclusivity, embracing traditional, modern, and non-Western architecture. He found privileged models of the latter in the configuration of Dogon and pueblo villages. The critical engagement with rationalism and functionalism in his work testifies to his enduring concern to produce a reciprocal integration of the individual and society, through the city-house analogy and the reassessment of dogmatic oppositions between ancient and modern, private and public.

As Francis Strauven remarks: "Van Eyck's design attitude towards the urban heritage has been twofold. On the one hand some of his major projects were based on the structure of the traditional city, on the other he always conceived his urban projects as a constructive contribution to the existing city." Thus the Amsterdam Orphanage (1957–61) is a "large house" conceived as a little city, establishing a formal homology between the whole and its parts. Van Eyck plays around the traditional contradictions and classical oppositions by means of a system of twisting streets that link and interweave public and private places, inside and outside, open and closed. As Strauven notes, this complex configuration "results in a truly urban fabric, a polycentric tissue of equivalent places interlinked by 'in-betweens' or 'doorsteps.'"

The Sonsbeek Pavilion (1966) functions on the antagonism of inside and outside. The façade, constituted of parallel walls, dissimulates a labyrinthine but perfectly intelligible interior. The dividing walls, straight and circular, concave and convex, are arranged so as to afford transverse perspectives. As van Eyck emphasizes, the building was designed to possess "something of the closeness, density, and intricacy of things urban." It was also conceived on the model of the city, where people and artifacts inevitably "meet, converge, and clash."

Van Eyck also designed several hundred playgrounds in Amsterdam. Arranged in the interstices of the urban fabric, these parcels form a discontinuous territory linked into a network. The inclusion of these constructions in the existing urban structure, the respect of the latter's formal and symbolic specificity, and the contribution to the city's historical richness all confirm the major directions of his conception of architecture. In his project for the Hubertus House, which he carried out from 1973 to 1978, van Eyck conceived the building as "an opening in the existing block giving access to the inside of the city" (Strauven). Here again, the house is a little city.

P. S.

Der Architekt Aldo van Eyck hat im Laufe seines Lebens eine urbane Konzeption entwickelt, die sich aus drei Quellen speist: der traditionellen Architektur, der modernen Architektur und der nicht-westlichen Architektur (hier dienten ihm vor allem die Anlagen der Pueblo-dörfer und der Dogon-Dörfer als Modell). Sein Werk ist in seiner kritischen Auseinandersetzung mit dem Rationalismus und Funktionalismus Ausdruck eines ständigen Bemühens um eine integrative Verflechtung von Individuum und Gesellschaft, die es durch eine Analogisierung von Haus und Stadt sowie eine Infragestellung der dogmatischen Entgegensetzung von Altem und Modernem, Privatem und Öffentlichem zu erreichen trachtet.

»Van Eycks Einstellung als Stadtplaner hinsichtlich des städtischen Erbes war stets von zwei Gesichtspunkten geprägt«, schreibt Francis Strauven. »Einerseits basierten einige seiner wichtigsten Projekte auf der Struktur der traditionellen Stadt, andererseits begriff er seine urbanen Projekte stets als konstruktiven Beitrag zur existierenden Stadt.« So ist zum Beispiel das Amsterdamer Waisenhaus (1957–61) ein »großes Haus«, das wie eine kleine Stadt konzipiert ist und in dem zwischen dem Ganzen und seinen Teilen eine formale Übereinstimmung herrscht. Van Eyck treibt durch ein System verschlungener Straßen, die private und öffentliche Orte, Drinnen und Draußen, Offenheit und Geschlossenheit miteinander verflechten, sein Spiel mit traditionellen Gegensätzen. Diese komplexe Konfiguration stellt, wie Strauven hervorhebt, »ein wirklich urbanes Gefüge dar, ein polyzentrisches Gewebe aus gleichwertigen Orten, die durch ›Verbindungswege‹ oder ›Türschwellen‹ miteinander verknüpft sind«.

Der Sonsbeek Skulpturenpavillon (1966) funktioniert über einen Antagonismus zwischen innen und außen. Die rechteckige Fassade verbirgt ein labyrinthisches, aber dennoch vollkommen klar strukturiertes Inneres. Die Innenwände sind gerade Linien und Kreissegmente dar und sind so angeordnet, daß sie transversale Perspektiven eröffnen. Das Gebäude sollte, wie van Eyck sagte, »etwas von der Enge, der Dichte und der Kompliziertheit der urbanen Dinge« besitzen, und es sollte auch insofern dem Modell der Stadt entsprechen, als in ihm »Menschen und Artefakte unvermeidlich zusammentreffen, konvergieren und kollidieren«.

Van Eyck hat auch mehrere hundert Spielplätze in Amsterdam eingerichtet. Diese in den Zwischenräumen des urbanen Gewebes angesiedelten Plätze bilden ein Territorium in Gestalt eines Netzes aus kleinen Parzellen. Die Einbeziehung seiner Konstruktionen in die bestehende urbane Struktur, die Wahrung von deren symbolischer und formaler Besonderheit wie auch der respektvolle Beitrag zum historischen Reichtum der

Sonsbeek Skulpturenpavillon/sculpture's pavilion, Arnhem, 1965–66
Grundriß/ground plan

Stadt stellen die Hauptlinien seiner Konzeption von
Architektur dar. Bei seinem Projekt für das *Hubertus-
haus*, das er zwischen 1973 und 1978 erbaute, hat van
Eyck, wie Strauven sagt, das Gebäude als »eine Öffnung
in dem bestehenden Block konzipiert, die einen Zugang
zum Stadtinneren ermöglicht..., als eine neue Kompo-
nente der bestehenden Stadt«. Auch dieses Haus ist
eine kleine Stadt.

P.S.

Marijke van Warmerdam

*1959 in Amstel, Holland. Lebt und arbeitet/lives and works in Amsterdam.

The fascination that the new possibilities offered by digital image processing and transmission exert on people has almost led them to forget that, ultimately, the roots of film lie in photography. In this era of hyper-accelerated video clips and zapping, Marijke van Warmerdam returns again and again to these technical filmic roots. In her film projection Rijst (Rice) *(1995)* we see a girl lifting a rice washing bowl above her head and emptying it. This scene, after a conspicuous cut, is repeated over and over again on a continuous film loop. Aesthetically speaking, the image that emerges is concentrated fully on the girl and totally subordinate to its subject. The manifest sense of distance is reminiscent of photography in the twenties when, particularly in Germany, photography pledged itself to documentary objectivity. One enchanting feature of Marijke van Warmerdam's whole oeuvre is that despite the inner distance, the images are direct and simple translations of the basic ideas.

The film is projected from behind a semitransparent screen so that the projection mechanism as such is constantly manifest and the observer cannot fall victim to the illusion that reality is being simulated here in the manner of illusionist narrative cinema. On the contrary, the effect is one of a compact installation that exists as an object in the room. The fact that you have to get up close to this object in order to be able to recognize what is happening on the small projection area refers in turn to habits associated more with looking at individual photographs than with classical cinema films. The almost abrupt cut that follows the scene each time it is repeated, and just as it begins to captivate the viewer, also has its part to play in avoiding any immersion in filmic illusions. The observer realizes with a certain frustration that the continuous loop of the film has no correspondence in the film's action, where the circle is never completed. After all, the little girl never refills the bowl she is constantly emptying. Both the action and the editing constitute a categorical refusal of the possibility of completion, as does the loop running on without end.

S. P.

Die Faszination, die von den neuen digitalen Bildverarbeitungs- und Bildübertragungsmöglichkeiten ausgeht, hat fast vergessen lassen, daß die Wurzeln des Films letztendlich in der Photographie liegen. Im Zeitalter von hyperbeschleunigten Videoclips und Zapping rekurriert Marijke van Warmerdam auf diese filmtechnischen Ursprünge. In ihrer Filmprojektion *Rijst (Rice)* (1995) sieht man ein Mädchen eine Reiswaschschüssel über den Kopf heben und diese ausschütten. Diese Szene wiederholt sich – jeweils nach einem deutlichen Schnitt – in einer endlosen Filmschleife. Das entstehende klare Bild konzentriert sich ganz auf das Kind und ordnet sich seinem Gegenstand ästhetisch vollkommen unter. Die spürbare Distanz erinnert an Photographien der zwanziger Jahre, als sich vor allem in Deutschland die neue Photographie einer dokumentarischen Sachlichkeit verschrieb. Daß die Bilder trotz der inneren Distanz direkte und einfache Umsetzungen der Grundideen bleiben, ist ein bestechender Zug in Marijke van Warmerdams gesamtem Werk.

Die Projektion des Films erfolgt von hinten auf eine halbtransparente Fläche. Dadurch bleibt der Projektionsmechanismus als solcher wahrnehmbar. Der Betrachter kann also nicht der Täuschung unterliegen, hier würde in der Manier illusionistischen Erzählkinos in irgendeiner Form Realität simuliert. Vielmehr ist der Effekt der einer kompakten Installation, die deutlich als Objekt im Raum existiert. Daß man diesem Objekt, um erkennen zu können, was sich auf der kleinen Projektionsfläche abspielt, ziemlich nahe treten muß, verweist wieder auf Betrachtungsgewohnheiten, die sich eher mit dem Einzelbild als mit klassischem Kino verbinden. Der fast grobe Schnitt, der die sich wiederholende Szene immer dann beendet, wenn sie gerade zu fesseln beginnt, tut ein übriges, ein Versinken in filmische Illusionen zu verhindern. Frustriert realisiert der Betrachter, daß die Endlosschleife des Films in der Handlung keine Entsprechung findet. Dort nämlich schließt sich der Kreis nie, denn das kleine Mädchen füllt seine Schüssel niemals wieder auf, obwohl es sie unentwegt ausschüttet. Handlung wie auch Filmschnitt verweigern kategorisch die Möglichkeit der Vollendung, wie letztendlich auch die Schleife ohne Ende weiterläuft.

S. P.

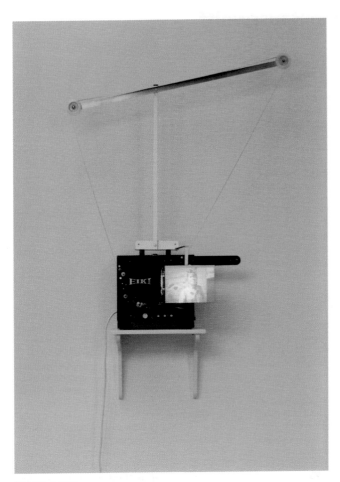

Rijst (Rice), 1995

Carl Michael von Hausswolff

*1960 in Linköping, Schweden/Sweden. Lebt und arbeitet/lives and works in Stockholm.

A former student of musicology, Carl Michael von Hauswolff is now mainly involved in research and production in the field of experimental music. Most of his work mobilizes installations using sound equipment. He favors collaborative work, seeking out all kinds of material to fit the circumstance. Relatively unfamiliar to the art world, he is a maverick whose apparent casualness conceals a systematic approach to finding just the right intervention to strike a nerve in a particular event. He likes to play with the conventions, and his work is a constant challenge to "the impossible," a kind of humorous jousting with authority figures.

Thus, during one exhibition, he invited the queens of all the countries involved to come and be "fertilized" by him and his friends in an installation created for that purpose (Royal Fertilization, 1996, with Leif Elggren). The work was censored, but von Hausswolff took photographs of the installation before it was hastily taken down, and put them on the Internet. Intrigued by systems of control and indoctrination, in 1995 he created a "subliminal" work called Elevated Memories of Previous Guests, *where he discreetly mixed radical statements by William Burroughs, Marshall McLuhan, John Lilly, and Kurt Euler into the usual Muzak of a hotel elevator. He has also recorded statements by or conversations with dead people, plants, or inhabitants of other planets. His most ambitious project to date, with his accomplice Elggren, is the constitution of a "virtual" state. The state is called Elgaland – Vargaland, and has its own embassies, its roll of citizens, a national anthem, and a coat-of-arms. A megalomaniacal and legally unfeasible project, the state is beginning to take shape as it attracts new citizens. Its territory is composed of gaps, made up of all the no-man's-lands to be found at the borders of every country in the world. In the border zone between Russia and Poland, von Hausswolff noticed the existence of fences demarcating the two countries. This became the starting point of his project for documenta. His installation consists of electric fences set up in the garden of the Ottoneum. The electrical junction box is located on the upper story of the building, between the windows that look over the garden. It provides alternating current, and von Hauswolff has amplified its hum into a kind of rhythmic techno sound. The viewer can experience the work in one of two ways, either by walking through the garden or by watching how people react to the potential danger through the windows.*

P.S.

Als ehemaliger Student der Musikwissenschaften beschäftigt sich Carl Michael von Hausswolff vornehmlich mit experimenteller Musik. Der größte Teil seiner künstlerischen Arbeit ist der Erfindung von Vorrichtungen gewidmet, die Töne von sich geben oder Geräusche machen. Er arbeitet gerne mit anderen zusammen und verwendet je nach den Erfordernissen der Situation alle erdenklichen Materialien. Er steht dem Kunstbetrieb relativ fern, und seine mit gespielter Lässigkeit übernommene Außenseiterrolle verschleiert, wieviel systematische und präzise Arbeit er aufwendet, um die angestrebten Ergebnisse zu erzielen. Er liebt das Spiel mit Konventionen, seine Arbeit ist eine permanente Herausforderung des »Unmöglichen« und ein humoristischer Kampf gegen Autoritäten.

So hat er anläßlich einer Ausstellung die Königinnen aller Länder aufgefordert, sich von ihm und seinen Freunden in einer eigens dafür konstruierten Installation »befruchten« zu lassen (*Royal Fertilisation*, 1996, zusammen mit Leif Elggren). Sein Werk wurde Opfer der Zensur, aber von Hausswolff machte von der Installation, bevor sie überstürzt abgebaut wurde, Bilder, die zur Zeit über Internet zugänglich sind. Aus seiner Begeisterung für Systeme der Kontrolle oder der Indoktrinierung entstand 1995 die »unterschwellige« Arbeit *Elevated Memories of Previous Guests*, bei der er auf unauffällige Weise dem im Aufzug eines Hotels ständig zu hörenden Hintergrundgedudel radikale Äußerungen von William Burroughs, Marshall McLuhan, John Lilly und Kurt Euler beimischte. Von Hausswolff machte auch Aufzeichnungen von Gesprächen mit Toten, Pflanzen oder Bewohnern anderer Planeten. Aber sein kühnstes Projekt ist seine Gründung eines »virtuellen« Staates, den er zusammen mit Leif Elggren konzipierte. Der Staat heißt *Elgaland – Vargaland*, er hat seine eigenen Botschaften, eine eigene Verfassung, ein Verzeichnis seiner Bürger, eine Nationalhymne und ein Wappen. Dieser Staat, ein größenwahnsinniges und juristisch unmögliches Projekt, behauptet sich in dem Maße, in dem er neue Bürger anzieht. Sein Territorium ist lückenhaft, es setzt sich zusammen aus all den »Niemandsländern«, die sich an den Grenzen aller Länder der Welt befinden. Von Hausswolff hat festgestellt, daß sich im Grenzgebiet zwischen Rußland und Polen eingezäunte Bereiche befinden, die beide Länder voneinander abgrenzen. Das war der Ausgangspunkt seiner Arbeit für die *documenta*. Seine Installation aus Elektrozäunen befindet sich im Garten des Ottoneums. Die Stromquelle befindet sich im zweiten Stock des Gebäudes, zwischen Fenstern zum Garten. Sie schaltet den Strom ständig ein und aus. Von Hausswolff hat das Geräusch, das sie von sich gibt, verstärkt und so eine Art von Technorhyth-

Electric Fence Controller, 1988–97
Detail

mus erhalten. Der Betrachter kann die Installation auf
zwei Arten ausprobieren: indem er im Garten spazieren-
geht oder indem er aus den Fenstern beobachtet, wie
die Leute auf die potentielle Gefahr reagieren.

P. S.

**Carl Michael von Hausswolff/
Ditterich von Euler-Donnersperg**

documenta meets radio/radio meets documenta

Martin Walde

*1957 in Innsbruck. Lebt und arbeitet/lives and works in Wien/Vienna.

Loosing Control *is a series of sequences mixing language and drawing in a cinematic progression. The sequences relate fleeting scenes witnessed by the artist. These short, fragmentary narratives describe the sudden appearance, in an urban setting, of a person whose strange presence, gestures, or behavior provokes a feeling of unease: a woman bedecked in ribbons kneels before a tram; an enigmatic, nightmarish scene unfolds in an underground passageway; a bald, toothless man cleans a subway car, muttering unintelligible phrases . . .*

As the series develops, the "off-screen voice" multiplies and the commentary becomes a chorus of diverging, unidentifiable voices. By choosing retrospective narration in the hybrid form of the story board, Martin Walde stresses the mnemographic process over the descriptive reproduction of on-the-spot photography. Sparked by a sudden shock or a passing sense of disquiet, these sequences tremble on the undecidable fulcrum of fiction and information. As Walde remarks, "Loosing Control *may locate some gaps in the fictions and structures of control." The behavior of these individuals does in fact escape normalization, perturbing the geometric organization of the space of circulation and stepping out of the rigid architecture of the city to reappear in the mental space of reminiscence. Like a notation of movement, Walde's drawings convey a fluctuating reality. They choreograph scenes involving irrational shifts of identity.*

Walde is fascinated with phenomena that elude all theoretical mastery and can only be reconstructed approximately through observation and study. Thus in an earlier project he took an interest in the fossilized traces of a creature dating back hundreds of millions of years. This creature, named "Hallucigenia," gave rise to a polemic in the scientific world. Walde has created sculptures of Hallucigenia in a strange, translucent shade of green, "terrestrial and alien at the same time." For him, the creature is "a unicorn of our time. Hallucigenia symbolizes the ability to dream." One of the problems the fossil poses is its correct lateral and vertical orientation. The double image of Walde's logo, Hallucigenia Products, *shows this reversible positioning. As the artist comments: "It is as if Hallucigenia mutates and reproduces itself beyond human control. It is this elusive and fluid aspect that attracts me. Hallucigenia moves between theories. Hallucigenia can exist in different forms of appearance at the same time. I think it indicates a remarkable process."*

P. S.

Loosing Control *ist eine Serie von Sprache und Zeichnung in einem quasi filmischen Ablauf verbindenden Sequenzen, die von flüchtigen Ereignissen berichtet, deren Zeuge Martin Walde wurde. Diese kurzen, lückenhaften Erzählungen schildern Szenen städtischen Lebens, bei denen eine Person durch ihre Gegenwart, ihr Verhalten oder ihre lästige und befremdliche Betätigung ein Gefühl des Unbehagens hervorruft: Eine schleifengeschmückte Frau kniet an einer Straßenbahnhaltestelle nieder; eine rätselhafte und alptraumartige Szene spielt sich in einem unterirdischen Gang ab; ein kahlköpfiger und zahnloser Mann reinigt einen Waggon und schimpft dabei vor sich hin.*

Im Verlauf der Serie wird der Kommentar der Stimme aus dem Off zu einer Polyphonie verschiedener und nur schwer lokalisierbarer Stimmen. Indem Martin Walde mit der Mischform des Storyboards eine nachträgliche Erzählweise wählt statt einer photographischen Momentaufnahme, zieht er die Beschreibung der Erinnerung an das Ereignis der beschreibenden Wiedergabe des Ereignisses selbst vor. Bei diesen aus einem kurzen schockierenden oder beunruhigenden Erlebnis hervorgegangenen Sequenzen ist nicht zu entscheiden, ob sie der Fiktion oder der Information zuzurechnen sind. Loosing Control, *sagt Walde, vermag vielleicht Lücken in den Fiktionen und den Strukturen von Kontrolle zu orten. Diese Individuen, die sich durch ihr Benehmen der Genormtheit des normalen Verhaltens entziehen, stören die geometrische Organisiertheit des Verkehrsraums und fallen aus dem Rahmen des geordneten städtischen Raums, wodurch sie im geistigen Raum der Erinnerung in Erscheinung treten und sich behaupten. Die Zeichnungen Waldes skizzieren in einer Notation von Bewegungen einen realen Ablauf und choreographieren eine Szene irrationaler Identitätsveränderung.*

Walde interessiert sich brennend für Phänomene, die sich jedem theoretischen Zugriff entziehen und sich nur approximativ rekonstruieren lassen. In einer früheren Arbeit hat er sich daher mit einem Geschöpf beschäftigt, das es vor Millionen von Jahren gegeben hat und dessen einzige Spuren Versteinerungen sind. Dieses Geschöpf trägt den Namen Hallucigenia, *und um seine genaue Identifikation entbrannte unter den Wissenschaftlern ein Streit. Martin Walde hat* Hallucigenia-*Skulpturen geschaffen, die von einer seltsam durchscheinenden grünen Farbe sind, irdisch und außerirdisch zugleich. Walde sieht in diesem Geschöpf ein Einhorn unserer Zeit.* Hallucigenia *symbolisiert die Fähigkeit zu träumen. Bei diesem Wesen blieb vor allem ungeklärt, wo hinten und vorne, oben und unten ist. Auf dem Logo, das Walde geschaffen hat,* Hallucigenia Products, *zeigt das geteilte Bild diese Vielseitigkeit im wahrsten Sinne des*

Hallucigenia, 1997

Wortes: »Es ist, sagt Walde, als ob *Hallucigenia* der Kontrolle der Menschen entzogen sei und mutieren und sich selbst reproduzieren würde. Dieser flüchtige und kaum faßbare Aspekt fasziniert mich daran. *Hallucigenia* bewegt sich zwischen den Theorien. Dieses Wesen kann gleichzeitig in verschiedenen Erscheinungsformen existieren. Ich glaube, es verweist auf einen bemerkenswerten Prozeß.«

P.S.

Jeff Wall

*1946 Vancouver, Kanada/Canada. Lebt und arbeitet/lives and works in Vancouver.

Milk (1984) is exhibited in an underground passageway in Kassel. It is a transparent, neon-lit image, mounted in a light box. Harsh sunlight strikes a sidewalk on a sloping street. A man whose clothing denotes his precarious social status is squatting at the foot a of a brick wall. Everything in the image is separated: the man does not lean against the blank wall, which is divided by a dark shadow and flanks a glass structure. Tough, dry plants sprout through the asphalt. The man's body conveys his straining inner tension. A spurt of milk bursts from the brown paper sack in his hand, like a cry. The photograph has frozen this surge of white. Milk is an emblematic image from Jeff Wall's early period.

After breaking off his career as a conceptual artist for several years to study art history, Wall created his first photographic works, which crystallized from a critical analysis of snapshot recording and a far-reaching study of the basic problems of representation. These works are based on an active opposition between photography (recording) and the tableau (a pictorial composition obtained through the staging of figures). The works are related to the model of cinematographic production and refer to media images of contemporary culture. In the eighties Wall concentrated on realistic images depicting dramatized scenes of urban life and modern alienation. In the early nineties he gave new breadth to his project, creating photographs laced with the grotesque and punctuated by eruptions of the fantastic. The recent images shown at documenta seem to indicate a new twist in his work, accompanied by a return to realism and internalized tension. For the first time (with the exception of A Sunflower) they are not light boxes. The images are still staged and presented in large format, but they are black and white. While retaining a speculative dimension, they borrow the rhetoric of documentary. The subjects are simple: a "Citizen" resting on a lawn; the nighttime encounter of "Passerby" in an illuminated alleyway; a "Housekeeper" caught as she leaves a hotel room; a self-absorbed "Volunteer" sweeping an empty room; a slumbering "Cyclist" propped up against a gray wall.

These narrative photographs are enigmatic, condensing their story in a single image whose ambivalence – between compositional artifice and naturalist description – drives a wedge between the spectator and her own emotional credulity. She (or he) must carefully examine them, pondering the possible reconstructions of the action.

P. S.

Das in einer unterirdischen Fußgängerpassage Kassels ausgestellte Bild Milk (1984) hängt in einer Art Schaukasten, wo es von hinten beleuchtet wird. Der Bürgersteig einer abfallenden Straße liegt in grellem Sonnenlicht. Am Fuß einer Backsteinmauer kauert ein Mann, dessen Äußeres darauf schließen läßt, daß er in schwierigen sozialen Verhältnissen lebt. In diesem Bild ist alles unverbunden: Der Mann lehnt sich nicht gegen die fensterlose Wand, die von einem schwarzen Schatten geteilt wird und neben einem verglasten Gebäude liegt. Aus dem Straßenbelag wächst eine dürre Vegetation. Der Körper des Mannes verrät eine extreme innere Anspannung. Aus einer Tüte, die er in seiner Hand hält, schießt, sich wie ein Schrei entringend, ein Milchstrahl. Die Photographie hat diesen weißen Strahl erstarren lassen. Milk ist ein symbolträchtiges Bild aus der ersten Periode von Jeff Walls Werk.

Nachdem er seine Laufbahn als Konzeptkünstler unterbrochen hatte, um sich für einige Jahre der Kunstgeschichte zu widmen, beginnt Wall 1978 seine ersten Photos zu machen, die die Möglichkeiten von Momentaufnahmen ausloten und sich mit Problemen der Darstellung auseinandersetzen. Seine Werke gründen auf einer aktiven Opposition von Photographie als bloßer Registrierung und dem Bild als Komposition und Inszenierung. Sie zeigen Ähnlichkeit mit einer Filmproduktion und verweisen auf die unsere Kultur dominierenden Werbebilder. In den achtziger Jahren macht Wall im wesentlichen realistische Bilder, die dramatische Szenen des Stadtlebens und der modernen Entfremdung zeigen. Zu Beginn der neunziger Jahre verleiht er seiner Arbeit eine neue Dimension, denn seine Photographien bekommen nun etwas Groteskes und spielen mit phantastischen und bizarren Einfällen. Die zur documenta gezeigten jüngsten Arbeiten scheinen anzuzeigen, daß er in seiner Kunst einen neuen Weg beschreitet, der zugleich eine Rückkehr zum Realismus und zur Verinnerlichung der Spannung bedeutet. Zum ersten Mal (mit Ausnahme von A Sunflower) werden sie nicht in einem Kasten gezeigt, in dem sie von hinten beleuchtet werden. Es handelt sich bei ihnen stets um großformatige Bildinszenierungen, allerdings in Schwarzweiß. Sie greifen auf die Rhetorik des Dokumentarischen zurück, ohne dabei ihre spekulative Dimension einzubüßen. Die Sujets sind einfach: Ein Citizen ruht sich auf einem Rasen aus, zwei Passerbys begegnen sich nachts auf einer beleuchteten Straße, ein Zimmermädchen verläßt nach dem Housekeeping gerade ein Hotelzimmer, ein in sich versunkener Volunteer kehrt einen leeren Saal, an eine Wand gelehnt, döst ein Cyclist auf seinem Fahrrad vor sich hin.

Diese rätselhaften narrativen Photographien verdichten die Erzählung zu einem einzigen unbewegten Bild,

Housekeeping, 1996

dessen Ambivalenz zwischen der Künstlichkeit der Komposition und der Natürlichkeit der Beschreibung den Betrachter daran hindert, sich ganz seinen Empfindungen hinzugeben: Er muß sie einer Prüfung unterziehen, und ihm ist aufgegeben, die Handlung zu rekonstruieren.

P. S.

Lois Weinberger

*1947 in Stams. Lebt und arbeitet/lives and works in Wien/Vienna.

Since 1988, in his garden on the outskirts of Vienna, Lois Weinberger has lent his hand to the development of wild vegetation from East and Southeast Europe. The garden is a departure point for the artist, who draws on it as a "cell" for the implantation of his outdoor projects. The flora is constituted of endangered species, generally known as weeds. Uncultivated, untamed, they demonstrate astonishing capacities for survival. They prefer the worst soils, sprouting in abandoned urban zones, on the edges of cities, where they wax on the waste products of human society. They provide a knotty, ironic counterpoint to the ideologies of beauty, purity, health, etc.

Weinberger's intervention for documenta is fourfold. First, an installation in the railway station, entitled Zelle (Cell), evokes the artist's living and working space. On the ground are a mattress and a dictionary of rare plants. On the wall, a portrait of Weinberger by a Russian street artist living in Berlin. Alongside the mattress is a phone booth from the former East Germany, with its receiver ripped off. The artist has hung up a red plastic panel taken from a Nazi-era air raid shelter, conveying the absurd injunction: "Save Light." The room also contains texts, photographs, drawings, objects, and sculptures referring to the diversity of the artist's activities – for instance, a photograph taken in 1994 in a field that was formerly crossed by the Wall, near the Brandenburg Gate in Berlin, where Weinberger, ironically equipped with a watering can (for plants requiring neither water nor any other care) participates symbolically in the birth of spontaneous urban vegetation.

Looking out this space from a window to the edge of a parking lot, one sees an expanse of fractured tarmac sprouting plants whose seeds have traveled from faraway places. "This energy field is symptomatic of an area of spontaneous chaos which gives way to a precise botanical system." Alongside the railroad tracks next to the station building, Weinberger has planted neophytes. This kind of vegetation grows rapidly, spreading out over large surfaces and combating the indigenous flora. A struggle begins: a vegetal metaphor for the migratory problems of our day, rooted in the artist's sense of black humor. On the path leading from the station to the Fridericianum, Weinberger has installed two little boxes in painted metal. They contain seeds of street plants from Kassel, along with drawings and texts. The boxes are locked. The key is available at the documenta office. A map of Kassel's path network with the names of the plants that grow there is fixed on the doors of the boxes. Wegwarte (Cichórium intybus) is the title of this installation. The word implies a double meaning (waiting by/watching over a path); it

Seit 1988 ist Lois Weinbergers Garten am Stadtrand Wiens mit seiner wilden, aus Ost- und Südosteuropa stammenden Vegetation der Ausgangspunkt künstlerischer Arbeit, denn er dient als Keimzelle und Reservoir der in Freiluftprojekten verwerteten Pflanzen. Diese Flora besteht aus gefährdeten Arten, die gemeinhin noch als »Unkraut« angesehen werden. Wild und keiner Kultivierung unterzogen, beweisen diese Pflanzen eine erstaunliche Fähigkeit zur Anpassung und zum Überleben. Sie wachsen mit Vorliebe auf schlechtem Boden, in aufgelassenen urbanen Zonen, am Rand der Städte, wo sie sich von den Abfällen der Gesellschaft ernähren. Sie sind ein ironischer Kontrapunkt zur Ideologie von der schönen, reinen, heiligen Natur.

Im Rahmen der documenta ist Weinberger viermal vertreten. Eine Installation im Bahnhof mit dem Titel Zelle evoziert den Ort, an dem Weinberger lebt und arbeitet. Auf der Erde liegen eine Matratze und ein Lexikon seltener Pflanzen. An der Wand befindet sich ein Portraitphoto Weinbergers, das ein russischer Straßenkünstler in Berlin gemacht hat. Neben der Matratze steht eine alte Telephonzelle aus der (ehemaligen) DDR, deren Hörer herausgerissen ist. Dort hängt ein rotes, aus einem Luftschutzkeller des Zweiten Weltkrieges stammendes Schild mit der Aufforderung, Licht zu sparen. Diese Installation verweist mit ihren Texten, Photographien, Zeichnungen, Objekten und Skulpturen auf die Vielfalt von Weinbergers künstlerischen Aktivitäten. Genauso verhält es sich mit einem ironischen Photo, das 1994 auf einem früher von der Mauer durchzogenen freien Feld in der Nähe des Brandenburger Tors entstand, auf dem sich Weinberger, mit einer Gießkanne ausgerüstet, obwohl die Pflanzen weder Wasser noch Pflege brauchen, symbolisch am Wachstum einer spontanen urbanen Vegetation beteiligt.

Durch das Fenster des Bahnhofssaals sieht man dort, wo am Rand eines Parkplatzes ein Teil der Straßendecke aufgerissen ist, Pflanzen wachsen, deren Samen aus fernen Ländern stammen. Hier schafft ein spontanes Chaos Raum für ein geordnetes botanisches System. Auf der Gleisanlage neben dem Bahnhofsgebäude hat Weinberger zwischen die dort schon immer wachsenden Pflanzen Neophyten gepflanzt. Diese Art von Vegetation wächst schnell, verbreitet sich großflächig und verdrängt die heimische Flora. Der so von Weinberger angezettelte Kampf ist eine von schwarzem Humor getränkte pflanzliche Metapher für die Migrationsprobleme unserer Zeit. Auf dem Weg, der vom Bahnhof zum Fridericianum führt, hat Weinberger zwei kleine, farbige Metallkästen aufgestellt. Sie enthalten Samen von Pflanzen, die in den Straßen Kassels wachsen, sowie Zeichnungen und Texte. Die Kästen sind verschlossen,

Brennen und Gehen, Szene Salzburg, 1993

designates a plant which opens its blue flowers at six in the morning and closes them again at noon.

P. S.

doch man kann sich den Schlüssel im Büro der *documenta* holen. Eine Karte der Fußwege Kassels mit den Namen der Pflanzen, die an ihnen wachsen, ist an der Klappe der Kästen angebracht. Der Titel dieser Installation lautet *Wegwarte (Cichórium intybus)* – dieses doppelsinnige Wort (am Weg wartend, den Weg wartend) ist der Name einer Pflanze, die ihre blauen Blüten um sechs Uhr morgens öffnet und schon zur Mittagszeit wieder schließt.

P. S.

Franz West

*1947 in Wien/Vienna. Lebt und arbeitet/lives and works in Wien/Vienna.

The art of Franz West has matured by unusual paths. Strongly marked by Vienna actionism in his youth, he went through a difficult early period, in which he was unable to win acceptance in Viennese art circles and had to elaborate his work not through exhibitions but by selling his collages in the street. At this time he immersed himself in the writing of Freud and Wittgenstein, then in postexistentialist French thought (Lacan, Deleuze, Barthes).

His work has developed through a plurality of media, from furniture to video by way of writings in philosophy and linguistics. His first sculptures, in crude, powerful forms, show traces of an expressionist influence. Fascinated by archaic societies, he cultivated a primitive technique and took great pleasure in "doing everything you must not do in art." His work contains a recurrent thematic element: the relation to the body. Thus he created wearable structures, kinds of prosthetic devices with rods and bandages, forcing the body into contorted positions (the Passtücke). He made "amorphous sculptures" of African inspiration and objects placed in "performative situations," such as the Liegen, which are metal couches composed of different elements of welded alloys.

Arranged within a context so as to pass almost unseen, Franz West's sculptures record the transition from the object to the accessory, from the presentation of the work as an object of contemplation to its use as an integral element of a given environment. The sometimes unconscious activation of the pieces by the spectator constitutes the artistic event of West's work, which completes the dissolution of the modern tradition in a baroque dimension, at once festive and dramatic. The proliferation of the objects inscribes them in the territory, like the sofa-carpets conceived for the open-air cinema of documenta IX or today, the chairs arranged in the documenta Halle to greet the public of the "100 Days – 100 Guests" event, in a space designed by Heimo Zobernig.

P. S.

Die Arbeit von Franz West hat nicht gerade eine typische Entwicklung genommen. Stark geprägt durch den Wiener Aktionismus, machte er eine schwierige erste Phase durch, in der es ihm nicht gelang, in der Wiener Kunstszene Anerkennung zu finden, und damit seine Arbeit dem institutionalisierten Ausstellungsbetrieb der Öffentlichkeit zugänglich zu machen, sondern seine Collagen auf der Straße verkaufte. In dieser Zeit vertiefte er sich in die Schriften Wittgensteins und Freuds und später auch in die Werke neuerer französischer Denker wie Barthes, Lacan oder Deleuze.

Sein Engagement findet in einer Vielzahl von Medien Ausdruck, vom Mobiliar bis zum Videofilm oder Texten philosophischen und sprachwissenschaftlichen Inhalts. Seine ersten, »formes brutes« aufweisenden Skulpturen zeugen von einer Beeinflussung durch den Expressionismus. Aufgrund seines Faibles für archaische Kulturen kultiviert er eine primitive Technik und hat seine Freude daran, »all das zu tun, was man in der Kunst nicht tun darf«. Sein Werk enthält ein wiederkehrendes thematisches Element: die Beziehung zum Körper. Er schuf auch »tragbare« Strukturen, so etwa eine Art Prothesen aus Stangen und Mullbinden, die den Körper zwingen, eine verdrehte Haltung einzunehmen (Paßstücke), oder seine Lemurenköpfe. Er hat »amorphe« Skulpturen geschaffen, die von der afrikanischen Kunst inspiriert sind. Und schließlich gehören zu seinem Werk Objekte, die er in eine »performative Situation« stellt, wie zum Beispiel seine metallenen Liegen, die aus verschiedenen Stahlelementen zusammengeschweißt sind.

Die Skulpturen Franz Wests, die er in eine Situation stellt, wo sie als Skulpturen unbemerkt bleiben können, erfassen den Übergang vom Objekt zum Accessoire, von der Präsentation des Werks als Objekt der Betrachtung zu seiner Verwertung und Nutzung an einem Ort als integriertes Element. Diese manchmal unbewußte oder unwissentliche Aktivierung seiner Werke durch den Betrachter konstituiert das künstlerische Ereignis der Arbeit Franz Wests. Sein Werk gibt der Auflösung der modernen Tradition eine barocke, festliche und dramatische Dimension. Durch ihre Verbreitung schreiben sich die Elemente in den Raum des Territoriums ein, wie etwa die Sofas, die er für das Open-Air-Kino der documenta IX gestaltete, oder seine Stühle, die er anläßlich der documenta X in der documenta-Halle verteilt hat, damit sie in dem von Heimo Zobernig gestalteten Raum bei den Ereignissen von Nutzen sind, die sich dort im Rahmen der »100 Tage – 100 Gäste« abspielen.

P. S.

Dokustuhl, 1997

Garry Winogrand

*1928 in New York. †1984 in Mexiko/Mexico.

Garry Winogrand, who showed with Lee Friedlander and Diane Arbus in the celebrated exhibition New Documents (1967), is one of the dominant figures of street photography. He refused to define himself as a reporter and rapidly gave up working for illustrated magazines. An intuitive photographer, his approach is guided by an enduring concern to avoid the classical rules of composition and to resist the diverse seductions of visual rhetoric. Throughout his work he portrays highly diverse situations which reflect the incessant and prolific activity of people in urban space.

The streets of New York, his native city, constitute a privileged terrain for Winogrand. In the sixties they were considered the open theater of modernity. The major arteries of New York are like corridors, they lend themselves more to functional circulation than to urban strolling. But as Winogrand's photographs show, the sidewalk users let themselves be distracted from their conditioned itinerary by occasional stops and circumstantial movements. Winogrand captures this proliferation of everyday gestures and micro-events: outbursts of laughter, chance meetings, impassioned discussions, crossing gazes, furtive exchanges, passing idylls, the play of reflections, self-absorbed figures, natural incidents, silent and solitary coexistence, ordinary enigmas. Peopled by members of all the city's social strata, the street, in Winogrand's eyes, was public space par excellence.

Of great visual complexity, taken from slightly odd angles, his straight photographs sketch a network of relations where people, grasped amid the flux of their dynamic trajectories, are immobilized in split-second configurations. Few photographers have so demandingly sought to frame chaos, to freeze it in a precarious form which continues to let it be felt as such. Garry Winogrand claimed to photograph things "to see what they would look like after being photographed." He was particularly fond of images where the tension between form and content was such that they "threatened to split apart." At his death, this compulsive photographer left more than three hundred thousand unexploited negatives. These photographs, taken near the end of his life, are often technically faulty and seem to have been done distractedly. The reason they were never exploited and the object of the artist's research remain mysteries. This rather staggering profligacy is perhaps explained by a confession he made a year before his death, when someone asked him why he took photographs: "I get totally out of myself. It's the closest I come to not existing."

P. S.

Garry Winogrand, der 1967 zusammen mit Lee Friedlander und Diane Arbus in der Ausstellung New Documents vertreten war, ist einer der wichtigsten Vertreter der »street photography«. Er weigert sich schon sehr früh, sich als Reporter zu verstehen, und verzichtet darauf, für Illustrierte zu arbeiten. Er ist ein intuitiver Photograph, der in seiner Arbeit ständig bemüht ist, die klassischen Regeln der Komposition zu mißachten und sich nicht durch eine visuelle Rhetorik verführen zu lassen. Zahlreiche Bilder seines Werks zeigen Situationen, die die permanente und übertriebene Geschäftigkeit der Menschen in den Städten entlarven.

Die Straßen New Yorks, der Stadt, in der er geboren ist, sind sein bevorzugtes Terrain. In den sechziger Jahren gelten sie als offenes Theater der Moderne. Die Schlagadern New Yorks sind wie Korridore, sie eignen sich eher für eine funktionale Zirkulation als für ein Umherschlendern. Doch die Benutzer der Bürgersteige lassen sich auch weiterhin vom strikten Befolgen ihrer Marschroute insofern ablenken, als sie gelegentlich haltmachen oder Bewegungen ausführen, die sich aus der Situation ergeben. Diese Verbreitung von alltäglichen Gesten, Bewegungen und Mikroereignissen ist es, was Garry Winogrand einfängt: ein Auflachen, eine zufällige Begegnung, eine hitzige Diskussion, sich kreuzende Blicke, verstohlen ihren Besitzer wechselnde Dinge, flüchtige Idyllen, das Spiel der Lichtreflexe, in Gedanken verlorene Menschen, natürliche Zwischenfälle, stille und einsame Zweisamkeit, alltägliche Geheimnisse. Die von Einheimischen aller sozialen Schichten bevölkerte Straße war für Winogrand der öffentliche Raum par excellence.

Seine sich durch große visuelle Komplexität auszeichnenden »straight photographs«, mit leichter Hand aus seitlicher Perspektive aufgenommen, zeichnen ein Netz von Beziehungen, in dem die in der ganzen Dynamik ihrer Bewegungen überraschten Menschen in einer momentanen Konfiguration erstarrt sind. Nur wenige Photographen haben mit einem solchen Anspruch versucht, das Chaos in einen Rahmen zu bringen, es in einer fragilen Form zu fixieren, die das Chaotische auch weiterhin spürbar sein läßt. Garry Winogrand erklärte, man photographiere etwas, »um zu sehen, wem oder was es gleicht, wenn es photographiert ist«. Die Bilder, die er besonders mochte, waren solche, wo die Spannung zwischen Figur und Grund so stark ist, »daß sie sich voneinander zu lösen drohen«. Der zwanghafte Photographierer Winogrand hinterließ bei seinem Tod mehr als dreihunderttausend Negative, die er nicht verwertet hatte. Diese in seinen letzten Lebensjahren aufgenommenen Photographien sind technisch oft schwach und scheinen nur zum Zeitvertreib gemacht worden zu sein. Warum er sie nicht verwertet hat und

Untitled, 1971

was er mit ihnen bezweckte, bleibt ein Geheimnis. Diese fast schon beängstigende verschwenderische Fülle erklärt sich vielleicht aus jenem Bekenntnis, das er ein Jahr vor seinem Tod in einem Interview ablegte, als man ihn fragte, warum er photographiere: »Ich gerate dabei völlig außer mir. So komme ich dem Zustand des Nichtseins am nächsten.«

P.S.

Eva Wohlgemuth/Andreas Baumann

Eva Wohlgemuth, *1955 in Baden, Österreich/Austria. Lebt und arbeitet/lives and works in Wien/Vienna.
Andreas Baumann, *1962 in Bern. Lebt und arbeitet/lives and works in Wien/Vienna.

Eva Wohlgemuth began her collaboration with Andreas Baumann in 1989 and developed System I – Around Vienna, *a conceptual location sculpture that would take her around the world. Wohlgemuth and Baumann's* System *is a mental network of objects, geographically located in very specific places.*

The documentation on all of these Location Sculpture Systems, *now gathered on one website, is an indispensable extension of this project with no limits. Each of the ten Systems Wohlgemuth has realized (often in collaboration with Andreas Baumann) plays on dispersion and localization, and the world of networks should by now be contaminated with this artistic practice.*

Concretely, the systems are location structures developed around a central core and set in a natural space selected on the basis of historical and cultural considerations. Around the core a network of geographic points is formed, all of which are linked together in different ways: information flows, associations of ideas, transformation of materials, etc., so that each point in the network is a source of information in its own right, yet remains related to all other points. The individual positions are generally marked by attaching a plate onto them that carries information on the system. The twin plates of the fixed points combine to form a block, the "central unit" of the system. It is the "battery" that maintains the connection to the outer plates. Together with the documentary material, photos, and videos, it builds up a material, as well as an imaginary and emotional, network.

Among those systems one might mention System II, A House, A Wood, A Lake, A Mountain and A Tunnel in Switzerland, *five plates and points representing the idea of Heimat ("homeland"), or* System IV, Moving Plates, *where nine titanium plates pursue the idea of a global kinetic sculpture, since they were put on moving objects (a car, train, ice-cream cart, tree, elevator, satellite, mill, submarine, and boat). There is also* System V, Red means yellow, yellow means red, *two points and plates situated exactly on the opposite side of the globe from each other, one on Easter Island in the Pacific, the other in the Thar Desert in India.*

In setting up this network of sculptures, Wohlgemuth is not trying to topologically encircle the globe, but rather to structure the way a thing becomes detached from its origins. She thus manages to link the object back up with its conceptual gestation, and yet to abandon it. We see that by taking note of particular points on things all over the world, an imaginary relationship between objects and their localization is effected, creating the mental image of a sculpture. S.L.

Eva Wohlgemuth begann ihre Zusammenarbeit mit Andreas Baumann 1989, als sie gemeinsam ihr System I, *Around Vienna*, entwickelten, eine konzeptuelle »Lokalisierungsskulptur«, die sie rund um die Welt führen würde. Die System-Arbeit von Wohlgemuth und Baumann ist ein geistiges Netzwerk von Objekten, die geographisch an ganz bestimmten Orten untergebracht sind.

Die Dokumentation über ihr gesamtes *Location Sculpture System*, die heute auf einer Website gesammelt ist, stellt die zwingende Weiterführung einer derart grenzenlosen Arbeit dar. Wenn jedes der zehn Systeme, die Eva Wohlgemuth realisiert hat (oft in Zusammenarbeit mit Andreas Baumann), sein Spiel mit Streuung und Lokalisierung treibt, dann muß die Welt der Netze von einer solchen Praktik infiziert werden.

Konkret sind die Systeme Skulpturen aus Standorten, die um einen zentralen Kern herum entwickelt werden, der in einen aufgrund historischer und kultureller Überlegungen ausgewählten natürlichen Raum gesetzt wird. Um den Kern herum wird ein Netzwerk aus geographischen Punkten gestaltet, die alle auf verschiedene Weise miteinander verbunden sind (Informationsfluß, Ideenassoziationen, Materialtransformation etc.), so daß jeder Punkt des Netzes eine selbständige Informationsquelle ist, aber doch zu allen anderen Punkten in Beziehung steht. Die einzelnen Positionen werden generell durch eine Tafel markiert, auf dem Informationen über das jeweilige System stehen. Ihre Duplikate werden zu einem Block zusammengefügt, der »zentralen Einheit« des Systems. Sie ist die »Batterie«, die die Verbindung zu den Tafeln draußen aufrechterhält. Zusammen mit Dokumentarmaterial, Photos und Videos ergibt das Ganze ein ebenso materielles wie imaginäres und emotionales Netzwerk.

Von den realisierten Systemen seien hier erwähnt das System II: *A House, A Wood, A Lake, A Mountain and A Tunnel in Switzerland*, fünf Tafeln und Orte, die für eine Vorstellung von Heimat repräsentativ sind; das System IV, *Moving Plates*, wo neun Tafeln aus Titan die Idee einer kinetischen globalen Skulptur entfalten, da sie auf mobilem Untergrund plaziert sind (Auto, Zug, Gletscher, Baum, Aufzug, Satellit, Mühle, Unterseeboot, Schiff); und das System V: *Red means yellow, yellow means red*, zwei Tafeln, die an sich exakt gegenüberliegenden Orten der Erde angebracht sind, von denen der eine auf den Osterinseln im Pazifik und der andere in der Wüste Thar in Indien liegt.

Mit ihrem Skulpturennetz will Wohlgemuth nicht den ganzen Globus topologisch erfassen, sondern vielmehr den Prozeß der Absonderung einer Sache von ihrem

Location Sculpture System, 1989–97
Screenshot

Ursprung strukturieren. Sie setzt das Objekt aus und
überläßt es sich selbst, und doch bindet sie es zugleich
zurück an seinen konzeptionellen Ursprung. Sieht man
also die um die ganze Erde verteilten Dinge zugleich als
Netz festgelegter Punkte, so installiert sich eine ima-
ginäre Beziehung zwischen den Objekten und ihrer
Lokalisierung, die das geistige Bild einer Skulptur her-
vorbringt.

<div align="right">S. L.</div>

Penny Yassour

*1950 in Israel. Lebt und arbeitet/lives and works in Kibbuz/kibbutz Ein Harod Ihud.

Penny Yassour's interest in mental maps, that is, in people's personal representations of a territory, came partially from her studies in geography at the University of Haifa in the 1970s. There she inquired into "mental maps and the vision of the environment," to borrow the expression of Kevin Lynch, whose book The Image of the City was decisive for her, along with her discovery of the work of Robert Smithson. To experimentally observe the subjective character of the relation to the landscape and the psychological, cultural, and political contents that individuals project on their surrounding environment, she worked with maps drawn up for her by the members of the Ein Harod kibbutz, where she lives in relative isolation from the Israeli art scene.

In 1988 she turned away from the natural, organic landscape to begin exploring the urban configurations produced by industrial technologies. At the same time she began to use iron for her own sculptures and environments, and to analyze maps, architectural plans, and technical drawings dating from the Second World War. For Screens (railway map, Germany 1938) (1996) she used graphite powder to transfer a drawing realized on a metallurgical plate to a sheet of parchment. The map reproduces the organizational network of the German trains. Yet its presentation as a double image, fused with its mirror reflection as in a Rorschach blot, lends it a psychological weight and an enigmatic quality, reinforced by the visual analogy between this configuration and the representation of a bird. This metamorphosis of map into figure recurs in the 1994 work Sealed Cape (Acephalus), created in silicon rubber (a fireproof material), which evokes at once a sheltering blanket and an imaginary animal.

Penny Yassour's work is a reflection on the disaster of the Holocaust and the reversal of utopia into a dream of omnipotence. She delves into the history of architecture and of industrial production to fabricate mental maps and imaginary figures, taking into account the specific history and contradictions of the state of Israel. As Jean-François Chevrier remarks, "The technical utopia has been negatively fulfilled in the expansion of the military-industrial megastructures. All mobility or extension of perception is now subject to this model of expansion, summed up by the obsessive power of cartography."

P.S.

Das Interesse Penny Yassours an geistigen Landkarten, das heißt an dem persönlichen Bild, das sich jeder von einer Gegend macht, ist zum Teil auf ihr Geographiestudium zurückzuführen, das sie in den siebziger Jahren an der Universität Haifa absolvierte. Heute studiert sie »die geistigen Landkarten und die Betrachtungsweise der Umgebung«, wie Kevin Lynch es formuliert, dessen Arbeit The Image of the City sie ebenso entscheidend beeinflußte wie die Arbeiten von Robert Smithson. Um den subjektiven Charakter der Beziehung zu einer Landschaft und die psychologischen, kulturellen und politischen Projektionen, die jeder seiner Umgebung aufpfropft, experimentell festzustellen, arbeitet sie mit Karten, die von Mitgliedern des Kibbuz Ein Harod, in dem sie relativ isoliert von der israelischen Kunstszene lebt, speziell für sie angefertigt werden.

Ab 1988 verlagert sich ihr Interesse von natürlich und organisch gewachsenen Landschaften zu urbanen Konfigurationen, die ihre Entstehung industriellen und mechanisierten Techniken verdanken. Gleichzeitig beginnt sie, bei ihren Skulpturen und Environments mit Eisen zu arbeiten wie auch Karten, Pläne und technische Zeichnungen aus der Zeit des Zweiten Weltkriegs zu analysieren. Screens (railway map, Germany 1938) (1996) ist das Ergebnis einer mit Hilfe von Graphitstaub bewerkstelligten Übertragung einer in eine Metallplatte gravierten Zeichnung auf Pergamentpapier. Die Karte ist die Reproduktion des Netzes deutscher Eisenbahnlinien. Doch ihre Präsentation in Form einer klappsymmetrischen Spiegelung, wie man sie vom Rorschachtest her kennt, verleiht ihr eine psychologische Dimension und zugleich etwas Rätselhaftes, das durch die Analogie dieser Konfiguration mit dem Bild eines Vogels noch verstärkt wird. Dieses Verfahren, Linien in eine Gestalt umschlagen zu lassen, findet sich auch in Sealed Cape (Acephalus) (1994), einer aus feuerhemmendem Isoliermaterial, nämlich Kautschuk und Silikon, gestalteten Arbeit, die gleichermaßen eine schützende Hülle und ein Fabeltier darstellt.

Das Werk Penny Yassours, das der Perversion einer in den Traum von Allmacht umschlagenden Utopie nachspürt und sich mit der Katastrophe des Holocaust auseinandersetzt, zitiert bei der Gestaltung geistiger Landkarten und der Schaffung imaginärer Figuren die Geschichte der Architektur und der Entwicklung industrieller Produktion. Ihre Arbeit enthüllt, wie Jean-François Chevrier sagt, daß »sich die technische Utopie auf negative Weise in der Expansion der militärisch-industriellen Megastrukturen vollendet hat. Jede Mobilität und jede Erweiterung der Wahrnehmung ist künftig diesem Expansionsmodell unterworfen, das sich bündig im Einfluß der Kartographie ausdrückt, die einem nicht aus dem Sinn geht.«

P.S.

Sealed Cape (Acephalus), 1994

Andrea Zittel

*1965 in Escondido, Kalifornien/California. Lebt und arbeitet/lives and works in New York.

Andrea Zittel attended the Rhode Island School of Design. Born on the West Coast, she now works in New York. Around 1990 she began making modifiable habitats, a kind of a biotic topos for the individual in society. In 1994 she made Living Units "that could be customized according to the needs of the owners and users." The A–Z Escape Vehicles she is showing at documenta are the direct descendants of those domestic prototypes. They are habitation capsules whose uniform exteriors are designed by Zittel, but whose interior design depends entirely on the owner. Inspired by the mobile home, the A–Z Escape Vehicles are built of stainless steel. Like trailers, they can be hooked to the rear of an automobile and driven away, but they are in fact designed to remain stationary, installed in a driveway or a yard. They are also small enough to be installed in a dining room, or in any other room of the house. The logo A–Z obviously refers to the artist's initials, but, through the metaphor of the alphabet, also refers to the idea of unity and totality.

"I operate from the standpoint of a consumer, not an expert. Which is more the role of an artist, not a designer," Zittel states. These object-environments are in fact quite ambiguous, and are situated somewhere between utilitarian equipment and artistic event. They also seem to belong to a tradition that comes out of various modern movements, like the Bauhaus or Russian constructivism, which attempted to extend the artist's activity to all levels of social production and to eliminate the distinction between the creation of a work of art and the fabrication of utilitarian objects. One could also draw a link between her work and radical Italian design in the sixties and the idea of the New Italian Domestic Landscape. But Zittel's work is driven neither by a utopian vision nor by a critique of the modernist vision. She is more interested in redefining the social ordering of the everyday. "A–Z is not an ideology, nor is it a strategy. It is a mission to learn more about our values, our needs, and how we choose the roles we play." Although she looks for the most simple, comfortable, and aesthetic solution to a functional necessity, Zittel brings out the artistic in the utilitarian, based both on the experience of the viewer and that of the collector. By leaving it up to the latter to intervene in the interior design of this habitable object, she clearly conceives of artworks in terms of an object used in privacy, or even privation.

P. S.

Andrea Zittel ist Absolventin der Rhode Island School of Design und arbeitet heute in New York. Um 1990 beginnt sie Wohnmodule zu bauen, die Biotope des Individuums in der postmodernen Gesellschaft darstellen. Ab 1994 fängt sie an, ihre Living Units herzustellen, »die den Bedürfnissen der Besitzer und Benutzer angepaßt werden können«. Ihre auf der documenta gezeigten A–Z Escape Vehicles sind die direkten Nachfahren dieser Wohnprototypen. Es handelt sich bei ihnen um mehrere anpaßbare Wohnzellen, die Andrea Zittel außen zwar gleich gestaltet hat, deren Inneneinrichtung jedoch ganz vom Eigentümer abhängt. Inspiriert vom Modell des »Wohnmobils«, bestehen die A–Z Escape Vehicles aus rostfreiem Stahl. Man kann sie wie Wohnwagen hinten an Fahrzeuge anhängen und sich mit ihnen auf Achse begeben. Doch sie sind eigentlich dafür gedacht, fest an einem Ort, im Hinterhof oder im Garten, installiert zu werden. Sie sind allerdings klein genug, um auch im Wohnzimmer oder sonstwo im Haus oder in der Wohnung aufgestellt zu werden. Die Bezeichnung A–Z bezieht sich offensichtlich auf den Namen der Künstlerin, doch sie verweist als alphabetische Metapher auch auf eine Vorstellung von Einheit und Totalität.

»Ich gehe vom Standpunkt eines Konsumenten aus, nicht von dem eines Experten. Letzteres ist eher die Rolle eines Künstlers, nicht eines Designers«, erklärt Andrea Zittel. Ihre Environment-Objekte allerdings sind mehrdeutig, sie halten die Mitte zwischen Gebrauchsgegenstand und Kunstobjekt. Sie scheinen sich in eine Tradition moderner Bewegungen wie dem Bauhaus oder dem russischen Konstruktivismus einzureihen, die das Tätigkeitsfeld des Künstlers auf alle Ebenen der gesellschaftlichen Produktion auszuweiten trachteten und den Unterschied zwischen der Schaffung eines Kunstwerks und der Fabrikation eines Gebrauchsgegenstands zu kaschieren bestrebt waren. Man könnte ihre Arbeit mit gleichem Recht auch mit dem radikalen italienischen Design der sechziger Jahre und dem Begriff der »Neuen italienischen Wohnlandschaft« in Verbindung bringen. Aber die Arbeit Andrea Zittels ist nicht von einer utopischen Zielvorstellung beseelt, und es geht ihr auch nicht um eine Kritik an der Moderne. Es geht ihr vielmehr darum, das Alltagsleben zu verbessern: »A–Z ist weder eine Ideologie noch eine Strategie. Es ist eine ›Mission‹, um mehr darüber zu erfahren, wie es um unsere Werte und unsere Bedürfnisse bestellt ist und wie wir uns für die Rollen entscheiden, die wir spielen.« Andrea Zittel sucht stets nach der einfachsten, komfortabelsten und ästhetischsten Lösung, und auf diesem Weg gelingt es ihr, die Kunst im Gebrauchsgegenstand aufscheinen zu lassen und ihn zum Sammlerobjekt wie zum Gegenstand einer ästhetischen Rezep-

A–Z Escape Vehicle Owned and Customized by Bob Shiffler, 1996

tion werden zu lassen. Indem sie die innere Ausgestaltung ihrer bewohnbaren Objekte dem Käufer und damit auch dem Kunstsammler überläßt, schafft sie Kunstwerke, die der privaten, wenn nicht sogar der alleinigen Nutzung ihres Eigentümers vorbehalten sind.

P. S.

Heimo Zobernig

*1958 in Mauthen. Lebt und arbeitet/lives and works in Wien/Vienna.

Heimo Zobernig's work has undergone many ruptures, both in the way it proceeds as well as in the languages and strategies with which it experiments. Yet there seems to be one constant, that of remaining faithful to the history and demands of modernism, whose project, still relevant in the eyes of the artist, intimates a need to continue progressing outside any constraint of autonomy or permanence for the artwork. Zobernig first came to prominence on the Austrian scene in the early eighties for his performances. In the mid-eighties he began show abstract geometric paintings, work that seemed related to neo-geo. But he is best known for installations that take objects (floors, benches, windows, walls, or mirrors) to be something ambivalent. Between the utilitarian and the artistic, and in some indeterminate zone between representation and the thing itself, they offer the viewer a twofold experience precluding any unequivocal reading. His work joins and articulates artistic practices that are normally separate: painting, sculpture, graphics, video, design, and architecture. However, he makes no pretense of undiverging unity.

Zobernig likes to employ a given context to create his work, which, although analytic and critical, is also formally effective and precise. He has always systematically used Helvetica, a typeface designed by a disciple of the Bauhaus, one which lends itself to any medium, newspapers no less than posters, and works well on any scale.

For documenta he has worked on the idea of the symposium, and has settled on a proposal that neither relates to nor criticizes architecture. Zobernig's piece consists of a simple array of elements: a platform for participants in the "100 Days – 100 Guests" program, and a large shipping container housing a videotheque and the technical crew which will record the discussions, as well as a booth for simultaneous translation. On either side of the dais he has hung large white banners with the names of the one hundred participants in black letters. The banners divide the huge space of the documenta Halle into several functional spaces, one for various activities like debates and performances, a space for recording, and one for the bookseller Walther König, designed by Vito Acconci. Zobernig has added nothing extraneous, nor is there the slightest ornamental element. He has collaborated with Franz West, who has created a free arrangement of his chairs. During the day the auditorium is empty, and the visitor is free to come view a videotape, to rest, or view Zobernig's staging as a sculpture, and the arrangement of the various elements as a visual and plastic proposal.

P.S.

Die Arbeit Heimo Zobernigs ist in ihren Verfahren, mit Sprachen und unterschiedlichen Strategien zu experimentieren, durch zahlreiche Brüche gekennzeichnet. Doch ein Charakterzug bleibt konstant: die Einbindung in die Geschichte der Moderne und das Festhalten an ihren Forderungen. Das progressivistische Projekt dieser Moderne hat in den Augen des Künstlers weiterhin Bestand und verlangt nach einer von den Zwängen der Autonomie und Beständigkeit des Werks freien Fortschreibung. Zobernig wurde zu Beginn der achtziger Jahre in der österreichischen Kunstszene durch seine Performances bekannt. Mitte der achtziger Jahre stellte er dann seine abstrakten geometrischen Gemälde aus, die den Arbeiten der Neo-Geo-Bewegung vergleichbar sind. Doch vor allem kennt man Zobernig wegen seiner Installationen, die das Objekt (Böden, Bänke, Fenster, Wände, Spiegel) auf unentscheidbar ambivalente Weise zwischen Gebrauchsgegenstand und Kunstgegenstand, zwischen einer Repräsentation und der Sache selbst in der Schwebe und dabei dem Betrachter eine doppelwendige Erfahrung offenhalten, die jede eindeutige Lesart unterbindet. In seiner Arbeit vereinigen sich Spielarten künstlerischen Schaffens, die für gewöhnlich separiert sind: Malerei, Skulptur, Graphik, Video, Design und Architektur.

Zobernig greift gerne einen vorgegebenen Kontext auf, um seine Werke in ihm und gegen ihn sowohl analytisch und kritisch wie auch formal effizient und präzise zu konstituieren. Er verwandte von Anfang an systematisch stets ein und dieselbe Schriftart: Helvetica. Diese von einem Bauhausschüler entworfene Schrift ist für alle Größen und Zwecke geeignet, für Zeitungen ebenso wie für Poster.

Für die documenta hat Zobernig sich die Situation eines Symposiums zum Thema genommen und eine plastische und funktionale Arbeit konzipiert, die nichts mit Architektur zu tun hat. Sie besteht aus einer Anordnung einfacher Elemente: einem Podium, auf dem die am Programm der »100 Tage – 100 Gäste« jeweils Beteiligten Platz nehmen, und einem angemieteten Container, in dem eine Videothek, eine Simultandolmetscherkabine und die für die Aufzeichnung der Debatten verantwortlichen Techniker untergebracht sind. Außerdem sind auf beiden Seiten des Saals große weiße, in den Raum hineinragende Banner angebracht, auf denen in schwarzen Buchstaben die Namen der 100 Gäste stehen. Diese Banner teilen den riesigen Raum der documenta-Halle in mehrere Funktionsräume: einen Raum für Aktivitäten, Debatten und Performances, einen als Aufnahmestudio nutzbaren Raum und einen Raum für die Buchhandlung König, den Vito Acconci ausgestaltet hat. Zobernig hat kein einziges überflüssi-

1 Bühne/Projektionswand
2 300 Stühle
3 100-Namen-Transparent
4 10 Video-Audiomonitore
5 Technikcontainer
6 Übersetzerkabine
7 Bücher/Zeitschriften

Ohne Titel, 1997

ges Element hinzugefügt und konsequent auf jedes
Ornament verzichtet. Er arbeitete mit Franz West zu-
sammen, der seine Stühle nach Belieben verteilte. Tags-
über ist das Auditorium leer, und der Betrachter kann
kommen und sich ein Video ansehen, sich ausruhen
oder die Szenerie Zobernigs als Skulptur betrachten,
wobei die Verteilung der Elemente wie ein plastischer
Vorschlag wirkt.

P.S.

100 Days – 100 Guests / 100 Tage – 100 Gäste

Catherine David's conception of the "cultural event" or manifestation culturelle entails a broadening of the spectrum traditionally encompassed by art exhibitions. "100 Days – 100 Guests," an integral part of documenta X, goes beyond the mere presentation and staging of artworks to create a forum allowing visitors to participate in lectures, discussions, and performances.

Today's creative practices no longer match outdated exhibition forms, making it necessary to react to the new conditions within the visual arts. For example, the works of artists operating in the virtual space of the new media are particularly recalcitrant to traditional modes of presentation. But up-to-date transmission networks are not in themselves a sufficient response. In this postindustrial age of accelerating information and expanding communications technology, Catherine David also considers it urgent to work against a deficit in public confrontation with the content of social, cultural, and economic issues. Thus the concept of the "cultural event" includes political discourse as well as aesthetic apprehension. Indeed, the clearly articulated political views of cultural representatives from a wide range of origins are decisive for the manifestation of art. Only through the construction of political forums for debate and critical reflection can the process of depoliticization so visibly taking place throughout the world be counteracted.

To achieve these ends, the documenta Halle has been redefined as a place of exchange, communication, and information, a place of critical questioning and contemplation. Located along the parcours, the space provides the possibility for each visitor to grapple with contemporary issues. This expansion of the documenta program transcends the boundaries of the "exhibition" medium and integrates a new element – the element of process.

The phenomenon of globalization and its effects on the economy, social politics, and culture can be regarded as the overall subject of the presentations given within the context of "100 Days – 100 Guests." Somewhat in the manner of an interdisciplinary research project, the diverse contributions will provide insight into the complexity of this multifaceted issue.

A number of the invited guests are from non-Western cultural complexes, from countries whose cultural production has traditionally evolved to a great extent outside the visual arts. These cultures will be represented at the documenta by the works of writers, scholars, and filmmakers whose presence may provoke questions about Eurocentric patterns of reception.

In general these interventions will not be modeled on the lecture rituals of academia but rather will take the form of "editorials," allowing viewpoints to be concisely formulated and controversially discussed. After

Catherine Davids Konzeption einer »manifestation culturelle« sieht vor, daß das traditionelle Spektrum der Ausstellung erweitert wird und über die bloße Präsentation und Inszenierung von Kunstwerken hinausgeht. Mit dem Programm »100 Tage – 100 Gäste«, das integraler Bestandteil der documenta X ist, wird ein Forum geschaffen, das den Besuchern die Teilnahme an Vorträgen, Diskussionen und Performances ermöglicht.

Da die heutigen künstlerischen Praktiken den Rahmen der traditionellen Ausstellung sprengen, galt es, auf die veränderten Bedingungen in der bildenden Kunst zu reagieren. Arbeiten jüngerer Künstler zum Beispiel, die im virtuellen Raum der neuen Medien operieren, entziehen sich traditionellen Formen der Präsentation. Aber hochentwickelte Kommunikationsnetze stellen an sich keine ausreichende Antwort dar. Zudem sieht es Catherine David als eine Dringlichkeit, im postindustriellen Zeitalter der beschleunigten Information und der expandierenden Kommunikationstechniken einem Defizit in der Auseinandersetzung mit politischen, sozialen, kulturellen und wirtschaftlichen Inhalten entgegenzuwirken.

Dementsprechend umfaßt der Begriff der »manifestation culturelle« den politischen Diskurs ebenso wie die ästhetische Betrachtung. Entscheidend sind daher die von den kulturellen »Akteuren« ganz unterschiedlicher Provenienz dezidiert artikulierten politischen Standpunkte. Nur durch ein politisches Forum für Debatten und kritische Reflexion kann dem weltweiten Prozeß der Entpolitisierung entgegengewirkt werden.

Die documenta-Halle wird so zum Ort des Austauschs, der Kommunikation und Information, aber auch des kritischen Hinterfragens und der Kontemplation. Auf dem Parcours bietet sich die Gelegenheit zum Innehalten und zur Auseinandersetzung mit zeitgenössischen Problemstellungen und Phänomenen. Durch diese programmatische Öffnung der Veranstaltung wird das Moment des Prozeßhaften in die Ausstellung integriert.

Das Phänomen der Globalisierung und seine ökonomischen, soziopolitischen und kulturellen Auswirkungen kann als übergeordnetes Thema der Interventionen im Rahmen des Programms der »100 Tage« angesehen werden. Durch die verschiedenen Beiträge nähert man sich gleich einem interdisziplinären Forschungsvorhaben den unterschiedlichen Facetten und der Komplexität dieses Phänomens an.

Eine Reihe von Gästen kommt aus nicht-westlichen Ländern, deren Kulturschaffen sich traditionell weniger im Bereich der bildenden Künste entfaltet. Durch die Werke von Literaten, Wissenschaftlern und Filmemachern werden jedoch auch diese Kulturkreise auf der documenta vertreten sein und durch ihre Präsenz eurozentrische Rezeptionsschemata in Frage stellen.

each presentation we would like to give the members of the audience the chance to enter into dialogue — not only with the respective guest but also with Catherine David and the documenta team.

At a very early point in the preparation of the event, two additional thematic blocks were established at specific points in the 100-day documenta program: a film week at the opening of the exhibition, devoted to the documenta coproductions, and a selection of "theater outlines" during the first weekend in September.

With the exception of the work directed by Aleksandr Sokurov, all of the six documenta X film coproductions will be premiered in Kassel. During the first exhibition week the filmmakers will be in the city as "100 Days" guests to talk about their cinematic work and its theoretical background, and following each of the premieres they will speak again at the BALI Cinema. Their films will then be screened regularly during the entire documenta as part of the film program.

Coinciding with the weekend devoted to theater sketches, the "100 Days" program will present a number of drama and dance critics invited to contribute their views on the current role of theater and the definition of its means and position in contemporary culture.

Political philosophers such as Etienne Balibar of France and Giorgio Agamben of Italy will express their outlooks on the relationship of state versus nation, the limits of democracy, and the future forms of society. Questions concerning identity, citizenship, and migration will be raised. These speakers will attempt to redefine the role of the individual in the postindustrial age. Urbanists including Saskia Sassen (whose analyses of the "global city" have made a valuable contribution to the epistemology of the metropolis) as well as Edward Soja and Mike Davis (the authors of studies on the agglomeration of Los Angeles from an urban-sociological point of view) will consider the effects of globalization on urban space. The Dutch architect Rem Koolhaas, also to be represented by a project in the exhibition, plans to introduce his theory of the "generic city" and talk about his observations and investigations of Asia. Picking up this thread, the culture critic Ackbar Abbas will reflect on the urban characteristics unique to Hong Kong and sketch the effects of its expiring lease with Great Britain. The presentation of another scholar of the Asian region, the literary critic Masao Miyoshi, will focus on Japanese culture. Further important thematic categories will be concerned with economy, ecology, and the study of armed conflicts. Artists whose production is theoretically oriented will have an opportunity to introduce the works they have conceived for documenta X and to take part in other discourses. The guest list also includes a number of writ-

Die Beiträge orientieren sich weniger an akademischen Vortragsritualen, sondern sie bedienen sich der Form des Editorials, um Standpunkte konzise zu formulieren und kontrovers zu diskutieren. Den Zuhörern wird nach jedem Beitrag die Gelegenheit gegeben, nicht nur mit dem jeweiligen Gast, sondern auch mit Catherine David und ihrem Team zu debattieren.

Zu einem sehr frühen Zeitpunkt standen in der Planung zwei thematische Blöcke auch von ihrer zeitlichen Einordnung im Ablauf der 100 Tage der documenta fest: eine den documenta-Koproduktionen gewidmete Filmwoche zu Beginn der Ausstellung und die sogenannten Theaterskizzen am ersten Septemberwochenende.

Mit Ausnahme des Films von Alexander Sokurow werden die sechs von der dX koproduzierten Filme in Kassel uraufgeführt. Die Filmemacher sind in der ersten Woche in Kassel anwesend und sprechen in der documenta-Halle zunächst über ihr filmisches Schaffen und ihren theoretischen Hintergrund und kommen nach der Vorführung ihres Filmes im BALI-Kino nochmals zu Wort. Die Filme werden während der gesamten documenta im laufenden Filmprogramm gezeigt.

Parallel zum Programm der Theaterskizzen werden sich eine Reihe von Theater- und Tanzkritikern mit der Rolle des Theaters heute und einer Definition seiner Mittel und seines Ortes befassen.

Politische Philosophen wie Etienne Balibar aus Frankreich und Giorgio Agamben aus Italien werden sich zum Verhältnis von Staat versus Nation, zu den Grenzen der Demokratie und zu Gesellschaftsformen der Zukunft äußern. Ebenso wird die Frage nach Identität, nach Bürgerrechten im Sinne der französischen »citoyenneté« und nach der Migrationsproblematik gestellt werden. Alle diese Beiträge versuchen eine Neudefinition der politischen Rolle des Individuums im postindustriellen Zeitalter.

Urbanisten wie Saskia Sassen, die durch ihre Arbeiten zur »global city« einen wichtigen Beitrag zur Epistemologie des Städtischen geleistet hat, sowie Edward Soja und Mike Davis, die die Agglomeration in Los Angeles aus stadtsoziologischer Sicht untersucht haben, werden in ihren Vorträgen die Auswirkungen der Globalisierung auf den städtischen Raum untersuchen. Auch der niederländische Architekt Rem Koolhaas, der mit einem Projekt in der Ausstellung vertreten ist, wird seine Theorie zur »generic city« vorstellen und ebenso auf seine Beobachtungen und Untersuchungen in Asien eingehen. Hieran anknüpfend wird sich der Kulturkritiker Ackbar Abbas mit urbanen Besonderheiten Hongkongs befassen und die Auswirkungen des abgelaufenen Pachtvertrags mit Großbritannien darstellen. Der asiatische Raum wird des weiteren durch den Literaturkritiker Masao Miyoshi repräsentiert, dessen Beitrag sich der japanischen Kultur widmet. Andere wichtige themati-

ers, selected above all with a view to their social commitment and uncompromising political stances.

In addition to the thematic categories to which many of the individual contributions can be assigned, there will be two podium discussions organized by documenta X in collaboration with the newspaper Frankfurter Rundschau.

All of the "100 Days" guests have been invited to stay in Kassel for three days. Several of them have visited the city repeatedly during the preparatory phase, advising the artistic director or participating in the documenta team training program. Many of them will extend their stay in Kassel during the exhibition to make additional contributions, perhaps entering into dialogue with other guests. The program of the "100 Days" is not conceived as a rigid structure, and we intend to react spontaneously to criticism, unplanned events, and guests invited on short notice.

Thomas Köhler
100 Days – 100 Guests
Program Department

sche Blöcke befassen sich mit der Ökonomie, der Ökologie und mit der Erforschung von kriegerischen Konflikten. Künstler, deren Arbeit in sehr starkem Maße theoretisch ausgerichtet ist, werden in ihre für die dX konzipierten Werke einführen können, sich jedoch darüber hinaus auch an anderen Diskursen beteiligen. Auch eine Reihe von Schriftstellern findet sich in der Gästeliste. Bei der Auswahl spielten vor allem ihr gesellschaftliches Engagement und ihre kompromißlose politische Haltung eine Rolle.

Über die den einzelnen Interventionen übergeordneten thematischen Blöcke hinaus, organisiert die *documenta* X in Zusammenarbeit mit der *Frankfurter Rundschau* zwei Podiumsdiskussionen.

Alle Gäste wurden für einen Zeitraum von drei Tagen nach Kassel eingeladen. Einige von ihnen waren schon während der Vorbereitungszeit der *documenta* immer wieder zu Gast in der Stadt und standen der künstlerischen Leitung beratend zur Seite oder beteiligten sich am Ausbildungsprogramm des Führungsdiensts. Manche der Gäste werden während der Dauer der Ausstellung ihren Aufenthalt in Kassel ausdehnen und über ihre Intervention hinaus weitere Beiträge leisten oder mit anderen Gästen in einen Dialog treten. Das Programm der »100 Tage« versteht sich daher nicht als starres Gebilde, und wir wünschen uns, auch spontan auf Ereignisse, Kritik oder kurzfristig eingeladene Gäste reagieren zu können.

Thomas Köhler
100 Tage – 100 Gäste
Programmplanung

Ackbar Abbas, *born in 1942, is a senior lecturer in comparative literature at the University of Hong Kong. His publications include articles in periodicals such as New Literary History, New German Critique, Public Culture, Positions, and Discourse as well as monographs on modern Chinese painting and contemporary photography. In addition to studies of Jean Baudrillard, Walter Benjamin, film theory, and postmodernism, Abbas reflects on culture in Hong Kong. His most recent book The Last Emporium: Hong Kong Culture and the Politics of Disappearance is to be published this year. It investigates the processes, epistemology, and social consequences of urbanization in the city-region of Hong Kong at the time of the expiration of the lease between China and Great Britain.*

Giorgio Agamben, *born in Rome in 1942, teaches philosophy at the University of Verona, the University Macerata, and the Collège International de Philosophie in Paris. He is the editor of the Italian edition of Walter Benjamin's complete works (the first such edition in chronological order). His publications The Idea of Prose (1987) and The Coming Community (1990) are particularly noteworthy. Agamben concentrates on the concepts of community and identity and the problem of establishing a community whose members contradict all criteria of affiliation. His investigations are a creative response to the works of philosophers such as Heidegger, Wittgenstein, Blanchot, Jean-Luc Nancy, and, further back in history, Plato and Spinoza. Agamben takes part in the liveliest current philosophical debates. His latest publication is entitled Homo sacer: Il potere sovrano e la nuda vita (1995).*

Sadik J. Al-Azm, *born in Damascus in 1934, studied philosophy in Sidon, Beirut, and at Yale University. After earning his doctorate he taught philosophy at Hunter College in New York and at the universities of Damascus, Beirut, and Amman, and was a visiting professor at Princeton. His professorship in Lebanon was revoked in 1968 as a result of his critical publications. Al-Azm now lives in Damascus and teaches at the university there. He has published numerous books and articles on Islamic studies and the relationship between Islam and Western philosophy. In this context he regards himself as a "participating observer," not adopting the Western perspective, but presenting his foreign culture as one which is not eternally inaccessible. His book Unbehagen in der Moderne, Aufklärung im Islam appeared in German in 1993. Al-Azm's contribution to documenta X is concerned with the effects of globalization on the reception of literature, as illustrated by the Satanic Verses of Salman Rushdie.*

Ackbar Abbas, geboren 1942, arbeitet als Professor für vergleichende Literaturwissenschaft an der Universität von Hongkong. Seine Veröffentlichungen umfassen Artikel in Zeitschriften wie *New Literary History, New German Critique, Positions and Discourse* und ebenso Monographien über moderne chinesische Malerei und über zeitgenössische Photographie. Neben wissenschaftlichen Arbeiten zu Jean Baudrillard, Walter Benjamin, zur Filmtheorie und zur Postmoderne widmet sich Abbas vor allem einer kulturwissenschaftlichen Aufarbeitung und Betrachtung Hongkongs. Die Veröffentlichung seines neuen Buches *The Last Emporium: Hong Kong Culture and the Politics of Disappearance* ist für dieses Jahr geplant. Diese Publikation untersucht die Formen des Urbanisierungsprozesses und die Epistemologie des Städtischen sowie die sozialen Konsequenzen der Metropolitanisierung der Stadtregion Hongkong im Hinblick auf das Auslaufen des Pachtvertrages zwischen China und Großbritannien.

Giorgio Agamben, geboren 1942 in Rom, unterrichtet Philosophie an der Universität von Verona, an der Universität Macerata und am Collège International de Philosophie in Paris. Er ist Herausgeber der italienischen und ersten chronologischen Werkausgabe von Walter Benjamin. Vor allem seine Veröffentlichungen *L'uomo senza contenuto* (1970), *Die Idee der Prosa* (1987) und *La comunità che viene* (1990) sind zu erwähnen. Agamben befaßt sich in seinen Schriften vor allem mit den Begriffen der Gemeinschaft und der Identität und der Problematik, wie sich eine Gemeinschaft konstituieren kann, deren Mitglieder eigentlich allen Zugehörigkeitskriterien widersprechen. Agambens Untersuchungen sind kreative Antworten auf die Werke von Philosophen wie Heidegger, Wittgenstein, Blanchot und Jean-Luc Nancy oder, ein wenig historischer, auf Plato und Spinoza. Agamben hat an den lebhaftesten aktuellen Debatten in der Philosophie teilgenommen. Seine jüngste Publikation trägt den Titel *Homo sacer. Il potere sovrano e la nuda vita* (1995).

Sadik J. Al-Azm, geboren 1934 in Damaskus, studierte Philosophie in Sidon, Beirut und an der Yale University. Nach Erlangung des Doktorgrades unterrichtete er Philosophie am Hunter College in New York und an den Universitäten in Damaskus, Beirut und Amman und war Gastprofessor in Princeton. Im Jahr 1968 verlor er infolge seiner kritischen Veröffentlichungen die Lehrbefugnis im Libanon. Al-Azm lebt heute in Damaskus und unterrichtet an der dortigen Universität. Er hat zahlreiche Bücher und Artikel zur Islamwissenschaft und zum Verhältnis des Islam zur westlichen Philosophie veröffentlicht. Er versteht sich dabei als »teilnehmender Beobachter«, übernimmt die westliche Perspektive

Ariella Azoulay is the director of the Program for Curatorial and Critical Studies, Camera Obscura School of Art in Tel Aviv, as well as a professor of art history and art philosophy. Her education included studies with Pierre Bourdieu and Louis Marin at the Ecole des Hautes Etudes en Sciences Sociales in Paris. For many years she was the director of the alternative space Bograshov in Tel Aviv. From 1994 to 1995 she was the director of the Museum of Israeli Art in Ramat Gan, and worked as assistant curator on the exhibition of the Israeli pavilion at the Venice Biennial. Her numerous publications and exhibitions focus on artists concerned with the Israeli occupation of Palestinian territory and the essence of the resulting war. Azoulay's article "Clean Hands" appears in documents 3.

Etienne Balibar, born in 1942, teaches philosophy at Paris X University. After his early work with and on Louis Althusser, he developed his investigations in Marxist epistemology during the 1960s and 70s. In addition to studies of Marx, Spinoza, Rousseau, and some of his contemporaries, Balibar focused on the political crisis of the 1980s in works such as Race, Nation, Class and an extension of the concept of citizenship in Les frontières de la démocratie. His most recent work is La crainte des masses. In the "100 Days – 100 Guests" program he will speak together with Ulrich Bielefeld.

Carlos Basualdo was born in Rosario, Argentina in 1964. In 1993, after studying art history at the University of Rosario, he emigrated to New York. There he participated in the Helena Rubinstein Foundation summer internship at the Museum of Modern Art and subsequently completed the Independent Studies Program at the Whitney Museum of American Art, where he focused on critical studies. Carlos Basualdo has curated and co-organized numerous exhibitions in the United States and South America, placing particular emphasis on South American art. In addition to his curating activities he regularly publishes articles on contemporary art in a variety of magazines and is a co-editor of the New York publication TRANS>arts, cultures, media (http:/www.echonyc.com/~TRANS).
Basualdo presently lives in New York, where he works as an independent curator and journalist.

Ulrich Beck, born in Stolp, Poland in 1944, has directed the renowned Soziologisches Institut of the Ludwig Maximilian University of Munich since 1992. The major emphases of his research are modernization theory, social inequality, labor, and ecology, as well as the problems of advanced industrial societies. He has been the publisher of the magazine Soziale Welt since 1982, and since 1995 has been a member of the Commission

nicht, sondern präsentiert uns die fremde Kultur als eine nicht ewig Unzugängliche. In deutscher Sprache liegt sein Buch Unbehagen in der Moderne, Aufklärung im Islam (1993) vor.
Sein Beitrag im Rahmen der documenta X befaßt sich mit den Auswirkungen der Globalisierung auf die Rezeption von Literatur am Beispiel der Satanischen Verse Salman Rushdies.

Ariella Azoulay ist Direktorin des Program for Curatorial and Critical Studies der Camera Obscura, Hochschule der Künste in Tel Aviv und Professorin für Kunstgeschichte und -philosophie. Die ausgebildete Historikerin und Philosophin, die unter anderem bei Pierre Bourdieu und Louis Marin an der Ecole des Hautes Etudes en Sciences Sociales in Paris studierte und lange das alternative Zentrum Bograshov in Tel Aviv leitete, war 1994 bis 1995 Direktorin des Museums für Israelische Kunst in Ramat Gan, und organisierte als Assistentin des Kurators die Ausstellung im Israelischen Pavillon auf der Biennale Venedig. In ihren zahlreichen Veröffentlichungen und Ausstellungen geht es um Künstler, die sich mit der israelischen Besetzung palästinensischer Gebiete und dem Wesen des daraus resultierenden Krieges auseinandersetzen. In den documents 3 ist Azoulay mit ihrem Aufsatz Saubere Hände vertreten.

Etienne Balibar, geboren 1942, Professor für Philosophie an der Universität Paris X. Nach seiner Arbeit mit und über Louis Althusser setzte er in den sechziger und siebziger Jahren seine epistemologische Auseinandersetzung mit dem Marxismus fort. Neben der Beschäftigung mit Marx, Spinoza, Rousseau und einigen Zeitgenossen konzentrierte sich Balibar dann auf die Analyse der politischen Krise der achtziger Jahre, auf Begriffe wie Rasse, Klasse und Nation und erarbeitete eine neue Definition des Begriffs der Bürgerrechte (»citoyenneté«) in Die Grenzen der Demokratie. Sein letztes Werk ist La crainte des masses (1997). Für die »100 Tage – 100 Gäste« wird Balibar gemeinsam mit Ulrich Bielefeld einen Beitrag liefern.

Carlos Basualdo wurde 1964 in Rosario, Argentinien, geboren. Nach einem Studium der Kunstgeschichte an der Universität von Rosario siedelte er 1993 nach New York über, wo er zunächst am Helena Rubinstein Foundation Summer Internship des Museum of Modern Art teilnahm und anschließend das Independent Study Program, Critical Studies, am Whitney Museum of American Art absolvierte.
Carlos Basualdo hat zahlreiche Ausstellungen in den Vereinigten Staaten und in Südamerika kuratiert und mitorganisiert und sich speziell mit der Kunst Südamerikas auseinandergesetzt. Über seine Kuratorentätigkeit

for *Future Issues*, founded by the states of Bavaria and Saxony to develop new welfare state models. Even outside professional circles Ulrich Beck has become widely known for his publications Risikogesellschaft: Auf dem Weg in eine andere Moderne *(1986)*, Die Erfindung des Politischen: Zu einer Theorie der reflexiven Modernisierung *(1993)*, Reflexive Modernisierung: Eine Debatte *(1996)*, and many others.

Fethi Benslama, born in Tunisia in 1951, is a psychoanalyst and maintains a practice devoted primarily to child psychiatry in St. Denis, a suburb north of Paris. In addition to his clinical work, Benslama teaches at the University of Paris VII and carries out investigations of the psychological effects of immigration. He has also studied a wide range of other subjects, including AIDS, individualism, women in Islam, and the question of identity. In 1990 he founded the periodical Intersignes, conceived as a forum for the free exchange of thought, critical questioning, and political commitment and intended to encourage intellectual exchange between the various disciplines of Islamic study. He has been primarily responsible for publications dealing with love and the Orient, the question of citizenship, the Algeria issue and, quite recently, the masculine image. Fethi Benslama was the author of the 1994 essay Une Fiction Troublante on the Rushdie affair and is presently working on a larger publication focusing on the treatment of this subject. His presentation in Kassel will deal with his concept of "genealogical deligitimation" in the postcolonial era.

Ulrich Bielefeld, born in 1951, is a sociologist and the director of research in the fields of nationalism, ethnicity, and xenophobia at the Hamburg Institute for Social Research. After receiving his diploma in Munich he investigated problems of migration and minorities and the experiences of young Turkish people in the Federal Republic of Germany. From 1982 to 1987 he was on the staff of the Institute for Sociology, Technische Hochschule Darmstadt, and has been at the Hamburg Institute for Social Research since 1988. Bielefeld is presently involved in a comparative study of the relationship between collective self-conceptions and the institutionalization of stereotypical images of foreigners. The major focus is on the dynamics of collectivization processes and the connection between power and enthusiasm—the transition from the act of imagining a community to that of postulating and finally realizing it. Under Bielefeld's supervision research is also being carried out on the biographies of young soldiers in the civil war of the former Yugoslavia as well as a project describing changes in the process of fixing national boundaries as illustrated by the German-Polish and

hinaus veröffentlicht er in mehreren Zeitschriften Artikel zur Gegenwartskunst und ist Mitherausgeber des in New York erscheinenden Magazins TRANS>arts, cultures, media (http://www.echonyc.com/~TRANS). Er lebt heute als freier Kurator und Journalist in New York.

Ulrich Beck, geboren 1944 in Stolp (Polen), leitet seit 1992 das renommierte Soziologische Institut der Ludwig-Maximilians-Universität München. Seine Forschungsschwerpunkte sind die Theorie der Moderne, soziale Ungleichheit, Arbeit und Ökologie sowie Probleme fortgeschrittener Industriegesellschaften. Seit 1982 ist er Herausgeber der Zeitschrift Soziale Welt und seit 1995 Mitglied der von Bayern und Sachsen gegründeten »Kommission für Zukunftsfragen«, die neue Sozialstaatsmodelle entwickelt. Weit über die Fachwelt hinaus bekannt wurde Ulrich Beck mit seinen Veröffentlichungen Risikogesellschaft – Auf dem Weg in eine andere Moderne (1986), Die Erfindung des Politischen – Zu einer Theorie der reflexiven Modernisierung (1993), Reflexive Modernisierung – Eine Debatte (1996) u.v.a.

Fethi Benslama, 1951 in Tunesien geboren, ist Psychoanalytiker und unterhält in St. Denis, einer Vorstadt im Norden von Paris, eine Praxis vor allem für Kinderpsychiatrie. Parallel zu dieser klinischen Arbeit unterrichtet er an der Universität Paris VII und führt Untersuchungen zu den psychologischen Auswirkungen der Immigration durch. Darüber hinaus hat er sich mit so unterschiedlichen Themen wie AIDS, dem Individualismus, der Frau im Islam oder der Frage der Identität beschäftigt. Im Jahr 1990 gründete er die Zeitschrift Intersignes, die sich als Forum des freien Gedankenaustauschs, des kritischen Infragestellens und des politischen Engagements sieht und den intellektuellen Austausch der Disziplinen der Islamwissenschaft fördert. Ihm sind besonders Ausgaben zur Liebe und zum Orient, zur Frage der Staatsbürgerschaft, der Algerienproblematik und kürzlich zur Frage des Männerbildes zu verdanken. Fethi Benslama ist Autor eines Essays über die Rushdie-Affäre mit dem Titel Une Fiction Troublante (1994), und er bereitet ein größeres Werk zum Umgang mit diesem Thema vor. Auch in Kassel wird sich sein Beitrag mit der Affäre um das umstrittene Buch die Satanischen Verse befassen. Sein Beitrag in Kassel befaßt sich mit dem Begriff der »genealogischen Entlegitimierung« im postkolonialen Zeitalter.

Ulrich Bielefeld, geboren 1951, ist Soziologe und Leiter des Arbeitsbereiches »Nationalismus, Ethnizität und Fremdenfeindlichkeit« am Hamburger Institut für Sozialforschung. Nach seinem Diplom in München widmete er sich zunächst Forschungstätigkeiten zu Migrations- und Minderheitenproblemen und zu Erfahrungen jun-

German-Czech borders. In the "100 Days – 100 Guests" program he will speak together with Etienne Balibar.

Azmi Bishara, born in Nazareth in 1956, studied philosophy in Berlin. He is now a professor of philosophy and political theory at the Bir Zeit University in West Jordan and the director of research at the Van Leer Institute of Jerusalem. Bishara is also a member of the Israeli parliament.

Stefano Boeri, born in Milan in 1956, is the director of an architectural firm and teaches urbanism and city planning at the University of Genoa's Department of Architecture and at the Polytechnic School of Milan. He is the author of the book Il territorio che cambia: Ambienti, paesaggi e immagini della regione milanese, a scientific study of the new external character of contemporary European cities. Stefano Boeri's essay "Eclectic Atlases" is featured in documents 3.

Ginevra Bompiani, born in Milan, studied literature in Paris and Rome. Today she is a professor of American and English language and literature at the University of Siena and travels regularly to England, France, and the United States for research purposes. Her first literary work bears the title Le Spezie del Sonno (1986) and analyzes myths and literary documents with regard to their depiction of sleep and dreams. Her latest work, L'Orso Maggiore (1994) tells the prosaic account of a childhood, of a mother's sorrow and her "falling out of love." Ginevra Bompiani is politically active and has frequently visited refugees' camps in Palestine, Somalia, and Bosnia-Herzegovina. Her contribution to the "100 Days – 100 Guests" program will deal with refugees and migration.

Colette Braeckman, born in 1946, is a journalist for the daily Brussels newspaper Le Soir and also writes regularly for Le Monde diplomatique and other magazines. For many years she has specialized in the journalistic coverage of Africa, concentrating particularly on the Central African region and the countries of Rwanda, Burundi, and Zaire. In addition to numerous articles, Braeckman has published three books on Central Africa: Le Dinosaure: le Zaïre de Mobutu (1992), Rwanda: histoire d'un génocide (1994) and Terreur africaine: Rwanda, Burundi, Zaïre, les racines de la violence (1996). Colette Braeckman's contribution to "100 Days – 100 Guests" will address current events in Central Africa, with a special focus on Zaire.

Andrea Branzi, see Archizoom Associati, p. 22

ger Türken in der Bundesrepublik. Von 1982 bis 1987 war er wissenschaftlicher Mitarbeiter am Institut für Soziologie der Technischen Hochschule Darmstadt und seit 1988 ist er am Hamburger Institut für Sozialforschung tätig. Bielefeld arbeitet derzeit an einer vergleichenden Untersuchung zum Verhältnis kollektiver Selbstverständnisse und der Institutionalisierung von Fremdenbildern. Im Mittelpunkt stehen die Dynamik von Kollektivierungsprozessen und das Verhältnis von Herrschaft und Enthusiasmus, der Übergang von vorgestellten zu postulierten und schließlich realisierten Gemeinschaften. Zudem werden am Arbeitsbereich Forschungen zu Biographien junger Soldaten im ex-jugoslawischen Bürgerkrieg durchgeführt, sowie ein Projekt, das die Veränderung von Grenzziehungsprozessen am Beispiel der deutsch-polnischen und deutsch-tschechischen Grenze beschreibt. Für »100 Tage – 100 Gäste« wird er mit Etienne Balibar einen Beitrag liefern.

Azmi Bishara, geboren 1956 in Nazareth, studierte Philosophie in Berlin. Er ist heute Professor für Philosophie und Politische Theorie an der Universität Bir Zeit im Westjordanland sowie Forschungsdirektor am Van-Leer-Institut in Jerusalem. Darüber hinaus ist Bishara Abgeordneter des israelischen Parlaments. Von Bishara liegen eine Reihe von Publikationen in deutscher Sprache vor, wie Demokratisierung der Machtlosigkeit (1994), Feindbild Islam (1993); zusammen mit Uri Avnery hat er Die Jerusalem Frage (1996) herausgegeben.

Stefano Boeri, 1956 in Mailand geboren, leitet ein Architekturbüro und unterrichtet Urbanismus und Stadtplanung an der Fakultät für Architektur der Universität Genua und am Polytechnikum in Mailand. Er ist Autor des Buches Il territorio che cambia. Ambienti, paesaggi e immagini della regione milanese, einer wissenschaftlichen Arbeit über die neuen Erscheinungsformen der zeitgenössischen europäischen Städte. In den documents 3 ist Stefano Boeri mit dem Aufsatz »Eklektische Atlanten« vertreten.

Ginevra Bompiani, in Mailand geboren, hat in Paris und Rom Literaturwissenschaft studiert. Als Professorin unterrichtet sie heute Amerikanistik und Anglistik an der Universität in Siena und reist regelmäßig zu Forschungsaufenthalten nach England, Frankreich und in die Vereinigten Staaten. Wir verdanken ihr Essays zum Werk Emily Brontës und Celines, jedoch sollte man sie weniger als Literaturwissenschaftlerin, denn als Autorin vorstellen. Ihre erste Untersuchung trägt den Titel Le Spezie del Sonno (1986) und analysiert Mythen und literarische Zeugnisse auf ihre Darstellung des Schlafes und der Träume hin. Ihre letzte Arbeit, L'Orso Maggiore (1994), erzählt in nüchterner Sprache von der Kindheit,

Charles Burnett, *see p. 40*

Ery Camara, *born in Dakar, Senegal in 1953, moved to Mexico in 1975, where he studied curatorship and museology. In addition to his work as a curator for public and private collections, Camara has served as the deputy director for museum research at the National Museum of Viceroyality in Mexico City. He is well known internationally as a curator and art critic, particularly for his profound knowledge of African art and culture and its reception in the countries of the West. Ery Camara also concerns himself with Mexican archaeology, colonial phenomena in art, and the contemporary art of Latin America.*

Yan Ciret, *born in Rennes in 1961, began his professional career as a journalist, having studied legal science and aesthetics in Paris. He contributed to several periodicals and broadcasting companies, and in 1993 became the editor of the Revue du Théâtre de la Bastille, a publication which has set new standards both editorially and in terms of design. Ciret's activities in the field of theater, primarily as a dramatic advisor, soon became his major professional focus. In 1995 he realized the exhibition Territoire de Koltès, shown in Europe, South America, and Africa, and in 1995–96 he was in charge of various stage projects at the Théâtre du Rond Point, Paris. This year he plans to complete his film L'Europe, le théâtre, l'archipel and to publish a novel as well as a book on the plays of Bernard-Marie Koltès.*

Jef Cornelis, *born in 1941, has worked for the Belgian Broadcasting Company Radio en Televisie (BRTN) since 1964, producing films on modern art, architecture, and literature. His documentaries of large-scale cultural events such as documenta, the sculpture projects of Münster, and Sonsbeek in Arnhem are penetrating records of the times. Cornelis's films also include sensitive portraits of artists like Marcel Broodthaers and Daniel Buren. Taken in their entirety, these cinematic productions constitute a chronicle of contemporary art since 1960. They have lost nothing of their relevance; they are examples of analytic perception greatly transcending the limits of standard journalistic coverage. In 1995 Cornelis also acted as a curator for the Witte de With Center for Contemporary Art in Rotterdam, organizing an exhibition entitled Call It Sleep which investigated the correlations between cinema and the fine arts.*

Mike Davis, *born in Fontana, southern California in 1946, was involved in the labor union movement and the Vietnam War protests of the 1960s. Earning a livelihood as a truck driver and stockyard worker, he studied economics and served on the editorial staff of the New*

der Trauer einer Mutter und dem »Sich-Entlieben«. Darüber hinaus engagiert sich Ginevra Bompiani politisch, was sie mehrfach in Flüchtlingslager in Palästina, Somalia und in Bosnien-Herzegowina geführt hat. Auch ihr Beitrag im Rahmen der »100 Tage – 100 Gäste« wird sich mit der Flüchtlingsproblematik und der Migration befassen.

Colette Braeckman, geboren 1946, arbeitet als Journalistin für die in Brüssel erscheinende Tageszeitung *Le Soir* und schreibt darüber hinaus regelmäßig für *Le Monde diplomatique* und andere Zeitschriften. Seit langem hat sich Colette Braeckman auf die Berichterstattung aus Afrika spezialisiert und hierbei besonders auf die zentralafrikanische Region und die Länder Ruanda, Burundi und Zaire. Neben ihren zahlreichen Reportagen hat Braeckman drei Bücher zu Zentralafrika herausgegeben: *Le Dinosaure: le Zaire de Mobutu* (1992), *Rwanda: histoire d'un génocide* (1994) und *Terreur africaine, Rwanda, Burundi, Zaïre, les racines de la violence* (1996). Im Rahmen der »100 Tage – 100 Gäste« wird Colette Braeckman auf die aktuellen Geschehnisse in Zentralafrika und insbesondere in Zaire eingehen.

Andrea Branzi Archizoom Associati, S. 22

Charles Burnett S. 40

Ery Camara, geboren 1953 in Dakar (Senegal), siedelte 1975 nach Mexiko über, wo er sein Studium als Restaurator und Museumswissenschaftler absolvierte. Neben seiner Arbeit als Konservator für staatliche und private Sammlungen war Camara als stellvertretender Direktor für Museologie des zum Staatlichen Institut für Anthropologie und Geschichte gehörenden Viceroyality-Nationalmuseum und am Staatlichen Museum für Volkskultur in Mexiko-Stadt tätig. Darüber hinaus machte er sich als Kurator und Kunstkritiker in internationalen Kunstkreisen durch seine profunden Kenntnisse der afrikanischen Kunst und Kultur sowie ihrer Rezeption in den westlichen Ländern einen Namen. Außerdem beschäftigt er sich mit mexikanischer Archäologie, kolonialen Phänomenen in der Kunst und der zeitgenössischen Kunst Lateinamerikas.

Yan Ciret, geboren 1961 in Rennes, war nach einem Studium der Rechts- und Kunstwissenschaften in Paris zunächst journalistisch tätig. Außer für eine Reihe von Zeitschriften arbeitete er für Rundfunkanstalten und übernahm 1993 die Redaktion der *Revue du Théâtre de la Bastille*, die sowohl redaktionell als auch durch ihre Gestaltung neue Maßstäbe setzte. Die Arbeit im Theaterbereich, zumeist als Dramaturg, wurde bald der Schwerpunkt seiner Tätigkeit. Im Jahr 1995 realisierte er

Left Review. *He teaches urbanism at the Southern California Institute of Architecture and is presently a scholar of the Getty Research Institute of Los Angeles. In 1990 he published the book* City of Quartz: Excavating the Future in Los Angeles, *already considered to be a classic work of urban sociology. In this sociohistoric study of Los Angeles, Davis analyzes the history of the city and dissects the myths connected with it. He focuses on infrastructural problems, multiculturalism, racism, and economic disintegration, describing his research object Los Angeles as the first "post-industrial city in pre-industrial garb."*

Clémentine Deliss, *born in London in 1960 to French-Austrian parents, studied anthropology and art in Vienna and London. Between 1992 and 1995 she was responsible for the concept and artistic direction of Africa '95, the largest festival to date on the subject of African art. In addition to the renowned Royal Academy of Art, over sixty other British institutions were involved in this event. She has also organized several exhibitions, e.g.* Lotte or the Transformation of the Object *(1990),* Exotic Europeans *(1991) and* Seven Stories about Modern Art in Africa *(1995). Deliss has been the editor of the art magazine* Metronome *since 1996 and she has worked in 1996 as an expert for the European Union in Dakar, Senegal.*

Diedrich Diederichsen, *born in Hamburg in 1957, teaches at the Merz Academy and the Fachhochschule für Gestaltung in Stuttgart as well as at the Art Center of Pasadena. He is a co-editor of the magazine* SPEX *and an author for* Texte zur Kunst. *For over fifteen years he has been writing about pop and counter-cultures, art, politics, and music, above all Afro-American music. A few of his most important publications are* Sexbeat *(1985),* Freiheit macht arm *(1993), and* Politische Korrekturen *(1996). He lives in Cologne. Within the context of "100 Days – 100 Guests" Diederichsen will collaborate with Mike Kelley on "Gitarre gegen Anti-Gitarre" (Guitar vs. Anti-Guitar).*

Corinne Diserens *has been the director of the Musées de Marseille since 1996, after studying art history in Paris, then participating in the Independent Studies Program/Critical Studies Program of the Whitney Museum in New York. Between 1985 and 1995 she worked as a curator and director for diverse Spanish institutions and museums, including the IVAM in Valencia, Spain, and organized numerous exhibitions and retrospectives. One main focus of her research activities is the work of Gordon Matta-Clark, which will be the subject of her contribution to the "100 Days – 100 Guests" program.*

die Ausstellung *Territoire de Koltès*, die in Europa, Südamerika und Afrika gezeigt wurde. In den Jahren 1995 und 1996 war er als Dramaturg am Théâtre du Rond Point, Paris, für unterschiedliche Regieprojekte verantwortlich. Für 1997 ist die Fertigstellung seines Filmes *L'Europe, le théâtre, l'archipel* sowie die Publikation eines Romans und eines Buchs über die Dramen von Bernard-Marie Koltès geplant.

Jef Cornelis, geboren 1941, hat seit 1964 für das Belgische Fernsehen Radio en Televisie (BRTN) zahlreiche Filme über moderne Kunst, Architektur und Literatur gedreht. Seine Dokumentarfilme über kulturelle Großveranstaltungen wie die *documenta, Skulpturenprojekte Münster* oder *Sonsbeek* in Arnhem sind scharfsinnige Zeitzeugnisse. Gemeinsam mit einfühlsamen Portraits von Künstlern wie Marcel Broodthaers oder Daniel Buren lassen diese Filme eine Chronik der zeitgenössischen Kunst seit 1960 entstehen. Auch retrospektiv haben Cornelis' filmische Beiträge nichts von ihrer Aktualität eingebüßt, sie sind Beispiele für eine analytische Wahrnehmung und gehen weit über journalistische Berichterstattung hinaus. Im Jahr 1995 war Cornelis auch als Kurator tätig und stellte für das Witte de With Center for Contemporary Art in Rotterdam eine Ausstellung mit dem Titel *Call it Sleep* zusammen, die die Korrelationen zwischen Kino und den bildenden Künsten untersuchte.

Mike Davis, 1946 im südkalifornischen Fontana geboren, engagierte sich in den sechziger Jahren in der Gewerkschaftsbewegung und gegen den Vietnamkrieg. Er arbeitete als Fernfahrer und in Schlachthöfen, studierte Wirtschaftswissenschaften und war Herausgeber der *New Left Review.* Er unterrichtet Urbanistik am Southern California Institute of Architecture und ist derzeit Scholar am Getty Research Institute in Los Angeles. Im Jahr 1990 hat er das *Buch City of Quartz. Excavating the Future in Los Angeles* veröffentlicht, das seit 1994 auch in deutscher Übersetzung vorliegt (*City of Quartz. Ausgrabungen der Zukunft in Los Angeles*) und bereits als Klassiker der Stadtsoziologie zu bezeichnen ist. In dieser historisch-soziologischen Studie zu Los Angeles analysiert Davis die Stadtgeschichte und demontiert die mit der Stadt verbundenen Mythen. Er bezieht sich auf infrastrukturelle Probleme, auf Multikulturalismus, Rassismus und die ökonomische Desintegration und beschreibt sein Forschungsobjekt Los Angeles als erste »postindustrielle Stadt im präindustriellen Gewand«.

Clémentine Deliss, geboren 1960 in London als Kind französisch-österreichischer Eltern, studierte in Wien und London Anthropologie und Kunst. Zwischen 1992

266

Manfred Eicher, *born in Lindau, Germany in 1943, is a producer of the record company ECM. Following a classical study of the double bass at the Music Academy of Berlin, Manfred Eicher was a bass violinist in the orchestra of the Berliner Philharmoniker and completed a three-year study of composition. He later played in jazz formations until he founded the label ECM – Edition of Contemporary Music near Munich in 1969, now one of the world's most renowned record companies for jazz. He produced records with such influential musicians as Paul Bley, Jan Gabarek, and John Surman. In the early 1980s he tread new musical paths with his New Series, working with the composer Arvo Pärt of Estonia, the vocal Hilliard Ensemble, the avant-garde musician Meredith Monk and the theater-director and composer Heiner Goebbels, who will also participate in the Theater Outlines of documenta. Eicher refuses to participate in the established music scene. He greatly appreciates the dramatic quality of soft tones; accordingly the leitmotif of the music produced by ECM is "the most beautiful sound next to silence." Eicher creates sound textures uniting acoustic, plastic, and visual spheres. He regards music to have a "cinematic" quality and is strongly influenced by the films of Tarkovsky, Bergman, Bresson, and Godard, while the literary works of Celan, Hölderlin and Barthes have also been a major inspiration for his idea of a musical Gesamtkunstwerk. The publication ECM – Sleeves of Desire was issued by the Lars Müller Publishing Company in 1996.*

Okwui Enwezor, *born in Nigeria, is the artistic director of this year's Johannesburg Biennial as well as the founder and publisher of Nka: Journal of Contemporary African Art, a critical art magazine issued in collaboration with the African Studies Center of Cornell University in New York. As a writer, critic, and freelance curator he has published several essays on African art and on various African artists. He works as a correspondent for a number of art publications and frequently gives lectures at universities and museums in Europe, Africa and the United States. The exhibition African Photographers, 1940-Present at the Guggenheim Museum of New York was conceived by Enwezor, who is also in the process of planning Global Conceptualism/Local Contexts, an exhibition which will open at Queens Museum in New York in 1998. Enwezor lives in New York and Johannesburg.*

Nuruddin Farah *was born in Baidoa (Somalia) in 1945 and grew up in Somalia, England, and India, where he also studied literature and philosophy. Upon completion of his studies he taught at the University of Mogadishu. Farah's criticism of Somalia's military dictatorship forced him into exile. Since then he has lived like a*

und 1995 war sie verantwortlich für das Konzept und die künstlerische Leitung von *Africa '95*, des bisher größten Festivals zum Thema »Afrikanische Kunst«, an dem neben der renommierten »Royal Academy of Art« über sechzig andere britische Institutionen beteiligt waren. Weiterhin organisierte sie Ausstellungen wie *Lotte or the Transformation of the Object* (1990), *Exotic Europeans* (1991) und *Seven Stories about Modern Art in Africa* (1995). Seit 1996 ist sie Herausgeberin der Kunstzeitschrift *Metronome*, die sie im Rahmen der »100 Tage – 100 Gäste« präsentieren wird (Ausgaben: Dakar, Mai 1996; London, Februar 1997, und Berlin, Juli 1997). Darüber hinaus arbeitete sie 1996 als Expertin für die Europäische Union in Dakar, Senegal.

Diedrich Diederichsen, geboren 1957 in Hamburg, lehrt an der Merz Akademie und an der Fachhochschule für Gestaltung in Stuttgart sowie am Art Center in Pasadena. Er ist Mitherausgeber der Zeitschrift *SPEX* und Autor bei *Texte zur Kunst*. Seit über 15 Jahren schreibt er über Pop- und Gegenkulturen, Kunst, Politik und Musik, vor allem afro-amerikanische Musik. Wichtige Publikationen (Auswahl): *Sexbeat* (1985), *Freiheit macht arm* (1993), *Politische Korrekturen* (1996). Er lebt in Köln. Im Rahmen der »100 Tage – 100 Gäste« präsentiert Diederichsen mit Mike Kelley *Gitarre gegen Anti-Gitarre*.

Corinne Diserens, seit 1996 Direktorin der Musées de Marseille, studierte Archäologie und Kunstgeschichte in Paris und absolvierte anschließend die Critical Studies des Independent Study Program am Whitney Museum of American Art in New York. Zwischen 1985 und 1995 arbeitete sie als Kuratorin und Direktorin für diverse spanische Institutionen und Museen, u.a. IVAM, Valencia, und organisierte eine Vielzahl von Ausstellungen sowie Retrospektiven. Einer ihrer Forschungsschwerpunkte ist das Werk Gordon Matta-Clarks, über das sie auch bei »100 Tage – 100 Gäste« sprechen wird.

Manfred Eicher, geboren 1943 in Lindau, ist Produzent des Schallplattenverlags ECM. Nach einer klassischen Ausbildung für Kontrabaß an der Berliner Musikhochschule war Manfred Eicher Bassist im Orchester der Berliner Philharmoniker und absolvierte ein dreijähriges Kompositionsstudium. Später spielte er in Jazzformationen, bis er 1969 in der Nähe von München das Label *ECM – Edition of Contemporary Music* gründete, das sich inzwischen zu einem der weltweit renommiertesten Plattenlabels für Jazz und notierte zeitgenössische Klassik sowie Neuinterpretationen alter Musik entwickelt hat. Er produzierte Platten mit bedeutenden Musikern wie Paul Bley, Jan Gabarek und John Surman. Anfang der achtziger Jahre beschritt er mit den *New*

nomad, wandering from one continent to the next and teaching at universities in the United States, Italy, England, Ethiopia, Uganda, and Nigeria, in addition to his work as a writer. His first two novels From a Crooked Rip (1970) and A Naked Needle (1976) were followed by the trilogy of Sweet and Sour Milk (1979), Sardines (1981), and Close Sesame (1983), for which he received numerous awards. Farah published Maps, his second novel trilogy, in 1996. He is currently a professor of English at the University of Texas in Austin.

Harun Farocki, see p. 60

Michel Feher, born in Brussels in 1956, studied in Belgium and the United States before receiving his doctorate in Paris. For several years he has been concerned with the difference between the sexes and the history of the art of love in the West. Feher has published numerous studies on related topics, ranging from courtly love to the eroticism of the libertines. He has also investigated the attitudes of the mannerists and the puritans toward love and taken a stance on current issues of feminism and the identity question in France and the United States. In 1997 Michel Feher is teaching a seminar at the Collège International de Philosophie on the sexual politics of the United States and its reception in France. Feher is the founder of Zone Editions, published in New York, and chief editor of the magazine by the same name. Several of its issues are devoted to the human body. His most recent publication, bearing the title Eroticism and Enlightenment in 18th-Century France (1997), is an introduction to the novels of libertinism.

Alexander García Düttmann, born in Barcelona in 1961, studied philosophy in Frankfurt and Paris. He now teaches at the University of Melbourne, Australia, having held lectureships at the Collège International de Philosophie in Paris and at the University of Stanford, California, among other places. He is the author of La parole donnée: Mémoire et promesse (1989), Das Gedächtnis des Denkens—Versuch über Heidegger und Adorno (1991), and a philosophical-political treatise on the issue of AIDS: At Odds with AIDS. Garcia Düttmann was first interested in critical theory and Adorno's concept of the non-identical; later the focus of his work shifted to phenomenology and the work of Heidegger and Derrida, whose writings he has translated.

Armand Gatti, born in Monaco in 1924, served in the British army during the Second World War following deportation and escape from a German camp. After the war he became a political journalist and began his dramatic work in 1948. In the mid-1950s he applied

Series neue musikalische Wege und arbeitete mit dem aus Estland stammenden Komponisten Arvo Pärt, der Vokalgruppe Hilliard Ensemble, der Avantgardemusikerin Meredith Monk und dem Theaterregisseur und Komponist Heiner Goebbels, der auch an den Theaterskizzen der documenta teilnehmen wird, zusammen. Eicher ging nie die Wege des etablierten kommerziellen Musikbetriebs. Er schätzt die Dramatik der leisen Töne, und so gilt für die von ECM produzierte Musik das Leitmotiv »Der schönste Klang neben der Stille«. Eicher schafft Klangtexturen, die klangliche, plastische und visuelle Ebenen vereinen. Musik hat für ihn auch eine »kinematische« Qualität, wobei ihn Filme von Tarkowski, Bergman, Bresson und Godard stark beeinflussen, aber auch literarische Werke von Celan, Hölderlin und Barthes sind für seine Idee vom musikalischen Gesamtkunstwerk wichtig. Im Lars Müller Verlag erschien 1996 die Publikation ECM – Sleeves of Desire.

Okwui Enwezor, geboren in Nigeria, ist der künstlerische Leiter der diesjährigen Johannesburg Biennale sowie Gründer und Herausgeber von Nka: Journal of Contemporary African Art, einem kritischen Kunstmagazin, das in Zusammenarbeit mit dem African Studies Center der Cornell University, New York, herausgegeben wird. Als Dichter, Kritiker und freier Kurator hat er zahlreiche Schriften zur Kunst und zu verschiedenen Künstlern Afrikas veröffentlicht. Er arbeitet als Korrespondent für eine Reihe von Kunstzeitschriften und hält häufig Vorträge an Universitäten und Museen in Europa, Afrika und den Vereinigten Staaten.
Die Photographieausstellung African Photographers, 1940 – Present, die die große Afrika-Ausstellung im Guggenheim Museum New York begleitete, wurde von ihm konzipiert und eine Ausstellung mit dem Titel Global Conceptualism/Local Contexts ist im Queens Museum, New York, für 1998 geplant. Okwui Enwezor lebt in New York und Johannesburg.

Nuruddin Farah, geboren 1945 in Baidoa (Somalia), wuchs in Somalia, England und Indien auf, wo er auch Literatur und Philosophie studierte. Danach unterrichtete er an der Universität von Mogadischu. Die in seinen Büchern veröffentlichte Kritik an der Militärdiktatur Somalias zwangen ihn ins Exil. Seitdem lebt der Schriftsteller wie ein Nomade zwischen den Kontinenten und unterrichtet an Universitäten in den USA, Italien, England, Äthiopien, Uganda und Nigeria. Auf seine ersten beiden Romane Von einer gekrümmten Rippe (1968) und Wie eine nackte Nadel (1976) folgte die Romantrilogie Variationen über das Thema: Afrikanische Diktatur, für die ihm zahlreiche Preise verliehen wurden. Mit Maps (1986) eröffnete Farah seine zweite Trilogie. Er ist Professor für Englisch an der University of Texas in Austin.

himself to the medium of film and worked with Chris Marker on the cinematic production Lettres de Sibérie, later also contributing to the development of film-scripts by other directors. Gatti's first film L'Enclos was completed in 1960 and received numerous awards. During the same year he immigrated to Berlin and produced plays in theaters all over Germany, including the Staatstheater Kassel. Gatti works intensively with marginal and minority groups with whom he pursues projects in film and theater. His film Le Passage de l'Ebre (The Crossing of the Ebro) will be shown within the context of documenta X.

Peter Gente, born in 1936, has lived in Berlin since 1953. He studied with Peter Szondi and Jacob Taubes. Since 1975 he has worked with Heidi Paris to direct the publishing house Merve Verlag Berlin, founded in 1970. He has organized symposia, exhibitions, and festivals, and held teaching positions at various institutions of higher education. The publication of twentieth-century philosophy is the major focus of the Merve Verlag. Within the context of the "100 Days – 100 Guests" program, Peter Gente will join Walter Seitter and Daniel Defert to discuss the present-day reception of Michel Foucault.

Susan George, born in the United States and a naturalized French citizen, now lives and works in Paris. She is the vice-director of the Transnational Institute (TNI) in Amsterdam, a union of researchers who work all over the world to investigate issues of development politics and the economy of North-South relationships, war, conflicts, and democratization processes. Although she is frequently referred to as an economist and has in fact often dealt with economic issues of politics, George's studies are based on the natural sciences and philosophy. She studied at universities in the United States and France and has published eight books to date on problems of development aid and indebtedness. From 1990 to 1995 she was on the board of directors of Greenpeace International and is presently still active on behalf of the French board of directors. Susan George has repeatedly been engaged as an advisor to the United Nations. Her most recent book, written in collaboration with her colleague Fabrizio Sabelli bears the title Faith and Credit: The World Bank's Secular Empire (1995).

Edouard Glissant, born on Martinique in 1928, moved to Paris in 1946 to study history, ethnology, literature, and philosophy. In the 1950s he intensified his literary production as a poet, essayist, and novelist, and was also active as a critic of literature and art. In 1959 he founded the Front Antillo-Guyanais, outlawed soon after, and in 1967 the culture and research center Institut Martiniquais d'Etudes. His consistent political invol-

Harun Farocki S. 60

Michel Feher, 1956 in Brüssel geboren, studierte in Belgien und in den Vereinigten Staaten, bevor er in Paris den Doktorgrad erlangte. Seit einigen Jahren beschäftigt er sich mit der sexuellen Differenz und mit der Geschichte der Liebeskunst im Okzident. Im Rahmen dieser Thematik hat Feher zahlreiche Studien veröffentlicht, die von der höfischen Liebe bis zur Erotik der Libertins reichen. Darüber hinaus hat er sich in weiteren kulturhistorisch orientierten Arbeiten mit der Haltung der Manieristen und der Puritaner zur Liebe auseinandergesetzt oder auch zu aktuellen Fragen des Feminismus und zur Identitätsfrage in Frankreich und den USA Stellung bezogen. Im Jahr 1997 leitet Michel Feher am Collège International de Philosophie in Paris ein Seminar zur Geschlechterpolitik in den Vereinigten Staaten und deren Rezeption in Frankreich. Feher ist Gründer der in New York herausgegebenen Zone Editions, und er leitet die Zeitschrift gleichen Namens. Eine Reihe von Ausgaben widmeten sich dem menschlichen Körper. Seine letzte Publikation führt in die Romane der Libertinage ein und trägt den Titel Eroticism and Enlightenment in 18th-Century France (1997).

Alexander García Düttmann, 1961 in Barcelona geboren, studierte Philosophie in Frankfurt am Main und in Paris. Heute unterrichtet er an der Universität von Melbourne, Australien, nachdem er unter anderem Lehraufträge am Collège International de Philosophie in Paris und an der Universität in Stanford, Kalifornien, innehatte. Er ist Autor des Buches La parole donnée. Mémoire et promesse (Paris 1989), eines Buches über Heidegger und Adorno (Das Gedächtnis des Denkens. Versuch über Heidegger und Adorno, 1991) und einer philosophisch-politischen Abhandlung zur AIDS-Problematik (Uneins mit AIDS. Wie über einen Virus nachgedacht und geredet wird, 1993). Nachdem García Düttmanns Hauptinteresse zunächst bei der Kritischen Theorie lag, beim Denken Adornos und seinem Begriff des Nicht-Identischen, verlagerte sich der Schwerpunkt seiner Arbeit schließlich hin zur Phänomenologie, zu Heidegger und Derrida, dessen Schriften García Düttmann auch übersetzt hat.

Armand Gatti, 1924 in Monaco geboren, diente im Zweiten Weltkrieg nach Deportation und Flucht aus einem deutschen Lager in der Britischen Armee. Nach dem Ende des Krieges betätigte er sich als politischer Berichterstatter und begann 1948 mit seinem dramatischen Werk. Ab Mitte der fünfziger Jahre wandte er sich auch dem Filmschaffen zu und arbeitete mit Chris Marker an dessen Film Lettres de Sibérie. In der Folge wirkte er bei der Erstellung weiterer Drehbücher ande-

vement is focused on the political and cultural emancipation of the Antilles. In his numerous publications Glissant concerns himself with questions of cultural identity. He describes the political circumstances in the West Indies and the deep wounds caused to the society there by slavery, colonialism, and neocolonialism, particularly in his work Caribbean Discourse (1981). Since 1980 Glissant has been the chief editor of the UNESCO Courier in Paris. Edouard Glissant resides alternately in Paris, New York, and Martinique.

Ulrike Grossarth, see p. 82

Serge Gruzinski, born in Tourcoing in 1949, studied at the Ecole des Chartes from 1969 to 1973 and received his diploma there as an archivist and paleographer. During the following eleven years, within the framework of various research projects, Gruzinski traveled to a number of Mediterranean countries as well as North and South America. The precolonial history of Mexico was to become one of his major focuses. In 1985 he published his first book, Les Hommes-dieux du Mexique, now also available in Italian, Spanish, and English translations. In 1991 and 1993 the two volumes of his treatise La Découverte du Nouveau Monde appeared and in 1991 the book L'Amérique de la découverte peinte par les Indiens du Mexique described the aesthetic encounter between pre-Columbian art and the European Renaissance. Serge Gruzinski is a research director at the Centre National de la Recherche Scientifique and the assistant director of the Center of Research on Mexico, Central America and the Andes (CERMACA). Serge Gruzinski is the author of a text on shifts in identity in Europe, published in the book of documenta X.

Andreas Huyssen holds a professorship in German and comparative literature at Columbia University, New York. He is a cofounder and editor of the magazine New German Critique and serves on the editorial staffs of October, Critical Studies, and Germanic Review. Having completed scholarly studies of German romanticism and the "Sturm und Drang" period, Huyssen now devotes himself primarily to culturally oriented issues. He is the author of the book After the Great Divide: Modernism, Mass, Culture, Postmodernism (1986) which critically investigates the significance of the concept of "the postmodern" for the fields of architecture, film, literature, and literary criticism as well as its relationship to feminism, aesthetic theory, and poststructuralism. The title of his latest book, published in 1995, is Twilight Memories: Marking Time in a Culture of Amnesia. Andreas Huyssen is the author of a text on pop art, published in the book of documenta X. Andreas Huyssen lives and works in New York.

rer Regisseure mit. Gattis erster Film L'Enclos wurde 1960 fertiggestellt und mehrfach ausgezeichnet. Im Jahr 1960 siedelte er nach Berlin über und inszenierte Stücke an Theatern in ganz Deutschland, darunter auch am Staatstheater Kassel. Gatti arbeitet ebenfalls sehr intensiv mit Minderheiten und gesellschaftlichen Randgruppen, die er in verschiedene Film- und Theaterprojekte einbezog. Im Rahmen der documenta X wird sein Film Übergang über den Ebro gezeigt.

Peter Gente, geboren 1936, lebt seit 1953 in Berlin. Studium bei Peter Szondi und Jacob Taubes. 1970 Gründung des Merve Verlag Berlin, den er seit 1975 zusammen mit Heidi Paris leitet. Neben der Organisation von Symposien, Ausstellungen und Festivals übernahm er Lehraufträge an verschiedenen Hochschulen. Die Veröffentlichung von philosophischen Schriften des 20. Jahrhunderts nimmt den breitesten Raum im Programm des Merve Verlags ein. Im Rahmen der »100 Tage – 100 Gäste« diskutiert Peter Gente mit Walter Seitter und Daniel Defert über die heutige Rezeption von Michel Foucault.

Susan George, geboren in den USA und naturalisierte US-Französin, lebt und arbeitet heute in Paris. Sie ist stellvertretende Direktorin des Transnational Institutes (TNI) in Amsterdam, einem dezentralen Zusammenschluß von Forschern, deren Arbeit zum gesellschaftlichen Wandel beitragen soll. Der größte Teil der Aufgaben wird dezentral erledigt: Etwa 30 Wissenschaftler arbeiten in allen Teilen der Welt über Themen der Entwicklungspolitik und die Ökonomie der Nord-Süd-Beziehungen, über Krieg, Konflikte und Demokratisierungsprozesse.
Obwohl sie häufig als »Ökonom« vorgestellt wird und sich tatsächlich oft mit wirtschaftlichen Fragen der Politik befaßt, basieren die Studien Susan Georges auf den Naturwissenschaften und der Philosophie. Sie hat an Universitäten in den Vereinigten Staaten und in Frankreich studiert und bisher acht Bücher zu Problemen der Entwicklungshilfe und der Verschuldung veröffentlicht. Von 1990 bis 1995 war sie Vorstandsmitglied von Greenpeace International und ist nun noch für den französischen Vorstand tätig. Für die Vereinten Nationen hat Susan George immer wieder beratende Funktionen übernommen. Ihr jüngstes, in Deutschland erschienenes Buch, das sie zusammen mit ihrem Kollegen Fabrizio Sabelli erarbeitet hat, trägt den Titel Kredit und Dogma: Ideologie und Macht der Weltbank und ist 1995 erschienen.

Edouard Glissant, geboren 1928 auf Martinique, siedelte 1946 nach Paris über, wo er Geschichte, Ethnologie, Literatur und Philosophie studierte. In den fünfziger

Alain Joxe, *born in Paris in 1931, first studied geography and history, then moved to sociology and the social sciences. He has been the director of the Groupe de Sociologie de la Défense at the Ecole des Hautes Etudes en Sciences Sociales since 1974, and since 1982 has served as the president of the Centre Interdisciplinaire de Recherches sur la Paix et d'Etudes Stratégiques (CIRPES), both in Paris. He is also the chief editor of the periodicals Le débat stratégique and Cahiers d'Etudes Stratégiques. As a geostrategist, Joxe concerns himself with various forms and causes of armed conflict and since 1986 has been involved in analyzing the military-political interrelationships between Europe and the United States. Joxe's present focus is on the military strategy of the United States and the changes it is undergoing in view of the collapse of the Warsaw Pact and the shifting constellations of global politics.*

François Jullien, *born in 1951, is a philosopher and Sinologist. His education included studies at the Ecole Normale Supérieure in Paris and universities in Beijing and Shanghai, as well as an extensive stay in Japan. Today Jullien teaches classical Chinese philosophy and aesthetics. He has translated several works by classical Chinese authors and published a series of comparative essays seeking to explain Chinese thought by means of Western philosophy. His book Eloge de la fadeur focuses primarily on problems of aesthetics. Two particularly noteworthy books are Le detour et l'accès (1995), a comparative study of philosophical structures of thought in ancient Greece and China, and Figures de l'immanence (1993), a philosophical study of the I Ching.*

Thomas W. Keenan *teaches at Princeton University's Institute for English Literature and Media Theory. He has translated the works of philosophers such as Derrida and Foucault and is the author of significant articles on deconstruction and postmodernism. He has expressed his views on current topics such as AIDS, armed conflicts, urbanism, the new technologies, multiculturalism in the age of globalization, etc. He contributed to the catalogue of an exhibition at the Fundació Antoni Tàpies in Barcelona with an article on the future of the museum as an institution. His most recent work,* Fables of Responsibility: Aberrations and Predicaments in Ethics and Politics *(1997), has a decidedly political orientation. Keenan is presently writing a book on humanitarianism and the role of the mass media, based on the media coverage of United States military intervention in Somalia, Rwanda, and Bosnia-Herzegovina.*

Mike Kelley, *see p. 114*

Rem Koolhaas, *see p. 126.*

Jahren intensivierte er sein literarisches Schaffen als Dichter, Essayist und Romancier und war als Literatur- und Kunstkritiker tätig. In seinen zahlreichen Veröffentlichungen beschäftigt sich Glissant mit Fragen der kulturellen Identität. Er beschreibt die politischen Verhältnisse auf den Antillen und zeigt die gewaltsamen Spuren auf, die die Sklaverei, der Kolonialismus und der Neokolonialismus hinterlassen haben, unter anderem in *Discours antillais* (1981, deutsch *Zersplitterte Welten*, 1986). 1959 gründete er die bald verbotene Front Antillo-Guyanais und 1967 das Kultur- und Forschungszentrum Institut Martiniquais d'Etudes. Sein durchgängig politisches Engagement gilt der politischen Unabhängigkeit und der kulturellen Emanzipation der Antillen. Seit 1980 ist Glissant Chefredakteur des UNESCO Kuriers in Paris. Er wohnt abwechselnd in Paris, New York und auf Martinique.

Ulrike Grossarth S. 82

Serge Gruzinski, 1949 in Tourcoing geboren, studierte von 1969 bis 1973 an der Ecole des Chartes, an welcher er im selben Jahr die Diplomprüfung als Archivist und Paleograph ablegte. In den folgenden elf Jahren bereiste Gruzinski im Rahmen diverser Forschungsvorhaben eine Reihe von Ländern des Mittelmeerraumes sowie Nord- und Südamerikas. Einer seiner wissenschaftlichen Forschungsschwerpunkte wurde die präkoloniale Geschichte Mexikos. Im Jahr 1985 erschien sein erstes Buch mit dem Titel *Les Hommes-dieux du Mexique*, welches inzwischen auch in italienischer, spanischer und englischer Übersetzung vorliegt. In den Jahren 1991 und 1993 erschienen die beiden Bände seiner Abhandlung *La Découverte du Nouveau Monde* sowie im Jahr 1991 das Buch *L'Amérique de la découverte peinte par les Indiens du Mexique*, in welchem er die ästhetische Begegnung der präkolumbianischen Kunst mit der europäischen Renaissance beschreibt.
Serge Gruzinski ist Forschungsdirektor im Centre National de la Recherche Scientifique und stellvertretender Direktor eines Zentrums zur Erforschung von Mexiko, Zentralamerika und den Anden (CERMACA). Gruzinski ist mit einem Beitrag, der sich mit dem Identitätswandel in Europa befaßt, im Buch der *documenta* X vertreten.

Andreas Huyssen hat eine Professur für deutsche und vergleichende Literaturwissenschaft an der Columbia University, New York, inne. Er ist Mitbegründer und Herausgeber der Zeitschrift *New German Critique* und gehört den Herausgebergremien von *October, Critical Studies* und *Germanic Review* an. Nach literaturwissenschaftlichen Arbeiten über die deutsche Romantik und zur Epoche des Sturm und Drang widmet sich Huyssen nun kulturwissenschaftlich orientierten Themenstellun-

Philippe Lacoue-Labarthe, *born in Tours in 1940, is a professor of philosophy at the University of Strasbourg and at Berkeley. His primary field of study is German philosophy and the relationship between philosophy and literature. In 1995 Lacoue-Labarthe received the Friedrich Gundolf Prize of the Deutsche Akademie für Sprache und Dichtung for the study of German culture abroad, an acknowledgment of his translations of the works of Hölderlin, Nietzsche and Benjamin. A large proportion of his work deals with the concept of "mimesis," which according to Lacoue-Labarthe has less to do with "imitation" than with "representation." His investigations of Heidegger and Nazism in* La fiction du politique *were the subject of controversial debate. This essay provides an analysis of national socialism as national aestheticism, revealing Nazi Germany's self-production of the Aryan myth as a Gesamtkunstwerk.*

Simon Lamunière, *born in Switzerland in 1961, lives and works in Geneva. After studying in Geneva, Basel, and Stuttgart, he began artistic experiments with the new media, curating numerous exhibitions in that field. Since 1992 Lamunière has worked in the cultural center Saint Gervais in Geneva and is a professor at the Academy of Art in Lausanne. He is the curator of artistic projects for the documenta X website.*

Antonia Lerch, *see p. 138*

see p. 138

Yang Lian, *born in Bern in 1955, the son of a Chinese diplomat, grew up in the Beijing of the Cultural Revolution and, like so many teenagers, was sent to the countryside for "re-education" in 1974. He returned to Beijing in 1977. Beginning in 1978-79 his poems circulated underground; in the eighties they were also published in official Chinese magazines. In 1983-84 he was sharply criticized within the context of the campaign against "intellectual contamination." Since the 1989 massacre on Tiananmen Square he has lived in exile. Lian's work has received international acknowledgment. Among the volumes of his works available in English are* Masks *and* Crocodile.

Laurence Louppe *studied art history, literature, and dramaturgy. She then trained to become a dancer and began her professional career as a dance teacher. In 1991 Louppe conceived the major exhibition* Traces of Dance, *curated by Bernard Blistène of Musées de Marseille, and authored the accompanying catalogue (published by Editions Dis Voir). Louppe teaches in and outside France, for instance at PARTS (Performing Arts Research and Training Studios), a school in Brussels directed by the choreographer Anne Teresa Keersmaeker. She writes reviews of dance for various art*

gen. Er ist Autor des Buches *After the Great Divide: Modernism, Mass, Culture, Postmodernism* (1986), welches die Bedeutung des Begriffs der Postmoderne in den Bereichen Architektur, Film, Literatur und Literaturkritik wie auch seine Beziehung zum Feminismus, zur Ästhetischen Theorie und zum Poststrukturalismus kritisch untersucht. Der Titel seines letzten, 1995 herausgegebenen Buches lautet *Twilight Memories: Marking Time in a Culture of Amnesia*. Im zur *documenta X* erscheinenden Buch ist Andreas Huyssen mit einem Aufsatz zur Pop Art vertreten. Andreas Huyssen lebt und arbeitet in New York.

Alain Joxe, geboren 1931 in Paris, studierte zunächst Geographie und Geschichte und anschließend Soziologie und Sozialwissenschaften. Seit 1974 ist er Direktor der Groupe de Sociologie de la Défense an der Ecole des Hautes Etudes en Sciences Sociales und seit 1982 Präsident des Centre Interdisciplinaire de Recherches sur la Paix et d'Etudes Stratégiques (CIRPES), beide in Paris. Er ist Chefredakteur der Zeitschriften *Le débat stratégique* und *Cahiers d'Etudes Stratégiques*. Als Geostratege befaßt sich Joxe mit den unterschiedlichen Formen und Ursachen kriegerischer Konflikte und analysiert seit 1986 vor allem die militärpolitischen Wechselbeziehungen zwischen Europa und den Vereinigten Staaten. Seit dem Zusammenbruch des Warschauer Paktes und den sich verschiebenden weltpolitischen Konstellationen untersucht Joxe verstärkt die sich wandelnden US-amerikanischen Militärstrategien.

François Jullien, geboren 1951, ist Philosoph und Sinologe. Nach seinem Studium an der Ecole Normale Supérieure in Paris, an den Universitäten in Peking und Shanghai sowie nach einem längeren Aufenthalt in Japan unterrichtet Jullien heute klassische chinesische Philosophie und Ästhetik. Er hat einige Werke klassischer chinesischer Autoren übersetzt und eine Reihe von komparatistischen Essays herausgegeben, die das chinesische Denken durch die Philosophie des Okzidents zu erklären versuchen. Sein Buch *Eloge de la fadeur* (1993) beschäftigt sich vorrangig mit Problemen der Ästhetik, jedoch ist eines seiner Bücher besonders bemerkenswert, da es sich mit dem Begriff der »Effizienz« befaßt und mit den unterschiedlichen Definitionen des Begriffes in Europa und China. Ebenso erwähnenswert ist sein Vergleich der philosophischen Denkstrukturen im klassischen Griechenland und China mit dem Titel *Le détour et l'accès* (1995) und eine philosophische Bearbeitung von Yi-king, *Figures de l'immanence* (1993).

Thomas W. Keenan unterrichtet in Princeton am Institut für Englische Literatur- und Medientheorie. Er hat die Werke von Philosophen wie Derrida und Fou-

magazines including the English-French art-press, to which she contributes regularly. Her book Poétique de la Danse Contemporaine, published by La Pensée du Mouvement, is to appear in Belgium this year.

Geert Lovink, born in Amsterdam in 1959, studied political science and was a pioneer of Internet activism. In a virtuoso manner he promoted undertakings of many kinds on the net, accompanying them as both a critical observer and a pragmatic utopian, whether they were militant organizations or speculative inquiries combining philosophy and the spirit of freedom. Geert Lovink is a proud member of Adilkno (the Foundation for the Advancement of Illegal Knowledge), and among the co-founders of the Digital City, a virtual metropolis, and Press Now, a magazine committed to freedom of the press in former Yugoslavia. Since 1991 he has traveled frequently to Eastern Europe and teaches art and new technologies there. He has organized several colloquia such as Interface 3 (Hamburg, 1993) and Ars Electronica (Linz 1996). His best-known publications are Empire of Images (1985), Hör zu—oder stirb: Fragmente einer Theorie der souveränen Medien (1992) and the Datendandy (1994).
For more detailed information: http://thing.desk.nl/bilwet.

Chris Marker, see p. 142

Rashid Masharawi, born in 1962, grew up in the refugee camp Al Shati in the Gaza Strip. He began experimenting with film at the age of 18, completing his first cinematic work Travel Document (a short film) in 1986. All of Masharawi's works – including both documentaries and features films – deal with the Israeli-Palestinian border conflict and the life of the people in the occupied. A film by Masharawi will be shown within the framework of the "100 Days – 100 Guests" program. Rashid Masharawi lives in Palestine and the Netherlands.

Paulo Mendes da Rocha, born in Vitoria, Brazil in 1928, was a student of the Department of Architecture and City Planning at Mackenzie University in São Paulo. In 1955 he founded an architectural firm in São Paulo, and is still its director today. In addition to his extensive teaching activities, Mendès da Rocha has been able to realize a large number of public and private building projects in Brazil during the past forty years. Stylistically he is associated with classical modernism and particularly with Oscar Niemeyer. His architectural work is characterized by its focus on the relationship between structural forms and their natural surroundings. In his designs he never loses sight of the architect's "solidar-

cault übersetzt und veröffentlichte eine Reihe wichtiger Artikel zur Dekonstruktion und zur Postmoderne. Wiederholt hat er sich zu aktuellen Themen wie AIDS, kriegerischen Konflikten, zum Urbanismus, zu den neuen Technologien und zum Multikulturalismus im Zeitalter der Globalisierung geäußert. Für eine Ausstellung in der Fundació Antoní Tàpies in Barcelona mit dem Titel Els limits del museu hat er einen Katalogbeitrag zur Zukunft der Institution Museum verfaßt. Sein letztes Werk Fables of Responsibility. Aberrations and Predicaments in Ethics and Politics (1997) ist dezidiert politisch ausgerichtet. Von der Berichterstattung der Medien zu den militärischen Interventionen Amerikas in Somalia, Ruanda und Bosnien-Herzegowina ausgehend, bereitet Keenan im Moment ein Buch zum Humanitarismus und der Rolle der Massenmedien vor.

Mike Kelley S. 114

Rem Koolhaas S. 126

Philippe Lacoue-Labarthe, geboren in Tours 1940, ist Professor für Philosophie an der Universität Straßburg und in Berkeley, Kalifornien. Sein Arbeitsgebiet ist hauptsächlich die deutsche Philosophie und das Verhältnis von Philosophie und Literatur. 1995 hat Lacoue-Labarthe den Friedrich-Gundolf-Preis für die Vermittlung deutscher Kultur im Ausland der Deutschen Akademie für Sprache und Dichtung erhalten, die damit seine Übersetzungen der Werke von Hölderlin, Nietzsche und Benjamin würdigte. Ein Großteil seines Werkes liefert Erklärungsansätze zu den Thesen Heideggers und dessen Konzept der »Mimesis«. Kontrovers wurden vor allem seine Untersuchungen zum Nazismus in Die Fiktion des Politischen: Heidegger, die Kunst und die Politik diskutiert. Dieser Essay liefert eine Analyse des Nationalsozialismus als Nationalästhetizimus und macht die Selbstproduktion des arischen Mythos als »Gesamtkunstwerk« in Nazi-Deutschland sichtbar.

Simon Lamunière, geboren 1961 in der Schweiz, lebt und arbeitet in Genf. Nach seinem Studium in Genf, Basel und Stuttgart experimentierte er als Künstler und Kurator zahlreicher Ausstellungen mit den neuen Medien. Seit 1992 arbeitet Lamunière im Kulturzentrum Saint Gervais, Genf, und ist Professor an der Kunsthochschule Lausanne. Als Kurator betreut er die Künstlerprojekte der documenta X website.

Antonia Lerch S. 138

Yang Lian, 1955 als Sohn chinesischer Diplomaten in Bern geboren, wächst Lian im Peking der Kulturrevolution auf und wird 1974 wie alle Jugendlichen zur

ity" with nature, endeavoring neither to subjugate nor to destroy nature with his structures. He respects nature and believes in mankind's responsibility towards its amid steadily changing social and economic circumstances, thus taking a virtually romantic position in the architectural history of the second half of the twentieth century.

Masao Miyoshi, born in Japan in 1928, is a professor of English, Japanese, and comparative literature and the director of the Program in Japanese Studies at the University of California in San Diego. Miyoshi studied English at the Universities of Tokyo and New York, then went on to obtain a doctorate. He subsequently held positions at the University of California in Berkeley, the University of Chicago, and Harvard University. In addition to his scholarly studies of modern Japanese literature (particularly the writer Kenzaburo Oe), architecture, and postmodernism, Miyoshi is concerned with the cultural, political, and social position of Japan. He has published numerous articles on this subject in the New York Times, the Washington Post, the Los Angeles Times, and the South Atlantic Quarterly. His publications include such titles as Japan in the World (1993), Postmodernism and Japan (1994), and Off Center: Power and Cultural Relations between Japan and the United States (1995).

Tierno Monénembo is a typical representative of African authors living in exile. Born in Guinea, he now lives in France. He wrote an extremely personal novel about Guinean students on the Ivory Coast. One of his novels takes place in a large city, depicting it as a place of loss and intermarriage. Many of his works are concerned with the uprooting of emigrants and the psychological consequences of migration. Monénembo's contribution to "100 Days – 100 Guests" will also focus on problems of emigration and identity.

Carlos Monsiváis, born in Mexico in 1938, is a journalist and writer. Within the framework of his journalistic activities he has worked for noted Mexican newspapers and periodicals, placing particular emphasis on Mexico's national history. Monsiváis is one of the most influential exponents of the Mexican culture of the past thirty years. In the seventies and eighties he was the director of the cultural supplement of the magazine Siempre!, La Cultura en México, as well as the editor of several radio programs. He has published short stories (Nuevo catecismo para indios remisos, 1982), anthologies (A ustedes les consta, 1980), and chronicles (Entrada libre: Crónicas de la sociedad que se organiza, 1987), and has received numerous prizes for his articles. He is a faithful chronicler of Mexican life, analyzing the

»Umerziehung« aufs Land verschickt. 1977 kehrt er nach Peking zurück. Ab 1978/79 kursieren seine Gedichte im Untergrund und werden in den achtziger Jahren auch in offiziellen chinesischen Zeitschriften veröffentlicht. 1983/84 wird er im Laufe der Kampagne gegen »geistige Verschmutzung« scharf kritisiert. Seit dem Massaker auf dem Platz des Himmlischen Friedens in 1989 lebt er im Exil. Lians Werk ist international bekannt. In deutschsprachiger Übersetzung liegen Pilgerfahrten (1987), Gedichte (1993), Masken und Krokodile (1994) sowie Geisterreden (1995) vor.

Laurence Louppe absolvierte nach ihrem Studium der Kunstgeschichte, Literatur- und Theaterwissenschaften eine Tanzausbildung. Im Anschluß daran arbeitete sie als Tanzlehrerin. Die große 1991 stattfindende Ausstellung Danses Tracées in den Musées de Marseille (Kurator: Bernard Blistène) wurde von ihr konzipiert, und sie veröffentlichte das Katalogbuch unter gleichem Titel. Louppe lehrt in Frankreich und an der Schule PARTS (Performing Arts Research and Training Studios) in Brüssel, die von der Choreographin Anne Teresa Keersmaeker geleitet wird. Als Tanzkritikerin schreibt sie für verschiedene Kunstmagazine, wobei sie regelmäßig Beiträge für die englisch-französischsprachige Zeitschrift art-press liefert. Ihr Buch Poétique de la danse Contemporaine erscheint noch in diesem Jahr in Belgien.

Geert Lovink, 1959 in Amsterdam geboren, studierte Politikwissenschaften und gehört zu den Internet-Aktivisten der ersten Stunde. Er hat äußerst virtuos Aktivitäten unterschiedlichster Art im Internet gefördert und als kritischer Beobachter oder pragmatischer Utopist begleitet. Er ist einer der führenden Medientheoretiker in Europa, arbeitete für das Cyber-Magazin Mediamatic und beim Piratensender Radio Patapoe. Geert Lovink ist Mitglied von Adilkno (Foundation for the Advancement of Illegal Knowledge). Er ist einer der Mitbegründer einer virtuellen Stadt, der Digital City, von Freenet und von Press Now, einem Magazin, welches sich für die Pressefreiheit in Ex-Jugoslawien einsetzte. Seit 1991 reist er wiederholt nach Osteuropa und unterrichtet dort Kunst und Neue Technologien. Auf ihn geht auch eine Reihe von Kolloquien zurück, wie Interface 3 (Hamburg 1993), und zur Ars Electronica (Linz 1996). Seine bekanntesten Publikationen sind Empire of Images (1985), Hör zu – oder stirb: Fragmente einer Theorie der souveränen Medien (1992) und der Datendandy (1994). Für ausführliche Informationen: http://thing.desk.nl/bilwet.

Chris Marker S. 142

Rashid Masharawi, geboren 1962, wuchs im Flüchtlingslager Al Shati im Gaza-Streifen auf. Im Alter von

rituals of the country's popular culture, pointing out contradictions between appearance and reality, and concerning himself with the economic and political circumstances, often in the bitingly sarcastic manner for which he is known.

Valentin Yves Mudimbe, *born in Likasi (Zaire) in 1941, is one of Zaire's most well-known writers. He studied economics, linguistics, and sociology in Kinshasa, Louvain, and Paris, receiving his doctorate in Romance philology. In 1971, upon returning from Europe, he became a professor of linguistics and comparative grammar of the Indo-European languages at the University of Zaire in Lubumbashi, a position he held until 1980. Since then he has lived in the United States, where he is a professor of literature and African studies at Stanford University in California. In addition to his occupations as a professor, scholar, and editor of magazines such as the* Encyclopedia of African Religions and Philosophy, *Mudimbe is the author of numerous books dealing with the conflicts Africa faces between tradition and European influence. He describes the process of Africa's disintegration and destruction caused by colonization, missionary work and development aid. Among his important publications:* The Invention of Africa *(1988),* The Idea of Africa *(1994) and, in French,* Le Bel immonde *(1976).*

Jean-Luc Nancy, *born in 1940, is a professor of philosophy at the University of Strasbourg in addition to holding guest professorships at various universities in the United States. His primary field of study is German philosophy (Kant, Nietzsche, Heidegger), but he is also interested in the theory of literature and the relationship between literature and philosophy. Nancy's fundamental work is* The Inoperative Community *(1986), in which he retraces the loss of community, whether in the formation of the myth, in politics, or in philosophy. Notwithstanding the Hegelian definition of "we," the recognition of loss cannot become a condition of possibility for a new community. Instead, the new community that forms represents the disparities of each member and is no longer the image of a single subject. Nancy continued his reflections on these problems, leading to his publication of* Etre singulier pluriel *in 1996. His most recent work is* Hegel, l'inquiétude du négatif.

Stanislas Nordey, see p.172

Michael Oppitz, *born in the Riesengebirge in 1942, grew up in Cologne and studied ethnology, sociology, and Sinology in Berkeley and Bonn. He has carried out ethnographic research in the Himalayas and Yunnan*

18 Jahren begann er mit Film zu experimentieren. 1986 machte er seinen ersten Film *Travel Document* (Kurzfilm). Ob Dokumentar- oder Spielfilm, in allen filmischen Werken Masharawis geht es um den israelisch-palästinensischen Grenzkonflikt und das Leben der Menschen in den besetzten Gebieten. Im Rahmen der »100 Tage – 100 Gäste« wird ein Film von ihm gezeigt. Masharawi lebt in Palästina und den Niederlanden.

Paulo Mendes da Rocha, geboren 1928 in Vitoria, Brasilien, studierte an der Mackenzie University in São Paulo am Fachbereich für Architektur und Stadtplanung. Im Jahr 1955 eröffnete er in São Paulo ein Architekturbüro, welchem er bis heute vorsteht. Neben seiner langjährigen Lehrtätigkeit war Mendes da Rocha in den letzten 40 Jahren mit der Realisierung einer großen Anzahl von öffentlichen und privaten Gebäuden in Brasilien befaßt. Stilistisch steht er der klassischen Moderne und hierbei besonders Oscar Niemeyer nahe. Kennzeichnend für sein architektonisches Werk ist die Beschäftigung mit dem Verhältnis von gebauter Form und natürlicher Umgebung. Bei seinen Entwürfen achtet er stets auf einen »solidarischen Umgang« des Architekten mit der Natur, die er mit seinen Bauten weder unterwerfen noch zerstören will. Er respektiert die Natur, glaubt an die Verantwortlichkeit der Menschen im steten Wandel der sozialen und ökonomischen Verhältnisse und nimmt so in der Architekturgeschichte der zweiten Hälfte des 20. Jahrhunderts einen geradezu romantischen Standpunkt ein.

Masao Miyoshi, geboren 1928 in Japan, ist Professor für Englisch, Japanisch, vergleichende Literaturwissenschaft und Direktor des Program in Japanese Studies an der University of California in San Diego. Miyoshi absolvierte sein Studium in Englisch an den Universitäten von Tokio und New York, das er mit der Promotion abschloß. Anschließend lehrte er unter anderem an der University of California in Berkeley, der University of Chicago und an der Harvard University. Neben wissenschaftlichen Arbeiten zur modernen japanischen Literatur, insbesondere über den Schriftsteller Kenzaburo Oe, zur Architektur und zur Postmoderne ist Miyoshis Forschungsschwerpunkt die kulturelle, politische und soziale Stellung Japans. Dazu veröffentlichte er zahlreiche Artikel in der *New York Times*, *Washington Post*, *Los Angeles Times* und *South Atlantic Quarterly*. Seine wichtigsten Publikationen der letzten Jahre sind *Japan in the World* (1993), *Postmodernism and Japan* (1994) und *Off Center: Power and Cultural Relations between Japan and the United States* (1995).

Tierno Monénembo ist ein typischer Vertreter afrikanischer Autoren im Exil. In Guinea geboren und aufge-

and is affiliated with the Ecole Pratique des Hautes Etudes in Paris, the Wissenschaftskolleg of Berlin, and the University of Texas. *Michael Oppitz is presently the director of the Museum of Ethnology as well as a professor of ethnology, both at the University of Zurich. He is the author of numerous publications on the history, life, and culture of the Himalayan peoples, including* Geschichte und Sozialordnung der Sherpa *(1968),* Frau für Fron: Die Dreierallianz bei den Magar West-Nepals *(1987) and* Drum Fabrication Myths *(forthcoming).*

Christos Papoulias *was born in Athens in 1953 and studied architecture at the University of Venice from 1971 to 1976. He has had his own architectural firm in Athens since 1977. Among his most well-known projects are the house built for the artist Jannis Kounellis on the Greek island of Hydra (1989-90), the offices of the Jean Bernier Gallery in Athens (1989), and the American artist Brice Marden's house and studio, also on Hydra (1991-93). His designs for an Acropolis Museum in Athens (1991) and a new Greek pavilion on the grounds of the Venice Biennial (1991) attracted widespread attention. Christos Papoulias has been commissioned to carry out the annex to the Moderna Galerija in Ljubljana, Slovenia, along with the project of "Urban Rooms" for Michelangelo Pistoletto's Minus Objects.*

Raoul Peck, see p.182

Marko Peljhan, see p.184

Claus Philipp, *born in Wels, Upper Austria in 1966, now lives in Vienna. Since 1990 he has written film reviews for the daily newspaper* Der Standard *while working on a freelance basis for various German-language print media and radio programs. In 1995 he founded the film magazine* Meteor *and since then has been responsible for its contents. He has published texts on David Cronenberg, Michael Haneke, Martin Arnold and Austrian film, as well as articles in* Meteor *on Jafar Panahi, Maurice Pialat, Christoph Schlingensief, David Lynch, and others. At "100 Days – 100 Guests" in Kassel, Philipp will make a presentation of* Meteor *and take part in a discussion with several filmmakers.*

Michelangelo Pistoletto, *see p.186*

Philip Pocock, *see p. 106*

Suely Rolnik, *a psychoanalyst, was born in Brazil in 1948 to Polish-Jewish parents. She participated actively in the reform movements of the 1960s, was arrested in*

wachsen, lebt er heute in Frankreich. Einen sehr persönlichen Roman hat er über guineische Studenten der Elfenbeinküste geschrieben. Sein einziger auch in deutscher Übersetzung vorliegender Roman *Zahltag in Abidjan* (1996) spielt in der Großstadt und zeigt diese als Ort des Verlustes und der Vermischung. Kennzeichnend für sein Werk ist die Beschäftigung mit der Entwurzelung der Emigranten, mit den psychologischen Folgen der Migration. Auch im Rahmen des Programms der »100 Tage – 100 Gäste« wird sich Monénembo mit Problemen der Emigration und der Identität befassen.

Carlos Monsiváis, 1938 in Mexiko geboren, ist Journalist und Schriftsteller. Im Rahmen seiner journalistischen Tätigkeit hat er für namhafte mexikanische Tageszeitungen und Periodika gearbeitet und sich vor allem mit der Nationalgeschichte Mexikos auseinandergesetzt. Monsiváis ist einer der Exponenten mexikanischer Kultur der vergangenen 30 Jahre. In den siebziger und achtziger Jahren war er nicht nur Direktor der Kulturbeilage *La Cultura en México* der Zeitschrift *Siempre!*, sondern auch Redakteur mehrerer Radiosendungen. Er veröffentlichte Erzählungen (*Nuevo catecismo para indios remisos*, 1982), Anthologien (*A ustedes les consta*, 1980) und Chroniken (*Entrada libre. Crónicas de la sociedad que se organiza*, 1987) und erhielt für seine Artikel mehrere Preise. Stets ist er Chronist des mexikanischen Lebens, analysiert Rituale der Populärkultur des Landes, zeigt Widersprüche zwischen Schein und Wirklichkeit auf und befaßt sich mit der wirtschaftlichen und politischen Lage, und dies oft in einer für ihn charakteristischen beißend ironischen Form.

Valentin Yves Mudimbe, geboren 1941 in Likasi (Zaire), gehört zu den bekanntesten Autoren aus Zaire. Er studierte Wirtschaftswissenschaften, Linguistik und Soziologie in Kinshasa, Löwen und Paris und promovierte in Romanischer Philologie. Nach seiner Rückkehr aus Europa erhielt er 1971 eine Professur für Linguistik und vergleichende Grammatik der indoeuropäischen Sprachen an der Universität von Zaire in Lubumbashi, die er bis 1980 innehatte. Seit dieser Zeit lebt er in den USA. Er ist Professor für Literatur und African Studies an der Stanford University, Kalifornien. Neben seiner Tätigkeit als Professor, Wissenschaftler und Herausgeber von Zeitschriften wie *Encyclopedia of African Religions and Philosophy* ist Mudimbe Autor zahlreicher Bücher, die sich mit der Zerrissenheit Afrikas zwischen Tradition und europäischem Einfluß auseinandersetzen. Er beschreibt den Prozeß der Auflösung und Zerstörung Afrikas, verursacht durch die Kolonialisierung, Missionierung und Entwicklungshilfe. Seine wichtigsten Publikationen der letzten Jahre sind: *The Invention of Africa* (1988) und

1970 and spent the years following her release in exile in Paris, where she lived until 1979. Within the framework of her professional career Suely Rolnik has been concerned primarily with the work of Gilles Deleuze and Félix Guattari, whose findings she has introduced to psychoanalytic practice in Brazil. One of her most well-known works is the study Micropolítica: Cartografias do desejo, published in 1986 in collaboration with Gilles Deleuze. Rolnik has an office for psychoanalytic treatment in São Paulo and teaches at the city's Catholic University. She has also worked as a translator and published a series of essays on contemporary Brazilian art, including texts on the work of Lygia Clark, an artist represented in documenta X.

Raoul Ruiz, born in Puerto Montt, Chile in 1941, first studied theology and law, then turned to film, which he studied in Santa Fé, Argentina. In 1968 he produced his first feature film, Trois Tristes Tigres. Until Allende's assassination in 1973 Ruiz was considered a major representative of Latin American cinema. In 1974 he emigrated to Paris, where he still lives today. He has made the majority of his films, numbering more than eighty, in France, Germany, and The Netherlands. He is also the author of the book Poetics of Cinema (1995). For his most recent feature film, Genealogies of a Crime (1996), Ruiz was awarded the "Silver Bear of Berlin" at the 1997 Berlinale.

Mikhail Ryklin, born in Leningrad in 1948, received his degree at the Philosophical Institute of the Moscow Academy of Sciences and has since become the institute's director. In 1984 he began to translate authors such as Barthes, Derrida, and Gadamer. He was also responsible for the Russian publication of the works of Sade, Blanchot and Lévi-Strauss, of Bakhtin and his contemporary Mamardashvili, as well as a number of volumes of "alternative poetry." In 1992 he published The Logistics of Terror and a series of essays dealing with artistic and literary production following the years of Stalinist terror. Ryklin is presently working on a presentation of the varying Eastern and Western viewpoints on the post-revolutionary avant-garde in the Soviet Union. He also has plans for a scholarly investigation of the aesthetics of the Moscow subway system.

Edward W. Said, born in Jerusalem in 1935 to a prominent Christian-Palestinian family, grew up in Cairo and the United States following the founding of Israel. Said is now a professor of English and comparative literature at Columbia University in New York. He is known as a culture critic, literary scholar and advisor to the PLO leader Yasir Arafat, having been regarded for many years as Arafat's "man in New York." In 1991 Said resi-

The Idea of Africa (1994) und in deutscher Sprache Auch wir sind schmutzige Flüsse (1982).

Jean-Luc Nancy, 1940 geboren, ist Professor der Philosophie an der Universität Straßburg und Gastprofessor an verschiedenen Universitäten in den USA. Sein Arbeitsgebiet ist hauptsächlich die deutsche Philosophie (Kant, Nietzsche, Heidegger), aber auch die Theorie der Literatur sowie das Verhältnis von Literatur und Philosophie. Grundlegend ist sein Werk Die undarstellbare Gesellschaft (La communauté désœuvrée, 1986), in welchem Nancy gewissermaßen noch einmal den Weg des Verlustes der Gemeinschaft, sei es nun in der Ausformung des Mythos, in der Politik oder in der Philosophie, verfolgt. Abweichend von der Hegelschen Definition des »Wir« kann der erkannte Verlust nicht zur möglichen Bedingung einer neuen Gemeinschaft werden. Vielmehr verhält es sich so, daß eine Gemeinschaft sich konstituiert, die die Disparitäten eines Jeden repräsentiert und nicht mehr das Bild nur eines Subjektes ist. Anschließend an diese Problematik hat Nancy 1996 die Publikation Etre singulier pluriel herausgegeben und sich dann in seinem jüngst erschienenen Buch wieder Friedrich Hegel (Hegel, l'inquiétude du négatif) gewidmet.

Stanislas Nordey S. 172

Michael Oppitz, geboren 1942 im Riesengebirge, aufgewachsen in Köln, studierte Ethnologie, Soziologie und Sinologie in Berkeley und Bonn. Er unternahm ethnographische Forschungen am Himalaya und Yunnan. Affiliationen mit der Ecole Pratique des Hautes Etudes in Paris, dem Wissenschaftskolleg zu Berlin und der University of Texas. Gegenwärtig ist er Direktor des Völkerkundemuseums der Universität Zürich sowie Ordinarius für Ethnologie am gleichen Ort. Er ist Autor zahlreicher Veröffentlichungen und Filme über Geschichte, Leben und Kultur der Völker im Himalaya: Geschichte und Sozialordnung der Sherpa (1968), Frau für Fron: Die Dreierallianz bei den Magar West-Nepals (1987), und Drum Fabrication Myths Manuskript (1997).

Christos Papoulias wurde 1953 in Athen geboren. Zwischen 1971 und 1976 studierte er Architektur an der Universität in Venedig. Seit 1977 betreibt er in Athen ein eigenes Architekturbüro. Zu seinen bekanntesten realisierten Projekten gehören das Haus für den Künstler Jannis Kounellis auf der griechischen Insel Hydra (1989–90), die Bürogestaltung der Galerie Jean Bernier in Athen (1989) sowie Haus und Atelier für den amerikanischen Künstler Brice Marden, ebenfalls auf Hydra gelegen (1991–93). Aufsehen erregten seine Entwürfe für ein Akropolis Museum für Athen (1991) und für

gned from the Palestine National Council and became one of Arafat's most vehement critics. He plays a major role within the context of the Middle Eastern conflict, working to gather democratically minded Palestinians around him in order to form an alliance against Arafat's dictatorial stance and take action against Israeli policy.

Saskia Sassen *is a professor of city planning at New York's Columbia University. She is the author of a large number of articles and books on urbanism and the global economy. Her publication* The Global City: New York, London, Tokyo *(1991) received international recognition and was translated into several languages; it has since come to be regarded as a standard work. In it Sassen introduces her concept on the interrelationship between the global economy and that of the city. Rather than discussing the metropolis from the point of view of national government, she develops a consistent international perspective, thus once again attributing integral significance to the economic space of the city, as opposed to the global village. Within the framework of a research grant Saskia Sassen is presently carrying out investigations at the Center for Advanced Study in the Behavioral Sciences in Stanford, California.*

Walter Seitter, *born in St. Johann/Engstetten, Austria, in 1941, studied philosophy, political science and art history in Salzburg, Munich, and Paris. From 1983 to 1985 he was an instructor of political science at the Rheinisch Westfälische Technische Hochschule in Aachen. Since 1985 he has taught aesthetics and politics at the Academy of Applied Art in Vienna. Within the framework of his scholarly activities Seitter has been especially interested in the work of Michel Foucault, whose writings he has also translated. In* Michel Foucault, Das Spektrum der Genealogie *(1996) he introduces various individual facets of Foucault's theories and production. For "100 Days – 100 Guests" he is joining Peter Gente and Daniel Defert for a presentation on the current reception of Foucault.*

Vandana Shiva, *born in India in 1952, is active in various projects as a physicist, philosopher, and ecologist. She received her doctorate for a study of the foundations of quantum physics, but is known to the public above all for her concept of combining ecological and feminist issues and for her publications on biodiversity and human rights. In 1982 she founded an independent research institute committed to environmental protection. She serves various governmental organizations as an ecological advisor, is actively involved in the preservation of the tropical rain forest, and regards herself as a combatant in the struggle against the bio-*

einen neuen griechischen Pavillon auf dem Gelände der Biennale di Venezia (1991). Christos Papoulias wird den Erweiterungsbau der Moderna Galerija in Ljubljana, Slowenien, ausführen und damit zusammenhängend die *Urban Rooms* für Michelangelo Pistolettos *Oggetti in meno*.

Raoul Peck S. 182

Marko Peljhan S. 184

Claus Philipp, geboren 1966 in Wels (Oberösterreich), lebt in Wien. Seit 1990 ist er als Filmkritiker der Tageszeitung *Der Standard* und freier Mitarbeiter für diverse deutschsprachige Printmedien und Radiosendungen tätig. 1995 gründet er die Filmzeitschrift *Meteor* und zeichnet seitdem als Redakteur für deren Inhalt verantwortlich. Er veröffentlichte Texte über David Cronenberg, Michael Haneke, Martin Arnold und zum österreichischen Spielfilm sowie in *Meteor* unter anderem über Jafar Panahi, Maurice Pialat, Christoph Schlingensief und David Lynch. In Kassel präsentiert Philipp bei »100 Tage – 100 Gäste« *Meteor* und wird Diskussionspartner von verschiedenen Filmemachern sein.

Michelangelo Pistoletto S. 186

Philip Pocock S. 106

Suely Rolnik, 1948 als Tochter polnischer Juden in Brasilien geboren, ist Psychoanalytikerin. Sie hat aktiv an den politischen Reformbewegungen der sechziger Jahre teilgenommen, wurde 1970 verhaftet und verbrachte die Jahre nach ihrer Freilassung im Exil in Paris, wo sie bis 1979 lebte. Im Rahmen ihrer wissenschaftlichen Tätigkeit hat Suely Rolnik sich vor allem mit dem Werk von Gilles Deleuze und Félix Guattari auseinandergesetzt und deren Erkenntnisse in die Praxis der Psychoanalyse Brasiliens übertragen. Zu ihren bekanntesten Publikationen gehört die Untersuchung *Micropolitica*. *Cartografias do desejo*, die sie 1986 in Zusammenarbeit mit Gilles Deleuze herausbrachte.
S. Rolnik unterhält eine psychonanalytische Praxis in São Paulo und unterrichtet an der katholischen Universität der Stadt. Sie war Übersetzerin und hat eine Reihe von Aufsätzen zur zeitgenössischen brasilianischen Kunst veröffentlicht, darunter auch Essays zum Werk der in der Ausstellung vertretenen Künstlerin Lygia Clark.

Raoul Ruiz, geboren 1941 in Puerto Montt (Chile), studierte Theologie und Jura. Seine Filmausbildung absolvierte er in Santa Fé (Argentinien). 1968 produzierte er seinen ersten Spielfilm (*Trois Tristes Tigres*). Bis zum Sturz Allendes (1973) galt er als einer der bedeutend-

piracy committed by Western industrial conglomerates in Third World countries. Vandana Shiva's approach is unusual in merging intellectual activity with work at the grassroots level, and global responsibility with local needs. In 1993 she received the Alternative Nobel Prize. Shiva lives and works primarily in Dehra Dun, India.

Wolf Singer, born in 1943, is a professor of neurophysiology and has been director at the Max Planck Institute for Brain Research in Frankfurt since 1981. He studied medicine in Munich and Paris, receiving his doctorate for a neurophysiological study in 1968. After obtaining his license to practice general medicine he went to the University of Sussex in England in order to acquaint himself more closely with methods of psychophysical examination. Beginning in 1972 he was engaged by the Max-Planck-Institute for Psychiatry in Munich. Upon attaining the qualification to lecture at a university, he was offered a position at the University of Bielefeld and two years later at the Brain Research Institute of the University of Zurich. His publications include "Development and Plasticity of Cortical Processing Architectures" in Sciences (1995) and "Der Beobachter im Gehirn" in H. Meier, D. Ploog, eds., Der Mensch und sein Gehirn (1997).

Abderrahmane Sissako, see p. 208

Edward Soja, born and raised in the Bronx, is a professor of city and regional planning at the University of California in Los Angeles. His experience of growing up in New York and the urban context of that city formed a significant starting point for his professional activities. Soja studied geography at Syracuse University in New York. He first investigated regional development in Africa and has since shifted his focus to postmodern Los Angeles. He is the author of the book Postmodern Geographies: The Reassertion of Space in Critical Social Theory as well as numerous articles on space and process in urban and regional development. His latest publication bears the title Thirdspace: A Journey through Los Angeles and other Real-and-Imagined Places.

Alexander Sokurow, see p. 212

Wole Soyinka, born in Abeokuta, Nigeria, in 1934, studied literature and dramaturgy in Leeds, England, and was subsequently engaged at the Royal Court Theatre in London as a dramatic advisor. In 1960 he returned to Nigeria to continue his study of dramaturgy. From 1967 to 1969, during the Biafran War, he was held in solitary confinement as a political prisoner in the maximum-security facility of Kaduna. Following his release he lived in exile in England and Ghana for

sten Vertreter des lateinamerikanischen Kinos. 1974 emigrierte er nach Paris, wo er noch heute lebt. Die meisten seiner über achtzig Filme drehte er in Frankreich, Deutschland und den Niederlanden. Er ist Verfasser des Buches Poétique du Cinéma (1995). Für seinen jüngsten Spielfilm Genealogie eines Verbrechens (1996) wurde Ruiz auf der diesjährigen Berlinale mit dem Silbernen Berliner Bären ausgezeichnet.

Mikhail Ryklin, geboren 1948 in Leningrad, hat seinen Abschluß am Philosophischen Institut der Russischen Akademie der Wissenschaften in Moskau absolviert und steht dem Institut heute als Leiter vor. 1984 begann er mit Übersetzungen von Autoren wie Barthes, Derrida und Gadamer. Darüber hinaus hat er in Rußland die Werke von Sade, Blanchot und Lévi-Strauss, aber auch jene von Bakhtin und dessen Zeitgenossen, dem Philosophen Mamardashvili, herausgegeben, ebenso wie eine Reihe »alternativer Poesie«. 1992 hat er »The Logistics of Terror« (In: New Russian Philosophy, Wien 1995) und eine Reihe von Aufsätzen herausgegeben, die sich mit der künstlerischen und literarischen Produktion nach dem stalinistischen Terror befassen. Im Moment arbeitet Ryklin an einer Darstellung der unterschiedlichen Standpunkte in Ost und West zur postrevolutionären Avantgarde der Sowjetunion. Er plant ebenfalls eine wissenschaftliche Arbeit zur Ästhetik der Moskauer U-Bahn.

Edward W. Said, 1935 in Jerusalem als Sohn einer prominenten christlichen Palästinenserfamilie geboren, wuchs nach der israelischen Staatsgründung in Kairo und den Vereinigten Staaten auf. Heute unterrichtet Said als Professor englische Literatur und Komparatistik an der Columbia University in New York. Er hat sich als Kulturkritiker, Literaturwissenschaftler und Mitarbeiter des PLO-Führers Yassir Arafat einen Namen gemacht und galt lange Zeit als dessen »Mann in New York«. Im Jahr 1991 trat Said aus dem Palästinensischen Nationalrat aus und wurde fortan zu einem der vehementesten Kritiker Arafats. Seine Stimme gehört im Nahostkonflikt zu den wichtigsten, und so versucht er heute, demokratisch gesinnte Palästinenser um sich zu scharen, um sich gegen Arafats diktatorische Haltung zu verbünden und um gegen die israelische Politik vorzugehen. In deutscher Sprache sind von ihm bisher Orientalismus (1981), Kultur und Imperialismus (1994), Der wohltemperierte Satz (1995) und Götter, die keine sind (1997) erschienen.

Saskia Sassen unterrichtet als Professorin für Stadtplanung an der Columbia University in New York. Sie ist Autorin einer Vielzahl von Artikeln und Büchern zum Urbanismus und zur globalen Ökonomie. Internationale Beachtung fand ihre Publikation The Global City: New

five years. *Again he returned to Nigeria, now to become a professor of literature at the University of Ife from 1975 to 1984. This was followed by a four-year period of exile in Paris. From 1988 to 1994 he was a professor at the University of Ibadan, Nigeria, but following the military coup he again chose exile and now lives in Atlanta. Soyinka has written numerous stage and radio plays, novels, essays, and volumes of verse. Among his most important publications are* Isarà *(1980) and* The Years of Childhood *(1983). In 1986 he was the first African to receive the Nobel Prize for Literature.*

Gayatri Chakravorty Spivak, *born in India, is a professor of English and comparative literature at Columbia University in New York. Her name is primarily associated with the concept of postcolonial studies and along with Edward W. Saïd and Homi Bhabha she is regarded to be one of the most important representatives of this Anglo-American theoretical field. Her literary analyses and theoretical writings have invariably dealt with the deconstruction of neocolonial discourses and a feminist-Marxist approach to postcolonialism, particularly to the schematized forms of representing women in the Third World. During the summer months Gayatri Spivak works with a non-governmental organization in Bangladesh to organize an educational program for women and a teacher training course.*

Ritsaert ten Cate, *born in 1939, attended international schools in Holland and Germany, after which he studied at Bristol University in England. In 1965 he founded the* Mickery Theater, *soon to become known as an internationally leading institution for innovative theater. During his more than twenty-five years as the director of Mickery, Ten Cate produced numerous plays, edited theater magazines, and was active as a theater critic. In 1991 he closed Mickery with the production* Touch Time. *He went on to participate in a series of international theater projects, collaborating, for example, with Jan Lauwers (Needcompany) of Brussels. In 1994 Ten Cate founded the institute DAS ARTS (De Amsterdamse School for Advanced Research in Theatre and Dance Studies) for theater, choreography, and mime, which he continues to direct. Ten Cate's collection of essays* Man Looking for Words *and a biographical portrait of him by Gary Schwarz were both published in 1996.*

Johan van der Keuken, *born in Amsterdam in 1938, is a filmmaker and photographer. In 1955 he published his first photo book* Wij zijn 17 *(We Are 17), soon to be followed by many others. Van der Keuken completed his studies at the Film Academy of Paris IDHEC in 1958 and went on to make over 45 films, including an hom-*

York, London, Tokyo (1991), die in mehrere Sprachen übersetzt worden ist und heute bereits als Standardwerk gilt. Sassen stellt in diesem Buch ihr Konzept über den Zusammenhang von Weltwirtschaft und Stadtökonomie dar, sie diskutiert die Metropolen nicht unter nationalstaatlichen Gesichtspunkten, sondern entwirft vielmehr eine konsequente internationale Perspektive, die der Stadt als Wirtschaftsraum im Gegensatz zum Global Village wieder eine integrale ökonomische Bedeutung zuweist. Momentan arbeitet Saskia Sassen im Rahmen eines Forschungsstipendiums am Center for Advanced Study in the Behavioral Sciences in Stanford, Kalifornien.

Walter Seitter, geboren 1941 in St. Johann/Engstetten (Österreich). Studium der Philosophie, Politikwissenschaft und Kunstgeschichte in Salzburg, München und Paris. Von 1983 bis 1985 Privatdozent für Politikwissenschaft an der Rheinisch Westfälischen Technischen Hochschule zu Aachen. Seit 1985 lehrt er Ästhetik und Politik an der Hochschule für Angewandte Kunst in Wien. Im Rahmen seiner wissenschaftlichen Tätigkeit hat sich Seitter vor allem mit dem Werk Michel Foucaults auseinandergesetzt. In Michel Foucault, Das Spektrum der Genealogie (1996) zeigt er einzelne Facetten von Foucaults Denken und Schaffen. Bei »100 Tage – 100 Gäste« gestaltet er mit Peter Gente und Daniel Defert einen Abend zu Foucaults Rezeption heute.

Vandana Shiva, geboren 1952 in Indien, arbeitet als Physikerin, Philosophin und Ökologin an unterschiedlichen Projekten. Sie erhielt ihren Doktortitel für eine Arbeit über die Grundlagen der Quantenphysik und wurde vor allem durch ihren Ansatz bekannt, Fragen der Ökologie mit Fragen der Frauenbewegung zu kombinieren sowie durch ihre Publikationen zur Biodiversität und zu den Menschenrechten. Im Jahr 1982 gründete sie eine unabhängige Forschungsinstitution, die sich aktiv für die Belange des Umweltschutzes einsetzt. Als ökologische Beraterin ist sie für diverse staatliche Organisationen tätig, engagiert sich für den Schutz des Regenwaldes und versteht sich als eine Streiterin im Kampf gegen die Biopiraterie der westlichen Industriekonzerne in Ländern der Dritten Welt. In seltener Form kombiniert Vandana Shiva intellektuelle Aktivität mit Arbeit an der Basis und globale Verantwortlichkeit mit lokalen Belangen. Im Jahr 1993 erhielt sie den Alternativen Nobelpreis. Shiva lebt und arbeitet vorwiegend in Dehra Dun, Indien.

Wolf Singer, geboren 1943, ist Professor für Neurophysiologie und seit 1981 Direktor am Max-Planck-Institut für Hirnforschung in Frankfurt. Er studierte Medizin in München und Paris und promovierte 1968 über ein

age to his home city, Amsterdam Global Village *(1996)*, presented at the *1997 Berlinale.* In addition to his activities as a filmmaker and photographer, Van der Keuken writes regularly for the film magazine Skrien. His essays on film and photography appear in Seeing Watching Filming *(1980)* and Abenteuer eines Auges *(1992).* His film Face Value *(1991)* will be shown within the context of "100 Days – 100 Guests."

Maerbek Vatchagaev, *born in Chechenia in 1965, is presently a doctoral candidate in the field of history at the Institute for Eastern Studies of the Russian Academy of Sciences. The title of his dissertation is* Chechenia During the Caucasian War *(1816-1859). A series of his publications have appeared in Chechenia, Russia, and France. Vatchagaev's research activities focus on the history of the Northern Caucasus, which will also be the topic of his contribution to "100 Days – 100 Guests."*

Jeff Wall, *see p. 242*

Lois Weinberger, *see p. 244*

François Zourabichvili, *born in 1965, has completed his study of philosophy and is presently writing a dissertation on Spinoza. In 1994 he published a book entitled* Deleuze, une philosophie de l'événement. *He teaches at the Institute for Photography and Multimedia of the University of Paris VIII and carries out critical investigations of the concepts of virtuality and interactivity. He is also interested in newly developed ideologies connected with multimedia methods as well as in the shifts that the new media have induced in the perception of the body and material values.*

neurophysiologisches Thema. Nach seiner Approbation als Arzt für Allgemeinmedizin ging er an die University of Sussex in England, um sich weiter in die Methoden psycho-physischer Untersuchungen einzuarbeiten. Von 1972 an war er am Max-Planck-Institut für Psychiatrie in München tätig. Nach seiner Habilitation erhielt er 1976 einen Ruf an die Universität Bielefeld und zwei Jahre später an das Hirnforschungsinstitut der Universität Zürich. Zuletzt publizierte er unter anderem: »Development and Plasticity of Cortical Processing Architectures«. In: *Sciences* (1995), »Der Beobachter im Gehirn«. In: H. Meier, D. Ploog (Hrsg.), *Der Mensch und sein Gehirn* (1997).

Abderrahmane Sissako S. 208

Edward Soja, geboren und aufgewachsen in der New Yorker Bronx, ist als Professor für Stadt- und Regionalplanung an der University of California in Los Angeles tätig. Seine Jugend in New York und der urbane Kontext dieser Stadt waren für ihn ein wichtiger Ausgangspunkt seiner späteren Arbeit. Soja studierte Geographie an der Syracuse University, New York. Er befaßte sich in seiner Forschung zunächst mit der regionalen Entwicklung in Afrika und konzentriert sich nun auf die Postmodernisierung von Los Angeles. Er ist Autor des 1989 erschienen Buches *Postmodern Geographies: The Reassertion of Space in Critical Social Theory* sowie mehrerer Artikel über Raum und Prozeß in der urbanen und regionalen Entwicklung. Seine jüngste Publikation trägt den Titel *Thirdspace: A Journey through Los Angeles and other Real-and-imagined-Places.*

Alexander Sokurow S. 212

Wole Soyinka, geboren 1934 in Abeokuta (Nigeria), studierte Literatur- und Theaterwissenschaften in Leeds (England) und war anschließend als Dramaturg am Royal Court Theatre in London tätig. 1960 kehrte er nach Nigeria zurück, um sein Dramaturgiestudium fortzusetzen. Während des Biafra-Krieges war er von 1967 bis 1969 als politischer Häftling in Isolationshaft im Hochsicherheitsgefängnis von Kaduna. Nach seiner Freilassung lebte er fünf Jahre im Exil in England und Ghana. Erneute Rückkehr nach Nigeria, wo er von 1975 bis 1984 Professor der Literaturwissenschaften an der Universität von Ife war. Anschließend ging er für vier Jahre ins Exil nach Paris. Von 1988 bis 1994 war er Professor an der Universität von Ibadan (Nigeria). Nach der Machtergreifung des Militärs wählte er erneut das Exil und lebt heute in Atlanta. Soyinka hat zahlreiche Theaterstücke, Hörspiele, Romane, Essays und Gedichtbände veröffentlicht. Seine wichtigsten Publikationen sind: *Aké, Jahre der Kindheit* (1986) und *Ìsarà, Eine Reise*

rund um den Vater (1994). 1986 erhielt er als erster Afrikaner den Nobelpreis für Literatur.

Gayatri Chakravorty Spivak, geboren in Indien, ist Professorin für Englisch und Vergleichende Literaturwissenschaft an der Columbia University in New York. Man verbindet ihren Namen vor allem mit dem Begriff der »Postcolonial Studies« und neben Edward W. Saïd und Homi Bhabha gilt sie als eine der wichtigsten Vertreterinnen dieser angloamerikanischen Theorieströmung. Durchgängiges Thema ihrer Literaturanalysen und Theorielektüren ist die Dekonstruktion neo-kolonialer Diskurse und ein feministisch-marxistischer Ansatz zum Postkolonialismus insbesondere zu den schematisierten Repräsentationsformen der Frau in der Dritten Welt. Während der Sommermonate hält sich Gayatri Spivak in Bangladesh auf, wo sie in Zusammenarbeit mit einer Non-Government-Organization ein Bildungsprogramm für Frauen und die Ausbildung von Lehrern organisiert.

Ritsaert ten Cate, geboren 1939, besuchte internationale Schulen in Holland und Deutschland. Dann Studium an der Bristol University, England. 1965 gründete er das Theater *Mickery,* das schon bald als die führende Institution für innovatives Theater auf internationalem Niveau galt. Während seiner über 25jährigen Tätigkeit als Direktor von *Mickery* war ten Cate als Produzent zahlreicher Theaterstücke, Herausgeber von Theatermagazinen und Kritiker tätig. 1991 schloß er *Mickery* mit der Produktion *Touch Time.* Danach beteiligte er sich an einer Reihe von internationalen Theaterprojekten, unter anderem bei Jan Lauwers (Needcompany), Brüssel. Er ist Gründungsdirektor des seit 1994 bestehenden Instituts DAS ARTS (De Amsterdamse School Advanced Research in Theatre and Dance Studies in Amsterdam) für Theater und Choreographie. 1996 veröffentlichte ten Cate seine Schriften unter dem Titel *Man looking for Words.* Im selben Jahr erschien ein biographisches Portrait von Gary Schwarz.

Johan van der Keuken, geboren 1938 in Amsterdam, ist Filmemacher und Photograph und veröffentlichte bereits 1955 sein erstes Photobuch *Wij zijn 17* (Wir sind 17), dem bald weitere folgten. Nach dem Abschluß seines Studiums an der Pariser Filmhochschule IDHEC (1956–58) machte van der Keuken über 45 Filme, darunter die auf der diesjährigen Berlinale präsentierte Hommage an seine Heimatstadt *Amsterdam Global Village* (1996). Neben seiner Tätigkeit als Filmemacher und Photograph schreibt van der Keuken regelmäßig für das Filmmagazin *Skrien.* Seine Schriften zu Film und Photographie sind publiziert in *Seeing Watching Filming* (1980) und *Abenteuer eines Auges* (1992). In Kassel wird im Rahmen der »100 Tage – 100 Gäste« der Film *Face Value* (1991) gezeigt.

Maerbek Vatchagaev, 1965 geboren in Tschetschenien. Er ist Doktorand der Geschichtwissenschaften am Institut für ostwissenschaftliche Studien der Russischen Akademie der Wissenschaften in Moskau. Der Titel seiner Dissertation lautet *Tschetschenien im Kaukasuskrieg (1816–1859)*. Eine Reihe seiner Publikationen ist in Tschetschenien, Rußland und Frankreich veröffentlicht worden. Vatchagaevs Forschungsgebiet ist die Geschichte des Nordkaukasus, über dieses Thema wird er ebenfalls bei »100 Tage – 100 Gäste« referieren.

Jeff Wall S. 242

Lois Weinberger S. 244

François Zourabichvili, geboren 1965, arbeitet seit dem Abschluß seines Studiums der Philosophie an einer Doktorarbeit zu Spinoza. 1994 hat er ein Buch mit dem Titel *Deleuze, une philosophie de l'événement* veröffentlicht. Momentan unterrichtet er an der Universität Paris VIII am Institut für Photographie und Multimedia. Er führt kritische Untersuchungen zum Begriff des Virtuellen und der Interaktivität durch. Ebenso befaßt er sich mit den neu entwickelten Ideologien in Verbindung mit multimedialen Verfahren und mit den durch die neuen Medien induzierten Verschiebungen bei der Wahrnehmung von Körper, Stoffen und materiellen Werten.

Hybrid WorkSpace

a temporary laboratory in the Orangerie / ein temporäres Labor in der Orangerie

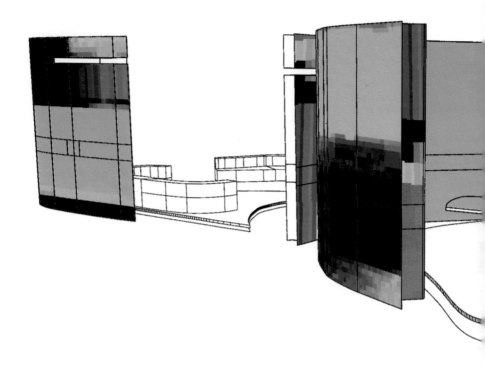

a project by Eike Becker and Geert Lovink/Pit Schultz, Micz Flor, Thorsten Schilling, Heike Föll, Moniteurs, Thomax Kaulmann, the dX team and many others

intitiated by Catherine David (documenta X), *Klaus Biesenbach, Hans Ulrich Obrist, Nancy Spector (Berlin Biennial)*

The Orangerie will be transformed into an open media studio to collect, select, connect, record, and distribute information and content. It will deal with current social, political and cultural issues. Hybrid WorkSpace will provide possibilities to comment, interview, discuss and present the resulting data objects and will forge connections with material brought in from outside. Distribution beyond the Orangerie will be realised via selected zones on the Internet as well as through print media and radio broadcasting. A subsequent publication will allow the content flow produced throughout the documenta X to be widely accessible.

Hybrid WorkSpace can best be described as a tem-

ein Projekt von Eike Becker und Geert Lovink/Pit Schultz, Micz Flor, Thorsten Schilling, Heike Föll, Moniteurs, Thomax Kaulmann, dem dX-Team und vielen anderen

Initiiert von Catherine David *(documenta X),* Klaus Biesenbach, Hans Ulrich Obrist, Nancy Spector (Berlin Biennale)

Die Orangerie wird umgestaltet zu einem Raum, der als offenes Medienstudio das Erstellen, Sammeln, Anwählen, Verknüpfen, Wiederaufnehmen und Verteilen von Informationen und Inhalten zum Ziel hat. Gegenstand sind vorwiegend soziale, politische und kulturelle Fragestellungen. Im Hybrid WorkSpace gibt es Möglichkeiten für Kommentar, Interview, Diskussion und zur Präsentation der entstehenden Datenobjekte. Sie werden mit dem von außen eingebrachten Material verknüpft. Die Distribution außerhalb der Orangerie wird über ausgewählte Bereiche im Internet sowie durch Druckmedien und Radiosendungen erreicht. Über eine anschließende Publikation wird der während der *documenta X* im Hybrid

porary laboratory that produces its own type of con-
tent. It also condenses the viewpoints and positions
brought to Kassel by the "100 Days - 100 Guests" pro-
gram into streams of subjective approaches, repre-
sented in digital data. Most importantly, it allows
remote participants to directly access the develop-
ments and debates in the Orangerie. This includes
input from external areas into the physical setting of
the Orangerie.

The architecture itself reflects a non-hierarchical
perception of different functions, zones, images and
situations. Similar to icons on a screen, the different
elements of the set can be decomposed and rear-
ranged. Projection columns, pedestals, and tables
create an interface between the real and the virtual.
The polymorphous and movable architectural elements
precipitate a playful dialogue among themselves,
including the hosts and guests. Furthermore the cho-
sen interior appears useful as a laboratory and work-
shop for programmed and spontaneous interactions
and presentations. Multifunctional video and audio
facilities are included into the movable projection col-

WorkSpace entstandene Fluß an Informationen und
Inhalten dokumentiert und weithin zugänglich
gemacht.

Hybrid WorkSpace kann am besten als zeitweiliges
Labor beschrieben werden, das seine eigene Art von
Inhalt produziert. Er verdichtet darüber hinaus die mit
dem Programm »100 Tage - 100 Gäste« nach Kassel
gebrachten Sichtweisen und Positionen in Ströme sub-
jektiver Herangehensweisen. Am wichtigsten ist, daß er
geographisch entfernten Teilnehmern erlaubt, direkt
auf die Entwicklungen und Auseinandersetzungen in
der Orangerie zuzugreifen. Das schließt auch Eingaben
aus externen Bereichen in den materiellen Raum der
Orangerie ein.

Die Architektur ist Spiegel einer nicht hierarchischen
Raumauffassung und versucht, die verschiedenen Funk-
tionen, Bildwelten und Situationen möglichst gleich-
wertig nebeneinander bestehen zu lassen. Ähnlich den
Symbolen und Zeichen der Bildschirmoberfläche kön-
nen die unterschiedlichen Raumelemente auf einfache
Weise dekonstruiert und neu arrangiert werden. Pro-
jektionssäulen, Podeste, Flächen und Tische erzeugen

Hybrid WorkSpace

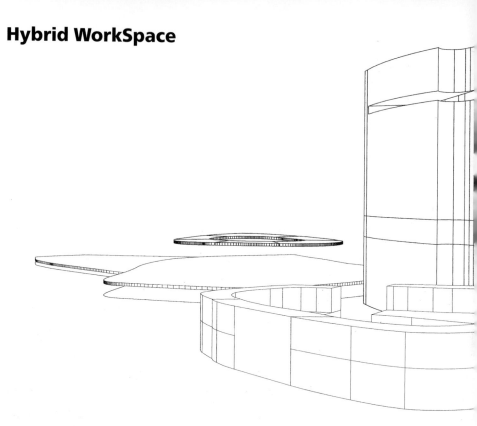

umns that structure and serve the space. The visitor can expect Hybrid WorkSpace to appear dark or light, full or empty, full of images or sound, noisy or completely silent.

Hybrid WorkSpace is an ambient space and document store; it is a pin-board and global newspaper; and it is both local and world wide radio channel. Out of this heterogeneity, the project constitutes itself professionally improvised as a media laboratory involving both transparent and opaque fields of activities. In this way, it becomes simultaneously a dynamic system - open and closed, private and public.

Hybrid WorkSpace mixes old and new media, connecting data streams of different sources. The polymorphous structure allows spontaneous rearrangements to suit the demands imposed on the space by discourse, presentations, events, and guests working in the Orangerie. This could be interviews, dialogues, group discussions or informal gatherings.

It is a zone of critical thought and productive conflict, a social space to manufacture consent, initiate dissent, a place where distribution, reception and production compress and expand. Within the social context the relation between senders and receivers makes things happen. Meanwhile traditional broadcasting

Schnittstellen zwischen dem Realen und dem Virtuellen. Die polymorphen und verschiebbaren architektonischen Elemente eröffnen untereinander sowie mit den Gastgebern und Gästen einen spielerischen Dialog. Darüber hinaus dient die gewählte Einrichtung als Labor und Werkstatt für geplante und spontane Interaktionen und Präsentationen. In die verschiebbaren Projektionssäulen ist multifunktionales Audio- und Videoequipment integriert. Den Besucher erwartet der Hybrid WorkSpace je nach Nutzung verdunkelt oder belebt, belebt oder leer, voller Bilder oder Klänge, laut oder still.

Hybrid WorkSpace ist ambient space und Archiv, Pinnwand und globale Zeitung, sowohl lokaler als auch weltweiter Rundfunkkanal. Aus dieser Mannigfaltigkeit entsteht das Projekt professionell improvisiert als Medienlabor, das beides ist, transparentes und undurchlässiges Tätigkeitsfeld. Zugleich wird es auf diese Weise ein dynamisches System, offen und geschlossen, privat und öffentlich.

Hybrid WorkSpace mischt alte und neue Medien, indem er Datenströme aus verschiedenen Quellen verbindet. Die polymorphen Strukturen erlauben spontane Neuordnungen, um den Anforderungen an den Raum gerecht zu werden. Diese Anforderungen sind dem Raum durch Diskurse, Präsentationen, Ereignisse und

media like radio, video or journals become technical metaphors to put information onto the Internet. The organisation of time, the scheduling, and the architecture of a collaborative archive as an arena of memory will be modeled in space as in software. We strongly encourage collaborations with radio producers, virtual communities, video makers, magazines, etc. to provide the technical facilities to easily produce vivid net content.

In addition to the co-ordinators of the space there will be temporary teams of 2 to 4 editors who will be in Kassel for a 10-14 days period. After the preparation and realisation in Kassel, the WorkSpace will be transferred to Berlin as a part of the first Berlin Biennial scheduled for summer 1998 in various locations throughout the city.

http://www.documenta.de/workspace
e-mail: workspace@documenta.de

Gäste, die in der Orangerie arbeiten, auferlegt. Das können Interviews, Dialoge, Gruppendiskussionen oder informelle Treffen sein.

Es ist ein Ort kritischen Denkens und produktiven Konflikts, ein sozialer Raum, in dem Konsens hergestellt und Dissens in Gang gesetzt wird. Eine Stelle, an der sich Verteilung, Aufnahme und Produktion verdichten und erweitern. Im sozialen Kontext läßt die Beziehung zwischen Sendern und Empfängern die Dinge geschehen. Unterdessen werden die traditionellen Massenmedien wie Radio, Video, Zeitschriften zu technischen Metaphern, um Informationen »aufs Netz zu legen«. Die Organisation zeitlicher Abläufe, der Terminplan, die Architektur eines gemeinsam erarbeiteten Archivs als Gedächtnisarena werden räumlich und softwaretechnisch umgesetzt. Wir regen gezielt die Zusammenarbeit mit Radioproduzenten, virtuellen Gemeinschaften, Videomachern, Magazinen usw. an. Unser Vorhaben ist es, die technischen Mittel zur Verfügung zu stellen, um auf einfache Weise lebendigen Netzinhalt zu produzieren.

Zusätzlich zu den Koordinatoren des Hybrid WorkSpace werden in Kassel etwa 10 verschiedene Teams von 2 bis 4 Redakteurinnen und Redakteuren für die Dauer von 10 bis 14 Tagen arbeiten. Nach der Vorbereitung und Realisierung in Kassel wird der WorkSpace nach Berlin verlagert, als Teil der erstmalig für den Sommer 1998 geplanten und an verschiedenen Orten der Stadt stattfindenden Berlin Biennale.

http://www.documenta.de/workspace
e-mail: workspace@documenta.de

»documenta meets radio/radio meets documenta«

Hessischer Rundfunk (hr2)

Hessischer Rundfunk (hr2)

The arts have been addressing themselves to the medium of radio since it was first invented. Composers and writers in particular have succeeded in expanding their expressive range either on the radio, or by using the radio.

In co-operation with documenta X, the radio station Hessischer Rundfunk/Hörfunk is placing the medium of radio at the disposal of contemporary artists, with their respective concepts of structure and experiences of reality. Thus disciplines that at first glance may seem to be irreconcilable – the fine arts being dependent on optical signals, radio on acoustic ones – are able to find out what aspects they have in common under shared circumstances.

Several of the artists invited to documenta X will create a radio feature in keeping with their own ideas. The resulting six features will be broadcast by Hessischer Rundfunk on its second radio channel, hr2.

Given the open nature of the work on this project, the dates when these features will first be broadcast cannot be fixed in advance. Should their concepts demand it, the respective artists are to be allowed to intervene in scheduled radio programs. Towards the end of documenta X, however, all six features will be broadcast in close succession.

The following artists are involved in the project "documenta meets radio/radio meets documenta":

Seit es das Radio gibt, setzen die Künste sich mit diesem Medium auseinander. Vorrangig sind es Komponisten und Schriftsteller, die im Radio und mit dem Radio ihre Ausdruckswelt erweitern.

In Zusammenarbeit mit der documenta X unternimmt der Hessische Rundfunk/Hörfunk den Versuch, das Medium Radio für Strukturüberlegungen und Wirklichkeitserfahrungen zeitgenössischer bildender Künstler zu öffnen. Auf den ersten Blick unvereinbare Disziplinen – die dem optischen Signal verpflichtete Bildkunst, das dem akustischen Signal verpflichtete Radio – erkunden Gemeinsamkeiten in einer gemeinsamen Gegenwart.

Mehrere zur documenta X eingeladene Künstlerinnen und Künstler werden eine nach ihren Vorstellungen entwickelte Radiosendung gestalten, die in der Hörfunkwelle hr2 ausgestrahlt wird.

Die offene Enstehungsweise des Projektes macht es selbstverständlich, daß die Erstsendetermine nicht langfristig festgelegt werden können. Die beteiligten Künstler sollen sich nach ihren Vorstellungen ins Radioprogramm einmischen. Gegen Ende der documenta X werden alle sechs Sendungen nochmals in enger Folge vorgestellt.

An dem Projekt »documenta meets radio/radio meets documenta« wirken mit:

Lilian Zaremba/Tunga & Cabelo (*Brazil*/Brasilien)
(*Second broadcasting date* / Zweitsendung: 1. 9. 1997, 23.00 – 24.00 Uhr, hr2)

Lothar Baumgarten (*Germany*/Deutschland)
(*Second broadcasting date* / Zweitsendung: 2. 9. 1997, 23.00 – 24.00 Uhr, hr2)

Mike Kelley (USA)/**Tony Oursler** (USA)/**Diedrich Diederichsen**
(*Germany*/Deutschland))
(*Second broadcasting date* / Zweitsendung: 3. 9. 1997, 23.00 – 24.00 Uhr, hr2)

Carsten Nicolai (*Germany*/Deutschland)
(*Second broadcasting date* / Zweitsendung 4. 9. 1997, 23.00 – 24.00 Uhr, hr2)

Carl Michael von Hausswolff (*Sweden*/Schweden)/
Ditterich von Euler-Donnersperg (*Germany*/Deutschland)
(*Second broadcasting date* / Zweitsendung: 5. 9. 1997, 23.00 – 24.00 Uhr, hr2)

Marko Peljhan (*Slovenia*/Slowenien)
(*Second broadcasting date*/Zweitsendung: 6. 9. 1997, 23.00–24.00 Uhr, hr2)

vielfalt in kultur

hr2

Documenta X-Editions will give the multiple its own place within this major cultural event wich corresponds to the significance of this medium in the development of contemporary art in the twentieth century.

Die documenta X-Edition will der Auflagenkunst einen eigenen Platz innerhalb des kulturellen Ereignisses "documenta X" einräumen, der der Bedeutung des Multiple für die Entwicklung der Kunst dieses Jahrhunderts entspricht.

Lothar Baumgarten
Baked enamel multiple, three parts / Email Multiple dreiteilig

Jordan Crandall
Fibreglass object on stainless steel / Fiberglas-Objekt auf Stainless Steel

Ulrike Grossarth
5 screenprints on plexiglass / 5 Siebdrucke auf Plexiglas

Richard Hamilton
Computer processed Iris giclée print / Computererzeugter Iris giclée-Druck

Christine & Irene Hohenbüchler
Book with CD-ROM, original drawing / Buch mit CD-ROM, orig. Zeichnung

Mike Kelley & Tony Oursler
1. Baked enamel plate 2. CD-ROM / 1. Emailliertes Metallschild 2. CD-ROM

Martin Kippenberger
1. Porcelain object 2. cast lead / 1. Porzellanobjekt 2. Bleiguß

Reinhard Mucha
Photographs, painted glass, aluminum / Photos, bemaltes Glas, Aluminium

Olaf Nicolai
Do-it-yourself light box / Selbstbausatz für Leuchtkasten

Michelangelo Pistoletto
7 phototypes on ceramic plates / 7 Daguerreotypien auf Keramik

Gerhard Richter
Offset print on Japanese paper / Offestdruck auf Japanpapier

Erik Steinbrecher
Series of 16 postcards / Postkartenserie

Rosemarie Trockel
Silkscreen on acetate, punched / Siebdruck auf gestanzter Folie

Martin Walde
2 die-cast polyurethane objects / 2 Spritzguß-Kunststoffobjekte

Jeff Wall
Photography / Photographie

 Editions published by documenta X / Edition Schellmann, München – New York

ACCONCI STUDIO

Info-System/Bookstore for documenta X, 1997
plexiglass, steel, wood
650 x 1000 x 2200 cm
Barbara Gladstone Gallery, New York

ROBERT ADAMS

Photographs (1968–74/77):
 Colorado Springs, Colorado, 1968
 Colorado Springs, Colorado, 1968
 Golden, Colorado, 1969
 Untitled, 1970
 Golden, Colorado, 1970
 Lakewood, Colorado, 1971

– Published in *To Make It Home. Photographs of the American West*, New York, An Aperture Book, 1989:
 Outdoor Theater and Cheyenne Mountain, Colorado Springs, Colorado, 1968, pl. 31
 Newly Completed Tract House, Colorado Springs, Colorado, 1968, pl. 37
 Tract House and Outdoor Theater, Colorado Springs, Colorado, 1969, pl. 29
 Newly Occupied Tract Houses, Colorado Springs, Colorado, 1969, pl. 30
 Colorado Springs, Colorado, 1969, pl. 33
 Basement for a Tract House, Colorado Springs, Colorado, 1969, pl. 40
 Pikes Peak Park, Colorado Springs, Colorado, 1969, pl. 48
 From Lookout Mountain, at Buffalo Bill's Grave. Jefferson County, Colorado, 1970, pl. 42
 From Lookout Mountain, at Buffalo Bill's Grave Smog, Jefferson County, Colorado, 1970, pl. 43
 On Lookout Mountain, at Buffalo Bill's Grave, Jefferson County, Colorado, 1970, pl.44
 From Lookout Mountain at Buffalo Bill's Grave, Jefferson County, Colorado, 1970, pl. 45
 On Green Mountain, Jefferson County, Colorado, 1970, pl. 46
 Adams County, Colorado, 1973, pl. 63
 Along Interstate 25, North Edge of Denver, Colorado, 1973, pl. 66
 Lakewood, Colorado, 1974, pl. 54

– Published in *Denver. A Photographic survey of the metropolitan area*, Denver, Colorado Associated University Press, 1977
 North Denver, Colorado, 1974, pl. 28

Fraenkel Gallery, San Francisco

Photographs (1982–83):
– Published in *Los Angeles Spring*, New York, An Aperture Book, 1986
 Broken Trees, next Box Springs Mtns., east of Riverside, California, 1982, pl.55
 Eucalyptus, Fontana, California, 1982, pl.14
 Looking into the San Bernardino Mtns. from east of Mentone, California, 1982, p.46
 Expressway near Colton, California, 1982, frontispiece
 On Signal Hill, Overlooking Long Beach, California, 1983, pl. 12
 Redlands, California, 1983, pl 18
 At the curb of a city street, Loma Linda, 1983, p. 24
 La Loma Hills, Colton, California, 1983, p. 50
 Eroding edge of abandoned citrus growing estate, East Highlands, California, 1983, p. 53
Fraenkel Gallery San Francisco

 Santa Ana Wash., nd, pl. 15
 Redlands, nd, pl. 16
 Remains of a eucalyptus windbreak among citrus groves, Redlands, nd, p. 25
 La Loma Hills, Colton, nd, p. 51
Private collection, Paris

 Our Lives and our Children, 1983
 74 black & white photographs
 gelatin-silver prints
 37 x 29 cm (framed)
Fonds national d'Art contemporain, Ministère de la culture, Paris, in permanent loan in Musée d'Art Moderne de Saint-Etienne

PAWEL ALTHAMER

 Astronaut 2, 1997
the project consists of three main parts:
1) An action/Happening involving two people in astronaut's suits walking with two video cameras, taping what they see. The third person with a video camera records their steps. After the action a film will be made documenting the action.
2) A vehicle will be placed in the park. It will be divided into two parts: the first part open to the public, will be arranged with exhibition items: a fan, bus seats, a vending machine with drinking water, a refridgerator. The other compartment will be a room for the exhibition guard, who will live in it for the duration of the exhibition.
3) The guard: will live in the trailer and take care of the exhibition.

Collection of the artist. Courtesy Foksal Gallery, Warsaw. With the support of the Soros Foundation and SONY.

ARCHIGRAM (Ron Herron †)

Instant City, Urban Action – Tune up, 1969
collage: foil, paper and ink on cardboard
46 x 61 cm
72,5 x 102 cm (framed)

Instant City, City Dissolve, 1969
Self Destruct Environ Pole, 1969
Gallery Project for Bournemouth (Bournemouth Arcade), 1970

Collection Deutsches Architektur–Museum, Frankfurt am Main

ARCHIZOOM ASSOCIATI

No-Stop City, 1969 – 72
(First theoretical project for a totally artificial homogeneous metropolis)
reproduction of original drawings
various dimensions

No-Stop City, 1969 – 72
Paesaggi interni, 1970
Archives of the Centro Studi e Archivio della Comunicazione, Università degli Studi di Parma–Sezione Progetto

No-Stop City, 1970
Model of *No-Stop City*
No-Stop Theater, 1970
Model of *No-Stop City*
Collection Centro Studi e Archivio della Comunicazione, Università degli Studi di Parma–Sezione Progetto

ART & LANGUAGE

Sighs trapped by Liars 1 – 192, 1996–97
12 vitrines (glass, wood, steel) each containing 16 small paintings (alogram and acrylic on canvas on wood). Paintings depict the open pages of books which contain printed theoretical texts by Art & Language without repetition.
paintings: 29,5 x 42,5 cm each
vitrines: 80 x 124,4 x 175,8 cm each

Sighs trapped by Liars 193 – 233, 1996 – 97
Sighs trapped by Liars 234 – 372 (etc.), 1997

Portrait of the Artist as an Optimist, 1995
Collection of the artists

JACKSON POLLOCK BAR in collaboration with ART & LANGUAGE

Art & Language's "We Aim to be Amateurs" in the style of the Jackson Pollock Bar, 1997
"Theorieinstallation": text by Art & Language and mixed media in connection with performance (see Jackson Pollock Bar q.v.)
Collection Jackson Pollock Bar Theorie-Installationen

AYA & GAL MIDDLE EAST

The Naturalize/Local Observation Point, 1996
computer, CD ROM, video projector, floor brick (polyurethane and rubber), metal box, bench
variable dimensions
Collection AYA & GAL MIDDLE EAST

OLADÉLÉ AJIBOYÉ BAMGBOYÉ

Homeward Bound, 1995
 MOVEMENT 1; MOVEMENT 2; MOVEMENT 3, 1997
 video laser discs, 5' each
 SPRAY; RESPECT; OMI-EKU, 1997
 video laser discs, 4' 8" each
 PARADIGM SHIFT-AFRICAN STORIES, 1997
 Two interviews from Africa about experiences in Europe. Transcripts available in English, French and German, on the internet: www.documenta.de
– *Chief (Prof.) E.D. Bamgboyé, The Eesa of Odo-Eku*
 Lived and studied in Scotland from 1975 to 1982
 Lives now in Benin City, Nigeria
 video laser discs, 9' 35"
– *Reuben Ayo Ibitoye*
 Lived and trained as a fighter pilot, then later as an Air Traffic Controller with the German Aiforce in Western Germany form 1963 to 1966
 Lives now in Igbaja, Nigeria
 video laser discs, 9' 35"
Courtesy of the Artist (a.k.a.) Living and Breathing Films, 1997
This work has been made possible with the support of: Taeko Nagamachi; Hessischer Rundfunk studio, Kassel (Online Beta SP Facilities); Mrs. Angela Schroeder (Editing assistance).

LOTHAR BAUMGARTEN

Manipulierte Realität, 1968, 1969, 1970, 1971, 1972

Vakuum, 1978, 1979, 1980
wall drawing, maquette (gelatine–silver prints,
pencil)
200 x 1400 cm
Collection of the artist. Courtesy Marian Goodman
Gallery, New York, Paris

1978–97
radio project
Production Hessischer Rundfunk

CATHERINE BEAUGRAND

LUNA PARK
Automaton version, 1997
colour video 20', sound, ferris wheel, "looping" and
other fair objects in plastic knex on a table
Collection of the artist, Paris
Produced with the support of SONY

JOACHIM BLANK/KARL HEINZ JERONI
(Internet)

Without addresses, 1997
self-writing website
URL: http://www.documenta.de
Co-production: *documenta* X and Internationale
Stadt Berlin

MARCEL BROODTHAERS †

*Section Publicité du Musée d'Art Moderne, Départe-
ment des Aigles*, 1972
mixed media
overall 300 x 600 x 425 cm
Courtesy Marian Goodman Gallery, New York

films:
1. *Wilhelmshöhe (Herkules mit Kaskaden)*,
Kassel 1972
2. *Section Publicité et Section Art Moderne du
Musée d'Art Moderne, Département des Aigles*,
Kassel 1972
Courtesy Maria Gilissen, Brussels

documentary video:
Extracts from the film of Jef Cornelis , "documenta 5,

Kassel", 28 juillet 1972, 16/35 mm, black & white,
sound, 53'30"
Archives BRTN, Brussels

Marcel Broodthaers in Kassel, 1972
*Section Publicité du Musée d'Art Moderne, Départe-
ment des Aigles*, 1972
installation view
Agentur für Geistige Gastarbeit, Harald Szeemann,
Tegna
© photo: Balthasar Burkhard

HEATH BUNTING
(internet)

Visitors Guide to London, 1994–95
hypercard project for the internet
URL: http://www.documenta.de

CHARLES BURNETT
(filmmaker)

The Final Insult, 1997
Am Ende
digital video, colour, ca 60'
Production: Charles Burnett
Commissioning editor: arte/ZDF, Doris Hepp
Produced with the support of SONY

JEAN-MARC BUSTAMANTE

Amandes Amères, Bitter Almonds, Bittere Mandeln,
1997
book: 38 colour plates, 80 p., colour cover
24,5 x 34,5 cm
Coproduction *documenta* X, Phaidon Press Limited and
Ministère de la Culture, Délégation aux Arts Plastiques,
FIACRE, France
Published and distributed by Phaidon Press Limited,
London

LYGIA CLARK †

Objeto: a água e a concha, 1966 (reconstitution)
Objeto: pedra e ar, 1966 (reconstitution)
Respire comigo, 1966

O eu e o Tu: série roupa-corpo-roupa, 1967
2 sky-blue plastic overalls connected by a diving tube
("umbilical cord") and 6 zippers.

Overall A: white loose cotton lining, pink rubber lining covered by nests of mane, plastic bag, plastic bag with water, piece of natural sponge, hood containing a blue plastic brush with the bristles facing up;
Overall B: white loose cotton lining, pink rubber lining covered by nests of mane, plastic bag, plastic bag with water, piece of natural sponge, pink foam, hood containing pink synthetic material.
155 x 90 cm each
hoods: 30 x 40 cm

Cesariana: série roupa-corpo-roupa, 1967
Collection Museu de Arte Moderna do Rio de Janeiro

Máscaras sensoriais, 1967
1. *Máscara vermelha*, 2. *Máscara vermelha*

Collection Lygia Lins Clark Barbosa, Rio de Janeiro

Máscaras sensoriais, 1967
1. *Máscara cereja*, 2. *Máscara branca*, 3. *Máscara de cor verde*, 4. *Máscara cor-de-abóbora*, 5. *Máscara azul*, 6. *Máscara preta*

Luvas sensoriais, 1968
Máscara abismo, 1968
Collection Museu de Arte Moderna do Rio de Janeiro

photographic documents (1966–75):
Respire comigo, 1966. 2. *O eu e o Tu: série roupa-corpo-roupa*, 1967. 3. *Máscaras sensoriais*, 1967. 4. *Máscaras abismo*, 1968. 5. *Arquitecturas biológicas*, 1969. 6. *Arquitecturas biológicas II*, 1969. 7. *Canibalismo*, 1973. *Baba antropofágica*, 1973. *Cabeça coletiva*, 1975.

Archive Centro de Documentação, Museu de Arte Moderna do Rio de Janeiro
© photo: Carlos, Hubert Josse, Patrice Morère/O, Sergio Zalis

documentary video
Memória do corpo, 1984
Rioarte, Rio de Janeiro

Exhibition co-produced by the Fundació Antoni Tàpies, Barcelona

JAMES COLEMAN

Connemara Landscape, 1980
projected image
Collection of the artist.

COLLECTIVE (La ciutat de la gent)

Cirilo Poblador, carrer d'Oristà, Vallbona, Barcelona, desembre 1995, 1996
Estació de França, avinguda del Marquès de l'Argentera, Barcelona, desembre 1995, 1996
La Paloma, carrer del Tigre, Barcelona, febrer 1996, 1996
Passeig del Cimal, Vallbona, Barcelona, febrer 1996, 1996
Passeig del Cimal, Vallbona, Barcelona, febrer 1996, 1996
Carles Ferrer Salat, carrer de Panamà, Barcelona, març 1996, 1996
Moll de Sant Bertran, Zona Franca, Barcelona, març 1996, 1996
black & white photograph
140,4 x 138 cm
150,4 x 148 cm (framed)

On loan to the Fundació Antoni Tàpies, Barcelona

STEPHEN CRAIG

Treppen Str. Pavilion, 1996–97
model in wood (scale 1:2), video projection in loop, colour, sound,
120 x 500 x 300 cm
© photo: Anselm Gaupp
Collection of the artist, Hamburg. Courtesy Produzentengalerie, Hamburg.

JORDAN CRANDALL

suspension, 1997
installation with video, digital animations, VRML and projected light, including 5 stainless steel processing units with multiscan projectors, computers, controllers, videocassette players, digital effect processors, video camera, series of calibrating units; fittings cast in stereolithography and fiberglass; set of digital and printed figures
multiple calibrations
Collection of the artist, New York
Produced with the support of SONY

DANIELE DEL GIUDICE

Il linguaggio degli oggetti, 1996
– model of a radar console
– video: computer reconstruction of the radar image during the last moments of flight ITAVIA 870, which plunged into the sea near Ustica on 27th June 1980. (from "Murder in the sky", a BBC production, 1982)
– original objects from street vendors: clothes, jewellery, soft toys, Senegal;
– Legal form "avviso di garanzia" , document mounted on cardboard
– 4 albums containing photos of Internet "Homepages"
– Pier Paolo Pasolini: 2 original poems typed from the collection "Poesia in forma di rosa" (1964) :
1."*10 giugno 1962*". "*Dattiloscritto con autografi cart. 6*, 1962 (first draft, with written annotations)
2."*10 giugno 1962*". "*Dattiloscritto cart. 10*", 1962 (final version)
Archivio Contemporaneo, Gabinetto G. P. Vieusseux, Firenze. Proprieta eredi Pasolini.
Photo: Gianluca Miano
Esposta in occasione della 19a Esposizione Internazionale della Triennale di Milano, Palazzo dell' Arte, 1996

STAN DOUGLAS

Der Sandmann, 1995
dual black & white 16 mm filmprojection with stereo sound, each rotation: 14'
Collection Hauser & Wirth, Zürich

WALKER EVANS †

Subway Portrait, New York, 1938–1940
black & white photograph, gelatin-silver print
10 x 17 cm
36 x 43 cm (framed)

Subway Portrait, New York, 1938–1940
Subway Portrait, New York, 1938–1940
Subway Portrait, New York, 1938–1940
Subway Portrait, New York, 1938–1940
Subway Portrait, New York, 1938–1940
Subway Portrait, New York, 1938–1940
Collection Sandra Alvarez de Toledo, Paris

Subway Portrait, New York, 1938–40
Collection Baudouin Lebon, Paris

Photographs published in Portfolios of the *Fortune Magazine*:
"The Athenian Reach", n 1 (Mother), 1964
"The Athenian Reach", n 2 (Sarah), June 1964
"The Athenian Reach", n 3 (E. Jones), July 1962
"The Athenian Reach", n 4 (Skulls), July 1962
"The Athenian Reach", n 5 (Blank), June 1964
"The Athenian Reach", n 6 (E. Brown), June 1964
The Arthur and Carol Goldberg Collection

ÖYVIND FAHLSTRÖM †

Meatball Curtain (for R. Crumb), 1969
© photo: Boris Becker

The Little General (Pinball Machine), 1967–68
Oil on photopaper on vinyl, plexiglass, metal, magnets, styrofoam floats with lead keels in a pool
100 x 280 x 550 cm (pool)

Collection Sharon Avery-Fahlström, New York
Estate of Öyvind Fahlström. Courtesy Aurel Scheibler, Köln

HARUN FAROCKI
(filmmaker)

Stilleben, 1997
Creating a Still Life
16 mm film, colour, 45'
Production: Harun Farocki Filmproduktion, Berlin and Movimento Production, Christian Baute, Paris
Commissioning editor: 3 SAT/ZDF, Inge Claßen

Peter FISCHLI & David WEISS

Untitled, 1997
ARTE TV late night program during the hundred days of *documenta X*. Filmed slide projection of photos taken by the artists 1987–1997 on several trips through Europe, the United States, Asia, Brazil, Egypt and Australia
8 hours
Collection of the artists, Zürich

PETER FRIEDL

Dummy, 1997
site specific installation: video (loop), colour, sound
Collection of the artist
Produced with the support of SONY

Kino, 1997
Collection of the artist

HOLGER FRIESE
(internet)

unendlich, fast...., 1995
internet page
URL: http://www.documenta.de

LIAM GILLICK

Discussion Island Development Screen, 1997
Discussion Island Resignation Platform, 1997
Erasmus Aß Zehn Jahre Opium #2, 1997
Courtesy Schipper & Krome, Berlin; Robert Prime,
London; Air de Paris, Paris; Basilico Fine Arts, New York

The What If? Scenario, Cantilevered Delay, Platform,
1996
Plexiglass, aluminum angle, aluminium fittings
variable 4' x 4'
Collection Andy & Karen Stillpass, Cincinatti

HEINER GOEBBELS
(theater)

*Ou bien le débarquement désastreux – Oder die glück-
lose Landung*, 1993
© photo: Mark und Brigitte Enguerand

DOROTHEE GOLZ

Überlebensmaßnahmen, 1995
Collection Wiener Secession

Grenzüberschreitungen, 1996

Hohlwelt, 1996
polythene sheet, epoxy resin, iron
diam: 200 cm
© photo: Sigrun Appelt

Ordnende Hände, 1996
Prinzip Hoffnung, 1996
*Wissenschaftliche Analyse eines nicht gelungenen
Tages*, 1996
(*Scientific Analysis of an Unsuccessful Day*)
Ebene Delta, 1997
Frauen und die 4. Dimension, 1997
Collection of the artist, Mülheim an der Ruhr

DAN GRAHAM

New Design for Showing Videos, 1995
Collection Generali Foundation, Wien
Video for Two Showcase Windows, 1976–1997
2 mirrors, 2 video monitors, 2 cameras, digital time
delay

TONI GRAND

Sans titre, 1990
Fishs, aluminum and laminated polyester
23,5 x 590 cm
© photo: Galerie Arlogos
Collection du Fonds Régional d'Art Contemporain des
Pays de la Loire, in permanent loan in Musée des Beaux-
Arts, Nantes

HERVÉ GRAUMANN
(internet)

l.o.s.t., 1997
shockwave movie
URL: http://www.documenta.de
Production *documenta* X

JOHAN GRIMONPREZ

Dial H-I-S-T-O-R-Y, 1995–1997
video installation
Projections at: 10h00, 12h00, 14h00, 16h00, 18h00
Co-production: Centre Georges Pompidou, Musée
national d'art moderne, Paris; Kunstencentrum STUC;
University of Leuven.
With the participation of: *documenta* X, Kassel; Ministe-
rie van de Vlaamse Gemeenschap Departement Welzijn,
Volksgezondheid en Cultuur; Muestra Internacional de
Vidéo Cadiz; Klapstuck 97, Leuven; Jan Van Eyck Akade-
mie, Maastricht
With the technical support of: AVID Belgium; SONY
Germany

JOHAN GRIMONPREZ and HERMAN ASSELBERGHS

"Prends garde! A jouer au fantôme, on le devient",
1995–97
"Beware! by playing the phantom you become one"
Co-production: Centre Georges Pompidou, Musée
national d'art moderne, Paris; *documenta* X, Kassel;
Time festival, 1995. In collaboration with De vereniging
van het Museum voor Hedendaagse Kunst, Gent/de
andere Film, Antwerpen
With the support of the Ministerie van de Vlaamse
Gemeenschap Departement Welzijn, Volksgezondheid
en Cultuur.

ULRIKE GROSSARTH

BAU I, 1990–1996
Untitled, 1997
Collection of the artist, Berlin

BAU 8
installation view Portikus, Frankfurt, 1986
detail

HANS HAACKE

*Shapolsky et al. Manhattan Immobilienbesitz, ein
gesellschaftliches Realzeitsystem, Stand 1. Mai 1971*,
1971

142 photos of building facades and empty lots, with
typewritten information on properties from the New
York County Clerk's records, each 20 x 7 in. (51 x 18
cm); 2 excerpts of map of New York (Lower East Side
and Harlem) with properties marked, and 6 charts
outlining business relations within real estate group,
each 24 x 20 in. (61 x 51 cm).
In 1971, Thomas Messer, the former director of the
Guggenheim Museum in New York, refused to show
the work as part of a solo exhibition in his museum.
He cancelled the exhibition six weeks before the
opening and fired the curator Edward F. Fry. Thomas
Messer is now director of the Schirn Kunsthalle in
Frankfurt.
Edition of 2
© photo: Fred Scrunton
Collection Musée national d'art moderne, Centre
Georges Pompidou, Paris

Standortkultur (Corporate Culture), 1997
Production *documenta* X, Kassel; Poster DSR
With the collaboration of Peter Klein GmbH, Hamburg:
reproduction; Büro X and Dennis Thomas

RAYMOND HAINS

Cassettes pour Kassel, 1997
Collection of the artist, Paris
Déménagement de la Rue Marbeau, Paris, Juillet
1988
© photo: Joël Audebert

RICHARD HAMILTON

Seven Rooms – Bathroom, 1994–95
Cibachrome and oil on canvas
black & white negative of North West wall of Ant-
hony d'Offay Gallery scanned to Quantel Paintbox,
transposed to positive, cleaned, contrast and
brightness adjusted and perspective corrections
applied. Transparency of bathroom at Northend
Farm scanned to Quantel Paintbox, cleaned, colour
corrected and perspective corrections applied.
Colour image cut and pasted to black & white image
of gallery wall. File output via magneto optical disc
to 10 x 8 in. (24,5x20,3 cm) transparency, printed as
Cibachrome enlargement, emulsion stripped from
paper backing, bonded on canvas, stretched and
retouched to remove flaws. Black red and white area
painted with oil paint. Central area varnished with
acrylic to heighten colour.
Collection Shirley Ross Davis

Seven Rooms – Kitchen, 1994–95 (previously known
as *Northend*)
Private Collection, Switzerland

Seven Rooms – Passage, 1994–95
Seven Rooms – Dining Room, 1994–95
Seven Rooms – Bedroom, 1995
Seven Rooms – Dining room/Kitchen, 1995
Seven Rooms – Attic, 1995–96
Courtesy Anthony d'Offay Gallery, London

RICHARD HAMILTON & ECKE BONK

the typosophic pavilion, 1996–97

THE TYPOSOPHIC SOCIETY
Finnegans Wake, p. 383
Monotype lead type
In collaboration with GHK/HbK Kassel,
Fachbereich 23

THE TYPOSOPHIC SOCIETY
Illuminated manuscript,12th century
tempera on parchment
Private Collection

THE TYPOSOPHIC SOCIETY
Wilson cloud chamber
mixed media
100 x 100 x 100 cm
In collaboration with Phywe GmbH, Göttingen

RICHARD HAMILTON
Diab DS-101 computer, 1985–89
mixed media, UNIX operating system
70 x 50 x 50
Diab Data AB
Collection Richard Hamilton, Northend

RICHARD HAMILTON
infowell – the typosophic machine, 1997
mixed media, Berkeley UNIX operation system
Assembled off-the-shelf components. The BSD ope-
rating system was downloaded from the internet.
Collection Richard Hamilton, Northend
In collaboration with Edward Thordén

ECKE BONK
Three Palindromes, 1986–97
mirror, fluorescent tube, aluminium frame
150 x 240 cm each
Collection Ecke Bonk, Primersdorf
In collaboration with Werkstatt Kollerschlag

SEBASTIEN LE CLERC †
L'Académie des sciences et des beaux-arts, 1695
Collection of Herzog Anton Ulrich-Museum,
Braunschweig

ALBRECHT DÜRER †
Das grosse Glück (Nemesis), nd
Kupferstichkabinett, second state
33,3 x 23,1 cm (plate)
Kupferstichkabinett der Akademie der bildenden
Künste, Wien

ALBRECHT DÜRER †
Melencolia I, 1514
copper etching
24,2 x 18,8 cm (plate)
Kupferstichkabinett der Akademie der bildenden
Künste, Wien

This work has been made possible with the support of:
Woolworth Fund, New York; Niederösterreichkultur–
Kulturamt der Niederösterreichischen Landesregierung,
St. Pölten; Dr. Joachim Rössl, Niederösterreichkultur;
Waldviertler Management, Zwettl; wv.server@wvnet.at;
PHYWEsysteme, Göttingen; Werkstatt Kollerschlag, Kol-
lerschlag; Kupferstichkabinett der Akademie der Bilden-
den Künste, Wien; Herzog Anton Ulrich-Museum, Braun-
schweig; Edward Thordén, Stockholm.

SIOBHÁN HAPASKA

Here, 1995
fibreglass, opalescent paint, acrylic lacquer and
lambswool, with harness and piped water and
oxygen
100 x 400 x 200 cm

Heart, 1995
Stray, 1997

Courtesy of the artist and Entwistle Gallery, London

MICHAL HEIMAN

Michal Heiman Test (M.H.T.), 1997
Box with 32 images (lithographic prints on cards
28 x 23 cm each) and text by Meir Agassi and Ariella
Azoulay, an L-shaped table, one chair for the exami-
ner, one chair for the subject, sign inviting people to
take the test, video camera & video tape, two sets of
head phones, students from Camera Obscura, school-
of-the-arts-Israel, conducting the test.
28 x 23, 5 cm each
Collection of the artist
This work has been made possible with the generous
support of: Mr. Doron Sabag, Company O.R.S., Israel;
Camera Obscura School of Art, Israel; The Yehoshya
Rabinowits Tel-Aviv Foundation for the Arts; Ministry of
Science and the Arts, Israel; Cultural and Scientific Rela-
tions department Ministery of foreign affairs, Jerusalem.

JÖRG HEROLD

Körper im Körper, Leipzig 1989
(Body in the body)
film super-8, black & white, 11'14", transferred to
laser-disc
Camera: Jörg Herold; Speaker: Frank Behrend
Collection Jörg Herold, Berlin

CHRISTINE HILL

Volksboutique, (1996 – present)
Volksboutique is a second-hand clothing shop and
work space. *Volksboutique* in Kassel will be open
during *documenta* X on Fridays and Saturdays from
10 a.m. – 8 p.m. During the remainder of the week,
visitors will have the option to either browse via win-
dow display or make the trip to Berlin to see the ori-
ginal store, open Sundays from 5 p.m. – 9 p.m. and
Mondays from 12 p.m. – 8 p.m. at Invalidenstrasse
118, Mitte.
Collection of the artist. Copyright 1996/97 Artslut.
Courtesy Galerie EIGEN+ART Berlin/Leipzig

CHRISTINE & IRENE HOHENBÜCHLER

multiple autorenschaft. Ein Kommunikationsraum,
1996 – 97
furniture in maple wood, painted and lacquered:
– Kommunikationsmöbel I: 1 bookshelf, C-form with
bench
– Kommunikationsmöbel II: 3 chairs with bookshelf
included
– Kommunikationsmöbel III: table, 3 chairs
– Kommunikationsmöbel IV: 1 bookshelf with bench
– Kommunikationsmöbel V: library
several objects made by the multiple autorenschaft
Lienz, 72 pillows, different sizes, silicon and clay
objects, drawings, paintings on fabric, photos, folders
1 computer for CD-Rom, monitor, video player, VHS
cassette, variable dimensions
Collection of the artists, Courtesy Paul Andriesse,
Amsterdam; Galerie Barbara Weiss, Berlin and Raum
aktueller Kunst, Martin Janda, Wien
Production of the furniture: Kommunikationsmöbel I:
Casper Tuyl, Amsterdam; Kommunikationsmöbel: II-V:
Fritz Kroher, München

CARSTEN HÖLLER & ROSEMARIE TROCKEL

Ein Haus für Schweine und Menschen, 1997
mixed media
house: 400 x 1200 x 600 cm
garden (for the pigs): 120 m^2

Co-production: *documenta X* and the artists
architect: Rolf Bandus, Cologne with Milce Dutton
advice: Harald Burger and Christel Simantke, advising
for Appropriate Animal Treatment e.V. Witzenhausen
looking after: Heinrich Schröder, Wildeck and *docu-
menta X*
farmers: Ottmar Holstein, Ulrich Rodewald
construction: Bauunternehmung H. Rumpf, Kassel;
During Betonfertigteile, Kassel
financial support: Stadtsparkasse Köln
thanks to Schipper & Krome, Berlin and Monika Sprüth
Gallery, Köln

EDGAR HONETSCHLÄGER

97 (13 † 1), 1994 – 1997
*A Projekt by Edgar Honetschläger in collaboration
with the Poor Boys Enterprise*
14 black & white photographs, colour video, 10'
50 x 40 cm each
Collection of the artist

FELIX S. HUBER/PHILIP POCOCK/FLORIAN WENZ/
UDO NOLL
(internet)

A Description of the Equator and Some OtherLands,
1997
editable hypermovie for the internet
URL: http://www.documenta.de
Co-Production *documenta X*, Akademie Schloß Solitude
Stuttgart

JACKSON POLLOCK BAR

*Art & Language "We Aim to be Amateurs" installed
in the style of the Jackson Pollock Bar*, 1997
tables, chairs, various studio items, slides, slide-pro-
jector, tape-recorder, tape, loudspeakers, headpho-
nes, 3 actors
(see Art & Language q.v.)
performance on: June 19, 20 and 21 1997 at 5 p.m.
and every friday at 5 p.m.
Collection Jackson Pollock Bar, Theorie-Installationen:

director Christian Matthiessen, in collaboration with
Michael Hirsch, Martin Horn and actors of the Theatre
Freiburg and Staatstheater Kassel

JODI

jodi.org; 1994–97
website
URL: http://www.documenta.de

MIKE KELLEY & TONY OURSLER

Poetics Project, 1997

MIKE KELLEY
Before and After, 1997
acrylic on wood panels
Two panels, 228,6 x 176,5 x 5 cm each

Pulpit Show, 1997
acrylic on wood panel
182,8 x 213,3 x 5 cm

Poetics Museum, 1997
acrylic and pencil on wood panel
182,8 x 141 x 5 cm

Boombox, 1997
acrylic on wood panels, speakers and audio system
137 x 182,8 x 5 cm

TONY OURSLER
Entrail Diatribe, 1997
acrylic on wood panel with video projection,
interview Glen Bronca
243,2 x 182,4 x 30,4 cm

Conceptual (Trip), 1997
acrylic on wood Panel with video projection
243,2 x 182,4 x 91,2 cm

Why I Love (Guitar), 1997
acrylic on wood panel with sound system,
music by Arto Lindsay
243,2 x 182,4 x 7,6 cm

Why I Love (Drums), 1997
acrylic on wood panel with sound system
243,2 x 182,4 x 7,6 cm

A Door Moves in Two Directions, 1997
acrylic on wood panel with video projection
243,2 x 182,4 x 7,6 cm

MIKE KELLEY / TONY OURSLER
Immaculate Conception, 1997
acrylic on wood panel, plexiglass, video projection
187,9 x 243,8 x 5 cm

X – C, 1997
acrylic on wood panel
185,4 x 365,7 x 5 cm

Crazy Head, 1997
acrilyc on wood panels with video projections,
various interviews with Lydia Lunch, Arto Lindsay,
Laurie Anderson, and Dan Graham
Two panels, free standing
panel 1: 228,6 x 228,6 x 5 cm
panel 2: 141 x 182,8 x 5 cm

Spineless Sack of Flesh. 1997
fibreglass, wooden chair, video projection
155 x 256,5 x 101,6 cm

Nondescript God, 1997
fibreglass, electric lights
diam: 177,8 x 127 cm

New Wave, 1997
acrylic on wood panel
243,2 x 243,2 x 7,6 cm

Composition, 1997
acrylic on wood with video projection featuring
Rober Appleton
243,2 x 182,4 x 30,4 cm

Courtesy of the artists, Metro Pictures, New York
and Jablonka Galerie, Köln

MIKE KELLEY & TONY OURSLER &
DIEDRICH DIEDERICHSEN

"Prole / Prog" 1997
audio work
Production Hessischer Rundfunk

WILLIAM KENTRIDGE

Felix in Exile, 1994
History of the Main Complaint, 1996
video installation: 35 mm animated film transferred
to video, ca.5', laser disc projection
Collection of the artist. These works were made possi-
ble with the assistance of the Goodman Gallery, Johan-
nesburg.

MARTIN KIPPENBERGER †

Metro-Net, Skulptur "Transportabler U-Bahn
Eingang," 1997
Metro-Net Sculpture "Transportable Subway-
Entrance"
iron painted in white
343 x 750 x 245 cm
Courtesy Galerie Gisela Capitain, Köln

JOACHIM KOESTER

Pit Music, 1996
video: colour, sound (Dmitri Shostakovich: Concert
Nº 18 110 in C Minor), duration 14'; stage
camera: Søren Martinsen, Nicolai Meedum and Ann
Lislegaard, Joachim Koester
editing: Jeanette Schou
music performed by: Julie Eskær, Emilie Eskær, Sara
Vallevik and Iben Teilmann at Galleri Nicolai Wallner,
Copenhagen, 1996
variable dimensions
installation view Galeri Nicolai Wallner, Copenhagen,
1996
Courtesy Galleri Nicolai Wallner, Copenhagen

PETER KOGLER

documenta X, 1997
wallpaper
variable dimensions
© photo: Rainer Pirker
In collaboration with: Rosa Brückl, Gregor Schmoll,
Thomas Kaufhold, Stefan Bidner, Mathias Høllige,
Christoph Hinterhuber, Ralf Schilcher, Petra Schilcher,
Franz Pomassl, Paul Petritsch, Tanja Kogler Rainer, Eva
Tenschert, Astrid Schneider, Sonja Karle, Annette Zindel.

AGLAIA KONRAD

Kassel, 1997

Without Title
installation view Museum Dhondt-Dhaenens, Deurle
1997

REM KOOLHAAS

New Urbanism: Pearl River Delta, 1996
colour xeroxes
various dimensions

Project undertaken by: "Harvard Project on the City", a
research conducted in 1996 at the Graduate School of
Design at Harvard University, as part of the "Harvard
Project on the City"
catalogue: (credits) The China Group at the Graduate
School of Design at Harvard University is composed of
the following persons:
Rem Koolhaas advisor
Bernard Chang, Mihai Craciun, Nancy Lin, Yuyang Liu,
Katherine Orff, Stephanie Smith with Marcela Cortina
and Jun Takahashi
book and installation design: Bruce Mau Design, Rem
Koolhaas and the China Group with Sanford Kwinter

HANS-WERNER KROESINGER
(theater)

Stille Abteilung, 1995
© photo: David Baltzer

SUZANNE LAFONT

Trauerspiel, 1997
9 "tableaux" made of 8 silk-screen printed posters in
primary colours
"tableaux": 240 x 380 cm each
posters: 120 x 95 cm each
Collection of the artist, Paris

SIGALIT LANDAU

Resident Alien, 1996
20 feet container, hammers, eastern toilet, transistor
radio
250 x 600 x 250 cm
© photo: Naomi Talisman

Collection Sigalit Landau, Jerusalem. Courtesy
Contemporary Fine Arts, Berlin

MARIA LASSNIG

L'Intimité, 1967
Selbstportrait als kommunizierendes Gefäß, 1969
Selbstportrait als Slog, 1969
Selfportrait as Gardenscissors, 1969
Thiwahn-Selbstportrait, 1969

Koordinatenvernetzung, 1994
pencil on paper
44 x 60 cm
© photo: Franz Schachinger

Mild Reception, 1994
Scientific Selbstportrait, 1994
Retinales Selbstportrait und Empfindungs-
selbstportrait, 1994
Scharfer Empfang, 1995
Parallele Parameter, 1995

Augen- und Oberlippensensationen, 1995
Collection of the artist, Wien

Gehirnströme, 1995
Collection Musée national d'art moderne, Centre
Georges Pompidou, Paris. Gift of the artist (1996)

Kopf mit offener Gehirnschale, 1995
Kopfmeridiane, 1995
Totaler Empfang, 1995
Auditus Auditor, 1996
Cerebral Stabilisator, 1996
Cognitif inkarniert, 1996
Der Mensch gebraucht zu seinem Nutzen, 1996
Frontal Circles, 1996
Gesichtsschichtenlinien, 1996
Man – Female Network, 1996
Science espiègle, 1996
Shooted Star, 1996
Successive Partition, 1996
Sweet Ear Sensation, 1996
Vertikale Gesichtsnerven, 1996
Hommage à tous les suicidés, 1997
Mensch und Tier, 1997
Collection of the artist, Wien

JAN LAUWERS
(theater)

The Snakesong, Teil/part 2: Le Pouvoir, 1996
© photo: Jean-Baptiste Dorvault

ANTONIA LERCH
(filmmaker)

Letzte Runde, 1997
Last Round
video, colour, ca 90'
Production: Romeo – Film, Berlin
Commissioning editor: arte/ZDF, Anne Even
Produced with the support of SONY

HELEN LEVITT

New York, 1936
New York, 1937
New York, 1938
New York, 1938
New York, 1938
New York, 1938
New York, 1938
New York, 1938
New York, 1938
New York, 1938
New York, 1938
New York, 1938
New York, 1939
New York, 1939

New York, 1939
(published in A way of seeing, 1981)
New York, 1939
(published in A way of seeing, 1981)

New York, 1941
black & white photograph,
vintage print
23,1 x 15,8 cm

New York, 1942

Collection Laurence Miller and Laurence Miller Gallery,
New York

New York, 1937
Collection Sandra Alvarez de Toledo, Paris

New York, 1938
Morgan, Evan and Compagny Inc.New York, N.Y.

New York, ca. 1939
New York, ca. 1939
New York, ca.1939
New York, ca. 1939
New York, ca. 1939
Mexico City, 1941
Fraenkel Gallery, San Francisco

In the Street, East Harlem 1945–46
Copyright Helen Levitt

CHRIS MARKER
Immemory, 1996–97
CD-Rom Installation
(will be presented in September)

Production: Centre Georges Pompidou, Musée national
d'art moderne, Paris-Films de l'Astrophore

KERRY JAMES MARSHALL

Better Homes Better Gardens, 1994
acrylic and collage on unstretched canvas
254 x 365,7 cm
Collection Denver Art Museum. Funds from Polly and
Mark Addison, the alliance for Contemporary Art, Caro-
line Morgan, and Colorado Contemporary Collectors

Many Mansions, 1994
The Art Institute of Chicago, Max W. Kohnstamm Fund,
1995.147

Untitled (Altgeld Gardens), 1995
Collection Johnson County Community College,
Overland Park, Kansas

Watts 1963, 1995
The Saint Louis Art Museum, Museum Minority Artists
Purchase Fund

CHRISTOPH MARTHALER/ANNA VIEBROCK
(theater)

Hochzeit, 1995
© photo: Matthias Horn

GORDON MATTA-CLARK †

Reality Properties – Fake Estates: Block 3398, Lot 116,
1973
Window Blow-Out, 1976
Collection Generali Foundation, Wien

City Slivers, 1976
Film, 16 mm, colour, silent, 15′
film still: Werner Kallgofsky
Courtesy of the Gordon Matta-Clark Trust

STEVE MCQUEEN

Catch, 1997
video, colour, 1′54″, silent
Courtesy of Anthony Reynolds Gallery, London and
Marian Goodman Gallery, New York
Produced with the support of SONY

YANA MILEV

A.O.B.B.M.E.
Research <– Urban –> Intervention
Expeditionen – Exkursionen, Kassel 1997
*Projektionsforum mit Material aus "Kinetisches
Archiv"*, 1996–97
A.O.B.B.M.E.
Research <– Urban –> Intervention
Expeditions – Excursions, Kassel 1997
*Projection Forum with material from the "Kinetic
archive"*, 1996–97
2 slide projectors (160 slides), 1 crossfading unit, 1
suspension ca. 200 cm, double projection ring, motor
variable dimensions
installation view Galerie EIGEN+ART, Berlin, 1996
© photo: Uwe Walter
Collection of the artist, Courtesy Galerie EIGEN+ART,
Leipzig/Berlin

MARIELLA MOSLER

Installation, 1997
Collection of the artist, Hamburg

Linien und Zeichen
installation view Künstlerhaus Bethanien, Berlin, 1996
detail
© photo: Friedhelm Hoffmann

JEAN-LUC MOULÈNE

Project documenta X, 1997
model: 11 ektachromes 4 x 5"; media planning

REINHARD MUCHA

Wartesaal, 1979 – 82/1997 (1983)

Auto Reverse, 1994 – 95 (1997)
2 scooters, 16mm endless loop black and white film
projection, light box with black and white transpa-
rency, audio-tape deck with two endless tapes and
auto-reverse operation, amplifier, 2 loudspeakers,
projection stand on wheels, 2 electrical cable reels, 1
wall piece (diptych of roundels)
variable dimensions
installation view Anthony d'Offay Gallery, London,
1995
Collection Reinhard Mucha, Düsseldorf

CHRISTIAN PHILIPP MÜLLER

Ein Balanceakt /A Balancing Act, 1997
– balancing bar, natural oak and polished brass:
2 x (300 x diam: 5 cm)
– Betacam video, colour, sound, ca 20'
camera and editing: Jan Lackner
– photo and text documentation, framed
– captions, german/english
serigraph under acrylic glass
– wall text, german/english
black letters on adhesive film, mat
– display with pamphlets, german/english
first edition 10.000 items

Courtesy of the artist, New York
This work was made possible with the support of: Die-
ter Schwerdtle, George Baker, Karin Steckel, docu-
menta-Archiv, Verein 7000 Eichen, Dia Art Foundation,
Heiner Friedrich, Philippe Petit, Heinz Weidner, Jeff
Preiss, Universität Lüneburg, Fachbereich Kulturwissen-
schaften, SONY, Pro Helvetica.

MATT MULLICAN
(internet)

Up to 625, 1997
internet project
URL: http://www.documenta.de
Production documenta X

ANTONI MUNTADAS
(internet)

On Translation: The Internet Project, 1997
internet project
URL: http://www.documenta.de
Co-production documenta X; sgg*; Goethe Institut;
äda'web

MATTHEW NGUI

"You can order and eat delicious poh-piah" amongst
other things, 1997
installation/performance: mixed media, industrial,
ingestible, photographic material, bitsa this and bitsa
that.
Performance: from June 19 to 29
part of ground floor, part of second floor and
external wall

This project was made possible with the support of: Na-
tional Arts Council, Singapore and the Australia Council

You Can Order and Eat Char Kwey Teow
(Cooking fried Rice)
installation view Biennale São Paulo, 1996

CARSTEN NICOLAI

"∞", 1997
SPIN – 72 soundloops – soundgraffiti located at
 several places in Kassel and surroundings
 (airport, radio, railway station, shop, ...)
SIGN – abstract logo ❶ located in different forms
 at several places throughout the city
STAGE – designed space at the eye of the double
 helix of the Kaufhof parking entrance.
 painted logo on parachute silk + stage
 Ø 900 cm
 sound piece (Noto and guests: Ø, Komet,
 Byetone): 21th June; 10 p.m. – open end
RADIO PROJECT: 72 soundloops, Hessischer Rund-
funk

This work has been made possible with the support of:
Hessicher Rundfunk; Kaufhof, Kassel; Forum Bahnhof,
Geschäftsbereich Personenbahnhöfe der Deutschen
Bahn AG.

NOTO
installation view EIGEN+ART, Berlin, 1996
© photo: Uwe Walter

OLAF NICOLAI

Interieur/Landschaft. Ein Kabinett, 1996–97
installation with wall paper, stones, plants, photo-
graphs, platforms
variable dimensions

Interieur/Landschaft
installation view Carl Zeiss Jenoptik AG, Jena, 1996
detail
© photo: Uwe Walter

Courtesy EIGEN+ART Leipzig/Berlin
This work was made possible by the support of the
Botanical Garden of the University of Leipzig

STANISLAS NORDEY
(theater)

Le Songe d'une nuit d'Eté, 1995
Photo: Mark Enguerand

HÉLIO OITICICA †

Maquette para Projeto Caes de Caça, 1960
B1 Bólide Caixa 1, 1963 *"Cartesiano"*
B2 Bólide Caixa 2, 1963 *"Platônico"*
B3 Bólide Caixa 3, 1963 *"Africana"*
B4 Bólide Caixa 4, 1963 *"Romeu e Julieta"*
B5 Bólide Caixa 5, 1963 *"Ideal"*
B7 Bólide Vidro 1, 1963
B6 Bólide Caixa 6, 1963–64 *"Egípcio"*
B8 Bólide Vidro 2, 1963–64
B10 Bólide Caixa 8, 1964
B11 Bólide Caixa 9, 1964
B12 Bólide Vidro 3, 1964
B13 Bólide Caixa 10, 1964
B14 Bólide Caixa 11, 1964
Bólide Caixa, 1964
B15 Bólide Vidro 4, 1964 *"Terra"*
B17 Bólide Vidro 5, 1965 *"Homenagem a Mondrian"*
B18 Bólide Vidro 6, 1965 *"Metamorfose"*
B21 Bólide Vidro 9, 1965 *"Dedicado a Pierre Restany"*
B22 Bólide Vidro 10, 1965 *"Homenagem a Male-*
vitch", Gemini I
B25 Bólide Caixa 14, 1964–66
Variation of *Bólide Caixa 1*
B28 Bólide Caixa 15, 1965–66
Variation of *Bólide Caixa 1*
B29 Bólide Caixa 16, 1965–66
Variation of *Bólide Caixa 1*
B31 Bólide Vidro 14, 1965–66 *"Estar" 1*

Collection Projeto Hélio Oiticica, Rio de Janeiro

*Do meu sangue/do meu suor/este mor viverá, Bólide
Caixa 17 Poema Caixa,* 1965–66
Private Collection, London

B32 Bólide Vidro 15, 1966
B39 Bólide Luz 1, 1966 *Apropriaçã 3, Plastiscópio*
B40 Bólide Plástico 1, 1966
B41 Bólide Plástico 2, 1966
B42 Bólide Plástico 3, 1966
B46 Bólide Plástico 4, 1966–67
B47 Bólide Caixa 22, 1966–67 *"Morgulho do Corpo"*
B48 Bólide Caixa 23, 1967 *"Do Mal"*
Collection Projeto Hélio Oiticia, Rio de Janeiro

Bólide Caixa 18 Homenagem a Cara de Cavalo, 1967
Collection Museu de Arte Moderna do Rio de Janeiro,
Rio de Janeiro

Bólide Vidro para "Ursa" em Eden, 1969

Parangolé P2 Bandeira 1, 1964
Parangolé P3 Tenda 1, 1964
Parangolé P4 Capa 1, 1964
Parangolé P6 Capa 3, 1964 *"Pedrosa"*
Parangolé P5 Capa 4, 1964–65 *"Homenagem a
Lygia Clark"*
Parangolé P5 Capa 4, 196465 *"Homenagem a
Lygia Clark"* (replica)
Parangolé P8 Capa 5, 1965 *"Mangueira", Homena-
gem a Jernimo da Mangueira*
Parangolé P8 Capa 5, 1965 *"Mangueira" Homena-
gem a Jernimo da Mangueira* (replica)
Parangolé P10 Capa 6, 1965 *"Dedicado a Mosquito
da Mangueira"*
Parangolé P15 Capa 9, 1967 (replica)
Parangolé P16 Capa 12, 1967 *"Da Adversidade
Vivemos"*
Parangolé P17 Capa 13, 1967 *"Estou Possuído"*
Parangolé P17 Cape 13, 1967 *" Estou Possuído"*
(replica)
Parangolé P22 Capa 18, 1968 *"Nirvana" com Antonio
Manuel*
Parangolé P25 Capa 21, 1968 *"Xoxôba" Homenagem
a Nininha da Mangueira* (replica)
Parangolé P32 Capa 25, 1972
Parangolé P33 Capa 26, 1972
Parangolé, 1979 *"Noblau"* (replica)
Parangolé, 1979 *"Rouge"*

Vitrine (Documents) :
Drawing plan for *Penetrável 1,* 1960
Folder with the text of Mário Pedrosa for the first

presentation of *Projeto Caes de Caça*, 1961
Study for *Bólide Caixa*, April 4th 1963
Studies for *Parangolé "Cabelairas"*, 17th March 1964
Study for *Penetrável-Parangolé*, 09 September 1964
Study for *Parangolé Capa 4 "Fernandes"*, June 1st 1965
Studies for *Bólide Vidro*, *Série Estar*, 1965
Maquette for *Parangolé P30 Capa 23*, 1965–71
Hélio Oiticica with *Bólide Caixa 18 Poema-Caixa 2*, 1965–66, "Homenagem a Cara de Cavalo",
© photo: Claudio Oiticica, 1967
Parangolé at Whitechapel Art Gallery, London 1969,
© photo: Hélio Oiticica
Study for *Parangolé de Cabeça*, 1976
Collection Projeto Hélio Oiticica, Rio de Janeiro

Hélio Oiticica in his studio, Ataulfo de Paiva, Rio de Janeiro, 1972

GABRIEL OROZCO

Black Kites, 1997
lead on bone
22,8 x 16,5 x 12,7 cm
Courtesy of the artist and Marian Goodman Gallery, New York

ADAM PAGE

Executive box, 1997
1 wooden bench. 1 container expanding on use into an executive box (V.I.P. Raum: german translation) with panoramic window view across Friedrichsplatz, table with built-in lightbox, 5 chairs, pay phone, fax, drinks machine, television and video player. All-weather carpet and metal track.
Executive box is available for use without charge from 10:00h to 20:00h daily during *documenta* X for appointments, transactions, entertaining or private concentration. Bookings for use of the space can be made on tel: (0561) 7072–70 and at the *documenta* X information container on Friedrichsplatz.
280 x 400 x 97 cm (not in use)
280 x 400 x 485 cm (in use)
Collection of the artist, Dresden
This project was made possible with the generous support of the Dresdner Kunstverein, Hübner Gummi – und Kunststoff GmbH, Kassel, Volkswagen Coaching GmbH Kassel, MVS Miete Vertrieb Service AG, Kassel and Jens Zender (architect).

MARC PATAUT

Projet du Grand Stade Plaine Saint Denis, 1994–95
black & white photographs
10 x 12 cm each
Courtesy Galerie Sylviane de Decker Heftler, Paris

RAOUL PECK
(filmmaker)

Le Temps des Lassitudes, 1997
Zeit der Müdigkeit
Times of Lassitude
video, colour, ca 20'

Production: JBA production, Jacques Bidou, Paris
Commissioning editor: arte/WDR, Ute Casper
Produced with the support of SONY

MARKO PELJHAN

MAKROLAB
autonomous modular solar and wind powered communication and survival environment
(a LADOMIR project – insulation/isolation strategy)
PROJEKT ATOL – PACT, 1997

duration phase 1: 40 days/reflection period: 30 days/manifestation phase 1: 10 days

location phase 1: LUTTERBERG, Kassel
N: 51° 23' 10"
E: 9° 35' 40"
altitude: 330 m
QTH-Locator: JO 40 SJ
radio beacon: 144.9625 MHz
call sign: DH/S57NTS

www: http ://makrolab.ljudmila.org
e-mail: makrolab@ljudmila.org
weekly news bulletin on HR 2, from June 21 on

project director: Marko Peljhan/collaborators: Borja Jelic, Frank Köditz, Christian Mass, Brian Springer/ engineers: Boštjan Hvala, Jurij V. Krpan/construction engineer: Goran Šalamon/concept production support: Špela Mlakar
590 x 1420 x 570 cm

MAKROLAB – CONSOLE
communication unit for *MAKROLAB* contacts
PROJEKT ATOL – PACT, 1997

wood, video-link, internet connection, personal computer, two monitors, radiotelephone
http://makrolab.ljudmila.org
e-mail: mconsole@ljudmila.org

Coproduction: Projekt Atol, *documenta X*, Hessischer Rundfunk, Global Teleport-BS
with the support of: City secretariat for culture and research, Ljubljana; Damm & Co. Qualitätsguß KG, Fuldabrück; Frank Köditz Nachrichtentechnik, Kassel; ISET, Kassel; LJUDMILA, Ljubljana; LoGING d.o.o, Novo Mesto.; Massimo Osti Production, Bologna; Ministry of Culture of the Republic of Slovenia, Ljubljana; Mobitel d.d., Ljubljana; REMA Tip Top d.o.o., Ljubljana; Savaprojekt d.d., Krško; SCCA, Ljubljana; SONY; SRC Computers d.o.o., Ljubljana; VHT GmbH, Enger

MICHELANGELO PISTOLETTO

Oggetti in meno, 1965–66:
 Colonne di cemento, 1965
 Lampada a mercurio, 1965
 Paesaggio, 1965
 Piramide verde, 1965
 Pozzo, 1965
 Pozzo, 1965
 Quadro da pranzo, 1965
 Rosa bruciata, 1965
 Sfera sotto il letto, 1965
 Specchio, 1965
 Bagno, 1965–66
 Casa a misura d'uomo, 1965–66
 Corpo a pera, 1965–66
 Fontana luminosa, 1965–66
 Letto, 1965–66
 Mica, 1965–66
 Mobile, 1965–66
 Scultura lignea, 1965–66
 Semisfere decorative, 1965–66
 Struttura per parlare in piedi, 1965–66
 Teletorte, 1965–66
 Ti Amo, 1965–66
 Vetrina, 1965–66
 Vetrina-Specchio, 1966
 Lé orecchie di Jasper Johns, 1966
 Metrocubo d'infinito, 1966
 Pozzo-Specchio, 1966
 Sarcofago, 1966
 Pozzo culla, 1966–68
A.C.P. Collection, Turin

Mappamondo, 1966–68
Collection Lia Rumma, Napoli

L'ufficio dell' Uomo Nero, from 1969
(The Office of the Black Man)
3 black & white photographs of "Oggetti in meno 65–66", paper on wood (294 x 400 cm, 250 x 338 cm (2)); 1 desk; 1 telephon; 1 monitor for video "Progetto Arte" Wien 1994 (30'), 1 monitor for video "Progetto Arte" München 1995 (43'); 1 monitor for video "Progetto Arte" Bucarest, Prato, Wien 1996–97 (32'); 1 monitor and 1 computer for instructions recording and saving visitors Art Signs.
Presentation and sale of publications on "Progetto Arte"

Rotazione dei corpi, (1973–89)
Segno Arte – Table, 1976
Segno Arte – Panca, 1976–93
Segno Arte – Plate, 1997
Collection of the artist, Turin

installation view Museo Civico, Bologna, 1970
© photo: P. Mussat

LARI PITTMAN

Once a Noun, Now a Verb, 1997
flat oil on 4 mahogany panels with attached framed work on paper and 3 attached framed works on panel
241,3 x 650,4 cm overall
Courtesy of the artist. Regen Projects, Los Angeles; Jay Gorney Modern Art, New York & Studio Guenzani, Milan

EMILIO PRINI

Muro in curva, Rilevamento del 67
Private Collection

Standard, 1967
Collection Giuliano & Anna Perezzani, Sanguinetto

Flaque de Couleur, 1973
Fermacarte
(Versione de Strasbourg, 1995)
Galerie Kienzle & Gmeiner, Berlin

1984 Vitrina, 1974 Cubo
© photo: S. Licitra

STEFAN PUCHER
(theater)

Ganz nah dran, 1996
© photo: Wonge Bergmann

DAVID REEB

Let's have another war, 1997
acrylic on canvas
160 x 140 cm

Let's have another war, 1997
Let's have another war, 1997
Let's have another war, 1997
Let's have another war, 1997
Let's have another war, 1997
Let's have another war, 1997
Let's have another war, 1997
Collection of the artist

Let's have another war, 1997
Courtesy Givon Gallery, Tel Aviv

Let's have another war, 1997
Collection of H. Brandes Family

GERHARD RICHTER

Atlas, 1962–1996
drawings, sketches, archive, photographic studies on
panels
633 panels
51,6 x 66,6 cm; 36,6 x 51,6 cm
60 x 80 cm; 40 x 30 cm (framed)
Städtische Galerie im Lenbachhaus, München

Atlas
installation view Städtische Galerie im Lenbachhaus,
München, 1989
detail
© photo: Gänsheimer

LIISA ROBERTS

Trap Door, 1996
four synchronised 16 mm silent film projections in
black and white and colour, continuous loops each,
6'; four film loopers and aluminium stands; four vinyl
screens, three translucent and one opaque
variable dimensions
installation view Lehmann Maupin, New York, 1997
© photo: Nicholas Walster
Courtesy of the artist and Lehmann Maupin, New York.
Commissioned by the Museum of Modern Art Oxford

ANNE-MARIE SCHNEIDER

"I.V.G.", 1997
Maastricht, 1996
Marché aux voleurs, 1996
Saint Bernard, 23 août 1996, Paris, 1996
Saint Bernard, 23 août 1996, Paris, 1996

Saint Bernard, Paris, 23 août 1996
charcoal on paper
32 x 38 cm

Sans titre, août 1996
Sans titre, 1996
Sans titre, 1996
Sans titre, 1996
Sans titre, 1997
Sans titre, 1997
Sans titre, 1997
Sans titre, 1997
Sans titre, 1997
Sans titre, 1997
Sans titre, 1997
Sans titre, 1997
Collection of the artist, Paris

JEAN-LOUIS SCHOELLKOPF

(Saint-Etienne), 1986–1996
Cibachrome and black & white photographs
mounted on aluminum
24 x 30 cm, 20 x 24 cm
55 x 66 cm et 55 x 47
Collection of the artist, Saint Etienne

THOMAS SCHÜTTE

Liebesnest, 1997
oil on wood
155 x 143 x 210 cm
197 x 143 x 210 cm
261 x 143 x 210 cm
© photo: Werner Maschmann

Portrait L., 1996

Mann und Frau, 1986
Private Collection, Belgium

MICHAEL SIMON
(theater)

Newtons Casino, Raumentwurf, 1990
© photo: Michael Simon

ABDERRAHMANE SISSAKO
(filmmaker)

Rostov-Luanda,
digital video, colour, ca 90'
Production: Movimento Production, Christian Baute,
Pierre Hanau, Paris
Commissioning editor: ZDF, Claudia Tronnier
Produced with the support of SONY

ALISON & PETER SMITHSON with Nigel Henderson

Grille de Alison & Peter Smithson, Ciam Aix-en-
Provence, 1952–53
Collage; photographs (by Nigel Henderson), ink and
stencil mounted on card and canvas; 8 panels
55 x 260 cm framed
Collection Musée national d'art moderne, Centre Geor-
ges Pompidou, Paris. Achat du Centre George Pompi-
dou, 1993

ALEXANDER SOKUROW
(filmmaker)

Mutter und Sohn/Mat' i sin, 1997
Mother and Son
35 mm film, colour, 82'
Production: Zero-film GmbH, Thomas Kufus, Berlin

NANCY SPERO

Bomb Proliferation, 1966
Collection Karen Davidson, New York

La Bombe, 1966
Courtesy Barbara Gross Galerie, München and Galeria
Stefania Miscetti, Roma

The Male Bomb, 1966
Courtesy Barbara Gross Galerie, München and Galeria
Stefania Miscetti, Roma

Les Anges – La Bombe, 1966
Courtesy Barbara Gross Galerie, München and Galerie
Montenay, Paris

Rifle/Female Victim, 1966
Courtesy Rhona Hoffman Gallery, Chicago and Jack
Tilton Gallery, New York

Bomb & Victims in Individual Bomb Shelters, 1967
Courtesy Rhona Hoffman Gallery, Chicago and P.P.O.W.,
New York

Canopic Son, Swastika Eagle, 1967
Courtesy Barbara Gross Galerie, München and Rhona
Hoffman Gallery, Chicago

Christ and the Bomb, 1967
Courtesy Barbara Gross Galerie, München and Galerie
Montenay, Paris

Helicopters, Soldiers, Victims, 1967
Courtesy Barbara Gross Galerie, München and Rhona
Hoffman Gallery, Chicago

Victims, 1967
Courtesy Barbara Gross Galerie, München and Galerie
Christine König & Franziska Lettner, Wien

Clown and Helicopter, 1968
Collection Tim Rollins, New York

Helicopter, Pilot, Victim, 1968
Courtesy Barbara Gross Galerie, München and Jack
Tilton Gallery, New York

Male Bomb – Rape, 1968
Courtesy Barbara Gross Galerie, München and Galerie
Christine König & Franziska Lettner, Wien

S.U.P.E.R. P.A.C.I.F.I.C.A.T.I.O.N., 1968
Courtesy Barbara Gross Galerie, München and Rhona
Hoffman Gallery, Chicago

The Great Mother Victim, 1968
Gouache and ink on paper
100,5 x 62,8 cm
© photo: David Reynolds
Courtesy Barbara Gross Galerie, München and P.P.O.W.,
New York

GOB SQUAD
(theater)

Work, 1996
© photo: Gob Squad

ERIK STEINBRECHER

FARMPARK/Station, 1997
16 posters – digital photoprints
ca 84 x 60 cm
Collection of the artist, Zürich/Berlin

MEG STUART
(theater)

No One Is Watching, 1995
© photo: Matthias Zölle

HANS-JÜRGEN SYBERBERG

Cave of Memory, 1997
A film to enter as room with 31 video/films 60', each,
shown on 21 monitors and 10 video projectors in six
stations: Schleef, Kleist, Goethe, Raimund, Mozart,
Beckett

Hélène Delavaut: sings Faust compositions at the pre-
miere of Faust 1819 by Anton Radziwill in Palais Rad-
ziwill, Berlin, Wilhelmstrasse 77
Klavier Susan Manoff
Margarethe Krieger: drawings Oskar Werner/Faust
1996 (from unpublished sound fragments from her
own archive: recorded 1983/1984 died 1984)
electronical editor: Lothar Albrecht; Johannes
Greberg: assistant of the Berlin shooting (Hélene
Delavaut/Susan Manoff)

A production of Syberberg Filmproduktion and Hebbel
Theater Berlin in co-operation with *documenta* X, Kassel
With the support of Alexander Kluge for providing
Schleef material, other material to Wilhelmstraße 1941
(22. Juli) and Wilhelmstraße 77, Bunker Reichskanzlei
heute ("Auf dem Müllplatz der Geschichte"); of ARRI
Munich & SONY Köln/Munich; of Suhrkamp Verlag; of
Süddeutscher Rundfunk and of ORF/arte.

SLAVEN TOLJ

Untitled, 1997
St Ignacie
two ambient light bulbs
diam: ca 40 cm each
© photo: Ana Opalic

TUNGA

Inside out upside down (Ponta Cabeça), 1994–1997
installation/performance on:
 June 19 at 4 p.m.
 June 20, 21, 22 at 11 a.m.
 September 5, 6, 7, 27, 28 at 11 a.m.

Collection of the artist and Marc Pottier
This project has been made possible with the generous
support of: Museu de Arte Moderna da Bahia; "Le feutre
S.A.", Paris; Jean-René de Fleurieu, Paris; Forum Bahnhof,
Geschäftsbereich Personenbahnhöfe der Deutschen Bahn
AG; Aga Ousseinou, New York; Christophe Lebourg, Paris.
In collaboration with the students of the Westfalen-
Kolleg Paderborn

URI TZAIG

The Universal Square/The Movie, 1996
a video screening room, theater seats, video, colour,
30', in loop, text by Uri Tzaig translated from hebrew
in french
250 x 450 x 450 cm
Private collection Brussels

a poster, 1997
Collection of the artist, Tel Aviv

with the support of: Israel Cultural Affairs and Foreign
Ministery

Desert, 1997
Collection of the artist, Tel Aviv

DANIELLE VALLET KLEINER

Istanbul – Helsinki, 1994–1997
(La traversée du vide)
– *Istanbul – Helsinki (La traversée du vide)*, 1997
black & white and colour Super 8 film and colour
video, 43', sound, transferred to Betacam
– *Inspection Istanbul – Helsinki*, 1997
black & white Super 8 film and black & white and
colour video, 6' 27"; transferred to Betacam: with the
collaboration of Jean-Paul Gratia
– *Istanbul – Helsinki (La traversée du vide)*, 1996
21 black & white and colour photographs
back cover: Jean-Christophe Bailly
book: 220 p.; 21,5 x 12,5 cm
edition of 250, signed, dated and numbered by the
artist
Editions Voix, Richard Meier, Montigny, 1996

ED VAN DER ELSKEN †

Photographs (1959–1960) published in *Sweet Life*, New
York, Harry N. Abrams, 1966:

Durban, South Africa, 1959–60, pp. 8–9
black & white photograph
25,4 x 38,5 cm

Durban, South Africa, 1959–60, pp. 14–15
Burutu, Nigeria, 1959–60, p. 16
Durban, South Africa, 1959–60, p. 17
Manilla, Philippines, 1959–60, pp. 36–37
Manilla, Philippines, 1959–60, p. 40
Manilla, Philippines, 1959–60, p. 41
Hong-Kong, 1959–60, p. 56
Hong-Kong, 1959–60, p. 57
Hong-Kong, 1959–60, pp. 58–59
Hong-Kong, 1959–60, p. 62
Hong-Kong, 1959–60, p. 70
Hong-Kong, 1959–60, pp. 72–73
Lo Wu (village on the border, between China and
Hong-Kong), 1959–60, pp. 48–49
Tokyo, Japan, 1959–60, p. 78
Tokyo (Koichi Karahara, Sony's director), Japan,
1959–60, pp. 80–81
Tokyo, Japan, 1959–60, p. 85
San Francisco, 1959–60, pp. 104–05
Disneyland, 1959–60, pp. 116–17
New York, 1959–60, pp. 124–25
New York, 1959–60, pp. 126–27
New York (Harlem), 1959–60, p. 128
New York (Harlem), 1959–60, p. 128
New York (Harlem), USA, 1959–60, p. 128

New York (Harlem), USA, 1959–60, p. 128
New York (Coney Island), 1959–60, pp. 130–31
New York, 1959–60, p. 140
New York (Harlem), USA, 1959–60, p. 141
Guadalajara, Mexico, 1959–60, p. 148
Mexico, Mexico, 1959–60, p. 150
Mexico (Diego Rivera's frescoe), Mexico, 1959–60,
p. 151
San Cristobal de las Casas, (Chiapas), Mexico,
1959–60, p. 162
Cuernavaca, Mexico, 1959–60, pp. 166–67
San Juan Chamula, Mexico, 1959–60, pp. 166–67
San Juan Chamula, Mexico, 1959–60, pp. 166–67
Collection Prentenkabinet Rijksuniversiteit Leiden

New York, USA, 1959–60, pp.144–45
San Francisco, USA, 1959–60, pp.166–67
New York, (Harlem), USA, 1959–60, p.128
New York (Harlem), USA, 1959–60, p.14243
Collection Anneke van der Elsken, Courtesy Galerie
Rudolf Kicken, Köln

book: *La douceur de vivre*, Editions Cercle d'art, Paris,
1966
Sweet Life, Köln, Dumont, 1966
Sweet Life, Buchgemeinschaftsausgabe, 1966
Sweet Life, New York, Harry N. Abrams, 1966
Sweet Life, De Bezige Bij, 1966
Sweet Life, Barcelona, Editorial Lumen, 1967
Sweet Life, Tokyo Photographic School, 1968
Collection Anneke van der Elsken

ALDO VAN EYCK

MARIJKE VAN WARMERDAM

Rijst (Rice), 1995
16 mm film, colour, projector, loop system, shelf,
paperscreen
edition of 5
15,4 x 21 cm paperscreen
© photo: Tom Haartsen
Collection of the artist

CARL MICHAEL VON HAUSSWOLFF

*Power electric controller posing a static mobil –
machung program for some possible actions*, 1997
(For Erik Pauser and Leif Elggren)
electric fence controller, wire, amplifier, loudspeaker
variable dimensions

Courtesy Andréhn – Schiptjenko, Stockholm
with the support of the International Programme of
Moderna Museet, Stockholm

Alte Schwede/Alte Deutsche, 1997
Production Hessischer Rundfunk

MARTIN WALDE

Loosing Control/Script 5, putzen, 1993
Loosing Control/Script 8, apple/cut/man, 1993
Loosing Control/Script 9, zählen, 1993
Loosing Control/Script 10, Endstation, 1993
Loosing Control/Script 13, keine Bewegung, 1994
Loosing Control/Script 18, C. Didrichson, 1995
Loosing Control/19, IN BETWEEN SCRIPTS, 1995
Loosing Control/Script 21, short man, 1995
Its a perfect moment (From the *Storyboards*), 1996
Loosing Control/Script 22, she was lying there, 1996
Loosing Control/Script 24, he came in so normally,
1996
Loosing Control/Script 25, scissorhands, 1996
Loosing Control/Script 26, it stinks, 1996
Loosing Control/Script 27, don't know, 1996
Loosing Control/Script 28, poor thing, 1996
Loosing Control/Script 29, how he's gonna move,
1996
Loosing Control/Script 30, no he was much older,
1996
Loosing Control/Script 31, white running shoes, 1997
Loosing Control/Script 32, no man, 1997
Loosing Control/Script 34, synchron/grain by grain,
1997
Loosing Control/Script 35, Happy hour, 1997
Handmate, 1997
(A collection of approx. 200 samples in progress)
Worm Complex, 1997
Loosing Control/Script 2, wenig Licht (1990), 1997
Edited by the artist, 1997
Loosing Control/Script 7, Federn (1990), 1997
Edited by the artist, 1997
Loosing Control/Script 26, it stinks (1996), 1997
Published by Graphische Kunstanstalt–Otto Sares
 GmbH, Wien, 1997
Loosing Control/Script 28, poor thing (1996), 1997
Published by Graphische Kunstanstalt–Otto Sares
 GmbH, Wien, 1997
Loosing Control/Script 31, white running shoes, 1997
Published by Graphische Kunstanstalt–Otto Sares
 GmbH, Wien, 1997
Collection of the artist. Courtesy Galerie Krinzinger,
Wien

Hallucigenia, 1997
Polyurethane/Die-Casting
Auflage: vorraussichtlich 250
15,5 x 18,5 x 8 cm; 22 x 16 x 10,5 cm
Edition *documenta* X, Schellmann, München/New York

JEFF WALL

Milk, 1984 (exhibition copy, 1997)
Collection FRAC Champagne-Ardennes, Reims
A Sunflower, 1995
Courtesy Marian Goodman Gallery, New York

Housekeeping, 1996
black & white photograph, paper mounted on panel,
wooden frame
edition of 2
192 x 258 cm

Citizen, 1996
Cyclist, 1996
Passerby, 1996
Volunteer, 1996
Collection Jeff Wall, Vancouver. Courtesy Marian
Goodman Gallery, New York/Galerie Johnen & Schöttle,
Köln

LOIS WEINBERGER

Das über die Pflanzen/ist eins mit ihnen, 1990–97
Zelle, 1990–97
Brennen und Gehen, 1992–97
broken asphalt, spontaneous vegetation
Wegwarte (Cichórium intybus), 1995
Wegwarte (Cichórium intybus), 1996
Courtesy Galerie Christine König & Franziska Lettner,
Wien

Onopordon acanthium, 1994/95
Private Collection, Amsterdam

Brennen und Gehen, Szene Salzburg, 1993

FRANZ WEST

Dokustuhl, 1997
stacked chairs, covered with senegalfancyprint

Demand of Sense, 1997
21 parts, mixed media
overall ca. 600 x 150 cm
Courtesy David Zwirner and the artist

GARRY WINOGRAND †

New York City, 1966
Untitled, 1967
New York City, 1968
Untitled, 1968
New York City, 1969
New York City, 1969
New York City, 1970
Untitled, 1970

Untitled, 1971
black & white photograph
27,9 x 35,5 cm

New York City, 1972
Untitled, 1972
New York, before 1976
Untitled, nd
Untitled, nd
Untitled, nd
Untitled, nd
Untitled, nd
Untitled, nd
Untitled, nd
Untitled, nd
Fraenkel Gallery, San Francisco

EVA WOHLGEMUTH (SYSTEM I-VI with
ANDREAS BAUMANN)
(internet)

Location Sculpture System, 1997
project adapted for the internet
URL: http://www.documenta.de

PENNY YASSOUR

Sealed Cape (Acephalus), 1994
iron mould of the railway map, Germany 1938,
impressed into silicon-rubber by vacuum
70 x 180 x 130 cm
© photo: Oded Lebel

Screens (railway map, Germany 1938), 1996

Collection of the artist, Ein Harod Ihud

ANDREA ZITTEL

*A-Z Escape Vehicle Owned and Customized by Bob
Shiffler*, 1996
steel, insulation, wood and glass
152,4 x 101,6 x 203,2 cm
Robert J. Shiffler Collection and Archive, Greenville, Ohio

*A-Z Escape Vehicle Owned and Customized by
Andrea Rosen*, 1996
Collection of Andrea Rosen, New York

*A-Z Escape Vehicle Owned and Customized by Dean
Valentine with "Optional Trailer Hitch for A-Z Escape
Vehicle"*, 1996
Collection Dean Valentine, Beverly Hills, California

*A-Z Escape Vehicle Owned and Customized by
Rachel and Jean-Pierre Lehmann*, 1996
Collection Rachel and Jean-Pierre Lehmann, New York

*A-Z Escape Vehicle Owned and Customized by
Miuccia Prada*, 1997
Collection Miuccia Prada, Milan

*A-Z Escape Vehicle Owned and Customized by the
Israel Museum*, 1997
Collection of the Israel Museum, Jerusalem

HEIMO ZOBERNIG

Ohne Titel, 1997
display for "100 Days – 100 Guests"

documenta X thanks all its sponsors
documenta X dankt ihren Sponsoren

Deutsche Bahn

SONY

Sparkasse Landesbank LBS SparkassenVersicherung

BINDING

Deutsche
Städte-Reklame
GmbH

documenta X

Organization 100 days – 100 guests/Organisation 100 Tage –
100 Gäste

Thomas Köhler
Consultant/Beratung
Nadia Tazi
Assistance/Assistenz
Barbara Großhaus
Collaborators/Mitarbeit
Marina Filippova
Juliane Heise
Elke Pfeil
Eberhard Weyel
Theresia Wienk
Website
Curator/Kurator
Simon Lamunière
Assistance/Assistenz
Ralf Knecht
Collaborator/Mitarbeit
Maren Köpp
Antje Weitzel
Theater Outlines/Theaterskizzen
Curator/Kurator
Tom Stromberg
Collaborator/Mitarbeit
Jens Hoffmann
Filmproducer
Brigitte Kramer
Press Contact/Pressesprecherin
Maribel Königer
Marketing and Public Relations/Marketing
und Öffentlichkeitsarbeit
Andreas Knierim
Collaborators/Mitarbeit
Ellen Blumenstein
Bettina Lange
Veronika Rost
Nicola Schäfer
Martina Schütz
Marion Sprenger
Ursula Tanneberger
Publications/Publikationen
Coordinating Editor/Redaktion und Koordination
Françoise Joly
Editor/Redaktion
Cornelia Barth
Assistance/Assistenz
Jutta Buness
English Editor/Englisches Lektorat
Brian Holmes
Design/Gestaltung
Lothar Krauss

Technical Department and Logistics/Technische Leitung
und Logistik
Winfried Waldeyer
Barbara Heinrich
Martin Müller
Carolin Rath
Organization of the Exhibition Buildings/Organisation der
Ausstellungsgebäude
Dieter Fuchs
Ralf Mahr
Christian Rattemeyer
Knut Sippel
H. P. Tewes
Installation Team/Aufbauteam
Pablo Alonso
Volker Andresen
Elena Caravajal Diaz
José de Quadros
Tatiana Echeverri Diaz
Martina Fischer
Heino Goeb
Ulrich Göbel
Hartmut Glock
Daniel Graffé
Peter Graulich
Olaf Hackl
Sidi Hamedi
Martin Hast
Masin Idriss
Sonia Karle
Christiane Krüger
Peter Limpinsel
Britta Lorch
Uwe Richter
Hartmut Schmidt
Katja Schneider
Heinrich Schröder
Eva Tenschert
Anette Zindel
Artists' Assistance/Künstlerassistenz
Stefan Biedner
Rosa Brückl
Daniel Congdon
Stephen Franck
Colin Griffiths
Jim Kanter
Thomas Kaufhold
Peter Lütje
Willem Oorebeck
Paul Petritsch
Georg Schecklinksi
Gregor Schnoll
Reinald Schuhmacher
Richard Sigmund

documenta X

Phil Smith
Michael Staab
Rony Vissers
Restoration/Restauratoren
Jesús del Pozo-Sáiz
Bärbel Otterbeck
Assistance/Assistenz
Carolin Bohlmann
Tilmann Daiber
Ulrich Lang
Maintenance/Haustechnik
Klaus Dunckel
Wolfgang Schulze
Hans-Jörg Weiser
Detlef Laube
Helmut Lottis
Cleaning/Hausreinigung
Angela Damm
Elke Restifo
Technical Consultants/Technische Beratung
Jens Lange (Video)
Frank Thöner (Projektion)
Walter Prause (Bauphysik)
Computer Specialists/Betreuung Hard- und Software
Wolfgang Jung
Uwe Bergmann
Photographer/Photograph
Werner Maschmann
Evaluation
Gerd-Michael Hellstern

Graphics/Graphik
Corporate Design
Büro X, Hamburg
Lo Breier
Sophie Herfurth
Tom Leifer
Barbara Schiess
Gunter Schwarzmeier
Logo
Büro X / Carl van Ommen
Execution in Kassel/Betreuung in Kassel
Design machbar

Guide Service – Visitor Service/
Führungsdienst – Besucherbetreuung
Matthias Arndt
Ulrike Kremeier
GhK-Seminar
Ursula Panhans-Bühler
Michael Wetzel
Moderation Seminar
Christoph Tannert
Thanks for special help/Dank für besondere Zusammenarbeit
Carlos Basualdo, Clémentine Deliss, Ery Camara
Thiam, Paul Sztulman
Organization Collaborators/Mitarbeit Organisation
Sonya Bouyakhf
Regina Caspers
Paul Galvez
Natalija Gavranovic
Mark Kiekheben
Tanja Möller

Guides/Führungen
Marvin Altner, Jens Asthoff, Seyhan Baris, Holger Birkholz,
Annette Brausch, Sabine Brox, Jutta Buness, Simone Buuck,
Dominique Busch, Rika Colpaert, Winnie Decroos,
Berit Fischer, Sabine Flach, Christine Fuchs, Elke Grützmacher,
Anja Helmbrecht, Stefanie Heraeus, Carine Herring,
Katrin Jaquet, Benita Joswig, Elisabeth Kenter,
Anahita Krzyzanowski, Holger Kube-Ventura,
Karin Langsdorf, Evelyn Lehmann, Vera Leuschner, Iris
Mahnke, Ulrike Massely, Christiane Mennicke, Tabea Metzel,
Viola Michely, Carmen Mörsch, Katrin Nölle, Barbara Otto,
Karin Rebbert, Petra Reichensperger, Barbara Richardz-Riedl,
Klaus Röhring, Andreas Rollmann, Claudia Schmähl,
Ulrich Schötker, Iris Schröder, Heike Schüppel,
Stefanie Sembill, Heike Sinning, Ursula Tax, Regina Thein,
Axel Tönnies, Eveline Valtink, Hannie Verwoert, Tobias Vogt,
Stephan Waldorf, Hilke Wagner, Tanja Wetzel,
Ernst Wittekindt

Insurance/Versicherung
AON Artscope, Monheim
Mund & Fester, Hamburg
Transport
hasenkamp Internationale Transporte

*Major Sponsors/*Hauptsponsoren
Deutsche Bahn AG
SONY Deutschland GmbH
Unternehmen der Sparkassen-Finanzgruppe

*Sponsors/*Sponsoren
Binding-Brauerei AG
Deutsche Städte-Reklame GmbH
IBM Deutschland Informationssysteme GmbH
SBK Software + Systeme GmbH
Volkswagen

*Media Partners/*Medienpartner
arte, Der Europäische Kulturkanal
bundmedia

*Supporters/*Förderer
Arbeitsamt Kassel
Centre pour l'image contemporaine Saint-Gervais,
Genf
Coutts Contemporary Art Foundation, Zürich
documenta-Foundation, Kassel
Forum Bahnhof, Geschäftsbereich
Personenbahnhöfe der Deutschen Bahn AG
Francotyp-Postalia GmbH
Goethe-Institut
Hübner Gummi- und Kunststoff GmbH, Kassel
Koch Hightex GmbH, Rimsting
Mannesmann Arcor
Mövenpick Hotel Kassel
MVS Miete Vertrieb Service AG, Berlin
pro-bike, Kassel
Röhm Chemische Fabrik GmbH, Darmstadt
Stahlbau Simon GmbH, Kassel
Bernhard Starke GmbH, Kassel
Volkswagen Coaching GmbH Niederlassung Kassel
Zumtobel Licht GmbH, Usingen
Für das Orangerie-Projekt
Eberhard Mayntz, Berlin

*Coproducers/*Koproduzenten
Cantz Verlag, Ostfildern-Ruit
Edition Schellmann für documenta X,
München-New York
Hebbel-Theater, Berlin
Hessischer Rundfunk, hr 2, Frankfurt
Theater am Turm, Frankfurt

*National Subsiders/*Länderzuschüsse
Gefördert durch die Kulturstiftung der Länder aus
Mitteln des Bundesministeriums des Innern
Australia Council for the Arts, Sydney, Australien
Bundesamt für Kultur, Bern, Schweiz
Bundesministerium für Wissenschaft, Verkehr und

Kunst, Wien, Österreich
Department of Foreign Affairs, Dublin, Irland
Department of Foreign Affairs and International
Trade of Canada, Ottawa, Canada
Embassy of the Republic of South Africa, Bonn
Foundation SPES, Belgien
Fundação Bienal de São Paulo, São Paulo, Brasilien
Italienische Botschaft, Bonn
Kanadische Botschaft, Bonn
Mestna Obcina Ljubljana, Oddelek za Kulturo in
Raziskovalno Dejavnost, Ljubljana, Slowenien
Ministère des Affaires étrangères, Paris, Frankreich;
AFAA - Association Française d'Action Artistique;
sous-direction de la politique du livre et des
bibliothèques; Service culturel de l'Ambassade de
France, Bonn
Ministerium der Flämischen Gemeinschaft, Brüssel,
Belgien
Ministry of Education and Culture, Jerusalem, Israel
Ministrstvo za Kulturo, Ljubljana, Slowenien
Mondriaan Foundation, Amsterdam, Holland
National Arts Council, Singapore
Soros Center for Contemporary Arts - Warschau,
Polen
Soros Center for Contemporary Arts - Zagreb,
Kroatien
Stimuleringsfonds voor Architectuur, Rotterdam,
Holland
The British Council, Köln
The Fund for U.S. Artists at International Festivals
and Exhibitions: United States Information
Agency; National Endowment for the Arts;
Rockefeller Foundation; Pew Charitable Trusts,
with administrative support by Arts International,
Institute of International Education
The International Programme of Moderna Museet,
Stockholm, Schweden
The Henry Moore Foundation, Hertfordshire,
Großbritannien
United States Information Service, Embassy of
the United States of America

Association Française d'Action Artistique
Ministère des Affaires Étrangères

The British Council

Gefördert von der **K**ulturStiftung der Länder
aus Mitteln des
Bundesministeriums des Innern

Colophon / Impressum

Herausgeber
documenta und Museum Fridericianum
Veranstaltungs-GmbH

Coordinating Editor / Redaktion und Koordination
Françoise Joly
Editors / Redaktion
Cornelia Barth *with* / mit **Jutta Buness**
English Editor / Englisches Lektorat
Brian Holmes

Texts / Texte
Paul Sztulman (P.S.)

and / und

Yan Ciret (Y.C.)
Bettina Funcke (B.F.)
Volker Heise (V.H.)
Jens Hoffmann (J.H.)
Brigitte Kramer (B.K.)
Simon Lamunière (S.L.)
André Lepecki (A.L.)
Suzanne Prinz (S. P.)
with / sowie **Oladélé Ajiboyé Bamgboyé, Yana Milev**
and / und **Reinhard Mucha**

Texts for 100 Days – 100 Guests /
Texte zu 100 Tage – 100 Gäste
Barbara Großhaus
Thomas Köhler
Nadia Tazi

Translations / Übersetzungen
French-German / Französisch-Deutsch
Jürgen Blasius
Gerlinde Beck
French-English / Französisch-Englisch
Brian Holmes
Warren Niedluchowski
German-English / Deutsch-Englisch
Pauline Cumbers
Ishbel Flett
Judith Rosenthal

Compilation of the Work List / Zusammenstellung
der Werkliste
Véronique Dabin
Isabelle Merly
Thomas Mulcaire

Proofreading / Verlagslektorat
Maria Platte
Christiane Wagner

Design / Gestaltung
Lothar Krauss

Typesetting / Satz und Repro
Fotosatz Weyhing

Production Coordination / Produktionskoordination
Stefan Illing-Finné

Production / Gesamtherstellung
Cantz Verlag

© **documenta und Museum Fridericianum**
Veranstaltungs-GmbH and the authors/und die
Autoren

ISBN 3-89322-938-8

Printed in Germany